The Asian Pacific American Heritage

GARLAND REFERENCE LIBRARY OF THE HUMANITIES
VOLUME 2109

THE ASIAN PACIFIC AMERICAN HERITAGE

A Companion to Literature and Arts

GEORGE J. LEONARD

Editor-in-Chief

DIANE ROSENBLUM

Editor

ROBERT LEONARD

Editor

AMY FELDMAN

Editor

STEFANIE KOHN

Associate Editor

THE ASIAN PACIFIC AMERICAN HERITAGE

A Companion to Literature and Arts

GEORGE J. LEONARD

Editor

GARLAND PUBLISHING, INC.
A member of the Taylor & Francis Group
New York & London
1999

Library of Congress Cataloging-in-Publication Data

The Asian Pacific American heritage : a companion to literature and arts /
 George J. Leonard, editor.
 p. cm.
 Includes bibliographical references and index.
 ISBN 0-8153-2980-6 (alk. paper)
 1. American literature—Asian American authors—History and
criticism. 2. American literature—Pacific Islander American
authors—History and criticism. 3. Pacific Island Americans—
Intellectual life. 4. Pacific Island Americans in literature. 5. Asian
Americans—Intellectual life. 6. Asian Americans in literature.
7. Ethnic arts—United States. 8. Arts, American. I. Leonard, George,
1946– .
PS153.A84A87 1999
996-dc21 98-33468
 CIP

Printed on acid-free, 250-year-life paper
Manufactured in the United States of America

Contents

Preface xiii
 George J. Leonard

Introduction xxiii
 George J. Leonard

PART I. FUNDAMENTALS

1. Reading Asian Characters in English 3
*Why "Chou" and "Zhou" Are the Same Word, and They Are Both
Pronounced "Joe": The Perils of Reading Chinese, Japanese, and Korean
Characters Transliterated into English; with Notes on Vietnamese and Thai*
 George J. Leonard

2. Characters: The Asian Ideogram Systems 15
An Invitation for Beginning Students
 George J. Leonard

3. Asian Naming Systems 29
*Is Du Xiao Bao Mr. Du or Mr. Bao? Chinese, Japanese, Korean,
Vietnamese, and Southeast Asian Naming Systems*
 George J. Leonard

4. The "Model Minority" Discourse 35
 Brian Niiya

PART II. THE FAMILY AND THE SELF

5. Confucius and the Asian American Family 41
A Personal View
 George J. Leonard

6. My Grandfather's Concubines 67
A First-Generation Woman Remembers Life in Peking
 Molly H. Isham

7. Japanese American Life in the Twentieth Century 85
A Personal Journey
 K. Morgan Yamanaka

8. The Nisei Go to War 113
The Japanese American 442nd Regimental Combat Team
 Brian Niiya

9. Being Nisei 119
Reflections on the Second Generation of Japanese Americans
"Building the Nisei-style House"—A Guide for Sansei
 Brian Niiya

10. Being Sansei 123
Reflections on the Third Generation of Japanese Americans
 Brian Niiya

11. First-Generation Memories 127
One Filipina's Story
 Salve Millard and Max Millard

12. Filipino American Values 139
 Daniel Gonzales

13. Korean American One-Point-Five 143
 Jeeyeon Lee

14. The Lizard Hunter 151
My Life as a Vietnamese Girl
 Thuy Tran

Part III. Roots, Traditions, and Asian Pacific Life: The Old Country and Its Cultural Legacy

15. Food and Ethnic Identity 171
Theory
Robert A. Leonard and Wendy J. Saliba

16. Chinese Food 181
Mary Scott

17. Japanese Food 189
Mary Scott

18. Filipino Food 197
Ed Romero, Dan Gonzales, Max Millard, and Salve Millard

19. Korean Food 199
Jeeyeon Lee

20. Vietnamese Food 207
Chuong Hoang Chung

21. Southeast Asian Food 213
The Durian and Beyond
Robert A. Leonard and Wendy J. Saliba

22. Tea 219
Kakuzo Okakura

23. Fengshui, Chinese Medicine, and Correlative Thinking 229
Mary Scott

24. Lunar New Year, the Moon Lady, and the Moon Festival 237
Molly H. Isham

25. Obon Season in Little Tokyo 247
The Persistence of Community
Brian Niiya

26. Filipinos and Religion 251
Salve Millard, Max Millard, and Marie Castillo-Pruden

27. Maoism and Surviving the Great Proletarian 271
Cultural Revolution
My Personal Experiences from 1966 to 1976
Molly H. Isham

Part IV. Asian Pacific Culture: Diaspora

28. The Chinese Diaspora 299
A Selection from the Work of Evelyn Hu-DeHart
Evelyn Hu-DeHart

29. The Arrival of the Asians in California 311
The Six Companies
Steven A. Chin

30. The Early History of Chinese, Japanese, 317
Koreans, and Filipinos in America
Brian Niiya

31. Chinatown, 1899 323
C.A. Higgins

Part V. Literature

32. Dialect, Standard, and Slang 333
Sociolinguistics and Ethnic American Literature
Robert A. Leonard

33. Dialect Literature in America 351
Theory
James J. Kohn

34. Roots 363
The Journey to the West
Mary Scott

35. Roots 369
Japanese Haiku and Matsuo Basho
 George J. Leonard

36. The Beginnings of Chinese Literature 377
 in America
The Angel Island Poems: Two Poems by Xu of Xiangshan
 Simei Leonard and George J. Leonard

37. D. T. Suzuki and the Creation of 381
 Japanese American Zen
 George J. Leonard

38. Asian American Literary Pioneers 395
 Jeffery Paul Chan and George J. Leonard

39. Asian American Literature 413
The Canon and the First Generation
 S.E. Solberg

40. First-Generation Writings 423
Younghill Kang and Carlos Bulosan
 S.E. Solberg

41. Asian American Autobiographical Tradition 427
 Brian Niiya

42. Frank Chin 435
First Asian American Dramatist
 Jeffery Paul Chan

43. Maxine Hong Kingston 439
 Amy Ling and Patricia P. Chu

44. A Reader's Guide to Amy Tan's *The Joy Luck Club* 447
 Molly H. Isham

45. David Henry Hwang 473
 Patricia P. Chu

46. A Reader's Guide to *Cebu* and *Dark Blue Suit* 481
Based on Interviews with Its Author, Peter Bacho
George J. Leonard and Diane Rosenblum

47. Jessica Hagedorn 497
An Interview with a Filipina Novelist
Joyce Jenkins

48. Lawson Fusao Inada 507
Japanese American Poet
Jeffery Paul Chan and George J. Leonard

49. Garret Hongo 513
An Interview with a Hawaiian Japanese American Poet
Jenny Stern

50. The Literature of Korean America 515
S.E. Solberg

51. The Korean American Novel 527
Kim Ronyoung
A Memoir by Her Daughter, Kim Hahn

52. Discovering Korean American Literature 535
The Manuscript of Clay Walls
S.E. Solberg

53. *Clay Walls* 537
The Great Korean American Novel
S.E. Solberg

54. Cathy Song and the Korean American 541
Experience in Poetry
Peering Through "Frameless Windows, Squares of Light"
S.E. Solberg

PART VI. THE ARTS

55. Chinese Opera 549
Mary Scott

56. Bernardo Bertolucci and 555
 the Westernization of *The Last Emperor*
A Conversation with Bernardo Bertolucci's Advisor,
the Emperor's Grand Tutor's son, Leo Chen
 George J. Leonard

57. A Viewer's Guide to Wayne Wang's **Dim Sum** 567
An Interview with Its Star and Co-Screenwriter, Laureen Chew
 George J. Leonard

58. Asian American Visual Arts 585
An Interview with Betty Kano
 Timothy Drescher

59. Story Cloths 591
The Hmong, the Mien, and the Making of an Asian American Art
 George J. Leonard

60. Toi Hoang 607
Painting and Healing
 Amy Feldman

61. First-Generation Painting 611
A Conversation Among Hung Liu, George J. Leonard, and Jeff Kelley
 Jeff Kelley

Appendix A. Asian Pacific American Chronology 619
 and Statistics
 Diane Rosenblum, with David Woo, Claire Eckman,
 Stephen Egawa, Debbie Lee, Galin Luk, and Max Millard

Appendix B. A Cultural Lexicon for Asian 643
 Pacific Studies
 Amy Feldman, Daniel Gonzales, and Geoffrey Nathan

Contributors 669
Index 681

Preface

The new American multicultural curriculum is one of the greatest challenges American education has ever faced. In the next few years reference librarians will be besieged by people seeking answers to new questions—besieged not only by students in the new multicultural courses, but by instructors attempting to teach multiculturalism for the first time.

When novelist Amy Tan refers to the "Moon Lady" or to the "Kitchen God," what does she mean? Is that "Confucianism"? Is "Confucianism" actually a religion? It's hard for a novelist to stop the plot and explain. Until we figure out that the Japanese American poet has used *"happa,"* a Hawaiian pidgin term ("half a") for someone half-white, half-Japanese, we are still in the dark. Is it a positive, a neutral, or a pejorative term? Are we reading irony or affection? Try to fit all that into a poem!

This book began many years ago when I took my class on ethnic literature to hear a fine young Japanese American poet. My mostly "Anglo" class could hear the beauty of his language, but the poems were unintelligible to them. Just a few casual, but important references to "my *issei* father," "the 442nd," "my *happa* child," and a curtain descended between the class and the poems.

Here we were, well-meaning modern people trying to escape the "Euro-centric" curriculum, trying to bridge the gap, and it wouldn't work. How is a student to learn?

What's more, not only the student, but the teacher/professor will be coming to ask the librarian for help. Multiculturalism is so new that few of us were educated to teach it. People who quite likely took their degree in Chaucer or Dickens will be asked to explain a reference to the Year of the Rat, nipa huts, Mu Lan, hangul, durians, the Great Cultural Revolution, or Basho's haiku.

If the student reading *Madame Bovary* is puzzled by a reference to Joan of Arc or to a "viscount," he or she can turn to Sir Paul Harvey's classic *Oxford Companion to French Literature.* But no such help exists for the student facing Asian Pacific American literature. (This volume follows the technical usage of the Association for Asian American Studies, of the LEAP Asian Pacific American Public Policy Institute, and the UCLA Asian American Studies Center in using "Asian Pacific" to refer to Americans with roots in Asia and the Pacific, from east of the Indian subcontinent to Hawaii. The largest "Pacific" group is the "Filipinos," as Americans with roots in the Philippine Islands are now conventionally designated.)

If we had written our 63 articles about 63 different authors, we would have to include, over and over, the same introductory explanations about the Confucian family tradition or Japanese internment, or Filipino folk religion. Instead we wrote long articles on *the topics that would unlock for the reader the greatest number of writers and artists now, and for years to come.* These are topics such as "Confucius and the Asian American Family," "The Nisei go to War," "Asian Naming Systems," "The Model Minority Discourse," "The Chinese Diaspora," "Tea," "Filipino American Values," and "Reading Asian Characters in English." We tried to create a *tool kit,* which the reader could use for a long time to come.

Although there are now single volumes dedicated to explicating authors such as Amy Tan or Maxine Hong Kingston, there is no Companion to the whole exploding field of Asian Pacific American humanistic studies, offering help with the greatest variety of authors and artists—those working now, and those that are going to appear. Our long specialized articles on Obon season, on Mao's Great Cultural Revolution, on the Korean alphabet, on Vietnamese food, on fengshui, and on Hmong needlework will help the user understand thousands of works now and for decades to come. We provide the *tool kit* to unlock the greatest number of authors and artists—now, and to come.

We have, to be sure, articles on the most-taught authors, and in all cases by great experts on them. If we write about Frank Chin, we have his former editor Jeff Chan discussing him. If we write about Maxine Hong Kingston, we have both Amy Ling and Patricia Chu. If we write about the Korean American classic, *Clay Walls,* we have the author's daughter, and the critic who discovered the author, each writing articles. If we write about director Wayne Wang's *Dim Sum,* his star and co-screenwriter explains her role; if we write about Amy Tan's *The Joy Luck Club,* the film's translator explains all the Mandarin expressions.

Timeliness, Usefulness

This is a crisis. The new American multicultural curriculum is one of the greatest challenges American education has ever faced. Not only have we mandated multicultural courses, but even the old courses are being given multicultural additions. A college course on romanticism now, to be modern, will try to include ethnic American authors. The anthologies add them as rapidly as they can.

Across the nation, school administrations and Presidential commissions have been telling teachers "do it" without telling them *how* they were to do it or even exactly *what* they were to do. Students, encountering literature and art from each other's ethnic cultures, have needed special help. Yet few people now teaching were educated to give the help needed.

The "Multicultural" Classroom: From Experts Teaching Insiders,
to First-Timers Teaching Outsiders

Our book is aimed at a new audience—the new multicultural classroom. This volume supports those students, instructors, and librarians facing this great change in the American canon.

I had to create the first photocopied versions of these articles for my classes because there was no reference work to which I could send *my kind of students.* I emphasize "my kind of students." Ethnic studies—itself so new—was being taught, and is still generally taught, by experts teaching insiders. The professors trained in ethnic studies were almost always people from the ethnicity whose works they were teaching. As it turned out, they were usually speaking to classrooms filled with students primarily from the same ethnicity. There was a lot that didn't need to be explained. The artist's weltanschauung was partly shared, or at least easily entered. Work, teacher, and class drew from a common store of experiences.

Instead of experts teaching insiders, the new mandated "multicultural" courses, however, will be taught primarily by first-timers teaching outsiders. The majority of professors will be people *outside* the ethnicity whose works they are teaching; speaking to classrooms filled with outsiders like themselves. I found myself in that situation in 1986, when—fresh from working with Los Angeles' Asian American community—I redirected some existing courses toward "multiculturalism."

Furthermore, many ethnic authors shuttle their action back and forth between two locales with which the new teacher will probably be unfamiliar: the

Asian American communities of America and the "Old Country" itself. Think of Amy Tan's *The Joy Luck Club*. Not only will teacher and student find themselves coping with unfamiliar parts of *American* experience, but with *Chinese* customs and experiences as well. Although it is highly unlikely the new teachers will speak Chinese, Tan's work, like Maxine Hong Kingston's, is studded with Chinese expressions, proverbs, and folk stories. The teacher will discover that the student who, reading the book at the beach two summers ago, permissively skimmed over everything she did not understand, is in a less forgiving mood when seated in a classroom. If you dare to stand in front of that classroom, you are Supposed To Know, and no one very much cares that you did your doctorate on Hawthorne.

There is serious peril here. John Dewey used to warn that the students are "always learning something" in class, but *not* necessarily what you wanted. They may be learning "math is boring" or "unlike me, boys do not have to raise their hands to speak." The new multicultural courses, taught by neophytes to outsiders, could wind up teaching them "even the teacher can't figure out these people," "nobody in class could guess why these people do these things," "I can't relate to people like this." It would be tragic if all the effort spent on enlarging the curriculum only ended up reinforcing a stereotype that Asian Americans are "mysterious" and "inscrutable."

Excellent critical works exist, but they assume the older ethnic studies situation, in which experts address insiders. The essays are more often *arguments* than *information*. They are not enough help for *first-timers bravely trying to teach outsiders*.

Humanities Students Have Different Needs

As if all that were not difficult enough, the new multicultural courses are generally taught by exposing students to literature or arts, albeit with reference to the political, sociological, and historical contexts of the works.

There are some reference works, such as the *Harvard Encyclopedia of American Ethnic Groups,* that address the needs of social scientists and historians. For years, however, I looked for reference works organized to help my liberal arts students comprehend ethnic literature and arts.

Books meant to help people reading novels, watching films, or confronting artworks must include *much different information than books meant simply for social scientists.* Indeed, standard reference works can lead the humanities student seriously astray. Imagine a student from Beijing trying to learn about Easter from, logically enough, fine books such as the *New Dictionary of Theology* or the *Maryknoll*

Catholic Dictionary. "The solemn celebration of Christ's resurrection, which begins on Holy Saturday night and includes the blessing of the paschal candle. . . ." Wouldn't the student conclude that Easter in America was a "solemn" and awesome time? How then, to decipher literary references to the Easter Bunny, or Easter bonnets, or kids coloring eggs for Easter baskets, not to mention Irving Berlin's *Easter Parade* (a Jew writing famous songs about *Easter?*). "Solemn celebration of Christ's resurrection" would be—if taken by itself—actually an obstacle to understanding American Easter's music, literature, and films.

I asked our contributors always to remember that humanists needed not only *more information,* but *different information,* than social scientists. Even when the subject matter of the essays overlaps topics in social science references, the content and emphasis will be quite different.

Special Features

This volume was edited under the supervision of distinguished advisory editors from the community. Many of the authors, who comprise a "Who's Who" of Asian Pacific American humanistic scholarship, are the founders of their disciplines. Our authors offer help on a variety of levels.

For Students
Each section contains articles that are popularly written and accessible, even to high school students.

For Instructors New to Asian Pacific Studies
Other articles are aimed at the person at the front of the classroom who is trying to teach a multicultural course for the first time—a person who, given America's demographics, is probably not an Asian Pacific American.

For Advanced Users
Each section contains articles by unique authorities in their field, articles so original or so definitive that even experts will be grateful to have them.

The articles address women's contributions in detail. They analyze not only books but drama and films, not only painting but cuisine and textile arts. The articles are written in varying genres, for sometimes a first person memoir can humanize and personalize a cultural custom better than a work of formal scholarship.

Since we assume that this is one of the first books people will be using in what will be a continuing self-education in the new American canon, we encouraged all our authors to add, when appropriate, an annotated Further Reading section at the ends of their articles, or to incorporate such advice clearly within the work. We have also added an appendix providing a detailed chronology detailing useful statistics of the Asian Pacific American experience.

Each article makes a special effort to build the user's cultural vocabulary. We encouraged the authors to define as many terms and concepts as possible in their writing. This volume also establishes a lexicon of key terms that inform the Asian Pacific American linguistic universe. Alphabetized in a separate Cultural Lexicon, these terms appear in the chapters in bold type.

Notice too, that we speak here of *Arts,* plural. Many ethnic cultures, and the women in them, practiced arts that were, until recently, dismissed as "crafts."

Daring To Do It

Ethnic studies frequently involve politics, and hot politics at that. It makes for fascinating classes, classes students look forward to, classes in which people who never talk at all suddenly argue points as if their lives depended on it, classes in which silent immigrant newcomers are suddenly turned to as experts and listened to with respect, classes in which friendships form across racial and ethnic bounds. No bones about it, it can be dangerous to teach classes that excite students that much. But people who rely on this volume can lead those classes with confidence.

The first obstacle to multiculturalism is that most of us were not educated to teach it and information has been hard to come by. The second obstacle is that the topic is so politicized, we wonder if we even *dare* teach it, even if we are of the ethnicity we are teaching. When teaching a newer canon means having to undertake a second education, who could blame people for deciding it's just not worth it?

Our book overcomes these obstacles by giving the person at the front of the classroom a reference work constructed according to a rigorous methodology. All the authors are not only renowned in their specialties, most are from the ethnic group being written about. Absolutely everyone was nominated by or worked under the direct editorship of distinguished advisory editors from that ethnicity.

Furthermore, all authors worked with novel and unique freedom. You cannot just *talk* about multiculturalism, you have to *do* multiculturalism. For that reason I refused to impose a "house style" on the authors, aside from a few agreements about typography. You cannot create a book celebrating America's many voices and then try to homogenize them—cannot celebrate diversity by pouring their essays into the old prose melting pot.

I do not by any means wish to imply that only scholars from an ethnicity can write about its art. Each perspective has value and validity. However, I do claim that, by having leading scholars of a particular ethnicity *supervise,* we produced a portrait of what *they* think their emerging canon is, and what topics *they* think need to be understood. We have all thereby gained something historically valuable.

I hope the wealth of information in this volume will newly encourage people to break out from the old canon, to dare teach exciting new works, to dare discuss in class the most controversial, and important, topics in America today. I repeat: For too long everyone has been telling teachers *"do it,"* without telling them *how* they are to do it, or even how they would be protected if they tried doing such a risky thing. This volume will help them dare do it.

A Personal Note

I confess to a personal agenda. I have a son—half-Jewish, half-Chinese, all-American—and I don't want him, or anyone else's sons or daughters, growing up studying a curriculum that marginalizes or trivializes them. This work, then, has been a labor of love.

There is nothing new or radical about multiculturalism. It is the logical continuation of the Western humanist project. The finest art works, the poet Shelley claimed, have a power no polemic has: they make us human to each other. "The great secret of morals is love," Shelley argued. By enlisting our imagination, art can put us "in the place of another, and many others," so that the "pains and pleasures" of all humankind become "our own" (*A Defence of Poetry,* 1821). This volume will, I hope, help ethnic art works "leap the gap" to the wider audience and accomplish that noble goal—long a central goal for the best spirits in Western culture.

George J. Leonard
San Francisco, 1998

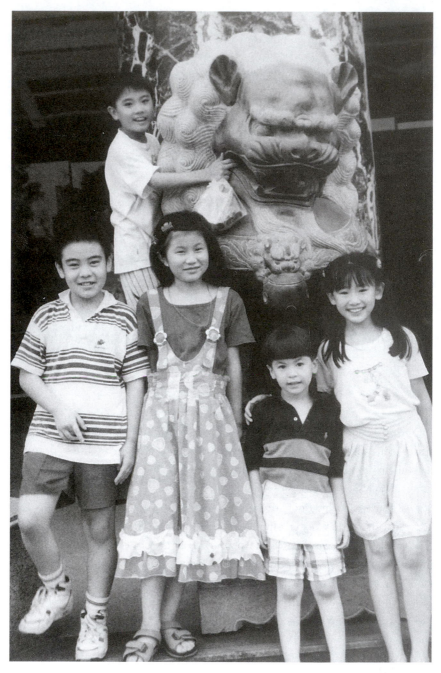

Figure 1: The author's son (second from right) with cousins and friends.
Photo by Simei Leonard. Courtesy of Simei Leonard.

This seven year labor of love was for my son,
Andrew Charles Leonard

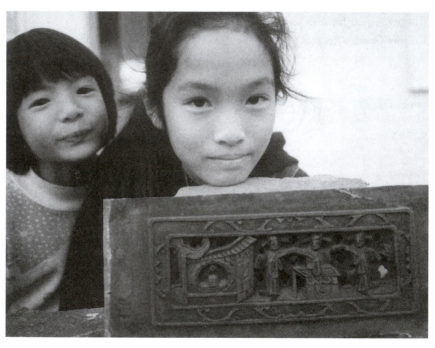

Figure 2: The Asian Pacific cultural heritage: Two modern Asian Pacific American girls with a Qing Dynasty carved wooden panel, San Francisco, 1996. Photo by George J. Leonard.

Introduction

GEORGE J. LEONARD

This introduction continues the discussion begun in the Preface. I hope the reader will start with the Preface, which not only describes the theory behind this volume but also describes special features it contains.

Methodology

My advisory editors and I faced various methodological questions, which I'll summarize here.

Whenever a question arose, we always thought back to *the user's situation*— to how the work would actually be used. This is not a sociological work. This is a work supporting multicultural arts and literature courses—new ethnic American literature and arts—American literature, written in English, not Asian literature, and primarily works created since 1970. The user will have encountered a specific work of literature or art in a course and will need help understanding (most frequently) the cultural context of some passage, some word, something. He or she will have come to the resource person (instructor, reference librarian) for that help.

The first question my advisory editors and I faced was the question of fairness to the different Asian Pacific ethnicities. If there is an article on a nationally known Chinese American novelist and a nationally known Japanese American novelist, one's instinctive reaction is to say that, to be fair, there should be an article on a nationally known Cambodian American novelist. While that method sounds "fair," it ignores an important, often stated truth about Asian Pacific America—how divergent a group of ethnicities the umbrella term has had to include. The Cambodian Americans, for instance, simply have not had much time

to produce a nationally known novelist, writing in English. The median age of Cambodian Americans is 4.7 years old. In 1990, 91 percent of Cambodian Americans were under the age of 10. The 13,266 individuals over the age of 10 were almost entirely first-generation immigrants who, if they were writing in English, would be writing it as a foreign language. "Asian Pacific America," Bill Ong Hing summarizes, "is tremendously diverse." (1990 Census of the Population, Five Percent Public Use Microdata Survey, cited in Bill Ong Hing and Ronald Lee, eds. *The State of Asian Pacific America: Reframing the Immigration Debate,* Los Angeles: LEAP Asian Pacific American Public Policy Institute and UCLA Asian American Studies Center, 1996, pp. 3, 48.)

Chinese Americans, by contrast, arrived in America almost simultaneously with the Irish and the Germans, half a century before the Jews and Italians arrived en masse. Japanese Americans began arriving not long after the Exclusion Act of 1882 set great restrictions on the Chinese. The Chinese Americans and Japanese Americans, accordingly, simply have had much more time, and sufficient numbers, to produce masters of English prose fiction than, say, the Cambodians. It implies no disrespect to the Cambodian Americans to take note of this.

Indeed, it implies some disrespect for the hardships the Cambodian Americans have overcome to be asking them, at this stage, where their English language novelists are. As Gen Leigh Lee has pointed out, "Nearly all Cambodians who have arrived since 1979 are survivors of war and genocide." (We could say the same of other Southeast Asian groups.) Yet even though the Cambodians "arrived penniless," the vast majority from an "agricultural background," their hard work and powerful family loyalties have led them to "dominate," as the *Wall Street Journal* put it, at least one industry in California. They now own 80 percent of the donut shops in California, and there are nearly 2,450 Cambodian owned stores. (Gen Leigh Lee, "Chinese Cambodian Donut Makers in Orange County: Case Studies of Family Labor and Socioeconomic Adaptations," *op. cit.* pp. 205–219.)

My editors and I look forward happily to the day, only 10 or 15 years from now, when the English-speaking children of those resilient and hardworking people start making their mark on American literature. It is as inevitable as the sunrise. We will eagerly revise our article list to explicate their novels.

For now though, the presence of articles about two Chinese American novelists—Amy Tan and Maxine Hong Kingston—although no article on a Cambodian American novelist appears, simply reflects the different historical situations. Space was not allocated mechanically, so many pages to each ethnicity,

however diverse their situations. We are here to help our users. We include information to help people understand the existing works of literature and art that they are most likely to encounter in a multicultural course during the next decade.

It is an unavoidable effect of America's political history—which led to a certain demographic history—that Asian American literature has been Chinese American literature and—later, and to a lesser extent—Japanese American and Filipino American literature. Nor was Chinese American dominance purely a question of their earlier entrance or greater numbers. We must not forget how differently World War II affected the communities. The thriving Little Tokyos were erased from the American map, their citizens forced to sell all their possessions within 48 or 72 hours and enter concentration camps. Simultaneously Chinese Americans, as Jeff Chan reports in this volume, found to their amazement that China's brave fight against the Japanese aggressors had changed China's status in America from "Yellow Peril" to Heroic Ally. Media titan Henry Luce, entranced by Chiang Kai Shek and Madame Chiang Kai Shek, threw *Time* and *Life* behind the Chinese people, who became his special project. The changed climate immediately led to a spate of books about and by Chinese Americans—a period that culminated with a Chinese American novel reaching 1950s Pop Apotheosis: it was made into a Rodgers and Hammerstein musical, *Flower Drum Song*. By contrast, no Japanese American author found, or could find, such fond interest in the eyes of the broad American audience.

Our book, then, does not pretend that the terrible injustice of the Japanese American concentration camps did not happen. All such factors affected, and still affect, the cultural output of the victimized groups. At the end of the 1990s, a book explicating nationally known Asian American literature and arts will still find itself explicating more Chinese American work than work by other groups. Since we include sociological or historical articles only as background to the literature and arts, that also means—for now—more articles on the Chinese and Chinese American cultural context.

However, even by the next edition of this book, we expect that to change. In 1990, 22.6 percent of the Asian Americans were Chinese Americans, but the Filipinos, at 19.3 percent of the total, were close behind. Within 10 years, the percentage of Cambodians—just as an example—who write English as their native language, will increase from about 10 percent to 90 percent, and the same will happen with more than 600,000 Vietnamese Americans. In this edition we already have included a variety of Korean American articles that 20 years ago there would have been no urgency to include. Asian American literature and arts, 20

years from now, will have diversified to reflect the diversified historical, statistical, and socioeconomic conditions.

A second decision we faced in organizing this book was more subjective. If we decided we could allot 150 pages to Asian American writers, say, we might have decided to give 15 writers 10 pages each. Again, when we thought of the users' actual situations, we decided otherwise.

From all the heated media discussion, you would think that the traditional curriculum was about to be thrown away. Even when multicultural courses are required for graduation, however, they are still getting, at best, a semester of the student's time. This means that in the few weeks, at most, that an omnibus course could devote to Asian America, there would be—again, at most—two novels assigned. For the next decade, that virtually guarantees that those novels be by Amy Tan and Maxine Hong Kingston. The Modern Language Association reports them the most frequently assigned now; Kingston's headstart and Tan's popular appeal make them hard to beat. Users will be asking questions about, and professors and librarians are going to be fielding questions about, those books. Tan's *The Joy Luck Club* comes complete with an excellent, and successful, Hollywood movie. Her youthful heroines face problems the classroom audience faces, finding romance and dealing with manipulative moms. The teacher trying to humanize an unfamiliar culture to a classroom filled with young people falls into *The Joy Luck Club*'s arms with relief. (In schools where the ethnic writers are "mainstreamed" into general literature courses, competing with Whitman, Melville, and Dickinson for space, the likely outcome is worse: Tan or Kingston, not both.)

We'll come to the researchers in a moment; but what the students need most is not a smattering of information about 15 writers—13 of whom, sad to say, are unlikely to be assigned. They need a lot of help with Amy Tan and Maxine Hong Kingston, and there should be back-up articles at higher levels of difficulty intended for the instuctor and advanced students. On the chance that time permits the instructor to go beyond, or that they try (through classwork or individual term projects) to situate the main authors within the general discourse, we included the most likely other candidates: Okada (Japanese American), Hagedorn and Bacho (Filipinos), Kim Ronyoung (Korean American) and some others. But Tan and Kingston received a far greater amount of space.

To determine what advanced researchers would need, we asked Rhona Klein, a reference librarian advising us, to design a computer search of the PMLA *(Publication of the Modern Language Association)* since 1970. Asking questions such as "Maxine Hong Kingston and . . . " and "Asian American authors and . . ." and

then counting the number of "hits," we learned where the interest of researchers has been going and allocated space accordingly. (This method, by the way, gave some "hard statistical evidence" that the vast majority of scholarly interest still centers on Chinese American and Japanese American authors.)

Thus were our choices made. Whenever in doubt, we remembered who would be using the book, and the pedagogical realities for instructors and librarians alike that would result.

How the Work Is Organized

As the Preface has explained, although our book concerns Asian Pacific American literature and arts, the teacher and class would also need help, we saw, with the larger cultural experience from which the work grew. That meant we would have to include several kinds of material, which we have grouped in several broad sections. (Please remember that users, in practice, will not be reading the work sequentially.)

Part I: Fundamentals

The first section covers material so basic that no research can be done without it. If you do not know that the Chou dynasty mentioned in your 1970s novel is the exact same dynasty as the Zhou dynasty mentioned in your 1990s critical work, you will be hopelessly confused. If researchers are unaware that Vy Trac Do's family name is Vy, not Do, they will not be able to look him up.

Part II: The Family and the Self

In the second section people write about themselves—as individuals and as members of families—and what they have lived through and endured. The first generation looks back to the Old Country, the customs they loved, the troubles that encouraged them to leave, and to what they achieved and endured when they arrived in this country. The next generations meditate on their existential situation, on what it means to be the American children of such parents. We made a conscious decision to ask authors to tell as much as possible in personal anecdotes and to use humanizing narrative genres that enlist emotions, identification, and sympathy. Simultaneously, authors were encouraged to include as much cultural vocabulary as possible, with definitions. Editors—and sometimes teams of editors, working for up to a year—enriched the narratives by blending in precise statistics, exact names, and dates. The authors,

themselves authorities in their fields, then revised, checked, and approved all added factual matter.

Part III: Roots, Traditions, and Asian Pacific Life:
The Old Country and Its Cultural Legacy
Ethnic works of art, like Tan's and Kingston's work, frequently shuttle back and forth between the Old Country and the new, and between the old neighborhoods where the immigrants landed, and the assimilated present. This section answers the cultural context questions which, in the course of our teaching, we have most often had to answer. It begins with chapters on food and ethnic identity, starting with a theoretical overview by a sociolinguist who specializes in cuisine. In Asian American literature as in all other, families naturally congregate in countless dinner-table scenes. Food is endlessly used as metaphor and as cultural marker. The later chapters address religious and cultural "traditions," the cultural celebrations and religious practices most likely to be encountered in the literature and arts. We include Maoism with the religions in this section.

Part IV: Asian Pacific Culture: Diaspora
This volume, in sum, starts with the self and then moves outward through the world in which the self finds itself, a world it both creates and by which it is created—first in Asia, then during the shocking transition to the United States or in families changed by that transition. In this section we address the works that flower from all this cultural cross-pollination. Articles concern the Asian diaspora, the transition to this country from the old. Then we divide the cultural products flowing out of Asian Pacific America into two broad working classifications. First comes:

Part V: Literature
This section is arranged chronologically from methodology through the formative years to the "high tide," the years when Asian Pacific authors were discovered by an appreciative national audience. The next broad class is:

Part VI: The Arts
The section on arts first presents the performing arts and is followed by writings on the fine arts. Although our topic is Asian Pacific American works, both this section and the section on literature begin with those Old Country folk arts or themes that Asian American artists have most frequently used for inspiration.

Appendices: Useful Information: Statistics, Chronologies,
and Definitions of Important Terms

The appendices centralize, for convenience, the data most relevant for the understanding of Asian Pacific American literature and arts. (It helps, for instance, to know that the median age of Cambodian Americans is under 5 years old.)

Appendix A, "Asian Pacific American Chronology and Statistics," presents relevant data about the communities. More than a simple time-line, it is another way in which we bring out the growth, evolution, and histories of the communities.

Appendix B is a glossary, "A Cultural Lexicon for Asian Pacific Studies," that deals with those words that occur in a variety of articles. However, each article serves as a cultural lexicon too. Contributors were encouraged to include and define as many significant terms as possible. Terms which appear in this Lexicon have been placed in boldface type.

Contributor biographies appear at the end.

A note on romanization: Throughout this volume, articles use whichever romanization (spelling of the Chinese sound in English) the readers will most likely encounter in their assigned texts. For the next decade, the assigned versions of the *Analects* will probably continue to be older versions, like Arthur Waley's, using the Wade-Giles system. The Confucius article, therefore, avoids writing Kong fu zi, though that romanization is more accurate, and recent.

<div style="text-align:right">

G.L.

San Francisco, 1998

</div>

At last the New arriving, assuming, taking possession,
A swarming and busy race settling and organizing everywhere,
Ships coming in from the whole round world, and going out to the whole world,
To India and China and Australia and the thousand island paradises of the Pacific. . . .

I see in you, certain to come, the promise of thousands of years, till now deferr'd
Promis'd to be fullfill'd, our common kind, the race.

The new society at last, proportionate to Nature,
In man of you, more than your mountain peaks or stalwart trees imperial,
In woman more, far more, than all your gold or vines, or even vital air.

(from Walt Whitman, "Song of the Redwood Tree," *Leaves of Grass*)

Part I

Fundamentals

Reading Asian Characters in English

Why "Chou" and "Zhou" Are the Same Word, and They Are Both Pronounced "Joe": The Perils of Reading Chinese, Japanese, and Korean Characters Transliterated into English; with Notes on Vietnamese and Thai

GEORGE J. LEONARD

One of the most respected English professors in the world once remarked confidently to an audience that he had become more multicultural, and had recently been reading Qing Dynasty poetry. He pronounced it, "Kwing." Presumably he thought the Qing dynasty and the Ch'ing dynasty were two different dynasties. They are not, and they are both pronounced, simply, "Ching." Why the bizarre spellings then? Spellings so unexpected they confuse even great scholars? Students will not get far if they think Qing and Ch'ing are different eras. In this essay I address myself to the professor who will have to deal, as soon as books are assigned, with this pedagogical emergency. I will discuss Chinese, then Japanese and Korean romanizations—the literature of the three most populous groups of Asian Americans with transliterated Old Country languages.

The colonial heritage makes it unnecessary to devote similar attention to the Filipino or Vietnamese. Colonialism led the Philippines to use a romanization worked out by the Spanish; and led Vietnam to use a romanization (called *quoc ngu*) worked out by a French missionary, Alexander de Rhodes, in 1651, and enforced by the French when they closed the China-oriented civil service schools earlier in this century. Vietnam is the only country in Asia using romanized letters. Thailand's situation will be more understandable when we know Korea's.

Chinese

Not only "Ch'ing" and "Qing," but "Zhou" and "Chou" are the same dynasty as well, and the latter two are both pronounced like the English name "Joe." As American students move from book to book during an introductory course, they become confused, as Zhou in one book changes to Chou in another, and all the philosophers,

titles of books, and names of artists shift under their eyes. If only for that reason, when studying Chinese topics, the professor must start the class by identifying which system of "romanization" he or she will use—and insist the class follow it. He or she should also insist, when the reading is assigned, on the whole class using one translation only—if only to avoid orthographic confusion.

The problem: there currently is no good **romanization** of Chinese—a method of spelling out Chinese sounds into our alphabet. The older, still most widely used version, the Wade-Giles romanization, is so bad it is comic. Its defenders argue, at best, that it was conceived back when Asian studies was the province of specialists and experts, who had the time to learn Wade and Giles fine distinctions. Others, less charitable, actually have hinted that Wade and Giles were not unhappy about how convoluted their romanization was, for it meant that only professional Chinese scholars like themselves would ever pronounce the Chinese sounds correctly.

For instance, the most important virtue for Confucius is spelled, in Wade-Giles, "jen." American readers pronounce it, naturally, like the first syllable of Jennifer. How do you think that "j" is supposed to be pronounced? Were they thinking of "j" in German, pronounced like "y"? No. As in Spanish, like "h"? No luck. Wade-Giles used a "j" as their symbol for the "r" sound at the beginning of words like "rip." The Confucian term is pronounced "ren."

Watch how the damage unfolds. Wade and Giles have used up the letter "j" to mean "r." How will they spell the name of the Taoist philosophic classic, which is pronounced Dao de Jing? They have used up the "j". So for the "j" sound they use "ch."

Why? I have no idea. They have to spell Dao de Jing as "Tao te Ching." They also, you'll notice, chose for some reason to spell the "d" sound with a "t." Generations of Americans have called the Dao the "Tao" (and soybean cake, dofu, "tofu.")

To recap, having used up "j" on the "r" sound, they then—for the "j" sound—used up "ch." So be it. But they're only painting themselves further into the corner. Having used up "ch" how can they spell the dynasty whose name starts with the "ch" sound, the Ching dynasty? Their amazing solution: when they print "ch" with an apostrophe in front of it, just say it the way you normally would. So the Ching dynasty they write Ch'ing.

Everyone, naturally, sees that strange apostrophe, thinks the Chinese must pause for a second in the middle of the word, and says "Ch . . . ing," two separate sounds. But all the apostrophe means is, "this 'Ch' you shouldn't say as 'j' but the way you usually say 'ch.'" If you must resort to an apostrophe, would it not have made more sense to add the odd apostrophe when you are *not* supposed to say it

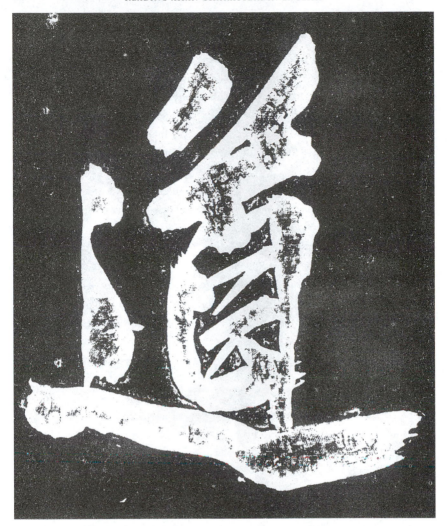

Figure 1-1: The character for the Tao (also transliterated "Dao"). Rubbing from Yuan Dynasty century stone tablet text of Tao te Ching (also transliterated "Dao de Jing"). Courtesy of George J. Leonard.

the way you normally would? Why should the *odd* spelling symbolize the *normal* pronunciation?

Alas, the name of the country was China, and the language, Chinese. According to their logic, Wade and Giles should now ask us to spell those two words "Ch'ina" and "Ch'inese." At this point Wade and Giles threw in the towel and said, "But go on spelling China and Chinese the way they have always been spelled, even though it violates our system." Chaos. (Or, ch'aos?)

The proof that Wade-Giles has been a catastrophe is that many authors have felt they had the right, even the duty, to make up a simpler system of their own. Then, in the 1950s, the Communists developed a new romanization called **Hanyu Pinyin** (or "pinyin" for short) which avoids many of the Wade-Giles problems and is increasingly used throughout the West.

Pinyin is better, and is becoming standard in newer books. Ren is, mercifully, ren, not "jen." But there are still symbols that Americans find difficult: *Q* like "ch" in "cheese"; *X* like "sh" in "sheep"; *C* like "ts" in "cats"; *Zh* like "dg" in "edge."

That is how the Ch'ing dynasty became the Qing dynasty and befuddled the famous professor. That is why Chou in an old book is Zhou in the newer ones, and it is still pronounced Joe. (Even closer than a "j" would be the harsh grinding sound made at the start of the name George.)

All these romanizations, from Wade-Giles to pinyin, only capture the way one of the eight main Chinese languages pronounces these words: **Putonghua**, the language of the North, of Beijing, of the Emperor's city, and his ruling class—the language we call "Mandarin." It is more accurate to say that Chinese is the name of a language family, like the Romance language family. Cantonese is as far from Mandarin as Spanish is from French. A 1955 People's Republic of China (PRC) government conference estimated that 71.5 percent of Chinese spoke Mandarin, while the second most common *fangyan*, "regional speech," accounted for only 8.5 percent and behind that came Cantonese with only 5 percent. Pinyin does not represent the sounds of any language but Mandarin. (Among American Chinese, however, Mandarin is not the most common. Until recently, 95 percent of American Chinese came from the six counties around the southern seaport of Canton, or Guangdong, and the language there was primarily Guangdonghua, which we call Cantonese. Toishanese was spoken frequently nearby, as well, and is in the United States as a consequence.)

Everyone in China has to study Mandarin in school, and all now learn pinyin as well as Chinese characters. Mao decided some central language, some *lingua franca* was needed, and decreed it would be Mandarin, the language of the Northern majority and of the capital.

To further complicate matters, Chinese dialects within the languages are further apart than dialects within English. It is only as far from Beijing to Shanghai as from San Francisco to Los Angeles, but the difference in their Mandarin is about as wide as the difference between the English spoken in California and in Scotland. I've watched Shanghaiese listen to a Beijingese, slowly repeat what they'd heard, mulling over the sounds, then suddenly exclaim "Ai-ya!" and understand.

Worst of all, the Chinese languages (or "regionalects," to use a more precise term) are tonal languages, and the same sound, said four different ways, means four things. Two different tones, two different words: the difference between Oh? and Oh! Pinyin tries to cope with the tones by using a series of accent marks but American books often omit them as just too much to handle. That means, however, that you'll read of Confucius' love for *li, courtesy/ritual*, and a few pages later of his opponent's (the Law and Order School's) belief in *li, force*. Confucius' li was said like a skeptical "li?" and his opponents' li was said like an emphatic "li!" The two tones make two different words—indeed, two opposing philosophies!

To avoid conflicting romanizations, the professor, if books are assigned, should insist the class all work from one translation. There's another reason. Chinese translations can legitimately differ from each other much more widely than two translations from, say, French into English, legitimately can.

Here are two translations from the Tao te Ching, Chapter 6:

The valley spirit never dies;
It is the woman, primal mother.
Her gateway is the root of heaven and earth.
(Feng and English)

The Valley Spirit never dies.
It is named the Mysterious Female.
And the Doorway of the Mysterious Female
Is the base from which Heaven and Earth sprang.
(Arthur Waley)

Is the valley spirit "primal mother" or Mysterious Female? There is a difference! In the first translation, her gateway "is," present tense, right now, the root of heaven and earth. But in the second, the Tao seems to be talking about a cosmic event long ago, the origin of "Heaven and Earth," some sort of creation myth: "the Doorway of the Mysterious Female is the base from which Heaven and Earth sprang."

Yet neither translation is wrong. The Chinese text permits both of them, and indeed, many others. It has to do with the great differences between Chinese and English. Chinese has no plurals, no "a" or "the," often avoids verbs, and has only the present tense. You put time first in a sentence to specify when something happened. We sometimes do that too: "Yesterday I'm walking along the road and

I see a girl walking toward me." The Chinese say that, in effect, to create a past tense. To create a future tense, they say something like, "Tomorrow, I'm walking along a road and I see a girl walking toward me." So literary texts can justifiably be translated many different ways. The Chinese sentence to be translated literally says, "He/she/it says/said/will say to him/her/it . . . ," and the translator has to pick the wording that makes the most sense.

Choose one translation; be aware from the start which romanization it uses; compare it with other translations if it seems odd. Chinese affords tremendous room for interpretation and many translators take advantage of it. Be particularly wary if the translation seems surprisingly trendy. Chinese gives plenty of room for a translator who is grinding some axe to turn ancient Chinese sexists into feminists, or pacifists, or whatever the soup du jour is. Watch out for "orientalism," for hippie translations full of mystic magic mumbo jumbo and, equally suspect, for yuppie translations that turn an old general like Sun Tse into a CEO giving tips on how to run an office.

Japanese

Fortunately, no other Asian language presents romanization problems as great as the Chinese situation.

The story of other Asian writing systems is, by and large, the story of that language's scholars wrestling with Chinese characters. In the first round of the battle, the Rome-like political and cultural splendor of Chinese civilization thrills the country's intellectuals. They note that the Chinese ideograms stand for ideas, not sounds; that different Chinese speakers already make very different sounds in response to the ideograms. Why should not Korean, Japanese, Vietnamese, or Thai scholars borrow Chinese ideograms to symbolize their ideas too? Why not, as it were, learn to use the "Microsoft Windows" of Oriental languages to tap into the vast library already written in that language and simultaneously be able to communicate not only with one's countrymen, but with everyone in Asia using that vast Chinese system? In the next round, that dream too often turns into a bad dream. The Chinese characters won't fit the grammar of the aspiring scholars' language. Or national/ethnic pride grows: politicians protest. In the final round, the scholars forge a happy synthesis, or banish the Chinese characters, or learn to live with them.

Luckily, it is not our job to describe the growth of several Asian writing systems. A sketch will alert the reader to the subject's complexity. We only need to suggest why romanization worked better or worse for these languages than it did for Chinese.

The Japanese had, as yet, no written language, when Chinese and Korean emissaries began going there in significant numbers, toward the end of the Han dynasty (the later third century A.D.). The Japanese adopted, at first, Chinese characters, and in a way, that was bad luck, since Japanese is even less related to Chinese than Latin is to German. Japanese and Korean, its closest relative, both belong to the Altaic language family, whose members include Mongolian, Manchu, and even Turkish. Japanese is not even a tonal language. Chinese characters, designed for that language at first, fit Japanese needs poorly, as I will describe. (Nonetheless, some 1,945 Chinese characters are still in everyday use and taught in the schools. There are, in addition, a much smaller number of characters the Japanese invented themselves.)

The characters' name in Japanese, *kanji,* simply means "Han Chinese characters." For instance, the symbol for "sun" was borrowed, but a Japanese would say a Japanese word, "nichi," seeing it, instead of the Chinese word. That method of borrowing worked well enough for many familiar nouns and verbs, but Chinese lacks as many grammatical features of Japanese as it does of English. English speakers might borrow the Chinese character for "sun," for instance, but what would we borrow if we wanted to write "-ing" on the end of a word, or use a tense like "have had," which doesn't exist in Chinese? If we were to borrow the Chinese symbols whenever we could; and when we could not, invent an alphabet in which we could write out "-ing" and "have had," then use both systems together at once; we would have a solution similar to Japan's successful one. The Japanese developed, not one, but two alphabets of syllables ("syllabary") to flesh out the Chinese characters. In the 700s a 48-character syllabary, *katakana,* was created, mostly for foreign loan words and names. It was soon found useful to link the 48 characters of katakana (marking foreign words) with yet another 48-character syllabary, *hiragana,* to deal with grammatical situations like the one described above. Collectively, the two syllabaries are referred to as **kana.** Each symbol represents at least two letters, instead of one, as our alphabet does. "Sa" "Su" "Se" and "So" each get a symbol unto themselves. It is assumed that goju-on, the "fifty sounds," are the basis of the entire Japanese language. Japanese schoolchildren start by learning hiragana, and books for them are written entirely in hiragana. They add katakana and kanji as they grow older. The Japanese system sounds as complex as English spelling. In practice, both work well.

Sticking to the topic at hand, romanization, now the reader can better understand why Japanese has not been nearly as hard to romanize into English as Chinese has been. Since Japanese, unlike Chinese, is not tonal, and does already include alphabets of syllables, it was a closer fit. Add to that, that unlike Chinese,

with its great variety of languages and dialects, Japanese, concentrated in one smallish island chain, has fewer regional variations to contend with. The "Hepburn" romanization is the accepted standard.

Korean

The early history of the Korean written language shows the same understandable desire to tap into the Chinese cultural network by adapting Chinese characters to Korean words. Korean, like Japanese an Altaic language, was also too different from Chinese for the fit to be smooth. Unlike in Japan, however, a strong nationalist party in Korea actually succeeded in replacing the old system with an alphabet of syllables (syllabary). **Hangul** is simpler and more rational than the Western alphabet—so much so, that you can learn hangul in a few days. In 1443 the Korean academy, encouraged by Korea's greatest king, King Sejong (ruled 1419–1450) created a 28-letter syllabary, Chongum, which would eventually come to be known as hangul. Sejong himself wrote in his 1446 promulgation of hangul that the new writing was intended, not to replace the Chinese classical characters and their texts, but for "the convenience for daily use of the ignorant people." The popular as well as nationalist fervor behind Sejong's revolution is unmistakable. The Korean literati immediately protested, claiming that adopting this "vulgar" writing would mean "throwing away Chinese culture and proclaiming ourselves Barbarians." By now Koreans see their unique writing system as a national symbol. When the Japanese occupied Korea early in this century, they suppressed hangul and forced them to use Japanese-based writing systems. When America defeated Japan and Korea was liberated, Koreans made the day they readopted hangul into a national holiday—one very popular today.

Hangul is indeed an admirably rational and even a witty writing system. The symbol used for "n" represents a sideways view of the tongue making an "n" sound, touching the inside roof of the mouth. Similarly, the sound for "t" is represented by the tongue taking that position, and sounds made in the throat include a picture of one. The "s" sound shows a tooth, to remind you of the "s" blowing over it.

Again, this brief introduction gives far from the whole story. Hangul does have alphabetic elements as Japanese hiragana and katakana do; but in practice it is a syllabary and easier to romanize than Chinese. Unhappily, it is the consonant sounds of Korean that have proved a great obstacle. Korean abounds in sounds, like the unaspirated "p" at the end of the English word "lip," for which

English has no separate letter. The Korean "p" sounds like their "b" to us, their "l" sounds like their "n," their "g" sounds like their "k." The popular Korean name "Kim" is our attempt to represent a sound that could justifiably be written "Geem." One of their "l" sounds could be one of our several sounds symbolized by "r." The popular name "Lee," therefore, could as easily be romanized "Rhee" and, indeed, often has been.

The dated official romanization system has been as bad as Wade-Giles in Chinese and it got everyone off on the wrong foot. As one writer reports, a province name pronounced "Cholla-pukdou" appears on maps using the official system as "Chonra-bugdo."

Vietnamese and Thai

In conclusion, we can understand that the Vietnamese willingness to abandon their own ancient, complex system using Chinese characters was not inexplicable, not like giving up the flag. Vietnam loved the Chinese superpower to the north even less than it did France. When the North Vietnamese kicked out the French—and with them, many ethnic Chinese who had been in Vietnam for generations—their nationalism certainly did not lead them back to the characters associated with feudalism and the oppressive past. Ho Chi Minh, their charismatic leader, had been educated in Paris and had been an early member of the French Communist Party. He respected French romanization as a break with the Mandarin past. Vietnamese, therefore, needs no transliteration, though some of the letters are pronounced in unique ways. The "Ng" on the front of the familiar name "Nguyen," for instance, is close to the English "w," or even better, the deeper sound symbolized by the archaic "Gu" on the front of "Guinevere."

Thailand began as a quilt of indigenous civilizations like the Mon, the Khmer and the Dai (Thai), the last pushed south from Chinese homelands by the Han Chinese. While India was still Buddhist, its influence overlaid, in several stages, these civilizations. Today 95 percent of the country espouses one of the oldest Indian versions of Buddhism, Theravada (or "Hinayana"). The great king Ram Khamheng, sentimentally regarded as the Solomon-like leader of a golden age, in 1283, codified Theravada Buddhism and also promulgated a new alphabet, a syllabary based on Sanskrit, the earliest Indian language.

There is no standard romanization for Thai, which has led one writer to lament that there is "no proper way to romanize Thai—only wrong ways." As in

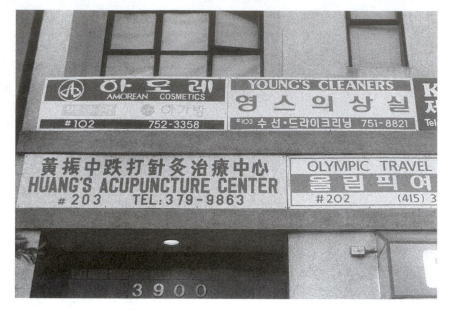

Figure 1–2: Chinese and Korean characters with their English Romanizations on signs on Geary Boulevard in San Francisco, California. Photo by Alyson Kohn. Courtesy of Stefanie Kohn.

the case of Korean, Thai uses sounds that the English language does not represent, like the unvoiced "p," which sounds, to us, almost identical with "b." Transliterators have great latitude to improvise, and they have used it.

Conclusion

We conclude this introduction by saying, forewarned is forearmed. The alert reader can now proceed with caution.

A further observation: advanced scholars who do proceed in this study will soon find themselves in a privileged position when confronting the entire wing of "deconstructionism" which traces back in some way to Jacques Derrida's work, *Of Grammatology.* Derrida attempts to create a "science of writing—grammatology." He argues that "it is a peculiarity of our epoch that, at the moment when the phoneticization of writing—the historical origin and structural possibility of philosophy as of science, the condition of the episteme—begins to lay hold on world culture, science, in its advancements, can no longer be satisfied with it." (Baltimore: Johns Hopkins University Press, 1976, p. 4.) But what of China, which had a different writing system? He makes a few stabs, uncomfortably aware that

"logocentrism is an ethnocentric metaphysics. It is related to the history of the West." In the 1960s knowledge of Asian writing systems and their history was required neither of Derrida nor of his readers, and as a consequence, problems abound. He tests his theories against some second-hand anthropological evidence from Levi Strauss about a preliterate tribe. How can he be excused from testing his ideas against an occasion much better documented and closer to home, the French forcing Vietnam to adopt a phonetic writing system? There's a perfect test case for him. Korea's change from Chinese ideograms to the (primarily) phonetic Korean system should also be a central study for Derrida. If he's right, we should expect to see enormous cultural damage soon after, along the lines he predicts. What of Japanese's wrestling with Chinese characters, and its *partly* phonetic compromise? In the 1960s scholars considering Derrida's grammatology would consider such questions arcane, but no longer.

Further Reading

Binyong, Yin. *Chinese Romanization: Pronunciation and Orthography.* Trans. by Mary Felley. Beijing: Sinolingua, 1990. The standard, and by far the most comprehensive, work on *hanyu pinyin.*

DeFrancis, John. *The Chinese Language: Fact and Fantasy.* Honolulu: University of Hawaii Press, 1984. The best book on all the Asian writing systems with an evaluation of the strengths and weaknesses of each.

Henshall, Kenneth G. *A Guide to Remembering Japanese Characters.* Rutland, VT: Tuttle, 1988. Long and comprehensive.

The Korean Language. Ed. by the Korean National Commission for Unesco. Arch Cape, OR: Pace International Research, 1983. An advanced introduction to Korean, this collection of linguistic articles was compiled in the official government publication.

Mangajin's Basic Japanese Through Comics. Atlanta, GA: Mangajin, 1993. An unusual and fascinating system of teaching Japanese idioms by analyzing Japanese comic book speech situations.

Characters: The Asian Ideogram Systems

An Invitation for Beginning Students

GEORGE J. LEONARD

Beginning students in a multicultural course cannot be expected to learn Chinese characters, but they can learn *about* them. My students are usually curious; they see these "mysterious" characters every day on a growing number of shop signs and food products, not to mention Jackie Chan movies. Demystifying the supposedly "exotic" Asian cultures is one of this book's central purposes. Understanding how Chinese characters work is intellectually important, also. Indeed, it is essential to any study of East Asian culture.

Even as the Western languages still show the cultural marks of the Roman Empire, and its long dominance, so the cultures of the East show the marks of China's far longer cultural reign. From the Zhou dynasty in the 1100s B.C. to the Qing dynasty in the Qian Long era (1700s) China's cultural prestige influenced East Asian life, from cuisine to literature. As Chapter 1 shows in some detail, Eastern scholars generally began their country's writing systems by trying to adapt Chinese characters to their language. To this day written Japanese still incorporates thousands of them; only Vietnamese has wholly banished them, and then only within the last century. Understanding the Chinese character system, so different from our alphabet system, is vital to any understanding of Asia's written tradition. Since Chinese art—and therefore, to varying extents, Asian art—esteems calligraphy as the highest genre, understanding Chinese characters is vital to any understanding of the Asian aesthetic as well.

For all these reasons I have put together, over the years, this very simple introduction to help beginning students understand how Chinese characters work—and even, perhaps, now to start enjoying them! Consider this essay no more than an invitation to their study.

The Mandarin word for "character" is *zi* (pronounced zeh). Our letters are written signs that represent sounds: when you see "b" or "z" you make a certain

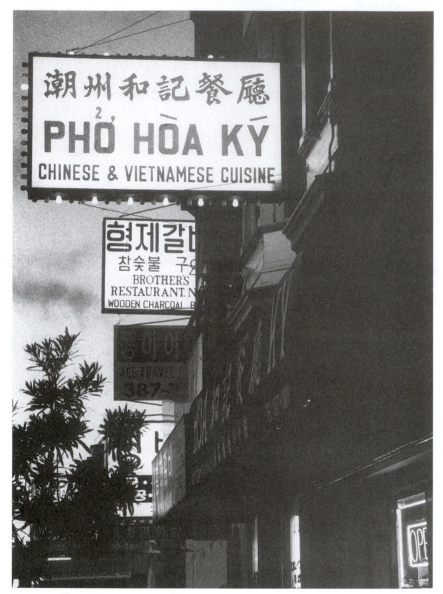

Chinese, Vietnamese, and Korean writing systems on store signs in San Francisco, California. Photo by Alyson Kohn. Courtesy of Stefanie Kohn.

noise. Chinese characters (also called "graphs") are "ideographs" or "ideograms": their ancestors were written signs that represented *ideas,* the way our numbers do. All over the West, when you see the symbol "7" you get the idea of seven. In response to the number 7, a Spanish speaker might say *siete,* a French speaker may

say *sept,* but both immediately understand the concept of "seven-ness" symbolized by that number. Although modern Chinese characters are a far more complex situation than that, they originated in such simple ideograms, and the ideogram idea still helps us understand their essential difference from our way of writing.

Ideograms are so useful, we in the West often resort to them also. We put a simple symbol for man or woman on restroom doors, we put a simple diagram of a wheelchair on parking spaces for the handicapped. We know that people who speak other languages live among us, and to avoid confusion we use a symbol that will evoke the same idea in everyone's mind, no matter which language they might use for that idea. You can see the symbol on the restroom door and think "men" or *"hombres"* or *"uomini"* but it won't matter. You'll walk into the right restroom. You won't park in the handicapped space.

Notice, then, that ideographs have a great advantage over our system: they transcend language barriers. This mattered to China, for "Chinese" is actually a family of languages, like the Romance languages. The north *(Beifang)* of the country primarily speaks **Putonghua,** Mandarin, while the south *(Nanfang)* speaks many languages, most famously **Guangdonghua,** Cantonese. Even the Mandarin speakers speak such different dialects that it is hard to communicate. How different are Mandarin and Cantonese? The word for "one" in Mandarin means "two" in Cantonese.

What a great unifier for the country, then! Just as easily as everyone in Europe can read the numbers on a check, everyone in China, no matter what their version of Chinese, can read all the literature, all the government announcements, can take all the same tests, can communicate with each other on computer networks. In a restaurant, when my Mandarin-speaking wife and the Cantonese-speaking waiter have different names for different dishes they simply scribble notes back and forth to each other. Instantly, they can communicate. Imagine if the Europeans, now struggling to unite, had an ideogram system that let all Europeans communicate like that.

The later Japanese character systems all leap off from the original Chinese characters. When you reflect that one Chinese word the Chinese use for themselves is **Han,** "the Han people," you realize that the Japanese word for writing, **kanji,** is just a translation of **Han zi,** "Chinese characters." Japan is a relative newcomer among nations, only about as old as England or France, and a great assimilator of foreign ideas. They get the elements of their written language from China during their Nara period, 710–794 A.D., when they are energetically adopting/adapting Chinese civilization. Japanese writing is a most complicated situation now,

a mix of three systems. A Japanese Buddhist priest, Kukai (also known as Kobodaishi) who lived from 774–885 devised a phonetic sign system that became the basis, eventually, of the contemporary Japanese phonetic sign system, called *hiragana*. For daily writing the Japanese employ a mix of Chinese characters, Hiragana, and *katakana,* yet another phonetic sign system. Some 3000–5000 Chinese characters are used daily.

We return with relief to the comparatively straightforward Chinese system—which is quite complex enough! To call Chinese characters "ideograms" implies that one character expresses one idea; 3,500 years ago that may have been true. Even in Shang dynasty times, however, more than 3,000 years ago, the Chinese were also inventively using the characters like a rebus, to represent sounds as easily as ideas. (A rebus is reminiscent of the old TV show *Concentration:* simple ideograms of an eyeball, the sea, and a sheep are put in a row to spell out the sounds for "eye sea ewe," "I see you.") Today it is more accurate to say that Chinese characters represent sounds primarily, and ideas only secondarily.

Consider too the way we in the West have already extended the meaning of our parking lot wheelchair diagram to mean not only people in wheelchairs but all "handicapped," most of whom are not even in wheelchairs. The mature Chinese system in use now is full of compound, abstract, and abbreviated images with greatly extended meanings, which bear only distant resemblance to the old pictographs.

That was, however, their origin: simple pictures called "pictographs" going back to the Shang dynasty, in the 1200s B.C. These pictographs, so representational that they were time consuming to write, were slowly simplified and stylized into the traditional characters—fixed about the time of Christ and not much simplified until Mao. They are called the "regular" *zi,* regular characters, and they were fixed in the Han dynasty, 206 B.C.–220 A.D. Imagine the cultural continuity! A modern Chinese scholar can, with practice, read material written in 100 B.C. Mao simplified the characters after the Communists conquered China in 1949 so that peasants could learn more easily. On the island of Taiwan, to which the Nationalist forces escaped, they still use many regular *zi,* untouched.

Even today, however, one can still decipher some of the simplest, most pictographic characters[1]: Figure 2–1 shows the sun, *ri* in its old form, on the left, sunbeams streaming from it and in the simplified form on the right. Figure 2–2 shows the moon, *yue,* in its old form as a crescent moon, and, on the right, the new form. The character for door, *men,* becomes obvious when we look at the old form on the left and picture the swinging bar doors that Wyatt Earp pushed through in the old Westerns (Fig. 2–3). Horse, *ma,* started out with nine strokes

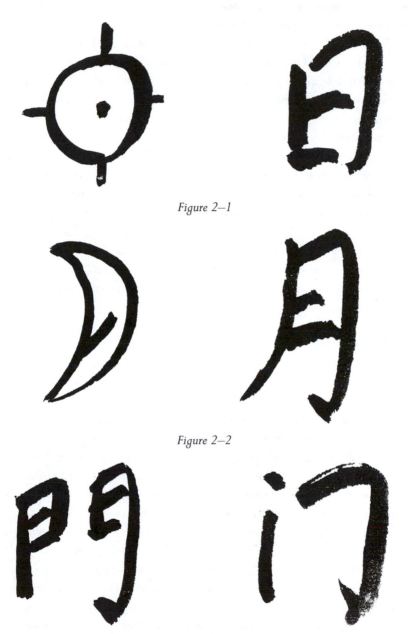

Figure 2–1

Figure 2–2

Figure 2–3

and was simplified to three. In the original on the left of Fig. 2–4, you can see the mane streaming behind the horse's neck as it runs left, and the four flying feet done as impressionistic dashes beneath.

But only 10 percent of modern characters are pure descendants of pictographs alone.[†] Ninety percent are compounds with a phonic or semantic addition added to help you guess the meaning. The second, helping sign may also suggest a sound, or a context. Combine sun and moon to suggest the concept "bright," "brilliant," *ming* (Fig. 2–5). For the word "dawn," the sun is shown lifting above the horizon line (Fig. 2–6). To give the abstract concept "glittering," "shining," three suns are massed together (Fig. 2–7).

Studying Western cultures, we sometimes use a "philological methodology." That is, we learn about the values of the distant past by looking at the root meanings of certain words. As Nietzsche points out, in ancient Latin, the word from which we derive "virtue" simply meant acting like a *vir,* a man. "Act virtuously!" meant little more, back then, than "Act like a man!" When you discover that our word "hysterical" originally meant "acting like a woman," you get a glimpse into an old idea of gender roles. Indeed, a woman would have to take on the qualities of a man to be truly "virtuous."

By the same token, looking at the Chinese ideograms, we can sometimes guess the *values* of the people who chose certain pictures to represent certain ideas. For instance, what pictogram, what visual symbol would you use for "male"? Your choice will reveal your values, what you think a "male" is. The Chinese chose *nan* for man, masculine (Fig. 2–8). The graph is a compound. It is made out of *tian,* which is a field (a birdseye view of one as shown in Fig. 2–9) and *li,* which is force (we can see the flexing, sinewy muscle attached to the arm in Fig. 2–10—it looks like someone "making a muscle" with fist pointing down). The male, then, is he who spends his force in the field: a rural, agricultural society's idea of a man. What would you pick to represent woman? Here is the traditional character for woman, *nu,* still in use (Fig. 2–11). It is more intelligible if we look at its ancestor, the Chou dynasty graph, from about 1000 B.C. (Fig. 2–12). As everyone points out, to give the essence of "woman" the Chou pictured a kneeling, submissive figure. The word "woman" is related in Chinese to the word "slave," *nú,* which means something like "a person with the status of a woman." The original form is on the left (Fig. 2–13a); the new form is on the right (Fig.2–13b).

Finally, if we want to know their most central values, let us examine what images they chose to symbolize the concept "good," *hao.* We know that the family is this culture's central value (*cf.* Confucius, *Analects* 1.2). To represent the word "good," they drew a woman and a child (Fig. 2–14). (The child is an infant tied in

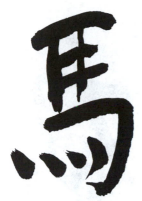

Figure 2–4

Figure 2–5

Figure 2–6

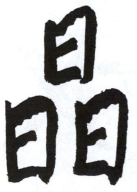

Figure 2–7

Figure 2–8

Figure 2–9

Figure 2–10

Figure 2–11

Figure 2–12

Figure 2–13a & 2–13b

Fig. 2–14

Figure 2–15

Figure 2–16

Figure 2–17

Figure 2–18

Figure 2–19

Figure 2–20

Figure 2–21

Figure 2–22

Figure 2–23

swaddling on a board, his large baby's head turned to one side.) The symbol for the abstract concept "peace," *an,* was the roof of a house and the wife under it (Fig. 2–15). The generic word for humans, "man," is **ren,** the animal that walks on two legs. So let the two legs represent man (Fig. 2–16).

Knowing that, we can better understand a very abstract concept, the central virtue for Confucius. It is also pronounced **ren,** but it means "humane," full of human decency—perhaps even "loving teamwork." (See Chapter 5 for more insight to this concept.) To suggest this abstract virtue, they coupled the symbol for "man" with the two dashes that symbolize the number two, in Chinese (Fig. 2–17). Why "man" plus "two"? Because *ren* is the virtue that appears when people live harmoniously together. For the Confucian Chinese, life is lived with other people, not alone. China thinks of life as a team sport, of society as a collection of families.

If you know man, it is easy to learn *da,* "big," a man holding his arms as far out as he can, pantomiming the idea (Fig. 2–18). And Heaven, *tian,* becomes what is "even above big," so to speak, by putting a line above it (Fig. 2–19), while small is something cut into two pieces (Fig. 2–20).

The word "fu," which appears in Kong Fu Tse, "Confucius," means distinguished person, or even husband, and adds a scholar's hat to "big" (Fig. 2–21). The idea of "too much," *tai dwole,* is created by adding an extra dot to the word "big" (Fig. 2–22), if you double "too much," you get *tai tai,* which, interestingly enough, is the standard word for wife (Fig. 2–23). So the symbol for woman may originally be submissive, but "wife" gets "too much" twice! Plainly, a powerful person.

By the way, we can now write the symbol for the famous Gate of Heavenly Peace, "Tian An Men" (Fig. 2–24), the front entrance to the Forbidden City, the emperor's compound in Beijing. The square in front of it takes Tian An Men's name.

The staple food of life is the pig, done here with a line for a head but with four feet and a suggestion of the curly tail (Fig. 2–25). For the word "family," *jia,* put the pig under a roof (Fig. 2–26). And to marry, also *jia* but a different tone, have a woman join the pig under the roof (Fig. 2–27). (No comments, please.)

We get a fuller sense of what the Chinese empire considered its place in the universe to be, when we reflect that China's name is not, in Chinese, China. It is *Zhong Guo* (zh is pronounced "j") (Fig. 2–28); one sees it translated as the "middle kingdom." But Fig. 2–28's left half shows the graph for Zhong, an arrow right through a target. "Middle" lacks in English any moral value. A better translation of the Chinese name for their country might be the "central kingdom," the center of the universe.

Figure 2—24

Figure 2—25

Figure 2—26

Figure 2—27

Figure 2—28

But now—having read this invitation—so that you do not go away with a false impression, re-read what was said earlier about the Chinese using their characters like a rebus to spell out sounds. Today, most Chinese characters represent *sounds primarily,* and *ideas only secondarily.*

Notes

1. The calligraphy is by Prof. Y.F. Du. This simplified introduction to a complex subject is indebted to my teachers in Beijing, to Prof. Du; and was tempered by the writings of John De Francis.

†Let it be noted, however, that my introductory purposes, and the examples I deliberately chose so as to make a parallel with Western philological arguments, obscure De Francis's main contention, which is that most modern characters now represent sound.

Further Reading

De Francis, John. *The Chinese Language, Fact and Fantasy.* Honolulu: University of Hawaii Press, 1984.

Asian Naming Systems

Is Du Xiao Bao Mr. Du or Mr. Bao? Chinese, Japanese, Korean,
Vietnamese, and Southeast Asian Naming Systems

GEORGE J. LEONARD

No one researching the Asian roots of Asian-American literature, no one trying to understand the relationships of Asian characters in a novel, will get far if he or she cannot tell a family name from a given name; but the Asian systems mentioned above are entirely different from the American. This article, of course, speaks of the practices of Asians, not of Asian Americans.

Everyone who discusses this topic starts by noticing one highly significant difference. In America, the individual's given name comes first. In mainland Asia, the family's name comes first. (To grasp the full significance, see Chapter 5.) This is true of informal spoken, as well as of formal written language. In Asian practice, you would say, in speech, "This is my friend, Lincoln Abraham." Mao Zedong's family name is Mao, and saying "Chairman Mao," which sounds like familiarity or affection in English, is merely the ordinary formal way.

Aside from that generalization, Asian naming systems are far more different from each other than European systems are from each other. So much so, that this article can only be an overview.

Chinese

Nearly 95 percent of Chinese belong to the dominant Han ethnicity. (Fifty-six ethnicities are officially recognized.) Han Chinese names have two parts: the *xing* (family name or surname) and the *ming* (given name). (Note: this article uses the pinyin system of romanization. See Chapter 1.)

Nearly all modern Han family names are one syllable (Chan, Du, Lee, etc.). Nearly all modern Han given names are two syllables. Until recently the two syllables were divided by a dash, so that we are used to seeing names like Chou

En-lai, and Mao Tse-tung. The modern pinyin system of romanization prefers to drop the dash, so that Chou En-lai becomes Zhou Enlai; and Mao Tse-tung becomes Mao Zedong.

In China women did not take their husband's name. (An elite woman might keep her patrilinear name. A peasant might be merely Zhou San's wife.) In Western-influenced Nationalist Taiwan—where Mao's enemies, the Guomindang, fled—women used their husband's surname and then their own, separated by a hyphen. If Miss Huang Xiaoyan marries Mr. Lee, she becomes Lee-Huang Xiaoyan.

Even formal terms of address like Mr., Mrs., Professor, Doctor, appear after the name, not before it. In pinyin they are not capitalized. Mrs. Lee is Lee taitai. Miss Wong is Wong xiaojie. Chairman Mao is Mao zhuxi. In English we routinely say Doctor Smith or Professor Jones, but do not, as a rule, specify many other professions. In Chinese, however, one would also routinely say "Technician Du," or even "Driver Tan," referring to a work unit's assigned chauffeur/delivery man.

Within the family, it is very common for even adult children to refer to each other by their roles as "elder brother," or "younger sister." (One might almost say, refer to each other by their rank.) In traditional China mentioning clearly who was the elder and who the younger served the same purpose as specifying who was the sergeant and who the private. Even today, a fiftyish brother will refer politely to his older sister as "Older Sister," "Jiejie," rather than call her by her name. Sometimes he'll shorten that casually to "Jie," but he uses it.

In pre-Maoist China, as in America, the children inherited only the father's name, and the mother's name was lost. Each year, for thousands of years, a surname vanished if a family had produced no sons. The 5,000 Han surnames that once existed have, through this erosive process, dwindled to a few hundred shared by some billion Chinese. We have the impression that there are more Chinese names than there are, since we will take a single name, like Wong ("King") and spell it many ways—Wang, Huang, Hwang, Hwong. Similar situations exist in Korea and Vietnam.

The Chinese, like the Koreans and Vietnamese, compensate with imaginative given names. Someone named Smith might name a child "Jaxon," rather than "Jack" if only to spare him lifelong difficulties with computers and post offices. The Chinese follow this logic. We, with our vast number of family names, can afford to give our children, over and over, the familiar 20 or 30 given names. The Chinese and Vietnamese, stuck with so few family names, created a great variety of given names.

Classical authors' names present different problems, because a man had his given name, plus a name he assumed on reaching manhood (his *zi*), plus, in some eras, yet another name he assumed on reaching a certain station in life, or

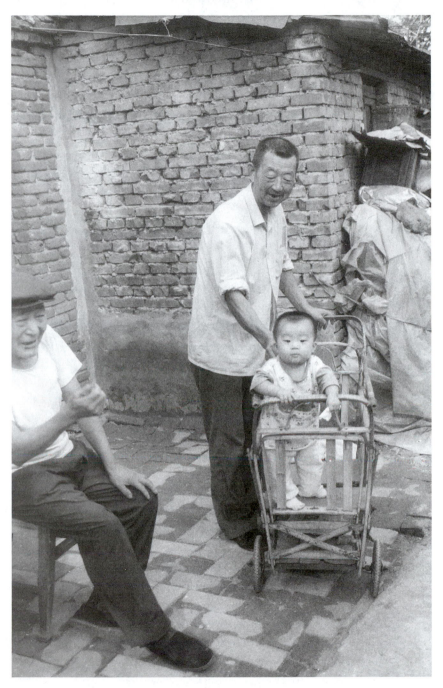

Figure 3–1: Grandfathers pushing their grandson in a bamboo baby carriage, Beijing, 1996. Photo by George J. Leonard

even just reaching maturity, the *hao*. In Kong Fu Tse's (Confucius') time there were, in addition, honorific titles a man could be awarded. His name, Kong, has had, over the centuries, two honorific titles signifying "master" added to it. The last sound, "zi," we romanize in many ways, as "tse" and "tsu" and "tzu" and "zi." It is pronounced most like "zih." Lao Tzu and Kong Fu Tse both, in Chinese, end in that one same sound. Yet a mistaken convention has developed in English to make Lao Tzu's name rhyme with the woman's name Sue. It should not.

We cannot begin to deal with all the conventions of pennames, Taoist names, Buddhist names, and nicknames that all 3,200 years of recorded Chinese culture have left us with. It is enough to be aware of the complexity.

Japanese and Korean

Since Japan and Korea were within China's cultural orbit during their early cultural history, it is no surprise that they share in much of what has been said above. Family names are given first in both languages. Someone named Suzuki Ken'ichi is Mr. Suzuki in English. (Suzuki is the most common Japanese surname.) A Korean named Lee Soon Chul is Mr. Lee in English.

In practice, however, Japanese names and name customs must partake of the entire exquisite code of Japanese behavior. If hierarchy and rank are preoccupations of the Chinese language, they are near obsessions of the Japanese. There are entire different forms of speech appropriate when speaking to a superior or to a subordinate, and the Japanese take care to denote "inside" from "outside" (of the family, the clan, the country, whatever), a care which surfaces in speech.

In practice, first names are not routinely given. Only small children are called by their first names, and then it is followed by the softening word "chan." People could work in an office together for years without using or even learning each other's first names. "My name is Yoshimura," is an adequate introduction. When single names like this are given, assume they are family names, not first names, as would more likely be the case in America. (One introduces *oneself* as "Yoshimura," humbly, but addresses another as "Yoshimura-san.")

As in Chinese, a great variety of professional titles are appended after Japanese names. Everyone must know the chain of command. "Ano, chotto ii desu ka, Shosuke-kakaricho?" would be, literally, "Excuse me, is it okay, Shosuke Section-chief?" One could also say "Shosuke Kai Cho," "Shosuke Company President," and many other specific titles. "San" for Mr. is routine, and "Sama," even more deferential, is frequent, depending on the rank difference between speaker and

person addressed. Women use different, and very deferential forms of address, especially when speaking to men, adding a particle to the end of the name. "Sensei," or "teacher," may be added to many professional men's names, as a simple honorific. Little of this is translatable, but translators try.

In Korean, the special problem is that no good romanization systems exist, and the same person's name appears in many conflicting translations. Syngman Rhee, the first president of the postwar Korean republic, could have been "Lee," in another system. Quite a problem, since 65 percent, at one estimate, of Koreans now share either the surname Lee or Kim. Furthermore, "the curious truth about the surname Lee," Jeeyeon Lee writes in Chapter 13, "is that in the Korean phonetic language, there is no such surname. My last name is Lee in English, but in Korean it is actually Ee. The pronunciation of it never includes a consonant sound."

Southeast Asian

The colonial term "Indochina," a translation of the French "Indochine," at least called attention to the distant dual heritage of South Asia—a heritage from ancient, still Buddhist India as well as China, a heritage more strongly Buddhist than Confucian. Over a thousand years ago Indian influence overlaid the indigenous civilizations.

As in the rest of Asia, the family name again comes first in Vietnamese, Thai, and the former Indochina. China, after all, dominated the region for a thousand years. Chung Hoang Chuong is in English, Mr. Chung. The name attrition we remarked in China and Korea has advanced even farther in Vietnam, where only 99 family names are left. On top of that, 50 percent of the country shares the name Nguyen (pronounced "win" or "gwin"; there is no "w" in Vietnamese, and various combinations of letters are used to produce it). Only 25 or 26 of the names are common; indeed, the top 14 alone account for most of the country aside from the Nguyens. The Vietnamese compensate by using as many given names as there are words in the language. A Vietnamese list of names, in the Old Country, would, of necessity, not start with the last name (half would be Nguyen) but with the first name.

Vietnamese is, like Chinese, almost entirely monosyllabic. The "middle name" that appears is very important, since it can distinguish male from female. Nguyen Van Minh would be a man, and Nguyen Thi Minh a woman.

Cambodians, by contrast, have no middle name. They give the family name first, and the two names that follow are, as in Chinese, actually a single two-syllable given name. Sam Sok Bo is Mr. Sam, and his first name is Sok Bo.

It is a mark of how far they rode outside the Chinese orbit that the Hmong use only two names, and give the family name last. General Vang Pao would be General Pao, not General Vang. The Hmong are a special case, a preliterate hill tribe. For their culture, see Chapter 59.

One reminder, in closing: this article speaks of practices back in the old countries. In this country—if only to stay on the right side of the Department of Motor Vehicles and the Internal Revenue Service—Asian American newcomers have had to conform to the general American system of given name followed by family name. Even so, as a point of cultural pride, some will, socially, prefer the traditional order.

Further Reading

APA Insight Guides. Series on East Asia. Hong Kong: APA Publications Ltd., 1991.

Mangajin's Basic Japanese Through Comics. Atlanta, GA: Mangajin, 1993.

Schwartz, Benjamin. *The World of Thought in Ancient China.* Cambridge and London: The Belknap Press of Harvard University Press, 1985.

State Bureau of Foreign Experts, The People's Republic of China. *The Foreign Experts' Handbook: A Guide to Living and Working in China.* Beijing: New World Press, 1988.

The "Model Minority" Discourse

BRIAN NIIYA

By the mid-60s, the image of Asians in America had shifted dramatically. The *yellow peril* moniker had mysteriously vanished to be replaced by the advent of the "model minority" label. Suddenly Asian Americans, or more accurately Chinese and Japanese Americans, were perceived as having overcome past injustice to make it in America. For instance, according to a mid-sixties *U.S. News and World Report* article:

> At a time when Americans are awash in worry over the plight of racial minorities—one such minority, the nation's 300,000 Chinese Americans, is winning wealth and respect by dint of its own hard work. In any Chinatown from San Francisco to New York, you discover youngsters at grips with their studies. Crime and delinquency are found to be rather minor in scope. Still being taught in Chinatown is the old idea that people should depend on their own efforts—not a welfare check—in order to reach America's "promised land."

A January 9, 1966 *New York Times Magazine* article by William Peterson about Japanese Americans made similar comments:

> By any criterion of good citizenship that we choose, the Japanese Americans are better than any other group in our society, including native-born whites. They have established this remarkable record, moreover, by their own almost totally unaided effort. Every attempt to hamper their progress resulted only in enhancing their determination to succeed. Even in a country whose patron saint is the Horatio Alger hero, there is no parallel to this success story.

While this sort of hyperbole makes for a good story, there is more to it than meets the eye.

For one thing, this "success story" was largely a myth. As pointed out by Bob H. Suzuki and others, things were not as they appeared. Although a good number of Chinese and Japanese Americans did achieve middle-class status, they still received less pay than whites for comparable levels of education. There were still few Asian Americans in positions higher than middle management. But, most importantly, there were also a large number of Asian Americans who still lived in poverty. Chinatowns across the country were still slums despite the glowing pictures painted by the Six Companies, and many elderly Issei—first generation immigrants—still lived in poverty in run-down dwellings in Little Tokyos all along the West Coast. Several hundred thousand new Asian immigrants had entered the United States by the early seventies as a result of the 1965 Immigration Act, and many of these people were desperately in need of help. And in talking about the "model minority," nobody seemed to mention groups like the Filipino Americans or the Korean Americans who didn't quite fit the image the media establishment wanted to project.

But perhaps more important than the degree of truth behind the "success story" image was the effect such stories had. During the mid-sixties, previously dormant minority groups found their voices and began to demand changes in American society. In the wake of the non-violent reform-oriented approach of Martin Luther King, more radical approaches began to emerge. Soon, ghettos across the country were in flames, and cries for self-determination could be heard from a variety of minority groups. Such militant organizations as the Black Panther Party scared and threatened the establishment. In light of all this turbulence it is not surprising that the quiet and seemingly successful Asian Americans should begin to draw attention. For here is a group that has achieved "success" without any help according to the *U.S. News* article: "At a time when it is being proposed that hundreds of billions be spent to uplift Negroes and other minorities, the nation's 300,000 Chinese Americans are moving ahead on their own—with no help from anyone else." If that were not enough, they also achieved their success by overcoming discrimination according to the *New York Times* article: "Asked which of the country's ethnic minorities has been subjected to the most discrimination and the worst injustices, very few persons would even think of answering: 'The Japanese Americans.' Yet, if the question refers to persons alive today, that may well be the correct reply." The implications seem clear regarding those groups who protested their conditions: "if these people who have faced more discrimination than you can become successful without any help. . . ." The American system is upheld, the problems of the oppressed are blamed on the victims and a neat roadblock is erected to quell any leanings toward organization between Asian Americans and other minorities. A "model minority" is created.

Further Reading

Fujita, Thomas Y. "Better Americans in a Greater America?: Japanese American Education, Occupation, and Income, 1940–1960." M.A. Thesis, UCLA, 1987.

Ima, Kenji. "Japanese Americans: The Making of 'Good' People." *The Minority Report*. Ed. by A.G. Dworkin. Boston: Holt, Rinehart, and Winston, 1976.

Petersen, William. "Success Story: Japanese American Style." *The New York Times Magazine* (Jan. 9, 1966): 20.

Reischauer, Edwin O. "Foreword." *Nisei: The Quiet Americans* by Bill Hosokawa. New York: William Morrow and Company, Inc., 1969.

"Success Story of One Minority Group." *U.S. News and World Report*. Reprinted in Amy Tachiki, et al., *Roots, An Asian American Reader*. Los Angeles: UCLA ASIAN American Studies Center, 1971.

"Success Story: Outwhiting the Whites." *Newsweek* 21 (June 1971): 25.

Suzuki, Bob H. "Education and the Socialization of Asian Americans: A Revisionist Analysis of the 'Model Minority' Thesis." *Amerasia Journal* 4.2. (1977): 23–51.

Part II

The Family and the Self

Confucius and the Asian American Family

A Personal View

GEORGE J. LEONARD

"The source of philosophical knowledge is not to be found in thinking
about mere objects or in investigating mere facts but rather in the unity of
thought and life, so that thinking grows out of the provocation and
agitation of the whole man—all this constitutes for Nietzsche's self
consciousness the real character of his truth: 'I have always composed my
writing with my whole body and life.'"

—Karl Jaspers on Nietzsche, quoted by Stanley Cavell in
*Conditions Handsome and Unhandsome: The Constitution of
Emersonian Perfectionism*, La Salle, IL: Open Court, 1990.

Toward Synthesis: The Global Philosophic Significance of the Asian-American Project

Any discussion of the Asian American families one encounters in our literature
inevitably confronts the philosophy of *Kong Fu Tse*, whose name the medieval Jesuit
missionaries who first encountered him Latinized as "Confucius" (551 B.C.–
479 B.C.); and what is often called the "Confucian family system." For the last 10
years the American media has extolled the Confucian family's strength, often at
the Western family's expense (*see* Chapter 4).

Like Nietzsche, quoted approvingly by Karl Jaspers above, W.H. Auden once
remarked that he trusted no learning that had not been "proved on the pulses."
I chose to write on this subject because, although I live in a large Confucian
family, I did not grow up in one, and I still retain some of my outsider's per-
spective. The fish, it is said, will be the last ones to know about the water, and
my Asian American students, when they try to write about their families for class,
have a hard time. To them, it is just "life." I am still conscious of the differences

from my previously Western family life, and can perhaps convey those differences better to other non-Asian Americans—inevitably the majority of this book's readers.

I write as a scholar of Chinese language and culture who works with the Confucian texts in Chinese, both in America and here in Beijing, where I am revising this essay. I have referenced scholarly accounts at the essay's end; but always, true to Auden's theory, I have concentrated on what I have personally confirmed, "proved on the pulses." I speak for no one but myself.

This study will so often argue Confucius' case, that I want to say, in advance, that there is no question of reinstituting classical *Confucianism* now. To take him whole would paralyze any modern country, and cut the West off from its great and successful tradition of extending human rights. The leading Western interpreter of Confucius in our time, William Theodore de Bary, has written a book bluntly titled *The Trouble with Confucianism*. Yet Confucius knows so much—and knows, it seems, exactly what the West has paid too little attention to. What I'll describe here is the fashioning of what we might well consider the birth of a new Confucian school—American Confucianism. And it is no small thing.

I will argue, in fact, that the Asian American communities are engaged, in their daily lives, in a project of world historical significance. The ordinary circumstances of their lives force Asian Americans, daily—particularly the newcomers—to try to salvage what works from the Asian value system and to graft it onto what works from the American system—the wildest of the West—discarding the worst from both.

The awesome, indeed anxious project forced on Asian Americans—the synthesis of East and West, of Confucius and feminism and the Statue of Liberty—is the central topic of Asian American literature and arts. (See, for instance, Chapters 48, 57, 59.) For that reason, their literature and art has a global philosophic significance beyond its undoubted historic significance to American culture. The twenty-first century will be the era in which East and West—shrunken together into a single global village, wired together by electronic nets and webs we cannot even imagine—will be forced into the work of synthesizing a global culture. That is exactly the work Asian Americans have, for better than a century, pioneered. And their synthesis, judging by material and non-material standards (not only incomes but divorce rates and numbers of advanced degrees) commands respect. In Asian American culture we get our best look into the future of *world* culture; and it is so far a heartening one.

Confucius' Centrality

No critic, whatever their politics, doubts that in some way the Asian American family system is at the heart of this matter. That returns us to Confucius.

Confucius helped define, but did not create this powerful family system. No one man could. Yale's Benjamin Schwartz notes that the archeological evidence of ancestor worship in China extends as far back as we can dig. That means Chinese family bonds were always exceptionally strong. Confucius gave this cultural predisposition its classic, and most influential, statement.

As a result there is no one figure equally central to all the West, not even Jesus. Confucius' thought spread through all of Asia east of India and colored all later philosophic orientations. (Buddhism, which America associates with China, is a late import, known to China about 67 A.D., and arriving in force over the Silk Road around 400 A.D.) Though Confucius wrote 2,500 years ago—a contemporary of the exiled Jews who compiled the Old Testament—some extract of his thought is a living presence in Asian and Asian American lives today, and the literature involving them. Asian American students who have never read a word of Confucius (or anyone but Stephen King, for that matter) read him in my class and say, "So *that's* where my Dad's coming from!"

The Bible makes a good parallel. Its values are so alive in a large part of the United States, we call it "the Bible Belt." You couldn't understand the South or West properly without knowing the Bible. You will understand Asian Americans better by knowing something about Confucius.

Americans of Asian Descent Are Not Asian

However, as I revise this in Beijing tonight, just after an enormous (and very Confucian) family banquet, I am moved to add a warning: *Asian Americans are not Asians.* Just as it would be preposterous to read of King David's concubines and expect to find them in a Bible Belt home, it would be preposterous to imagine Confucius took you inside a modern Asian-American home. My Chinese American niece, 10 years old, has had such culture shock since she arrived in China (the shock *any* American-born mall-dwelling 10-year-old Tiffany or Kimberly would have in a foreign country) that she frequently grows dizzy. We had to stand her in front of an air-conditioner tonight, where she gulped the air and wailed, "It smells like home!"

This study about Confucius *is not* a guidebook to Asian America. For them his thought is only a legacy, a *substratum* of values, now heavily overlaid by the standard American ones—democracy, feminism, equality, air-conditioning. In addition, so many Asian Americans are Christians that their Confucian substratum is deeply buried beneath Christian values. And with every generation the family spends in America, the Confucian values get buried deeper.

Yet, having said all that, the Confucian substratum is the rock on which the rest stands. When we try to describe certain characteristics that give an elusive sense of unity to the different communities of Asian America, we discover we are talking about the Confucian values. (Scholars take the trouble to distinguish Filipinos as "Pacific" culture, not "Asian" culture, because—unless they are ethnically Chinese—Filipinos do not share the Confucian substratum.)

Confucius: The Man Himself and His Times

The name "Confucius" is a Latin form of his name plus his title. His actual name is Kong, to which the Chinese respectfully added either "tse" or "fu tse," both words being honorifics. (See note on romanization at this article's end.) "Kong fu tse" means "Master Kong." In his best-known book, a collection of his sayings called the *"Analects,"* many chapters begin with *Tse yue,* "The Master quoth" (*Yue* is an antique form of *shuo,* "said.") It wasn't necessary in China to say who the "Master" was. East Asians have quoted Kong's sayings at each other for 2,000 years. (But never in fortune cookies, which were invented in San Francisco in 1909 by a Japanese American.)

His dates were worked out hundreds of years after his death, but he is said to have been born in 551 B.C. in Qu Fu, near Shandong, at that time the state of Lu, the most civilized state in China, a state proud to be descended from the Chou dynasty, which had given China its Golden Age. He died in 479 B.C., age seventy-two, the year after the battle of Marathon safeguarded the Greeks from Persian tyranny, allowing an independent "Western" history to develop. He is a contemporary, then, of Guatama Buddha, and of Aeschylus' father and of the first Athenian republicans. He died the year before Socrates was born. These were the pivotal years ("axial ages") for the Indian, Western, and East Asian cultures alike.

Confucius was born during a time of continual war between the many petty states into which the great Chou dynasty had broken—the so-called "Spring and Autumn period," 770–464 B.C., given that name simply because that distant time is covered in a terse, even oracular book with the words "Spring and Autumn" in

its title. This era is followed, from 463 to 222 B.C., by the Warring States period, even bloodier. Like Dante, he lived in a dark age, looking back nostalgically to a great empire that had spread peace, prosperity, and the pleasures of civilized life across the land. Dante lived in the ruins of the Roman Empire, in an Italy where a scholar needed a safeconduct pass to travel a hundred miles between the feuding cities and their petty princelings. Confucius' China looked very similar. During his life he trudged from minor court to minor court, looking for employment and offering his ideas about reordering society to the Dukes. He looked back worshipfully to the Chou (pronounced like the English name "Joe") dynasty, a period lasting several hundred years. You will read many dates for the Chou but 1000 to 800 B.C. was their high point, the period Confucius most admired.

In 518 B.C. the Duke of Lu had given Confucius a kind of scholarship to visit Lo, the old capital of the Chou dynasty. There he examined what books and objects remained of Chou greatness, already more than 300 years in the past. Confucius was thrilled by the Chou ideal (which we will discuss in some detail). Later he claimed to be merely their humble "transmitter." He sustained himself through setbacks with his sense of mission: to restore the Chou culture to China (*Analects* 9.2) and thereby end the wars and bring another Golden Age.

As his fame increased, he taught and traveled with disciples. But in 528 B.C. Confucius abandoned public life for 3 years to mourn his mother according to the most orthodox old customs. He must have been trying to set an example. As he once said, no one "preaches what he practices until he has practiced what he preaches." (*Analects* 2.13) Actions speak louder than words.

The *Analects*, read carefully, reveal a teacher who had tremendous personal charm. His human frailty is recorded and his humility. Go into any village with 10 families in it, Confucius said, and you could find someone "quite as loyal and true to his word" as Confucius. "But I doubt if you would find someone with such a love of learning." (*Analects* 5.25–5.27. Hereafter I will just write the book and section numbers.) He loved music (8.8, 17.11) and collected and edited the Chou classic songs. He thought rulers led best by setting a good example, and if you tried to rule by passing a lot of oppressive laws instead, you would only make the people into sneaks and tricksters. (2.20) Asked what kind of life he wished he could achieve, he said he wished he were someone who could live up to this ideal: To "comfort" the aged; to keep his word to his friends; and to "cherish" the young. (5.25) That's attractive.

When he was 52, the court of Lu finally gave Confucius a big job. But—when push came to shove—rather than sell out, he quit the job he had sought for so long. That noble decision became one of the foundations of his morality: it's normal and

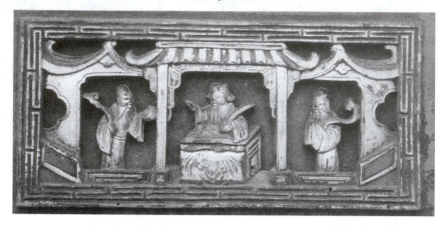

Figure 5-1: Confucius and two sages: Qing Dynasty carved wooden panel.
Photo by George J. Leonard.

right to want power; the moral question is, what are you willing to trade for it? For the next 14 years he traveled with his students from court to court, trying to interest one of the petty barons in running a state according to his principles. In the very first paragraph of the *Analects,* Confucius notes how important it is to "remain unsoured even though one's merits are unrecognized by others." (Fig. 5–1) Confucius knew what it meant to struggle *and to lose.* It gives authority to his endlessly repeated advice about never turning bad or selling out, no matter what. The *Analects* faithfully record that ordinary people sneered at him for failing to win worldly success— when actually he had rejected it rather than sacrifice his integrity (14.35, .39).

At 68, old and ignored by politicos (14.41, .42), he settled back in Lu to put together the old Chou documents, which he decided was his real job. If the Chou works were available, people must read them—he hoped—and change their ways. He put together edited texts of the still famous *I Ching,* the Book of Changes; as well as the Book of Documents, the Book of Songs, the Book of Rituals, and others.

Although Confucius met with meager success during his lifetime, his influence slowly spread. There was one final setback. In the 220s B.C., the first Emperor of Chin finally unified China. This tyrant spent perhaps a million lives building the Great Wall. His tomb at Xian, his new capital, is surrounded by the famous army of lifesize terracotta statues—statues of his soldiers carrying their weapons, sometimes leading lifesize horses. All these statues were buried with him, to serve him in the next world.

The first Emperor of Chin's way of thinking, *Fa Jia,* is given the misleading name "Legalism." Westerners automatically connect that term with "the law above the king" and "the rule of law." Actually, "legalism" in China meant

the opposite—it meant that might makes right, that whoever rules, makes the rules. In 213 B.C., reasoning that philosophers who taught people to *think* inherently interfered with his teaching them to *obey,* the Chin emperor ordered all philosophy books burned and philosophers killed. The tyrant died, his son was overthrown, and the Confucian texts dug out of their hiding places. (Legalism, alas, has made periodic comebacks in China up to the present day.)

The triumphant Han dynasty started the next of China's several Golden Ages by adopting Confucius and his commentators (principally Mencius) as the official State philosophy. The Han are the Romans' contemporaries, and are profitably compared to them. As the Romans spread—indeed, enforced—the earlier Hellenic culture through the West, so, for 400 years, the Han spread Confucius' nostalgic vision of Chou culture through China, and ultimately Asia.

During that time Confucius became so influential that his value system is now the backbone, the "cultural DNA" as Bill Moyers once happily phrased it, of all East Asia, from Vietnam to Korea and Japan. (The further south you go, the closer to India, the more cultural influence India once had. For this reason the French called the South, "Indochina." Thailand, Burma, and Laos are still now "primarily" Buddhist, not Confucian.) Other important Chinese philosophies have had to phrase themselves as reactions against him. Soon after his death, a short-lived philosophy, Mohism, worried that strong Confucian families would just be out for themselves and to hell with society. During periods of corruption in China, that is exactly what has happened. The Taoists—recluses, mystics, quietists—think Confucius sets the wrong example entirely, in his rationalism and his enthusiasm for political action. (See *Tao te Ching,* Chapters 5, 19, 20.) They never confuse his caution with their quietism. "To see what is right and not to do it is cowardice," Confucius said. (2.24) The Taoists take that hard.

When the Han declined in the 200s A.D. Confucianism declined. From the 400s to the 1200s A.D. China's expanded form of Buddhism (heavily colored by the native Taoism) dominated the religious landscape. From the 900s on, however, Confucianists were "appropriating," as de Bary puts it, the most desirable qualities of Buddhism—the compassion of the bodhisattva, the feeling for nature, respect for meditation as a spiritual training. The great Chu Hsi (1130–1200) synthesized those elements with what China had always found most attractive in Confucianism: the Confucian family system; respect for education; practical activism; and the cardinal virtue, "ren," empathy, human-heartedness. Chu Hsi's attractive synthesis, "Neo-Confucianism," swept East Asia in the next few centuries. (Fig. 5-2)

No one has fought the Confucian heritage harder than twentieth century communists. Confucius was involved in all their cultural battles to change China—

he is not a quaint old figure in China any more than Jesus is a quaint old figure in Texas. Chairman Mao fought the Confucian family system the way the Russian communists had to fight the Russian Orthodox Church. During the 1966–1975 Great Cultural Revolution (see Chapter 27) Chairman Mao ordered, *"Pi Lin Pi Kong"*—"criticize Lin Biao (a competing political figure), criticize Confucius." Although Confucius, at that time, was little read, Mao saw him at the root of China's problems, and took him on as if he were a living counterrevolutionary. Mao's *Little Red Book,* which the Red Guards clung to, was a counter-Analects of Mao's sayings, which replaced all the Confucian family duties with duty to the revolution. Yet China has brushed Mao's communism away; the Confucian heritage remains. The Nationalist government that fled Mao to the island of Taiwan has always revered him.

It remains to be said that many of the horrors done in Jesus' name in the West, have been done in Confucius' name in the East. As Jesus was somehow used to justify the Spanish Inquisition and pogroms against the Jews, so Confucius has been invoked by Japanese militarists, by Guomindang China and Lee Kuan Yew's robotic Singapore state. We need not judge any beloved philosopher by the acts of brutes trying to hide their crimes behind his good name. We will speak about their "Asian values" defense later.

The Confucian Texts

Most important are the *Analects,* the *Lun Yu.* The term was not used until about 120 B.C. by an editor. The *Analects* are a loose collection of Confucius' sayings and of materials relevant to them, compiled by his students after his death.

The Chin emperor's rampage left us with no texts by Confucius or his opponents older than 213 B.C. Some books, like the *Book of Music,* were almost completely destroyed, and the fragments were made into chapters of other books. (That is why you will sometimes read that there are five "Chou classics" and other times, six.) But also, when the ru jia (the "scholar school," as his followers are called) rewrote the texts after the tyrant emperor's death, they could not resist the temptation to improve them.

Our text of the *Analects* is therefore corrupt and disordered. To begin with, Confucius did not write these sayings down himself. Second, at least three clear versions of the *Analects* exist: the "Lu version," the "Ch'i version," and the "ancient script" version, claimed to have been found hidden in the walls of Confucius'

house, written in ancient characters. There are too many spurious stories about it. The Lu version became standard.

Not even all the Lu text seems authentic. Books 3–9 comprise the oldest layer. The student should trust those books the most. Book 20, the last, looks like a miscellany. Book 10 is not about Confucius at all, although they sometimes stick his name in this bunch of old maxims on performing ritual duties. Scholars agree that the book feels pre-Confucian. Book 18, on the other hand, feels as if it were added hundreds of years later, since it brings some Taoist-style recluses in so that Confucius can dispose of them with a few well-chosen words. Confucius himself never saw Taoists (though he may have seen their distant ancestors), but in the 200s the Confucian scholars were debating them and wished the Master had.

The other side spread its own hostile myths about Confucius. There is no evidence for stories that Confucius met their founder, Lao Tzu, let alone that he proclaimed Lao Tzu a wiser man! (In fact, there's no evidence to indicate that "Lao Tzu" ever existed.) Nor is there evidence that Confucius divorced his wife, or was illegitimate, or the child of a rape. The Tao jia, the Taoist philosophers, liked to rewrite history, too.

The Confucian Values: The Family and Teamwork

What is that Confucian substratum of values, then, that people all over Asia shared, and brought with them to America? (Our goal, remember, is not to explicate any of the classical Confucian schools, but to talk about a legacy of living values.)

The West pictures a society as a collection of individuals, like a tennis tournament or golf tournament. Confucius pictures society as a collection of teams—specifically, families. When the West talks philosophy, it talks about people as individuals—sometimes almost as if they had no family ties. Confucius starts by assuming that few people live as hermits and the fullest human life is only possible in a family.

Our word "teamwork" could be explained as the active expression of your love for those around you. One sacrifices for the team's good and finds one's own pleasure in whether the *team* wins or loses. Teamwork—love, courtesy, and subordinating your desire for glory to the good of all—leads to victory for all. You do not hog the ball. You pass and set up shots. You all get Superbowl rings together—or nobody does.

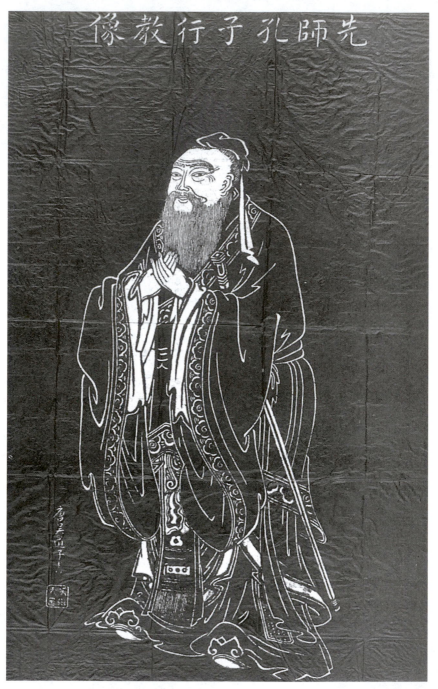

先師孔子行教像

Figure 5—2: Confucius (rubbing of Qing Dynasty stone portrait) c. 1750. The Qian Long emperor had the 800,000 characters of the central Confucian works carved on stone pillars (still standing at Beijing's Confucian temple) a project which took twelve years. Courtesy of George J. Leonard.

Confucius calls the central virtue that leads to teamwork ren (pronounced ren, it is preposterously spelled jen in the old books following the Wade-Giles romanization. Just this once, I'll break with Wade-Giles and spell ren as it sounds). Ren, a homonym for the word human, has been defined as "human-heartedness," "empathy," "deeply humane," "a real human being" (or if you know Yiddish, a mensch). It is written in Chinese by adding the graph for "human" or "man" to the graph for "two": people in society, people getting along with other people. (*see* Ch. 2, fig. 2–17)

China's Chen Jingpan simply translates it "love" or "benevolence." To Western ears, however, that makes ren sound too much like our notion of selfless, unconditional love. That is why I am suggesting that "teamwork" and "team spirit" come closer to ren's meaning. When Michael Jordan hands off the ball to a teammate, he does not do it because he loves the teammate like a mother. Yet Jordan is sacrificing: Jordan's income is directly connected with the amazing number of baskets he makes. Teamwork may not be "love," exactly, but it is "loving." Anyone who has played on a successful team knows the emotion one comes to feel for the others. All for one and one for all! Teamwork cannot be reduced to "building networks of mutual obligation in case one needs help later on," as one (flint-hearted) American observer has described ren. I count on the reader to remember the emotion involved in joyful teamwork; to remember identifying so fully with an entity larger than oneself, that the team's good fortune was your good fortune, and your happiness. Now picture yourself identifying that way with your extended family, knowing they would help you even as you would help them. You all win together.

After the 1994 Los Angeles earthquake the TV news profiled a Chinese restaurant that was doing great business, because it was the first restaurant able to reopen. "Fifteen people came over to clean up," the owner said, "Brothers, cousins, cousin's wives" One pictures this restaurant's Western competition trying vainly to get a janitorial service on the phone.

Any Westerner who joins an Asian family has countless anecdotes about the surprise he or she felt at the living Confucian philosophy, expressed in loving teamwork. A friend, whose son married a Chinese newcomer, mentioned to his daughter-in-law that his wife had to go back East to attend a funeral. The daughter-in-law mentioned it to a cousin, who called to volunteer his Frequent Flier miles so my friend's wife wouldn't have to pay for the trip. "Imagine," my friend said, "my daughter-in-law's cousin! In the West we wouldn't even consider that a relative, and he's trying to give Jeanie a free air ticket."

In Western books about Confucius and Asia, one reads the perplexing phrase "filial piety" for this teamwork mindset. It is significant that the West does not really even have a name for it, and has to make do with that awkward term.

"Team spirit" would come closer. Bringing in the word "team" also correctly implies "competitiveness" and gives an image of life as constant, joyful, active exertion, on behalf of everyone you love.

Li: Dancing Well the Dance of Life

If life is lived in families, and the art of life is teamwork, then successful life can reach the intricate beauty of professional basketball teams—a beauty much like dance. Confucius pictures life as a constant intricate dance done with others, and the li of life are its steps. Again, it's significant that we Westerners have no word for this. Western books try to translate li with the religious word "rites," but that's too churchy. They try "etiquette" or "courtesy," but these days we think of courtesy as artificiality, the opposite of honesty. You'll come closer to li by thinking of couples dancing, or—to continue the teamwork metaphor—the plays that great football teams smoothly execute. Confucius sees life as a stream of social interactions.

Comfort the aged, keep your bargains at work, your word with friends, your vows to your spouse, and take time to love kids. That is the living heart of the li. When every member of the team is infused with team spirit and you all know exactly how to run each play—that is successful li. Confucius believed the Chou really did all this, and that was why they ruled China peacefully for hundreds of years. The only mystery, for Confucius, is that we know exactly what works, yet we do not do it. Confucius once sadly said that he had never met anyone who could do goodness "with his whole might even as long as a single day." (4.6) He had never seen anyone whose "moral power was as strong as sexual desire." (142.17) Confucius isn't self-righteous: he said he himself didn't get his will fully under control until he was seventy—a very modest admission, when you think about it.

The Political Significance

It is one thing to describe a good society and another to tell you how to get there. In the West we divide the public from the private, but by working on the family, Confucius believed a ruler could cure all the problems of society too. Since the term "family values" was captured by the far right, I hesitate to use it, but Americans of all political persuasions have begun, in the late 1990s, to come around to Confucius' conviction. A great English philosopher, John Ruskin, once remarked that he had little interest in discussing prisons. If you got the schools right, you wouldn't even need the prisons, Ruskin argued. Confucius starts earlier. Get the *families* right, and *all* the rest of society will take care of itself, including the schools.

That's just life, he would say. Life is almost always lived in families, good families produce good individuals, bad families produce bad ones, so the most important job of any political system has to be: *get the families right*. A country's families are its building blocks, its most important social institution. The really wise man, his followers said, works on the "trunk" of the tree, he doesn't fuss with the endless little branches shooting off from it. "And surely proper behavior toward parents and elder brothers is the trunk of Goodness?" (*Analects* 1.2) "Be filial [dutiful], only be filial and friendly toward your brothers," Confucius claims, and "you will be contributing to government." (*Analects* 2.21) We can guess what Confucius means when we think about Frank Capra's well-known film, *It's a Wonderful Life*, which is a deeply Confucian film. Jimmy Stewart's character, George Bailey, actually tries to commit suicide, believing he's wasted his life. He's spent it stuck in a little town, just being a good son, then a husband and father, doing his job, keeping his word. An angel shows him how the whole town would have collapsed had not he (and all the other George Baileys, both male and female) been quietly holding up their end. The country rests on the family.

My students at San Francisco State University are familiar with the truth of this. Families from Korea or Vietnam or mainland China arrive in San Francisco with poor English and little money. They live in "bad neighborhoods" with high crime rates, such as the Tenderloin. (Americans attribute great moral influence, social critic Jane Jacobs once observed, to grass and trees. Place shattered families in a housing project full of lawns and they will reform, reformers in the 1950s used to think.) The intact Asian families attend schools with high dropout rates. They do fine. We attribute too much power to our schools to change lives. Confucius would only ask about the families, not the schools, and the majority of these families are strong. There are exceptions, of course—but they *are* exceptions, not the usual thing.

Since the 1980s it has become common to speak of Asian Americans as a classic immigrant success story, and to praise the Confucian family system for it. That praise finally made the Asian American leadership nervous, for it was sometimes coupled with indirect attacks on other groups. "The system works. If they can do it, why can't you?" Asian American leaders now call this the "model minority" myth. (See Chapter 4.) No one wants to be the teacher's pet—especially if your example is used to shame other minorities.

As Sau-ling Cynthia Wong protests, "the Asian immigrant family remains a much analyzed and greatly romanticized institution." She dates the model minority thesis from an influential 1966 *New York Times Magazine* article, "Success Story Japanese-American Style."

Ronald Takaki, in his excellent work, *Strangers from Another Shore: A History of Asian Americans*, spends five pages analyzing statistics, trying to deny that Asian Americans are a success at all. We understand Prof. Takaki's anxiety when he ends the section, saying "Significantly, Asian-American 'success' has been accompanied by the rise of a new wave of anti-Asian sentiment. On college campuses, racial slurs have surfaced 'M.I.T. means Made in Taiwan.' . . . Nasty anti-Asian graffiti have suddenly appeared . . . in the elevators of classroom buildings: . . . 'Stop the Chinese before they flunk you out!' . . . Meanwhile, anti-Asian feelings and misunderstandings have been exploding violently in communities across the country." And he wrote this five years before the Rodney King L.A. riots, which saw concentrated attacks on Korean American stores. When he argues so anxiously that Asian success is a "myth," Prof. Takaki seems to have been contemplating one of the oldest proverbs in Asia, "The nail that sticks up gets hammered down."

Takaki rightly argues that figures on family income are slippery—the whole family might be at work in a modest 7–11. But educational attainment, a clearer litmus test, confirms the success story the income statistics implied (at the very least). The U.S. Census Bureau reports that "Almost one out of seven (14 percent) of Asians and Pacific Islanders age 25 or older have a graduate or professional degree—almost twice the percentage for whites (8 percent) and three to four times the rates for other minorities." (pp. 29–30, "America's Minorities," William O'Hare, Population Bulletin 47:4). If the Hawaiian Islanders, a large, impoverished population, succeed in having their U.S. Census status changed from "Asian" to "American Indian," those percentages will fly even farther upward. As for the future, when Americans between 16 and 24 were classified "school only," or "school and work," or "work only," or "neither work nor school," 49 percent of the Asian Americans were "school only." Non-Hispanic whites had only 26 percent in school full time.

Love of Learning: The Second Step to the Good Society
Confucius' system, remember, was a practical proposal to rulers who wanted to reform society. In his system, the first step to the good society must be strengthening the family. The second step is inculcating love of learning.

Confucius loved learning and intelligence so much that he kept no more than polite respect for birth and wealth and rank. If not a democrat, he is what we now call a "meritocrat." He thinks that helping the best and brightest to rise will strengthen a society. He says over and over, he taught anyone who came to him, even if they were lowly born and so poor that they could not pay him in

money, just some strips of dried beef. (7.7) "If even a single peasant comes and asks me a question, I am ready to thrash the matter out, to the very end." (9.7) As recently as 50 years ago you could not have gotten Oxford or Yale to agree to that admissions policy.

Confucius' very careful (even clever) use of words like "gentleman" (chun-tzu) enlarges them beyond the aristocracy to cover anyone refined by learning. That is a revolution: you are not born a gentleman, you make yourself one through study. "Culture cannot make a gentleman!" an offended lordling splutters at one point, "A gentleman is a gentleman." (12.8) Not for Confucius. "It is possible," Confucius tactfully conceded, "to be a true gentleman and yet lack Goodness." That is, he will not deny that a nobleman's son is a "gentleman" in some sense of the word, no matter what he does. "But there has never yet existed a Good man who was not a gentleman." (14.7) Even to the Victorians that would have been a shock—any lowborn chap at all could make himself the equal of a nobleman's son, just by reading books? Outrageous! "A gentleman makes demands upon himself. A little man makes them upon others." (15.20) In other words, you could "make yourself a gentleman" through learning, goodness, and personal responsibility. And Confucius was preaching this radicalism 2,500 years ago, to a far haughtier aristocracy than England ever saw.

It is too much to claim that the Han dynasty put these revolutionary ideas into practice. They did, however, begin the famous Civil Service system in which government posts became available to many, regardless of low birth, provided they were bright enough to pass rigorous exams on the Confucian classics. This system, revived by the Neo-Confucianists, was so successful it lasted (on and off, despite wars and corruptions) until 1911 A.D. As many have observed, China's substitute for democracy was meritocracy, and it was a very successful one. People didn't mind not having a vote, as long as they knew that they could rise very high through hard work. There is not, to this day, a native democratic tradition anywhere in Asia. Americans find it strange that the people tolerate this. Yet until very recently the governments were considered tyrannical only if they failed to encourage the meritocracy that Confucius insisted on. This is where Asian dictators, stung by Western criticism of their "human rights" abuses, have tried to hide behind the idea of "Asian values." Nothing in Confucianism supports conformism, and Confucius himself was an undaunted nonconformist, whose stubborn devotion to his Tao and the preaching of it resembles that of an Old Testament prophet, as de Bary points out. A great part of Confucianism concerns the training of the highest, noblest individuals, the chun-tzus. He praises strong families, yes, but for Confucius, the strong family and the chun-tzu were as inseparable as the root and

the flower. How could there be flowers without sound roots? What use would the roots be if they didn't send up flowers? De Bary, in conversation, goes so far as to say that if Confucius thought the family wasn't the way to produce the magnificent, moral chun-tzu, Confucius would have lost interest in it. Hypothetical questions aside, Confucius saw family and noble individual as inseparable.

Confucian Values and Western Values

Asian American literature has become largely a speculation about the Confucian family heritage: its blessings and its costs. The tight-knit extended family we encounter in novels like *The Joy Luck Club* and movies like *Dim Sum* is Confucian. First generation and second generation, like my air-conditioner loving niece, battle it out. Amy Tan, second generation, starts *The Kitchen God's Wife*, "Whenever my mother talks to me, she begins the conversation as if we were already in the middle of an argument." The strain of maintaining, in individualistic America, a system that sees "proper behavior toward parents and elder brothers" as the very "trunk of Goodness" weighs on all the generations.

Nor did Confucianism have much interest in the sisters. In the West, to our credit, we do. Where does the Kitchen God's American feminist wife fit in? In the Asian Confucian system women seem condemned to play supporting, rather than starring roles. (Notwithstanding Confucius' willingness to suspend his life for 3 years to mourn his mother.) Maxine Hong Kingston, Amy Tan, and other feminist American authors wrestle endlessly with the downside of Confucian values.

There were costs to China too. No Western country could follow Confucius uncritically now. At best, we can salvage parts of it. What is the proper attitude to parents, Confucius is asked. "Never disobey!" he replies. He is asked again. "Never disobey!" (2.5) This powerful loyalty created very stable political structures in China, from the Han dynasty on. People who behave dutifully to their parents and elder brothers never start a revolution, the *Analects* claim. (1.2) For nearly 2,000 years China was the largest, most prosperous, most civilized country in the world. There were invasions, wars, and corruptions, but nothing to equal our Dark Ages and the endless wars fought out among a hundred petty states.

But one has to notice that China was conquered by foreign tribes several times, principally the Mongols, who founded the Yuan dynasty that Marco Polo encountered, and the Manchu, who became the Ching dynasty. The West's long dark age may have helped China drift along, its arteries becoming more and more sclerotic.

After the West got off its back and started the Industrial Revolution, China faced competition from us for the first time in millennia. Within 50 years the British had humbled China and begun the era of Western domination. Once the Industrial Revolution arrived, change became the "only constant." Confucianism helped keep China rigid, and it fell behind. You cannot tell if a man is good by whether he obeys his father while his father is alive, Confucius actually says once. If, after the father dies, the son mourns for three years as ritual prescribes, and during that time still does "everything exactly as in his father's day, that is a good son indeed." (1.11) In the timeless pre-industrial agrarian world, China could survive like that, but once the Industrial Revolution started us on the road toward our current pace, that had to go. Go it did, but too late for China, which fell disastrously behind the West, and was brutally exploited by the European powers during the 1800s.

And as for "never disobey," that authoritarian attitude has had terrible costs as well. No matter what the governments called themselves, the role of the governed has been pretty much the same. This morning, in Tiananmen Square, directly in front of Mao's tomb, I watched jackbooted troops doing showy exercises with machine guns. It is June, the sixth anniversary of the Tiananmen Massacre of the Beijing students, and the government has already arrested a group of people who made a silent demonstration there. These troops will use those machine guns, and the quiet circumspect people in the square know it. I had taught in Beijing the summer before Tiananmen, and students from the college where I taught were shot down. As I watched the soldiers, their weapons chest-high, trotting in close formation like show horses, mouths set, eyes blank, Confucius' words went through my mind, "Never disobey! Never disobey!"

Confucianism Compared to Western Religion: This World, Not the Next

The West—the Anglo Saxon West, in particular—can be proud of its role in building democratic systems that greatly enlarged the number of humans who were perceived to have "human rights," work which we continue to pioneer. Asia admires us for it. The 1989 student rebels in Tiananmen Square constructed a giant replica of the Statue of Liberty. On the videotape of the massacre, you can watch it slowly, eerily fall, while the troops fire. (If philosophers like Richard Rorty really wanted to know what the West would be like without the Enlightenment they could come watch the soldiers trotting through Tiananmen Square.)

That said, we have much to learn from Confucius. His program for social reform by strengthening the families, by inculcating love of learning, and by working toward meritocracy is impressive and practical.

What he finds it possible to do *without* is also very intriguing. To begin with, Western philosophers from the Age of Reason until now have been startled by the Confucian ability to live without any interest in supernatural religious thought. He promises no afterlife and dislikes speculating about it. Confucius spoke as little as possible about ghosts and the supernatural (7:20), and when someone asked him about proper procedures for "serving" ghosts and spirits, Confucius only replied, "Until you have learned how to serve men, how can you serve ghosts?"—a kind of shrug. (11.11) He assumes that humans, through their powers, can improve their life. In 500 B.C., as Marvin Nathan points out, that was a revolution in human thought: instead of gods, or even God, humans run the show. "The Master took four subjects for his teaching," the *Analects* records, and none of them is God or heaven: "culture, conduct of affairs, loyalty to superiors [primarily the family hierarchy, of course], and the keeping of promises." (7.24)

Confucianism has been justly called "religion," but it is not one in the common Western sense, for we Judeo-Christians expect a "religion" to involve the supernatural. Confucianism is more what we would call a "system of values" and of "ethical behavior." The topic of the supernatural is not left out, but it is avoided. Confucius himself is neither God nor prophet.

Just as people in the West may go to church and yet observe many ancient superstitions (like erecting buildings with no thirteenth floor), the Confucian family exists in the middle of a great number of folk religious practices that are much older. Educated people may laugh at talk of ghosts and spirits, but people with peasant roots—many of the people who came to America seeking opportunity—carry on a great number of folk practices, together with their Confucian family values. There is nothing in Confucius about keeping a picture of the "kitchen god" in your kitchen, as the mother does in Amy Tan's *The Kitchen God's Wife*. The many folk gods have found a physical home in the obliging Taoist temples, though they have nothing to do with the classical Taoism of the *Tao te Ching*. The Baiyunguan, the central Taoist temple of Beijing, is crammed with realistic doll-like figures of the Jade Emperor and Suntse Niang Niang, the "Grandma who gives male children." The Western god is famously "jealous," as we know from the First Commandment, but in Asia—as in classical Greece— all the gods practiced coexistence, and you could patronize as many as you wished. At the Baiyunguan my sister-in-law places her money in the large glass

这眼开旦千井水清次州口州·旧旬禾禾杁
考的举子们，到孔庙拜谒孔子后，如饮井中的
"圣水"，定能文思泉涌笔下生花，以此水发墨，
便会浓墨喷香，落笔如神．清乾隆皇帝赐名为
□水湖"．

Figure 5–3: Beyond East and West: The author's son at the Inkstone Well, the
Confucian Temple, Beijing, 1996. By tradition, those who drank from the
temple's ancient well would pass their imperial examinations. In 1996,
when water returned to the Inkstone Well after a thirty year drought,
temple officials—no strangers to symbolism—carefully removed the top
from a Chinese Coca-Cola can, fastened a string to it, and made it into
an ostentatiously "modern" bucket for drawing up the water of wisdom.
Photo by George J. Leonard.

tank, kneels on the cushion before the figure (who sometimes wears a beard
made of real hair) and "kow tows" (literally *"ke-tou,"* to "knock the head" against
the floor). When the monk, watching her, hits his gong, her prayer comes to
the Jade Emperor's attention.

At the Confucian temple on the West side of town, the Kong Miao, there
is none of that. No monks, no gongs, no prayers. Is "temple" even the right word?
Early missionaries encountering what they called "temples" built to Confucius
filled with people bowing before his statues projected the Western term "reli-
gion" onto Confucianism. Think, instead, of the Lincoln Memorial. People make
family trips to this giant seated figure, get teary-eyed in front of it, read rever-
ently to their children his words carved onto the walls, and leave feeling some-
how strengthened and rededicated to Lincoln's sacred ideals. A man (or woman)
from Mars could easily confuse their behavior at the memorial with religious
"worship."

Now imagine if the government decided it would be good for the country if there were copies of the popular Lincoln Memorial in all our cities, perhaps inside a small walled park, where one could find a quiet place for reflection; and even a small library attached, where we could be re-inspired by Lincoln's writings. Not a bad idea, in fact. Such are the Confucian "temples" and such is the veneration in which East Asia (China, Japan, Korea, and Southeast Asia) holds Confucian values to this day. He has "temples" in most cities, often located next to a library or school.

Confucianism Compared to Western Religion: Humanism, Not Mysticism

The central East Asian philosophy then is humanist, not mystic. Americans studying China must take care to abandon the popular misconception (almost an article of faith among aging hippies and the New Agers) that China is more mystical or "spiritual" than the West. China's central current is humanist, practical, Confucian.

Confucius, far from being a mystic, is uninterested in matters beyond this life. He feels no need to speculate, with Jesus and Paul, about the origin of the universe or the end of time. Christians assume no one can live until they figure out Who made the world and whether we go anywhere after death. The Confucianists—like the Old Testament Jews, who rarely speculated about life after death—are perfectly satisfied with this life. Their whole interest is in how human beings can best get along while enjoying it.

For that reason, Confucius does share Jesus' interest in the "Golden Rule." In fact, he is more interested than Jesus, whose main concern is with the dawning Kingdom of God, not with how humans can best live together down here. Five hundred years before Jesus, the Golden Rule appears no less than three times in the *Analects*, in a refined version with a typically practical moderate twist. Confucius carefully says, "Do not do to others what you would not like yourself." (12.2) He considers the Golden Rule central: when asked if there were "any single saying that one can act upon all day and every day," Confucius replied, "Never do to others what you would not like them to do to you." (15.23)

Jesus will later say, "Do unto others as you would have them do unto you." Why the slight difference from Jesus' version? Oscar Wilde later complained about Jesus' version, saying "Do not do to others what you would have them do to you! They may not have the same tastes!" From that point of view, Jesus' version is overheated, intrusive. You decide what is good for everyone based on your own likes. One of Confucius' principles was "moderation" or "the Mean." (6.27, .29)

Confucius' carefully phrased version gets the most good out of the Golden Rule without sending you bustling out to impose yourself on everyone. That is typical of his careful, moderate, workable philosophy.

On the other hand, as polymath author Joel T. Smith argues, Jesus' version is "proactive," while the Confucian version is, by comparison, passive. Jesus acts; Confucius, too cautious, abstains. The Western ideal became the charismatic young preacher, Jesus, out and about challenging the world. The Eastern ideal became Confucius, who is always pictured old and who said he had finally won control over his will only in old age. We might even see, in these two archetypal figures, the Western preference for youth and the Eastern preference for age.

Confucius and Jesus: Contrasting Role Models

The Westerner, comparing those two role models, must also wonder if Christianity accidentally predisposes us to weaker families and, thereby, to Western loneliness, alienation, and identity crises. The contrast between Jesus and St. Paul, on the one hand, and Confucius on the other, could not be starker. Look at the role modeling. Jesus famously rejects Mary and his family, in his eagerness to serve God. "Then his mother and his brothers arrived; they stayed outside and sent in a message asking him to come out to them. A crowd was sitting round him when word was brought that his mother and brothers were outside asking for him. 'Who are my mother and my brothers?' he replied. And looking round at those who were sitting in the circle about him he said, 'Here are my mother and my brothers. Whoever does the will of God is my brother and sister and mother.'" (Mark 3:31–35) "His parents were astonished to see him there, and his mother said to him, 'My son, why have you treated us like this? Your father and I have been anxiously searching for you.' 'Why did you search for me?' he said. 'Did you not know that I was bound to be in my Father's house?'" (Luke 2:48–50)

If you accept Jesus as the Son of God, perhaps that need not bother you. But the apostles are presented as ordinary people who rightly abandon all social and personal duties to serve Jesus. They are not praised as good fathers, good community members, dutiful sons, supportive husbands. On the contrary, they are praised for abandoning all those "ordinary" roles for supernatural goals. "Peter said, 'What about us? We left all we had to follow you.' Jesus said to them, 'Truly I tell you: there is no one who has given up home or wife, brothers, parents, or children, for the sake of the kingdom of God, who will not be repaid

many times over in this age, and in the age to come have eternal life.'" (Luke 18:28–30) Ironically, one wing of feminism accuses Jesus of being a "patriarch," a term that means "rule by the fathers." We may say, if only he were a patriarch! Not only is Jesus not a father, he pulls fathers out of their homes. Anyone unwilling to give up being a patriarch, unwilling to abandon "wife, brothers, parents, or children" is doomed. St. Paul, a notorious misogynist, reluctantly approved marriage, but said it would be better if everyone "kept under the body" and lived celibate like him: loving no wife, nurturing no child, comforting no aged parent. The end of the world was at hand. Nothing ordinary mattered anymore. That is the "continuing paradox" of Christianity, David Antin has commented. "How do you build a continuing society on an apocalyptic model?" Indeed, on a role model who appeared in order to "announce the end of the world—an end he himself hoped to bring about?" How do you build on such a base "a society which has no intention of ending?" Such a society rests on a paradox and will be full of paradoxes from the start.

Confucius and Jesus: Pleasure and Guilt

Christianity began with hostility to the pleasures and satisfactions of this life. Pleasure appears in the very first lines of the *Analects* as a normal human goal. "The Master said, To learn and at due times to repeat what one has learned, is that not after all a pleasure? That friends should come to one from afar, is this not after all delightful?" (1.1) By St. Augustine's time, the 300s, Christ's and St. Paul's tendency to look at this life as no more than a giant college entrance exam for the next life had hardened into real hatred for "the world, the flesh and the devil." Christ had said it was easier for a camel to pass through the eye of a needle than for a rich man to enter Heaven, and the Sermon on the Mount is full of statements blessing the poor, the meek, the lowly. Passages like that led the German philosopher Nietzsche to write Christianity off as a sour-grapes religion for the underclass ("slave religion"), which "transvalued the values," turned all their misery into virtues, as if they had made some sort of noble choice to be poor and lowly. We in the West retain a nagging suspicion of "worldly" success. "Sure he's rich, but is he happy?" We feel guilty for wanting the good things in life and for envying those who have them.

One of the most attractive things about Confucianism, I think, is that it never "transvalues the values." Of course, you want to be rich and famous, Confucius says. It's natural. Relax. "Wealth and rank are what every man desires Poverty and

obscurity are what every man detests." You may be poor, but Confucius (unlike Jesus) doesn't make you feel guilty on top of it, because you wish you weren't. The moral question isn't whether you want to be rich and famous—that's only natural—the moral question is, what are you willing to trade for it? "If wealth and rank can only be retained to the detriment of the Way he professes," the truly good man must "relinquish them." (4.5) Confucius did.

Confucius' whole system deals with how you might go after wealth and honor without becoming someone you are ashamed of being, or someone who helps ruin life for everyone else. Someone of Confucian heritage would have no problem with the Beatles making millions of dollars by making a billion people happy. (The Beatles did not earn their money by "oppressing" anybody.)

To Christians, this whole-hearted enjoyment of even innocently gotten gains can look suspect, materialist, and "shallow." As if misery were "deeper" than happiness, Nietzsche notes with scorn. Say a kind word for money and the classroom tenses, as if waiting for Michael Douglas to jump out of a cake and give the speech praising greed from the movie *Wall Street*. But Confucius disdained materialism and relegated mere merchants to the lowest stratum of society. Wanting wealth and rank may not be wrong, and "What are you willing to trade for them?" may be the question. But plainly, the answer was, almost everyone is willing to trade too much. The *Analects* continually try to remind us of other joys: the joy of learning, of friendship, of music, of family. Yet, despite Confucius' personal disappointments, he never descends to "sour grapes." The *Analects* never try to "transvalue the values," and tell us wealth and rank are bad to have. It is natural to want them. Quit feeling guilty—but that does not mean, "sell out (4:14, 16)."

In the end, someone comparing Western and Confucian philosophies is struck by the absence of so many topics we consider problems. I suggest it may be a healthy absence, the kind of absence which the philosopher Wittgenstein would have approved.

Confucian philosophy believes that if you have a job you like, a family that loves you, and you're able to afford to take care of your aged parents—secure in the knowledge that you will be cared for and respected in your turn—not only will you be happy, but you'll be a productive member of society. And that's it. The personal and political are solved. Confucianism doesn't bother to speculate about the "afterlife" or "alienation" or the "meaning of life" or "identity" or "eschatology" or countless other Western philosophic "problems." The person described above isn't "alienated," knows who he is, and knows why he does what he

does. Perhaps the great number of philosophic "problems" the West mulls over is a sign that we are asking the wrong questions. Historically, we started with the wrong assumptions about what we like and what would make us happy; perhaps because the Christians started with a life-despising philosophy remarkably indifferent to the worthwhileness of loving a spouse, nurturing a child, doing work you like, taking your place in the community. Perhaps our sense that life is "mysterious" and our sense that life is full of philosophic "problems" is nothing but a confession that, starting from such a place, we have been handicapped figuring out what works. Confucius has the calm and simplicity of one who knows.

Once again, Asian Americans are not Asians, and many Asian Americans are ardent Christians. Not the smallest part of the Asian American synthesis, then, has been to reconcile these often opposing value systems.

Summation: The Global Significance of the Contemporary Asian American Experience

The next century will take place in what we now call cyberspace, more than in physical space. East and West will be dated notions—are dated already. The world project during the next century will be the project forced on every Asian who ever landed in America intending to stay: deciding what to leave in, what to leave out. Their many, and varied, pragmatic working solutions, which as a group I have called "American Confucianism," offer us an advance look at world culture. It is best studied not in abstract dissertations, but in (I repeat Karl Jaspers' phrase, with which I began this essay) "the unity of thought and life" which art and literature excel at conveying. For that reason, Asian American literature and art are not only of national, but of world importance. In it, we see the global future.

[Jack Miles' Pulitzer prize-winning book, God: A Biography, *inspired this chapter, and I thank Jack Miles for reading a draft of it and offering advice. I thank William Theodore de Bary for reading a partial draft of this chapter and offering invaluable suggestions which redirected parts of it. David Antin critiqued a draft, as did Mary Scott, Joel T. Smith, Y. F. Du, Simei Leonard, and Dean Zhu, who originally arranged for me to teach at Beijing Advanced Teacher's College, where many colleagues shared ideas. I am also indebted to Xianrong Shi and Marvin Nathan.]*

Further Reading

"America's Minorities: The Demographics of Diversity." *Population Bulletin* 47:4 Dec., 1992. The nonprofit Population Reference Bureau's pamphlets provide nonpartisan discussions of U.S. Census statistics.

de Bary, Wm. Theodore. *East Asian Civilizations: A Dialogue in Five Stages.* Cambridge: Harvard University Press, 1988. De Bary's Reischauer Lectures at Harvard. A concise (138 pages) but magisterial overview, by the West's leading Confucian scholar, of 3,000 years of East Asian civilizations, principally in the form of dialogues among the major systems of thought that have dominated the Asian world's historical development. For the teacher, the best introduction to Asian thought.

——. *Neo-Confucian Orthodoxy and the Learning of the Mind-and-Heart.* New York: Columbia University Press, 1975. An impassioned and stunningly erudite *apologia* for Neo-Confucianism. De Bary, in this and other books, helped spark the revival of interest in Confucius in our time.

——. *The Trouble with Confucianism.* Cambridge: Harvard University Press, 1991. De Bary's sober, and sobering analysis of the significance of Confucianism to the world today. De Bary examines the way this liberal humanist teaching has been wrongly appropriated to serve conservative regimes. He destroys the dictators' argument that "Asian values" are somehow inimical to Western "human rights."

Fingarette, Herbert. *Confucius: The Secular as Sacred.* New York: Harper, 1972. This esteemed work makes points disputed occasionally by Benjamin Schwartz (see below).

Graham, A.C. *Disputers of the Tao.* LaSalle, IL: Open Court, 1989.

Jingpan, Chen. *Confucius as a Teacher.* Beijing: Foreign Language Press, 1990 reprint of 1940. A useful work from the People's Republic of China for those who want the Chinese characters and terms. See also Xigin (below).

Lau, D.C. *Analects.* New York: Penguin, 1979. This version is easier reading than Waley's, but paraphrases more, so that it loses some accuracy. It has a long, useful introduction and helpful notes; it is much assigned.

Legge, James. *Analects.* New York: 1971 facsimile of Oxford: Clarendon Press, 1893. 2nd rev. ed. See as companion his Confucian classics, "The Great Learning" and "The Doctrine of the Mean." Though badly dated, this inexpensive book, available in a Dover paperback, contains the Confucian text as Legge knew it side-by-side with his (fussy, Victorian) translation and a running commentary on the terms and characters. Legge, an English missionary, went to the East in 1839, and was patronized by Joseph Jardine, one of the British robber barons who created Hong Kong. He published the first version of this book in 1861, so the 1893 revision has a lifetime's experience behind it.

Miles, Jack. *God: A Biography.* New York: Knopf, 1995. My essay was an attempt to emulate Miles' methodology.

Schwartz, Benjamin. *The World of Thought in Ancient China.* Cambridge, MA: Harvard University Press, 1985. My article is much indebted to this book.

Waley, Arthur. *The Analects of Confucius.* New York: Random, 1989 reprint of New York: Macmillan, 1938. My quotations come from this unpoetic but faithful translation. Waley's long introduction is dated, but still suggestive.

Xigin, Cai. *Analects of Confucius.* Beijing: Sinolingua, 1994. A bilingual translation.

My Grandfather's Concubines

A First-Generation Woman Remembers Life in Peking

MOLLY H. ISHAM

The phonetic system used in this article is the official **hanyu pinyin** system used in the People's Republic of China since 1958 (see **pinyin**). The pronunciation of the six difficult symbols is explained as follows: *Q* like "ch" in "cheese"; *X* like "sh" in "sheep"; *Z* like "ds" in "beds"; *C* like "ts" in "cats"; *Zh* like "dg" in "edge"; *E* like the "e" in "the" before a consonant.

The Traditional Peking Courtyard House

Three years ago I saw Asian American director Peter Wang's film *The Great Wall*. A lot of the Beijing scenes were shot in a Peking courtyard house; all at once my childhood experiences returned to me.

It has been 40 years since I lived in a *sihe yuar,* a typical Peking-style courtyard house, but a child's memory of a dwelling, of delicious things to eat, of fun things to play with, will never vanish, regardless how long ago it may have been. I remember the beauty and fragrance in *chun tian,* spring, when the pink crabapple flowers, and the purple lilacs were in full bloom; and *xia tian,* summer, always came with the sweetest and juiciest *da xigua,* big watermelons. Everyday I ate a quarter of a watermelon after my nap, listening to the cicadas hum. Those two things affected me in a strange way, while the watermelon made me feel wide awake, the cicadas often made me sleepy. The melancholy serenity of *qiu tian,* autumn, with the quietly falling leaves sometimes brought tears to my eyes. But when *dong tian,* winter, came, the fun I had making a snowman, in the yard or in the inner garden was unforgettable.

I was born in a Peking-courtyard house that belonged to my *yeye,* paternal grandfather, and *nainai,* paternal grandmother. I lived there until the age of six,

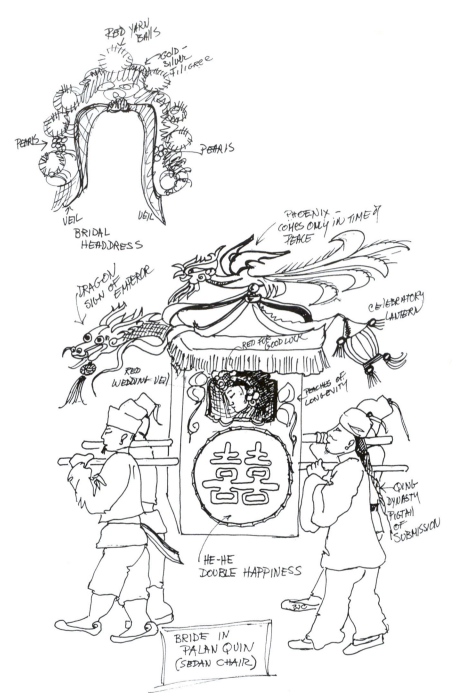

Figure 6–1: Bride arriving at wedding in traditional sedan chair, c. 1900. Drawing by Betty Cornell. Used by permission of the artist. Courtesy of George J. Leonard.

then left with my *muqin,* mother, and *fuqin,* father, for another city. My grandfather was a scholar and a Qing dynasty official. When the Qing government was overthrown by the Kuomintang (pinyin Guomindang), a political party that ruled China between 1911 and 1949, my grandfather bought this large house to settle down and raise a family. The house used to belong to an ex-Qing prince and was situated in a nicely kept-up *hutong,* alley. With just a few exceptions, all the hutongs in Peking are through roads, some are quite wide, nicely paved, and even have buses running through them.

The name *sihe yuar* refers to the architectural style: *si* is four, *he* means closed, and *yuar* is a courtyard; thus, four buildings join into a square shape with a courtyard in the center. The basic design and arrangement of all the Peking-courtyard houses are mostly identical except for minor differences. First, the sizes of the courtyards may be different. Then the number of rooms may differ. Aside from that, the courtyard houses all look alike. The building bordering the north side of the yard, called *bei fang,* north building, has all its windows facing south. It usually has five rooms—a combined eating and sitting room in the center called *tang wu* (used more like a family room), two *wo fang,* bedrooms, one on each side of the family room; then a *ce suo,* toilet, and a storeroom at the two extreme ends. The last two rooms have lower roofs, and they look like ears, thus, also called *er fang,* ear-rooms. Sometimes the toilet is in the outhouse. The north building is usually occupied by the oldest and most important people in the family, such as the grandparents. The building on the south side of the courtyard is *nan fang,* south building. Since its windows face north, those rooms are cold in winter and stuffy in summer, and, if located close to the front gate, they provide living quarters for men-servants. The other two buildings with windows facing east and west are called *xiang fang,* wings. Though they are not as pleasant to live in as the north building, they are still much better than the south building. The wings on the two sides usually have two to three rooms each, and are occupied by the children of the family and the maid servants who take care of the children.

In big mansions the kitchens, pantries, and dish-washing rooms are not located in the same courtyard as the bedrooms, at least not near the important people's bedrooms, because the noise and the smell can be disturbing to them. For the same reasons the *fan ting,* dining room, and *ke ting,* guest hall, which is the official sittingroom shared by the family, are also far away from the living quarters. In the case of my grandfather's house, after entering the main gates, one saw that the first two courtyards were servants' quarters and storage rooms; then one came to the *ying bi,* a screenlike wall facing the gates that blocked the path of entry. This screen wall is an important feature of the traditional Chinese

Figure 6–2: A 1920s upper class bedroom (reconstructed), Beijing.
Photo by George J. Leonard.

architecture, because any visitor entering the house would have to walk around it before the rest of the buildings come into view. Evil spirits as well as unwelcomed visitors, I was told, were stopped by it. The second function was, when there was a big celebration and the main gates were left wide open, no passers-by could see right through to the inner courtyards. The third courtyard had a very large north building, serving as the livingroom, and the fourth courtyard had the dining room, kitchen, and a storage room for food. Only after walking through those four courtyards would one see my grandfather's and grandmother's courtyards. Every building was connected by *zou lang,* roofed walkways on the courtyard side, and nobody needed to get wet on rainy days walking from one building to another, or one courtyard to the next.

It was the Chinese tradition to have three or four generations living in the same house. If a wealthy man had many *erzi,* sons, and *sunzi,* grandsons, and managed to have *wu dai tong tang,* five generations sharing the same *tang,* the main room of a house (somewhat like an important family room), he would be considered very fortunate and win respect in his community. On the other hand, if a man had no sons, only *nu er,* daughters, then he presumably had done something *que de,* morally lacking, or mean, in his past life; so Lao Tian Ye, Old Heaven Master, was punishing him by giving him no sons to carry on his ancestors' name. When Chinese people quarrel, one of the very strong curses is: *"ni juezi juesun,"* you shall have no sons and no grandsons.

My grandfather, with the help of his *da taitai,* first wife, or lawfully wedded wife, and four *yi taitai,* concubines, fathered 14 sons and 9 daughters (please see "The Chinese Expressions" in Amy Tan's *The Joy Luck Club,* p. 43 under *Huang Taitai,* and p. 71, under "Concubines," hereafter referred to as *JLC*). On his 94th birthday when we, his direct descendants, had to line up and take turns to kowtow to him, I estimated there to be at least 60 or 70 of us, including the spouses, the 36 grandchildren, and the 4 great-grandchildren.

Only four of grandpa's sons and one unmarried daughter lived in his *jia,* home; the others were working in different cities. Since there were 14 courtyards in the house, there was plenty of room for each small family to have a whole courtyard to themselves and, thus, have some privacy, although the old-fashioned Chinese really did not know the word "privacy" in our sense. Even today, a Chinese mother would consider it perfectly natural for her to open and read her grown-up children's mail before the latter got them or ask to examine how much money they brought back on pay day. In the *New English-Chinese Dictionary,* published by the Commercial Press, 1987, the three Chinese definitions given under the word "privacy" were: "to live in seclusion," "to conceal," "to be a hermit."

After spending many years away from the place where I was born, I went back as a teenager to live in grandpa's house while I was attending *gao zhong,* senior high school, in Peking. Since I was an unmarried young girl, I was only allowed to live in one of the courtyards farthest away from the main gate. I chose the up-stairs of a two-storied building to the north of the inner garden, in spite of the fact that my *wu bo,* fifth uncle on my father's side, repeatedly assured me it was haunted by Huli Jing, the Fox Spirit, and other ghosts (see *JLC,* p. 33, Ghost). The building I chose had been vacant for six or seven years at the time I moved in, and I knew two of my *tang jiejie,* female cousins on my father's side, had tried but were scared away by the strange noises at night. However, there was a pleasant view from my window: directly underneath, a fish pond full of *hong liyu,* red carp; to the right, a *jia shan,* man-made rocky hill, topped with a red, green, and gray pavilion; further ahead there were a few rows of tall *zi zhu,* purple bamboos, through which I could see the roof of my grandfather's *shu fang,* study, which he tastefully named *Xule Tang,* the Hall to Discuss Happiness. The inner garden, or back garden as some call it, was different from all the courtyards in the house. It had no buildings on the other three sides, so I was the only one in an area of about 5,000 feet, and I enjoyed total privacy. I did occasionally hear footsteps on my veranda, but when I peeked through the window, it was just a *huang shu lang,* yellow weasel, frolicking with his mate. I had heard many stories about weasels visiting old houses and vacant places, and they were harmless to human

Figure 6–3: An old man waters plants in the courtyard of his Beijing courtyard home. Photo by George J. Leonard.

beings; so I did not mind having them play outside my rooms at all. During the first 18 months I was living there I never saw a single ghost or Fox Spirit.

By that time, everybody, including the servants, in that big family was praising me for my *dan liang,* courage. I was all ready to go to my fifth uncle and tell him he should not be so *mi xin,* superstitious, when something happened. One night, I almost fainted.

It was the middle of June, and I was preparing for my *biye kaoshi,* graduation exam. The night air was hot and stuffy, and I was trying to cram a lot of knowledge into my head at the last moment. Because of the heat I had turned out all the ceiling lights and the light in the hallway, keeping only my desk lamp lit. Suddenly I heard a rustle by the entrance of my room. I looked toward the darkness, and there was a figure, in a loose white shirt and no legs, floating into my room. It had a long rectangular-shaped face. I thought I was hallucinating. I blinked and looked again. The figure was still there, only this time, its mouth was open. I screamed. The figure jumped slightly, and mumbled something.

"*Ai-ya! Xiasi wole.*" Oh! You scared me to death, the figure said quietly, emerging from my dark doorway (see *JLC,* p. 23, *Aii-ya*). Only then did I realize it was my grandma's maid, who was dressed in a white cotton top and black pants. She had come to tell me that my grandma wanted me to go over for a midnight snack, because she knew I was staying up late to study.

We Chinese have a saying: *ren xia ren, xia si ren,* only a human being can scare another human being to death. And that is quite true!

Two days later, as soon as my final exam was over, I moved out of the "haunted" building.

My Grandfather's Concubines: Traditional Chinese Family Roles in the First Part of the Century

The family I have been describing undoubtedly seems strange to you, and perhaps even "immoral," by contemporary Judeo-Christian standards. But Grandfather was a thoroughly upright and upstanding member of society. Since many contemporary Chinese films are set back in that period, and Chinese American films and literature love to flash back to that time, it is worth explaining.

In mainland China, up to 1949, it was fairly common for rich men to "take in" *yi taitai,* concubines. A man's lawfully wedded wife is called his *taitai.* The word *yi* with the second tone has the following definitions: (1) one's wife's sister, (2) one's mother's older or younger sister, (3) a maternal aunt, (4) a father's

Figure 6–4: Glimpse from the street into the courtyard of a traditional Beijing house. Photo by George J. Leonard.

concubine, so called by his children. (See the Chinese Encyclopedia *Ci Hai, Sea of Words,* p. 1101, published by the Shanghai Ci Shu Publishing House, Shanghai, China, 1979 edition.) It does make sense to address the concubines as *yi taitai,* and I will tell you why I think so.

The lawfully wedded wife in an old-fashioned Chinese *jia ting,* family, was not unwilling to allow one or more concubines to join as family members, and to come and live in the household. There was more than one reason why a wife would allow or encourage her *zhang fu,* husband, to take in concubines: one, she could not *sheng erzi,* give birth to sons; two, to please her husband; three, to keep him away from *ji nu,* prostitutes and *ge nu,* sing-song girls; four, under some situations, to have someone to wait on herself. The first wife and the concubines would each have a separate bedroom, and the *lao ye,* old master, would make the choice as to whose bedroom he would spend the night in. The first wife and the concubines would eat at the same table, play *Majiang* (see *JLC,* p. 5, *Mah jong*) together, or go to the *miao,* temples, and worship the Buddhas as a group. They sometimes gave people the impression they were sisters, addressing each other as *san mei,* number 3 younger sister, or *er jie,* number 2 older sister; at other times they plotted against one another behind their backs and acted as if they were implacable enemies. The children would call the lawfully wedded wife "Mama," mother, and call the concubines "Yi," aunt. The Chinese film *Raise High the Big Red Lanterns* offered examples of the lives of the old-fashioned Chinese concubines.

My *zu fu,* grandfather, or colloquially, *yeye,* grandpa, had one wife and four concubines in his lifetime. When he was a young man his family was very poor, and he could not afford to study in school. At eighteen, his parents had him betrothed to my *zu mu,* grandmother, colloquially called *nainai,* grandma. My grandma, who was a few years older than my grandpa, was not only more mature, but also extremely capable. During the daytime she served her *gonggong,* father-in-law, and *popo,* mother-in-law, did the household chores, handled the shopping and cooking, and washing and cleaning. When night came, and the old people were asleep, she worked under an oil lamp making wicker baskets and straw hats to sell in the *shi chang,* marketplace. Night after night she worked long hours, with no weekends, no holidays, to save up some money so my grandfather could buy *shu,* books, *zhi,* paper, and *bi mo,* ink and brush pens. I must have heard my mother relate to me more than a dozen times the episodes of my grandfather's determination in self-study and my grandma's thriftiness in keeping house. Whenever I became wasteful in my mother's eyes, or I complained too much, she repeated the following story:

"When your grandpa and grandma were young, they shared one *you deng,* oil lamp, to study and work at night. They used only one lampwick, because they *she bu de,* were reluctant, to use two lampwicks to make the light brighter. Eventually their eyes deteriorated so quickly, they had to take turns using the oil lamp. One would sleep the first half of the night, and the other, the second half. For seven years your grandma mended your grandpa's *yifu,* clothes, and *xie wa,* shoes and socks, over and over again. Not until the time he was ready to go to *sheng cheng,* the provincial capital, to take the examination, did she make him a suit of *xin yifu,* new clothes. He was determined to pass the exam, and she was firm in supporting him. And he did pass it with honors, and became a *Ju Ren,* an official at the provincial level. Later he was appointed to a post in Hebei province." (Hebei, formerly known as Hopei, is located in North China. Both Beijing and Tianjin are in Hebei province.)

My mother, in her story telling, never mentioned a word about my grandfather's concubines. She came from a *yang pai,* Westernized, family, and she could not stand the idea of somebody having a concubine. Nevertheless, she had great respect for my grandma, so whatever my grandma wished, she put up with it. My grandma, born in 1848, was a very old-fashioned Chinese housewife. She not only accepted concubines into her family, she sometimes made it her job to get a concubine for her husband. Many teachings of the ancient Chinese Sage, **Kong Fu Zi,** Confucius, stuck tenaciously to the Chinese mind. *"Bu xiao you san,"* there are three acts marking a person unfilial (not a dutiful child), said Confucius, *"wu hou wei da,"* the most serious one, is not to have an heir; an heir refers to a male child, because only he can carry on the family name. On several occasions when I found my grandma in a low-spirited, self-blaming mood, she repeated Confucius' words to me and bade me remember them when I *zhang da,* grew up. "Don't be like me," I could hear the pain in her voice when she said that, "I tried so hard to give your grandfather *erzi,* a son, but only gave birth to four *nu er,* daughters.

During the ninth year of their marriage, when my grandma's only son died in infancy, she decided to buy my grandfather his first concubine. Everybody called her *da yi tai,* Big Concubine. *Da,* big, very often in the Chinese language means "first" or "oldest."

The Chinese say *qu qi,* wed a wife, and *na qie,* admit, or take in, a concubine, because the ceremonies are totally different. There is usually a big celebration at the wedding of the *da taitai,* first wife. If it is in a village, not only the friends and relatives of the *xin niang,* bride, and *xin lang,* groom, are present, but the whole village will be invited to a feast that may last 3 days. The groom's family sends over a *hua jiao,* bridal sedan chair (see *JLC,* p. 52, Palanquin) to pick up the bride

Figure 6–5: Goldfish tub beneath persimmon trees in a courtyard house, Beijing. Photo by George J. Leonard.

on the day of the wedding; and the bridal procession will also include a wind and percussion band, and a team of hired hands carrying the *jia zhuang,* dowry. When the bride arrives at the scene, all the guests are already there, lined up to welcome her. However, nobody gets to see what she looks like, because her head is covered with a large piece of red *chou,* silk, or *bu,* cloth, which is kept on all through the wedding ceremony including *bai tian di,* kowtowing to Heaven and Earth, and kowtowing to *zu zong,* ancestors. After the banquet, when the new couple get into the *dong fang,* bridal chamber, the groom will take away the red veil and see the face of his lawfully wedded wife for the first time.

The concubines—however many there may be—are "taken in" quietly, without *hunli,* the wedding ceremonies. They do not have to come from comparable families, nor do they need to be educated women. On the arranged date, a concubine would come to the house on her own, or be accompanied by a *mei po,* matchmaker (see *JLC,* p. 43, Matchmaker), put away her little bag of personal belongings, and settle down to serve her husband's family for the rest of her life. Sometimes, a concubine is chosen from one of the *ya tou,* unmarried servant girls sold to a rich family at a very young age; in that case she will already be in the house when she is made a concubine. That was a common practice in many households, because the first wife felt she had more control over a servant girl and knew the new concubine would serve her well.

Two out of the four concubines my grandfather had were chosen from young servant girls in the family. Since my grandfather was a Qing dynasty *guan,* official, as well as a *xue zhe,* scholar, he had no time to sit in teahouses or wander about in brothels, from which places men often brought back concubines for themselves. He just relied on my grandmother to pick the right ones for him. First Concubine gave birth to two sons, one of whom died as an infant, the other lived; but she herself died quite young. After many long years of hoping and trying, my grandfather finally had one son, but my grandma was still worried: what if that only son died before he arrived at the marital age. Infant mortality in China, even in big cities, was extremely high in those years.

There was a pleasant, hard-working girl among the servant girls that my grandma had been observing for quite a while, and she wanted to make her *er yi tai,* Second Concubine. So one night, when grandpa walked into his bedroom, he was surprised to see a familiar-looking yet unknown young girl sitting on the edge of his bed. *"Lao Ye."* She addressed my grandfather, Old Master, as though she were still a servant. *"Taitai* (servants address the mistress of the household as "Taitai." See *JLC,* p. 43, Huang Taitai) told me to come and wait on you," was

· 78 ·

all she said. And she stared hard at her toes. The next morning, when my grandpa did not get up at his usual hour, grandma knew that he was pleased with her choice of a second concubine.

Second Concubine got along very well with my grandma who, of course, was still in total control. She was good at bearing children and had three sons in the course of five years; they were my *wu Bo,* Fifth Uncle, *liu Bo,* Sixth Uncle, and *jiu Shu,* Ninth Uncle. Paternal uncles that are older than one's father are called *bobo,* those younger are called *shushu.* In a large family not only the *xiong di,* brothers, and *jie mei,* sisters, born of the same father but different mothers are sequentially numbered, male and female cousins, too, are numbered according to their ages. For example I have eleven female cousins, six of them older than I; I was, therefore, Number Seven Sister.

Twenty years after my grandparents were married, my grandpa, then 38, through the arrangement of a matchmaker, took in his *san yi tai,* Third Concubine. The third concubine, also known as *si taitai,* Fourth Wife, was a young lady from a well-to-do family and had a lot of *ku shui,* bitter water, to spit out when she came to my grandpa's household. To spit out bitter water means to pour out one's stories of misery and torture. Her father was a well-educated man and one of the advisors in a provincial office; she and her three *gege,* older brothers, had all received a decent education. At the age of 19, she was betrothed to the son of a rich *shangren,* merchant, and a propitious date was chosen for the big wedding ceremony. However, two weeks before the lucky day, the groom-to-be died suddenly of an unknown disease. Regardless what happened, the two families had to keep their vows, so the wedding took place anyway with the bride going through the ceremony alone, holding her husband's *pai wei,* a memorial tablet made of wood with a name written on it. From that day on she was clad in white, in mourning of a husband she had never met. The third concubine's mother-in-law was a mean woman. When a fortune-teller mentioned to her, it was due to the character of her new daughter-in-law that her son died, she used that as an excuse to mistreat her daughter-in-law. All day the young widow was made to work like a slave; at night she was ordered to sew or embroider by the side of her mother-in-law. As soon as she dozed off due to fatigue, the *lao taitai,* old lady, would drill into her thigh with an awl, or burn the back of her hand with incense. At first the young widow blamed it on *ming,* fate, that Heaven had mapped out for her; but when it became beyond endurance, she wrote a letter to her *fu mu,* parents, describing the tortures she had to put up with, and begged them to find an excuse to invite her home for a visit. She gathered all the *yin yuan,* silver dollars, she had, and gave them to a *yong ren,* servant, asking him to find a carrier who might be

willing to deliver the letter to her parents two cities away. A few weeks later, when her father-in-law came home from a business trip, he ordered her whipped by two servants while kneeling in front of him. She cried and demanded an explanation from him. He said, "This is for telling blatant lies about your mother-in-law. No one in my household will get away easily when spreading rumors like that." She knew at that moment the servant had betrayed her. The next day she was thrown into a dark room where she was given *leng fan,* cold food, and *leng shui,* cold water, and was ordered to sleep on the cold ground.

The neighbors heard her continuous *ku sheng,* weeping sound, and words soon reached the matchmaker who was responsible for her marriage. The matchmaker approached the family with a "bright idea" to make some more money for herself and, possibly, to save the young widow.

"Since you no longer have a son, your *er xi fu,* daughter-in-law will not do you any good remaining in your house. She is still a *huanghua guinu,* virgin, and I know a rich man who might want her as a concubine. That way, at least you can get a lot of money for her." The old couple agreed that it was a good way to get rid of her. The matchmaker came to speak to my grandma, and out of *hao xin,* kind-heartedness, she agreed to take in another concubine for my grandfather.

The fourth wife was my grandfather's favorite, and he spent a lot of time with her. With her educational background, they found much to do together; they even wrote *Shi,* poems, to each other. She gave birth to three sons and a daughter. One of her sons, the number seven son, was my *baba,* father.

My grandfather's fifth wife—Fourth Concubine—was again a servant girl sold to the family. She was 45 years younger than the old man, but she was smart and managed to have a good relationship with everyone, including the servants. She gave birth to five sons and two daughters. Thus, at the age of 75, my grandfather had fathered 14 sons and nine daughters, many of whom did not live to be adults. When he died a natural death at the age of 97, his *da erzi,* oldest son, had he lived, would have been 75, and his *zui xiaode,* youngest son, was only 21.

A Note: The Different Names Used for the City of Beijing

The reader has noticed that this article's title refers to "Peking." It must be confusing for an English-speaking person to see four different names used in reference to the capital of the People's Republic of China (PRC) and frustrating not knowing which is the right one to use. In official Chinese documents and pub-

lications in the People's Republic of China, one sees the name Beijing; in articles written by westerners earlier in the century, Peking; in writings published in Taiwan, Peiping; and in books mentioning the city in its old historical context, Beiping.

The two Chinese characters *bei* and *jing* literally mean northern capital. The earliest settlement in the Beijing area dates back to around 2,000 B.C. Historically when the city was made the capital, it was called Beijing; when a kingdom or dynasty did not choose Beijing as its capital, the leaders gave Beijing a different name. For example, at the beginning of the Ming dynasty (1368 A.D.), a city in southeast China, Nanjing, southern capital, was made the capital, so the northern capital was renamed Beiping, northern peace.

One time in history the city of Beijing was burned to the ground during a war (thirteenth century). Another time the whole city, including the palaces, sank 30 meters during a big earthquake. It was not until mid-Ming dynasty (1441 A.D.), when the Emperor Yongle, Forever Happy, formally announced Beiping to be once more the national capital and changed its name back to Beijing, that the city started to flourish with its many architectural splendors, including Gu Gong, the Imperial Palace, Tiananmen, the Gates of Heavenly Peace, and Tiantan, the Temple of Heaven.

In 1911 the Qing dynasty was overthrown by the Kuomintang (KMT for short, later in pinyin, Guomindang); the Nationalist party and the KMT government moved its capital to Nanjing, then known to Westerners as Nanking. In 1928 the city of Beijing was once more renamed Beiping, northern peace; however, it was spelled Peiping. In December 1948 when the Chinese Communist troops were rapidly taking over most of the mainland, the KMT government and the majority of its officials and military personnel left for the island of Taiwan, currently known as the Republic of China.

In October 1949, with the establishment of the People's Republic of China, Beijing became the capital, and the name Peiping was eliminated.

During the latter part of the nineteenth century, with the wide acceptance of the Wade-Giles system of transliterating Chinese characters, Beijing came to be spelled as Peking, both in the western world and in China herself. For a little more than two decades, between 1928 and 1949, this ancient city was known in English by two names: Peiping and Peking. After 1949, Westerners and English-speaking Chinese continued to refer to the capital as Peking, until 1958, when the PRC government announced the nationwide use of the new phonetic symbols hanyu pinyin, the Han dialect phonetic spelling, only then did the official spelling of all the proper nouns change. Peking became Beijing.

Figure 6–6: The 13th Century bell tower hovers like a dream above shoppers in a Beijing street market. Photo by George J. Leonard.

Actually, the Chinese characters for Beijing and Peking are the same. The difference in spelling is attributed to the two kinds of phonetic system: Beijing and Beiping are spelled according to the Chinese pinyin; while Peking and Peiping are spelled according to the Wade-Giles phonetic system. Today publications in Taiwan still use Peiping instead of Beijing. Peking, as a name, is widely known to Westerners and frequently found in English language publications, thus, Peking Man, Peking University, Peking Union Medical College (PUMC), Peking duck, names familiar to the West for three quarters of a century, are still used today.

Further Reading

Chan, Charis. *Imperial China*. London: Penguin Books, 1991.
Cheng, Manchao. *The Origins of Chinese Deities*. Beijing: Foreign Language Press, 1995.
Morton, W. Scott. *China: Its History and Culture*. New York: McGraw-Hill, 1980.
Sites with Stories in Old Beijing. Beijing: Chinese Literature Press Panda Books, 1990.

Japanese American Life in the Twentieth Century

A Personal Journey

K. Morgan Yamanaka[1]
AS TOLD TO DIANE ROSENBLUM

Immigration and the Early Years of the Century

My parents immigrated from a small fishing village in the southern part of Japan. There was no economic potential there. Like many immigrant families, their motive for coming to the United States was just to try to make a living, despite the anti-Oriental atmosphere. (Fig. 7–1)

Opportunities turned out to be minimal. My father became domestic help. So did my mother. That was the environment in which I grew up. My parents were **Issei**, the first generation, and we kids, American born, were **Nisei**, second generation.

You've mentioned that many people who are in ethnic studies now use the Japanese generational terms in a slang way, discussing any group, because the terms are more precise. "Issei Russians" and "Nisei Italians" and so forth. Otherwise when you say "first generation," your listeners aren't sure you mean the "first generation to arrive" or the "first generation born here."

We should clarify those terms. The Issei are the first generation to arrive here—my parents. The Nisei, my generation, are the first generation *born* here. (Fig. 7–2.) One thing to remember though: in the Japanese American community of the 1920s and 30s, the Issei and Nisei were unusually far apart in age. The Issei had been very poor and had to wait a long time to marry and have children. When Pearl Harbor happened, their average age was over 50, but the average age of us kids, the Nisei, was only 18. I was 18 myself. So there was an unusually large gap between us.

The **Sansei** are the third generation. For Japanese Americans, that usually means the Baby Boomers, born right after we got out of the camps. And they have kids now, the **Yonsei**, fourth generation. All Japanese Americans, together, all the generations, are called **Nikkei**.

Figure 7—1: K. Morgan Yamanaka on the Lowell High School crew team. Courtesy of K. Morgan Yamanaka.

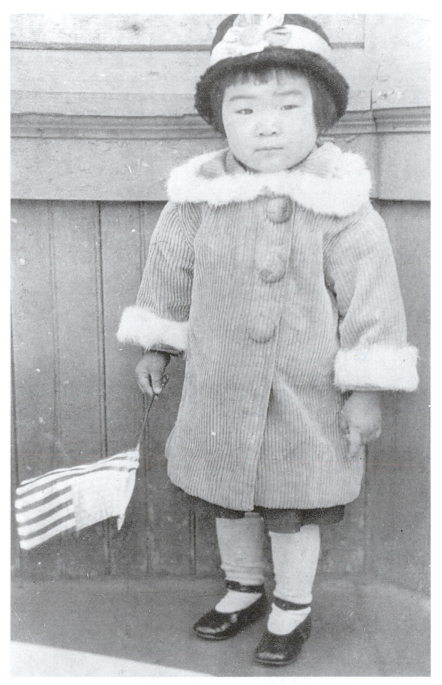

Figure 7–2: Showing the flag. Shizuko Horiuchi Collection. Used by permission of the Japanese American National Museum.

I was born in 1924, the third son. My oldest brother was six years older; second brother was three years older. In 1926, my parents sent the three of us to Japan to my maternal grandmother. I was there for five years from ages two to seven, second brother from ages five to ten, and my oldest brother from eight to thirteen.

Was it the customary thing to do? No, not customary. Perhaps 10 percent of the kids were sent. There are several likely reasons for my parents doing it: first, it looked like there were no opportunities over here so they thought one should have a Japanese education. This was not unknown within the Japanese community—you play it safe. Another possibility is the attraction of that built-in-baby-sitter back in Japan! My parents could devote their full time to income-producing activities. Or perhaps they wanted us to become good Japanese.

From 1926 to 1931 the three of us were in Japan. My sister was born during that period. In 1940 she needed *her* Japanese upbringing and so my parents sent her to Japan. And she was caught in the war there.

Not customary, then, but it was done often enough so that there was a name for the American kids who had been sent back to Japan for a few years of education like that: the *Kibei*. In Michi Weglyn's excellent book, *Years of Infamy,* she prints part of a secret report on the Japanese Americans, prepared for the State Department in late 1941 by Curtis B. Munson. He calls the Kibei "the most dangerous element" in the community, "closer to the Issei," the first generation, in attitudes than American-raised kids were. But Munson also says "it must be noted" that "many" of the Kibei "come back with added loyalty to the United States!" He notes that in fact there was "a saying that all a Nisei needs is a trip to Japan to make a loyal American out of him. The American educated Japanese is a boor in Japan and treated as a foreigner." In my case, however, I was there so young, age two to seven.

And then I was home in the United States. During the thirties we were in San Francisco, living pretty much the way kids do. There were difficulties, sure. My brother, my sister, and I were the only ethnic Japanese in our grammar school, because we lived in the very posh area in San Francisco—Pacific Heights. That is where my parents were doing domestic work. It's the wealthiest area, the homes looking out over the Bay by the Golden Gate Bridge. So I grew up with well-to-do Pacific Heights kids. Our whole grammar school went to Lowell High School, the finest in the city and one of the finest in the country. Except for a couple of the young ladies who went to private girls' school and one Chinese, Allen Lim, whose father was a cook. He went to Galileo High because that's where all the Chinese went.

Difficulties? Well, one of my best friends from grammar school and high school was from a very, very wealthy San Francisco family. His grandmother would send her chauffeured limousine with my friend *but* the car could never pick me up in front of my home. You could say that was an awkward or "difficult" situation for a teenager, but really it was difficult only looking back. At that time I was just doing it.

Naturally I used to go over to my friend's house. They had a Japanese chauffeur and a Chinese cook. Every afternoon we would go, after Lowell High School, and the Chinese cook would make us snacks, the chauffeur would greet me. Here is the awkward question. How do I greet the chauffeur? How *do* you greet a servant? But this man is a friend of my father! It raises questions of **on** and **giri**, your obligations and duties. (More about those values in a minute.)

Or try this for a confusing situation: My wealthy friend Al lives one block away from where my father used to clean houses. I, without question, helped my father. I was obliged to go scrub the outdoor steps there, every Saturday. (There was no stress. It was Dad's work. I was helping the family.) One block away from Al's house. What do you do? You scrub the front household steps. When do you do it? Before Al wakes up. So I was cleaning the steps at three o'clock on Saturday morning.

You have to understand the concept, **shikataganai**—very roughly, "it cannot be helped." It is a very important value to the Japanese. Whatever cannot be helped, you just adjust, you do it. People shrug and say, "shikataganai" and they tell each other "**gaman**," which means something like "Strength!" or "Endurance!" (Even, "Hang in there!") That was our culture.

My Senior Year: Pearl Harbor

In 1941, I'm a senior in high school, riding to Lowell High with my friend in his Grandmother's Cadillac. I'm an athlete; I've got my letter and my stripes and all that. My brother is at San Francisco Junior College, my parents are working. Then Pearl Harbor.

It's true the press had been building up to this since the 1930s. By the 1940s the war clouds were definitely there. In a way it was not a surprise. But it *was* a surprise.

And everything changed. Our status changed. My older brother, very knowledgeable in Japanese culture, in Japanese language, went to volunteer for the military intelligence, to see how they could use him. He thought Naval

Intelligence was the best—as did I. Naval Intelligence said, "No, we don't want no 'Japs.'" As did the army.

Everything had changed.

A small percentage of the Japanese American families who had children had gotten them dual citizenship. Our parents had done that. Anybody born in the United States like me, is an American citizen by birth. But if the immigrant parents registered their children with, in this case, the Japanese consulate, then they had Japanese citizenship too.

My brother Albert and I thought, "Now that it's war, we should be American citizens." We gave up our Japanese citizenship and became entirely American. It didn't matter. We were sent to camp anyway. Again, when I turned 18, I registered for Selective Service. In high school I had been one of the athletes. A healthy young man. I thought, Good, I'm Number One Cannon Fodder for the military.

I got this beautiful card back from the Selective Service. It said, "You are Kunitake M. Yamanaka." My draft status: "4-C."

4-C? What's that? I knew what a 1-A was; I knew what a 4-F was. But 4-C meant nothing to me. Finally I found out I was classified as an enemy alien! I found out in internment camp. "Oh, you got 4-C, too? That's an enemy alien!"

I was interned for 4 years.

Executive Order 9066: We Must Sell Our Homes and Belongings and Report to Be Imprisoned

You mention you've read accounts from this time, in which Japanese Americans say how furious they felt with the Japanese, felt they had been put on the spot. I think those accounts are Monday morning philosophizing about Saturday's football game. Kind of playing into what they think other people expect them to say. I had no emotions like that.

After Pearl Harbor, America certainly panicked. The Californians in Congress pressured President Roosevelt to get all the Japanese Americans out. They were terrified of sabotage, and there was even that hysterical episode when Los Angeles became convinced it was having a Japanese air raid.

Earl Warren, who later became the Chief Justice of the U.S. Supreme Court, was an ambitious young man then, the Attorney General for California, and he was very anxious to get the Japanese out. So was the Military Commander for the West, Lieutenant General John DeWitt. And the Hearst newspapers were out for blood.

There had been a long history of anti-Oriental racism in the West—California in particular. In 1882 the anti-Chinese labor movement managed to get the Chinese Exclusion Act passed. The American Federation of Labor lobbied very hard for that. In 1884 the Japanese were first allowed to leave their homeland, and they started replacing the Chinese. In 1884 "Little Tokyo" in Los Angeles was founded by the Issei, the first generation—mostly agricultural workers. (See a full history in Appendix A.)

The California politicians had, over the years, gotten the United States government to pass all sorts of legislations where the Issei could never become citizens, own land, lease land, etc. But the Nisei were American citizens. Anyone born here is, no matter what your parents' status.

So when we Nisei were rejected, locked up—everything being done to us was unquestionably illegal and unconstitutional, done to us on the basis of our ancestry alone. It was complete violation of our civil rights as American citizens. In fact, the legislation called for interning people who had as little as 1/16th Japanese blood.

In 1907 Japan had been incensed, for one thing, that the San Francisco Board of Education had suggested setting up segregated schools for Japanese children. They were losing face. Teddy Roosevelt had helped settle the San Francisco school bond issue on segregated schools for Nikkei, and he got, as a kind of favor, the Japanese government's agreement to stop its people in the "laborer" category from immigrating to America: the "Gentlemen's Agreement." In 1913 California passed the *Alien Land Bill,* which made it illegal for anyone ineligible for citizenship—Asians—to own land. The Japanese had started doing very well, buying non-productive farm land and making it productive. Many white Californian farmers resented that.

All this ultimately led to Franklin Roosevelt signing *Executive Order 9066* on February 19, 1942. In theory, it applied to Germans and Italians too, but nothing was done to them unless they had been specifically involved with the foreign governments before the war. This set up the so-called *Evacuation* which was applied only to ethnic Japanese.

The F.B.I. implemented the *"ABC"* list immediately after Pearl Harbor, interning approximately 2,000 Japanese. The families in Terminal Island near the U.S. naval base were given only 24 hours to vacate their homes and businesses. They had to virtually give their properties away to the scavengers that raced in. (You can imagine.) General DeWitt declared that California, Oregon, Washington, and a small western part of Arizona were now "military zones" from which Japanese Americans had to be evacuated.

Civilian Exclusion Order No. 5

WESTERN DEFENSE COMMAND AND FOURTH ARMY
WARTIME CIVIL CONTROL ADMINISTRATION

Presidio of San Francisco, California
April 1, 1942

INSTRUCTIONS
TO ALL PERSONS OF
JAPANESE
ANCESTRY
LIVING IN THE FOLLOWING AREA:

All that portion of the City and County of San Francisco, State of California, lying generally west of the north-south line established by Junipero Serra Boulevard, Worchester Avenue, and Nineteenth Avenue, and lying generally north of the east-west line established by California Street, to the intersection of Market Street, and thence on Market Street to San Francisco Bay.

All Japanese persons, both alien and non-alien, will be evacuated from the above designated area by 12:00 o'clock noon, Tuesday, April 7, 1942.

No Japanese person will be permitted to enter or leave the above described area after 8:00 a. m., Thursday, April 2, 1942, without obtaining special permission from the Provost Marshal at the Civil Control Station located at:

1701 Van Ness Avenue
San Francisco, California

The Civil Control Station is equipped to assist the Japanese population affected by this evacuation in the following ways:

1. Give advice and instructions on the evacuation.

2. Provide services with respect to the management, leasing, sale, storage or other disposition of most kinds of property including: real estate, business and professional equipment, buildings, household goods, boats, automobiles, livestock, etc.

3. Provide temporary residence elsewhere for all Japanese in family groups.

4. Transport persons and a limited amount of clothing and equipment to their new residence, as specified below.

Figure 7–3: A poster ordering Japanese Americans to report for internment.

Courtesy of K. Morgan Yamanaka.

You say your students were moved by Jeanne Wakatsuki Houston's account of her parents having to sell everything off in *Farewell to Manzanar*. (See Chapter 38.) A profiteer tries to buy her mother's heirloom dishes for a song, and her mother, enraged, starts smashing them instead. Michi Weglyn's book is also well-known in the Japanese community. There *were* other mature writers, who later wrote about the camps. The writer Hisaye Yamamoto, for instance, author of "The Legend of Miss Sasagawara." (See Chapter 38.)

Evacuation

Most of America's 126,000 Japanese were on the West Coast. Ninety-three thousand in California. The "Evacuation" meant get out. (Fig. 7–3.)

But getting out was not that easy. At best, through voluntary evacuation, you could leave the coastal states. But the mountain states, we found out, were not a particularly hospitable place. Also, at first, many of the western half of California people went to the eastern half of California—inland—until the Sacramento legislature decided, "We don't want any Japs in California, period." Those people had to move again. Some tried going to Nevada or Colorado. They were met by Vigilantes saying "We don't want you Japs." Gas stations would not sell them gasoline . . . or no one would let them buy food or get something to eat in the restaurant . . . many were forced back. (Fig. 7–4, Fig. 7–5)

There's a sign that became a famous poster, all people of Japanese ancestry have 48 hours to sell out and go. It varied, though. In many areas, the families had one week to get ready to go. One week to get rid of an entire household accumulated over the years. A household with all the furnishings for a family. The ethnic Japanese lost one hell of a lot.

Yes, the evacuation scenes your students saw in *Return to Manzanar* are accurate. Vultures were there. But what the hell could we do? The evacuation orders were, we could take exactly what we could carry in two hands. That included bedding, clothing, medicine, eating utensils, whatever—two hands, that was it.

We were fortunate in that my father was well-liked as a domestic servant by his employers. He had been working with this family for a long time. They were very sympathetic. "Why don't you store everything in our basement?" We just moved it from our house to the basement of this huge mansion in Pacific Heights. Lucky.

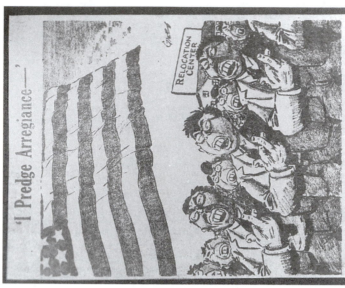

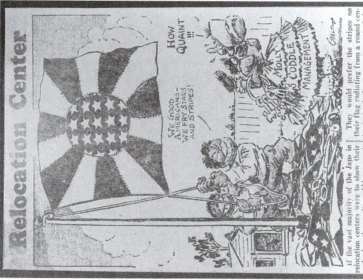

Figure 7–4: Hate campaign: political cartoons from the San Francisco Bay area. "Molly Coddle Management" and "I Predge Arregiance." Courtesy of K. Morgan Yamanaka.

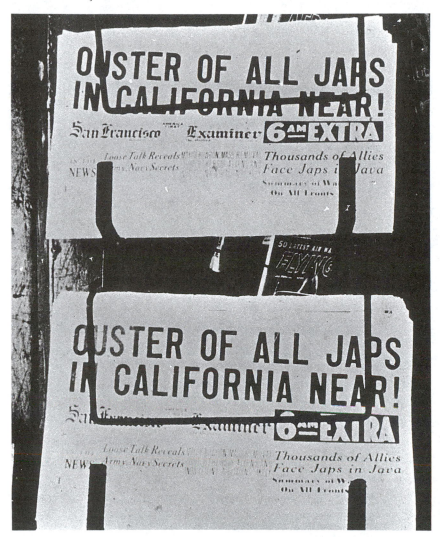

Figure 7–5:"Ouster of All Japs": Newsstand at 14th and Broadway, Oakland, Feb. 27, 1942. Courtesy of K. Morgan Yamanaka.

But we did not try to store anything the government had now declared illegal for a Japanese American to own. Contrabands. A Japanese American, citizen or not, was no longer allowed to own a radio or cameras. Binoculars were contraband too. Japanese Americans were not even allowed to own a Brownie camera. No firearms or any heirloom ceremonial swords.

We were told we must take our contraband to the police station on 6th Avenue and Geary. (Fig. 7–6) It's a rinky-dink police station, nobody even knows

Figure 7–6: A camp in the desert: Topaz relocation center, Utah. Courtesy of K. Morgan Yamanaka.

it's there, next to the old French Hospital. Since this family was helping us, we could have put our cameras and radios in that basement and nobody would have known the difference [laughing]. But we did not even try. We turned the stuff in. We believed, "What the government says, you do. If it's contraband, you don't try to hide it." At least in my family, it was an ethical issue. Remember, we *were not* traitors. We had renounced our dual citizenship and tried to volunteer for the military. We tried to do our bit.

My father's hobby was ancient Japanese swords. *And* he did flower arranging, along with my mother. My mother taught flower arranging and the tea ceremony. The objects of the tea ceremony and flower arranging were not contraband. And scroll paintings were okay. But Dad's swords became contraband. We took them along to the police station and turned them in.

Most people did that. They did their duty. Most of them, 4 years later, never got very much back.

The great irony is—and it shows how needless this was, and how much it had to do with California politics—in Hawaii, where the bombing took place, where the invasion would have to hit first, where the ethnic Japanese were nearly one third of the population, and where you would really have trouble if they revolted . . . The government did not intern the Japanese Americans. The commanding officer of Hawaii said no, it is not necessary.

Figure 7–7:Victorious Japanese American troops in Europe. Photo, U.S. Army National Archives. Used by permission of the Japanese American National Museum.

The so-called ABC list prepared by the British Naval Intelligence, U.S. Naval Intelligence, and the F.B.I. back in September and October of 1941—3 to 4 months before Pearl Harbor—was a survey of the ethnic Japanese community, and to some extent, the Italian and German communities. The government knew something was up. But the recommendation of the ABC list researchers was, "You don't have to worry about the Japanese." The Commander of Hawaii said, unlike General DeWitt, "Okay, we don't have to worry about them." Of course, what the hell was he going to do with one third of the population? They had talked about making one of the Hawaiian Islands a giant concentration camp, but they never did it; and I think it was primarily because of that commanding officer.

In the end, utilizing the ABC list, not quite 2,000 Japanese Americans were picked up in Hawaii and the U.S. mainland—mostly community leaders, Buddhist priests, Japanese language teachers, and the Kibeis like me, Niseis who had been sent to Japan for part of our education. The government felt, if we were Japanese educated, we might be dangerous.

Thus, some Hawaiian Japanese were sent to the mainland to be interned, as were some Latin American and South American Japanese as well! There is a good book about the period called *Triangle of Hate*. The United States essentially said, "We will practice the Monroe Doctrine." Washington said to the Latin American countries, Mexico, South America, "Send us all of your Japs, and we will put them in the concentration camps." Everybody except Brazil and Paraguay, I think it was.

The government started building four different kinds of camps. After Pearl Harbor, as I said, they started rounding up all on the ABC list—the people they had decided beforehand were most likely to be dangerous. They picked up approximately 2,000 Japanese, 2,000 Germans, and 600 Italians. The "A," "B," and "C" stood for, I think, "most dangerous," "not so dangerous," and "least dangerous" people. The ABC people were sent immediately into the internment camps. There were some internment camps run by the Department of Justice, and internment camps run by the Immigration and Naturalization Services, for the Mexican, Latin American, and South American people shipped up. There were 27 of those camps, small camps.

Then there were the 15 Assembly Centers. The "Removal" was, as the L.A. *Times* said, a "staggering task." (Fig. 7–7)

My family was "evacuated" from San Francisco on April 7th. By evening we were in the Santa Anita Assembly Center near Los Angeles. The race track, yes. I'll tell you why they used a race track in a moment.

The day of evacuation, we somehow got to the designated place with our two packages. It was morning. You may have read in some of the literature that the American Red Cross was there, the Quakers were there, seeing us off. Well, the day we left, we were the first ones out of San Francisco, *nobody* was there at the corner of Van Ness and Jackson Streets to see us off. The buses came and that was it. Some of the literature does record that people were seen off by white friends, white church people. I guess we were ahead of the game. But I know nobody came to see us off.

Do I remember any of the emotions? Was there disbelief or shock? Nope. Generally there was acceptance. You see, *today* we say, there must have been "stress," "there must have been shock"—must have been *this, that*. That is the 1990s mentality. In the 1940s, to the general American, this was a *beautiful* war—to save democracy and all of that. Everybody volunteered. It is only the current young people who experienced the Vietnam situation, who think of war as something terrible. Even Korea was not thought so bad as all that, and Korea wasn't thought of as highly as World War II. No war is *nice* but. . . to answer your question, it wasn't the 1990s, and we were loyal citizens: there was much, much more acceptance of the idea that we had to be evacuated.

Our family's acceptance also had something to do with the Japanese morality. Your government can do no wrong! You have an *obligation* to your country. This is to help our country, and if you and some other people are suffering, you must remember your cultural value: *shikataganai,* it cannot be helped. There is another word too, "you must endure this," *gambaru.*

Of course the concept "it can't be helped" is a concept every culture has to some extent. But the power of it within the ethnic Japanese community goes back to historical Japan.

It's partially feudalism, a carryover from the social structure of Japan in the feudal era. When you consider that Japan came out of feudalism only in the 1860s, that's quite recent. My grandfathers' day. Which means our grandfathers were brought up in this concept, our parents too. *Shikataganai* was just the facts of life for the majority of the ethnic Japanese population.

Again we encounter those two other words: *giri* and *on*. *On* means one's obligation—social obligation. *Giri* is your duty to fulfill the obligation, the *on*. Until you have performed your duty, you are wearing the *on*. You are always stuck with this obligation, whatever the obligation is. It sounds very Jewish, you say? Of course! Yes, you could say there is a sense of guilt in the uses of the term *on* and *giri*. Yes, I know about the anthropologist Ruth Benedict's distinction between "shame cultures" and "guilt cultures" (Japan, she says, is a "shame" culture). That's a non-Japanese person writing. Every culture has its own thing.

This is not to say no one resisted the evacuation. They were very few, but they were important, particularly later when we were suing for reparations. They had unusual reasons and personal histories. There are only 27 cases of people avoiding the camps by one means or another. In San Francisco one person hid in the Caucasian's home where he was doing domestic work for about 3 years until the owner of the house said, "What are you doing? I'm not going to jail."

The three important cases, legally, were *Yasui, Hirabayashi, and Korematsu.*

Min Yasui—who was a U.S. Army reserve officer—was a lawyer. He donned his officer's uniform in a small community in Oregon and said, "I'm supposed to be in camp. I won't go. I'm breaking the law," to his friend who was a cop. "Are you going to arrest me?" "What the hell are you trying to do? Go home, you'll get in trouble." Yasui wanted to test the law. Finally the cop acquiesced and said, "Oh, all right, I'll arrest you." And he went to jail that way. The case went all the way up to the Supreme Court.

Gordon Hirabayashi was a good Quaker helping people move, in time of need, which was violation of curfew. He was arrested for the violation and his case, too, went all the way up to the Supreme Court.

And there was Fred Korematsu. Korematsu was an entirely different thing. He was a young man who didn't want to go to camp because he had a Caucasian girl friend. He wanted to stay out with his girlfriend. He went back to his old neighborhood, and the people recognized him and said, "What are you doing here?" And they put him in camp right away.

UNITED STATES DEPARTMENT OF JUSTICE
Immigration and Naturalization Service
Tule Lake W.R.A., California

6 1945

TO: _____YAMANAKA, Kunitake M._____

ADDRESS: _____1416-B_____

You are hereby notified that in accordance with
General Order of August 31, 1945, you have been ordered
interned at the Tule Lake Segregation Center by the
Attorney General of the United States.

You will be notified by your block manager as
to the date and time when you are to be at the Registra-
tion Office of the Immigration and Naturalization Service.

Ivan Williams
Officer in Charge

*Figure 7—8: Papers removing a "no-no boy" to the Tule Lake Camp.
Courtesy of K. Morgan Yamanaka.*

There is a documentary on Fred, but it's really Gordon Hirabayashi who I feel should be portrayed. He was an honorable man trying to do community service. All in all, only about 27 people did not go voluntarily to the camps!

The Assembly Center: We Go to Live in a Horse Stall

The 15 makeshift Assembly Centers set up for Japanese American families were spread throughout the West Coast. This is where the families were first brought together from their homes on a temporary basis while the government

Figure 7–9: Alien registration card for an American born Japanese.
Courtesy of K. Morgan Yamanaka.

was building more permanent camps for us. Looking at where the Assembly Centers were located you could see where most of the ethnic Japanese had been living: one camp in Washington; one in Oregon; and 13 in California.

From the 15 Assembly Centers, each one of which was operating from late March to about late October of 1942, the ethnic Japanese were later moved to permanent camps. In late 1942 they closed the last Assembly Centers.

An Assembly Center had to be a large place where the Nikkei could be interned together in some habitable space as quickly as possible. Most of the suitable facilities that were available were fair grounds and race tracks. (Fig. 7–8)

A race track, you see, has horse stalls. My whole family was moved into a horse stall in Santa Anita. We lived in it from April 7 to November. Four people in a horse stall for six months.

Here is how it worked. These stalls were built for two horses. You bring the horse in from the front under a long covered walkway outside the stall. The military took 4 by 8 plywood siding and extended the stall out under that walkway. They fit two army cots in the regular stable and two cots outside underneath the walkway enclosed by 4 by 8 plywood. No heat, no running water, no privacy. And that is how we stayed for six months.

Fortunately Santa Anita is neither cold nor hot. It could be somewhat warm, especially living in an uninsulated horse stall. (And when it was warm I smelled the horses, their urine.)

There was no place to cook or eat, just the cots. We ate at mess hall. Santa Anita set up three kitchens for 18,000 people. Every day was spent lining up. For breakfast, lunch, dinner. For the bathrooms, for anything. (Fig. 7–9)

Later in the permanent camps we could at least try to adjust. There's a book, *Beauty Behind Barbed Wire*—about the gardens, but not at the horsestalls. I remember making a garden in Topaz, but in Santa Anita there was no place for a garden.

So there we were. I never saw so many Japanese in one place as I did when I arrived at Santa Anita. I never knew so many Nikkei existed.

What did I do all day at Santa Anita? Or later at Topaz? What the hell does an eighteen-year-old do? You look around for girls. You hang around with your buddies. Then you try to find a job, just to fill the monotony. In San Francisco our family used to live across from the fire station. I used to go there to read the English newspapers. There were four newspapers in San Francisco at that time: *Chronicle, Examiner, Call Bulletin,* and *San Francisco News.* Anytime I went there were two morning and two afternoon papers. In the camps there were jobs because all the camps, Assembly Centers, and Relocation Camps were essentially, if I may use the word, manned by the ethnic Japanese, other than top administration. You were paid eight, twelve, and sixteen dollars a month for working at most of the jobs, slightly more for white-collar jobs.

But it was very hard, very trying. There were incidents. They'd start with something in itself trifling. If you can imagine the horse stalls—with the horses housed there, the electrical usage is minimal, if any. How many lights do you need to keep a horse in a horse stall? Maybe in the end room where they keep the saddles. So you have maybe one power cord.

Now you try to put family units in those horse stalls, you have problems. Families need lights. So you hang lights, using extension cord. Mothers want to heat milk for their babies. They're plugging in hotplates to the extensions. Soon the fuses are blowing, the lights are going out all the time, all over camp.

The administration went out to find out what's blowing the fuses because the fuses were continuously burning out. The mothers didn't want to hand over their hotplates. The internees see these security people going through, pulling hotplates away from the women—maybe overzealous in their efforts. . . . Out of that came an incident, and then a riot. And then a curfew. The hotplates weren't really the issue anyway. It was sheer frustration. The straw that broke the camel's back.

In Poston somebody beat up one of the pro-Japanese American Citizens' League supporters. The military found the perpetrator, locked him up, and were going to take him to a special prison for the Japanese. Penalties were very harsh. People whom the administration thought were causing trouble were even sent to Leavenworth prison. At Poston, suddenly the group trying to take this individual away was surrounded by the people. The Camp Commandant called the military police, and there was a confrontation, and somebody somehow gave the order to shoot. Two Japanese Americans were killed. Meaningless.

*The Rise of the Nisei and the
Japanese American Citizens' League (JACL)*

These were in no way normal communities. For one thing, no Japanese language was allowed to be spoken at any public meetings; had to be "all English." Here, you must remember the ages again. We second generation, the Nisei, spoke English, our average age was 18. The community leaders had all been our parents, the Issei, average age over 50, who spoke very little English, if at all. But now meetings have to be conducted in English rather than in Japanese. So, a small group of older Nisei—but still very young people—turned into the community leaders: the Japanese American Citizens' League.

Originally the Issei, like first generation from all immigrant ethnic groups, tended to seek out people from the old hometown or province. You called those people your *kenjin.* People from the Old Neighborhood. The Chinese had the Six Companies; the Jews had the Landsmanschaften. Typical of that stage. Ninety percent of the Japanese came from 11 **ken**, 11 provinces in south Japan. Organizations grew up, the **kenjinkai***,* where each province's kenjin could get together. They spoke the same dialect, socialized, circulated newsletters, chipped in to loan each other money to start businesses. And, very important, money to help poor people stay off public assistance, so your Kenjin would not lose face.

By the 1930s some of the older Nisei resented the way the Issei-controlled kenjinkai kept its face turned back to Japan. They started forming Nisei America-oriented citizens' leagues. The Japanese American Citizens' League (JACL), which became consolidated in the 1930s, cut across the old *ken* lines, tried to unify the Nisei. Notice the title. The Nisei were *citizens,* and the Issei could not be, by law. The Issei were the unquestioned community leaders, however, all through the 30s.

Now we are in the camps and the Issei are not even allowed to speak Japanese in public meetings. The power really shifted to the JACL. This was a small group of older Niseis, college-educated, that started organizing themselves. After Pearl Harbor their credo became "Defense comes from being 200 percent American. We are going to show our loyalty to America by going voluntarily to camp and cooperating in all ways." Mike Masaoka was certainly the spokesman and continued to be considered the spokesman for the Japanese American community long after the war. The outside world still thinks the JACL speaks for all of us. They publish the *Pacific Citizen* newspaper, and in the eighties they built a headquarters in Los Angeles.

We Enter the Concentration Camps

Late 1942 found the Nikkei living in 15 Assembly Centers like Santa Anita. We were some of the few who were sent from San Francisco to Santa Anita. Topaz Relocation Center was not ready for occupancy. Other than us, all of San Francisco and the Bay Area Nikkei went to Tanforan, then on to Topaz, Utah. Because we were San Franciscans, we were finally sent to Topaz too. The friends I made in Santa Anita were sent to two camps in Arkansas.

The government built the 10 relocation camps wherever they had federal grounds that were good for absolutely nothing else. The Japanese were sent to the swamps in Arkansas, to remote deserts—to Topaz, out in the Painted Desert. Oh, I remember. I had read every one of Zane Grey's books and one of them was *The Painted Desert*. When I heard we were going to the Painted Desert, I was looking forward to it. Romantic! A kid. Until I got there. (Fig. 7–10)

Every camp had a perimeter with barbed wire and watch towers. *Not* romantic. Inside the barbed wire fence—approximately 15 feet inside, I don't remember exactly—there was a picket fence. Between that picket fence and the barbed wire was No Man's Land. In Topaz, if someone went over the picket fence, Bingo! they were shot dead. In Topaz an elderly man stepped over the picket fence—an *old* man, how could he be trying to escape!—and some trigger-happy guard shot him.

In fact, there is no recorded incident of anybody trying to escape. There are two cases of two elderly men who were found dead in the desert. It is surmised that they were out collecting arrowheads and became lost—not escaping. Later, after they got rid of the No-No boys like me to Tule Lake, I read that in one camp some people wanted posts to hang their clothes on and the camp director said, "Why don't you use the posts that hold up the barbed wire?" It was that laid back. (Whether that's actually true, I don't know.)

The camps are now universally called "concentration camp," but that term came out of the 1960s. Prior to that people said "relocation camp," "assembly center," and "internment camps." It was not until the Sansei, the third generation, was in college in the 60s that they started using the term. Oddly enough, the earliest use of the word "concentration camp" (for Japanese Americans) was by Franklin Delano Roosevelt! In 1936, five years before Pearl Harbor, he is purported to have said, "We may have to put all the Japs in Hawaii into concentration camps." After Pearl Harbor, a significant number of people in Washington did use the word concentration camp. But the ethnic Japanese did not until the Sansei in the 60s.

*Figure 7–10: Professor K. Morgan Yamanaka today. Photo by
Debra Whalen. Courtesy of K. Morgan Yamanaka.*

I use the words. Indeed, the title of my course is "Concentration Camp
USA." But I make damn sure I discriminate the term from the Nazi "concentration camp," which was an *annihilation* camp. And from the Japanese concentration camp in Southeast Asia, which was indeed a severe "concentration camp."

The Japanese occupational forces in Southeast Asia did have camps in which they held the Americans, the British, and the Dutch. There is a novel, *Three Came Back;* it is one of the better portrayals of the concentration camps run by the Japanese army in Southeast Asia. Ours was a *holding facility* to "keep the Japs out" of a certain area. In this sense, of course, any prison is a holding facility. So ours was more of a *holding facility* camp, but it was by dictionary definition, a true "concentration camp." I follow the "dictionary definition" of the word concentration

camp; not the Holocaust, Nazi Germany, or Japanese idea of what a concentration camp was. You say there are some people in the Jewish community who have actually taken offense at the use by the Japanese Americans of the words "concentration camps"? They have every right. They say, "Only we were in concentration camps." When I use the word "concentration camp," I am respectfully aware of this feeling of the Jewish people.

Topaz

Topaz held 9,000 people. The buildings were 100 feet by 20 feet and raised off the desert floor by about 2 feet. Made out of raw lumber, not seasoned lumber. Raw lumber for outer walls on which tar paper was nailed. These buildings were divided into six sections, 20 feet by 20 feet cubicles with a bare bulb hanging down. And that is where the whole family was, inside the cubicle. Twenty by twenty with one door. Small, they were small. The doors were again raw lumber, nailed together.

I keep mentioning it was *raw* lumber because in desert country that lumber dries up fast. As it dries up, it warps, and the nails holding the tar paper start tearing the tar paper. And then you have holes. At Topaz, desert sandstorms were daily occurrences. The nature of the soil is such that after a rain it clings to your feet. You just can't walk on it. The soil there is not sand. It is a fine, fine dust. So fine it got into everywhere and everything, especially with the raw wood and the torn tar paper. It was impossible to keep clean.

What did we do at Topaz? Most people didn't do much. People lived in their bare room with the one light hanging. Or in my father's case he tried to make it as habitable as he could.

Your students ask how accurate is *Farewell to Manzanar,* where living in the camp really destroyed the narrator's father, broke up the family, and he never recovered? I don't think that happened to a lot of families. I really don't know of *any*. All the families that I know of—and my parents were very close to the Japanese community—none ended up like that novel's father. I would think that is more personality. It sounds nice, you know . . . "the intensity of the evacuation!" But I don't think that was the rule.

At Topaz, monotony again. I wanted to work, so they said, "What can you do?" "I'm a college-bound high school student." "Well, don't you know how to do anything?" I lettered in crew. "I know how to row a boat." Big demand for that in the desert. "So what else can you do?" "Well," I said, "I used to go read newspa-

pers at the fire department.""Ah!You know something about firefighting!You can be a fireman." [Laughs] Within two years I was the captain of the fire department.

Becoming a "No No Boy"

The evacuation had been America's quick fix to the Japanese problem—with little thought given to "What are we going to *do* with 110,000 locked-up Japanese?" After Pearl Harbor, in their panic, the only thing on their minds had been, "Get rid of the Japs!" So they indeed got rid of the Japs—into the camps.

But in late 1942, well after America won the decisive Battle of Midway, and invasion fears subsided, the War Relocation people looked at each other and said "Well, we got them here. The question is, 'Now what!?'" They were not quite ready to feed and house 120,000 people indefinitely!

Meanwhile, by late 1942 the military was saying, "We need more manpower!"

So all the geniuses thought it over, and decided, "We have deprived the Nisei of the chance to join the Armed Services! Now we shall offer them the opportunity."

On January 28, 1943 the Secretary of War announced that he was responding to "earnest requests" by "loyal" Japanese American citizens and drawing up plans for a special Nisei fighting unit. Indeed, the JACL had been urging this. Eventually, the Army set up the 442nd Regimental Combat Team and the 100th Battalion, approximately 33,000 Nisei. The Nikkei community is very proud that they won more decorations than any other American battalion, and they had over 9,486 casualties and over 600 outright fatalities. All this while their parents were locked up behind barbed wire. Some people suspected from the start that the Army was looking for a suicide squad, and they thought these incredible casualty figures proved it. The "Go for Broke" Battalion. They were indeed heroic. They fought all through the Italian campaign, terrible fighting against the retreating Germans. And they were really the ones that rescued those soldiers who were trapped behind the enemy lines—"The Lost Battalion." Some Nisei even served in the Pacific against the Japanese Army.

The demand for manpower led to the questionnaires. Now it is early in 1943, we have been locked up for nearly a year in one place or another, and suddenly they start sending us questionnaires. Rumors are flying, there's talk of deporting us, of "repatriating" some of us to Japan. (We are American citizens, how can we be "repatriated" to a foreign country?) And then this very strange questionnaire, "War Relocation Authority Application for Leave Clearance." "What's a Leave Clearance?" "Are they going to let us out?" Nobody knew what was going on.

The question they ask when you join the military is, "Will you be loyal to the United States and forswear allegiance to the emperor or anybody else? If you go into the military will you go anywhere the army sends you?" That's fair to ask somebody joining the military.

But they made this an application, not for the military, but to leave the camps. "Application to Leave." Everybody over 17 had to fill out the questionnaire.

Many thoughts went through the Nikkei's minds. First, if you leave camp, just where are you going to go? You still cannot go home to the West Coast. What would happen if we went to the Midwest or the East, where they don't know us, and we don't know them. Second, if you were Nisei, you thought, "If I go, what will happen to my parents? They're old. They don't speak English. Okay, they have to go too. I'll go out first, get a job, support them—but could I? Could a Japanese American find jobs in a strange place"?

Then one would say, "Well, we ought to go into the army!" And another kid would say, "Yeah, but what for?" "Well, we're Americans." "Sure, but look what they did to us!" Parents would say, "You must join the army! You must show your allegiance."

All we knew was here was this piece of paper everybody 17 and over had to sign. "Application to Leave."

But Questions 27 and 28 were what got me most. "Are you willing to serve in the armed forces of the United States on combat duty, wherever ordered?"

Why ask me this again? I thought. I had registered for the draft. *They* were the ones who would not take me. That was 27. Question 28 was "Will you swear unqualified allegiance to the United States and faithfully defend the United States from any and all attacks by foreign or domestic forces"— all of which I had already done by registering for the draft—"and forswear any form of allegiance or obedience to the Japanese Emperor, or any other foreign government, power or organization?" Which I had done by renouncing my Japanese citizenship.

Many people were troubled by that word "forswear." *Forswear. Stop* doing, give up, renounce. You can't win here. It's like, have you stopped beating your wife? Will you stop being faithful to the Emperor? If you say "No," that's bad, and if you say "Yes, I'll stop being faithful to the Emperor," you're swearing you *were* faithful to him before. Did they ask German American citizens to swear they'd stop being faithful to Germany? You're swearing a written oath that you weren't a good citizen before.

Some Nisei said this was their way to get out of the obvious illegality of locking up U.S. citizens.

I still say, if you are going into the military, there is no big deal answering those two questions. But this was on a form titled "Application to Leave." Did they mean, sign this and you're out? We didn't know *anything!* There was no clarity other than the fact that everybody 17 or over must sign. Very unclear!

My brother Al had tried to join the military and was refused. We had both given up our dual citizenship. I had signed up for Selective Service and got the 4-C classification. And we had been locked up here now for going on two years. If we were to go now, where the hell would we really go, what the hell kind of work would we be allowed to do? These questions came up. "If we go, what's going to happen to Pop and Mom? This is a concentration camp, not an easy place to live." "We can't go *home*. The West Coast is still off limits."

And so my brother and I finally ended up saying, "No" and "No." The military sign up business, "No." We would not go into the military. If the second question had been, "Will you swear allegiance to the United States?" we would have had no difficulty signing "yes" to that. But "forswear" allegiance to the Emperor? The answer was "No" I will not *forswear.* Because I was *never* loyal to the Emperor of Japan. Catch 22.

So I became what was called a **No No Boy**. And the real reason I signed "No . . . No" was, for lack of a better word, being pissed off at this whole damn issue. "Was it retaliation?" you ask. For being put in the camp? No. "Retaliation" has a little different meaning than being pissed off. I really cannot think of a better way to say it. We were finally just *pissed off.*

And so, we signed "No. No." We were a small number. Approximately 95 percent of the Nisei said "Yes. Yes." I would say that plus or minus 95 percent were much more cool-headed than we were. You may have read John Okada's *No No Boy,* that book Jeff Chan discovered. When the hero is back in Japan Town and runs into a guy he had known before the war the guy asks him why it took him so long to get out of camp. Then he realizes and says, "No–no boy, huh?" and calls him a "rotten bastard." That is all changed. The Sansei generation, during the 1960s and 1970s, dared to speak up about what had been done to us, and now there's a totally different attitude to people who resisted.

Tule Lake

The government set up a special camp for "disloyal" Japanese Americans, Tule Lake. They selected the camp where they had the most No-Nos and made that into a segregation camp: Tule Lake in Northern California. About 19,000 people,

including the relatives of the No-No boys who had come along, and others. Less of a camp, more of a prison: More fences, more guards.

Also more politically conscious people, so more trouble. One day there was a dragnet through the camp by the MPs and the administrators, and selected individuals were put in the stockade. Both my brother and I were selected and, actually, I do not know why. I was captain of the fire department and I was not agitating. In the stockade—kind of a prison barracks—about 120 of us slept on cots. There were endless bed checks. I have taught sociology, and I think the real point was to harass us. One time they pulled us out of our barracks and marched us outside where we stood for 5 hours in the snow, surrounded by armed MPs and a machine gun aimed at us. Another time, a midnight check, I was really scared. There was a young MP, really a kid, younger than I was, with a Thompson machine gun. He was absolutely quaking in his boots to be up against these troublemakers. I was scared he would pull the trigger.

I was at Tule Lake long after the war ended. I needed to get a special clearance to be released, in 1946. I was in custody from age 17 to 22. I had nothing when I left camp and found work as a dishwasher in Chicago. The last dishwasher had been a wino. At 22, that was where I was.

The 1960s: The Sansei and Redress

In the 60s the consciousness changed with the third generation, the new Sansei college students. But also, the *Nisei themselves* were now no longer in "survival mode." No longer scared of resisters who jeopardized them, as they saw it. By the 60s, they had their education, and their occupation. They had caught up. Many felt safe.

When the **Redress** movement started, and even the JACL started supporting the idea that the government should admit it broke the law, apologize, and pay something for all the property and years that were lost, I said, "At last the JACL did something right!" And I became very involved.

A friend of mine, John Tateishi, who used to be an instructor at San Francisco City College, volunteered to help the redress movement, to the point where he was spending more time with the redress movement than with his teaching. He resigned his teaching and worked full time for redress. John got me involved. John Tateishi, working with the JACL and Random House, created the book about the whole era: *And Justice for All: An Oral History of the Japanese-American Detention Camps.* He let people tell their stories and blended them into a narrative. Some of the eye witnesses interviewed in the late 70s and early 80s are gone now.

The Redress movement divided the United States into eight areas and assigned an area coordinator for each of the eight areas. I became the area coordinator for Northern California/Western Nevada.

On September 17, 1987 the House of Representatives voted 243 to 141 to pay $20,000 to each of the surviving people who had been put in camp. About 60,000 were left, of the 100,000 plus. Two Japanese American California congressmen, Norman Mineta and Robert Matsui, led the House fight. It passed the Senate, and Reagan signed it, about a year later. If people had been deprived of their freedom for three years, say, that would be about $7,000 a year.

On Loss

One last story. Remember the swords we turned in to the police? In 1946, I went with my father, with the receipt, to the 6th Avenue police station. We said to the policeman at the desk, "We left this article here in 1942, can we reclaim it?"

"Oh, my God," was their response, "1942? We don't know what the hell happened to it! That was 4 or 5 years ago."

That was that, we thought. But before we could go, there was an older policeman there who heard this. He said, "Oh, you were one of *those* people. *I* remember you guys! You know, we *have* a package in the back. We don't know what the hell it is. Maybe it's yours."

And there they were, the swords! So we were some of the very few fortunate people who did not lose all their things. If they had shipped it to the main police station, it probably would have been gone. But they just stuck it in the back, because it was a rinky-dink police station. So we got the whole thing back. Amazing!

But who can say how much we really lost. I lost the years from 17 to 22. I was in a federal jail, essentially, without a trial, without so much as a charge being filed against me. Redress for that was very important for *all* Americans. If they can do that to you just for the color of your skin or where they think you come from, no one is safe. When they had to admit it was wrong, apologize, and pay us something for the years we lost, every American became safer.

Notes

1. Thanks to George J. Leonard, Christine Owens, Sonja Hird, Joyce Morgan for a year of editing the transcripts that became this composite narrative, and to Mr. K. Morgan Yamanaka for his final revision.

Further Reading

Clark, Thomas Blake, and O.D. Russell. "Hail Our Japanese-American GIs." *Reader's Digest,* 47 (July 1945): 65–67.

Gillespie, James J., and Lauren E. McBride. "The 100th Battalion (Nisei) Against the Germans." *Infantry Journal,* Overseas Edition 55 (Dec. 1944): 8–15.

Grodzins, Morton. *Americans Betrayed: Politics and the Japanese Evacuation.* Chicago: University of Chicago Press, 1949.

"How to Tell the Japs from the Chinese." *Life,* 11:25 (Dec. 22, 1941): 81.

Martin, Ralph G. *Boy from Nebraska: The Story of Ben Kuroki.* New York: Harper & Brothers, 1946.

McWilliams, Carey. *Prejudice: Japanese-Americans: Symbol of Racial Intolerance.* Boston: Little, Brown and Company, 1944.

Murphy, Thomas D. *Ambassadors in Arms.* Honolulu: University of Hawaii Press, 1955.

Rostow, Eugene V. "Our Worst Wartime Mistake." *Harper's Magazine,* 191 (Sept. 1945): 193.

Tanaka, Chester. *Go for Broke: A Pictorial History of the Japanese American 100th Infantry Battalion and the 442nd Regimental Combat Team.* Richmond, CA: Go for Broke, Inc., 1981.

Shirey, Orville C. *Ambassadors in Arms.* Honolulu: University of Hawaii Press, 1955.

Thomas, Dorothy Swaine, with Charles Kikuchi and James Sakoda. *The Salvage.* Berkeley: University of California Press, 1952.

Thomas, Dorothy, and Richard S. Nishimoto. *The Spoilage.* Berkeley: University of California Press, 1946.

The Nisei Go to War

The Japanese American 442nd Regimental Combat Team

BRIAN NIIYA

Soldiers loom large in our history. If a typical non-Japanese American knows anything about Japanese American history, it is likely to be about the all-Nisei (second generation Japanese Amerian) **442nd Regimental Combat Team** and about the concentration camps. Since World War II, Nisei veterans have been put on a pedestal representing the best of what we can become and have played a leading role in the Japanese American community, both in tangible ways and in our collective psyche. Sometimes, I wonder if this is such a good thing.

Before 1941, there was little reason for most Americans to distinguish one Asian American from another. For decades, Chinese and Japanese Americans had filled similar roles in the American labor market and occupied similar positions in society. After Chinese and Japanese immigration was cut off, many Filipino immigrants had come to America and assumed the same roles as the Chinese and Japanese immigrants. Although stories of Japanese military activities in Asia alarmed many Americans, the positions of Japanese, Chinese, and Filipino Americans did not change much as a result. However, the Japanese attack on Pearl Harbor changed all that. There was now ample reason to make distinctions. Suddenly, *Life* magazine was publishing an article purporting to tell us how to distinguish the Chinese from the Japanese:

> *In the first discharge of emotions touched off by the Japanese assaults on their nation, US citizens have been demonstrating a distressing ignorance on the question of how to tell a Chinese from a Jap. Innocent victims in cities all over the country are many of the 75,000 US Chinese, whose homeland is our staunch ally To dispel some of the confusion, Life here addresses a rule of thumb from the anthropometric conformation that distinguish friendly Chinese from enemy alien Japs.*

The piece goes on to describe the purported differences between the groups: "An often sounder clue is facial expression, shaped by cultural, not anthropological factors. Chinese wear rational calm of tolerant realists. Japs, like General Tojo, show humorless intensity of ruthless mystics." Undoubtedly, Pearl Harbor led many Americans to look upon "friendly" Chinese and Filipino Americans in a more sympathetic light given the common bond of Japanese aggression toward China, the Philippines, and the U.S. Not surprisingly, Japanese Americans came to be viewed with a good deal of hostility after the Pearl Harbor incident. This hostility soon manifested itself in an unprecedented removal of all Japanese Americans from the West Coast to concentration camps by the end of 1942.

In the years immediately after World War II, the image of Japanese Americans improved tremendously to the point where they may have been regarded more favorably than Chinese and Filipino Americans. Much of the credit for this turn of events has to go the highly publicized exploits of the all-Nisei 442nd Regimental Combat Team and the 100th Battalion in Europe. Wartime newspapers and newsreels printed such material with relish and postwar books such as Orville C. Shirey's *Americans: The Story of the 442nd Combat Team* and Thomas D. Murphy's *Ambassadors in Arms* glorified these soldiers. Such publicity had a good deal of propaganda value, showing how America allowed even these people who looked like the enemy to participate in the war effort. Aside from Nisei soldier heroism, the growing consensus that the internment was unjust also built sympathy for the Japanese Americans. For example, in *Harper's Magazine*, Eugene Rostow wrote

> *Time is often needed for us to recognize the great miscarriages of justice. The Dreyfus case had lasted four years before public opinion was fully aroused. The trials of Sacco and Vanzetti endured six years. As time passes, it becomes more and more plain that our wartime treatment of the Japanese and the Japanese Americans on the West Coast was a tragic and dangerous mistake.*

Additionally, the largely cooperative attitude the Japanese Americans exhibited toward the internment, as exemplified by the Japanese American Citizens League position, no doubt added to the positive image of Japanese Americans. By 1948, the climate had changed to the extent that Congress could pass the Evacuation Claims Act authorizing limited payments to Japanese Americans for losses incurred in the internment. While this legislation stopped short of calling the internment a mistake, it did seem to indicate a conciliatory and apologetic attitude on the

part of the U.S. Government and people. This may well represent the popular perception of Asian Americans after World War II.

I find myself thinking about this every time I see another news feature commemorating the rescue of the "Lost Battalion" by the 442nd, perhaps the most famous episode in the history of that fabled group. It is undeniably a fascinating, sobering, horrific story. In late October 1944, 275 members of the 141st Infantry Regiment from Texas had overextended themselves in eastern France and found themselves surrounded by German troops. Out of food, water, and medical supplies, they were in a dire situation. Having just liberated the French towns of Bruyeres, Belmont, and Biffontaine, the 442nd was called on after just two days rest to rescue this lost battalion. Two other battalions from the same regiment had already tried to rescue them, but had been driven back. Four days of hellish fighting followed as the Nisei soldiers made slow progress against an enemy entrenched in treacherous mountain and forest terrain. The first advance patrol reached the Texans on October 30; the "lost battalion" had been saved. 800 Nisei casualties had been taken to save 211 Texans.

This episode, like seemingly everything done by the 442nd and the 100th Battalion, both before and after it became part of the 442nd, has been repeated often enough so that most Japanese Americans know about it and many non-Japanese Americans as well. So what's wrong with that?

Well, strictly speaking, nothing, I suppose. It is a stirring story, as is the general story of the segregated Nisei troops and their heroic actions in Europe as well as the lesser known story of Nisei soldiers in the Pacific war. I guess what I don't like about it is how the Nisei soldiers have become sacred cows of sorts in the Japanese American community, overshadowing all in their path.

There are several dimensions to this phenomenon. For one thing, all the attention on the Nisei soldiers has tended to blot out attention from all the other stuff that was going on in the community at the time. The highly nuanced story of "loyal" and "disloyal," of complex responses to forced mass removal and incarceration, was in effect simplified to a story of young men eagerly volunteering to serve their country while their families were in concentration camps. (Never mind that the vast majority of 442nd soldiers either came from Hawaii, enlisted after leaving camp, or were drafted.) When the third generation, the Sansei, came of age in the 60s and 70s, this was the only image they knew; other stories—of legal challengers to the mass exclusion, of mass uprisings in camp, of an organized draft resistance movement, of mass renunciation of citizenship, not to mention the evicting of Issei from the camps who didn't want to leave—were largely buried, to be slowly excavated over the years.

The other thing that bothers me about the dominance of the Nisei soldier is that they have always been used to "prove" how American we were. It is a natural thing to do. If some bigot calls you a "Jap," the easiest response is to cite the valor of the 442nd to validate your American-ness.

But in so doing, are we not accepting the prevailing mainstream notion of what it means to be American? Aren't we in effect accepting that one can only be American by assimilating, by embracing mainstream values, and by killing foreign enemies in its name? The downside of this perspective is that those who don't follow this path, who indeed question it must then be "un-American." Thus our community has largely vilified "No-No Boys," draft resisters, and other dissenters. (See Chapter 7.) Even in the 60s and 70s, significant segments of the community viewed Sansei anti-war protesters and the like with suspicion.

Worst of all, I think the role thrust upon the Nisei soldier has hurt the veterans themselves. If you tell someone how great they are long enough, he will eventually come to believe it—and become hard to live with in the process. Frankly, there are some Nisei veterans who have an inflated view of their own importance.

Furthermore, the image of the Nisei soldier as courageous, eager, and loyal fighting machines has tended to dehumanize them. In much the same way as we stereotyped the Japanese soldier as superhuman, so it was with the Nisei soldier. It has only been in recent years, with the publication of books such as Masayo Duus' landmark *Unlikely Liberators* that we have begun to see the human side of these men.

I feel that in accepting the mainstream definition of heroism and the role of the returning war veteran, we have lost sight of what to me is the most interesting aspect of the Nisei soldier story: how the image of the Nisei soldier has been used—by mainstream America, by the Japanese American community, and by the veterans themselves. It was not the case that the American government allowed Nisei to serve in the military because it needed the personnel (this does not apply to those in the Military Intelligence Service); it had much more to do with the propaganda value Nisei soldiers would have during and after the war. Indeed, the story of the 442nd was told in glowing terms in the mainstream media from the middle of the war on. It was a way to show how open American society was to minorities (as long you weren't African American, of course) and served as a key propaganda weapon in the Cold War.

We too have reaped the benefits of the Nisei soldier story. The image of the Nisei soldier was key in postwar political gains in Hawaii and in the overturning of anti-Japanese legislation on the mainland. It's never really stopped. In the Redress movement too, the image of the Nisei veteran was very important in getting the key votes for the redress legislation.

The Nisei veterans themselves have also used the story to their advantage. Individual Nisei veterans have ridden that image (and the GI Bill) to successful careers in politics, business, and many other fields. Other Nisei veterans, however, never got much from their military service. Like so many other American war veterans, they were used and cast aside, many damaged physically or psychologically from their wartime travails. Most of us know a few like this. We never hear much about their story.

We also hear little about women and families. Though few know it, there were Nisei in the Women's Auxiliary Corps during and after the war. And for every Nisei man in the military, there was a family back home—parents, siblings, wives, children—whose lives were dramatically affected.

Like everything else, I guess, the Nisei soldier story is more complicated than it first appears. The story raises fascinating questions about the role of minority veterans in American history, of the meaning of being a veteran in American history, and indeed of what it means to be American period. I hope we can displace the Nisei soldier from his superhuman pedestal long enough to explore some of these questions and to get to know him, and her, as a human.

Further Reading

Clark, Thomas Blake and O.D. Russell. "Hail Our Japanese-American GIs." *Reader's Digest,* 47 (July 1945): 65–67.

Gillespie, James J., and Lauren E. McBride. "The 100th Battalion (Nisei) Against the Germans." *Infantry Journal,* Overseas Edition 55 (Dec. 1944): 8–15.

Grodzins, Morton. *Americans Betrayed: Politics and the Japanese Evacuation.* Chicago: University of Chicago Press, 1949.

"How to Tell the Japs from the Chinese." *Life,* 11:25 (Dec. 22, 1941): 81.

Kotani, Roland. *The Japanese in Hawaii: A Century of Struggle.* Honolulu: Hochi, Ltd., 1985.

Martin, Ralph G. *Boy from Nebraska: The Story of Ben Kuroki.* New York: Harper & Brothers, 1946.

McWilliams, Carey. *Prejudice: Japanese-Americans: Symbol of Racial Intolerance.* Boston: Little, Brown and Company, 1944.

Murphy, Thomas D. *Ambassadors in Arms.* Honolulu: University of Hawaii Press, 1955.

Rostow, Eugene V. "Our Worst Wartime Mistake." *Harper's Magazine,* 191 (Sept. 1945): 193.

Shirey, Orville C. *Americans: The Story of the 442nd Combat Team.* Washington, D.C.: Infantry Journal Press, 1946.

Tanaka, Chester. *Go for Broke: A Pictorial History of the Japanese American 100th Infantry Battalion and the 442nd Regimental Combat Team.* Richmond, CA: Go for Broke, Inc., 1981.

Thomas, Dorothy Swaine, with Charles Kikuchi and James Sakoda. *The Salvage.* Berkeley: University of California Press, 1952.

Thomas, Dorothy, and Richard S. Nishimoto. *The Spoilage.* Berkeley: University of California Press, 1946.

Being Nisei

Reflections on the Second Generation of Japanese Americans. "Building the Nisei-style House" A Guide for Sansei

BRIAN NIIYA

[Until the early 1960s, many desirable new suburbs legally advertised that no homes would be sold to anyone but Christian whites. Purchasers even had to sign a clause guaranteeing that they would never resell the house to anyone non-Christian or non-white. When that changed, the great exodus of newly prosperous second generation Asians (the 'Nisei,' in Japanese) began. Brian Niiya has disguised this affectionate, comic memoir of the Nisei generation's escape from the Little Tokyos to Brady Bunch suburban prosperity as a set of deadpan instructions to his third (Sansei) generation, on how to build a "Nisei-style house." — The Editors.]

The Nisei-style house (NSH) was once a major West Coast–based architectural style. Found in mostly suburban enclaves surrounding major cities in California, Washington, Oregon, and Hawaii, the NSH enjoyed a peak of popularity in the 1960s and 1970s. Though many fine examples still exist today, many neighborhoods that once were filled with NSHs just a generation ago, have seen these homes gradually disappear, as the Nisei owners pass on, sell out, or worst of all, turn over their houses to their Sansei children.

As is the case with any architectural style that sees its popularity fade, there is little that can be done to prevent the gradual extinction of the NSH as a living entity. We can, however, try to preserve the best existing examples for posterity and to record our recollections of life in an NSH.

There are even a few brave Sansei who are trying (probably in vain) to restore or convert existing houses to NSHs. Based on several years of sporadic research, I have compiled some basic observations on the major elements of the NSH for the benefit of these enterprising souls. This is a preliminary list, so any additions or comments would be welcomed.

NSHs typically begin life as basic suburban tract homes. However, the extensive customization that follows renders the homes instantly recognizable as an NSH.

The Outside

For the novice, the most distinctive and eye-catching elements of the NSH are gardening elements. There should be a well-cared-for front lawn with a small Japanese-garden-like area between the lawn and the house itself. This area should feature sculpted, bonsai-like pine trees, junipers, and miniature maple-looking things. To magnify the effect, a Japanese-style stone lantern and sometimes, in advanced cases, a small orange bridge or torii gate over a little stream of rocks can be added. A rock garden is another option, though most Nisei abandoned these when Sansei kids persisted in throwing the rocks at anything that moved. Subtlety is important in designing the garden area, however; it is important not to go overboard in this area.

The cars parked outside the house are also important parts of the NSH effect. For starters, there should be two mid-size or larger American-made sedans, one of which should be more than 10 years old, in mint condition and have less than 50,000 miles on it. (The relatively recent phenomenon of Nisei buying Japanese cars makes it permissible to substitute one Japanese car.) Alternatively, one car can be replaced with a gardening truck or other business-related vehicle. To create the Sansei-son-living-at-home effect, one can simply park a customized Japanese made sports coupe or Yuppie luxury car out front.

Backyards should feature some combination of grass, flowers, and edibles. To get a younger Nisei effect, there should be relatively more grass, indicating that work on the yard is ongoing and that kids had recently needed grass to play on. For an older Nisei effect, grass should only serve as buffer zones between the fruit trees, vegetable patches, and flower gardens. Trees should include some combination of apples, oranges, lemons, and persimmons (there may be more varieties in regions whose weather allows them); among the most popular vegetables are cucumber, eggplant, zucchini, and tomatoes. The importance of home-grown produce cannot be overemphasized: though a majority of the produce will not be eaten by those who grow it, it is vital ammunition for the yearly summer produce exchanges that occur between Nisei as well as the produce giveaways to talentless apartment dwelling, brown-thumbed Sansei and Yonsei children and grandchildren.

The Inside

The inside of the typical NSH might be described by the phrase "organized clutter." The first reaction for most people upon entering such a home (and after removing one's shoes, if the owners hail from Hawaii) is one of sensory overload. There is simply too much for the average person to take in at once.

Having lots of stuff cannot be overemphasized in capturing the NSH effect. Old, out of style furniture must be spread throughout the interior. The expensive and meticulously polished solid wood tables and cabinets, console televisions and stereos, and mint condition sofas and chairs must be draped with layers of tablecloths, throws, plastic sheeting, or embroidered doilies so that they are virtually invisible. More stuff—old magazines, Japanese dolls, picture frames with images of ungrateful grandchildren—should be piled on the doilies on the furniture. One cabinet in the corner should be filled with kokeshi dolls and similar treasures from Japan, along with American additions such as old wedding party favors and the kids' sports trophies. The walls should be covered with Japanese screens and scrolls with an occasional original artwork done by a crazy relative. A shrine area—sometimes a very large area—can be found in many NSHs as well.

Craft items must play an important part in the decor of the living room as well. Authentic Issei and Nisei crafts must be spread throughout the room. Ribbon fish (1968–1974) should hang from the ceiling, multicolored but clashing-since-they-were-made-from-remnants cushions (1945–1970) arranged on top of zabuton with homemade covers (1955–1964) on top of the already covered sofa, and kleenex boxes covered with handmade covers (ca. 1960s) should top every end table. Bathrooms should sport spare toilet paper covers made of an imitation Barbie doll with a carefully crocheted flowing dress (1962–1972) while kitchens should have all surfaces covered with an assortment of handmade potholders (1952–present).

The organized clutter theme must continue in other rooms of the house as well. The kitchen/dining room should have an expensive wood dining table covered with a cheap plastic tablecloth (or several of them to be safe). Ample cabinet space should be allotted for the everyday dishes, the guest only dishes, and the Japanese dishes. Kitchen gadgets and utensils should abound; it is important that there be at least a few such gadgets that have no apparent purpose whatsoever. In addition to the homemade potholders, there should also be the one that came in the mail in the 1970s inscribed "Vote for Dick," which was just too good to throw away.

Extra bedrooms should have the appearance of small warehouses. Boxes of stuff—kids school-work organized by grade, old small appliances that might still be fixable, *National Geographics* that no one can bear to throw away—should be stacked against the walls, next to file cabinets filled with bills and receipts from the 1950s. Somewhere in the mix, there should be a box of camp treasures, usually photographs, yearbooks, and craft items such as bird pins or shell pins. Old sports and exercise equipment—bent golf clubs, cracked bowling balls, and expensive home gyms/coat racks—can also be stuffed in here. In one of these rooms, there should also be a usable bed somewhere.

Time marches on and fashions change. As the Nisei generation passes from the scene, the Nisei-style house cannot help but go with it. The Sansei and Yonsei houses of the present and future will be much improved in many aspects, uncluttered, color coordinated, and filled with new technology. But the NSH must not be forgotten and must not be allowed to die completely. To those who are working to preserve existing NSHs or to recreate new ones, you are doing valuable work. Though we joke about them today, we may well look back on those Sansei who continue to live at home in NSHs, who resist the urge to renovate, clean up, modernize as heroes tomorrow, as the keepers of history.

Whatever the future holds, we spoiled Sansei will undoubtedly look back and remember the NSH fondly.

Further Reading

Hosokawa, Bill. *Nisei: The Quiet Americans.* New York: William Morrow & Co., 1969.

Being Sansei

Reflections on the Third Generation of Japanese Americans

BRIAN NIIYA

I don't speak Japanese. I don't read Japanese. I don't know where in Japan my ancestors came from.

This used to bother me. For one thing, it made communication with my grandmother (who lived with us) and other Japanese-speaking relatives difficult. Secondly, grandmothers and Japanese-speaking relatives have a way of making you feel guilty for not knowing Japanese. As a child, I remember meeting Japanese relatives who would speak to me in Japanese. I would look helplessly at my mother (a Nisei who is unusually proficient in Japanese) who would say something to them (the Japanese equivalent of "No, my stupid American son doesn't speak a word of Japanese, isn't that terrible. Where did I go wrong?" no doubt) at which point they would all shake their heads in disapproval. A few years of this and any self-respecting Sansei kid would begin to feel a bit inadequate.

Of course none of my Sansei friends spoke Japanese either. Oh, we knew a few words here and there—mostly food-related terms—and knew enough to laugh at white people who say "sah-key" and "sah sheem ee." Though none of us would admit to it bothering us, I knew it did. So it was a Sansei thing, then; we were an entire "substandard" (to use my Japan-educated Uncle Sam's term) generation.

(There *was* always that one oddball who did speak Japanese and enjoyed rubbing that fact in your face. "What about that Kubota boy," said Nisei mothers, when Sansei kids complained about being harassed about their language inability, "he is sooo good at Nihongo." I have no idea what happened to the Kubota boy, but I hope he's languishing at some dead-end job interpreting for some racist Japanese politician or something.)

There was only one solution to the problem: **Japanese school**. Like many if not most Sansei, I was shuttled off to Japanese school against my will. Never

mind that Nisei had once been sent to the same schools against their wills and had gained little in the way of language ability out of it; 30 years later, they were making us go too.

The results were predictable. Even the best of teachers could do little with classrooms filled with Sansei kids who did not want to be there. Morale was low, tension was high. Goofing off and not studying became the norm and soon we competed to see who could be the worst student. Even those few kids who wanted to be there and wanted to learn were harassed by the others so that they got as little as possible out of it as well. It is a familiar dynamic—see post-segregation Tule Lake; just call us the "Derelicts of Company J—School."

After two-and-a-half years of complaining, my parents finally relented and let me stop going. I seem to be about the median in this regard as compared to people I know. "You'll regret it later," they warned me. I resigned myself to being substandard. Substantially happier, but substandard nonetheless.

Ironically, it was the process of getting interested in my roots, of embracing Asian American studies and learning about Japanese American history that turned things around for me. As I became more knowledgeable about these matters, it became clear that knowing how to speak Japanese was pretty much irrelevant to how Japanese American I was. Maybe it was a matter of becoming more comfortable in accepting who I was as a whole—even the part that did not speak Japanese. I began to see that not speaking Japanese was an important part of my identity as a Sansei. Indeed, those few Sansei who did speak Japanese were oddballs among their peers (those who learned as adults for work-related purposes being excepted).

Asian American studies (at least in the early days) also taught us that we were not "Oriental," but Asian American. "Do you speak Japanese?" I remember asking Lewis, a fellow and Asian American graduate student. "No. Why the %$#! should I?" he replied. What he was trying to say (I think) is that not speaking Japanese made his status vis-à-vis Japan clear. We were not Japanese, but Japanese American, as were our parents. As such, there was no reason to speak Japanese. I soon became proud of my inability to speak Japanese.

It was a similar thing with not knowing which prefecture my ancestors had come from in Japan. It's not as if I haven't been told. It's just that as a Sansei who has been to Japan only once for two weeks, the place names have no meaning for me. I know enough about history to know which prefectures most Issei originated from, that these prefectures were mostly rural and in southern Japan, and that my own grandparents came from the same places most other Issei came from. Which prefecture in particular was mostly irrelevant to me since

I didn't have any idea what set Hiroshima apart from Wakayama apart from Yamaguchi, etc. This particular piece of information would never stick in my memory for very long.

As I got more into the Asian American studies material, I stopped being proud of not being able to speak Japanese. I soon realized that Japanese language skills were important for doing historical research on the Issei and Nisei years. I even took a couple of years of Japanese while I was in graduate school, though I realized that I had no aptitude for languages in general.

So I guess it's kind of come full circle. Knowing Japanese certainly doesn't make one less Japanese American. Knowing Japanese is a useful thing, whether your business is doing research, providing services, or selling stuff. I kind of wish I was better sometimes. But as a Sansei, I don't lose much sleep over it.

Further Reading

Gehrie, Mark. "Sansei: An Ethnography of Experience." Dissertation, Northwestern University, 1973.

The Open Boat: Poems from Asian America. Edited and with an introduction by Garrett Hongo. New York: Doubleday, 1993.

Walls, Thomas. *The Japanese Texans.* San Antonio: Institute of Texan Cultures, 1987.

First-Generation Memories

One Filipina's Story

SALVE MILLARD AND MAX MILLARD

The Philippines, or the P.I. as it is sometimes called, consists of more than 7,000 islands. But it has just three main areas. In the north is Luzon, the biggest island, where Manila is located. In the south is the island of Mindanao, which is almost as big, and where about one quarter of the people are Muslims. Then in the middle is a group of many islands called the Visayas, or Bisayas, as Filipinos prefer to call them. The word means "slaves" from the Indian. Many women are named *Luzviminda*. It's sort of a nationalistic thing.

Altogether, the Philippines is a little bigger than the British Isles and a little smaller than Japan. The two biggest islands make up 65 percent of the land area and contain 60 percent of the population. About 6 percent of the population is Muslim, and almost all the rest is Catholic.

I was born in 1966 on the small *Visayan* (Bisayan) island of Masbate, in the geographic center of the Philippines. In the Visayas, the first language is not *Tagalog*, but *Visayan*. Tagalog, also called Pilipino, is the national language. It was originally the dialect of the Tagalog people of Manila and southern Luzon. Tagalog is taught in most schools throughout the Philippines.

Also, most Filipinos learn English in school. English has been used as a language of instruction for more than 80 years. Filipinos like to speak English because they admire anything from the United States. A lot of Filipinos speak English and Tagalog together, sometimes changing from one language to another in the middle of a sentence. In most Filipino magazines, you will see a lot of this *Taglish*. But most Filipinos grow up speaking the language of their own province. There are about 70 different languages and dialects in the islands.

Visayan is not just a dialect, but a separate language, which people use for writing letters and books. It has many of the same words as Tagalog—especially the most commonly used words—but contains more Spanish, probably because

it is farther south, where Spanish has more of an influence. But most of it is different from both Tagalog and Spanish, and Visayan has different dialects from one island to the next, so people throughout the Visayas cannot all understand each other.

The Visayas are very important in Philippine history. The oldest city in the Philippines, and the second biggest, is Cebu City, on the island of Cebu in the Visayas. Ferdinand Magellan landed on the *Visayan* island of Samar in 1521, where he was killed in a skirmish with a Filipino chieftain named Lapulapu. When General Douglas MacArthur returned to the Philippines in 1944 to drive the Japanese out, he came ashore on the Visayan island of Leyte. That is also where the **tinikling** came from, the folk dance where the dancer jumps up and down between clicking bamboo sticks.

I would like to tell you about my experiences, using Tagalog words in place of Visayan ones.

I grew up in a small **barrio**, village, with nine brothers and sisters. We lived in a **nipa hut**, the traditional Filipino thatched house that is raised off the ground on four tall wooden poles. Nipa huts are light in weight and can actually be lifted up and carried to another location if necessary. Their distance from the ground protects the people inside from heavy rain and from snakes. Also, it makes the inside cooler, because the air can circulate. Nipa huts have a bamboo floor and a roof made of *cogon* leaves. Cogon is a kind of dry grass, like straw.

When I was small, I was very close to my grandmother, whom I called **lola**, and my grandfather, **lolo**. In the Philippines, we use these words not only for grandparents, but as a title of respect for any elderly people. My parents owned a **sarisari**, a small variety store, and if a customer came in who you didn't know, you could say, "Lolo, may I help you?"

In the Philippines, titles should always be used when talking to an older person—especially someone within the family. If you have an older brother, you have to say **kuya** before his name, and if it's an older sister, you have to call her *ate*. When I was a little girl, I got mad at my older sister Virgie, so I started calling her Virgie. My father came after me with a stick and said, "What did you say?" He hit me with a stick until I said *ate* Virgie.

You can also use "ate" for friends who are older than you, out of respect. But for younger people, including brothers and sisters, you just call them by their name. For aunts and uncles, you use the same words as in America—auntie and uncle. You can also call people this if they are not related to you, the same as with "lola" and "lolo."

My parents sold many kinds of food at their store, such as *bangus,* also known as milkfish, the national fish of the Philippines. It is a tender, saltwater fish

with white flesh and many bones. We would always fight for the head and the stomach, which we considered the best parts. The first thing we would eat was the eyes. Another fish we sold at the store was *tilapia*. Both of these are easy to find in America, at least in San Francisco.

In my barrio, most people couldn't afford to have fish very often. The main diet of our town was white rice and *bagoong*, a fermented shrimp paste that smells like it is rotten but tastes very good. When the hungry Japanese troops came across some *bagoong* during World War II, they would throw it away because they thought it was bad. And sometimes we would have *balut*, duck eggs that are half hatched. Part of the egg is the yolk, and the rest is the duck embryo, with some bones and feathers. It is boiled for about 45 minutes, then eaten whole. These are considered a treat all over the Philippines and are sold in Philippine stores in America.

Sometimes when I was small, I would get up in the middle of the day and sneak into the middle of the cornfield, where I'd light a fire and cook corn. In the daytime, I'd climb up the fruit trees—guava, mango, jackfruit—and just stay up there and eat the fruit, so that I was not hungry again all day. In the Philippines, they believe some mango trees have a ghost. You have to apologize to the tree before you climb into it, and make the sign of the cross.

We would often have hot *pandesal*, breakfast rolls. And on special occasions we ate foods like *pancit*, which is a lot like Chinese chow mein. It's made out of rice noodles, vegetables such as garlic, onions, tomatoes, carrots, celery, cabbage, and leeks, and sometimes shrimp or pieces of pork or chicken. We ate everything with our hands. When we went on picnics, we would wrap the rice in banana leaves, which made it taste better. I didn't learn to use a fork until I went to Manila.

Another popular dish of the Philippines is **lumpia**, a pastry wrapper filled with vegetables, such as carrots and celery, and pork, shrimp, or chicken—a lot like a Chinese egg roll. In fact, the small ones, usually made of meat, are called Shanghai. Other times we would have *adobo*, which is often considered the Filipino national dish. It is a stew of chicken or pork, flavored with vinegar and soy sauce, garlic, and bay leaves. Or we might have *kari-kari*, a meat and vegetable stew in a thick peanut broth. Some of these dishes, such as pancit, are served with *calamansi*, a small Philippine lime that can be squeezed over them.

When Filipinos have a really big feast or celebration, the centerpiece is **lechon**, a whole baby pig roasted for hours over a fire with a big stick through it, which is constantly turned around so it doesn't burn. The best part is the brown, crispy skin.

The dessert at a feast might be *biko*, made of sticky rice that is boiled first, then blended with coconut and sugar in another pan. Only rich people can af-

ford to have *leche flan,* sweet egg custard, because eggs are very expensive. In fact, most of the foods you find in Filipino restaurants in America are not common in the Philippine provinces.

For a snack, we might buy *halo-halo,* which means mix-mix. It's sold by vendors with pushcarts and is covered with shaved ice, which makes it refreshing in the summer. Halo-halo is a sweet snack made out of jackfruit and at least three kinds of beans including *mongo,* mung beans, evaporated milk, white sugar, and *pinipig,* a white grain.

One special occasion we celebrated every year was All Souls' Day, the day of the dead, on November 2. We would bring food to the cemetery and spend all day at the tombs of our loved ones. To decorate the graves, we would bring bunches of red and white *sampaguitas,* the fragrant national flower of the Philippines. This flower is often dried and made into garlands.

Another common type of celebration in the Philippines is the **death anniversary**. We would invite people to our home and gather around an altar that we would decorate in memory of the person who had died on that date. We would not put his or her picture on the altar, but we would light candles and place things there that would remind us of the person. For example, if he had been a smoker, we might put a pack of cigarettes. And we would always have the person's favorite food. If he drank *tuba,* coconut wine, or beer, we would put them on the altar. After praying, we would all share the food.

Most Filipino homes have a little altar, with an image of the **Santo Niño**, the baby Jesus. Filipinos have always loved babies very much. There is a story that when Magellan landed in the Philippines, the islanders were attracted not by the cross, but by a statue of the Christ child. This was one of the reasons the Philippines was converted to Christianity.

The Santo Niños placed on altars can be up to about one foot high. Others are only one or two inches high and are quite flat so they can be carried in a purse or wallet for good luck, usually in a plastic folder with a printed prayer. No matter what size it is, the baby Jesus is always shown dressed in fine, brightly colored robes that spread out in triangular shape, with a gold crown on his head.

Before the Spanish arrived, Filipinos practiced animism and had idols. They believed in the souls of departed ancestors, the spirits of nature, and mythical monsters. Many of these beliefs were absorbed into Christianity. Filipinos believe strongly in miracles. Sometimes a Filipino will claim to have a vision of the Virgin Mary, and thousands of people will come from many miles away, to try to see her too.

Filipinos are superstitious. When I was growing up, if there was an eclipse of the sun, people in the town would bang pots and pans to make the sun come

back. A lot of Filipinos don't know how tall they are, because they think it's bad luck to be measured. The only time you do that is when your dead body is measured for a coffin.

When Filipinos dress up for special occasions, the women wear a **sarong**, the Filipino national dress. It is a long dress of light material, usually brightly colored, and with very wide, exaggerated shoulders that balloon outward as a type of decoration. The men wear a *barong tagalog,* an elegant shirt with fine needlework that is worn over a white shirt. The barong tagalog has no collar, because the Filipinos were forbidden by the Spanish to wear neckties. At the time, ties were considered too high class for people of color, and this ban was one way of making the Filipinos feel inferior. But ties are not well suited to the heat of the Philippines anyway, and today all Filipinos wear these native shirts with pride— even the president.

Besides the store, my parents had *carabaos,* water buffalos, for ploughing the field, carrying water, and hauling wood. We could also ride them. Carabaos like to stop and rest about every four hours. When this happened, my Dad would stop and rest too, and take a nap.

My father cut down small trees with a bolo, a long, sharp knife that is used for everything—building the nipa hut, cleaning fish, and cutting off the heads of chickens. On our land we had tamarind and coconut trees. Dried tamarind pods are a treat in the Philippines. They are flavored with sugar and rolled in salt. From the coconut trees, my father would make tuba. If he had extra money, he would buy some *serbesa,* beer.

My father was a **mestizo,** of one-quarter Spanish blood. I was darker than most other kids, and my father would call me Negrita. That is not considered an insult. Nobody thinks about it. The Negritos are a black pygmy tribe from the interior of the Philippines.

Nobody in my town, not even the *alcalde,* mayor, had a car. Instead, we all got around by **jeepney**. The jeepney is a jitney bus that was invented after World War II, when the Filipinos took the jeeps that the Americans left behind and converted them into something new, that reflects the Filipinos character. The jeepney is very brightly decorated, with paintings, ornaments, and words all over it—usually a combination of prayers like "Lord deliver us safe," and funny sayings like "Papa's in Saudi, mama's in the disco." They even have little statues of horses on the front, with springs in them so that they jiggle up and down. The jeepney can hold at least 10 passengers—two in the front seat with the driver, and the rest on the long seats in the back section, in two facing rows. Passengers get in and out through the open rear end.

Figure 11—1: The author's father in front of Nipa hut with his carabao.
Photo by Salve Real. Courtesy of Salve Real.

Another type of transportation that's very common throughout the Philippines is the tricycle, which is a motorcycle with a side car for two passengers. It's not the same as a tricycle in the United States. You can often rent these, along with the driver, for long trips lasting an hour or more.

My family didn't have much money when I was growing up. If one of us got sick, the only thing we could afford was a quack doctor, a faith healer who does things like touching your stomach and speaking a strange language. But sometimes they can cure you.

When I was 12 years old I moved to Manila to live with my auntie and to attend school there. It was very different from Masbate. I learned new words, like **manong** and **manang**, which people used for Mr. and Mrs. They are titles of respect for older persons, even if they are just a little older than you. You can use them for anyone who is about 15 and up—even for a house girl, a domestic

servant who lives with you. My auntie lived in a condo. In the Philippines, this word means a one-storey house, usually a fancy one. My auntie's house had aircon, our word for air conditioning.

Manila is a big city with many districts. The best section, where the banks and hotels and the best shops are located, is called Makati. The poorest section, with the worst crime, is the Tondo district. In the middle is the huge Luneta Park, also called Rizal Park.

In Manila, I saw a lot of Americanos, Americans, for the first time. In the Philippines, this means a white person, whether he is from the United States or not—even if he doesn't speak a word of English. If a person is a black American, we call him Negro, not Americano. Until recently there were many black Americans in the Philippines, from Clark Air Base in Angeles City and Olongapo Naval Base in Subic Bay. When they heard Filipinos call them Negro they would get mad, so the Filipinos used a different word for them—*baluga*. The Baluga people are one of the Negrito tribes from the mountains. Even in America, if a Filipina has a black husband, she calls him a black, not an Americano.

At school, my friends and I were very interested in rumors, which means gossip. We bought newspapers filled with rumors about movie stars. My favorite was Sharon Cuneta, a singer and actress. She is a megastar, which is one level below a superstar. In order to be a singer or an actress, you have to have white skin and a long nose. A lot of the girls on TV are beautiful but don't have any talent. They're always O.A., overacting. In the Philippines, if someone has a pointed nose, it means he is proud.

In school, we studied about Philippine history. We learned about Dr. Jose Rizal, the Philippine national hero, who was executed by the Spanish during the Philippine Revolution of 1896. For a very short time then, a Philippine republic was declared, with General Emilio Aguinaldo as the first president. Then in 1898, the Americans took over the Philippines from the Spanish.

We learned about the Philippine scouts, the young soldiers who fought side by side with the Americans when the Japanese invaded the Philippines in 1941. Together, they retreated to the island of Corregidor, and when they finally surrendered, they were forced to march 100 miles up the Bataan Peninsula in the hot sun to a prison camp in Pampanga. Out of the 80,000 American and Filipino soldiers, about 10,000 died on the way, which is why they called it the Bataan Death March.

The Philippines was granted independence in 1946. But soon afterwards, the country was threatened by the *Huks,* a large group of communist-led guerrillas. Ramon Magsaysay, president of the Philippines from 1953–1957, eradicated the Huks, then was tragically killed in a plane crash. He is considered our greatest

president. In 1965, Ferdinand Marcos was elected president, then made himself dictator and stayed in office for 20 years. Under his leadership, a new problem arose—the New People's Army (NPA), a guerrilla group based in the mountains that wants to overthrow the government. The NPA remains a problem today. Marcos is still considered a hero by many *Ilocanos*, people from Ilocos province in northern Luzon, where he came from.

When I lived in the Philippines, I took many trips to different places. I visited Baguio, north of Manila, which is called the mountain capital or the summer capital of the Philippines. It is almost a mile high, which gives it a mild climate, and it is the most popular city in the Philippines outside of Manila.

I saw the beautiful Mayon volcano, which is on many postcards. It has the most perfect cone shape of any volcano in the world. From the town of Banawe, a mile high in the mountains north of Baguio, I saw the famous Banawe rice terraces, built by the Ifugao people between 2,000 and 3,000 years ago. They cover 100 square miles and are considered one of the wonders of the world.

Ever since I had milk in my mouth, I wanted to marry a 'kano, American, and come to the United States. It is because I have a mole on the bottom of my foot. That means you don't want to stay in one place. In 1986 I got my wish, and since then I have been living in San Francisco. There is a Filipino saying: "Keep both eyes wide open before marriage, half closed afterwards." But my husband and I have a good marriage. I have six big photo albums of our life together. We are rich in photographs.

In the United States, I have made friendships with many Filipino Americans—*pinays* and *pinoys*. That means people of Filipino blood, whether or not they were born here. At school, we often get together for a *merienda,* midday snack. Whenever I have my "off"—or day off, as they say in America—I like to visit them. The Fourth of July is a good time for this, because the Philippines got its independence on that day in 1946, and it is a national holiday for us too.

In San Francisco I've learned a lot about Filipino culture and history that I didn't know before. I've been to a concert of the kulintang, the Muslim gong (a musical instrument) from the southern Philippines that is played by lining many of them up like bells and hitting them with a stick. And I've learned about Carlos Bulosan, the Filipino writer who came to the United States as a laborer, then wrote a famous novel about the immigrant experience, *America Is in the Heart.*

In America, I often hear the word *mabuhay,* which is a type of greeting. But Filipinos don't really use it among themselves, except on the airline and as a greeting for the president. They used to say "Mabuhay si Cory," for Corazon Aquino, which means, "Long live my Cory."

Figure 11—2: The author, age seventeen, in front of her Nipa hut, La Union, Philippines, 1983. Photo by Vivian Real. Courtesy of Salve Real.

I've returned to my barrio in the Visayas three times since I emigrated to America. It hasn't changed. My parents still live in a nipa hut, have carabaos for the farm work, and cook over a wood fire. Most houses still don't have electricity, and nobody has running water—just a well. When I go back, people always expect some gift. Whether it's before or after Christmas, they hold out their hands and say "Merry Christmas." Or they just say, "Where's my Christmas?" If they ask me for something I can get easily, I tell them, *"Walang problema,"* no problem.

I'm the only one from my barrio who married an Americano, and everyone knows who I am. When I walk down the street, I can hear them whispering, *"Asawang 'kano,"* which means, "her asawang, husband, is an American." (Asawang is often shortened to asawa.) It's more dangerous in the Philippines now than before. There are too many holduppers, robbers. Between my visits back home, I send them **balikbayan** boxes, which are filled with gifts from America.

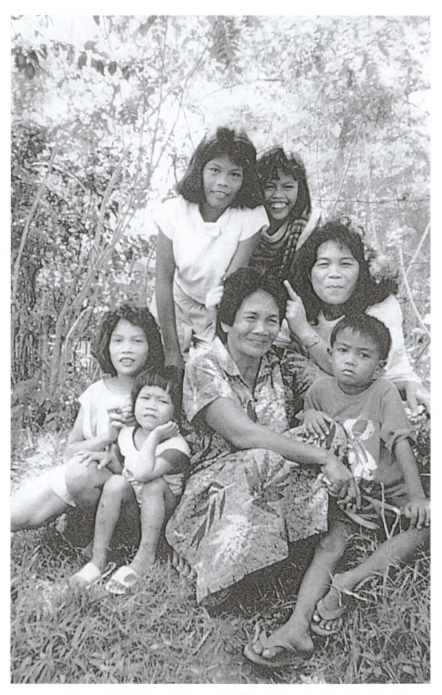

*Figure 11–3: The author's extended family. Photo by Salve Real.
Courtesy of Salve Real.*

A balikbayan means a traveler who returns home. *Balik* is return, and *bayan* is town. They like anything that's imported because it's considered high class. For example, only the poor people drink fresh-brewed coffee with milk. People prefer to drink instant Nescafe with Coffee Mate, because it is more expensive and it shows you are high class. If I send some clothes to the Philippines, I don't wash them first. People like it if the clothes smell, because they think they smell American.

I sent my family a bottle of shampoo, and instead of using it, they put it on display, with the bar code facing outward so people would know it came from the United States. Some people in my town have refrigerators and television sets just for display, even though they don't have electricity. In the Philippines, people sometimes have their good teeth pulled out and replaced with false ones, because it's considered high class for people to have metal in their mouth.

When my family asks me how much something costs in America, I never tell them the truth because if they converted it into pesos and centavos, Filipino money, they would faint.

They don't waste anything in the Philippines. They use a newspaper at least three times. First, someone buys it in Manila and reads it fresh. Then he sells it to someone who takes it to the provinces, where it is read late. Then it is used by a small merchant for wrapping sugar. When it is bought and taken home by a house-wife, it is stuffed with tobacco and smoked as a cigarette, or used as toilet paper.

When I arrived in America, there were many things I didn't understand. I thought mothballs were to make blankets smell good. The language is confusing. Once I was going to use a stepladder and it said, "Put all four feet on ground." I said, "This is crazy. We only have two. Where's the other two?" So much to learn! My brain gets dry.

I'm surprised by how much Americans love animals. In the Philippines, one of the most popular sports is **sabong**, cockfighting, which isn't allowed here. And many people eat dogs in the Philippines. If you have a pet dog there, you have to be careful that one of your neighbors won't kill it and eat it.

My first job in the United States was at Wendy's. I was proud to be work-ing there, because in the Philippines, you have to have two years of college just to work at McDonald's. I found that many of the people I worked with spoke Spanish instead of English. But I could understand a lot of what they were saying, because so many words are the same in Visayan, Spanish, and Tagalog, even if they might be spelled a little differently.

The Tagalog for apple is *mansana*, for horse it's *kabayo*, and for shoes it's *sapatos*. The Spanish words for these are *manzana, caballo,* and *zapatos.* In Visayan, they use all the Spanish numbers—uno, dos, tres, ciento. Tagalog speakers don't

use Spanish numbers as much, although they usually understand these numbers. I found that some words are a little different in Spanish and Tagalog, such as barrio, which in Spanish means a neighborhood, not a village.

I still miss the Philippines a lot, and I hope to go back there someday to start my own business. Every week I read the *Philippine News,* the leading Filipino newspaper in America, which is published in South San Francisco, next to Daly City. Daly City's population is about one-third Filipino, so if I buy a house, that is probably where it will be.

The *Philippine News* keeps me in touch with all the news in the Philippines and with Filipinos in America, including the rumors about my favorite entertainers. A new one I like is Lea Salonga. She was the star of *Miss Saigon* on Broadway, and she won an Oscar and a Grammy award for her song in the movie *Aladdin*.

But my favorite is the Apo Hiking Society, a popular Filipino rock group that is named after the tallest mountain in the Philippines. They have a song that I often think about. It says: "Why do we work so hard in other countries and not in our own? We have to work together in order to lift up our country."

Further Reading

Cordova, Fred. *Filipinos: Forgotten Asian Americans, A Pictorial Essay. 1763-circa 1963.* Seattle, WA: University of Washington Press, 1983).

Hunne, Shirley, Hyung-chan Kim, Stephen S. Fugita, and Amy Ling, eds. *Asian Americans: Comparative and Global Perspectives.* Pullman, WA: Washington State University Press, 1991.

Takaki, Ronald. *Strangers from a Different Shore: A History of Asian Americans.* New York: Penguin, 1989.

Filipino American Values

DANIEL GONZALES

[Editor's Note: This article is the edited transcript of an interview with Daniel Gonzales, Associate Professor of the Department of Asian American Studies of San Francisco State University. The interview was conducted on August 4, 1992 by George Leonard.]

There are four values that traditionally are cited by typical texts on anthropology or psychology as the central elements of the Filipino culture, and many Filipinos still describe their culture this way. I'm offended by it, because I think it's short-visioned. I don't consider any of these four to be high values; I think they are all secondary or tertiary values. They are values that govern everyday behavior, not the formation of life concepts and hopes.

The four values were first proposed, as far as we know, by a sociologist and anthropologist by the name of Frank Lynch, S.J., an American Jesuit priest. Unfortunately, he kept consulting with the more conservative element in the elite. And the elite always describe themselves as being apart from the rest of the culture.

Frank Lynch is still living. He was the most famous writer on this subject around the mid-1950s. And in the 1960s he developed the concept of SIR, Smooth Interpersonal Relations, to describe a central paradigm of Filipino culture—mechanisms all trying to save face and avoid confrontation.

One of the four values is *pakikisama*. It comes from the root word **kasama**, which means constant companion. It can mean anything from very close friend, without whom you are never seen, to your wife or brother. It's belonging to an "in" group—a peer group. Pakikisama means just hanging with your group and being a member. It means going along with your peer groups' direction, whatever that might be. If they say, "We're going to the movies. Be ready to split at seven," and you say, "Oh, I can't. I have too much homework," they'll say, "Hey,

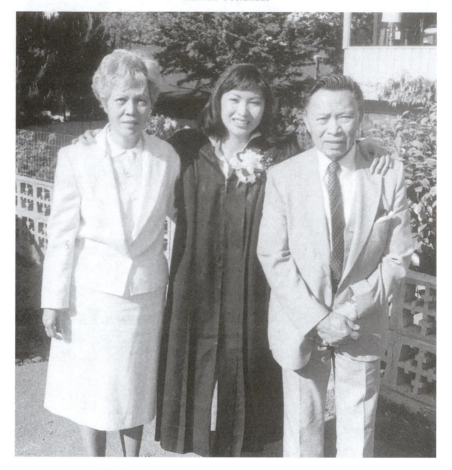

Figure 12–1: First American graduate: a Filipina poses in her robes with her proud parents, Seattle, Washington. Photo by Reme Bacho. Courtesy of Reme Bacho.

bakit, pakikisama." Bakit means "why." "Walang pakikisama?" means "Don't you have any of this value? Don't you want to be with your buddies?"

The second value is *utang na loov.* Utang means debt. Any phrase with the word loov in it has to do with the internal character of the person. Utang na loov means the consciousness of one's moral obligation.

The third is *amor proprio*—sensitivity to personal insult. When someone insults you, you turn away and vow to never talk to him again. There's been a testing of a person's integrity—an appropriate reason to get angry. You have perhaps a valid excuse for violence, but you stay your hand and walk away. And the violence is transmuted to social and psychological violence, cutting off the relationship.

In the Filipino context, violence is not always appropriate. You wouldn't challenge somebody to a duel if he said, "Aren't you getting a little chubby?" You would challenge him if he accused you of being a cuckold or if he said you were illegitimate. They used to have the duel—a challenge to a fight to near-death or death, with weapons. It probably started disappearing in the 1920s or 1930s.

The fourth cultural value is *hiya*. All the standard texts translate it as "shame." But to me, it doesn't make any sense to call it shame, because shame is not a value. Walang hiya means you have no shame—no sense of propriety. When you violate the concept of common etiquette, you should be ashamed, because you're showing people that you're uncultured.

If these are the four cornerstones, how could Filipino culture survive? The irony is that because of the completeness of colonialism, both Spanish and American, there is a controversy over whether indigenous psychology is to be taken seriously.

When people want to get reductionistic about Filipino culture, they'll mention just two values—utang and hiya.

These four so-called cornerstone values would make the culture a doormat to the world, because the people would be too concerned about violating these rather petty values. And it didn't make sense to me, because how could the culture survive?

Further Reading

Almirol, Edwin B. *Ethnic Identity and Social Negotiation: A Study of a Filipino Community in California.* New York: AMS Press, 1985.

Cordova, Fred. *Filipinos: Forgotten Asian Americans, A Pictorial Essay, 1763-circa 1963.* Seattle, WA: 1983.

Peoples of Color in the American West. Ed. by Sucheng Chan and Douglas Henry Daniels. Lexington and Toronto: D.C. Heath and Co., 1994.

Takaki, Ronald. *Strangers from a Different Shore: A History of Asian Americans.* New York: Penguin, 1989.

Korean American One-Point-Five

JEEYEON LEE

My Superior English Skills

I am often asked by well-meaning folks why I speak English so well. Answering their own question, with looks of surprise and relief on their faces, they exclaim, "You must have been born here!" Actually, the reason I speak English so darned good is not because I was born here. I only came to America twenty-one and a half years ago, having spent my two most crucial years of life carousing about Seoul. (In the Korean American community, those of us who came to the United States before puberty are known as the *"One-Point-Five" generation*.) The turning point came when I arrived in San Francisco one fine day in 1975, with my mother attached to one hand, my brother attached to the other, and not one word of English under my belt. I was nearly two at the time, so you can imagine how cute I must have been, chatting away in Korean like nobody's business, but completely inept at holding up my end of the conversation should some American approach me from nowhere. Soon it was clear, the choice was mine: adapt, learn the language, get a feel for the new life, or else get out of the kitchen. Since Soon Chul and Kap Soon (my parents) weren't gonna raise no quitters, I chose the former. That is why, today, after all these years, I speak like a "real American." That is not to be confused with a Native American, with whose speech patterns I am less familiar.

My father and mother (I know them as Soon Chul and Kap Soon, but only when they're out of earshot) always flatter me about my English, saying (in Korean): "You are so lucky to speak English so well!" and, "I wish I could speak English just half as well as you!" They, like other Koreans, see English as a priceless asset to have in this day and age. No Korean parent in America—at least none that I've met in the last twenty-one years—wants their child to speak anything

other than flawless English, and as a result, many Korean parents do not enforce Korean in the home, for to do so may interfere with learning the (to them) "more important" language. Of course, I would rather be shot than toot my own horn, but I was brought up to learn both English and Korean, and thus I am not only fortunate to be bilingual, but I can also rate high on the politically correct scale, for being "true to my people."

Allow me to digress a moment and offer my parents' point of view in the matter, and simultaneously toot their horns. They like to recall the daily vocabulary sacrifices they made in order for me and my brother, who is one and a half years my senior, to not lose our Korean. One story has it: my brother and I return from nursery school one evening, jumping to and fro in our jeans and wide leather belts, screaming "Stick 'em up! Stick 'em up!" It is precisely at this time that my father, in all his patriarchal glory, decides to employ Tough Love. He refuses to "stick 'em up." He will not yield to our new English speech. His poker face conceals his understanding of "Stick 'em up!" and thus makes us understand that if ever we hope to communicate with *him,* we are simply going to have to keep using our Korean.

By enforcing Korean in the home, my parents believe they sacrificed their own big ticket to English fluency. They know a whole slew of Korean parents who benefited from speaking English with their kids, and therefore speak "so much better" than they. This is my parents' big dilemma. How sad, they thought, to see Korean parents unable to scold their own children in their mother tongue! How embarrassing to see kids with Korean faces greeting Korean visitors with "Hello," instead of "Ahn-hong-ha-shim-nee-ka." Yet, at the same time, how nice it must be to have acquired all that English from one's own children.

Culture Clash

If in the California-based Lee residence English is viewed as a big commodity, in Seoul, Korea, it is viewed as gigantic. Verging on ridiculous, the pressure and expectations put on children and adults alike to learn their English have never been higher. I can attest to this firsthand. Eighteen months ago, after twenty years of California living, my darned good English led to my boarding a badly logoed Asiana aircraft, and flying my Americanized ass to Seoul, Korea, where I saw for myself the desperate reaching for command of, what is to them, a foreign language. I went to Seoul looking for a teaching job. I had just finished my undergraduate studies, and I rather longed for some adventure, not

to mention income. The deal was, I was to go to Seoul, find a job teaching English (a "piece of cake" according to my mother), and reconnect with my birthplace during my free time.

I suppose I should start from the beginning.

Now I wouldn't want to badmouth my own mother, but I could read in her face all sorts of concerns that I might arrive in Korea and just not fit in. She'd never admit she'd had any such concerns, but I'm pretty sure she did. We were on the plane, you know, because she and my dad thought that since I was going to Korea after all these years, they'd enjoy tagging along (they both had taken trips there in the 80s, but they figured they could use another). I wasn't particularly thrilled about their company, but I knew they'd really save my life in any morbid family encounters, so in some ways I just pretended to wish I were going alone. I was only twenty-one, and my worst sophomoric qualities were still with me. (Let me at this juncture point out that, unlike my *Ko-mo*—my father's only sister—whose unaffectionate but caring ways I really took to, some of my relatives turned out to be major letdowns. They resented my parents for shamelessly displaying their wealth by living in such an ostentatious house—a modest home by American standards.) I have many many uncles, aunts, and cousins in Korea, and a substantial part of my stay involved getting reunited. And sometimes it didn't feel so good.

Part of the problem was that some of my relatives possess a distinct raised-by-wolves essence, poorly hidden by weak veneers of courtesy and fake "warm" smiles. Everyone has "bad" relatives, but it's strange to find out the ones you are supposed to respect most, for their age or for their ranks in the Korean Army ages ago, are none other than the biggest frauds.

On the plane over, my mother kept sending me this air of, "I don't know, you're looking sorta . . . well, we'll see," which told me that Kap Soon was struggling within herself. She probably wanted to alert me that college women in Seoul wear make-up by the pound; that my overalls and thermal undershirt looked too boyish; that my glasses with the taped edge would have to be swapped immediately for a new pair, or preferably contact lenses! Somehow my mother knew it would be wrong to blurt out my deficiencies. At one point, she stared at me in that searching way of hers, and reflected, as though she were beginning to understand my nature in its entirety, "You don't like dresses, is that it?" Before I could choke on my reply, she swiftly checked herself and said, "It'll be far too cold to wear any dress, anyway." (How horrible to have to watch one's own mother struggle within herself like that!) "Mother," I said, "I love dresses so long as they're long and elegant. The problem is I can never find the kind I

like, or afford the kind I like." To this Kap Soon sat back and breathed a little. Apparently, I had just saved her crashing dreams with a parachute. "*We'll* get you one, don't worry," she said.

Kap Soon is always two steps ahead. When we landed at the Seoul airport, my first thought was, "I look like a bum, and I hate my glasses, and I need to put on some lipstick." Even at 2:00 A.M., the airport was all a-buzz, everyone dressed to the nines in their Burberry trench coats and mink furs. The Korean people, I would soon decide, are the biggest sticklers/suckers for Expensive Brand Names, and in Seoul, they're absolutely shameless about it. Meanwhile, I was beginning to feel utterly ashamed.

Even my father had warned me, in his own poetic way, before we'd ever left for Korea, "Jeeyeon, remember, 'When in Rome!'" meaning I had better deal with Seoul standards and philosophies, and abide by them; it would be the only path of reasonable behavior. Standing in the airport, being greeted by two of my well-dressed uncles, I realized that the experience of going back and living in the land of my ancestors was not going to be some bowl of shining cherries. I realized that to some degree I would be considered a foreigner, and in addition, if I continued to wear sloppy dungarees, I would be considered a *loser*.

Truly, I was blown away by how fashion-conscious and savvy Seoul was! If I had expected to breeze in as the ultra-Western stylish dresser and make heads turn, I had another thing coming. The first two weeks, my parents and I toured around in buses and taxis. The streets of Seoul were exactly like the airport scene: swarming with fur coats of all lengths and for all genders. Even Kap Soon gasped upon seeing multitudes of boys donning minks: "That's a little disgusting." Soon Chul and I agreed. For me, the shocking reality was that I had been misinformed. Korea in the 1990s was not the poor-but-diligent, wholesome-and-dowdy country I had pictured. For my parents, the shocking reality was that, in their absence, Korea had totally changed.

Sure, there had always been lots of people in Seoul, but never this many! And of course Koreans are all born with a devour-life mentality in their guts, but had they ever seen so much obvious competition and obvious devouring of life! My parents were somewhat beside themselves. They had grown up in the 1950s during the war (both my grandfathers were captured by the North Koreans), and before any major industry was transferred from Japan to Korea. They were not used to this Brave New World—or to so much blatant consumption.

Nonetheless, they undoubtedly felt proud, to some extent, because their homeland was alive and kicking with a very postmodern pulse. Not to mention a very fast pulse. Americans may attribute the "New York minute" with some speed,

but I would say no U.S. minute, New York or otherwise, compares with the Korean clock, which is always racing, always flying. Koreans value time like the day values light.

After traveling with my parents, I stayed with relatives who had recently moved to Ilsan, a new apartment suburb of Seoul. These relatives were considered solidly middle class; their small apartment had four bedrooms and was covered wall to wall in linoleum. My uncle (Kap Soon's younger brother), my aunt, and their two daughters, Soo-Mee and Kyung-Mee, each rode his/her personal little rocket throughout the week. All left home by seven o'clock sharp. The family had one car and four separate destinations, so in order to accommodate everyone, and navigate the absurd traffic, they always had to leave very early, and very together. They all worked six days a week, then had their own activities at night. My oldest cousin, for example, worked late and went to English class until midnight. Even on the one grand day off, nobody rested. Every good citizen had to make the most of their one-day "weekend." Museums, parks, and theaters overflowed with fun seekers.

With Korean zeal extending to zeal for learning English, it was a "piece of cake" getting hired. My job at the ECC English Academy began at 3:00 P.M., so I opted to ride the bus at my convenience/inconvenience. My six-days-a-week commute to and from the ECC took two hours. Each way. I would rise with the best of 'em at 6:30, play around the house (read, watch the English channel on TV, help myself to the refrigerator) until 1:00, then leave for work, meeting the icy winter air as I went. Korea's winters parallel the blizzards on the East Coast of the United States. Once I, along with many other Koreans, flagged down a bus, the trip to work was all coziness and warmth. Since crowds on street corners were ever-present, one had to make it painfully obvious that one was actually waiting for the bus. Jumping in front of the moving vehicle was not an uncommon tactic. Provided one found an empty seat, bus rides in Seoul were very pleasant. They were narrower than the buses I'd grown up with, but they were clean, well-kept, and heated. Also, the radio played within the bus, and I became quite fond of listening to American pop songs redone by Korean superstars.

To be sure, there were certain areas of Seoul through which the bus would pass that would break my heart. Even though the busy city parts of Seoul seem so ahead of themselves, so excitedly thriving, there are still many poor, meagerly fed parts to see, as well. These sadder parts are most sad in the winter. I'd watch the passing scenes from the bus and wonder how anyone could survive in what were essentially tiny boxes of collapsing wood, with no windows, and

no real doors. But it was never long before we hit the skyscrapers and reentered the land of mink coats, racing clocks, and growing industry.

Gender Roles

Today, five years older, having survived my three-month stint in Korea—which made me reevaluate my opinions—I think about cultural difference, especially in terms of Korean womanhood, in a whole new light. The rigid tenets of Korean femininity, the stereotype of which has spread forth quite indelibly into the American imagination, are, as I found, a partial fallacy on the one hand, and in the process of transformation on the other.

I once had very strong opinions about the cultural differences between Koreans and Americans, and thus hadn't particularly wished to visit Korea. My most hostile attack on what I perceived to be Korea's "backwardness" came in the form of a "research" paper. I was uptight and fed up and eighteen years old when I wrote "Cultural Differences" for Soc. 1 at UCLA. In it I confronted, with a TV reporter's seriousness, such topics as individualism, divorce, male "dominance" via ethnomethodology, and burdens of virginity. At the time I wrote the paper I was heavily pro-American and definitely trying for heavily feminist.

Although playing "good girl" is still ranked important in the motherland (as well as in this country), I found that the issue merits much more than the surface (and standard college) conclusion:

America = liberation for women

Korea = oppression for women

Of course, I never really got over that whole nonsense about covering your mouth with one coquettish hand whenever you laugh, just to show how pure and flowerlike you are. Or the fact that it goes without saying that any Korean girl worth any Korean praise can play about four hundred tunes on the piano or violin, by heart. My sojourn in the homeland opened my eyes to Korean society's subtleties. I realized that in my American attempts to rebel against the feminine ideal, I was overlooking the fact that Korean women had arranged their own ways of dealing with their social duties. For example, although my aunt scolded me for having "too forceful" a stride, she would turn right around in her exaggerated modesty and control every move her husband made, especially when it came to finances.

As a result of this trip, my ethnocentricity was humbled, and I gained a new cultural sensitivity to Korean ways. Yet I returned home, to the United States, with many questions. Clearly, traditional Korean ways are not *my* ways. But I

wouldn't hasten to define myself as totally American either. I often find myself resisting any attempts to categorize me as strictly Asian, Korean, Korean American, or American. I am proud of my Korean heritage and of my American citizenship. So, while I may speak like both a "real American," and a "real Korean," I am still struggling to find a balance between the two.

Further Reading

Light, Ivan, and Edna Bonacich. *Immigrant Entrepreneurs: Koreans in Los Angeles, 1965–1982.* Berkeley and Los Angeles: University of California Press, 1989.

Rieff, David. *Los Angeles: Capital of the Third World.* New York: Touchstone, 1991. Deals with the experiences of more assimilated Korean Americans.

Park, Kyeyoung. "Impact of New Productive Activities on the Organization of Domestic Life: A Case Study of the Korean American Community." *Frontiers of Asian American Studies: Writing, Research, and Commentary,* edited by Gail M. Nomura, Russell Endo, Stephen H. Sumida, and Russell C. Long. Pullman: Washington State University Press, 1989.

The Lizard Hunter

My Life as a Vietnamese Girl

THUY TRAN

The Mountain: My Father

There is a Vietnamese poem that children usually recite as their introduction to poetry.

Cong cha nhung Nui Thai Son
Ngia me nhung nuoc trong nguon chay ra

Father's effort of rearing a child is as high as Mount Thai Son
Mother's love for her child is as deep as the spring that runs out from the
mountain cavern.

Mount Thai Son is the highest mountain in Vietnam, but with instruments the height can be measured; just as the father's effort in rearing his child is great, but it is contained and tempered. The woman's love for her child goes deep into the womb, before the child opens its eyes or takes its first breath of air. For nine months, the child is part of the woman, her source of love for the child runs deep, like the sweet spring that feeds the moss and ferns on the mountainside. In the dark caverns, the water talks among the rocks, echoes bounce around in the dark, then it tumbles into the sunlight sparkling and clear. There is no measurable depth to its source, rich in minerals from earth, passing by earth's heaving crimson heart.

When a Vietnamese child begins to have some impressions of the world, he is then taught the poem about that world.

As a child I used to recite this poem until sleep yanked me away; and in my deep sleep, I still hear myself reciting this poem. At first I did not have any impression of the piece. All I knew was it rhymed, went up and down, a delight

for the tongue; it was not a quiz for the mind. It was as easy as chewing rice. As I grew a little older, I was allowed to roam a little further from my house. I went climbing the mountain in back of our house with the neighborhood boys. When we were together and chasing and firing at each other with our sling shots, I had no thought for the poem. But when I knew the way to the mountain by myself, and I was sitting on one of the mountain's rocks, underneath an old tree that put out many leaves, its gnarly roots popping out of the earth like big veins, the poem came to me. I wondered if this mountain with this old tree with big arms and fat hands, if this was Mt. Thai Son. As I ran through the mountainside, feeling its soft feathery grass brush against my face and the rocks crunching at my feet, I heard Mt. Thai Son roar in my ears: "Thai Son! Thai Son!" My small feet barely touched its soul. They must have scratched the small rocks on its surface. Yet I had a deep respect for this mountain, solid, immovable, lofty, and awesome. Thai Son was in my mind and heart when I sat gazing at the fallen leaves cast away by the gnarly grandpa tree; when I ran upon its strong bosom; when I walked mindlessly thinking. Heedlessly, Thai Son bore my weight, and I was impressed that he did not even once complain that I ran on him too roughly. My respect and wonder for him was immeasurable.

When I came into the world, my father was in the South Vietnam army's police force, and I did not see him until I was old enough to walk and talk. After my father came, he was often away on business. When he came home from his worldly affairs, his face was dark with knowledge from the outside, the muscles on his hands were tense, and veins ran down from his dark arms like small rivers. He would bathe all his children at dusk. I, the oldest, was first to be bathed, while my brothers and sisters sat naked waiting. My father would use that time to ask me about school and to recite poetry. While his calloused hands moved swiftly over my body, I reported to him all I could about my studies. My body seemed so small and fragile under his sandy hands. I wiggled nervously over a sentence, a pause seemed to last an eternity. I told my father all that I knew, but my father was impenetrable for me. I could tell when he was vexed with me by the lines on his forehead and the knotting of his brows, or when he was pleased by the soft lines of his lips, but aside from the surface ripples of his still pond, I could see nothing else. I could sense an inexplicable depth, and the water and waves there would be rough and foreign for my young body. I loved my father from afar and I respected him near. Like an umbrella, he sheltered me in his shade; his hands were callous, mine were supple and soft; his thoughts were complicated, bitter, mine were simple and sweet. Like a mountain's bosom, my father let me rest on his; like Thai Son, my lofty father, I respectfully loved from afar.

The Spring: My Mother

A spring or a pond was very hard to find in dry rocky Nha Trang, a fishing town. There was one in a temple near the cemetery. I could see nothing impressive in the small stream of water that seemed to take such effort oozing out, drop by drop. I was then a little older, and over those years, I would hear many explanations about that small spring. "Though it is small on the surface, yet its root is deep. It crosses massive underground distances to make its appearance here. It is the many canals of the underground world. It runs in every nook of the earth."

On hot afternoons, sitting under the leafy canopy of the temple, I looked at the spring. My stare was locked to the wall where the water oozed out. Suddenly the water, dark and deep, came alive, moving off the dark mossy wall like a giant spider, its legs spread in all directions. I jumped back, the spider jumped back on the wall, the quiet spring continued to run like tears upon soft cheeks. I put my ears closer to the wall, I heard the spring's soft voice, murmuring from the depth. I imagined the mother spider moving in her lair, her dark extensive legs wiggling in all directions sending water everywhere. As I listened I felt her music fanning my ears, and her wiggling legs tickling up my back. My bare feet felt a tickle at the thought of her moving underneath. I laughed and ran.

It was quite hard to feel love for my mother. We were so close that love was not easy to conjure up between us. She was young and her mouth often chanted gibberish things when she was tired. She patched my clothes, fed me, urged me to eat things I did not want to eat, spanked me for hundreds of reasons. Of my mother I was not afraid, therefore I did not have deep respect for her. Sometimes when she completely lost her head over my many insolences, she would chase me around our yard with a stick. When she was completely tired she sat fanning herself in the shade. I peered from afar into her perspiring face. I knew that face so well. It was plain and human, and the thoughts in that head ran very shallow, only to the fish market, the patching of clothes, the pot of rice, the many sandals floating downstream, which her careless children had thoughtlessly lost, which she must replace. No sooner did my mother sit down to fan herself than she forgot about my insolence and how angry she was with me. Her thoughts wandered into her other worries, weaving in her mind webs around those dark kitchen pots and pans, that noisy fish market where she had to deal with cunning customers, and the hundreds of fish heads awaiting her big knife when the fishing fleet came in, maybe in the light of morning or in the dog hour when dogs howled at the cold half moon and stars shone brightly in their ebony sky.

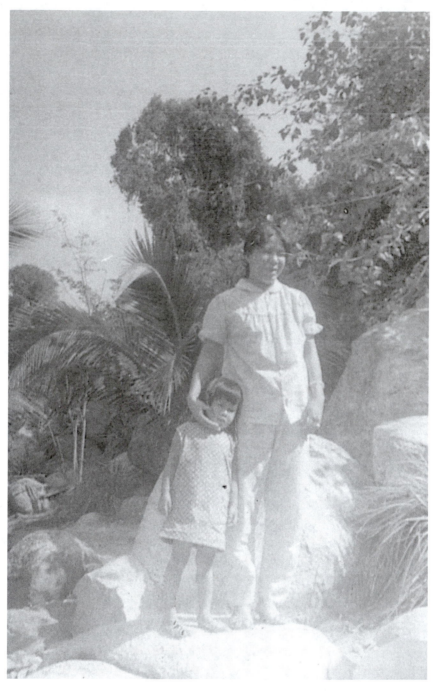

Figure 14–1: The author and her mother at home in Nha Trang, 1972.
Courtesy of Thuy Tran.

When the fishing fleet came in, the street in front of my house was filled with women's trotting feet raising up dust as they carried dangling baskets overflowing with fish balanced by a bamboo pole on their shoulders. The dust they raised clung to their loose black nylon pants, traditionally worn by all married Vietnamese women. The dust clinging on the smooth dark pants seemed so dirty, so tainted to me. A child who still wore colorful patterned clothes, I did not understand the depth of those dark pants. Eternally, those loose dark pants were swept over with dust, lived-in dust mixed with the splashing blood of fish which disappeared in the darkness. It brought awe to my mind, making my heart cringe at the enormous filth those pants stored, and contained so deceptively.

Across the street from my house stood a fish sauce factory where, in the courtyard, mounds of starkly white salt rose in peaks from the pavement. The busy feet from women on the dirt road made their way into this factory, their black pants skirted these white mounds. Beside these mounds there was a mountain of jugs in which the glaze-eyed fish would go, covered up by salt, and a canvas cloth over the mouth of the jugs. The sun then would ripen these jugs into fish sauce.

The procession of these women from before dawn to dusk was a dizzying sight. Even when I was still in bed, holding on to whatever night was still left to sweet sleep, in the street, the crunch, crunch, forceful repetition of feet bearing heavy loads, and the stench clear from the sea, salt water, seashells, seaweed, fish scales, fish blood came flooding into the nostrils. In my half-sleep I whined and motioned with my hand for the sound and smell to leave. They became more intense and I woke up with a start. Wiping off the saliva from my cheek, I came to the street to watch the women.

With every step the women took, their hanging baskets would squeak, then the scratching of their feet on loose gravel produced a monotonous sound that dulled my heart. The procession of women in their pants and conical bamboo hats seemed to me a procession of the dead, with dust eternally climbing around those dark pants, burying the people in those pants. The fate of womanhood I saw in front of me was not pleasant. I hated to be a girl. Soon I would join that procession as a woman, joining the fate of the people wearing those dark wretched nylon pants.

The Lizard Hunter

I wanted so very much to be a boy. Running with the neighborhood boys I felt free. I thought if I hid among them long enough, I would become one of them. I learned how to shoot a sling shot, I became a fierce hunter for the lizards that

hung upside-down on ceilings. After a successful hunt, we would string those lizards by their tails and roast them in Old Eight's fire. After the lizards were scorched by the flame and emitting a pleasant burnt smell, we blew the lizards to cool and broke off their heads, cleaning away the dark stuff connecting the head to their necks, then we crunched them in our mouths. The taste was not bad, a little burnt, but after many tries, it took on a depth of smoky meat that was delicious in the dark night among whispering voices, the smell of burnt wood in a roaring fire, and the running feet of rats scratching the rocky ground, their shadows cast by the fire. The secretive children and the rats wore the same glow, both were devious before that bonfire.

At night, the boys would sneak out of the house to go to the town square to watch Batman movies. I joined them sometimes. Crouched together we oohed and aahed, marveling at the power of Batman and the Boy Wonder, to capture villains: the Joker, the Penguin. In the daytime, we cast the show on our own stage. We swung from the vines in the mountain, picked berries that stained the skin purple. We used our sling shots, shooting at each other. The one who, most stained, bore the most resemblance to the Joker or the Penguin, lost. We were quite a sight for all the mothers to behold, clothes drenched in sweat and purple faces marked up like clowns, appearing from the woods, eyes peering out in shame after the day's fun was over.

I detested girls, and their mere shadows on hot afternoons made me want to jump on their shadows, strangle them, smother them with my weight, especially those little girls with voices like bells ringing in my ear the words, "Big sister." I did not want to be big or anybody's sister. If nobody was looking, I would pinch their cheeks, round like bells, and run away. I did not bother with house chores or learning how to sew. I ran wild all day, into the mountain to the quiet spring temple, or just sat in the street and watched people argue over prices. I was the most useless daughter in the neighborhood.

Day after day my mother chased me around our courtyard. Then she became tired, beads of sweat forming on her forehead and she sat down to fan herself. Her mind wandered. She forgot about me until she saw me again. I was then a heavy boulder she could not lift. She did not understand why I was so hard to move, to rear. I resisted every little thing. Sometimes out of anger my mother pinched me. Her teeth ground together and her face twitched in a weird way. She would call me a ghost, a demon, but to me those terms were much more comforting than being called a woman. At least a ghost was a supernatural being with magic power. A mere woman was a bearer of grief, a being always condemned to those dark pants in which filth disappeared and was absorbed, and which still

maintained their glossy black, rich as night, soft and placid, tempting the fingers to touch the rich velvety folds. Those deceptive pants, how I hated them, how I loved them, their dark beauty I thirsted to be near, putting my head on that glossy black, sinking into that unfathomed depth, yet I was repelled at the thought of the stench, the dust, the slimy monster that lived in such a realm. I did not trust those velvety knees, and could never rest comfortably on them.

What It Is to Be a Woman

The years waxed and waned, blooming colors in spring and brooding dark clouds in winter, gentle rain blowing kisses to the flower petals, while heavy rain came shouting with thunders, tearing trees and stealing tin roofs. Then one day, I turned seven. To me, it was an ordinary age, no different from being six or even five; besides I was ageless. The reason I remembered being seven was that that year first marked me with age.

That year my mother was pregnant with my brother Hung, the sixth child. She bore one child after another, and by then I was familiar with the swelling of her stomach. Of how a child came out of her stomach I could not reach an agreeable explanation yet.

One night in the cool December air when the sky was dark, and clouds veiling a pale moon threatened a thunder storm, my grandma peered into the mosquito netting and tapped on my shoulder. I woke up, surprised to find my grandma there at my bedside in the pitch dark, too early for my mind to conceive that time could exist at such an hour. I awoke in a time void, a world not mine but the ghosts' and . . . the adults'? Grandma had a big family of her own, a child she still breast-fed. What was she doing at my bedside? Could she be sleepwalking? Maybe if I closed my eyes again, she would leave. I became frightened and cold, sweat ran down my back. I was dazed and when my grandma's cold hand reached for mine, I let out a gasp. My grandma began to pull me out of bed, I resisted, but it was no use, she was a big and strong woman.

"Your mother went into labor. Come, you need to bring her food in case she is hungry afterward."

With these words my grandma handed me a tin container divided into three sections. The top section was filled with rice, the second with a special fish dish prepared for women to eat after their labor, and the third contained a thin fish soup. Then my grandma began to walk into the dark night, and I stumbled after her. Finally, we came to a stone house with a lamplight flickering from within.

Figure 14–2: The author's father in his southern uniform, 1965.
Courtesy of Thuy Tran.

My father was there, his dark face blended with the dark night. My grandma began to go into the building, turning to my father she nodded, and he bowed to her solemnly. Then she took me aside, her big hands grasped my shoulders, her eyes shone a gentle glow in the half-dark light.

"You are a big girl now. Your mother is having a baby. You are the oldest and a daughter, it is time you share what it is to be a woman. In time you will be inside there with your mother."

With those words, my grandma lifted up the cloth that was strung across the door. I looked after her. Inside was dim. I could not see my mother. The cloth

came down putting an end to my curious eyes. My father motioned me to sit down on a stone seat, while he just stood holding on to a trunk of a coconut tree, his head tilting up, eyes gazing searchingly into night yet not searching for anything, his lips seemingly moving. Yes! They were moving. From them I heard a low chant, a prayer to my ancestors. But it was not like other prayers, low and solemn, this was choked, like a sobbing child, in between its choking cry struggling out promises to its parents or crying of injustices done to it by another. My father, my strong-chinned, high-foreheaded father, a man of steel to me, was sobbing to his parents who lived only in spirits, possibly nearby rustling in the coconut fronds, mingling in the cold wind, the shimmering coal ashy night.

I looked at my father. I forgot my fear of him. I felt like touching him and patting his back. I walked up to him and extended my arm. It stood suspended in mid-air for awhile, then I decided to withdraw it. While I was sitting, my heart seemed to warm my whole body urging me to go. But once I stood up, I was all alone, standing in the cold wind, ashes of night sprinkled all around me. From where I sat my father seemed small and vulnerable, but up close he was again an adult, a giant in my world. I tiptoed to the rock and sat again.

I sat there quite awhile looking at my father who stood only a couple of feet away, but the shady night made him seem further. He became calm and motionless. The person I had seen some time ago seemed like a mirage, he jumped back down the well of my father's soul and here stood my unmoved father again, lips shut tight, the hard face resembling a bronze statue. My eyes became tired looking at the still figure, they became heavy with sleep. Night closed in around me like a blanket. The stars hung around my head, they went through my mind, the clouds carried me up nearer to the moon. I heard night hum its night song, soft like the sound of crickets in summer. The universe opened before me, entered my body, and I drank it down, the stars tickled my throat and the ash of night bumping against each other in my stomach, they tasted like the cold ocean water, salty and raw, roaring in my stomach, making waves. When the waves calmed down and the moon came out, the waves pushed by the wind made tiny ripples. I was floating on those ripples bathing in the moonlight, my body glowed with soft light, my lips, my forehead and cheek and long bushy hair softened by the light. I felt supple and calm, floating down the river of the universe.

As I was gently pulled along, by the rope of sleep, stars and moon crossed in my mind, I heard an awful sound that yanked my floating spirit and plunged it back into my earthly body. At first I thought the sound came from one off-tune star, and my eyes struggled to remain shut. The sound came again, cutting into the dark. The clouds floated back into their sphere; the stars, their depth, and only

Figure 14—3: The author's family in front of their home in the author's village. Courtesy of Thuy Tran.

the moon remained, at a watchful distance peering down. The sound echoed into the night in such agony that night seemed to shut itself down, putting its hands over its ears. It crouched under the shade of a tree waiting for the sound to stop.

I woke up yelling. "Ma!" My father rushed to my side. He held me in his arms and rocked me on his lap. Now the muffler of dream had vanished and the yelling came from within the stone house like a lashing whip. My heart was squeezed with pain. Again the sound came, washing my whole body with heavy rain, like October's. The weight beat down my head in unbearable strength, carrying hidden currents of electricity. It made my whole body dance with pain. Father locked me tight in his arms as if he were trying to muffle the sound out of my ears with his weight. I struggled in his locked arms, but it was no use. Then the sound came again as if from a dying animal, a helpless pig when it was strung upside down suspended on top of a boiling pot, waiting for the unknown. Another wave of that awful sound drenched our bodies in teary agony. I managed to yell:

"Father, go save Ma!"

"I can't . . . I am a man and not allowed inside. Your grandma is inside with your ma. She has a problem delivering the baby. The doctor is in there too. He thinks she needs an operation. The baby is taking a long time coming out."

"Father, go inside with Ma. The doctor is there and he is a man, so why can't you? She needs you."

I slipped off my father's lap, and he stood up and mechanically walked to the door, hesitant before the cloth curtain, then he slowly lifted it and went in. My poor mother, I moaned in my heart. Could she be my mother? The voice was not human, not the voice of my mother who chased me only once around the yard before stopping to fan herself. Could she have that much strength to scare even powerful night away? Her voice mingled with the calm ashes of night and rang like bells, rustled the leaves in the trees. People compared women to the spring of the earth. Could my mother have been transformed into that huge black spider? Did water run through her? And was that why my mother had such supernatural strength in her voice?

No wonder women are cursed with those smooth, glossy black pants, I thought, their lives are eternally black. The water that runs out of them is clear and bright in the light, but the source that produced that water remains hidden in the dark. Deep in the earth, the mother spider extends her legs to feed all lives, animals, trees, flowers, little ponds, and lakes. When a life pokes out of the earth, does the mother spider yell in pain like my ma?

The holy Bo-tree with majestic leaves and broad branches, the silly guava tree whose fruit the children eat, the fuzzy dandelions swaying on the hill, the strong

minute smell of the orange-and-yellow lantana flowers in the hot sun, the dogs, the humans—everything comes from the earth, sucking at her breasts for milk, for nourishment. The farmers who work with earth, squeezing the earth, haranguing her for rice, squash, bright yellow pumpkins, lima beans, sugar cane, see her breeding in youth, how she yells out in pain when he uses her savagely. He loves her, this great young mother who yields grandparent-crops, parent- and children-crops. But when she stops her breeding, her soil runs dry, she needs time to rejuvenate, he kicks her dry dust, crying to heaven and asking why she treats him so harshly.

When the night subsided and the waves of my mother's cries stopped, out of the dark sky there was light, noisy talkative light looming impatiently out of the darkness. I stood there drenched in sweat, my hands wringing still, to the crazy ruptures of my inside, my feet seemed like they had walked miles in the darkness following a ghost, my body was possessed and wasted. Finally, out of the darkness, the cries of a baby were heard. The happy sound freed the solemn night and stilled my moving feet; light had come to take away our long burden. Never had I seen night so eager to give up its darkness for light, happy talking light, bringing on a world of sounds, taking away the secret somber world of night. As more light came, it could not contain itself and burst into rays of brightness. Roosters exploded the morning with cock crow tones. Little birds flew and sang, busily fluttering their wings and chirping, as though the morning was entirely for them. People began to ascend the rocky road swinging their empty tin cans from a bamboo pole on their shoulders, heading to the temple well for water, their sandal feet scratching the dry pavement.

From the muffled night came my brother, light and sound. Floating down many dark rivers and then out of the mouth of the woman's cave, he came into the world, like so many babies before. Yet to me he was holy. He called out light, commanded sounds and put a stop to the awful sounds of night. His wailing echoing in the still air seemed sacred, making my heart flutter with joy. Such was the birth of my brother Hung, a creation, a beginning in the world. My childhood poem rushed into my body, replete with thunderous sound:

> Cong cha nhung Nui Thai Son
> Ngia me nhung nuoc trong nguon chay ra
> Mot long tho me kinh cha
> Cho trong chu hui moi la dao cou.

> Father's effort in rearing a child is as high as Mount Thai Son
> Mother's love for her child is as deep as the spring that runs out from the

mountain cavern.

Worship your mother, respect your father.

When your filial piety is completely rounded then you are their own true child.

The Dancer Goddess of Xon Bong

There was my religion, my beginning and my end. Over the years of moving from Vietnam, then to Japan, then to the United States, from Texas to San Francisco, all my childhood songs and poems faded, my language melted on my palate as other rich and recent flavors conquered my taste buds, yet my poem, my creation song I clasped close to my bosom. The poem was possibly inspired by the old Chinese Confucian ethics. Living among the Vietnamese on the tongues of the children who cared nothing for the author or the place and time in it, the poem began to have a life of its own, changing with the moods of each child. By the nature of its existence, poetry, it danced, resonated into many forms. It darted from mother earth to woman, both stretching out their bodies, wasting them-selves with child. The world of man called for respect, while in the woman, there was a helplessness, a reservation in woman, that quietly yielded to life.

Looming over the small village of Xon Bong were feminine images, stat-ues, one in particular. She was possibly the goddess Kuan Yin, but more likely she was one of the dancers from India professing the sacred text, the *Bhagavad-Gita.* Through her dances, the Cham people worshiped her, the dancer, instead of the text, long ago when Hindu religion filtered through the great kingdom of Champ. Now, we Vietnamese lived on Champa land, which we gained through military conquest. The goddess statue, for our different people had different names. We called her Ba, the great mother. Yet her essential quality, her femininity, her saving power for mankind, her dances, were the same for all people, Vietnamese and Cham.

The Dancer Goddess of Xon Bong protected the fishermen out at sea. When a baby fell and nothing happened to it, no serious bruises, mother would give a quiet prayer to Ba, our goddess. Her image revolved above the women, children, and the old. Old women in Xon Bong claimed that during the final con-frontation of the North and South armies, the town of Nha Trang was protected by Ba. Many rockets, missiles, and loud hisses were heard from the sky, all through the night, by people in their underground bomb shelters; yet only one row of houses was burnt and most of Nha Trang was preserved. It was believed by women that Ba protected Nha Trang, she shielded it with her arm. The missiles and rock-

ets ended in the open sea. The old, especially women, had profound respect for Ba. They alone seemed to know her true power. And the very young knew, the ones still crawling on the ground who could not speak yet, except their squirms and giggles, as if the air was tackling them and speaking to them in a secret language.

Every baby had one or two miraculous experiences in Xon Bong, in a town where their existence depended on careless young baby-sitters, their big sisters, of six or seven years of age. Their mother was too busy managing the fish market from sun up to sun down, making a living. Their father died sometime ago in the war or was still occupied in the war. Nha Trang belonged to the women, her children, and the old, spreading the net at sea, mending the net, folding the net, the gill net hanging upon a wooden pole glistened like a jewel in the sun of Nha Trang.

Every spring there came from the wood, quiet women who dressed in bright clothing, yellow and orange, journeying to Thap Ba, Ba's shrine. The women, who were priestesses from an unknown place, just appeared one special day in Spring when the buds began to open up on the peach trees. They were maybe Cham women, but the question never came up while they were there dancing in the courtyard of Thap Ba. It only arose after they were gone. There on the courtyard with flower blooms exploding like firecrackers swaying in the trees, the men would blow away on their horns, others beat their gongs, and the women danced to the music, stepping in and out of the two clapping bamboos held by the men at their bare, delicate feet. They stepped between the poles again and again escaped elegantly. When the men no longer blew their horns or beat their gongs, and the two bamboo poles lay on the ground making not a sound, the watching crowd of people, who had been in high spirits a minute ago, held their breath. The lead dancer quietly came up to Ba's altar, lit several sticks of incense, the smoke brushing against her tan face and lips. She and the other dancers bowed their heads three times and placed the incense in the urn. Then they looked right at Ba's altar and began to pray, a prayer silent yet intense, and the crowd watched in respectful silence. The incense smoke wafted in the air, and the women prayed. Then out of the cloudy air would come two white butterflies fluttering with a haunted gaiety that made the cloud gasp aloud. Every year they came. The butterflies flew with a grace, beauty, and a romance that touched all hearts and made them flutter with a tenderness like the young shoots of Spring. The hearts opened wide, receiving youthful Spring, with gentle rain landing on red flower petals, on young leaves, on woman's dark hair.

The same butterflies and the five or so dancers, all brightly dressed, came every Spring, to welcome Spring. They danced in front of Ba's altar. The musicians and the pole carriers were men, but they stood in the holy procession merely

as shadows, like the puppeteers in a Bunraku puppet show. The women did not talk, their mouths were shut tight, yet the profundity that echoed from such silence was awesome, making hearts beat with a weird conscious rhythm. One could almost see one's heart, the color like the dark cherry lips of the dancers. The butterflies came and everybody knew they would come every year, yet every year they surprised everyone anew, releasing the heavy hearts, making the town of Xon Bong light, happy, and alive at that flicker of a moment.

Why Vietnamese Women Like Sad Songs

Such was the world of my childhood, a feminine world, of woman, my mother, the Goddess, Ba, the fishing fleet, and the fish sauce factory. Those women ran the marketplace and paced up and down the rocky road to the fish sauce factory. A painful and lowly existence they led, no better than those scurvy rats running about the fire in the dark, their shadows darting with the flames. Yet those mere shadows held up the society of Xon Bong. While the men were at war, the women stayed home for the children, kept the marketplace busied with voices. At night in the half-darkness, a woman's lullaby hummed a child to sleep, her voice bounced on the water, carried by the wind from the houses standing on stilts down on the bay—a wonderful hypnotic quality, like a song from the beginning of the world, lasting until now. Woman turned into loving mother, angel in the night, bending over her sewing in the soft light of the oil lamp, and every now and then she rocked gently her baby's cradle, and from her mouth wonderful sounds escaped, nonsense that rhymed.

Yet even with woman's and Ba's effort to maintain that small pocket of life, their boy would someday grow up to be a man and join his father at the eternal war. All their love poured into their child, all their youthful years, then he turned into a young man, he went to war and in one way or another, he died there. The poem I have told you knew this helplessness in the female, her inability to protect her own creation, her child. She would pray over the child's every bruise; but when it came to his head being blown off, she could do nothing. I once asked my mom why she had so many children—six, four girls and two boys—and she answered me that she wanted two boys in case one died in the war. My mother had a calculating mind. Anticipating her children's death, she could not be close to them. Her youngest son, who was in my care, addressed himself to his mother with the endearing term of "your younger brother" for she gave him not a mother but a sister. She did not hear him wail in the night or know of his bad dreams. All

that she entrusted to me, her daughter. She handed over her baby, a beautiful boy who stared at the world with large brown eyes, his fists punching air. Young girls in my society grew up quickly. They joined the woman in her endless toil, became nurturers and caretakers of their brothers, then their husbands, then widows donning their white mourning clothes for lost brothers, husbands, and sons.

The young always wondered why Vietnamese women liked sad songs, but until they became women themselves they could never know the depth of such a song, a sadness, a helplessness of a young wife waiting for her husband, of an aging mother waiting for her son. All they could do was to sing, hum with their hearts, moving a stone Buddha in their sadness. They lived in that gloom for so long that they came to celebrate that state of human existence with songs yearning for the peace of happy neighbors, husbands reunited with their wives, a white-haired mother embracing her young son, a peace that only existed in those soap bubble songs.

The songs went through many governments, singing all the more sweetly over the same drudgeries that claimed to be new. The promises of the song became idyllic, a state so simple, yet unapproachable under any government, even a government that may have worn the son's mask to win over people with renewed promises of the songs throbbing in man's blood. Foreign literature like the Communist Manifesto only added fire to an already roaring flame. Of course those romantics died still dreaming of the good society, still drunk on its sweet and pungent potion. In the end, one government was like the next, the female was left with those songs, forever moaning for the impossible. She still dangled her baskets which swung from a bamboo stick, which she carried on her shoulders heading to the market in the dim light of dawn. Her husband was still occupied in one of those tireless wars, then her son, while she walked the same path, eternally feeding that ungrateful and useless masculine lot, so it could go on eternally with its raging war games.

Afterword: The Ghost

Though the small world of my childhood was peaceful enough, outside that childish realm the war went on and on. In 1975 the South came under the northern government's control and, "liberated," became communist.

Many South Vietnamese fled Vietnam at this point to avoid political persecution and the social unrest of a war-torn country under the rule of an "enemy" government. Many felt that was the only way they would have a fair chance at life. Fishing towns like my village, Nha Trang, became hot spots for escape.

Figure 14—4a & b: After the North Vietnamese conquest of Vietnam, the author and her family escaped in a tiny boat. On board the Japanese cargo ship that rescued them (top photo), she and thirty-five other "boat people" watch their boat drift away (bottom photo). Courtesy of Thuy Tran.

In the autumn of 1977, my family fled from Vietnam along with 36 other people in a single boat. Like so many refugees before us, we floated into the unknown, resting our dreams, hopes, our heavy burden on a weak, small dinghy that would easily be swallowed by the waves if one of autumn's frequent storms began at sea. And of course, left behind us forever, was our house beside the coconut trees, and our beloved moped which had whizzed us through endless small Nha Trang streets, and our friends and relatives, and the rows of coconut trees lining miles and miles of beaches.

All those we put into our memories.

There they stayed, perfect, warm, and safe, until one day we were allowed to go back to our homeland.

But truly, *was* it our Vietnam we returned to? No, it was not ours.

Vietnam had ripened many seasons ago. Its fruit, reaped long ago, tasted good on someone else's tongue. Now we returned to taste the bitterness of a fruit reaped out of season.

We ghosts from the past—now called "the people on the other end of the world," the "Viet Kieu"—we ghosts rampaged through Vietnam, waving our American dollars, looking for remnants of our past, only to find ourselves lost in an opium dream, as Vietnam, in return for our money, supplied us our drug and staged our past for us.

Just as in these pages, in my imagination I have returned, like a ghost, to Nha Trang and the world of my childhood.

Further Reading

Caplan, Nathan, John K. Whitmore, and Marcella H. Chow. *The Boat People and Achievement in America: A Study of Family Life, Hard Work, and Cultural Values.* Ann Arbor: University of Michigan Press, 1989.

Nguye-Hong-Nhiem, Lucy, and Joel Martin Halpern, eds. *The Far East Comes Near: Autobiographical Accounts of Southeast Asian Students in America.* Amherst: University of Massachusetts Press, 1989.

Rieff, David. *Los Angeles: Capital of the Third World.* New York: Touchstone, 1991.

Scott, Joanna C. *Indochina's Refugees: Oral Histories from Laos, Cambodia, and Vietnam.* Jefferson, N.C.: McFarland & Co., 1989.

Part III

Roots, Traditions, and Asian Pacific Life
The Old Country and Its Cultural Legacy

Food and Ethnic Identity

Theory

ROBERT A. LEONARD AND WENDY J. SALIBA

This volume contains an entire section on Asian American food ways, or food culture, not only to help explicate the countless literary scenes involving the culture's food ways, but because in American literature, as in American life, food is not only bodily sustenance but an important component of ethnic identity. Jessica Hagedorn titles her novel about the Philippines *Dogeaters*. One of the first Asian American magazines of the 1980s called itself *Rice*. We have no difficulty understanding that identity, not nutrition, is at stake.

Consider the identity issues raised by a food choice in this scene from a 1992 Korean American novel. A 16-year-old Korean American has invited a boy, a "blond," "dimpled" football player she has a crush on, over to her house while her parents are away. He looks for a beer in her refrigerator:

> "Hey, what's this?" he says . . . He drags out a huge Mason jar
> full of Father's kimchi.
> "Oh, that's just kimchi," I say. "Korean spicy pickles—it's stuff
> my mom and dad eat." Stinky pickles, I want to add, but I don't . . . I
> don't want him to think that we sit around eating stinky things all day.
> [He tries a piece.] "Hey, this is pretty good," he says. "Only it isn't
> all that spicy."
> "Really?" I say. "All Mom and Father ever do is talk about how
> spicy it is."
> "You mean you've never tried it?"
> "No, but it's always around if I want to."
> [The boy spears a piece.] "Here."
> "That's okay, Tomper," I say, as the wilted leaf, mottled with angry-

*looking red spices, dangles in front of my nose. The garlicky vinegar smell
is starting to seep into my nostrils, so I hold my nose.*

*"Ellen," he says. "What's the point of life if you aren't up to trying
new things?"*

[*Finding My Voice.* Marie G. Lee. (Boston:
Houghton Mifflin, 1992, pp. 96–97)]

The irony here—dare we call it a delicious irony?—is that the white boyfriend is
offering the Korean American 16-year-old her first taste of kimchi and chiding
her for not being willing to try "new" things! This is a good satire (biting satire?)
on the much discussed drive of the second generation in all American ethnicities
to be "normal" Americans, a drive that has everything to do with Ellen bringing
this blond football player into her kitchen, a drive symbolized by her pathologi-
cal aversion to kimchi. "I hold my nose." The scene relies on the reader knowing
that kimchi is the emblem food (explained below) of Korean culture.

You Are What You Eat

Ellen's fear, we may fairly call it, of kimchi, rests on her intuition that eating cer-
tain foods identify her as a member of a group.

What we eat and don't eat is largely a result of what group we belong to.
There is of course a biological component limiting our choices—humans don't
digest bark, stones, or fur too well—but every society teaches its members to
avoid a great number of items that biologically could serve our nutritional needs
quite nicely. Food behavior is a product of culture as well as genetics.

To the members of a culture, cultural rules are invisible. People don't think
they are following cultural rules, they think they are doing things the natural, logi-
cal way. But different human groups approach the world in very different ways,
not least in the realm of food.

Some food rules and procedures are motivated by different circum-
stances, environments, raw materials, and other unavoidable differences.
People who live near water, for example, are more likely to eat fish. But very
often the different foods people eat *cannot* be explained that way. It often
appears that the difference serves to *define, solidify, and justify the group.* We
will discuss an example below of a group, Italian Americans in Mormon Utah,
that goes to great lengths to keep their food culture distinct from that of their
neighbors.

Food is an important part of who you are. The food you eat, and how you eat it, can identify you as a member of a group, and further identify what smaller group you belong to within that group. Think of your own food. Compare it to the food eaten by your parents, your children, poor people and rich people. There will be obvious differences. Compare your food to the foods different ethnic groups in your area eat. Here you will probably see even clearer differences.

Of course, this assumes that we are able to accurately know what someone else's diet is; often all we know of other groups' food is stereotype: "bland," "greasy," or "hot," some groups eat frogs or dogs (why a derogatory British term for the French is Frogs, why Hagedorn ironically calls her novel "Dogeaters"), some groups eat innards.

These characterizations of others' food generally amount to claiming that *they* eat what *we* do not; we don't eat it either because it is not good food (too smelly, too hot), or because it is not food at all (dogs, frogs, innards). Within our own groups, we affirm our membership by preparing and eating certain good or "real" foods.

A Vocabulary of Ethnic Food Ways: Indispensable, Emblem, and Insider Foods

We will better be able to analyze the roles food plays in ethnic identity if we distinguish three concepts: *Indispensable* foods, *emblem* foods, and *insider* foods.

Indispensable Foods
Members of some groups do not feel they have eaten a "meal" unless the meal has "included a certain food." For some it is rice. Indeed, the English word *eat* translates into Thai as *kin khaw,* "eat rice." For other groups, like many assimilated Americans, it is a large piece of meat; for Mexicans, tortillas; for southern Italians, a pasta such as spaghetti.

Emblem Foods
In the novel quoted above, Ellen recoiled from kimchi because she saw it as the Korean emblem food. Foods can serve as "emblems of a cultural group," and typify a certain cuisine. This 16-year-old daughter of Korean immigrants claims never to have tasted kimchi and recoils from it—so potent is its identification for her with "Koreanness." The white boyfriend has no such emotional investment in kimchi. To him it's pickles. In truth Ellen probably would have eaten it as a child until, in some gradeschool rite of lunchbox sharing, having kimchi in her lunchbox made

her appear "different" from some other children. No child wants to be "different." Such incidents fuel the desire of many second generation children to want to simply blend into the larger culture.

Often insiders and outsiders identify different "emblem foods" for the same group. For example, non-Chinese may view chop suey and fortune cookies as emblem foods of the Chinese, yet these are barely eaten at all by Chinese. They are foods that largely exist for consumption by non-Chinese at Chinese restaurants. (Fortune cookies were, in fact, invented in 1909 by a Japanese American in San Francisco!) Chinese often identify rice, an indispensable food, as their emblem food. Many Americans would view tacos as the emblem food of Mexicans. Mexicans, however, might consider their emblem food to be tortillas, also their indispensable food, or tamales. Assimilated Americans might claim hot dogs or hamburgers as their emblem foods. As mentioned above, the British denigrated the French by calling them the name of what was to the British a French emblem food: frogs.

Insider Foods

There are foods that researcher Wendy Saliba terms insider foods: group members feel that "to truly be a member of the group, one must eat this food." Further, only they eat this food; outsiders do not eat it because they are unwilling or physically unable to eat it, or because it is unknown to them. There are, of course, geographical, social, and religious divisions within groups as well as individual differences in food habits or opinions. But the following insider food examples hold for some part of the named groups. The durian fruit (a delicious fruit with a highly pungent smell Westerners dislike) is a Southeast Asia example, as is raw kibbeh (chopped lamb meat with onions and olive oil) among Lebanese. Extremely hot chili peppers are insider foods for several groups. Thais utilize meng da, a waterbug-like insect, for seasoning. (Meng da, according to American Thai food shops, are illegal to import; a synthetic essence is legal.) Yemenis and Somalis chew qat leaves, not precisely a food, but a mild stimulant. Chinese Americans consider the heads of fish and prawns, with their intensely fishy flavor, to be an insider taste and remark scornfully at the faint-hearted non-Chinese discarding them in seafood restaurants. In the following example, brains are an insider food that helps differentiate Italian Americans in Utah from their Mormon neighbors.

A good example of the importance of food in ethnic identity comes from fieldwork done in Utah. Researcher Richard Raspa analyzed the food behaviors of first-, second-, and third-generation Italian Americans who trace their ancestry to Calabria in south Italy and who now live in an area near Salt Lake City, Utah. When Italians first arrived to live among the Mormons who predominated there,

they were regarded "as a violent people—non-whites from southern Europe who practiced Roman Catholicism, displayed socialist tendencies, and enjoyed quaint and often disgusting food," as Raspa puts it. The Italians clung to their food traditions in this hostile environment. They might not have been as tenacious had their neighbors not been so different and hostile to their ways.

The Mormon food preferences we find in Raspa's discussion illustrate how food is a good example of a dynamic found in many other aspects of assimilated American culture: the idea that *Science* should triumph over *Nature*.

Raspa tells the story of an Italian's granddaughter assisting with the preparation of a special frittata, carrying a freshly slaughtered lamb's "warm brain, holding it bravely in her hands, from the shed to the kitchen where her grandmother mixes it with eggs to prepare a frittata, or omelet. It is important that food be fresh."[1] One of the major divisions between the Italians' foods and those of the surrounding Mormons is the link of the food to their natural sources as opposed to the supermarket meats and produce bought in plastic and raised in a chemically processed world of food factories and preservatives. The Italians' food culture entails realizing and reaffirming that the food has natural sources—that the meat comes from real, killed animals, for example. Another major division between the Italian food and the Mormon food is variety. The Italians eat many foods that the Mormons refuse, for example, goat head, goat cheese, or chicken feet. There are other differences, for example the order and components of a meal. Clearly one way that the Italians reinforced their sense of identity was by eating their "insider foods," made all the more important by their being viewed by the Mormons as a despised "emblem" of their natural, not to say uncivilized, cultural traits.

This Science versus Nature division is one we see between the foods of assimilated American culture and many new or unassimilated American groups. The Chinese are a good example of the latter, famous for insisting on the freshest produce, for example, and fresh, even live fish, for sale in the Chinatown market of some cities. Contrast this to many Americans who say they cannot stand to look at, much less eat, a fish with its head on. The Chinese also eat a great variety of foods, many of which are too reminiscent of their origins to be generally acceptable to American society: duck feet, fish bladders, sea slugs.

Assimilation and Foodways

Over time, the food patterns of many immigrant groups change. One way is through the general assimilation of immigrants' culture into the larger American

society. Another is through second-generation anxiety over their identity. Plainly Ellen's children will grow up ignorant of Korean-America's emblem food.

Immigrant food patterns can change within the first generation as well. An interesting example is Mexican food in New York City. In 1993 the press became aware of a rising Mexican population in New York City. Newspaper articles and radio shows discussed the Mexican food now available to the public. The food critics on one radio show explained that prior to the arrival of any real numbers of Mexicans in New York, what was called Mexican food was mostly one of two Americanized varieties—the heavy greasy masses of undifferentiated glop called platters of enchiladas, burritos, and the like, and Tex-Mex adaptations of traditional Mexican foods—very spicy, very hot, and existing mainly as a vehicle for "Mexican" drinks such as frozen margaritas. With the arrival of Mexicans, more "authentic" food was made available. Very noticeable to the press was the proliferation of *taquerias,* small shops or food stands on trucks serving tacos, meat fillings wrapped in small tortillas. These are quick, cheap, and portable and thus comparable and can compete with pizza, an important part of New York City's food economy. (This will be discussed below.) They also show what is a classic pattern in immigrant food.

These tacos in New York were "authentic" in that they were a food that was served in Mexico, and they were prepared by recent arrivals from Mexico. However, for several reasons, these tacos did not taste "authentic" in the sense of tasting the same as a taco does in a taqueria in Mexico City.

First, although these New York tacos are mostly prepared by Mexicans (virtually all young men from the Mexican state of Puebla), the cooks were Mexicans who might have been plumbers, engineers, or laborers at home, rather than food preparers. Many may never even have cooked before, especially because they are men coming from a culture where cooking is the province of women.

Second, New York ingredients are different than Mexican ones. Even if the cooks were to use genuine Mexican spices and other imported items, too many ingredients simply have to be different. American meat, for example, does not taste the same as Mexican meat. The corn meal used to make the tacos is different. Even the water would not be the same.

A third reason is the influence of the surrounding culture. These cooks have been exposed to many different tastes since they left home, and their perception of what tastes good may have changed. Also, and importantly, they want to sell to Americans as well as to Mexicans and may aim the taste of their food to try to appeal to both.

Recent immigrants who do not speak the new language and have no other qualifications often begin small food operations selling prepared food to other recent immigrants. They all, of course, want to eat what they consider real food, the food of their homeland. This has a double advantage for the food preparers. They can supply themselves with food they buy in bulk while making a living working within their own community and language. But as they become more adept at dealing with the larger society, or just as the larger society discovers the availability of their food, the now not-so-recent immigrants expand their horizons and begin to sell food to outsiders. This is the position in which the New York taco sellers found themselves as they were discovered by the press.

As time goes on, these fairly "authentic" tacos will become accepted by more and more Americans as, perhaps, a lunchtime alternative to pizza. The taco sellers who will make the most money will be those that are the most successful with the largest number of customers, probably because they offer the combination of taste, price, and convenience that most of their American customers want. Even their Mexican customers, as they assimilate to the larger culture, will alter their food priorities. It is easy to predict that preparing tacos with an "authentic" taste will become less and less important to the majority of sellers. This is the classic cycle of food assimilation.

Chinese restaurants in most areas of America are another well-known example of this same pattern. However, Chinese restaurants in communities like the Chinatowns of New York and San Francisco need never completely assimilate their menu items and tastes for they have a large enough "authentic" customer base. A constant stream of new arrivals and a stable population of successive generations of earlier arrivals are isolated enough from the larger society so that their demand for "authentic" food continues. Another situation can occur in restaurants that cater both to Chinese and non-Chinese patrons. Specific food is cooked for each group. Chinese and non-Chinese will sit at adjacent tables and eat from different menus—one the Americanized menu in English and the second the "authentic," written only in Chinese.

And the Return to "Roots"

Food as an indicator of ethnic identity may continue after most other differentiators have gone. Many assimilated European Jews do not go to temple, speak no Yiddish, and celebrate Christmas, yet they may observe New Year— the Christian New Year, not the Jewish New Year—with a dish of herring, a

Jewish tradition. (One current slang term for assimilated Jews is, significantly, "lox and bagel Jews." They've given up everything about being Jewish but won't give up that.) Totally assimilated Lebanese may celebrate a special occasion with stuffed grape leaves. Ritual times like holidays and birthdays are of course events that attempt to preserve traditions, and the food prepared for them may be the last remnants of a once pronounced ethnic identity.

But the loss of ethnic food through assimilation is not a smooth slope down. An enduring truth concerning American ethnic identity is contained in the proverb, "The grandson wishes to remember what the son wished to forget." Or in the case we have been working with, the daughter Ellen, second generation, is so unsure of her American identity she cannot even afford to taste the Korean emblem food. Her children will have no such anxieties—particularly if they are also the children of that secure, adventurous football player, whose taste for kimchee and for "trying new things" says a lot about his possible interest in Ellen. The third generation of Asian Americans were the ones who enrolled in the new ethnic studies courses of the 1970s, eager to find their "roots." It is Ellen's children who, looking for an identity within the vastness of the American experience, may well demand from their mother the reason why she did not raise them to understand Korean or with an authentic ethnic diet—including, no doubt, kim chi.

Notes

1. Linda Brown and Kay Mussell. *Ethnic and Regional Foodways in the United States: The Performance of Group Identity* (Knoxville: University of Tennessee Press, 1985), p. 190.

Further Reading

Brown, Linda, and Kay Mussell. *Ethnic and Regional Foodways in the United States: The Performance of Group Identity.* Knoxville: University of Tennessee Press, 1985. Collection of scholarly yet readable articles on a number of American food cultures. Contains the Raspa work on Italian Americans in Utah.

Camp, Charles. *American Foodways.* Little Rock, AK: August House, 1989. Food from the folklorist's point of view.

Harris, Marvin. *Good to Eat: Riddles of Food and Culture.* New York: Simon and Schuster, 1985. Highly readable explanations, by a well-known anthropologist, of food choices and avoidances. Harris shows how cultures are making practical responses to their particular nutritional and ecological situations.

Kittler, Pamela, and Kathryn Sucher. *Food and Culture in America.* New York: Van Nostrand Reinhold, 1989. "Culturally sensitive information" for "practicing health professionals." Discusses food in relation to virtually every ethnic and cultural group in America. Very readable and informative.

Sokolov, Raymond. *Why We Eat What We Eat: How the Encounter Between the New World and the Old Changed the Way Everyone on the Planet Eats.* New York: Summitt Books, 1991. Erudite yet highly readable. Includes excellent discussions of many U.S., Latin American, and Asian food cultures.

Visser, Margaret. *Much Depends on Dinner.* Toronto: McClelland and Stewart, 1986.

————. *The Rituals of Dinner.* New York: Grove Weidenfeld, 1991. Both Visser books are intelligent and fascinating for anyone interested in the past 2,000 years of interaction of food and culture.

Chinese Food

MARY SCOTT

Wherever Chinese people come together, in China or the United States, food is a favorite topic of conversation. Perhaps because China has always been a predominantly rural and agriculturally based society subject to drought, floods, and famine, the traditional greeting "Have you eaten?" still conveys a more intimate friendliness than the rather bland and formal "How are you?" From Beijing to Hong Kong to San Francisco, Chinese people endlessly discuss the art of eating: which restaurant has the best take-out roast pork, which market vendor sells the freshest fish, or which is the only right way to cook Sichuan-style noodles.

Chinese Americans differ greatly in the degree of their cultural identification with China, depending on how recently they or their forebears came to this country, what circumstances led them to come, and how they have fared economically and socially since their arrival. China's own identity has also been transformed drastically in the past hundred years or so, and its passage from disintegrating absolutist empire to troubled but economically and politically powerful socialist state has left many Chinese Americans uncertain about the exact nature of their relationship to China. For many, Chinese food provides one of their strongest links with their heritage, stronger even than language. In cooking and eating together, families quietly perpetuate what they most value in their own past. For Chinese Americans, this may include not just a particular way of thinking about family relationships in the narrowest sense, but at least something of the broader traditional Chinese philosophical understanding of all human experience.

In China, people's thinking about food was always closely bound up with ideas about family and about the ways in which the lives of the individual and the family fit into broader social rhythms and natural cycles. In rural communities, where the gathering of several generations in a courtyard dwelling has traditionally been the ideal of family life, one's immediate family are those with whom

one shares a kitchen stove, and the bitterest family quarrels often end in a decision to "divide the stove." The stove was traditionally the symbolic center of the family, the point of connection between the family's daily life and the spirit world. Many Chinese families all over the world still keep a printed image of the **Kitchen God** on the wall near the stove. In some parts of China, this image shows only the Kitchen God himself, while in others he and his wife both appear as an expression of the ideal of marriage and domesticity. At **Chun jie, Chinese (lunar) New Year,** the Kitchen God's lips are smeared with honey to ensure that he will say only sweet things about the family when he ascends to heaven to make his report, and his image is then burned in the stove and replaced with a fresh one. This is the story that Amy Tan's novel, *The Kitchen God's Wife,* takes as its point of departure.

In pre-1949 China, many of the habits surrounding the cooking and serving of food were based on the belief that the Confucian patriarchal family was the natural social unit. In spite of the profound social upheavals in China, this pattern of belief and behavior persists there to a surprising extent, and it is also found in Chinese-speaking communities outside of China that have preserved the customs of earlier times. Although men were and still are generally the chefs in restaurants and food specialty shops, in the home the women—the daughter-in-law if there was one—were and still are the cooks. Though Confucian proprieties are now not always observed with their previous rigor, seating and behavior at the table still reflect Confucian principles: old before young, male before female. Formal meals at which guests are present are routinely preceded by a decorous and entirely predictable attempt by all to yield precedence in seating to others. Senior people are entitled to the choicer bits of food, and it is a mark of favor if a senior person insists on giving a younger person some special tidbit.

Many Chinese food customs emphasize group cohesion. In China and in overseas Chinese communities, if people go out to eat together, they do not split the bill. Doing so would feel like an ungenerous and undignified finale to a convivial gathering. Instead, one person will always be the host and pay for the whole meal, after a round of polite attempts by others to do so. (Who that person is depends on many factors, including his or her seniority, the reason for the gathering, and the degree of accumulated mutual obligation among those present.) If someone is planning a banquet, the restaurant will quote a price per table of 10 guests, rather than by the head. If alcohol is served at a formal meal, one does not drink whenever one pleases, but only when making or responding to a toast, an act that emphasizes the communality of the group rather than the pleasure of its individual member. Food is not served in individual portions, but in serving

dishes from which all may help themselves with their chopsticks, but only one bit at a time, which further emphasizes the communal nature of the meal. Cantonese speakers, particularly, will avoid the rudeness, self-assertion, and general bad luck of taking the last morsel on the dish, while people from northern China are more apt to resolve the difficulty by offering the last bite to the guest of honor.

Offerings of food and drink are traditionally made to the family's ancestors at an altar in the home, so that even after death family members continue to be part of the family's community of food. Traditionally, it was the worst of misfortunes to have no son to make the offerings after one's death, and among the worst of unfilial acts to let one's ancestors go hungry. Food is thus simultaneously an emblem of the family's present well-being and of the hope that it will continue.

Some foods make this point explicitly. One eats long noodles on birthdays, to ensure long life. The New Year's feast often includes a whole fish *(yu),* so that in the coming year the family will enjoy abundance *(yu*—homonym, written with a different character), and New Year's dumplings *(jiaozi)* signify prosperity not only because they are filled with meat, but also because they are shaped like gold and silver ingots. Although the political upheavals and social migrations of the last century have led to a general lapse in the observance of many minor holidays, Chinese New Year and a few other major holidays are still celebrated among Chinese people everywhere. Particular foods traditionally marked the rhythms of the seasons, starting with the New Year's meat dumplings and continuing with the sweet sesame-paste soup dumplings eaten at the close of the New Year season, on Yuan xiao jie, the Lantern Festival. People still eat *zongzi,* a kind of sticky-rice tamale steamed on lotus leaves, on the fifth day of the fifth lunar month, to commemorate the suicide by drowning of the ancient poet and archetypal loyal minister Qu Yuan, who sought death when he lost his lord's favor. All over China and in Chinese communities from Singapore to Queens, people make or buy *yue bing,* **mooncakes***,* round pastries with a variety of sweet or savory fillings, to mark Zhong qiu jie, the festival of the mid-autumn moon. All of these things may be given to friends and guests as a sign of the family's hospitality and to affirm that the seasons of the year are unfolding in their proper sequence, unmarred by misfortune of any kind.

Food and well-being are traditionally linked in another important way, for food and medicine were never seen as separate categories in earlier times, and many people of Chinese heritage still hold this view. The traditional understanding is that the human body is a miniature replica of universal patterns of energy,

and that good health is the balance and harmony of the body's humors within those larger patterns. If that harmony is disrupted, it may be restored by eating the right combination of *yin* and *yang* foods, medicinal herbs, and other medicinal substances—the right combination depending not just on the nature of the imbalance but on the person's age and sex.

Yin and yang, literally "shady side" and "sunny side," are the general terms used to express the ancient view that the cosmos is made up of an infinite set of mutually defining complementary qualities: hot and cold, light and dark, male and female, dry and wet, high and low, elder and younger, and so on. The traditional **Five Tastes** of Chinese cooking (sweet, sour, bitter, pungent, and salty), which should be balanced in seasoning a dish or planning a meal, are derived from an ancient theory explaining the cosmos in terms of a perpetual interaction among the Five Elements—earth, fire, water, wood, and metal. Each of these elements is also associated with a tendency or humor that loosely corresponds (but is not equivalent) to an organ of the human body. What Western medicine would diagnose as a specific disorder of the spleen might be seen by a Chinese doctor as either an excess or a shortage of the earth element in the whole body. He might then suggest a combination of diet, acupuncture, and herbal decoctions that would gently and gradually remedy the imbalance.

Some things, like *ren shen,* **ginseng,** are considered good general tonics for most people. Some are specifics for particular ills, and some may actually create a systemic imbalance in susceptible persons. Lichees (a fruit), for example, should be eaten only sparingly, because they are very yang, and crabs should always be eaten with ginger, a combination which not only balances the crab's extreme "cold" (yin) with ginger's powerful "heat" (yang) but also happens to be delicious. For about a month after a child's birth, new mothers (who are at risk of a dangerous excess of yin) are given a very yang dish, pig's feet cooked in soy sauce with lots of ginger. The theory of cooking and eating thus blends imperceptibly into the theory of healing, and the cultivated person should ideally know something of both.

No single dish should dominate the meal, and no single ingredient should overwhelm a dish. Instead, the cook tries to create a balance and harmony among many diverse elements, by playing off contrasting tastes, textures, shapes, colors, and cooking techniques. A spicy, oily dish needs to be counterbalanced by, perhaps, a roasted chicken or a simple steamed fish. Bean curd's whiteness may be set off by bright-colored vegetables, or a dark, soy-based sauce. The blandness of rice complements the rich variety of flavors in the other dishes. Good Chinese cooks do this sort of thing without even thinking much about it, but it is very

much in keeping with the ideas, familiar in other areas of Chinese life, of balancing opposite qualities and creating a harmony among disparate elements by framing them all within the notion of an infinitely various whole.

The diversity of Chinese food reflects the ecological and social variations within the Chinese cultural sphere. The Chinese rural economy is based on the labor-intensive cultivation of grain: rice in the south, millet, wheat, and sorghum in the north, corn on steeper, poorer land, rye and barley in the coldest regions. Thus the everyday diet of most Chinese consists mostly of whatever grain is grown in that region, with fresh, dried, or pickled vegetables according to the season. Northerners often prefer wheat noodles and wheat bread to rice, while the poorest people in many regions never eat rice at all, but subsist on sweet potatoes, cornmeal cakes, *wotou,* or millet gruel. Now and then, especially in the more bountiful south, there may be fresh-water fish or duck, which can be efficiently raised in rice paddies. On special occasions like weddings or the New Year, country people will eat pork and chicken, which they normally raise for market. These farmyard animals, which can forage for themselves or be raised on table scraps, corn cobs, and soybean husks, exemplify the Chinese rural economy's efficient use of all available resources. This frugality carries over into the cooking habits of urban Chinese as well, and Chinese Americans are also apt to see it as a part of their Chinese heritage. In *WomanWarrior,* for example, Maxine Hong Kingston describes a ferociously stubborn mother sending the same unappetizing leftover to the family dinner table day after day after day.

No matter where it is being cooked, the design of a good Chinese meal is an indissoluble mix of practical and aesthetic considerations. Everything should be put to use and nothing should be wasted, whether it is rice crusts, chicken feet, or duck's tongues. Most things are cooked in a **wok** (Cantonese; Mandarin *guozi*), a round-bottomed pan that allows quick cooking at high heat using a minimum of expensive cooking oil and scarce fuel. Other dishes are steamed in bamboo steamers or simmered slowly in covered clay pots, methods which use relatively little fuel and no oil. Oven-roasting, which is much less energy-efficient, is not done at home but at specialty shops. Food is always prepared so that it may be eaten with chopsticks alone, either by cutting it in small pieces before cooking—which also allows it to cook quickly—or by cooking large pieces of meat or fish until they are very tender.

In keeping with these practicalities, and perhaps also with the Confucian emphasis on family harmony as the basis for civil order, knives are used only in the kitchen and never appear at the table. Through the centuries the use of chopsticks, a very ancient feature of Chinese civilization, has been one of the most

obvious marks that allowed Chinese to distinguish civilized people from barbarians. The most common kind of chopsticks is a pair of bamboo sticks, used pincer-fashion to pick up food; the upper one moves while the lower one is held still, braced by the thumb and fingers. Chopsticks these days are often made of plastic, but they may also be made of other kinds of wood, often lacquered red or black, or of ivory or silver. It is rude to point or gesticulate with chopsticks, and one must not stand them upright in a bowl of rice, a bad omen because that is how rice is offered to the ancestors.

The most important thing of all to good Chinese cooking is fresh, local, seasonal ingredients, cooked to emphasize the intrinsic qualities of the food. The greatest delicacies are not necessarily the expensive banquet dishes like bird's nest or shark's fin, but things that are available only at certain times of the year or in certain places, like *dou miao,* pea sprouts, or Jinhua ham from Jinhua, or Shanghai river crabs.

In China, beef and dairy products are not part of most people's diet, because the shortage of agricultural land almost entirely precludes its use for pasture. Although people in the parts of China nearest to Central Asia may eat yogurt and kumiss, fermented mare's milk, and Chinese Muslims and people from the mixed pastoral economies of northwestern China do eat beef and lamb, for most Chinese a beefsteak is still a very foreign, Western thing. Likewise, many Chinese who have grown up eating only Chinese food find cheese disgusting. Most Chinese find it difficult to eat raw or undercooked meat, preferring meat, poultry, and seafood cooked precisely to the point of doneness and not beyond. Vegetables are almost never eaten raw in China because of the widespread use of human waste for fertilizer, so people recently arrived here from China are often unwilling to eat green salads. Chinese Americans may share these preferences to some degree or not at all, depending on their individual and family history.

Because people from Guangdong, Canton, and other parts of coastal southern China have had more incentives and opportunities to emigrate during the past century and a half, their regional cooking style has become the most familiar to non-Chinese. Émigré Chinese workers all over the world struggled to reach the degree of economic security represented by ownership of a small restaurant, and restaurant work continues to be the first step on the economic ladder for many recent arrivals from China in this country. Because early Chinese immigrants adapted their cooking to North American tastes, many of the Chinese restaurant dishes familiar to non-Chinese in the United States have no counterparts in China. One of these is chop suey, a mixture of stir-fried meat, vegetables, rice, and soy sauce. The word is an anglicized spelling of a term, *zasui* in Mandarin, that means

"odds and ends." Another is the *fortune cookie*, a mildly sweet wafer cookie folded around a strip of paper printed with a usually but not always benign prediction about the recipient's future. This found instant popularity after its introduction in 1909 by the Japanese proprietor of the Japanese tea house in Golden Gate Park, San Francisco, and it was soon being mass-produced in San Francisco's Chinatown. The dish that non-Chinese know as chow mein, a crisp, brittle mass of dry noodles topped with a soupy mixture of meat and vegetables, bears little resemblance to *chao mian,* soft-fried, only slightly crisp fresh noodles with slivers of meat, seafood, or vegetables. Chinese restaurants in this country also rarely observe the Chinese custom of serving soup at the end of the meal, because it is the custom here to serve soup first.

The home cooking of Chinese Americans varies with their region of origin and the number of generations since their families left China. Because many of the earlier generations of immigrants were from various parts of Guangdong province, these local food preferences are still found in many Chinese American families. This cooking does not particularly resemble Chinese American restaurant food. It is generally simpler and sometimes very frugal, often making use of various kinds of preserved vegetables and dried or salted fish that do not appear on restaurant menus. Home cooks are more likely to make soups and steamed or slow-simmered dishes than complex restaurant-style dishes that involve several different cooking techniques. *Congee* (Cantonese, *jook;* Mandarin, *zhou*), thin rice porridge with various kinds of savory seasonings and side dishes, is a typical comforting, home-style dish that may be eaten as part of a meal or as a snack at any time of the day or night. Most Chinese Americans have also adopted many foods that were not traditionally part of the Chinese diet, from dairy products to beef to soft drinks—all of which have recently made some inroads in China itself.

The lightness and sweetness of Cantonese food is worlds away from the rich cold-weather tastes of Beijing or the peppery heat and intense flavors of Sichuan cooking. Southern Chinese cooking styles have also evolved in contact with local cuisines in many parts of the world, from Thailand and Singapore to Guatemala, and Hong Kong chefs have been pioneers in the development of an eclectic and truly international style of Chinese cooking. Because of emigration from many parts of China after World War II, various regional styles have also become better known outside China. Food in the style of any province from Shandong to Yunnan can be found in Hong Kong or Taibei, and in the prosperous overseas Chinese communities that now overshadow older North American Chinatowns one can find the full range of Chinese urban food styles: Cantonese *yum tsa* or "*dim sum*" tea snacks, Taiwanese-style noodles and seafood, or North

Chinese Muslim sesame cakes with lamb. In some places there is even street-stall breakfast foods, such as *doujiang,* hot, sweet, or salty soybean milk with *shaobing youtiao,* feather-light, foot-long oil fritters stuffed into a wheatcake—the ultimate taste of home.

Further Reading

Anderson, E.N. *The Food of China.* New Haven: Yale University Press, 1988. Historical, sociological, and ethnographic account of Chinese food from the Bronze Age to the twentieth century. Authoritative, thorough, carefully footnoted, but very readable.

Lu, Henry C., Ph.D. *Chinese Herbal Cures.* New York: Sterling, 1994. Scholarly, detailed, well-organized and heavily illustrated by a Canadian Ph.D. who is also a practitioner of Chinese medicine.

Simonds, Nina. *China's Food.* New York: Harper Collins, 1991. A literate, gastronomic journey through China. Gives a good sense of how many different cuisines China includes. A good introduction to the topic.

Japanese Food

MARY SCOTT

Ever since Japanese immigration to the United States began in earnest in the 1890s, Japanese American cooking has incorporated many new kinds of foods while maintaining a tenacious hold on certain basic foods, styles of cooking, and attitudes toward food. The balance between the wish to adopt new ways of cooking and eating and the wish to keep older ways has shifted somewhat in each generation of Japanese Americans, and in many ways this balancing of contending feelings about food reflects much larger issues in Japanese American history.

Many of the **Issei**, first-generation immigrants, had been farmers from rural parts of Japan. Because their immigration followed on the heels of a sustained outburst of anti-Chinese activity in the United States, they were seen from the first as part of a broader East Asian economic threat to the native born. As a result, they suffered from considerable economic and racial discrimination and found it nearly impossible to find work in manufacturing or the building trades. For all these reasons, many Issei turned to family-owned service businesses like corner groceries, laundries, and restaurants, or to agricultural work of various kinds, from landscape gardening to truck farming to large-scale single-crop agriculture. Their success in these enterprises made a major contribution to the development of the early twentieth-century U.S. economy, particularly in California and Hawaii, but for individual Issei and their families it was often a hard struggle, particularly when rural work isolated them from a larger Japanese American community.

Food took on a particularly important role in the maintenance of family closeness and emotional ties with the past under such circumstances, and Issei women showed great determination and ingenuity both in obtaining Japanese ingredients and in making do with what was available locally. Rural families could grow their own fresh vegetables, including distinctively Japanese ones like *gobo,* burdock root, and *kabocha,* Japanese pumpkin, and urban-dwellers could buy them

in Japantown markets, along with imported rice, dried fish, and other necessities. Families who lived near the seacoast often made trips to gather fresh shellfish and seaweed.

Just as they often tended to congregate with people from their own region of origin in Japan, the Issei tended to preserve the food customs of their old homes, often including a preference for local kinds of *tsukemono,* homemade pickled vegetables in rice bran. At the same time, many Issei adjusted their diet to include foods unknown in Japan—though one newly arrived bride whose Issei husband told her that raw beef was "American *sashimi*" remained unconvinced. In Japan, sashimi always means raw fish.

Nisei, second-generation Japanese Americans, remember delicious childhood treats like *maki-zushi,* rolled sushi, raw fish or vegetables rolled in vinegared rice, and *nori,* a dark purplish dried seaweed—while at the same time they often remember their parents' fondness for other Japanese foods that they themselves found unpalatable. Their own childhood preferences encompassed everything from rice balls with black sesame seeds and *umeboshi,* sour pickled plums, to hamburgers, hot dogs, and milkshakes. This mixture of foods mirrored their emerging sense of a distinct identity, not émigré Japanese, but Japanese American.

The most wrenching moment in the creation of Japanese American identity was Roosevelt's internment order soon after the Japanese attack on Pearl Harbor in December 1941. Thousands of American citizens of Japanese descent, many of them children and young people who had known no other home than the United States, lost their property and livelihood and were moved from their homes to internment camps in remote areas of the U.S. interior. Conditions there were difficult, especially in the first year, and it can only be a small footnote to a great tragedy to note that for many people the food in the camps was one of the hardest things to bear. It was not just that it was skimpy in quantity, barely adequate in nutrition, and neglectful of traditional food preferences, for in many camps the internees had partially compensated for this by the second year, by raising vegetables and chickens. For many people, what was worst was that the food in the camps was cooked in mass quantities and carelessly served, all running together with no regard for how it looked on the plate. This was particularly hard because Japanese custom put a very high value on food's appearance, not only as a dimension of its appeal to the appetite, but also as a mark of the personal bond of respect or affection between the cook and the person eating the food.

The importance of the internment for the creation of Japanese American identity reveals itself through food in other ways as well. People were generally forbidden to cook for themselves because of the strain it put on a camp's power

supply, and eating in communal mess halls tended to weaken food's role in maintaining family closeness. Some later came to believe that the experience of the camps had fundamentally altered their family relationships, by making it impossible for people to continue in their customary family roles. Men suffered from the loss of their sense of self-sufficiency as providers, women could no longer cook for their families, and children could choose to eat in the mess halls with their friends rather than with their parents. Parents almost always felt that this was a change for the worse, though some Japanese American women later mused that, ironically enough, it was in the camps that for the first time in their lives they found themselves with free time to do things besides household labor.

At this point in the late twentieth century, many Japanese Americans represent the third, fourth, or even fifth generation of U.S. citizens in their family, so their preference for Japanese foods is often no longer particularly marked. In many families it shows up mostly in a few favorite family dishes and in a general preference for rice, seafood, and light, simply cooked food. The older forms of Japanese cooking often require a lot of labor and time in spite of their apparent simplicity, so in the United States, and to a lesser degree in Japan, home cooking has been modified to reflect the schedules of working wives and mothers. Many Japanese Americans have reached the point of feeling a need to rediscover the cooking of their grandmothers and great-grandmothers, so a brief introduction to traditional Japanese food—with a few contemporary notes—is appropriate here.

It is a bit of a misnomer to speak of "Japanese food," for people in Japan eat many different kinds of things: traditional local specialties, some kinds of Chinese food, imported Western haute and not-so-haute cuisine, and foods that look "foreign" but exist nowhere else but in Japan. Even the category "traditional local specialties" turns out to include a few sixteenth- and seventeenth-century European influences, in dishes like tempura, batter-fried seafood or vegetables, and Portuguese-style sweets and sponge cakes. *Kari raisu,* curry rice, or spaghetti in tomato sauce may be as much a part of an ordinary person's diet as sushi— vinegared rice usually topped with raw fish—especially since the price of really good sushi puts it outside the range of everyday fare. The internationalization of Japanese food, especially since World War II, reflects the profound social and economic changes in Japanese life since Japan reorganized its structure of government and opened its doors to European and North American trade and influence in the mid-nineteenth century. These changes included a large-scale migration of rural people into Japanese cities and a wave of Japanese emigration to the United States and elsewhere.

Figure 17–1:"Sushi boats," Tokyo, Japan. A popular style of fast food restaurant. Sushi chefs continually put new orders on an endless conveyer belt which rotates past the customers. At the end, the customer is charged according to the number of empty plates in his or her stack. Photo by George J. Leonard.

In spite of the transformation of Japanese life during the past 125 years, most Japanese continue to prefer traditional Japanese food most of the time. "Traditional Japanese food," however, covers a lot of ground, from the simplest bowl of *soba*, buckwheat noodles, to the rarified elegance of the *kaiseki ryori*, the meal that accompanies **chanoyu**, the Zen ritual of tea. The common qualities across this range are subtlety and simplicity. Good cooks everywhere insist on the freshest possible materials, but good Japanese cooking depends more on absolute freshness than most other kinds of cooking do. Many foods are eaten raw or very lightly cooked, and the Japanese cook's exceptionally plain and simple means of seasoning foods will not mask any imperfection. In this, Japanese cooking is reminiscent of Japanese ink painting, in which a painter's unhesitating and unalterable gesture speaks through plain black ink on white paper of the pure immediacy of Now.

Freshness also means seasonality. If one eats *matsutake*, pine mushrooms, at their autumnal peak of perfection, then anything other than the simplest way of cooking them actually detracts from their sheer mushroom-ness, their autumnness. Matsutake are a great delicacy, but the same principle applies to humbler foods as well: one eats cold noodles in summertime, *oden*, root vegetables, beancurd, and *kamaboko*, fish sausage, stewed in broth in winter. The old custom of eating outdoor meals in cherry-blossom or maple leaf season is another aspect of the traditional sensitivity to the moods of the turning year.

Here Japanese cooking shares with other Japanese arts a deeply felt attunement to the nuances of seasonal change, which has its roots in the ancient Japanese attribution of divinity to all aspects of the natural world and in Buddhist teachings on the ephemerality of all experience, for which seasonal change provides an apt metaphor. The kaiseki ryori, which derives from the tradition of Zen monastery cooking, is the most powerful example of the ways in which the ideals of freshness and seasonality in food can be seen as aspects of the Zen emphasis on simplicity, frugality, and mindfulness that has shaped so many aspects of Japan's past and present cultural life. Although many Japanese Americans are Christians, and those who are Buddhists are not necessarily Zen Buddhists, many still find meaning in the Zen emphasis on the spiritual importance of the ordinary details of life—particularly cooking, which has been important to Zen practice for hundreds of years (*see* chapters 22, 35, 37).

Rice, *gohan*, is the staple food of Japan, and rice and **sake**, rice spirits, have played an essential part in Japanese ritual practice since ancient times. **Mochi**, sticky cakes of pounded rice, are an important ceremonial food that is always eaten on New Year's day. Rice farming was traditionally the mainstay of the rural economy, and the urbanization and secularization of contemporary life have only

added another layer of nostalgia to the ordinary Japanese person's feelings about rice as the quintessential product of Japanese soil. Parents in Japan still tell their children to eat every last grain of their rice, because each grain represents a drop of a farmer's sweat, and many Japanese Americans grew up hearing the same thing from their parents.

Traditionally, other foods were often thought of simply as ways to enhance rice, and most people in Japan still consider a meal incomplete without it. A common, homey Japanese lunch is *ochazuke,* a bowl of rice with green tea poured over it. Rice is also the subject of much connoisseurship. Not only can most people distinguish this season's new rice from last year's, but some say that they can tell where in Japan the rice was grown and in what soil and weather conditions. The pure, bland taste of good rice is appreciated for its own sake, and rice is most often cooked without added salt or other flavoring.

Traditional Japanese food reflects the pre-industrial Japanese economy's dependence on the sea. One of the fundamental flavors of Japanese cooking is *dashi,* an infusion of dried, shaved bonito fish and *kombu,* a kind of seaweed. This is the basis for the clear soup that begins a formal meal, and it is also the liquid in which many foods are simmered, giving them a delicate ocean perfume. An ordinary home-style traditional meal generally consists of "soup and three": the soup is followed by *sashimi,* raw fish, *yakimono,* grilled things—often fish or seafood, though chicken, beancurd, or meat may also appear here, and *nimono,* simmered things, often seafood or vegetables. These are followed by rice, various kinds of pickles and salad, and tea. The importance of the ocean to the Japanese diet is still visible in the extraordinary variety of fish, shellfish, and other ocean produce available in Japanese markets.

Some of the other basic flavors in Japanese cooking are *shoyu,* soy sauce, a thin, fermented liquid made of grain and soy beans, and miso, a thick, salty fermented grain and soybean paste. Tofu, or beancurd, is only the best known of the many other fresh soybean products commonly eaten in Japan. Like rice, all of these things come in a great many local varieties. In Osaka, for example, people prefer a light-colored, saltier shoyu, while Tokyo people like a darker, less salty type. Hometown miso and home-made pickles are nostalgic items for many urban dwellers, as they have also been for many Japanese Americans. Visits to almost any place in Japan are only complete if one takes home gifts of some of the local specialty food: an unusual kind of rice cake, a particularly delicious variety of dried persimmon, a distinctive pickle or rice vinegar or preserved fish. Like traditional Japanese painting and poetry, traditional Japanese food draws on a wealth of local place associations.

One of the most striking features of Japanese food is the attention that the cook pays to the food's appearance. Once again, simplicity, seasonality, and absolute freshness are crucial. A dish may be garnished with nothing more than a sprig of *kinome,* Japanese prickly ash, but those fragrant bright green leaves speak eloquently of springtime. Serving dishes, which vary widely and are not generally used in matched sets, are carefully chosen to enhance the food through their shape, color, texture, and seasonal associations. Some Japanese American families still treasure a few graceful, subtly glazed plates or tea cups brought from Japan by a grandmother or great-grandmother.

Food should be arranged with the traditional painter's eye for graceful spareness and asymmetry. The traveler's lunches sold in Japanese train stations *(ekiben)* work visual wonders through the careful arrangement of the most ordinary things: rice, perhaps a piece of broiled eel, a pickled plum, a few black sesame seeds. Even the most conspicuously foreign additions to the Japanese culinary repertoire are prepared with the virtuoso knife work of the traditional Japanese cook, and they will usually have a touch of contrasting seasonal color, even if it is no more than a scattering of green peas or a piece of green paper cut to suggest a leaf.

Dairy products and meat are fairly recent additions to the Japanese diet. Buddhism, which has been a powerful force in Japanese society since the sixth century C.E., forbids the taking of life. Although this prohibition was not observed to the letter in Japan, it did result in a general distaste for the meat of four-legged animals, in the low social status of butchers and tanners, and in the still widespread practice of vegetarianism among devout Japanese Buddhists. In the nineteenth century, some Japanese political reformers attributed European and North American strength and aggressiveness to meat-eating, and they urged the Japanese to eat meat as part of the national effort to meet the challenge of the West. *Sukiyaki,* a well-known one-pot meal made with beef and vegetables, was one early response to this call for the inclusion of beef in the Japanese diet. Early Japanese immigrants to this country thought of meat and dairy products as typically American foods, and Issei parents often attributed their children's height and good health to their consumption of these foods in particular. Now, of course, Japanese beef from Kobe is included among the best in the world, and fast-food hamburgers are as popular in Japan as anywhere.

Although they have become popular in twentieth-century Japan, highly sweetened foods were not part of the Japanese diet in earlier times, and chocolate was not introduced until the 1860s. *Okashi,* confections of slightly sweetened rice flour and bean paste, were and still are served to complement the subtle bitterness and astringency of green tea, but they were not considered part of a regular

meal and most people did not eat them much. Ordinarily, people's taste for sweet things was satisfied with fresh or dried fruit. Now, however, pastries, cookies, and candy are commonplace, and ice cream comes in neo-traditional flavors like red bean, green tea, and ginger.

Because traditional Japanese food emphasizes freshness and avoids red meat, most fat, and refined sugar, it attracts the interest of many people who would like to avoid the health consequences of the modern Western diet. This has led many non-Japanese to believe that Japanese food is uniformly austere, and encouraged an unfortunate neglect of the contemporary Japanese diet's playful hybridity. Where else, for example, can you find such a delicious and inventive array of supermarket snack food? Where else do vending machines in the middle of nowhere dispense fairly decent and filling soup noodles, sake, and tea? And where else in the world can a hungry traveler who doesn't know the language simply point to a plastic facsimile in a restaurant window and know for certain that its edible twin will soon appear on the table?

Japan's economic power and cultural inventiveness have had an enormous impact on many aspects of late twentieth-century international culture. The internationalization of Japanese food is one sign of this influence: Japanese visitors make a point of trying New York's excellent and relatively cheap sushi, Japanese-French restaurants are popular in Paris and Los Angeles, and a Japanese American invention, California roll, maki-zushi, with cooked crabmeat and avocado, has been successfully re-exported to Japan.

Further Reading

Anderson, Jennifer L. *An Introduction to Japanese Tea Ritual.* Albany: State University of New York Press, 1991. An excellent specialized study on the history and practice of *chanoyu,* with an introduction to *kaiseki ryori.*

Mura, David. *Turning Japanese: Memoirs of a Sansei.* New York: Atlantic Monthly Press, 1991. A sensitive and articulate account of a Japanese American's encounter with modern Japan.

Sone, Monica. *Nisei Daughter.* Boston: Little, Brown, 1953. A moving memoir of Japanese American life that includes many notes on food.

Tanizaki, Jun'ichiro. *In Praise of Shadows.* Boston: Leetes Island, 1977. A famous Japanese novelist's charming and idiosyncratic introduction to Japanese traditional culture, including comments on food.

Tsuji, Shizuo. *Japanese Cooking: A Simple Art.* Tokyo: Kodansha, 1980. The most comprehensive book on Japanese food in English, and also the best practical cookbook.

Filipino Food

ED ROMERO, DAN GONZALES, MAX MILLARD, AND SALVE MILLARD

[Note: This article is a conversation among four sources—Ed Romero, Dan Gonzales, Max Millard, and Salve Millard. As the article emerged over the course of several years, our editor, George Leonard, was struck by the diversity of interpretations and definitions. He chose this form to preserve that diversity. Readers encountering Filipino literature should be aware how various Filipino experience has been—all those islands, all those dialects, and all those classes and ethnicities grouped under one political heading. There are no unanimous opinions about anything, including cuisine. If a term appears in more dialects than Tagalog, that is noted. If a source had a special comment, or strongly dissenting opinion, that is noted too.]

Adobo: Pork dish, spice, a favorite dish eaten in the islands and in the United States. Party food. Slowly cooked in water with vinegar. Tagalog and other dialects. *Dan Gonzales:* It's definitely a party food. People expect it at parties, but some people eat it as an everyday food, sometimes as much as twice a week.

Biko: A dessert made of sweet rice and coconut milk. It's a delicacy that people make on holidays and special occasions. You can buy it in Filipino bakeries. *Salve:* This is a cheap, common dessert throughout the Philippines, although it's only made on special occasions. The best version is made from red rice, brown sugar, and coconut. It gets its brown color from the brown sugar, not from brown rice. *Dan Gonzales:* There are equivalent desserts in other Southeast Asian countries. I've had a Thai dessert that is very, very close to it. Biko is universal, throughout all the different language groups.

Bitso bitso: Sweet potato pancake fritter. *Salve:* It's not just for holidays, but is made for a snack anytime. Tagalog and other dialects. *Dan Gonzales:* It's a Visayan name.

Canong: Rice. "A meal without rice is like a day without sun." Rice is the staple food of the Philippines. *Salve:* Never heard of the word "canong."

Duhat: A black, plum-like fruit.

Halo Halo: Dessert. Slices of sweet potato, sweet banana, *kaong*—palm tree fruit—served over shaved ice.

Sweet Rice Kalamay: Dessert. Sweet rice cooked in coconut milk until dry and sticky. Cooled on banana leaves and topped with cooked, shredded coconut milk. There are different kinds of kalamay, but the sweet rice kalamay is most popular.

Kasuy: Cashew nut.

Langka: Jack-fruit.

Lumpia: A Filipino deep-fried egg roll. Rice cake wrapped around fillings—pork, shrimp, or chicken and vegetables. It's time-consuming to make. *Salve:* It's quite a luxury, because vegetables are expensive in the Philippines. It's sold everywhere by street vendors. Tagalog and other dialects. *Dan Gonzales:* It's a party food. There are two varieties—fried lumpia is deep-fried, and fresh lumpia is made in a burrito wrapper with fresh vegetables.

Macopa: Salve: It's a type of fruit. Not common. I'm not sure what it is, although I have heard of it. It might be from Mindinao. I think it's very expensive.

Malagkit: Glutinous rice.

Manok: Chicken. Tagalog and other dialects.

Maruya: Banana fritter.

Merienda: An important custom, like 4 o'clock tea in England. Post-siesta snacks with tea, coffee.

Nganga: Bitternut leaves with lime mixed together.

Pancit: Noodles, like spaghetti without the red sauce. Tagalog and other dialects.

Santol: Salve: It's a big yellow fruit with seeds inside. You chew the seeds and throw the fruit away, except for the skin, which you can eat.

Tuba: Coconut wine.

Ube: Dessert. Made out of violet sweet potato.

Further Reading

Law, Ruth. *The Southeast Asia Cookbook.* New York: Donald I. Fine, 1990. Includes historical introduction and 40 pages of traditional recipes submitted by chefs in four-star Manila restaurants.

CHAPTER 19

Korean Food

JEEYEON LEE

I have never eaten dog. I think there is a rumor out there that dogs are a Korean delicacy, but all I know about Korean food is what I've seen and eaten at home. (My parents, I should add, are immigrants.) Occasionally I've tried strangers' Korean food, i.e., my parents' friends, and in the past year I've eaten in many Korean restaurants, but my primary connection to Korean food remains at home. This is not a negative thing, except sometimes I think about my cousins, and what their mothers make for them, and I feel a small pang of jealousy because I know that their tables are always topped with a great deal more variety than our own.

My own mother is a genius about making what is essentially a Korean vegetable dip stretch for weeks on end as our dinner's focal point. She makes this dip with red chili paste (the kind we have right now was sent over from my father's dear sister in Korea, so I should be grateful, and probably not get too used to the good life, since soon we'll run out, and then be forced to deal with the ordinary stuff that comes from the nearest Korean grocer in Seaside or Marina). She tosses in a bit of sugar, some minced garlic, chopped green onions, just a wee spill of sesame oil, and just a wee spill of soy sauce. Oh, and also some ground sesame seeds.

The important thing to note at this juncture is that the ingredients I just listed are the six key goods that 90 percent of Korean foods include. In Korean, spices are called *yang-nyeom,* to pray for health, because they are frequently used for medicinal purposes. Perhaps this is why my dear mother feels okay with presenting her Korean vegetable dip, night after night, accompanied only with assorted steamed vegetables, and needless to say, rice, always the meal's central dish, and **kimchee**. These six key ingredients play a major role in upholding the essential (to Korean cooking) *Five Tastes*: salty (salt, soy sauce, bean paste), sweet (sugar from beats, sweet potatoes, honey, maltose candy), sour (rice, citron vinegar), hot (red peppers, mustard), and bitter (ginger). In addition to the five tastes,

traditional Korean cooking includes a careful arrangement of five colors: red, green, yellow, white, and black. Black, being the most difficult color to accurately throw into the mix, is usually represented by various mushrooms.

My mother would chase me around with a paddle if I were to omit all the other dishes she prepares; so, here we go: marinated spinach, marinated eggplant, kimchee soup, soy-bean soup, bean-sprout soup, chap-chee (glassy noodles with vegetables and usual seasonings), acorn noodles, eggs on the half shell, and the like. When my father and I were relentless beef eaters she met our demands with *bulgogi* or *kalbi,* Korean-style beef and ribs that Americans think of as "Korean barbecue," which are now only cooked for guests, or my brother, who perennially looks emaciated in Mother's eyes. (He's never emaciated.)

The timeline of my life, in my head, shows a steady decline of my parents' interest in fixing complicated, exciting Korean foods at home. Even my father, whose cuisine needs are based not only on his own peculiar taste buds, but also on his aesthetic ideals ("I can't enjoy this soup in this hideous bowl; go get me the cute one") seems to have found a certain peace in eating just varied vegetables, with rice, kimchee, and maybe a daring can of Japanese mackerel that he gussies up himself. He, like my mother and myself, seems to have accepted that Korean food at home is like a minimalist painting: to the point, and leaving something to be desired, but not altogether disagreeable.

The irony is that while presently the Lee family is experiencing a domestic, gastronomic breakdown, the outside world seems to be reveling in a fabulous kimchee extravaganza. One goes innocently into the nearest Lucky's or Safeway, browsing for a small tub of Country Crock, or a pack of Ball Park Franks, and what else does one invariably encounter? Rows and rows of kimchee, *dak-kwan* (I wish I could describe the taste of dak-kwan, a preserved radish, but there are no words to describe such a queerly sweet and yellow ordeal), and, of course, tofu: firm, medium, and soft. All right, so perhaps one doesn't encounter rows and *rows,* but undeniably, many major supermarkets, at least in California, have cleared a substantial refrigerated ledge for the Korean items. Meanwhile, let me just reiterate that I've never eaten any part of a dog.

Indeed, the phrase "Korean cuisine" belongs, for me, strictly to the present decade of the 1990s. In the 70s, when I was very little, people seemed convinced that an Asian person had to be either Chinese or Japanese. And even upon discovering that I was neither, people still tended to assume I ate Chinese food at home and was therefore lucky. No white person had ever heard the term "kimchee" before, and if I managed to describe in detail what kimchee was, or, indeed, if I *showed* what it was to a non-Korean, I knew what would necessarily follow: "You

eat that?" or, with equal disbelief, "Do you like it?" Of course, in the 70s, my acquaintances were usually children, but those children's parents probably weren't too familiar with Korean food either. I will avoid beating around the bush: no adult or child in his right mind would imagine cold cabbage, that has been fermented and pickled with dried red pepper and green onions and garlic and sugar and a bit of fishy flavoring, give or take a heaping spoonful of mashed ginger, to taste good. Even today, if I am explaining kimchee to someone who's never tried it, I find myself exasperated with the task of trying to make it sound tasty. I find myself urging over and over, "Well, you might have to acquire a taste for it, but some people really love it!" Obviously I wouldn't want anyone to think I or the whole Korean population were nuts to enjoy such a thing. I don't want to point fingers, but certainly there are other "foods" for which we can be justifiably considered nuts. Providing the rumor is true. (Dog meat, which is eaten because of a belief in its health benefits—that it increases virility, for instance—has gone pretty much under cover in Korea these days. Beginning with a countrywide purging of dog and snake butcher shops from the streets of Seoul during the 1988 Olympics, in order to spare Western visitors any dismay, it has become more and more difficult to find.)

At any rate, I have to say that the new surge of interest in and acceptance of Korean cuisine in the 90s, by American culture, owes much to the opening of American cuisine by the Japanese in the 1980s. Along with Ronald Reagan and yuppies and aerobics, sushi was introduced. It became a hip and happening, if not nauseatingly Californian, fact of life. The combination of raw fish and expensive prices insured for many that non-European foreignness could equal classy-ness; that to accept and "simply adore" sushi was to build an understanding that one was far from ignorant, *inches* from cosmopolitan. As such, I believe that people's minds can be pried open by mass agreement (that, for example, sushi rules) during one decade, and in the next, other ideas, *i.e.,* the idea of kimchee, can seep through: "By golly, I've allowed raw tuna to pass these lips; let's give this fermented cabbage a whirl!" I think this attitude is terrific.

If as a child I was embarrassed to admit I ate and liked kimchee, as an adult I feel only embarrassed about ever having felt embarrassed. Some of my American friends find certain Korean foods too spicy, or simply prefer other foods, but a couple of them think the world of kimchee, and anything similar to it. These friends are always seeking out new Korean restaurants, and even informing me about dishes I've never tried. In any case, what once represented a cultural gap for me and my non-Korean friends is one no longer. As a child or teenager I didn't necessarily contemplate Korean food as a cultural issue that affected me, but now

I realize it did. For instance, I rather dreaded having friends visit my home and peer into our refrigerator and say, "Ooh, what's *that?*" Or, much worse, "What's that smell coming from?" because Korean food can be very pungent and fairly exhausting to an unaccustomed nose. I didn't want to have to apologize for the queer smells and looks of things, yet I think I often did.

I resist learning to cook Korean foods based on the flimsy excuse, "It will never be as perfect as Mommy's, so why waste the ingredients?" Meanwhile, my brother (who is in law school and runs marathons for fun, so he's clearly the over-achiever offspring, and I shouldn't compare myself to him) is a fabulous cook when it comes to Korean cuisine; he makes all the great favorites my mom used to make when we were growing up. Kap Soon (my mom) can still wield her magic when she wants, or when my dad or I ask for it specially; in fact she's always more than happy to, but I have to say my best Korean cuisine memories belong to the long-gone years between 1982 and 1985.

Although there are some quite delightful Korean festivals, and dishes that accompany those festivals (for example, on one's sixty-first birthday, Keun Sang, important because the normal life span in Korea is considered to be 60 years, and also because the cycle of the lunar calendar is 60 years, after which the cycle starts anew, and a great feast is served), nothing was more delightful than having my mother team up with a few of my aunts to concoct a truly exciting table of grub. The weekend parties that occurred between 1982 and 1985, the years we lived in San Francisco, were, to phrase it mildly, inspirations for my appetite. Four fami-lies, related by blood and marriage, congregated bi-monthly at Golden Gate Park for a barbecue-bollyball (volleyball)-blast.

I always deplored these corny get-togethers as a kid, for I was anti-social and stuck-up; but I loved the feasting part. Without fail someone brought barbe-cued beef and barbecued ribs, bulgogi and kalbi respectively. Someone else brought two or three different kimchee variations: cabbage, cucumber, and radish, all spicy as hell. My favorite was all three. Then there was the pretty Korean sushi: thinly sliced dak-kwan, carrots, spinach, fried egg, ground beef, and flavorless-yet-hot-pink-and-thus-aesthetically-indispensable fish cake; all rolled up with rice in a tight seaweed sheath, then sliced into mini hockey puck disks. These were mouth pop-ping fun, and delicious to boot.

In addition to these foods there was a great deal more, including water-melon and cookies for dessert. However, something I find particularly interest-ing in retrospect, is that only the women did the cooking. In Korea, where Con-fucian morality traditionally governs social relationships, women are responsible for sustaining Korean dietary customs. These particular women, my aunts, all

cooked with a similar style, even though they weren't the ones related by blood. It seemed their primary goal was to suit the tastebuds of their husbands. And since their husbands were all brothers, and all raised with the same cuisine standards, the result was naturally a homogenized flavor ideal. My dad and his brothers each had a wife who learned to make the sauces just salty enough and the noodles just sweet enough.

I've experienced, at non-relatives' homes, very bizarre kimchee, or overly garliced bulgogi. When this is the case I am reminded that the final analysis of cuisine happiness all depends on what one has come to prefer. Given that I am no exception, thank goodness Kap Soon doesn't dig on canine.

Has this article enticed you? I have prepared (in consultation with Kap Soon!) a short course in Korean Food 101, for you to try.

Americans love bulgogi, and it's certainly a traditional Korean food—the best choice of beef, that which is very thinly sliced and tender and lean. Indeed, Kap Soon would tell you, the finest beef cannot be found in an American super-market, but can be found in a Korean grocery store. The quality of the beef is monumentally important, and it must be thin, thin, thin! Then, the process by which boring old beef becomes mouth-watering and savory bulgogi, is marinat-ing. To marinate right, one should be equipped with either a Korean mother or a highly acute intuitive sense of ingredients and measurement. I have the former, and therefore can whip up a mean dish of bulgogi, with nary a measuring tool. (Despite my inability to cook anything else, I can make bulgogi, oddly enough!) So, without further ado, the essential ingredients to marinate bulgogi are: soy sauce, sesame oil, garlic (galore), green onions, sugar, salt, and black pepper.

Some folks are known to include white onions, or mushrooms, or finely chopped carrots, or even honey to accommodate their own needs. Personally, I like sticking to the classic, unadulterated version and, confidentially, I even pre-fer it raw, as in before-cooked, as in creepy cannibalish Korean comes forth with the truth.

However, for those who enjoy cooked bulgogi, the trick is to flame broil, or oven broil, or stove-top heat. There's one consideration that I'd like to address presently: non-juicy bulgogi is non-exquisite bulgogi. Therefore, one must always consider the unretractable perils of flame broiling or barbecuing in any manner that is not conducive to trapping in every iota of juice.

Next lesson: Kalbi. Almost word for word as bulgogi. The key difference is that kalbi is beef ribs, and although it should be tender and lean, it needn't be thin. On the contrary, the substantiality of the meat on the bone calls for a longer marinating time, in order that every bite be rich with marinated flavor. Indeed,

Figure 19–1: Korean market, San Francisco, California, advertising "Korean Barbeque Meat" in English. Its popularity is no longer confined to the Korean community. Photo by Alyson Kohn. Courtesy of Stefanie Kohn.

to help tenderize the meat and encourage the marinating process, one should incise the meat a bit, before introducing it to any other ingredient. My mother, for example, will take each individual beef rib and sort of give it a little hacking job with a knife. When I watch her doing this I always picture a stern masseuse firing away rapidly on someone's tense shoulders. Both the tense-shouldered someone and the dense beef rib are ultimately improved, for having received such treatment.

An advanced lesson: dak kwan and pan chan. Actually, dak kwan is a Japanese invention, which the Koreans have appropriated into their own cuisine. (I say "their" and not "our" because I refer to Koreans of long ago; Koreans with whom I will not presumptuously group myself.) At any rate, dak kwan is a radish which has been preserved in salt and sugar, and rice extracts. Sometimes dak kwan is yellow, and sometimes it is more white. (A hidden analogy for Asian American people, perhaps?) In Korean cuisine, dak kwan is not an ingredient, per se, but a "pan chan" item (akin to kimchee or marinated spinach leaves). The area in which dak kwan excels, in my opinion, is its role in Korean sushi, *kim-bahp*, because I feel its most formidable asset is its hyper-yellowness.

"Pan chan" is a term which describes the numerous little dishes that help save white rice from being a dull meal. (Although in Korea, plain rice is still considered the main dish.) In stage terms, I suppose rice and bulgogi might be the main characters, and yet they are wholly dependent upon kimchee and dak kwan, etc. to support, nay, actualize their full potential. In fact, it seems to me the rule rather than the exception that pan chan, when good, steals the show.

Some people might argue that anything besides the rice is pan chan. However, I tend to think of pan chan as spicy little vegetable dishes. Of course, the specific definition of pan chan is never anyone's concern, so long as there's plenty to eat.

Enjoy!

Further Reading

Hyun, Judy. *The Korean Cookbook*. Holly Corporation, Publishers, 1970.
Marks, Copeland, and Manjo Kim. *The Korean Kitchen: Classic Recipes from the Land of the Rising Sun*. San Francisco: Chronicle Books, 1993.

Vietnamese Food

CHUONG HOANG CHUNG

Vietnam has been a meeting point for many different cultures—the Chinese, Indian, Portuguese, and French all left their marks on Vietnam's native Lac Viets, who populated the area around Hanoi from ca. 2000 B.C.E., and who explain their genesis as the union between the Sea God, Lac Long Quan, and the mountain goddess, Au Co. With each wave of invaders/immigrants came different foods and culinary skills that mingled with indigenous tastes to produce the current state of Vietnamese cuisine, with its sophisticated combination of colors, flavors, textures, and temperatures.

Vietnam is generally divided into three major cultural regions: north, central, and south. The regions' capitals are Hanoi, Hue, and Ho Chi Minh City (the former Saigon), respectively. Regional differences in the country's cuisine correspond roughly to these areas as well. But before discussing differences, I should mention the basic components that unify Vietnamese cooking. The first is rice, called *com*. Rice is central to any Vietnamese meal. It is filling as well as soothing after a mouthful of fiery peppers. The importance of rice to Vietnamese cuisine was illustrated in the 1993 film, *The Scent of Green Papaya*, when a South Vietnamese family, after a tragic loss of all their money, must make their supply of meat and vegetables stretch as long as possible. Their servants purposely over-spice and over-salt the food so that the family, spoiled by wealth, is forced to eat the more luxurious items as simply a sauce to flavor the rice.

Ginger, garlic, *tamarind*, the tart, thick flesh inside the pods of the tamarind tree, and hot chilis are also important throughout Vietnam. Playing the role in Vietnam that soy sauce plays in China, *nuoc mam*, fish sauce made of fermented anchovies, lime juice, chilis, garlic, vinegar, and sugar is served as a dipping sauce, salad dressing, or poured directly over rice dishes.

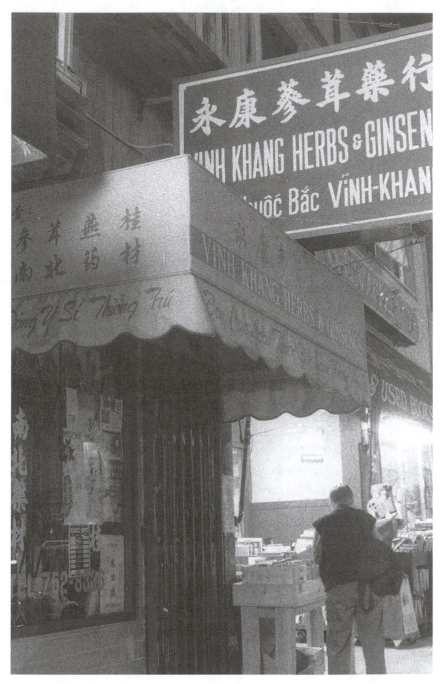

Figure 20–1: A Vietnamese store sells herbs and ginseng. San Francisco, California. Photo by Alyson Kohn. Courtesy of Stefanie Kohn.

Since Vietnam stretches thinly along 1,000 miles of coastline, fish, *ca,* is eaten avidly throughout the country. Beef, chicken, and pork are also eaten—less, of course, among poorer families. The Vietnamese, unlike the Thais who use forks and knives, eat with chopsticks, as a result of Chinese influence. From the Chinese they also inherited Confucian family values, demonstrated even at the table in the fact that each member of a family must ask permission of his older relatives before beginning to eat.

Another pan-Vietnamese tradition is the roadside food stall. Travelers to Southeast Asia are always surprised at the abundance of different types of food at each street corner. Food stalls big and small take up alleys and sidewalks and teeter on the edges of curbs. A dish typical of Hanoi's street and marketplace stalls, but now popular all over Vietnam, is *pho bo,* beef noodle soup. The broth is added immediately before serving over noodles and slices of tender beef with chopped green onions and cilantro. Pho can be served at practically any time of the day. It's good for breakfast, lunch, dinner, or a midnight snack. The soul of pho is the broth. A good broth simmers for many long hours with soup bones, ginger, onion, and carrots and will make a cook famous. Some famous pho chefs from Vietnam have crossed the Pacific Ocean and set themselves up in San Jose, Houston, Boston, Seattle, and New York. Their new restaurants and stands are now becoming part of the multicultural food scene not only in California but in places like Tampa Bay, Chicago, and Falls Church, Virginia. Among throngs of Vietnamese customers, Americans are learning to manipulate chopsticks expertly and can add, in a very "connoisseur way," a mixture of bean sprouts and basil leaves to their pho.

Vietnamese noodle aficionados proudly declare, "We can take on spaghetti and chow mien anytime, anywhere." Indeed, central and south Vietnam have their own versions of pho. The southern style is called *hu tieu. Bun bo,* spicy beef soup with rice noodles, represents the central region. Another variation of bun bo is *bun thang,* vermicelli soup served with broth, pork sausage, and egg.

Vietnam's northern region is perhaps the area most influenced by the Chinese, and its food reflects this connection. Stir-fry dishes, rice porridge, and cooked (as opposed to southern-style raw) vegetables, *rau,* are commonly served seasoned with black pepper and ginger, milder spices than the chilis used in south and central Vietnam.

In the area around Hue, central Vietnam's ancient imperial capital, food preparation is very complex and reflects imperial court tastes. Cooks pay much attention to elaborate spice mixtures and elegant presentation. Lemon grass beef wrapped in delicate rice papers and *Banh Xeo,* "sound" crepes, named

for the sizzling sound of batter hitting the griddle, are typical dishes of this region that is low on rice fields, but which grows lettuce, avocados, strawberries, and cabbage.

Southern Vietnamese flavors are often sweeter and spicier than those of northern and central Vietnam. Coconut milk, tropical fruits like pineapples and papaya, raw bean sprouts, lettuce, and mint often appear in dishes like *cha gio,* a thin rice paper filled with minced pork or chicken, crab meat, grated carrots, onions and mushrooms, then fried and eaten wrapped in lettuce. Excellent cha gio—making skills are required of every good Vietnamese bride.

In Ho Chi Minh City, backpackers and travelers have found wonderful uses for French bread and puff pastries. *Banh mi thit,* a Vietnamese sandwich on a French roll, originated in Saigon (now Ho Chi Minh City) but is now eaten all over the country. An especially tasty variation might include several kinds of spreadable pate, a few slices of barbecued pork, shredded radish and carrot, pickled cucumber, with a pinch of sugar and hot chilis, all piled onto a baguette.

In Vietnam, people usually eat three meals a day in addition to snacks—fruit drinks, fresh fruit, sweets, and sandwiches. Eating dessert is not a traditional Vietnamese habit; pastries, candy, and coconut custards are reserved for snacktime. The pho and sandwiches mentioned above are both breakfast options as well as lunch and dinner meals. In Ho Chi Minh City, toasted French bread and jam are common breakfast treats.

The Vietnamese generally take a midday break, known as "siesta" in other cultures (Vietnam, especially the South, can become excruciatingly hot and humid during the middle of the day). This break makes it logical for the Vietnamese to eat their main meal at lunch. Middle-class families who can afford kitchen help usually spend a great deal of time preparing lunch. A good *canh rau,* vegetable soup, accompanied by a deep fried pompano soaked in nuoc mam, sprinkled with a little red chili pepper, and, of course, steamed rice, would be the ideal combination for any Vietnamese worker returning home for the truly necessary lunch break. Others who do not have such luxury can pick up a quicker meal at the roadside stands, which sell a variety of *com dia,* rice plates. Most lunch plates include a combination of grilled or stir fried meat and vegetables, an indispensable part of a Vietnamese meal. *Com bi cha,* rice with minced tender pork and sausage, is one of the most popular dishes for lunch. Again, a well prepared fish sauce on the side is a must for all rice plates.

Many Vietnamese Americans stick to this basic eating pattern thanks to the availability in the United States of most ingredients and herbs. It is a well known fact that food habits are not easily changed. Middle-class immigrants frequently

try to recreate what their cook and servants used to prepare for them at home. To us, a vegetable soup mixed with pork or fish and vegetables from our own backyards is truly unbeatable. My mother would always add a little *ca kho,* salty fish stew with some cooked or boiled vegetables, to our simple dinners. With such busy schedules these days Vietnamese Americans often prefer to eat out. Once in a while, their children manage to drag them to local fast food outlets, or pizzerias. However, due to large Vietnamese communities in the United States, they can now choose from restaurants in America that rival the best in Vietnam.

Further Reading

Law, Ruth. *The Southeast Asian Cookbook.* New York: Primus, 1995.

Southeast Asian Food

The Durian and Beyond

ROBERT A. LEONARD AND WENDY J. SALIBA

The Place of the Durian

Bangkok. June 10.

When you open a **durian,** you know you are in Southeast Asia.

Now, in June the durian season has peaked. Just this morning we approached a stall and together with the seller picked a likely candidate. With a heavy knife he splits one of the seams that run the length of the large, spiky fruit, and a small portion is extracted. We taste it. Heaven. Durian is an expensive food, and worth it. (Expensive, but, had the fruit been bad, the seller would have quite peacefully discarded it. I have always found that odd—the seeming ease with which such a valuable item is set aside.)

A month ago, in New York, we found to our amazement that we could buy durian milk shakes in a new Vietnamese restaurant on Long Island. No Westerners seem to order it, though, the manager told us pointedly. A food writer for the local paper *(Newsday)* said she hadn't drunk one there because she couldn't get past its smell—although there was none in the several shakes that we sampled. Possibly the writer had read somewhere that that was supposed to be a Westerner's reaction to durian—"that smelly fruit."

The durian is a fruit that is extremely popular in Southeast Asia yet is almost universally despised by contemporary Westerners. J.M. Piper, in her excellent *Fruits of Southeast Asia,* introduces the durian:

> It is hard for most Westerners to understand the place of durian in South-
> East Asian societies—yet perhaps champagne plays a similar role in the
> West. Above all other fruits, the durian is anticipated, discussed, shared,

and maybe even saved for. It is an expensive fruit, and good ones are very costly indeed. Barely known outside Asia as it becomes rancid a few days after ripening, the durian received a mixed press from early travellers. "To eat Durian is a new sensation, worth a visit to the East to experience," said the great naturalist, Alfred Russell Wallace. "The more you eat of it, the less you feel inclined to stop."

I quote Piper at such length because the reader should be properly prepared: almost any non-scholarly references the reader is likely to encounter regarding the durian will describe it as "nauseating" and having a smell like a sewer. Wallace does say he disliked the odor at first but after having tasted the fruit he at once became a "confirmed durian eater." Wallace quotes "The old traveller Linschoot, writing in 1599, says: It is of such an excellent taste that it surpasses in flavour all the other fruits of the world."

Some years ago in Thailand my research partner Wendy Saliba and I organized a durian tasting. Eight varieties were sampled, all of which were purchased at a single group of roadside stands. I had the same experience Wallace so beautifully describes:

> *Its consistence and flavour are indescribable. A rich butter-like custard highly flavored with almonds gives the best general idea of it, but intermingled with it comes wafts of flavour that call to mind cream cheese, onion sauce, brown sherry, and other incongruities. Then there is a rich glutinous smoothness in the pulp which nothing else possesses, but which adds to its delicacy. It is neither acid, nor sweet, nor juicy, yet one feels the want of none of these qualities, for it is perfect as it is . . . the more you eat of it the less you feel inclined to stop.*

While I have never tasted any of the incongruities that Wallace notes—similarly food writer Sri Owen says she has never tasted the garlic flavor some claim they taste—I have, I admit, overtasted the "king of fruit." Perhaps it was the knowledge that in Southeast Asia it is known as a "heaty" food, one that you should neither overeat nor combine with alcohol. Our Thailand durian tasting went perfectly, though. There was considerable variation in taste, creaminess, tart/sweetness, but all eight varieties were good to simply superb.

In the United States, durian is an "insider food" for at least the Thais. (For the concept of "insider food" see Chapter 15.) Thais are amazed that "Americans" will eat and appreciate durian. In Thai food stores and restaurants in New York,

Chicago, San Francisco, we have noticed the attitudes of Thais changing toward us as soon as we mention durian. They become more open and seem to assume our knowledge of Thai food is much higher than they had only a few minutes prior.

Southeast Asian Cuisine in General

Southeast Asia is a very diverse land—culturally, demographically and topographically—and certainly also in terms of food. Yet some overall statements can be made.

The staple food of the region is rice. Rice, as is bread in much of Europe, is the "staff of life." In English we can say to "break bread together," meaning to eat food with someone. In Thai the very phrase that translates English "to eat," *kin khao*, literally means "to eat rice." Noodles, made of rice flour, wheat, and other flours are also important but only a distant second to rice.

Americans are often surprised that Southeast Asians (and indeed most Asians) serve white rice devoid of spice or seasoning, cooked almost to the point of blandness. But rice is intended to be eaten at every meal. If it had too pronounced a flavor, its presence, morning noon and night, would cloy. Instead rice, since it is omnipresent, is thought of as the white canvas on which each meal's painting will appear. The seasonings are as strong and varied as the rice is neutral. Predominant seasoning ingredients are fish sauce, a salty sauce based on a fish essence (but without much of a fish taste), lime, lemongrass, garlic, ginger, galangal (a rhizome something like ginger), coconut cream, and chilies. Southeast Asians conceive the classic tastes to be salty, sour, sweet (sugar), bitter, hot (spicy).

The fish sauce so characteristic of Southeast Asian cuisine is much misunderstood. This is a fermented extract of fish, a salty brown or amber liquid. There are many brands. It is used in much the same way as soy sauce is used in Chinese cooking, and in cooking does not impart a fishy taste. Rather, it might be called a "deepener" of existing tastes, the way salt is. Anchovy paste is sometimes said to be an acceptable Western equivalent. Interestingly, the *New York Times* once ran an article that quoted several well-known professional chefs saying that they used anchovy paste to augment and deepen the flavors of many dishes, unknown to their customers. The classical Romans relied heavily on a condiment, a fermented fish sauce called "garum" apparently quite similar to Southeast Asian fish sauces.

Many kinds of seafood are eaten—finfish, crabs, lobster, shrimp, cockles, clams, snails, turtles, squid, etc., as well as seaweeds and frogs. Pork and chicken are the most popular meat. However, protein is not abundant and rice, vegetables, and fruit make up the mainstay of the diet.

Figure 21–1: "King of Thai Noodles." Clement Street, San Francisco, California. Photo by Alyson Kohn. Courtesy of Stefanie Kohn.

Cultural Influences and Customs

Outside influences on Southeast Asian cooking are Chinese, Indian, and of tremendous import, the opening of the region by the Portuguese who became a conduit for European and New World foods. Chilies and chile sauces, for example, are now as important to the cuisine of Southeast Asia as say, tomatoes and tomato sauce are to Italian cooking. Yet no chile existed in the region until the Portuguese came in the 1500s. (Nor, of course, did tomatoes exist in Italy, tomatoes also being a New World food.)

Nonetheless, the Westerner would have no hesitation about calling the cuisine Asian, instead of Western, and when the region aspires to high cuisine, it still thinks of China. Davidson points out (p. 269) that, "Chinese cookery possesses, in Southeast Asia, something like the prestige accorded to French cuisine in Europe. It is everywhere a noticeable and in some places the dominant influence."

Utensils are sometimes a surprise to Westerners, who often expect all Asians to use chopsticks as the Chinese do. But in general, food is eaten with a fork and spoon, or with the fingers (of the right hand). Only noodles are eaten with chopsticks. Once in a Thai restaurant in the American Midwest I overheard an American diner ask the Thai owner for chopsticks. "What do you want chopsticks for?" he bellowed, "We don't use them! Use the fork and spoon I gave you." I was very surprised by the vehemence as I had never seen a Thai restaurateur become visibly angry over anything.

Westerners in Southeast Asia are often surprised by the richness and ubiquitousness of street food and night markets. It is as characteristic of Southeast Asia as are excellent cafes in Paris, or tapa bars in Madrid. Nothing similar really exists elsewhere, at least in North America.

Further Reading

Brennan, Jennifer. *The Cuisines of Asia*. London: Macdonald, 1984.

————. *Thai Cooking*. London: Macdonald, 1985.

Christie, Anthony. "Buddhist Attitudes Towards Food: Aspects of Tradition and Practice in Southeast Asia." *Petits Propos Culinaires 35*. London: Prospect Books, 1990.

Davidson, Alan. *Fish and Fish Dishes of Laos*. Tokyo: Charles E. Tuttle, 1975.

————. *Seafood of South-East Asia*. Singapore: Federal Publications, 1976. Davidson, one of the most knowledgeable people in the world on food, and one who has a special interest in Southeast Asia, has in this volume among other marvels a wonderful summary of the ingredients in Southeast Asian cookery.

Hosking, Richard. "The Candle-Scented Cakes and Sweets of Thailand." *Petits Propos Culinaires 42*. London: Prospect Books, 1992.

Iddison, Philip. "Edible Fungi of Thailand: A Glossary." *Petits Propos Culinaires 40*. London: Prospect Books, 1992.

Kittler, Pamela G., and Kathryn Sucher. *Food and Culture in America*. New York: Van Nostrand Reinhold, 1989.

Morris, Sallie. *South-East Asian Cookery*. London: Grafton Books, 1989. An accessible introduction, well-written.

Owen, Sri. *Indonesian Regional Cooking*. New York: St. Martin's Press, 1995.

————. *The Rice Book*. London: Doubleday, 1993.

————, and Roger Owen. *Indonesian Food and Cookery*. London: Prospect Books, 1986.

Piper, Jacqueline M. *Rice in Southeast Asia: Cultures and Landscapes*. Oxford: Oxford University Press, 1993.

————. "Public Eating, Public Manners in Asia." *Proceedings of the Oxford Symposium, 1991*. London: Prospect Books, 1992.

Wallace, Alfred. "Durian." Reprinted in Alan Davidson, *On Feasting and Fasting*. London: Macdonald Orbis, 1988. From Wallace's *The Malay Archipelago*, first published in 1869.

Tea

KAKUZO OKAKURA

[Kakuzo Okakura, Curator of Chinese and Japanese Art at the Boston Museum of Fine Arts, published in 1906 a slim volume which has become a classic, *The Book of Tea*. We reprint here, from the original edition, a selection from the second and seventh chapters on the history of tea. Okakura's account is marked, understandably, by his pride in the Japanese contributions to what he calls "Teaism": his posture, as lawyers say, is that while Teaism first reached true greatness in China, today it is only in Japan that the true flame still burns. Later writers on tea have all taken Okakura's much quoted book as their jumping off place. Yet only Okakura's *fin-de-siècle* prose, delicate to the point of affectation, captures the atmosphere of exquisite sensibility and almost painful refinement that truly characterizes Asian tea ceremonies. Our text is from the Fox, Duffield and Company first edition of 1906.—Editors.]

Tea is a work of art and needs a master hand to bring out its noblest qualities. We have good and bad tea, as we have good and bad paintings—generally the latter. There is no single recipe for making the perfect tea, as there are no rules for producing a Titian or a Sesson. Each preparation of the leaves has its individuality, its special affinity with water and heat, its hereditary memories to recall, its own method of telling a story. The truly beautiful must be always in it. How much do we not suffer through the constant failure of society to recognise this simple and fundamental law of art and life; Lichihlai, a Sung poet, has sadly remarked that there were three most deplorable things in the world: the spoiling of fine youths through false education, the degradation of fine paintings through vulgar admiration, and the utter waste of fine tea through incompetent manipulation.

Like art, Tea has its periods and its schools. Its evolution may be roughly divided into three main stages: the Boiled Tea, the Whipped Tea, and the Steeped Tea. We moderns belong to the last school. The Cake-tea which was boiled, the

Powdered-tea which was whipped, the Leaf-tea which was steeped, mark the distinct emotional impulses of the T'ang [618 A.D.–906 A.D.], the Sung [910 A.D.–1279 A.D.], and the Ming [1368 A.D.–1644 A.D.] dynasties of China.

The tea-plant, a native of southern China, was known from very early times to Chinese botany and medicine. It is alluded to in the classics under the various names of T'o, She, Chu'uan, Chia, and was highly prized for possessing the virtues of relieving fatigue, delighting the soul, strengthening the will, and repairing the eyesight. It was not only administered as an internal dose, but often applied externally in the form of paste to alleviate rheumatic pains. The Taoists claimed it as an important ingredient of the elixir of immortality. The Buddhists used it extensively to prevent drowsiness during their long hours of meditation.

By the fourth and fifth centuries Tea became a favourite beverage among the inhabitants of the Yangtse-Kiang valley. It was about this time that the modern ideograph Ch'a was coined [to symbolize tea], evidently a corruption of the classic T'ou. The poets of the southern dynasties have left some fragments of their fervent adoration of the "froth of the liquid jade." Then emperors used to bestow some rare preparation of the leaves on their high ministers as a reward for eminent services. Yet the method of drinking tea at this stage was primitive in the extreme. The leaves were steamed, crushed in a mortar, made into a cake, and boiled together with rice, ginger, salt, orange peel, spices, milk, and sometimes with onions! The custom obtains at the present day among the Tibetans and various Mongolian tribes, who make a curious syrup of these ingredients. The use of lemon slices by the Russians, who learned to take tea from the Chinese caravansaries, points to the survival of the ancient method.

It needed the genius of the T'ang dynasty to emancipate Tea from its crude state and lead to its final idealisation. With Lu Wu [d. 804 A.D., author of the first book about tea] we have our first apostle of tea. He was born in an age when Buddhism, Taoism, and Confucianism were seeking mutual synthesis. The pantheistic symbolism of the time was urging one to mirror the Universal in the Particular. Lu Wu, a poet, saw in the Tea-service the same harmony and order which reigned through all things. In his celebrated work, the Ch'a Ching (The Holy Scripture of Tea) he formulated the Code of Tea. He has since been worshipped as the tutelary god of the Chinese tea-merchants.

The Ch'a Ching consists of three volumes and ten chapters. In the first chapter Lu Wu treats of the nature of the tea-plant, in the second of the implements for gathering the leaves, in the third of the selection of the leaves. According to him the best quality of the leaves must have "creases like the leathern boot

of Tartar horsemen, curl like the dewlap of a mighty bullock, unfold like a mist rising out of a ravine, gleam like a lake touched by a zephyr, and be wet and soft like fine earth newly swept by rain."

The fourth chapter is devoted to the enumeration and description of the 24 members of the tea-equipage, beginning with the tripod brazier and ending with the bamboo cabinet for containing all these utensils.

It is interesting to observe in this connection the influence of tea on Chinese ceramics. The Celestial porcelain, as is well known, had its origin in an attempt to reproduce the exquisite shade of jade, resulting, in the T'ang dynasty, in the blue glaze of the south, and the white glaze of the north. Lu Wu considered the blue as the ideal colour for the tea-cup, as it lent additional greenness to the beverage, whereas the white made it look pinkish and distasteful. It was because he used cake-tea. Later on, when the tea-masters of Sung took to the powdered tea, they preferred heavy bowls of blue-black and dark brown. The Mings, with their steeped tea, rejoiced in light ware of white porcelain.

In the fifth chapter Lu Wu describes the method of making tea. He eliminates all ingredients except salt. He dwells also on the much-discussed question of the choice of water and the degree of boiling it. According to him, the mountain spring is the best, the river water and the spring water come next in the order of excellence. There are three stages of boiling: the first boil is when the little bubbles like the eye of fishes swim on the surface; the second boil is when the bubbles are like crystal beads rolling in a fountain; the third boil is when the billows surge wildly in the kettle. The Cake-tea is roasted before the fire until it becomes soft like a baby's arm and is shredded into powder between pieces of fine paper. Salt is put in the first boil, the tea in the second. At the third boil, a dipperful of cold water is poured into the kettle to settle the tea and revive the "youth of the water." Then the beverage is poured into cups and drunk. O nectar! The filmy leaflets hung like scaly clouds in a serene sky or floated like waterlilies on emerald streams. It was of such a beverage that Lu T'ung, a T'ang poet, wrote: "The first cup moistens my lips and throat, the second cup breaks my loneliness, the third cup searches my barren entrails but to find therein some five thousand volumes of odd ideographs. The fourth cup raises a slight perspiration—all the wrong of life passes away through my pores. At the fifth cup I am purified; the sixth cup calls me to the realms of immortals. The seventh cup—ah, but I could take no more! I only feel the breath of cool wind that rises in my sleeves. Where is Horaisan? [A mythical island paradise with life-giving herbs and a Fountain of Youth.] Let me ride on this sweet breeze and waft away thither."

The remaining chapters of the *Ch'a Ching* treat of the vulgarity of the ordinary methods of tea drinking, a historical summary of illustrious tea drinkers, the famous tea plantations of China, the possible variations of the tea service, and illustrations of the tea utensils. The last is unfortunately lost.

The appearance of the *Ch'a Ching* must have created considerable sensation at the time. Lu Wu was befriended by the Emperor T'ai Tsung (763–779), and his fame attracted many followers. Some exquisites were said to have been able to detect the tea made by Lu Wu from that of his disciples. One mandarin has his name immortalised by his failure to appreciate the tea of this great master.

In the Sung dynasty the whipped tea came into fashion and created the second school of Tea. The leaves were ground to fine powder in a small stone mill, and the preparation was whipped in hot water by a delicate whisk made of split bamboo. The new process led to some change in the tea-equipage of Lu Wu, as well as the choice of leaves. Salt was discarded forever. The enthusiasm of the Sung people for tea knew no bounds. Epicures vied with each other in discovering new varieties, and regular tournaments were held to decide their superiority. The Emperor Huei Tsung (1101–1124), who was too great an artist to be a well-behaved monarch, lavished his treasures on the attainment of rare species. He himself wrote a dissertation on the twenty kinds of tea, among which he prizes the "white tea" as one of the rarest and finest quality.

The tea-ideal of the Sungs differed from the T'angs' even as their notions of life differed. They sought to actualise what their predecessors tried to symbolise. To the Neo-Confucian mind the cosmic law was not reflected in the phenomenal world, but the phenomenal world was the cosmic law itself. Aeons were but moments— Nirvana always within grasp. The Taoist conception that immortality lay in the eternal change permeated all their modes of thought. It was the process, not the deed, which was interesting. It was the completing, not the completion, which was really vital. Man came thus at once face to face with nature. A new meaning grew into the art of life. The tea began to be not a poetical pastime, but one of the methods of self-realisation. Wang Yuan Chih eulogised tea as "flooding his soul like a direct appeal, that its delicate bitterness reminded him of the after-taste of a good counsel." Sotumpa [Su Tung-p'o] wrote of the strength of the immaculate purity in tea which defied corruption as a truly virtuous man. Among the Buddhists, the southern Zen sect, which incorporated so much of Taoist doctrines, formulated an elaborate ritual of tea. The monks gathered before the image of Bodhidharma [the first "patriarch," half-mythical, who brought Buddhism to China from India] and drank tea out of a single bowl with the profound formality of a holy sacrament. It was this [Chinese] Zen ritual which finally developed into the Tea ceremony of Japan in the fifteenth century.

Figure 22–1: Traditional cast iron teapot, Qing Dynasty.
Photo by Amy Feldman. Courtesy of Y.F. Du.

Unfortunately, the sudden outburst of the Mongol tribes in the thirteenth century, which resulted in the devastation and conquest of China under the barbaric rule of the Yuen Emperors, destroyed all the fruits of Sung culture. [Note: Untrue. From here on Okakura begins grinding his axe: that Chinese culture somehow declined and only Japan preserved the authentic methods of Tea.—Eds.] The native dynasty of the Mings which attempted re-nationalisation in the middle of the fifteenth century was harassed by internal troubles, and China fell under the alien rule of the Manchus in the seventeenth century. Manners and customes changed to leave no vestige of the former times. The powdered tea is entirely forgotten. We find a Ming whisk mentioned in one of the Sung classics. Tea is now taken by steeping the leaves in hot water in a bowl or cup. The reason why the Western world is innocent of the older method of drinking tea is found in the fact that Europe knew it only at the close of the Ming dynasty.

Figure 22–2: Yixing ceramic teapot in the shape of a bottle gourd.
Photo by Amy Feldman. Courtesy of Y.F. Du.

Japan, which followed closely on the footsteps of Chinese civilization, has known tea in all its three stages. As early as the year 729 we read of the Emperor Shomu giving tea to one hundred monks at his palace in Nara. The leaves were probably imported by our ambassadors to the T'ang Court and prepared in the way then in fashion. In 801 the monk Saicho [returning from China with cultural information] brought back some seeds and planted them in Yeisan. Many tea gardens are heard of in the succeeding centuries, as well as the delight of the aristocracy and priesthood in the beverage. The Sung tea reached us in 1191 with the return of Eisai Zenji, who went there to study the southern Zen school. The new seeds which he carried home were successfully planted in three places, one of which, the Uji district near Kyoto, bears still the name of producing the best tea in the world. The southern Zen spread with marvellous rapidity, and with it the tea ritual and the tea-ideal of the Sung. By the fifteenth century, under the patronage of the Shogun, Ashikaga Yoshimasa, the tea ceremony is fully consti-

tuted and made into an independent and secular performance. Since then Teaism is fully established in Japan. The use of the steeped tea of the later China is comparatively recent among us, being known only since the middle of the seventeenth century. It has replaced the powdered tea in ordinary consumption, though the latter still continues to hold its place as the tea of teas.

The connection of Zennism with tea is proverbial. We have already remarked that the tea ceremony was a development of the Zen ritual. The name of Lao Tzu, the founder of Taoism, is also intimately associated with the history of tea. . . . We shall not stop to discuss the authenticity of such tales, which are valuable, however, as confirming the early use of the beverage by the Taoists. Our interest in Taoism and Zennism here lies mainly in those ideas regarding life and art which are so embodied in what we call Teaism.

It is in the Japanese tea ceremony that we see the culmination of tea-ideals. Our successful resistance of the Mongol invasion in 1281 had enabled us to carry on the Sung movement, so disastrously cut off in China itself through the nomadic inroad. Tea with us became more than an idealisation of the form of drinking; it is a religion of the art of life. The beverage grew to be an excuse for the worship of purity and refinement, a sacred function at which the host and guest joined to produce for that occasion the utmost beatitude of the mundane. The tearoom was an oasis in the dreary waste of existence where weary travellers could meet to drink from the common spring of art-appreciation. The ceremony was an improvised drama whose plot was woven about the tea, the flowers, and the paintings. Not a colour to disturb the tone of the room, not a sound to mar the rhythm of things, not a gesture to obtrude on the harmony, not a word to break the unity of the surroundings, all movements to be performed simply and naturally—such were the aims of the tea ceremony. And strangely enough it was often successful. A subtle philosophy lay behind it all. Teaism was Taoism in disguise.

[Okakura ends his book by extolling the tea-masters, who changed what had been cuisine into a way of life, exemplifying the Zen virtues. The person who raised tea to art (could we call it performance art?) and indeed, to religion, was, as Okakura faithfully reports here, Sen-no-rikyu (1522–1591), revered by all the Japanese cha-do (Way of Tea) schools. He practiced at the Daisen'in subtemple within the magnificent Daitoku-Ji Temple in Kyoto, the headquarters of Zen's powerful Rinzai sect. In our time, the Zen writer that the West knows best, D. T. Suzuki, belonged to this sect. Sen-no-rikyu, ordered to commit suicide by Hideyoshi, his former patron, gave one last tea ceremony and exited with consummate personal

Figure 22–3: Yixing ceramic teapot in the shape of a reed chest.
Photo by Amy Feldman. Courtesy of Y.F. Du.

dignity, a gesture still admired in Japan. There are parallels to Socrates'
exemplary suicide in the face of tyranny. His tomb, near the tea ceremony
room, is a national landmark.—Eds.]

The tea-masters held that real appreciation of art is only possible to those who make of it a living influence. Thus they sought to regulate their daily life by the high standard of refinement which was found in the tea-room. In all circumstances serenity of mind should be maintained, and conversation should be so conducted as never to mar the harmony of the surroundings. The cut and colour of the dress, the poise of the body, and the manner of walking could all be made expressions of artistic personality. These were matters not to be lightly ignored, for until one has made himself beautiful he has no right to approach beauty. Thus the tea-master strove to be something more than the artist—art itself. It was the Zen of aestheticism

Figure 22—4: Japanese teahouse, Katsura Imperial Villa, Kyoto, Japan.
Early 1600s. Photo by George J. Leonard.

Manifold indeed have been the contributions of the tea-masters to art. They completely revolutionised the classical architecture and interior decoration. All the celebrated gardens of Japan were laid out by the tea-masters. Our pottery would probably never have attained its high quality of excellence.

Great as has been the influence of the tea-masters in the field of art, it is as nothing compared to that which they have exerted on the conduct of life They have given emphasis to our natural love of simplicity and shown us the beauty of humility. In fact, through their teachings, tea has entered the life of the people.

[By the Editors: About the teapots illustrated in this article (Fig. 22—1), Du Feibao and Hong Su have written that Yixing, Jiangsu Province, known in China as the "Pottery Metropolis," produces a much-valued red ware or boccaro ware. "Already in the Song Dynasty, one thousand years ago, these teapots were appraised as superior vessels."

The Japanese artworld has a word for this form of popular craftwork: "Mingei." China now esteems Yixing teapots much the way America has come to

esteem its homemade quilts—the Yixing teapots are widely collected, and even appear on China's stamps. Du and Hong write,

> "Yixing earthenware is generally marked by simplicity and exquisite craftsmanship: it is also appreciated for its practical utility. The material, called zisha (purple sand), is abundantly available in the area. Although not as white or as fine as kaolin, it needs no glazing and, after firing, the product is solid and impermeable, yet porous enough to "breathe." A Yixing teapot enhances the tea brewed in it in terms of color, perfume, and taste. Its walls seem to absorb the tea and keep its fragrance. In summer tea can be stored in the pots overnight, without spoiling. With hot tea inside, the pot does not scald the hand because purple sand is a slow heat conductor. But in winter it can also serve as a handwarmer, and is left on a low fire to make certain types of tea which require simmering. To the Chinese connoisseur, it is the "ideal teapot."

What makes the Yixing earthenware all the more attractive is the tasteful designs it bears. Artisans cut or incise on the unfired wares pictures of birds and fish, flowers and animals, Chinese characters and seal marks all in the traditional style, thus turning practical objects into works of art with national character. Prof. Y.F. Du graciously loaned us Yixing teapots for our photographs.]

Further Reading

Anderson, Jennifer L. *An Introduction to Japanese Tea Ritual*. Albany: State University of New York Press, 1991. Excellent, specialized study on the history and practice of the tea ceremony.

Blofeld, John. *The Chinese Art of Tea*. Boston: Shambhala Publications, 1985.

Lu Yu. *The Classic of Tea*. Trans. by Francis Ross Carpenter. Boston: Little, Brown, 1974.

Okakura, Kakuzo. *The Book of Tea*. New York: Dover Publications, 1964.

Fengshui, Chinese Medicine, and Correlative Thinking

MARY SCOTT

If you walk down a street anywhere in the Chinese-speaking world from Beijing to Bangkok to Vancouver, you may notice a small round, hexagonal or octagonal mirror hanging on a building. It may have a *yin-yang* diagram inscribed on it, or it may be framed by the *eight trigrams*, or it may be quite plain. Whatever it looks like, you can be sure that someone has put it there to adjust the building's *fengshui* by deflecting the flow of *sha qi*, malign qi.

Fengshui, or geomancy, is the art of properly placing oneself within one's environment. It is based on an ancient Chinese understanding of the universe as a continuous flow of *qi*, vital energy or cosmic breath. Everything is made of qi: human bodies, clouds and mountains—or wind and water, which is what the term fengshui literally means. Qi is believed to operate as a complex fluctuation around complementary poles called yang and yin, commonly represented in a diagram like two interlocking commas, one black and one white, each with a dot of the other color in it.

Every thing, event, or situation in the world has both yang and yin qualities. The terms "yang" and "yin" may describe any pair of complementary qualities: positive and negative, male and female, hot and cold, hard and soft, dry and wet, active and passive, outer and inner, heaven and earth, mountains and water, light and shadow. All of these are aspects of qi, and one should understand them as mutually defining qualities that give rise to each other, rather than as absolute opposites. In fact, there are no absolutes or first causes in this kind of thinking, for any single element can only be understood in relation to the system as a whole. Moreover, qi is not static. At any particular moment or at any particular place, qi may tend toward the positive or the negative. It may be more concentrated in some places or persons than in others, or it may become blocked and stagnant, or even malignant.

Figure 23–1:"Feng Shui Supplies."A store near famous surfing beaches in Encinitas, California, sells fengshui supplies and Chinese medicine. Photo by George J. Leonard.

The same correlative thinking[1] that underlies fengshui also underlies the various kinds of traditional Chinese health and medical practices. All of these practices are based on the belief that human beings can intelligently redirect the flow of qi to enhance human life. Fengshui redirects the flow of qi on an interpersonal and environmental scale. Acupuncture, herbal medicine, the gentle, flowing exercises of *tai ji chuan*, and the various practices of spiritual concentration known as *qi-gong*, "qi mastery," all aim to harmonize the flow of qi in the body. Practitioners of traditional Chinese medicine and martial arts see the human body as a universe in miniature, just as geomancers see buildings and city sites as human bodies on a gigantic scale. The well-being of both body and universe depends on conserving one's qi while keeping it in steady and harmonious circulation.

The eddies within the flow of qi may be very complex, so several interrelated descriptive and classificatory systems have evolved to describe them. Yin-yang is merely the simplest and best known of these. The Yijing trigrams and

hexagrams, the Five Phases, or Five Elements, the animals of the zodiac, and the *gan zhi,* "stems and branches," of the calendrical system are all commonly used both in fengshui and in medical practice, as well as in other aspects of daily life. Like the yin-yang polarity, all of these systems are based on the understanding that any configuration of circumstances involves an interplay of only relatively dominant or subordinate factors, a network pattern of causation rather than a linear pattern.

The eight trigrams of the Yijing, or Classic of Changes (old spelling: I Ching), one of the most ancient sets of such analytic terms, consist of eight sets of three parallel horizontal lines each. The lines may be either continuous or broken, so that one of the trigrams (*qian,* or ultimate yang) has three unbroken lines, and one (*kun,* or ultimate yin) has three broken lines. The other six trigrams, which include all possible combinations of broken or continuous lines, represent points within the yin-yang continuum. To express a further degree of complexity, the trigrams may be stacked in pairs to become hexagrams. There are sixty-four possible permutations of continuous and broken lines in this system, expressing very fine gradations within the yin-yang continuum. Both the eight trigrams and the sixty-four hexagrams are emblematic of the Taoist way of harmony and holism, which is what the practice of fengshui aims to achieve.

Another ancient set of descriptive terms for complex systems is the *wu xing* (five elements or five phases) system. This is a series of correspondences between the five mutually generative or destructive phases of qi (fire, water, wood, metal, earth), the five directions (south, north, east, west, center), colors (red, black, blue/green, white, yellow), and various other aspects of experience. Like the trigrams and hexagrams, this system can express variations in qi through time as well as space, through its associations with particular seasons of the year. The animals associated with each of the five phases are also part of the traditional timekeeping and calendar systems.

In this part of the system, the practice of fengshui shades into the practices of divination and prognostication, since one's fortunes are often predicted through the eight characters *(ba zi)* linked to the minute, hour, day, and year of one's birth, and through the qualities attributed to the zodiac animal associated with the year of one's birth. It is particularly lucky, for example, to be born in the year of the dragon, while women born in a horse year are generally thought to be undesirable marriage partners.

All of this is a fund of common knowledge and terminology that Chinese physicians and practitioners of fengshui apply in their particular specialized ways. A doctor uses them to describe the patient's symptoms and to think through the

best course of treatment. A fengshui master also uses these terms to describe a presentation of symptoms and to devise a remedy, for the task of a *fengshui xiansheng*, "master geomancer," is to determine the best arrangement for any built environment, whether it is a gravesite, a new hospital, an existing office building, a garden, or a house that is being remodeled.

Rather like a physician, the fengshui master first evaluates the existing configuration of qi on the site, looking at it with a practiced eye and assessing its hidden patterns of qi with a *luopan*. This is a magnetic compass with sliding concentric rings, which may be inscribed in various ways with the trigrams and hexagrams, the five phases, and the calendrical characters.

Some kinds of sites and buildings have ideal fengshui, because they catch and hold auspicious qi while still allowing it to circulate. Luoyang, Xi'an, and other ancient Chinese cities were geomantically sited, protected by a screen of mountains to the north along which a vein of auspicious qi was believed to run. The Forbidden City in Beijing was built according to fengshui principles, with a southward orientation, an artificial mountain on the north side behind the palace, and a stream diverted and channeled to flow past the main entrance on the south side. The sites of the imperial tombs were also chosen for their perfect fengshui. Ideally, gravesites should be elevated and well-drained, protected at the north and northeast by mountains, with a view southward over a body of water. The same basic set of principles still governs the ordinary person's choice of gravesites today.

Most of a fengshui xiansheng's practice, however, is to devise alterations that will make the best of physical environments that are less than ideal, or to help someone to avoid a truly disastrous physical setting. Fengshui is linked to the practice of Chinese medicine in that the physical environment can influence one's health or sense of well-being. It is not good fengshui, for example, to have a toilet too near a kitchen, or to place a desk so that one sits with one's back to a door or squinting into bright sunlight. Many people believe that a house at the juncture of a T-intersection has "inauspicious qi shooting straight toward the door," but it may in fact be less tranquil because of its site, and the inhabitant's sense of well-being may be affected.

A fengshui xiansheng may recommend placing a crystal ball or windchimes in a corridor or by a badly placed door, or he may suggest hanging a Chinese flute on a wall to redirect qi. He might recommend painting a room a brighter or gentler color, softening a jutting corner with a carefully placed green plant, or adding a tank of brightly colored tropical fish. Fengshui decisions often make good sense in terms of sensory pleasure and comfort. Careful placement of mirrors, lighting, ventilation, and furniture can certainly enhance an interior and prob-

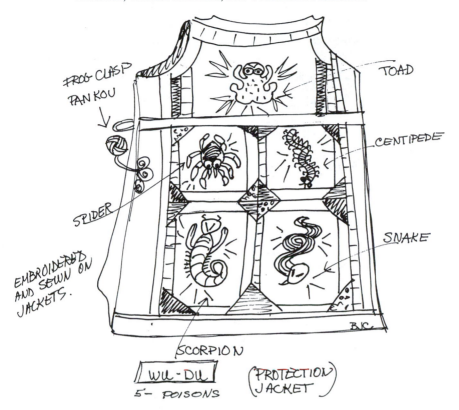

FROG CLASP
PAN KOU

TOAD

CENTIPEDE

SPIDER

SNAKE

EMBROIDERED
AND SEWN ON
JACKETS.

B.C.

SCORPION

WU-DU
5- POISONS

PROTECTION
JACKET

Figure 23–2: Child's Protection Jacket. Drawing by Betty Cornell. Used by permission of the artist. Courtesy of George J. Leonard.

ably makes for more harmonious human interaction as well. Fengshui can seem like a sophisticated form of urban studies, in its analysis of how the shape or shadow of other buildings may affect a site, or how vehicular and pedestrian traffic patterns might affect a business there. It can also be a form of market analysis or consumer psychology, in its understanding of the subliminal effects of a bright neon sign or a wide, welcoming door on potential customers.

People often consult a fengshui xiansheng when considering a real estate purchase. Many people in the Chinese-speaking world would also consult a fengshui specialist in cases of inexplicable illness, infertility, family discord, or business losses. A restaurant owner may swear that profits have gone up since he took a fengshui xiansheng's advice to widen the entrance to his restaurant. A man may be convinced that his wife has borne a son because of his own careful attention to the size or placement of their bed. A woman may be sure that her child's serious illness has been caused by an open spiral staircase in their home. Through-

out Chinese history a family's misfortune has often been attributed to incorrect placement or inadequate care of their ancestors' graves. Sometimes people will explain an event like the conquest of a city or the death of a political leader as the consequence of a disastrous shift in fengshui caused by re-channeling a river, leaving a city gate open so that all the auspicious qi drains away, or demolishing an important building.

In similar fashion, traditional Chinese doctors understand illness as a disruption of the body's *qi*. Good health is a balance among the various functional systems of the body. Chinese physicians refer to these in five phases/five elements terms: the metal element is associated with the respiratory system, for example, while the water element is associated with the kidneys, the earth element with the spleen, the fire element with the heart, and the wood element with the liver. In spite of this superficial correspondence of English and Chinese terms, the functional systems are bodily processes, which do not correspond to what Western anatomy identifies as bodily organs.[2]

Illness is thus a disharmony of the functional systems, which corresponds to a shortage or surfeit of one or more of the five phases. This shortage or surfeit unbalances all of the other systems, which can be re-balanced in several ways. One of the most important is diet, which should be carefully tailored to the person's age and sex, as well as to the season of the year and the physical environment. It is also important to care for oneself by avoiding all bodily and emotional shocks and excesses, from drinking icewater to sitting in a draft to overindulging in sex or alcohol.

The first thing a traditional Chinese physician does is examine the patient's appearance, including the skin, the eyes, and the tongue. Along with this, a doctor asks questions about the patient's symptoms. An equally important diagnostic technique is to take the patient's pulse, or pulses, for there are a number of different ones. It is not just the pulse-rate that matters, but its character. Weak, strong, rapid, slow, fluttering, thready, irregular, lethargic, or agitated pulses at any of the several pulse-points are the physician's best guide to the particular character of the imbalance. Once the imbalance has been diagnosed, it can be treated with some combination of diet, rest, medicine, acupuncture, moxibustion, exercise, baths, and massage. Although anaesthesia and surgery were known early in Chinese history, the practice of Chinese medicine since that time has rarely included them. Chinese physicians have generally conceived of medical treatment as an adjunct to the human body's enormous capacity to heal itself. Broken limbs, for example, are set with very light splints and the patient is encouraged to use the limb as soon as possible.

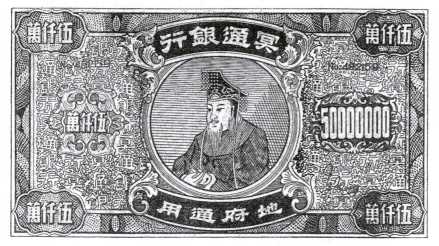

Figure 23–3: Spirit bank note, to be burnt during a sacrifice, thereby sending the "money" to the ancestors. Bundles of these are for sale in ordinary grocery stores, much the way Roman Catholic votary candles are in the United States— a similar practice. Purchased in Hong Kong. Courtesy of George J. Leonard.

Acupuncture is the virtually painless and bloodless insertion of fine needles into the body at particular points that are meant to stimulate or redirect sluggish or deficient qi. Sometimes a mild electrical current is passed through the needles as well, intensifying the sensation of numbness or tingling that the needles induce by themselves. The map of acupuncture points on the body has been built up through centuries of clinical practice. For some kinds of pain and disorders of the musculo-skeletal system acupuncture is very effective, and it may also be a part of a successful treatment for a wide variety of other problems. An acupuncture point generally governs some relatively distant part of the body; a point between the thumb and forefinger, for example, can be used to control nausea. Moxibustion, the controlled, slow burning of a cone of dried *moxa* (an herb that English speakers call artemesia) at certain points on the skin to induce a mild burn, operates on the same general principles as acupuncture, as does the technique of applying pressure to various points on the body. Although in recent years acupuncture has become almost synonymous with Chinese medicine in the West, a traditional Chinese doctor is more likely to treat a patient with medicine alone.

Treatment with orally administered herbs and other substances is a central part of Chinese medical practice. The Chinese traditional pharmacopia is extensive, and a medical prescription may have many different ingredients. A Chinese apothecary is likely to stock hundreds of medicinal plants, including **ginseng**, ginger, mulberry, chrysanthemum, cinnamon, cassia, angelica, and many other common

and uncommon plants. The apothecary will also stock deer antlers, silkworm co-coons, dried lizards, and various minerals, but most prescriptions consist only of a variety of leaves and roots. Some prescriptions can be bought already made up, but generally a physician prescribes medication with some ingredients specific to the imbalance itself and others appropriate to imbalances of that sort in a person of the patient's age and sex. The prescribed ingredients are then simmered in hot water to make a medicinal tea, which the patient drinks in frequent doses, often over a con-siderable time. A course of treatment with herbs often includes the recommenda-tion that the patient should be wrapped up in a bed quilt to sweat.

Because the practice of Chinese medicine has existed side by side with Western medicine in China for almost two hundred years, most Chinese-speak-ers are acquainted with at least the rudiments of both and choose between them according to the nature of their illness. For immediately life-threatening injuries or illnesses, most would choose Western-style antibiotics or surgery. For less immediately life-threatening conditions, many people prefer Chinese medicine. Although it often takes longer to work, many patients find that it is at least as ef-fective as Western medicine and has few or no side effects.

Notes

1. This now standard term was first widely known through Joseph Needham's monu-mental *Science and Civilization in China*.

2. See Porkert and Ullman, pp. 13–57, for a more detailed explanation of the differences between Chinese and Western conceptions of the body.

Further Reading

Howson, Mark. *The Practice of Chinese Medicine*. Trans. by Manfred Porkert and Christian Ullman. New York: William Morrow, 1988. A clear and thoughtful guide to both theory and practice.

Lip, Evelyn. *Fengshui for the Home*. Union City, CA: Heian International, 1990.

Needham, Joseph. *Science and Civilization in China, Vols. I & II*. Cambridge: Cambridge University Press, 1959. The classic account of the correlative thinking underlying Chinese medicine and the practice of fengshui.

————. *A Shorter Science and Civilization in China*.

Porkert, Manfred. *The Theoretical Foundations of Chinese Medicine: Systems of Correspondence*. Cam-bridge: MIT Press, 1978. The best description of Chinese medical ideas.

Rossbach, Sarah. *Fengshui: The Art of Placement*. New York: E.P. Dutton, 1985.

Lunar New Year, the Moon Lady, and the Moon Festival

MOLLY H. ISHAM

Chinese New Year at Grandma's House

In the United States, even very assimilated Asian Americans still enjoy celebrating the great holiday of Lunar New Year. In San Francisco, the schools even have off, so many students—Asian and non-Asian—love to take part. (The only other ethnic holiday as popular is Cinco de Mayo.) The United States Postal Service now issues stamps every year commemorating the new Lunar year, with Chinese calligraphy giving the year's name, and an appropriate animal symbol.

Every twelve years in the Chinese calendar is a cycle, and each year is represented by an animal symbol. The twelve animals are Rat, Ox, Tiger, Rabbit, Dragon, Serpent, Horse, Ram, Monkey, Rooster, Dog, and Boar. The year 2000 in the Western calendar will be the year of the dragon, 4698th year in the lunar calendar. Regardless in which part of the world the Chinese people live, they always have a big celebration during the Lunar New Year. I have vivid memories of the Lunar New Year celebrations at my grandmother's place in China in the 1930s.

As a young child I lived with my parents in the British Concession of Tianjin, north China, better known to Westerners as Tientsin. My *wai po,* maternal grandmother, lived in Peking, today's Beijing, only a little over an hour away by *huoche,* train. During every major festival, like *Duan Wu Jie,* Dragon Boat Festival, or *Zhong Qiu Jie,* Moon Festival, my parents and I would go over to Grandma's house for a short stay. But, during *Zhongguo Xin Nian,* the Chinese New Year, also called *Yinli Nian,* Lunar New Year, we would stay and celebrate for at least a month. Weeks, even months, before the New Year, I would start counting the days and impatiently awaited its arrival.

The preparation for the New Year actually began on *La Ba,* December eighth on the Lunar calendar, and on that day my grandmother would make several big

jars of *la ba cu* (*cu* is pronounced "tsu"), December 8th vinegar. She put a lot of *suan,* garlic, and a little bit of sugar into the dark brown *Zhenjiang,* vinegar, and they would be ready for consumption on New Year's Eve. Zhenjiang is a city in Jiangsu province, about 137 miles west of Shanghai, famous for its high quality brown vinegar. She would also cook a big pot of *la ba zhou,* December 8th porridge, a rice porridge eaten on that day. La Ba Zhou is sweet, and has eight nourishing ingredients including glutinous rice, lotus seeds, dried Chinese dates, and different kinds of nuts and dried fruit. I remember how I used to love La Ba Zhou; and if nobody stopped me, I could eat two big bowls of it.

The two weeks after La Ba would be the busiest time for the women in the household. All the children had to have *xin yifu,* new clothes, to wear on *Nian Chu Yi,* New Year's Day. My mother and *yima,* aunties, would go from shop to shop buying different colored silks, blue for boys and maroon for girls, to make *mian ao,* padded jackets and *mian ku,* padded pants, for my cousins and myself. They would usually buy a new coat for Grandma and a fur hat or a warm winter vest for *wai gong,* maternal grandfather, as well. As a rule, twice a year the family provided all the domestic servants with new clothes, once in summer, and the other at Chinese New Year. By the time Mother got home with boxes of materials, Grandma's two favorite tailors were already in the sewing room taking the measurements of all the children. I hated to be measured, it took so long, and I was not allowed to move. Even the chirp of a bird would be an excuse for me to run outside, and then my *Amah,* maid, would chase after me all around the courtyard.

Grandma loved to shop at the farmers' market, so during those two weeks she would stock up on *shuiguo,* fruits, and *lingshi,* between-meal nibbles, for the *guo pan,* fruit plate, a big round bowl-shape plate with a lid, 12 to 15 inches in diameter; it had dividers making it possible for the plate to hold nine different kinds of *guofu,* dried fruits, *guoren,* nuts, and *guazi,* melon seeds. She would take me on most of those trips, and my Amah would go along to help carry the heavy baskets. As a reward for going with her I came back loaded with all sorts of good food and toys. *Dong shizi,* frozen persimmons, has always been one of my favorites; I mixed it with powdered milk, and made it into a persimmon ice cream. This is also the time of year for people to indulge in *tang chao lizi,* chestnuts roasted in sugar and fine sand, and *kao baishu,* baked sweet potatoes. The vendors would carry their ovens on *biandan,* shoulder poles, and bake them at street corners, the hunger-provoking smell made it irresistible for passers-by. As for toys, Grandma would buy me paper dolls, *budao weng,* a roly-poly fisherman that refused to lie down, and sometimes *jianzi,* shuttlecocks, which I learned to kick with the inside of my ankle at a very young age.

On the 23rd of the Lunar December, offerings were laid out on the table for *Zao Wangye,* the **Kitchen God***,* and *Zao Wangnainai,* the Kitchen God's wife. By evening, a male representative would be chosen to *ketou,* kowtow, to the paintings of the celestial beings who had blessed and protected the kitchen of the family for almost a year (females are not allowed to pay respect to Kitchen Gods). Then came the ceremony of seeing the Kitchen God and his wife ascend to Heaven, *i.e.,* of burning the grease-spotted paintings in the backyard. My cousins and I loved to take part in this ceremony, because, after that we ate all the offerings. The new Kitchen God would not be "invited" back into the kitchen until the last day of the year. To show respect, when one purchases a painting of the Kitchen God, he cannot use the word "buy"; instead he says: "I would like to invite a Kitchen God into my house." Of course, he still needs to pay for it.

The next day, the 24th, was the beginning of a thorough house cleaning. Everything in the house was washed, swept, cleaned; all the brass candlesticks, bronze incense holders, and silverware polished. Meanwhile the food preparation went on without any interference. *Zui ji,* drunken chicken, *xun yu,* smoked fish, *huo tui,* ham, and various kinds of cold meat were precooked and kept for the New Year's Eve dinner. It was believed that cooking during the first few days of the Lunar new year might bring bad luck to the family, so lots of *baozi,* steamed dumplings, *mantou,* steamed buns, and meat and vegetable dishes were prepared on or before the 30th, enough to last the family for a whole week.

Grandma was an exceptionally good cook; she not only mastered the technique of cooking all the well-known northern and southern dishes for everyday meals and for banquets, she also made various different kinds of *dianxin,* snacks (please refer to "The Chinese Expressions" in Amy Tan's *The Joy Luck Club,* hereafter *JLC,* p. 10, Dyansyin). She used to make wonderful *zongzi,* pyramid-shaped dumplings, of various sizes and moon cakes with different fillings. (*JLC,* p. 71, Zong zi.) Some zongzi she made were as big as Chinese rice bowls, others as tiny as ping-pong balls, which she strung together for me to hang around my neck, like a necklace. Just before Chinese New Year, she would make three or four different kinds of *nian gao,* New Year cakes, which were made of sweet glutinous rice flour with walnut, pine nut, sesame seed, or bean paste fillings. They were steamed in wooden molds, and when ready, they came out in the shape of a fish, a turtle, a plum flower, a rose, and so on.

The most important dinner is the one on New Year's Eve, called *tuan yuan fan,* the family reunion dinner. The southerners in China call it *Nian Ye Fan,* New Year's Eve dinner. Since my grandparents were still alive, all my uncles and aunts with their children came to celebrate in the old people's house. The children would

sit at a separate table, and have *fan,* rice, *cai,* meat or vegetable dishes, and *tang,* soup. They wanted to get through dinner as quickly as possible, so they could attend to their *bianpao,* fire crackers, and would not miss the display of the *yanhuo,* fireworks. The adults would start with *pijiu,* beer, and *hong putao jiu,* red grape wine, accompanied by the *pinpan,* assorted cold dishes, which would include *jiang nurou,* beef cooked in soya sauce and the five spices, *haizhe,* jellyfish, shredded and mixed with sauces and green onions, *pidan,* thousand-year eggs, *bai qie ji,* white cut chicken, *pao cai,* pickled green vegetables, *su ya,* vegetarian duck. The hot dishes would include a huge *huoguo,* hot pot, with meat balls, fish balls and vegetables, *sixi rou,* Four Happiness Pork, *quan ya,* whole duck, *xia,* shrimp, and *qingzheng yu,* steamed fish. Fish is essential on New Year's Eve, because the Chinese word for fish, *yu,* has the same sound as the word "abundance" or "surplus." To eat fish, or to give a present bearing a fish, will bring good luck for the whole year.

When the clock strikes 12 at midnight, the *Jiaozi* party begins. This custom is not only observed in the Beijing area, but in many other cities and provinces as well. To make *jiaozi,* one uses a round shape wheat flour wrapping, stuffs it with meat and vegetables, then folds it in half and presses the outer edges together tightly. Jiaozi can be boiled or steamed; on New Year's Eve people usually boil them. There are a dozen different kinds of fillings we use to make jiaozi; the most popular ones are pork and cabbage, beef and chive, mutton and scallion, and for the vegetarians, pumpkin, fennel, or *doufu,* tofu, with spinach and mung bean thread.

Now, the whole family once more gathered by the round dining table to share the bowls of steaming hot, freshly cooked jiaozi. We children were still sweaty from running about dodging the fire crackers, and some of us even came in holding a handful of them. Impatiently we waited in line to wash our hands, and more impatiently we waited for the jiaozi on our plates to cool down, so we could eat them quickly. The fanciest fireworks went off after twelve o'clock. I remember seeing my uncles carrying them out, some looked like huge Quaker Oats boxes, others were in the shapes of large cookie tins or oversized shoe boxes. Once the uncles lit it, we all stood back and held our breath for what seemed to me to be nearly two minutes before there was any action. Then the bottom fell off, and the box made a hissing sound. The most exciting part was to watch colorful sparks shoot up 20 or 30 feet and gradually turn into a green *long,* dragon with yellow claws, or a bight red *feng,* phoenix with a long tail. My favorite one was called *Tiannu Sanhua,* Heavenly Beauty Scattering Flower Petals, in which the beauty kept throwing out flower petals from her basket. The flowers and the basket even had a three-dimensional look to them.

After the fireworks the grown-ups go back to the house to play cards or Mah jong (please refer to *JLC,* p. 5, Mah jong). We children would be ushered to bed, but before we went to sleep, we had to make sure all the *ya sui qian* we got that night were neatly tucked under our pillows. Ya sui qian is the money given to children at New Year's for good luck; it comes in a small red envelope, and the Cantonese speaking people call it *hong bao.*

On the first, second, and third days of the Lunar New Year children follow their parents around calling on relatives and friends to *bai nian,* wish (them) a Happy New Year. Again the children may get a lot of good luck money from the families they visit. We did not have many relatives to visit in Peking, therefore, my parents would usually take me to a place called *Changdian,* similar to a bazaar or a village fair. We watched the *mu ou xi,* puppet shows, and ate *tang hulu* (candy-coated haws strung on a bamboo stick) that were almost three feet long. The tang hulu sold in stores were only seven to nine inches long; only at New Year's time, and only in Changdian did they have the extra long tang hulu.

At the end of the fourth day of busy activities, everybody was exhausted. A few days of quietness and recuperation was a good change. However, we couldn't rest for long. *Yuan Xiao Jie,* the Lantern Festival, the fifteenth of the first Lunar month, was going to be another big celebration. Grandma, my mother and my aunts were busy shopping for ingredients and making *yuan xiao,* a small round dumpling, about the size of an American quarter, made of sweet rice flour with black sesame seed, red bean paste, or scented osmanthus fillings. One can easily get these in the stores in San Francisco Chinatown and eat them for breakfast, for a mid-afternoon snack, or as a dessert after dinner. They are very filling and having too many of them can cause indigestion.

During that period the children would be picking out their favorite lanterns from the stores—*long deng,* the dragon lanterns, *zou ma deng,* the walking horse lanterns, *bing deng,* the ice lanterns, or, with the help of older friends, make their own lanterns. On the fifteenth, everybody would be out in the streets with a candle-lit lantern, watching, socializing, eating, or just enjoying the crowd.

Every year, after we got back to Tientsin from Grandma's place, I would be sick for a week or two. But, weighing the gains and losses, I thought the sickness was well worth the fun. When I was seven my parents moved southward to Shanghai, and we never had that kind of a *re nao,* exciting, New Year again. *Re Nao* literally translates into "hot and noisy," when describing a place or a situation it means "bustling with activity and excitement."

I missed Chinese New Year at Grandma's so much that I often went back in my dreams.

The Moon Lady and the Moon Festival

Amy Tan has already written a popular children's book about the Moon Lady. When President Clinton, in 1995, made a trip to San Francisco, he very publicly stopped to buy and enjoy some delicious moon cakes, eaten during the Moon Festival. The festival happens to fall each year after back-to-school but before Halloween, in a long slack time with no holidays for the children, and on the West Coast all children have taken to it, since you hear a charming story and get to eat sweets stamped with pictures. There's even a friendly rabbit involved. With Lunar New Year, the Moon Lady and her festival are sure to be China's contributions to the American child's holidays.

The 15th of the eighth lunar month is *Zhong Qiu Jie,* Mid-Autumn Festival, also known as *Yueliang Jie,* Moon Festival. This date usually falls in the latter part of September of the Gregorian calendar, if there is not a lunar intercalary month (*JLC*, p. 132, Lunar calendar). The Chinese people celebrate many general and local *jie qi,* festivals, but, except for *Zhongguo Xin Nian,* the Chinese New Year, the Moon Festival is one of the most widely celebrated festivals in both the People's Republic of China and in Taiwan. The Chinese New Year, also called *Chun Jie,* Spring Festival, and the Moon Festival are holidays when families have a *da tuan yuan,* big reunion; and like the *Duan Wu Jie,* Dragon Boat Festival (5th day of the fifth lunar month), they are times for relaxation, eating good foods, visiting, and merrymaking.

In the evening of the Moon Festival, it is believed, the silhouettes of *Chang E* (pronounced "chang er"), the **Moon Lady** (*JLC,* p. 67, 68, Moon Lady, Chang O), and *Tu Ye,* Master Rabbit, can be seen most distinctly against the bright yellow light of the full moon. Therefore, after the feast, the whole family would gather in the *yuanzi,* courtyard, to *shang yue,* enjoy the moon, while eating *yue bing,* **moon cakes** (*JLC,* p. 69, Moon Cake). This is a most exciting evening for children. I remember my mother was very strict about my bed time being no later than nine o'clock, but the Moon Festival was one of the very few nights she would allow me to stay up late and listen to the adults *jiang gushi,* tell stories. It was a popular belief that Master Rabbit, a symbol for longevity, resided in the moon. My cousins claimed they could see the rabbit and his long ears, but had a hard time locating the Moon Lady, while I had no trouble finding her. I could even see her many *piao dai,* silk streamers, flowing in the wind. When I told my mother I saw her, she related to me the sad story of the Moon Lady:

"During the rule of Xia, roughly 4,500 years ago, there was a skilled archer named Hou Yi (see *JLC*, p. 81, Hou Yi), and he was married to Chang E. There

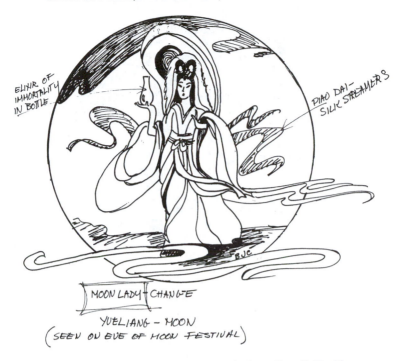

ELIXIR OF
IMMORTALITY
IN BOTTLE

PIAO DAI—
SILK STREAMERS

BJC

MOON LADY † CHANG-E

YUELIANG — MOON
(SEEN ON EVE OF MOON FESTIVAL)

Figure 24—1: The Moon Lady. Drawing by Betty Cornell. Used by permission of the artist. Courtesy of George J. Leonard.

came a time when the *tai yang*, sun, started to multiply into many suns. Small animals and plants couldn't stand the heat and gradually died. However, ferocious beasts and pythons grew stronger and stronger and were eating up the human race. Looking up and seeing ten suns, Hou Yi took out his bow and arrow, and he shot down nine of them, leaving only one sun in the sky. Everything became normal again and mankind was saved. Xi Wang Mu, the highest of the goddesses (see *JLC*, p. 239, Syi Wang Mu), gave Hou Yi the elixir of immortality as a reward. Chang E stole the elixir for her own consumption, and then fled to the *yueliang*, moon. Soon after she arrived there, she was severely punished by the gods, who turned her into a *chan*, toad."

I felt so sorry for her after hearing the story. My only comfort was that every Moon Festival I could still see her, frail but beautiful, bending with the wind. I never once saw the toad, the embodiment of the Moon Lady.

My *a po*, maternal grandma (see *JLC*, p. 33, Popo), was a devout Buddhist, and on different occasions she would *shang gong*, send up offerings, which meant putting various kinds of food on her altar table, and *shao xiang*, burn incense, to show her respect for the gods and ancestors. For example, Guan Yin, the Goddess of Mercy, was worshiped on the 19th day of the second moon and sixth moon.

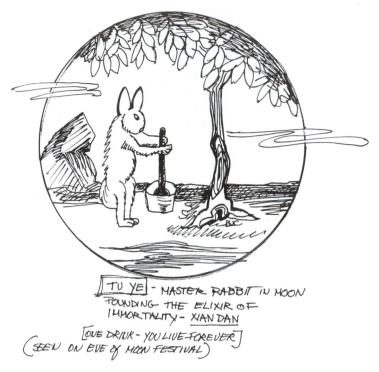

Figure 24–2: Master Rabbit in the Moon. Drawing by Betty Cornell. Used by permission of the artist. Courtesy of George J. Leonard.

On the 23rd of the twelfth moon she would set her altar table full of good food to worship Zao Wangye, the Kitchen God. Then every other month when the moon is full, my grandma would burn incense and ketou, kowtow, to her favorite God, Lu Chun Yang, the God of Healing. Lu Chun Yang, ca. 798 A.D., also known by the name Lu Dong Bin, was one of the legendary *Ba Xian,* Eight Immortals. While wandering over land and sea he was taught the technique of using secret prescriptions by the chief of the Eight Immortals, Zhong Li Quan. My grandma would always turn to Lu Chun Yang for help when there was sickness in the family.

Aside from worshiping the gods, she also had many *zu zong,* ancestors, to kowtow to. On my great grandfather's or great grandmother's birthday she would burn incense, offer food, and kowtow to a portrait. Whichever deity or ancestor she was worshiping, she always had a portrait or an idol on her altar table. During the Moon Festival she made offerings to the Moon and paid homage to Master Rabbit. So, instead of having a portrait of the Moon, she would have the maid servants help her carry the altar table out into the courtyard, where the Moon could look down on it. No male person was allowed to touch anything related to

bai yue, Moon-worshiping; it was strictly a female's job. On the other hand, no female should touch any food that was to be offered to the Kitchen God; that would bring bad luck to the family. On the altar table *ah po* would stack up dozens of moon cakes and large plates of fruit. In the center of the table sat a clay idol of Master Rabbit, bought at a specialty shop the day before. Dishes of fresh green soya beans boiled in salted water were specially prepared for Master Rabbit, because he did not care for moon cakes.

The apparel of Master Rabbit was most interesting: he had on full armor including a helmet, like a *yong shi,* warrior; if it were not for his *chang erduo,* long ears, and his *huo zui,* harelip, I could hardly tell he was a rabbit. Grandma usually paid quite a lot of money for Master Rabbit, but after the offering was over, he just became one more toy, sitting among my dolls and wooden soldiers.

The ceremony and rituals would be over by the end of that day, but my fun days at Grandma's house would usually last a few days longer. *Qiu tian,* autumn, is the best time in many parts of China as far as the climate is concerned. It is a time for picnics, boating, and *guang shichang,* wandering around (meandering) in the bazaars. Grandma often took me to *Guozi Shi,* Fruit Market, the street that got its name because every fall all the fruit vendors gathered there to sell their freshly picked fruits. The juicy pears were as big as baseballs. The pale green *ma nai* grapes were so delicious I could never have enough of them. *Ma nai* means horse nipple, and they got that name because they were long and juicy as though *nai,* milk, would drip from them any minute. After we had bought all the fruit we could carry, we would go to Dong An Shichang, the Eastern Peace Market, where we would taste a variety of different *xiao chi,* literally "small eat," meaning snacks (see *JLC,* p. 10, Dyansyin). The ones I have most vivid memories of are first, the *tang hetao,* sugar-coated walnuts, they were crispy and sweet-smelling, and now one can buy them in Los Angeles Chinatown. Secondly, the *wandou huang,* pea paste cakes, which were pale yellowish-green in color, and tasted like the highest quality pea soup, except they were sweet, and in the shapes of square, jelly-like cakes. Last but not least, the *fuling bing,* a sweet snack of Chinese date paste and nuts sandwiched between very sheer rice pancakes, looked like two flat, round pieces of styrofoam, about 4 inches in diameter, enclosing some chewy, sweet filling. I have not yet been able to find the latter two sweet *dianxin,* refreshments, in America.

My Grandma was a frugal woman. Even though she bought me and my cousins (her other grandchildren) many expensive snacks, she herself would be reluctant to eat in large quantities the sweet things she really liked. She was always *she bu de,* unwilling to let herself enjoy, because of the thought of extrava-

gance. I used to hear my mother, *quan,* try to persuade my grandma so often: "Ma, don't *she bu de* eat, and *she bu de* drink. The children are young and have many more years to taste the good things. Think of yourself now." My *Baba,* dad, was just the opposite. He was *she de* eat, willing to treat himself with good food, *she de* drink, and *she de* spend money, that is, bare no grudge in spending money.

One year, when my *Xiao Jiujiu,* Little Uncle, my mother's younger brother, came home from college to spend the Moon Festival with us, my grandma decided to hold the ceremony on our *chuan,* boat. The boats in Peking looked very different from the boats we have here. I had seen Chinese junks or fishing boats in China, but had not known anyone who owned a sailboat. Our boat was a *youting,* pleasure-boat, kept in a boat house at Beihai Park. One of the men-servants knew how to *cheng chuan,* push and move a boat with a long pole, but the one who was really crazy about doing it was my Little Uncle. I suspected that might have been the reason why Grandma decided to spend the Moon Festival on the lake that year. The boat had a half-covered deck, but there was no below-deck. A long, rectangular-shaped dining table took up most of the space on deck, and there were long benches on either side of the table where people could sit and *he cha,* sip tea, or *chi fan,* eat a meal. Amy Tan gave the best description of that kind of boat in *The Joy Luck Club* (p. 72). She called it a "floating teahouse."

A full nine-course meal was cooked and brought to the boat, but my Dad and my Little Uncle still bought a lot of *haochide,* goodies, from *fang shan,* a famous restaurant in Beihai Park that used to cook for *xi tai hou,* the princess dowager. I had the same palate as the Qing dynasty's Princess Dowager, my aunt used to say to me, because I loved the *xiao wotou,* a sweet, pyramid-shaped bun made of ground chestnuts, which was the Princess Dowager's favorite, too. That night at Beihai Park, Little Uncle and I had so much fun, and we stayed so late, until the Moon even got tired and began to sink into the west.

To my deepest sorrow, that night was the last time I saw my Little Uncle. After graduating from college in 1940, he joined the Chinese Air Force to fight the Japanese who had invaded our country. He died in an accident while he was in the last stage of his training at the Luke Air Force Base in Phoenix, Arizona.

Further Reading

Cheng, Manchao. *The Origin of Chinese Deities.* Beijing: Foreign Language Press, 1995.
de Bary, William Theodore. *East Asian Civilizations: A Dialogue in Five Stages.* Cambridge and London: Harvard University Press, 1988.

Obon Season in Little Tokyo

The Persistence of Community

BRIAN NIIYA

One hears many gloomy predictions about the ultimate fate, through success, assimilation and what have you, of the Japanese American community. But the persistence of obon season tells another tale. On a recent Saturday night, my wife and I were walking through Los Angeles's Little Tokyo looking for a place to eat before taking in a play later that evening. Parking on Central in front of the Japanese American National Museum (they don't ticket on weekends), we walked through the Japanese Village Plaza, then headed toward Honda Plaza in search of inspiring food. As we approached Second and Central, the smell hit us. Teriyaki wafted through the air calling our names. We poked our heads into a couple of restaurants on Central. Not coming from there. We crossed the street and walked through Honda Plaza. The smell seemed to get more distant as we peered into the various restaurants there. As we were leaving Honda Plaza, I happened to notice a sign: Higashi Hongwanji. Obon. Today. We looked at each other, smiled, and hightailed it to the church.

For Japanese Americans, summer means obon season. Up and down the West Coast and in other areas where there is a significant Japanese American presence, obons take place on virtually every weekend throughout the summer. To us Sansei and Yonsei, they are like mini carnivals, a place to come to eat teriyaki chicken and grilled corn on the cob, play carnival games, and meet other young people, preferably of the opposite sex.

Considering this carnival atmosphere, it's a bit surprising to note that the origins of the obon festival have to do with commemorating the spirits of the dead. In its "traditional" Japanese incarnation, the obon festival is a Buddhist ritual taking place in July involving the return of the spirits of the dead to earth. Over a period of three days, graves are tended, food offerings are made, and religious ceremonies are held. As with many other elements of "traditional" Japanese

culture, this mostly private ceremony has evolved into something entirely different in a Japanese American context.

Generally, Japanese American obons are put on by Buddhist churches as fundraisers. Other local community groups also participate by putting on carnival games or by selling food or drink. The food tends to be pretty similar in type from one obon to another. Chicken teriyaki is the staple, featuring sauces concocted by Nisei women church members and cooked over the grill by their husbands. Each church's teriyaki recipe is different and secret to some extent; I am convinced that the Nisei will take the recipes to their graves before telling the Sansei. (Even if they did tell us, we probably wouldn't be able to duplicate it.) While the women sell the teriyaki boxes—the chicken (and sometime beef) is augmented with rice, some sort of tsukemono, and usually some other fruit or vegetable—the men brave the heat of the grill basting and turning chicken all day. Each group has its partisans who claim that they have the best chicken or the best corn. I have my favorites, but I'm not foolish enough to actually say what they are—all of them taste good when eaten in the context of the obon.

After devouring the chicken, there are other food booths to explore. Usually, someone is selling maki and inari sushi ("footballs" and "tires" to Sansei and Yonsei), soda cans, and some sort of frozen dessert. There is also corn on the cob, chili, and other side dishes. You also see regional variations sometimes as well; tamales are sold at some downtown or Eastside obons, for instance.

After eating, you have to buy some lottery tickets. The big prize is usually airline tickets or a TV or VCR, these being the only items Nisei and Sansei/Yonsei have in common; I'm happy if I can score a plant or a bag of rice. (An 18-speed mountain bike was a prize at one obon; I'm not sure what the average Nisei would do with one of these except give it to some lucky child or grandchild.) There are many carnival-type games to play, usually benefiting boy/girl scouts or some other youth organizations. Though I never seem to win at bingo or any of the other games (I'm not sure what I'd do with the cheesy stuffed animals anyway), I'm always reassured that the money is going to a good cause.

In the evening there is the ondo dancing in the parking lot or on a neighboring street. Here, both organized and informal groups dance to "traditional" Japanese music. Though I know nothing about dance, I swear that some of the moves I see owe more to the Temptations than anything "traditional."

Inevitably, you run into friends, acquaintances, or even people you've been trying to avoid at these things. It's a good time to renew friendships and comment on how big the kids have grown. If you're single, its a good place to find out the latest gossip on who's seeing whom and who's newly available. Even if

you don't run into someone you know, you might end up with new "old" friends by the end of the day. At one obon, we ended up talking for half an hour with a Nisei woman who thought my wife looked like her daughter.

It was by now getting late. We said our goodbyes to the friends we had run into and headed off leaving the games, dancing, and smell behind. The walk back to the car was somewhat bleak, as we headed through a nearly deserted Little Tokyo and past vacant lots and empty storefronts. Somehow, it didn't seem to matter, though. The real significance of the obon festival was this: a community is made up of people, not buildings. The Japanese American community may have, in its material success, moved from the inner city Japantowns to the suburbs, but it did not—as some have feared—evaporate in the process. In fact, if the obons are any indication, the Japanese American community, at least here in Los Angeles, is in pretty decent shape.

Further Reading

DeFrancis, John, and V.R. Lincoln. *Things Japanese in Hawaii*. Honolulu: University Press of Hawaii, 1973.

Van Zile, Judy. "Japanese Bon Dance and Hawaii: Mutual Influences." *Social Processes in Hawaii* 30 (1983): 49–50.

Yano, Christine Reiko. "Japanese Bon Dance Music in Hawaii: Continuity, Change and Variability." Thesis, University of Hawaii at Manoa, 1984.

Filipinos and Religion

SALVE MILLARD, MAX MILLARD, AND MARIE CASTILLO-PRUDEN

[Filipino religion, as actually practiced, blends a passionate faith in Catholicism, acquired from the Spanish colonialists, with an equally passionate conviction that the pre-Spanish, pre-Catholic world of the spirits still exists. So argue the husband and wife writing team of Max and Salve Millard. In the first part of the article, Max Millard writes about Filipinos and Catholicism, noting the inroads made by pentecostal faiths. In the second part, Salve Millard writes about Filipino folk religion, particularly as she experienced it first hand during her childhood in the Philippines. In the third part, Marie Castillo-Pruden writes about the synthesis of Catholicism and folk custom in Filipino Christmas.]

Catholicism: The Official Religion

MAX MILLARD

Asia's only predominantly Christian country, the Philippines is approximately 85 percent Catholic, five percent Protestant, and 10 percent "other"—Muslim, Buddhist, and pagan. Muslims are concentrated in the southern Philippines, where they form about one-quarter of the population of the large island of Mindanao. According to the Reverend Rolando Bacani of the Church of God in Los Angeles, "There are still about 75 tribes in the mountains of the Philippines who are heathens or pagans. Many have not been reached by missionaries."

Christianity was introduced to the Philippines in 1521 by Ferdinand Magellan, a Portuguese who was in the employ of Spain. Stumbling upon the islands while in search of the precious spices of the East Indies, he came ashore on the site of what is today Cebu, the country's second-largest city. At the time, it was a village of several hundred bamboo huts, with a natural harbor that seemed

ideal for a trading base. Magellan envisioned converting the people to Christianity and ruling the area as Spain's viceroy.

Communicating with the local chief, Humabon, through a Malay interpreter, Magellan held a Catholic mass and erected a cross upon a hill, telling the natives that it would protect them against evil. Within a week, some 2,000 locals had been baptized as Catholics.

Soon afterward, Magellan was killed by a rival chief named Lapu-Lapu, the ship departed, and the natives lapsed back into paganism. But in 1565 the Spanish returned to the islands in force, choosing Cebu as their first permanent settlement. After bombarding and burning the town, the men discovered in the rubble a tiny, perfectly preserved statue of the infant Jesus that had been brought by the earlier expedition. It remains today in Cebu's Church of Santo Niño, an object of veneration. Over the centuries, Cebu has had a particularly fierce devotion to the cult of Santo Niño, the concept of a child god. (See part 3 of this chapter.)

For more than 300 years the Catholic Church was a major pillar of Spanish colonialism in the Philippines. Catholicism took root naturally, merging with the tribal traditions, which were based on the family and the village. Priests went throughout the islands, teaching the natives how to identify with the Holy Family—God, the powerful father; Mary, the compassionate virgin mother; and the suffering Christ, whose misery matched that of many Filipinos.

The islanders' pre-Hispanic beliefs in miracles, the spirits of nature, and the souls of dead ancestors were absorbed into the new faith, forming a medieval brand of Catholicism that still predominates in the Philippines. Besides the original Santo Niño, the country has some 50 major icons of Mary and the Holy Child that are surrounded with stories of miracles. Some of them have been recognized as authentic by the Catholic Church in Rome.

Most Catholic homes in the Philippines have a *belen,* a little shrine for private worship, with a Virgin and Child. There, families kneel for the evening rosary, gather to pray for the sick, and perform ceremonies, such as laying bridal bouquets or blessing newborn babies. Statues of the Virgin Mary abound, especially on hills in the countryside. And the most common talisman among Filipinos is a tiny figure of the Santo Niño, carried in the wallet or handbag to bring good fortune and safe traveling.

Filipino Catholics tend to be "more devout, more fanatic," says Rolando Bacani, a Protestant minister and former Catholic. "When people attend mass, they sometimes kneel all the way from the door of the church to the altar, even when it's very far. That's the means of penitence or sacrifice. When they reach the altar, they kiss the feet of the *black Nazarene,* a statue of Jesus hanging on the

cross. They wipe their handkerchiefs on the feet and they kiss the feet. They repeatedly recite the *novena*, the prayer ritual I think the women in the Philippines are more religious than the men. They outnumber the men in attendance, by about 70 to 30."

During Holy Week, the nearly week-long holiday period around Easter, Philippine Catholicism comes into full flower. The *cenaculo*, a local version of the European passion play, is enacted in town plazas. Flagellantes, Catholics who express their faith through self-flagellation, come out on the streets wearing *kapirosas*, white cotton hoods, to hide their identity. Soon their bare backs are bloody from repeated lashes with leather thongs or sturdy leaves. In Pampanga province in Luzon island, some individuals fulfill the ultimate *panata*, vow, by having their hands and feet nailed to a cross at high noon.

Only one Filipino, Saint Lorenzo Ruiz, has ever been canonized and that wasn't until 1988. The beatification process that precedes sainthood is now underway for Mother Ignacia, who founded a congregation of religious women in 1684. The congregation is now known as the Religious of the Virgin Mary, and has educational centers in the Philippines and the United States.

Throughout Philippine history, religion and politics have been closely intertwined. The whimsical description of the Philippines as "300 years in a convent followed by 50 years in Hollywood" has much basis in fact. Spain sealed off the Philippines from the outside world until the 1800s, when liberal Spanish kings finally opened the country to foreign trade. Under Spanish rule, the Catholic Church was authoritatively run by European-educated Spanish priests who conducted mass in Latin, a language incomprehensible to the islanders. Filipino churchgoers were discouraged from reading the Bible, which was not readily available in Spanish or Tagalog.

When the Philippines revolted against Spain in 1896, and Filipino patriot Jose Rizal was executed by the Spanish, he was seen as a national messiah, martyred like Christ. The pattern would be repeated 87 years later, when Philippine opposition leader Ninoy Aquino was assassinated immediately upon his return to the Philippines from exile. Fueled by support from the Catholic Church, Ninoy's widow Corazon (Cory) Aquino swept into office in the "People Power" revolution of 1986.

Christianity in the Philippines underwent revolutionary changes starting in 1898, when the United States replaced Spain as colonial master. That year, before America's war of conquest subdued the islands, the Philippines had a brief flickering as an independent state. Delegates from all over the country met to draft a constitution and, after considerable debate, voted not to make Catholicism the

official religion of the new republic. This openness toward religious differences continues to this day, with little or no sense of rivalry between Catholics and Protestants.

With the ejection of Spain from the Philippines, the Spanish priests were replaced by a Filipino clergy. Catholic masses were suddenly conducted in the Filipino tongues—especially *Tagalog, Visayan* and *Ilocano*—and in English. The Bible became available in these languages.

At the same time, American missionaries began to arrive—some Catholic but mostly Protestant. The American government made English the language of instruction throughout the Philippines, and many missionaries became teachers in the public schools, where they taught the Bible alongside the regular academic subjects. As Filipinos were exposed to the teachings of the gospel, many were converted to Protestantism.

The missionaries spread out to all parts of the Philippines. The churches concentrated on particular geographic areas, establishing schools, seminaries, and houses of worship. To the northern island of Luzon went Presbyterians, Episcopalians, the Church of Christ, the Disciples of Christ, the United Brethren, and some Baptists. Baptists of many denominations concentrated on the Visayan islands in the central Philippines. The Christian and Missionaries Alliance, a missionary-minded sect, went to the southern island of Mindanao, where they now have more than 1,000 churches.

Today, besides the major denominations, there are a lot of small independent churches in the Philippines, established mainly by Australian and American missionaries.

After the Philippines gained its independence in 1946, the Catholic Church generally kept out of politics, except for a limited social action program among the poor, through such organizations as the Federation of Free Farmers. Local priests, especially in the rural areas, are often the molders of public opinion in the Philippines, and there began to develop among the lower ranks of the clergy a growing identification with the poor and their concerns.

This movement, known as liberation theology, gained strength in the late 1960s and early 1970s, during the rule of strongman President Ferdinand Marcos. It still represented a minority opinion when Marcos declared martial law in 1972, and the church's initial reaction was restrained. But as priests, nuns, and lay church members began to be arrested and abused, particularly by the military, the church became more critical. Eventually, Marcos succeeded in alienating himself from virtually the entire Catholic establishment.

Ninoy Aquino, who spent more than seven years in prison for opposing the Marcos regime, claimed he had received a vision from the Virgin Mary during

his imprisonment. After being exiled in America, he decided to return to the Philippines, while speculating on the likelihood of his own assassination. Gandhi was one of Ninoy's heroes, and Aquino was quite conscious that he was modeling himself after a martyr. Some observers believe that, against the backdrop of the mystical symbolism that thrives in Philippine Catholicism, the times demanded a martyr to unleash the frustration and anger of the people, and Ninoy knew this.

In the speech he planned to give upon his arrival in Manila, Ninoy wrote: "According to Gandhi, the willing sacrifice of the innocent is the most powerful answer to insolent tyranny that has yet been conceived by God and man." Aquino's death was indeed the galvanizing event he hoped it would be.

Marcos, shaken by charges that he had ordered Aquino's assassination, tried to relieve the political pressure by calling an immediate election for February 1986. Aquino's widow Cory, a devout Catholic, was urged to be the challenger. "Dear God, let it not be me," she prayed. But when a million signatures had been gathered, she spent a day in meditation at a convent, then declared her candidacy. Jaime Cardinal Sin, Archbishop of Manila and the nation's most influential clergyman, rallied Catholics everywhere to support her. Cory's campaign took on the look of a religious crusade.

In preparation for the election, churches began holding classes on non-violent resistance. This helped to prepare for the training of half a million poll workers, many of whom were ready to give their lives to protect the ballot boxes.

When Aquino won the election and Marcos tried to snatch it from her by fraud, more than 100 Catholic bishops openly declared that Marcos' attempt to retain power "has no moral basis." Cory staged a massive rally in Luneta Park, the largest open space in Manila, calling for civil disobedience to force Marcos out of office. In the crucial days that followed, Archbishop Sin kept up a barrage of pro-Aquino broadcasting over the Catholic television and radio stations, urging Filipinos to embrace Cory as their lawful president. The result was a bloodless transfer of power, and the flight of the Marcos family to Hawaii. Cory attributed her election victory, and her survival of seven coup attempts during her presidency, to divine providence.

Catholicism as practiced in the Philippines remains quite different from its American counterpart. For Filipinos, Catholic ritual is a part of everyday life. When Catholics leave home in the morning, or pass by a church, they automatically make the sign of the cross.

Masses in the Philippines tend to be livelier, less theological in tone, more in touch with everyday life, and based more around singing than preaching. Recalls one Filipina, who returned to visit her rural province after years in the United States:

"They express their sin by singing forgiveness songs. When I went back to church, the first Sunday I arrived, I cried a lot because the music and songs were so moving. There's a big choir—three different groups, all in uniform, and all singing together. The service is a full hour. In America, it's only 30 minutes. But in the Philippines, you don't even notice how the time goes by because of the beautiful songs.

"In America, the sermons are so boring. The priests talk about problems in the city, and how you should donate more to the church so they can help churches in other countries. In the Philippines, they don't ask for money. They ask you to pray for those people instead. I noticed when you go to church back home, you feel down when you come out, because you've been thinking about the sins you committed, and what you should do to help people who are suffering. But here, nothing. I feel sleepy when I get out.

"In the Philippines, after the mass, some people stay and say a prayer in front of a statue or image, if they have a special problem they want to solve. They might tell it to Jesus Christ, the Virgin Mary, or one of the saints. For example, if the doctor tells someone she can't have any more children because of problems in her ovary, she might pray to the Virgin Mary, because that's the image of mother."

According to Pastor Ricardo David of the Church of the Open Door in San Francisco, California, Protestantism has been growing rapidly in the Philippines since the early 1970s. "Most of the Protestant churches in the Philippines are evangelical. If you go to the provinces, the stronghold of Catholicism is still there."

One main difference between the Protestants and Catholics in the Philippines, points out a member of his congregation, is that "the Catholics have a lot of idolatry. They will be offended if you tell them that wooden sculptures don't have eyes and ears. Our religion has no idols."

Except for the languages used in the service, there is little difference between Protestant worship in the Philippines and in the United States. Evangelical Protestant churches, like the Open Door, are known for their demonstrative method of worship, in which members shout "amen" and "hallelujah," clap their hands, and do a lot of singing. They have classes in Bible studies and crusades to recruit new members.

Still, they are more restrained than the charismatic Protestants, who are mainly associated with the Pentecostal group. The pentacostals stress the speaking of tongues and the power of healing, and preach anywhere—streets, shopping malls—whereas the evangelicals do most of their worshiping inside the church.

When Pastor David was growing up in the Philippines, "our parents would tell us that if you join the evangelical church, it will lead you to hell. That is changing. They're recognizing the evangelical churches now. Before, it was common to see messages in the newspapers saying, 'Beware of evangelical Christians.' Lately I haven't heard of that going on."

In the United States, he says, "most Filipinos are struggling immigrants who like to go to a place where people can understand and relate to them. They start looking for the kind of churches they had before. And if they can't find them, they stop going. Most of our converts are converted here.

"Protestantism is growing in the Philippines because I think the spiritual needs are not being met through Catholicism. The evangelical churches cater to the outgoingness of Philippine society and to the community kind of fellowship or gathering. Protestant churches get involved in people's lives." He observes that "wherever you go, whether attending a Baptist church or an Assembly of God, there's a lot of similarities among the Protestant churches in the Philippines—less difference than in America."

As Protestantism gains strength in the Philippines, the Catholic Church continues to lose ground. Still, says David, the churches do not consider themselves rivals. "I see more unity rather than division. They tend to promote what they have in common."

He does not believes the Catholic Church in the Philippines loses potential priests because of the celibacy rule. "The family is grateful if a member of the family wants to become a priest. It's still part of the culture. It's a privilege, because you gain an acre of land in heaven They have a practical program of recruiting priests. They usually court good students, such as the valedictorians from elementary schools. They offer them scholarships to attend a seminary for priests, where they live in a dormitory. Most of the parents are very supportive of this. It's all for free, so this is an attraction."

Rolando Bacani, Minister of the Church of God in Los Angeles and co-founder of dozens of evangelical churches in the Philippines, says the "freedom of worship" is one attraction of Protestantism. "People can express their feelings of the Holy Spirit without being inhibited.

"The evangelicals are not noisy people like the charismatics," he explains. "The evangelicals follow strictly the teachings of the scriptures. The charismatics sometimes make their own interpretation of things. They make certain predictions about the second coming of Christ. The evangelicals say they don't know when Christ will come."

The fanaticism of some Filipino Christians sometimes reaches suicidal proportions. In the 1980s, the Philippine press reported on a family who was so

devout that they believed if their son killed himself, he would return to earth in three days. The young man, who had just graduated from college, went to the town square, covered himself with gasoline, and lit a match. With his parents and horrified townspeople watching, he rolled around and died in agony. The family's own grief did not begin until he failed to return three days later.

According to Philippine superstition, only certain people are born with the power to see spirits. This tradition carries over to the Catholic faith when miracles are reported. One of the most widely publicized "miracles" of recent years was the "apparition" of the Virgin Mary on March 6, 1993, in the farming town of Agoo, 120 miles north of Manila.

The apparition was predicted by a 16-year-old seer, Judiel Nieva, who said the Virgin Mary had been appearing to him every month since 1989. Many residents of Agoo claimed that communion wafers and wine turned to flesh and blood in Nieva's mouth. The boy's family had an image of Mary that was said to shed tears of blood. As news of these events spread through the Philippines, Catholic pilgrims began flooding into Agoo. By the day of the predicted apparition, an estimated one million people gathered on seven hills outside the town.

Nieva said the Virgin Mary would appear that afternoon. Anticipation gripped the throngs of believers, as they wailed, wept, and prayed under a blazing sun. About 1:15 p.m., people began screaming that they had seen the silhouette of a woman, hovering over a guava tree and lasting for just a few seconds. Ten minutes later, according to witnesses, the sun "danced" and a spectrum of colors broke out from all directions and moved toward the sun. The aroma of flowers pervaded the air.

A large majority of the people said they saw nothing. But thousands claimed to have witnessed the miracle. In mid-afternoon, Nieva appeared on a hillside, flanked by police; they pushed aside the weeping zealots who tried to touch him. The boy claimed to have seen the Virgin, who had asked Catholics to pray for the children of famine-wracked Somalia. He said the next apparition would be September 8 and then "the blessed Mother will disappear forever."

Whether miracles or not, the events in Agoo brought rich and poor together in spiritual celebration, and the Catholic Church saw it as an opportunity for strengthening their ties to the faithful. "While we do not encourage the people to come, let us not turn them away when they do," said Bishop Salvador Lazo, a representative sent by the pope. "Let us take advantage of it."

The Roman Catholic hierarchy reacted cautiously to the claims. Only the Vatican has the authority to proclaim a purported miracle as authentic. The Reverend Socrates Villegas, a spokesman for Cardinal Sin, said the church accepts miraculous events only after years—sometimes decades—of study and examination.

The Vatican said it would adopt a "hands-off policy," leaving the investigation to local Catholic officials. Paul Gallagher, first secretary of the Papal Nuncio, said the Vatican was confident the local bishops "are fully competent to judge the apparitions," and that the Holy See will accept any findings that come out of the proceedings.

One of the biggest issues facing the Catholic Church in the Philippines today is the debate over condom usage to stop the spread of AIDS. In February 1993, the Philippine Catholic bishops issued a pastoral letter read in all Catholic churches nationwide, denouncing the condom distribution program. The letter read in part:

> We cannot ignore the possibility that through this pandemic (AIDS), the loving Lord may be calling us, his children, to profound renewal and conversion: "For whom the Lord loves, he disciplines; he scourges every son he acknowledges."
>
> HIV-AIDS and other calamities that visit us are not necessarily the punishment of a loving and forgiving God for our personal and collective sins. But we know that Nature itself has often its own unremitting laws of reward and retribution with regard to actions we take, freely or not.

Soon after the pastoral letter was issued, Philippine president Fidel Ramos, a Protestant, spoke out in favor of condoms for AIDS prevention. But he took pains to avoid any significant disagreements with the Catholic Church. Manila's Archbishop Jaime Cardinal Sin, who wields formidable political influence behind the scenes, is perhaps the most outspoken Philippine church official in opposing the use of condoms. The Church's endorsement of public officials or political candidates can make or break their careers.

The argument in favor of condoms is well expressed by Rodel Rodis, a columnist for the South San Francisco-based *Philippine News,* the nation's leading Filipino American newspaper.

Writes Rodis:

> The Church continues to stand by its position that the rhythm method (the "Vatican roulette") is the only proper means of birth control. The madness of this method is that it doesn't work in the Philippines where most of the homes have just one room where the father, mother and their assorted children all eat and sleep together. There is no privacy at night. The parents "procreate" when they can snatch some moments of privacy (usually

when the kids are in school or in the field somewhere), and it doesn't mat-
ter to them if the rhythm is right or not.

As Roman Catholics, the bishops must adhere to the doctrinal word
from the Vatican on any issue. But because the pope has not yet stated his
position on the use of condoms, the Philippine bishops have actually even
'out-poped' the pope. The tragedy here is that the spiritual leaders of a
poor, overpopulated, and disease-ridden country should be the last to con-
demn the use of condoms.

But however the debate is resolved, the Church's final position on the
matter will probably follow the same pattern of assimilation, accommodation, and
pragmatic self-preservation that has kept Catholicism a pillar of Philippine cul-
ture for more than 400 years.

Folk Religion in the Philippines

SALVE MILLARD

Ghosts are very real in the Philippines, especially in the provinces. They are al-
ways shown in the movies and in comic books. Most people believe in them, and
everybody talks about them. If something is missing and no one will admit taking
it, you might say, "Then who took it? A ghost?"

But ghosts are nothing to joke about. When I was growing up as a young girl
in the Philippines, I learned about the different kinds of ghosts and spirits. My home
province, a small island in the Visayas, in the Central Philippines, had many stories
of ghosts. They are common in the province rather than in the city, because cities
are too crowded and there's no place for them. Some are good and some are bad,
but people are always afraid of them. Some ghosts are invisible, and some can be
seen, but only by certain people. The ghosts that you can see are always women—
never men. The names for the ghosts are used in both Tagalog, the national language
of the Philippines, and in Visayan, the language of the Visayan islands.

White Ladies

The good ghosts are called white ladies. Filipinos say the term in English,
even when they are talking in Tagalog. The white ladies are Filipino, not Cauca-
sian. They always have long white hair and a white dress. You can't see their face
because the image is not there. It's like in the shadow, because they only show up
in the evening. Often people see them from behind.

If you see a white lady, it means she is disturbed. White ladies are people who have unfinished business when they die, and they're unhappy. It might mean they hid their money and died without telling anyone where it is, or there were some things they forgot to tell before they died. So they keep going back, because they want to talk. But they can't just talk to anybody. They're looking for the shy people, the *mahinhin.* If you're shy and not talkative, the white lady will be friendly with you. Sometimes she will tell you magic words, that you can use to cure people or use when you are in danger. Faith healers have these magic words, but they never tell anyone what they are, because if they do, the words lose their power.

I had a friend, a young woman like me, who was living in an old house in Angeles City. One night she was watching TV and there was no wind, and the curtain just started blowing. She stood up and saw a white lady coming out of the other room, where her children were sleeping. My friend just prayed. She said, "Please don't scare me and my children." Maybe somebody died in that house, and their soul is still there. Maybe the children were in the room where the white lady used to sleep when she was alive. Sometimes white ladies are just visiting.

Once, when I was coming home from the market with my uncle, I saw a white lady standing near the coconut trees. It was maybe 9 o'clock at night, and there was a full moon. I know it was a white lady because why would a young woman be there in the middle of the night, on the mountain? We were in the middle of nowhere, about three hours from the town by *carabao,* water buffalo. There was nobody living around there—just a small path in the woods. When I got close to her, I closed my eyes because I was scared, and she disappeared. My uncle didn't see her.

White ladies only choose particular people to see them. Sometimes in a whole group, only one person will see her.

Maybe she wanted to be friendly with me. She knew that I have a good heart, but she couldn't trust me, because she also knew that I'm talkative. She could tell just by looking at me. Sometimes a white lady will show up and just stand there, or walk in front of you, and not talk. They don't harm people.

Agta

A couple of days after seeing the white lady, I went to the river to get some water for cooking, and I saw some *agta,* little people, playing in the water. There were about three of them. They didn't look at me. It was very far outside of town. They were wearing small shorts.

Agta is a Visayan word. They are little people—spirits that can live in the water or on the ground. If you step on them, they do bad things to you. People are afraid to walk around in the dark at night because you might accidentally step on them.

When I saw the agta that afternoon, I didn't look close, because I was very scared. I was with my cousin, but she couldn't see them. My cousin knew they were attracted to me because I have a big black birthmark on my back. That's a sign that the spirits like to follow you. They want to be friendly with me, but they can't because I'm really talkative. So when I told my cousin about the spirits, she didn't want to come with me anymore.

A couple of days later, I got really sick, with a high fever, and I looked out the window and saw small people sitting down near the trees. My auntie went to get a faith healer. He came there and started saying things in a strange language. He had a small piece of white paper with a cross and something else written on it. He burned it in his hands, then spit on it, then he put it in a little water and made me drink it. A couple of days later I felt better.

He also made me wear a belt with some kind of medicine inside it—maybe chopped-up wood and grass, to scare the spirits, because they're afraid of it. I'm not sure what was in it—I think it's some special wood. He made me wear it all the time, even when I used a bucket to clean myself. There's no bath or shower there.

The faith healer told me that whenever I was walking in the dark, I should carry salt around with me, to scare away the agta. If I felt scared because I thought they were around me, I would scatter a little salt. They hate salt.

Faith Healers

In the provinces, but also in Manila, if people can't afford to go to the doctor, they hire a faith healer. In my province, the island of Masbate in the Visayas, there were two kinds of faith healers—the *mang-hihilot* and the *mang-gagamot* or *albularyo*. (These words are both singular and plural.)

A *mang-hihilot* can fix broken bones, act as a midwife, or help a woman get pregnant by treating her ovaries. A *mang-gagamot* deals with people who are sick. They can cure headaches and stomach aches and help people who are hurt by bad spirits.

When I got kicked by a horse, the bones in my arm were almost sticking out. The *mang-hihilot* massaged my arm and pulled it hard, and the bones went back in place. A *mang-hihilot* will manipulate the bones and look for the ones that are separated. It's very painful. They don't use a cast because no one can afford one. They just wrap a cloth around the limb.

Faith healers are naturally born. If a baby is born backwards—feet first—it automatically becomes a *mang-hihilot* or a *mang-gagamot*. They don't have to go to school for it. The *mang-hihilot* don't usually come from a family of faith healers. It's not common for the profession to be passed down from one generation to the next.

Sometimes faith healers get their power because Jesus Christ or the Virgin Mary comes to them in a dream and tells them to use certain words to heal people.

When they reach a certain age, they just start healing their relatives, and the word gets around. Some of them use special words if someone is sick. In my province, about half the faith healers are men and half are women. I think it's like that throughout the Philippines.

If a woman can't get pregnant, or if her ovary is down, the *mang-hihilot* can move the ovary up by pushing it with their hands. If a woman has been married a couple of years and doesn't yet have a baby, she'll go to see a female *mang-hihilot*. Maybe she'll go back once a month after menstruation, so the *mang-hihilot* can push the ovary up.

When my sister was sick, she went to a *mang-gagamot,* who killed a chicken and prayed in the river. Then they cooked the chicken and had a little feast near the river, with *tuba,* coconut wine.

Other Ghosts

When I was just a 10-year-old girl, some people in my town saw someone who had no head, riding a horse around the neighborhood in the middle of the night. When they went near it, it disappeared. That year, a lot of people in the town were dying suddenly, so at all the houses, they hung a gas lamp under a red shade, and they put a black cross on the shade, to scare away the ghosts. The ghosts hate red because it blinds them, and they're afraid of black too. They put a lamp inside the house and one just outside the door, so the ghosts couldn't come in. Hardly anyone in the town had electricity then. Now, a few more do.

In the Philippines, you sometimes hear people walking around your house in the middle of the night, or you hear someone washing dishes when everyone is sleeping. Once my Mom heard a horse walking around the house.

When I call my girlfriend Medy in the Philippines, if it's in the middle of the night there, she won't answer the phone because she thinks it's a ghost. That happens a lot there. When you do answer the phone, no one is there. The ghosts call you just to scare you. Or maybe they're just playing.

Angels

When a baby smiles while it sleeps, it means the angels are playing with it. Babies are angels, and angels are babies. They communicate. We consider children

to be babies until they're five years old. We call children "angel" because they don't know how to commit sin, and they always tell the truth. We treat the Santo Niño, Christ child, as an angel.

If someone has a young child who dies, the parents aren't supposed to take a bath on a Tuesday and Friday for the rest of their life, because on those days the angels come down to earth to play, including their child. If the parent gets wet, the baby will also get wet and can't return to Heaven. The other angels will fly away, and leave the baby behind.

If a baby wakes up and cries in the night, people will buy a tiny amount of gas to light up the room. They believe she cries from being bothered by a ghost, and the light scares the ghost away. If the baby is crying when the light is on, you know that she's safe, but if she's crying in the dark, you know it's because of the ghost, so the mother usually gets up right away. I always had the light on at night, until I was eight.

Sometimes dead people can come back. Two years after my grandmother died, I had a dream that she was dying. I woke up, and I saw her in the corner.

Another time, when I was in San Francisco, I saw a big brown butterfly outside the window, flapping its wings on the glass. I automatically thought, "Oh, it's my Grandma visiting me," because when she died, she was wearing brown clothes. In my province, they believe that dead relatives can visit you in the form of butterflies. Everywhere you see butterflies around you—in the street, in the park, or wherever—you assume that they are your dead relatives. Spirits are anywhere.

Tree and River Spirits

Some people are afraid of swimming in water that is over their head, because they believe that agta, little people who might be living in the water, could drown them. Whenever Filipinos wade through a shallow river, they will say a prayer for the little people under the surface because you might step on them.

Where my Dad grew up, there was a river where a few people drowned, so they thought the agta had dragged them down. Whenever people cross a river or walk by a big tree, or climb into the tree, they say, "*pakitabe*, please step aside" and make the sign of the cross. It scares the bad spirits, because they're afraid of the cross. Some trees have bad spirits living in them.

A *capri* is a giant that lives in a big tree, such as a tamarind, and smokes a big cigar. He moves around at night. If you're bad to him, he'll grab you and take you away, and you'll disappear. If he likes you, he might give you a charm, and tell you where you can go to find gold. He'll give you riches—*kayamanan*.

One morning my sister went to a river where big trees are. That night she was so sick. So she thought a bad spirit was there. She got a fever and said, "It's coming, it's coming." We were so afraid, because we knew if we didn't do something, she could die. After she got better, she told us that she saw a very big man who kept appearing in front of her.

Dwarfs

A *dewendi,* dwarf, is a very small spirit who lives in a *puntod,* mound. I don't mean small human beings. They're like gnomes or fairies. You shouldn't play around the mound because you might accidentally step on the dewendi. You can't see it. The dewendi might hurt you; it can cause high fever. You will get chills when you go home and start screaming, "It's coming, it's coming," because a lot of people do that. It's a *bad* spirit. No one ever sees one, but they show it in comics and in the movies. It's one or two feet high and has a big nose.

A lot of people believe that when workmen build or repair a bridge in the Philippines, the workmen kill little children, then bury them under the bridge. That's because the land used for building the bridge has a spirit there. By digging a hole you might hurt the spirit, so you offer a human being to them. *Delugo* means making the bridge stronger by offering a body to them. When the workmen start to dig, they let the blood drip in the hole to make the bridge strong. Usually Filipino parents tell their children not to go near the bridge because when a bridge is being built, children disappear.

Asuwang

Another type of ghost I often heard about as a girl is the *asuwang.* It's an evil spirit that came originally from the province of Capiz, on the island of Panay in the Visayas. When you meet someone from the Philippines and you find out they're from Capiz, the first thing you think of is the asuwang. Right next to Capiz is the province of Iloilo, and people from Capiz usually say they're from Iloilo, because otherwise people might think they're an asuwang.

Asuwangs are really people, who turn into other things in the evening when they want to suck blood. Your next door neighbor might be one, secretly. Some people have a reputation of being an asuwang. While I was growing up, I kept hearing that my Mum's friend was one. Later I found out that it was because some people saw her hiding under her friend's house one night. Asuwangs get under people's houses so they can try to suck blood and see if someone is sick. Later I found out the woman was spying on her husband, because she heard he was having an affair.

The asuwang is shown in a lot of Filipino movies. It has a very ugly face and an ugly nose and usually long uncombed hair. It's tall, and wears black. The asuwang likes to fly around at night. In the movies, they show how the lower half of the asuwang's body remains on the ground, and the upper half flies away. When the two halves separate, it's awful—all the blood bubbles out. I don't know why they show this. It's not part of the story I heard when I was growing up.

You see asuwangs hanging upside down in trees when they're ready to fly. We lived far away from the road, and several times my Mum saw someone's shadow near the tree. She would say, *"Asuwang ka, demonyo ka,* don't scare me, I know you." She just kept on walking. You're not supposed to show you are afraid, or they will scare you more. If you try to fight them, they can strangle you. But if they feel that you know them, they will get scared and fly away.

I have an auntie from Iloilo. When she was five years old, she was left at home alone one night because her parents were out in the neighborhood visiting friends. She was crying, and an asuwang popped in the window and grabbed her from her bed, then put her down and flew away. She was very scared. She still remembers it. She had never heard about asuwangs at the time, but later she found out that's what it was.

One time when my Mum and Dad were out drinking, my sister woke up in the middle of the night and wanted to go to the bathroom. The floor broke and her foot was stuck in the floor. She couldn't pull it out, and it was bleeding. She was so afraid the asuwang would come and eat her foot. We were the only ones home, just two young girls. So I got a bolo, a long sharp knife, and stuck it through the floor beside her foot, so that if something started eating her foot, I would get it. I said, "Don't cry, or the asuwang will know you're stuck." It was very dark. We couldn't find the matches. We stayed up all night, waiting for my parents to come home.

In the Philippines, parents tell kids, "Don't cry, or the asuwang might hear you and come and get you." My Mum always scared me like that. Asuwangs like babies and young children, so when they hear children crying, they come.

Usually the asuwang goes where there are sick people. In the province, where people only use a gas lamp and it's very dark, the asuwang has somewhere to hide. Sometimes the asuwang looks like a real person, walking at night. When you scream, it will disappear.

When you're around sick people and you hear the sound "kik kik kik," it means the asuwang is present. The sound is made by a bird. My Dad will go outside and say, *"Demonyo ka,"* you are a devil. Usually it's birds around sick people.

The asuwang also comes around when people are giving birth, because it wants to suck the baby's fresh blood or hurt the baby. When my mother was about to have a baby, my father went outside to beat on the wall with a stick to scare away the ghosts. Usually this stick comes from the dried tail of a long-tailed fish, which is powerful and very painful, because of its rough edges. Also my father would burn an old tire near the house, because it's very smoky, and the asuwangs don't like that kind of smell.

Asuwangs can change into different forms when they go out in the evening—cat, dog, carabao, bird. They don't go far away from where they live. If you see a very black cat in the middle of the night, you think it's a ghost. One night when I was back in the Philippines in 1992, my brother saw some ghost dogs. I was lying on the bamboo floor, which has some spaces in it, and something kept poking me in the back. My brother went down and said he saw two huge dogs. I said, "My God, it's an asuwang. It wants fresh blood." It must have known I had just come from the United States.

Filipino Christmas

MARIE CASTILLO-PRUDEN

There remain quite a few Filipino Christmas practices that are traceable neither to Spain nor the United States, the two countries who colonized the Philippines. One such custom is that children must take a bath on Christmas Eve. Why a bath is a must for Filipino children on Christmas Eve and Easter Sunday (and a no-no on Good Friday) is a mystery even to the Catholic Church, but kids do it anyway: first, wet your hair and body and lather vigorously with soap. Then, with a "tabo," an empty can or cut bamboo tube used for scooping water from a bucket, rinse by pouring water on your head and shoulders. Shake to dry.

It's quite simple, really, unless a fastidious maiden aunt catches you doing a *"paligong uwak,"* hawk's bath, in which case you get dragged back kicking and screaming into the bathroom and scrubbed with a stone and wood ashes until you are red and gleaming like a prawn.

Perhaps because of the expense involved in celebrating Christmas American-style (all the partying, shopping, card-sending and gift-giving), Filipinos have very much stuck to the way they had celebrated Christmas centuries ago, based on what they had been taught by Spain notwithstanding, about the birth of Christ. Although Bethlehem is far away, Filipinos like to think that the Christ Child has visited them in history. A statue of the *"Santo Niño,"* the Holy Child, dressed in

princely attire had come to Cebu Island in the central Philippines in 1521 when Ferdinand Magellan landed on that island. Magellan was to die there, having taken sides in a battle between tribes, but not before some marvelous things had come to pass. Magellan had presented the Santo Niño as a gift from the mad Queen Juana of Spain to a chieftain's wife, who was instantly converted and consequently had taken the name Juana upon her baptism. As God is supposed to work in mysterious ways, to this day the Santo Niño has fostered a special devotion among Filipinos everywhere and the statue itself is enshrined in a stone basilica in Cebu.

Filipinos are also aware that Jesus was born in an animal shelter (Luke 2:7), and so they believe that farm animals were the first to adore the infant king. Even now, animals are first to announce the start of the yearly celebrations of the birth of Christ. For nine consecutive days before Christmas, Filipinos wake up to the roosters' crowing at dawn to attend a novena of masses called "Misa de Gallo," the Mass of the Rooster. In Spain and most Latin countries, the term applies only to the Christmas midnight mass, but in the Philippines, it means all nine masses prior to Christmas.

Misa de Gallo is dear to Filipinos, whose expectations include the special breakfast that people eat during the season. Cooked and sold in stalls just outside the church doors, it consists of "puto-bumbong," purple rice pudding steamed in bamboo tubes, "bibingka," rice flour cake topped with grated coconut, cheese, and boiled egg slices, and "tsaa," tea. Compared to the regular Filipino breakfast of "sinanag," garlic fried rice, smoked fish, tomatoes, and coffee, the Misa de Gallo repast is very special indeed.

Bibingka is baked in a clay pan lined with fragrant banana leaves, not in an oven, but between two open fires: one on top of the pan and another underneath. Some people are known to break their fasts on their way to church for a bibingka snack and thus cannot receive communion. Bibingka has got to be the Filipino's version of original sin!

And what of the dawn masses themselves? From childhood I remember them being packed with sleepy-eyed children who barely managed to wash their faces or comb their hair after an interrupted sleep. In fact it was a rare child who got to complete all nine masses. Very few actually made it to the sixth or seventh.

So you know that Christmas Eve is anything but quiet. Children's enthusiasm is usually rekindled on the night before Christmas as they anticipate "Simbang Gabi," midnight mass. Gone are the bibingka and puto-bumbong stalls, the center of attention having shifted to the kitchen table. Family members and relatives who live far away have come home, bringing "pasalubong," homecoming

presents, of pineapple from Tayabas, Quezon, "puto-Biñan," rice flour steamed cakes from Binan, Laguna, and imported apples and Chinese pears still wrapped in tissue paper.

Older relatives busy helping Mother cook the "Noche Buena," after-midnight Christmas dinner, would urge us children to get some sleep with the promise to wake us up when the church bells ring just before midnight. But it was difficult to sleep with one's cousins and uncles and aunts from far-away places, now laughing and chattering away the slowly ending year that had kept them apart. My mother always kept her promise and woke us up just before midnight, but often we would sit up, stretch, yawn, then get back under the bedsheet. Not until the town's brass bands, marching in full regalia with their music in full blast would we be able to wake up and get dressed.

It is the church that is the center of celebrations in most towns. In Paete, my hometown, the church is lavishly decorated with greenery, lighted candles, and colored paper flags. A big star parol—paper lantern—to symbolize the Christmas star, glides down from the choir loft during midnight mass and stops just above the "Belen," nativity scene, at the altar of which are life-size statues of the Virgin Mary, St. Joseph, farm animals, and of course, the Santo Niño.

One beautiful tradition introduced by Franciscan Friars in the seventeenth century is the "Pastores," now observed mainly in Iriga, Camarines Sur. In medieval times, "carol" meant a ring-dance accompanied by singing. In Iriga, this custom is alive. Children dressed as shepherds form a circle and, joining their hands, they sing and walk in rhythmic dance-steps in the manner of the original carols.

Filipino children had no idea of Santa Claus until the Americans came almost a hundred years ago. What Filipinos have instead of Santa are "ninong," godfather, and "ninang," godmother, who give their godchildren Christmas presents of silver coins. Ideally, a godparent should first give the child a little admonishment on good behavior before handing over the present. And these days Santa, ubiquitous in modern Filipino shopping malls, is a guest in the celebrations too.

The Christmas tree, which Americans also introduced to Filipinos, caught on. In my time, the most popular Christmas trees were naked coffee trees, painted white but with red berries still attached to the branches. They made perfect Christmas trees in that they are symmetrical and the berries make such lovely ornaments. But the practice failed to catch on as there were not enough coffee trees to make it from Christmas to Christmas.

Nowadays, any tree will do. Christmas trees in the Philippines are decorated not with ornaments, but with cookies and candies wrapped in tinsel. As the celebrations turn to New Year's Eve and finally, to Three Kings' Day on January 3,

the cookies and candies would have all been picked and it would be time to throw away the tree.

It is good that Filipinos have adopted the Christmas tree as part of their Christmas celebrations. Once upon a time, a tree grew in Paradise and though forbidden by God, its fruit was eaten by the first people. Now this tree has grown into a cross and in place of the forbidden fruit now hangs a carpenter to reconcile heaven and earth. That carpenter was once the Christ Child. And the tree, so universal in concept, transcends all seasons and traditions of people through all the earth.

Further Reading

Cordero-Fernando, Gilda, ed. *Culinary Culture of the Philippines*. Manila: Vera-Reyes, 1976.

Cushner, Nicholas, S.J. *Spain in the Philippines*. Manila: Loyola, 1951.

Miller, Stuart C. *"Benevolent Assimilation:"The American Conquest of the Philippines, 1899–1903*. New Haven: Yale University Press, 1982.

Maoism and Surviving the Great Proletarian Cultural Revolution

My Personal Experiences from 1966 to 1976

MOLLY H. ISHAM

BACKGROUND

I am a survivor of the Chinese "holocaust." Many westerners compare the *Wuchanjieji Wenhua Da Geming,* the Great Proletarian Cultural Revolution (*Wenhua Geming,* Cultural Revolution, for short) to the Holocaust of World War II. The French Revolution's Reign of Terror has also been mentioned. In a sense it was like both, with masses of innocent people constantly trying to hide or run away from their persecutors; nobody, not even the high officials with power, could predict what fate had in store for them. An entire nation lived in uncertainty and fear for almost ten years, during which time millions died or spent long years in prison or labor camps. From the very beginning of the Cultural Revolution people were encouraged to be suspicious of each other, and, with just a few exceptions, every educated person was a suspect. In those years, wives were turned against their husbands; children were forced to betray their parents. At the middle school where I taught, one of our young algebra teachers, under peer pressure, beat her own mother to death in front of the whole school, then fainted over the dead body. Millions of Chinese have memories such as that, and for the last ten years they have been appearing in the Chinese American literature of this country.

Since the Cultural Revolution started off as an ideological revolution, educated people, and especially those from a "bad" class background, suffered the most. They secretly referred to that period as *Hongse Kongbu,* the Red Terror,

The phonetic system used in this article is the official *hanyu pinyin* system used in the People's Republic of China since 1958 (see *pinyin*). The pronunciation of the six difficult symbols is explained as follows: *Q* like "ch" in "cheese"; *X* like "sh" in "sheep"; *Z* like "ds' in "beds"; *C* like "ts" in "cats"; *Zh* like "dg" in "edge"; *E* like the "e" in "the" preceding a consonant.

just as the underground Communist fighters used to refer to the Guomintang's massive arrests and massacre as *Baise Kongbu,* the White Terror. The Guomindang, also known as GMD, was the Nationalist Party that ruled mainland China prior to 1949. From 1949 until today, the GMD government has ruled the Republic of China on the island of Taiwan. During the Cultural Revolution I was purged and punished primarily because of my *chu shen,* family background, secondarily because of my Western educational background and my family's contact with Americans. It strikes Westerners as strange that the Communists punished people because of the social class of their parents. Further evidence of personal guilt was easy to trump up; as the well-known Chinese saying goes: *Yu jia zhi zui, he huan wu ci,* if you are determined to condemn somebody, you can always trump up a charge. According to the Communist criterion my family background was terrible. Both my parents, and all four of my grandparents, were either capitalists, landowners, or reactionaries; my *wai zufu,* maternal grandfather, was an ambassador, and my *zufu,* paternal grandfather, who owned land and real estate, was a Qing dynasty official. They had both worked for the wrong regime. The Qing dynasty started in 1644, and ended in 1911 when it was overthrown by the GMD. My parents were intellectuals educated in Western countries, therefore, I, coming from such a family, was assumed to be saturated with *fandongde zichanjieji sixiang,* reactionary bourgeois ideology.

Since 1949 when the army of the *Gongchandang,* the Communist Party, finally won the long civil war in China, there has been a very tight census control, and a *dang an,* file, has been kept for each individual at the person's *gongzuo danwei,* work unit. Students' files are kept at their schools, and the *paichusuo,* local police stations, keep the files of retired persons, housewives, and the unemployed. In those secret files the authorities kept records of people's family background for at least three generations. Also recorded was information about their educational levels, vocations, and their immediate family members. Should there be a *fandong fenzi,* reactionary, among the relatives or friends of a particular person, that information would be recorded in his or her file. For example, if a young teacher's grandfather had been a *dizhu,* landlord, and was cruel to the peasants who worked for him, that piece of family history would surely be included in that teacher's file, and it would be used against him during political purges. High Communist officials and employees of the personnel departments had access to everybody's personal files, but you, as an individual, were never allowed to see what was in your file. Thus people did not know what information had been put in their files until they were arbitrarily punished for crimes they had never committed. These files followed the people around when

they transferred from one job to another, until the day they died. People were so angry about what was placed in their files that during the chaotic part of the Cultural Revolution, there were many incidents of robbing the offices of the files and then burning them.

When the Cultural Revolution began in 1966, I was a middle school English teacher, and, together with the other teachers from "bad" family backgrounds, we were singled out by the *Geming Weiyuanhui*, Revolutionary Committee, and labeled "enemies of the people." We were locked up and beaten. Every school, university, factory, or government organization had a Revolutionary Committee; it was a temporary organization operating on an emergency basis in lieu of the original *lingdao*, leaders. A few months later, officers of the *Renmin Jiefang Jun*, People's Liberation Army (PLA) entered the schools and took over the leadership.

During the time I was held in detention in a tiny cell at the school where I taught, I was constantly criticized or beaten by students born of good families— workers', poor peasants', military officers', or high Communist cadres' families. Every time I was criticized, I tried to argue with them using, as the Communists did, *mao zhuxi yulu*, quotations from Chairman Mao: "a person cannot choose his family background, but he can choose the revolutionary path" (Fig. 27–1). Every time I was beaten, I reminded them that Chairman Mao had stressed: *"yao wendou, buyao wudou,"* which meant "make it an ideological struggle; don't make it a physical fight," but they always found an excuse to beat me harder, or insult me in a more humiliating way. Three times I was almost killed. It was the thought of my children, and the fear that they would be labeled *fangeming houdai*, offsprings of a counterrevolutionary, and the determination to protect them from being beaten and from being robbed of every opportunity in life, that kept me alive. At times I felt I had only one faint breath left in my lungs; I did not have enough energy to inhale any more. Then the voices of my children rang in my ears. I forced myself to inhale one more breath, then another and another. My children actually saved my life.

The Start

The Cultural Revolution started on June 3, 1966. I remember vividly the events of that afternoon. Final exams were coming up in three weeks, so I was in my office drafting a plan to help the students review efficiently. Around 1:30, some student representatives came knocking on all the office doors notifying teachers to stop whatever work they were doing, and prepare to go to a conference hall

Figure 27–1: Chairman Mao's photo in his "Little Red Book," the Bible of the Cultural Revolution. Foreign Languages Press, Peking. Courtesy of George J. Leonard.

near Tiananmen Square for a *zhengzhi baogao,* political lecture. I asked the stone-faced 17-year-old standing at my door who had sent him. He cut me off. *"Shangji tongzhi,* notice from higher authorities," he said loudly, not looking at me.

In less than five minutes, most of the teachers were gathered in the hall-way. I sensed uncertainty and concern in many of my colleagues' faces, but nobody I spoke to seemed to know what was about to happen. In the past, during

each political purge, a certain group of people were pre-selected by Party leaders to be the targets of that movement. Those people had to sit through long hours of meetings called *pipan hui,* criticism meetings, at which they were attacked by their peers and showered with accusations and invectives. This continued until the people confessed. After they admitted everything, if their supposed mistakes or crimes were serious, they could be disciplined or even go to jail. I, up until 1966, had managed to escape that fate. Nevertheless, that afternoon, like everybody else, I was wondering: which of us were going to be the targets?

The political lecture was to announce to everybody that an unprecedented, great revolutionary movement led by Chairman Mao Zedong had begun; every patriotic citizen must actively take part in it. Mao at that time was chairman of the Communist Party, the highest leader in the nation. Liu Shao-Qi, the Head of State, was next to Mao in power. The teachers were also told that at the instruction of Mao, the first *dazibao,* big character poster, entitled *Bombard the Headquarters with Cannons,* had appeared on the campus of Peking University, a place where major revolutionary movements originated. Big character posters, used throughout the Cultural Revolution, were means of promoting a view point, making a criticism, voicing a complaint or simply stating a fact in public. They were written with Chinese *maobi,* brush pens on white or colored paper, two feet by three feet in size, and then pasted on bulletin boards and walls of buildings. The sad thing was, many people also used them to fabricate lies.

I and thousands of other bewildered middle school teachers sat motionless in the huge stuffy conference hall for four hours, listening to the important government official, Mr. Hu, shout out the orders of Mao Zhuxi, Chairman Mao, and Dang Zhong Yang, the Party Central Committee. My head was spinning with anxiety; some of his words I heard, and others were blocked out. Repeatedly Hu cried out, working himself into a deliberate rage: "It's time to wake up. Our country is in danger!" "Class enemies in disguise are everywhere—sitting in the same room with you, even sleeping beside you at night, without your knowing it." "Counterrevolutionaries and spies, wriggling like snakes, are ready to spit poison. If you don't catch and kill them now, they will in time kill you." He warned the teachers, *linghunde gongchengshi,* engineers of human souls, as Mao called us, to take this movement very seriously and think over carefully: "Who are our friends, and who are our enemies?"

When the political lecture was over and we got back to our school that afternoon, a Revolutionary Committee had taken over the leadership of our school. The members of the Committee were mostly officials from government organizations with a few factory workers. They claimed they were sent to the school by a higher authority, and called themselves *geming ganbu,* revolutionary

Figure 27–2: Sculpture of the Chinese people inspired to revolution by Chairman Mao's "Little Red Book" (held aloft); at the entrance to Mao's tomb. Courtesy of George J. Leonard.

cadres. On that same day the principal, the dean, and the Communist Party secretary of our school were not only stripped of their jobs, but of their power as well. Like the rest of the faculty and staff, they would now only take orders from the members of the Revolutionary Committee. The first time I caught sight of the chairman of that Committee, he was shouting out cacophonous commands at a group of teachers. Immediately, new rules were announced: No one was allowed to leave school without the committee's permission; everybody, including students, teachers, employees, even part-time janitorial workers, must start writing big character posters; no more classes or exams until further instructions.

Mao himself, we were told, had lit this revolutionary fire, and he intended for the fire to spread throughout the nation (Fig. 27–2). Whether it was his mistake or somebody else's to let the fire burn out of control for almost 10 years, we were never told. Mao called on his people to "*dadao dangnei zouzipai,* do away with the leaders with power in the Communist Party who are capitalist-roaders"; also to "*dadao di, fu, fan, huai, you,* do away with landlords, rich peasants, counterrevolutionaries, bad elements, and rightists." Later a sixth target, *zi,* capitalists, was added to the five above. Mao defined all of them as *jieji diren,* class enemies, and referred to them in general as "*niu gui, she shen,* ox demons, serpent spirits," in other words,

all forces of evil that hid behind seemingly harmless human forms. The capitalist-roaders, according to Mao, were long-time Communist Party members trying to usurp power and lead China onto the road of capitalism, together with the six kinds of "demons"—landlords, rich peasants, counterrevolutionaries, bad elements, rightists, and capitalists—they were *renminde sidi,* deadly enemies of the (Chinese) people. Mao wanted the masses to "dig out the hidden enemies and expose them." At the same time he encouraged the cadres to *yin huo shao shen,* direct the fire to burn their own bodies. That meant to confess, to admit their mistakes, to exercise self-criticism in public, and self-criticism included making self-incriminating statements. The masses remembered well Mao's words: "Never for a moment forget the class struggle," and did just what Mao instructed them to do. They saw to it that leaders of every level were criticized or punished.

Most people were far better at criticizing others than incriminating themselves. Thus, *douzheng hui,* struggle meetings, took place where one or more individuals had to bend or kneel on platforms to be shouted at, insulted and tortured while others were forced to watch. Many schools, factories, and organizations set up *shouxing shi,* torture chambers, to punish those who were accused of being disloyal to Chairman Mao or of being enemies of their motherland. I would describe the torture chambers as a place set up by a vicious few who built their pleasure on other people's agonies as they tortured and killed large numbers of basically innocent people.

One would imagine that those people who treated others so inhumanely would not get away with it, but they did, at least for the first few years. The reason was, since the beginning of the Cultural Revolution, all our laws were suspended. Chairman Mao's words were considered *zuigaozhishi,* the highest instructions. Aside from them, there were no laws or regulations, no central power base. The entire legal system was paralysed. Judges and lawyers, even employees of the court systems were sent to labor camps. One of my mother's friends, who had been a reputable judge for many years, suddenly disappeared one day. A few weeks later the public security people informed his family of his whereabouts: he was toiling in a labor camp. When his brothers asked what he was charged with, the only answer they received was, "the old legal system needs to be smashed." During the first few years of the Cultural Revolution, any individual or group of people could purge, harm, torture, or kill another individual or group of people. A lot of innocent citizens died without even knowing why.

In the middle schools and colleges students and young faculty members who belonged to *hong wu lei,* the red five categories—namely those born in families of workers, peasants, soldiers, high communist cadres, and revolutionary

military officers—grouped together and formed *Maozhuxide Hong Wei Bing,* literally, the Red Defending Soldiers of Chairman Mao, better known as the **Red Guards.** Therefore, most of the first groups of Red Guards were sons and daughters of high communist officials and military officers. They had a feeling of superiority and, with few exceptions, were unusually cruel to children or adults born of "reactionary" families. The Red Guards took it upon themselves to take charge of the revolution while interpreting every one of Chairman Mao's instructions any way they saw fit. When they wanted to torture their peers, their teachers, their superiors, even for personal reasons, they were able to find something in the highest instructions to justify their actions. Here are a few incidents I witnessed:

1. In the Foreign Language Section of our school, there was a Russian language teacher in his 20s, named Wen-Chang Yang. He bragged a lot about his revolutionary family background, and repeatedly told people how loyal he was to Chairman Mao, how much he loved his students. In 1967, when thousands of students were getting free train rides, traveling all over China, Yang's students went, too. He later discovered that seven of his students solicited money while visiting another middle school out of town, and gave his name as a reference. He took those students, all of them between ages 13 and 15, to the torture chamber and whipped and beat them so hard that the cement floor of the tiny room was covered with blood. He claimed they "lost his face" and lost face for the school, and therefore were disloyal to Chairman Mao. At midnight Yang forced the vice principal of our school, one of the so-called capitalist roaders, to clean away the blood with a sponge and dust bin; half way through the job, she fainted among the puddles of blood.

2. When some of the teachers and students of our school went to a nearby farm to help the peasants harvest wheat at the end of June 1967, we all stayed in the homes of *pinxiazhong nong,* the poor and lower-middle peasants. One night a group of students, most of them Red Guards, put a wet blanket over live wires in their landlady's room, tied up her hands, and made her walk on the wet blanket. They wanted to punish her, because a villager said she was the widow of a local tyrant, and, therefore a *fan geming* counterrevolutionary. The landlady, a thin, shrunken woman with bound feet in her late sixties, died that night. Only after they killed her did they learn that they had believed in a lie. Both she and her deceased husband were poor peasants. The person who told on her bore personal enmity against her. The Red Guards were not apologetic for what they had done. Instead they tried to justify their actions by quoting Mao's words: "In a revolution there definitely will be sacrifices." Af-

terwards, a Red Guard told me, he thought it was very entertaining. "I have never seen anything quite so funny in my life before. She danced all over the blanket every time they plugged in the plug." I wanted to slap him on the face good and hard. Instead, I bit the insides of my mouth until I tasted blood.

3. One of my neighbors, a quiet, reserved shop assistant in his early 50s, was pulled off his bicycle and beaten to death on his way home from work one day, because one of his coworkers had told the Red Guards that the man used to be a capitalist in his younger days. The truth was: my neighbor was an expert in repairing bicycles, and two years before *jiefang,* liberation (1949), he bought a space and owned a bicycle repair shop. Business was so good he hired three or four helpers; but soon after 1949, he was afraid of being classified as a business owner, so he surrendered his shop to the government.

The Red Guards Appear

During the initial months there were bewilderment and confusion in the minds of the masses as to exactly why Chairman Mao chose to start the Cultural Revolution in 1966. China had hardly recovered from the disasters of Mao's *Da Yao Jin,* "Great Leap Forward" campaign in the late 1950s and the three years of *ziran zaihai,* natural disasters, between 1960 and 1963. It became clear later there was struggle for power among the leaders in the Communist Party. During the first part of the Cultural Revolution, many high Party officials, such as the Head of State Liu Shao-Qi, the mayor of Beijing Peng Zhen, Chief of Staff Luo Rui-Qing, Secretary of the Communist Party Deng Xiao-Ping, and later Chen Yi and He Long had all been purged, either forced to resign, or put under house arrest; some were imprisoned, killed, or driven to commit suicide. Everyone in the hierarchy who disagreed with Mao's policy or opposed Mao's chosen successor Lin Biao encountered the same fate.

There had been many *zhengzhi yundong,* political movements, since the Communist government became the ruler of China in 1949, but the Cultural Revolution was by far the most widespread of all. Victims of the revolution were tortured or beaten to death, many committed suicide or died in prisons. A great many of them were the educated, who were usually the *douzheng duixiang,* targets of the struggle, which meant they were singled out to be purged. No official figures were released as to how many people died during those years of chaotic unrest, but I know, not a single one of my friends or relatives did not have at least one tragic death in the family. Some unofficial *xiao bao,* small

newspapers, which carried a large amount of *xiaodao xiaoxi,* small street information, reported that casualties were in the millions, and that during the first few years of the Cultural Revolution, tens of thousands of educated Chinese citizens—college graduates, British and American returned students, business owners, doctors, lawyers, professors, engineers, writers, actors and actresses—had died. Considering that this was a country where more than 80 percent of the population were farmers, and the educated only added up to less than eight percent, it was an irretrievable loss to China.

Since a movement this huge was unprecedented, no one really knew what to do, or how to handle the new situations as they developed. People listened to the newscast as though it were war time; even the teachers who paid the least attention to politics dived for the morning papers when they got to school. Mao's newest instructions were always printed in bold characters on the front page of the *Renmin Ribao, People's Daily.* After having lived under Communist rule for 17 years people had gotten used to waiting for instructions from Chairman Mao and *Dangzhongyang,* the Party Central Committee. Nobody dared make a move without the approval from the Party.

Now, Mao wanted the Cultural Revolution to be on the order of *Tianxia Daluan,* "a big upheaval under heaven." When he met with leaders of the different Red Guard groups, his instruction was *"yue lun yue hao,"* "the bigger the upheaval the better." Suddenly society was turned upside down by the teenage Red Guards and their revolutionary leaders. They interpreted Mao's words *"geming wuzui, zaofan youli,"* "it is not a crime to make revolution, one has the right to rise in rebellion" to be a permission from the Chairman for them to do anything they thought was revolutionary.

Many Red Guards worshiped Mao to the point that they had become fanatical (Fig. 27–3). Mao told them that since only they were born under Communism, only they were pure and good. Mao would typically give one sentence of advice, and those teenagers, carried away by their first taste of power, would try to outdo each other by carrying his instructions to extremes. When Mao asked them to *puosijiu,* smash the "four olds"—old ideas, old culture, old customs, old habits—they marched into the streets and into private homes, they marched into the National Library and the Palace Museums, they committed dreadful crimes under the pretext of revolutionary acts. Priceless bowls and vases dating as far back as Tang dynasty were smashed with hammers; old paintings and calligraphy scrolls, whether privately owned or state owned, were shredded. Many irreplaceable Chinese classics were taken out of the National Library and burned. Older people, who understood what this destruction meant, swallowed their tears

Figure 27–3: Papercut (a Chinese folk art) of Chairman Mao as heroic leader. The sunflowers beneath Mao symbolize the Chinese people who, in a popular Red Guard saying, "follow Chairman Mao all day like the sunflowers following the sun." Stone sunflowers surround Mao's tomb in Tienanmen Square. Courtesy of George J. Leonard.

as they witnessed the acts. Three thousand years of deference to experience and age were forgotten in an instant. All the Confucian family values were thrown out the window. America is almost used to youthful rebellion, but China had no experience of this. The world turned upside down.

In Shanghai the Red Guards stopped adult pedestrians and cut open their tight-legged pants, just because that was the latest fashion in the Western world.

Ladies' skirts were ripped open and the heels were knocked off their high-heeled shoes; those too were bourgeois fashions. To pursue beauty was a sin, because it did not conform with the austere Communist style of living. They smashed pianos and violins, burned music books, and stomped records of classical music into thousands of pieces. Anything not Chinese they considered capitalistic, imperialistic. Beethoven, Chopin, Dvorak, and Tchaikovsky were condemned because their music was so well loved by *Zhishi Fenzi,* the intelligentsia. They were respectively labeled an imperialist, a capitalist, a counterrevolutionary, and a revisionist. The youngsters started bonfires in front of people's doors, tossing in millions of books written in foreign languages—medical, technical, music, and art books, as well as rare editions of Chinese classics. Anything Western, anything old was now evil.

In Beijing, the students' "revolutionary" acts were even more horrifying: people's pets, including dogs, cats, birds in cages, and fish in aquariums were thrown out of fourth or fifth floor windows after they accused the pet owners of having a bourgeois lifestyle. With rocks and bricks, sticks and metal tools, they beat to death the men and women who were accused of being counter-revolutionaries. As for the ones mortally injured and taken to the hospitals by friends or family, the students standing guard at the gates of the hospitals would make sure they did not get in for treatment. The kids accused women with permed hair and men who wore their hair a little longer than usual of having a "bourgeois hair style." They would tackle them and give them a special hair cut called *yin yang tou,* yin-yang hair style—the right side shaven until the scalp was blue and shiny, the left side dangling over the left eye. The boys of our middle school learned it from another school after they went for a *geming chuanlian,* exchange of revolutionary experiences. They came back and did the same thing. There were scenes I can never erase from my memory, even though it has been almost 30 years.

The Violence Escalates

As an English teacher, I was immediately a suspect. After the Revolutionary Committee announced to the whole school that I was an American spy, none of the students that I had taught English to dared speak to me in the hallways, but when we accidentally met in the school yard, I knew from their expressions that they had their doubts and were sympathetic to me. One girl student who was aware that I was not getting enough to eat would pretend she was walking past me, then quickly and

quietly put a roll or a Chinese bun in my hand when no Red Guard boys or girls were in sight. Others would let me take a longer break from my work, which was usually cleaning toilets and sweeping floors, because they knew I had high blood pressure. One of my students, however, treated me very fiercely at first.

She was the best student in my ninth grade English class, Lee was her last name, and she was the daughter of the Vice-Minister of Finance, and therefore among the earliest to join the Red Guards. Before the Cultural Revolution, she was also my good friend and came to my house to visit me often. I translated Chinese songs into English and wrote short plays for the class, and she would organize her classmates to put up performances. One day during the Cultural Revolution, I saw Lee standing guard on the roof of a shed. She had cut her hair very short, her long braids were gone. In her hand she held tightly a four-foot-long black wooden rifle, pointing it toward the front. When I looked her straight in the eye, I was surprised to see anger and hatred. "*Ditou!* Bow your head low," she shouted at me, "*chou meiguo tewu,* you stinky American spy." I felt sorry for her. She must be hurting, because she thought I had cheated her all those years. Three or four weeks later I bumped into Lee again when I was turning a corner. We were both surprised to see each other. This time it was she who bowed her head low. She tried to avoid my eyes and quickly walked past me. I was curious and asked another student what had happened to Lee. "It's her father," the student answered, "he's been purged and stripped of his position. Now he is locked up in one of the cells in his Ministry, accused of treason." Like my two sons, Lee, I was sure, had to learn to grow up in a very short time.

One afternoon in August, three months after the Cultural Revolution started, I was ordered to clean all the windows in the second-floor classrooms. Suddenly there was commotion on the playground—laughter, shouting, and lots of footsteps. I looked out, but I had to rub my eyes twice before I could believe what I saw was true. Ten adults, all with half their heads shaved blue, were ordered to jog around in a large circle. They looked half human, half demon. About 25 to 30 kids and Red Guards outside the circle were shouting commands, and making fun of them, some were poking them with sticks and wooden guns. Because of the half-covered faces, I could only vaguely tell that the principal, the dean, the Party secretary, and my good friend Lan, a Chinese-literature teacher, were among the group being tortured. Chills ran down my back. It was such a formidable sight that I immediately felt weak in my legs. I stooped down, half walked and half crawled to the nearest ladies' room, and hid there trembling for the rest of the afternoon. My instinct told me that if anyone saw me, or remembered me, I would be out there shaved and running, too.

At dinner time I tried to walk into the teachers' dining-room as quietly and as inconspicuously as possible. Usually the students and Red Guards did not hang around the teachers' dining-room, but that night, as my luck would have it, they had. They named it "weed-eating night." Four Red Guards, two in the kitchen and two in the dining-room, made sure that the teachers who were affluent, who had bourgeois ideas, who came from "bad" family backgrounds, were only served boiled weeds and wild vegetables, unchopped, with muddy roots still attached. The reason for this was, they explained to the cooks who were objecting, "the teachers need to experience one night of a peasant's life." That was ridiculous, because the weeds we had that night in no way resembled what the peasants ate.

As soon as I walked into the dining-room, the Red Guards noticed that I still had long hair; the two teen-agers in the kitchen left their job of supervising the cook, grabbed a pair of scissors and came at me. One pushed my face onto a square dining table, and the other started to cut my hair on the right side, saying in a scolding voice: "So, you're still reluctant to part with your American imperialists' hair style? We'll show you." Luckily the cook was my friend; and when I started struggling and arguing with them that I never had a Western-style perm and that my hair was always that way, he came out to grab their scissors and finally chased the Red Guards away. The cook, whom all the teachers affectionately called *erpang,* fatso number two, was one of the very few among faculty and staff that dared argue or fight with the Red Guards. He not only belonged to the working class, but also was a *disandai pinnong,* third-generation poor peasant. From the very beginning he was chosen to serve on the Revolutionary Committee, at that time the highest authority in our school. He was given that nickname for being the number two son in his family and for being quite a bit overweight. During the entire Cultural Revolution, whenever teachers were being tortured by the Red Guards, they often came to him to ask for help. That night, he spared me from a frightful experience.

Prisoner

A few months later, a group of six or seven officers from the PLA drove into our middle school in a military vehicle, each carrying a small suitcase and rolled-up bedding. "Chairman Mao sent us here," the highest ranking officer announced. "We are here to stay and to take over the leadership of the Cultural Revolution." I was relieved, hoping the officers would bring some law and order into our school. My first thought was: if the Red Guards did not take advice from anybody, at least

they had been taught to love and respect the PLA since childhood. I could talk to the officer in charge and let him know I have been wrongly accused. The first thing the new leaders emphasized was to "follow Chairman Mao's instructions closely and precisely: never forget class struggle, but let it be an ideological battle, not a physical fight." I was even more relieved to hear that.

The next morning, when I was still asleep in bed, somebody came banging on my front door. Before I could properly open up, a Red Guard kicked open my door and threw herself in. She was a chubby 14-year-old, about five-foot tall, and had very dark skin. I did not know her name, but had seen her in school a few times. The students in my class called her *xiaoheipi,* little black skin, and told me she lived with her aunt, across the street from my house, because her parents were in Indonesia.

"Get your things together. Take a toothbrush and your bedding. All the teachers have to spend the nights in school from now on. *Bie moceng!*" This expression, meaning "don't you dawdle," is used by an adult when scolding a child. Hearing a fourteen-year-old give orders to an adult with such swollen arrogance made the situation seem almost comical, but I had to take her orders very seriously.

Go to live at the school? I was a single mother and had two young sons, 9 1/2 and 11, to take care of. What could I do? I gave my older son all the money I had on me and made him promise me to use it carefully, only to buy food, and not waste it on nonessential items such as cookies and candies. I told them I didn't know how long I would be gone. They didn't cry. They both stood silently by the open door. I could tell they were very frightened. I tried hard to smile and assure them Mama would be all right and hoped I was far enough away before I cried, so they could not see my eyes swelling with tears.

(Later I learned that my older son bravely took over after I was taken away. At 11 years old he was forced to be the man of the house. He comforted his brother. Home Alone indeed! He kept an account of what food he bought every week. He talked his little brother out of eating candies and cookies for a month, and they lived on just tofu, vegetables, and rice, spending the money I left him wisely.)

At school, we waited in line for the PLA officers to assign us classrooms to live in. I was assigned a smaller classroom with five other teachers. My friend Lan and our Party secretary, Min, were in my room. The students' desks had been grouped together; six desks formed a twin size bed and every night we unrolled our beddings onto them. For the first week we went through the same routine: attended the officers' lecture in the morning, held discussions in the afternoon and evening. Lights out by 10:30 P.M. and up with the bugle at six.

We were supposed to be living like soldiers in a military camp. Seven days passed. On the eighth day, word came by that we were allowed to go home. When Lan and I and the Party secretary were packing our things, four Red Guards came in to say: "You three are not going home; you are moving to a different room."

We were moved to one of the cells in the basement. After we got in, the four Red Guards locked our door from the outside. I was very upset, and asked the Party secretary why we were treated this way. Instead of giving me an explanation, she told me many stories about her experiences during the *Zhengfeng Yundong,* Rectification movements, within the Communist Party. Finally she said: "Just remember one thing. No matter what they do to you, try to keep yourself alive. Everything will be clarified in the end." I was thinking: "I have no intention of dying anyway. I'm a middle school teacher, no American spy, and I am not going to let them beat me into one!"

Altogether, seven teachers and three employees were held under detention as class enemies. For three months we were under the control of a newly formed *Baoweizu,* Security Section, and had to obey their orders unconditionally. The Security Section was comprised of PLA officers, *geming jiaoshi,* revolutionary teachers, and a large number of Red Guards. The rest of the teachers were allowed to take part in revolutionary activities, but we were not. The other teachers and employees could go to lectures, hold group discussions, write big character posters, or visit other schools, but we were forced to clean the toilets, sweep the school yards, and carry garbage to the dumps day after day.

Torture Sessions

The three of us—Lan, the Chinese teacher, Min, the Party secretary, and myself took turns in doing manual labor around the school. Sometimes, one person was ordered to stay in the room to write so-called confessions while the other two labored. Everyday we went through torture sessions—publicly they were called educational sessions—two to three times, usually after midnight or just before dawn. Those hours were considered "safe," because most of the teachers and students had gone home. The *xingju,* torture tools, used by the Red Guards ranged from simple ones, sticks and leather belts, to sophisticated ones like narrow bamboo strips with nails or screws sticking out on one side, or bicycle chains with metal teeth, which were made by pushing metal wires through the holes and fastening them onto the chains by twisting them. The latter two were not designed to kill the victims, but to give a sharp sting and scratch until the blood came.

Very seldom did they beat us in our own rooms; perhaps they did not want the tell-tale blood and hair to remain there. We were always escorted to the remotest corner of the administrative building, then ushered into a large rectangular-shaped meeting room. These meeting rooms, formerly used as music classrooms, were now used for struggle meetings. They usually had a raised platform in the front, and rows of chairs facing the platform. Across on the back wall were two sentences in very big characters: *Tanbai cong kuan; kangju cong yan,* meaning Confession brings leniency; resistance brings harshness. Every time we were brought into one of these rooms, the Red Guards would point at these words and remind us not to forget *dangde zhengce,* the Party's policy. The male teachers and employees lined up on one side, and female teachers and employees on the other. At the beginning of the session we had to *zuo feiji,* "ride in an airplane," which meant we had to kneel or stand and bend our heads forward with our arms stretched out behind us, resembling a jet plane. During that period—the warm-up period they called it—the Red Guards interrogated us about our "crimes." I was almost sure these students in their early teens had never witnessed a court scene before, but they made believe that they were to pass a judgement on us, the criminals. They very often started with questions like: "What's your full name? Your age? The class status of your family?" or, "Do you know you have committed a serious crime?" "Do you admit to be a deadly enemy of the Chinese people?" "Do you plead guilty to a charge of counterrevolutionary activities/ of being a landlord/ of being an American spy?" The first denial on our part would then trigger the beating session. By that time we were already too worn out to resist or ward off the blows. Two or three Red Guards would take turns doing the job; when one became tired, a second would take over. It would go on for hours until all our youthful torturers were exhausted. We were then ordered to go back to our rooms and go back to sleep. "If you dare tell anybody about this we'll kill you tomorrow night." Those would be the last words before we heard the lock click on the other side of the door.

Two or three times my friend Lan fainted during the torture sessions; she was much older than the rest of us, possibly in her 50s. According to the Red Guards in charge, there were two of us who were most *bulaoshi,* dishonest—a history teacher named Liu and myself. We were always arguing with them, they complained, and would not *renzui,* admit guilt. Therefore, Liu and I usually got the most beatings. Once I was repeatedly hit on the head with a big enamel mug, seven inches tall and five inches in diameter, and was unconscious for a whole day. The bump on my head was as big as a large egg. My cell mates were afraid I wasn't ever going to wake up and wanted to get the school doctor to see me, but

were not allowed. Another day I was almost choked to death three times, and, as I mentioned before, if it were not for the thoughts of my children that strengthened my determination to live, I would have died.

The attack that almost killed me happened when I was ordered to stay in my room and write confessions and self-criticisms. The door to our room was still locked from the outside, so the Red Guards from the Security Section could barge into our room any time of day or night, and we could not even go to use the toilet unless someone opened up to let us out.

That particular day, I was sitting there thinking about the charges, but writing nothing. A Chinese phrase, *kuxiao bude,* not knowing whether to laugh or to cry, best explained my mental state. The accusations were so outrageously ridiculous that I wasn't sure where to start or what to write. What *guojia jimi,* state secret, would a middle school teacher know? I didn't even have enough materials to make up a story, if just for the sake of escaping a few beatings. My whole body was aching terribly from the beating I received the previous night. I decided: "to hell with the confession. I am going to write a note and have somebody sneak it out to some high officials in charge of the Revolution, so they can put a stop to the beating and torturing in this school." Just as I was finishing my note, a Red Guard kicked open the door and came in. I had nowhere to hide my note, so I crumbled it up and stuck it into my mouth, remembering a scene I saw in a movie once, where an underground messenger swallowed classified information when he was caught by the enemies. That boy happened to be the shrewdest, meanest, and most unreasonable Red Guard of the Security Section. He literally jumped onto my back, holding my head back by my hair, dug out the crumbled paper with his thumb and index finger. Quickly he read the note.

"*Ni hao ah,*" he said, putting the stress on the middle character *hao.* Here the phrase does not carry its usual meaning, "How are you?" He meant: "How dare you!" "You are a bad element, an American spy, and now you are also *xianxing fangeming,* an active counterrevolutionary." While saying this, he was shaking the note horizontally in front of my eyes. I did not blink, nor did I move back. I refused to acknowledge defeat, because all I did was to tell the truth. "I'll show you what you deserve for telling on ME?" He was a hefty six-foot-tall sophomore, a schoolyard bully who often got into fights with his schoolmates. His first name was Laishun, meaning "Lucky." The Security Section let Lucky join because he had extraordinary strength for a sixteen-year-old. With one quick shove Lucky pushed me off my chair; then gripping me by the shoulders he pinned me against the wall. "Do you admit you are an American spy?" he yelled at me. I said, if I admitted, I would be lying, because I really am not an American spy, in fact, I am

not any kind of a spy. The fact that I did not submit to his power made Lucky angry. "Do you admit that your parents and your grandparents all belong to the bourgeois class?" he shouted again. "That I admit," I said, "but that doesn't mean that I am naturally bad."

He started to chant a juvenile student-created rhyme: *"Longshenglong fengshengfeng, haozi sheng er huidadong,"* meaning: "Dragons are born of dragons, phoenixes are born of phoenixes; the sons of rats know how to dig holes." That was the first time I heard this silly jingle, and I wanted to laugh in scorn. Instead I suggested he should let me get back to writing my confession. He said: "You are not going to get away with this." Lucky was six feet tall, and I am five-foot-two. He put his huge thumb and his index finger on my throat and started pinching it shut until my eyes were ready to pop out and my head, on the verge of exploding. I barely managed to squeeze out a few words with my last breath: *"Bie, wo you gaoxueya."* "Don't, I have high blood pressure." He did not let go.

When I came to I was lying on the cold cement ground, Lucky was still there. He had been pouring cold water on my head and neck. Seeing that I had opened my eyes, he pulled me up once more; choked me again until I fainted, and then he repeated everything he did before. The last time he throttled me, I was told later, I did not wake up; so he locked the door from the outside and left me for dead. In other schools, teachers had been killed almost every week.

When my roommate Lan came back from manual labor, she was shocked to find me on the ground, my left cheek touching the cement, my hands and feet all cold. She half carried and half dragged me onto my bed, rubbed my hands and feet with hot water, and then forced some warm tea down my throat. I have no memory of all this. The only thing I do remember was through the penetrating coldness around me I heard faint voices. The voices kept saying: "Keep breathing, make an effort, don't stop breathing." My mind was a blank when Lan spoke to me; my limbs were numb; my body was cold and stiff. I felt Lan wiping my face saying: *"ni teng ba,* you must be in pain." Despite the sharp pain at my throat and jaw, I slowly shook my head. I felt happy that I was still alive. Because I could see my sons again one day.

Sent to the Countryside

Three months later, all the teachers and employees held in custody in our school were free to go home. We were given seven days to make arrangements at home, to have our children and elderly persons taken care of, then get ready to go off to do "voluntary" labor on a farm in *nongcun,* "the countryside," for one whole year.

*Figure 27—4: Intellectuals moving rocks by hand in the re-education camp.
One still wears a white office worker shirt. The author (far left) wears a Mao
cap. In this posed propaganda photo, all must smile, displaying the right
attitude toward their "re-education." Courtesy of Molly Isham.*

I saw my two sons Ted and Jimmy for the first time in three months. They
had not only grown taller, but also acted more maturely. Ted showed me his book-
keeping, where weekly and monthly expenses were recorded. I was very proud
of them managing so well on the meager allowance they were given (when I was
a prisoner, the Revolutionary Committee only allowed my children to have one
fourth of my salary to live on and held on to the rest of my money). Now, they
were returning to me all the money they had withheld. I suddenly felt very rich
and bought nice things for the children. In preparation for the *xiafang laodong,* farm
labor, I had asked my mother, who lived in Shanghai, to come to Beijing and stay
with the boys for one year.

It was announced that Chairman Mao had a new instruction called the
Wuqizhishi, May Seventh Instructions, ordering leaders of every level and people
with higher education to take turns in going to the countryside to live and work
under peasant conditions, and be reeducated by the peasants for at least a year at
a time. The "countryside" mentioned here is quite different from what Western-
ers think of as rural areas. Even in the mountainous areas only 150 miles outside
of Beijing, the capital, most of the peasants lived under primitive conditions. Some
did not have electricity; no household had plumbing facilities, in other words, no
running water, no bathrooms. The outhouses were usually a two-to-five-minute
walk from the main living quarters, which was very inconvenient if one needed

to go at night. Work started very early in the morning, so two meals out of the three were consumed out in the fields. You rose with the sun and went to bed when it got dark. In summer we all had to get up at 4 o'clock and get to the fields by 5. Breakfast was brought to the work site at 8, and lunch at 1. Nobody got back to the village before 8:30 at night (Fig. 27–4). But I have to say that though most intellectuals hated being sent to the farms, I did not mind going at all. In fact, I was happy to get away from our school and the students that tortured me. Besides I tried to look at the positive side of things. We Chinese have a famous saying: "*jilaizhi ze'anzhi,* since you're here, you might as well make the best of it." I talked to the peasants quite often and did indeed acquire a lot of agricultural knowledge from them.

When it came to the end of one year, I was sad to have to go back to the city and back to our school. In the countryside, living conditions were harsh, and I had to work long hours; but at least everybody respected me, and I didn't have to be interrogated or beaten everyday. Besides, I liked being close to nature, among trees and plants. Once back at school I would be cleaning toilets and toiling in the school yard again. At no time in my life did I fear hard *tili laodong,* manual labor; it was the *wuru,* humiliation, that came with it I could not stand.

Mao himself came from a peasant family. In his young days he lived and worked among peasants. He understood them and he loved them. During the early years of the revolutionary wars Mao usually took long walks away from the head-quarters to visit with the poor and lower-middle peasants. Not until I lived in villages and talked to the peasants about Mao's ideas did I realize how deeply they worshiped Chairman Mao.

During the Cultural Revolution, the peasants' habits were disrupted by the mandatory *junshihua,* militarization, of their activities. For many thousands of years the Chinese peasants had been independent, family oriented people, not used to *jiti xingdong,* collective activities. They told me they really resented some of the things they were forced to do: having to line up in two rows to walk to work in the morn-ing; eating the same kind of food at mess halls instead of going home for dinner; sitting through lengthy political meetings at night after a 12- to 13-hour work day. They did not complain, however; they just did what they were told to and protested silently with their actions. For example, the meetings at night usually began at around 9 and lasted until 10:30 or 11. The lecturer, who was also the Communist leader in the village, did not have a microphone, so it was challenging for him to make him-self heard by over a hundred people. A few times, the men that snored the loudest would group together and sit close to the podium. They would snore so loudly in chorus that nobody else could hear what was being said.

The Fall of the Gang of Four—The Cultural Revolution Ends

As the Cultural Revolution wore on, year after year, China was paralyzed. Groups of Red Guards holding opposite viewpoints started fighting with each other, first with tongues and rocks, then with real guns and bullets stolen from the PLA soldiers. The two most prestigious universities, Tsinghua University and Peking University, were turned into battlegrounds. *ZhongyangWenge,* the Central Cultural Revolutionary Committee, called on workers to step in and stop the warring parties, but hundreds of workers were killed on the day they drove into Tsinghua when the two parties were shelling each other's strongholds. For a period we believed a civil war was going to erupt any day.

During the course of the Cultural Revolution four names became associated with the most radical execution of Maoist policies. They were Mao's wife, Jiang Qing, two leftist writers, Zhang Chun-Qiao and Yao Wen-Yuan, and the head of a factory militia, Wang Hong-Wen, who later became the leader of a Red Guard organization called *Gongzongsi,* The Workers' Main Headquarters. All four grabbed power in their own ways during the Cultural Revolution, and they later became the notorious *Sirenbang,* Gang of Four.

My own memories center most vividly on Jiang Qing, a former Shanghai B-movie actress with political ambitions, whom Mao married against the advice of his friends. In the 10 years she was in power, she did irrevocable damage to Chinese art and culture. She persecuted, jailed, and killed tens of thousands of fine writers, artists, opera singers, movie actors and actresses, musicians and playwrights. Within a period of 8 years, she only allowed eight plays and operas to be performed in public. The eight plays were: *Bai Mao Nu, The White-haired Girl, Hongse Niangzijun, The Red Women's Army Detachment, Hongdeng Ji, The Tale of the Red Lantern, Shajiabang, Shajia Creek, Zhi Qu Weihushan, Capture Weihu Mountain by Wisdom, Qixi Baihutuan, A Surprise Attack on the White Tiger Regiment, Longjiang Song, Ode to the Dragon River,* and *Hai Gang, Seaport.* They were rearranged into Peking operas, local operas, movie scripts, dance dramas, and ballets and were performed in cities, towns, and villages throughout China over and over again. Every time the performers or the movies came to the village where I was working, the whole village, young and old, were forced to watch. The children, after having seen most of them for more than a dozen times, knew all the music and words by heart. They just sang along with the singers.

Here is another story to show how dictatorial Jiang Qing was: In the early 70s, she designed a Western-style dress, a V-necked, three-quarter-sleeved dress made with a solid colored material, nothing special. At first, Jiang announced

Figure 27–5: "Chiung-hua and Hung-lien put on the uniform of the Red Army fighters for the first time and felt full of strength. Their new life was bringing them endless joy." Red Women's Army Detachment, by Liang Hsin, illustrated by Li Tzu-shun. Foreign Languages Press, Peking. Courtesy of George J. Leonard.

it was mandatory for young women actresses to purchase the dress for wearing to receptions and parties, whether they liked it or not. Later, she ordered every Chinese woman, young and middle aged, to buy one. The dresses were all made by the same company, and cost 35 Yuan RMB, which was quite expensive for a young worker who only earned 50 to 60 Yuan a month. I remember it was equivalent to almost half of my monthly salary, and I could hardly afford to buy it. If a Westerner walked down *Wangfujing*, the most animated shopping street in Beijing, he might think that Chinese women all had to wear the same uniform.

The fall of the Gang of Four came shortly after Mao Zedong's death in September 1976. That fall, crab vendors started selling crabs tied together, four in a row, three males and one female, calling out to people: "Buy The Gang of Four!" Why did they use crabs as a metaphor? Because crabs *heng xing*, walk sideways, and the Gang of Four *Heng Xing Ba Dao*, were domineering tyrants. The phrases have the first two characters in common.

Blaming Jiang Qing was, of course, a way for the Communist Party to avoid blaming Mao, whom the peasants still revered.

In 1972, the American president Richard Nixon visited China. Prior to his visit, we were told there was a possibility that Mrs. Nixon might request to see our educational systems and visit schools, so the authorities put the teachers back into their classrooms again. By that time the PLA officers had withdrawn from the schools and the former leaders had resumed their power.

Mrs. Nixon did not come to our school, but she unexpectedly walked into a small *fan guan,* restaurant, near our school where one of my former students was working as the *da shifu,* chief chef. He told me all about the excitement of that incident after the American guests had left China. It turned out that Mrs. Nixon was visiting the Beijing Children's Hospital that afternoon; as she came out she noticed this little restaurant on the same street. She told her *fanyi,* interpreter, and her escorts that she wanted to go and get something to eat. Her escorts were nervous, but they could not find any excuse to stop her from walking in. They could not say that it was just a local restaurant, certainly not elegant enough to serve foreign guests. Mrs. Nixon randomly ordered a few dishes, then she asked to speak to the chief chef.

"I would like you to cook me a very unusual dish that's worth $200," said Mrs. Nixon.

My student nodded and smiled and went back to the kitchen. An emergency meeting was called and everybody contributed ideas: shark's fin with shredded sea cucumber; steamed crab eggs; dried scallops cooked with ginseng. Those were expensive dishes, but they certainly don't cost $200. Then my student had an idea. He immediately got on the phone and ordered two hundred *tian ya,* force-fed ducks, which were the typical kind used to make *Beijing kao Ya,* Peking duck. He then cut off the tips of the ducks' tongues and made a dish of stir-fry duck tongues in ginger sauce for Mrs. Nixon. That dish actually cost more than $200.

Early in 1973, all the teachers and employees in our school who were labeled class enemies during the Cultural Revolution were *ping fan,* rehabilitated. We were invited to take part in an all-school meeting at which the Revolutionary Committee, represented by a faculty member, and the school authority, represented by the principal, formally apologized to each one of us separately. At the end of the meeting, they took out all the self-criticisms and confessions written by these people—boxes and boxes of them—and burned them in front of the whole school.

In the spring of 1976, Premier Zhou En-Lai had just passed away; Chairman Mao was already very ill with Parkinson's disease; students were back in their classrooms again. Law and order was partially restored in Beijing, and people who had committed murders or robberies during the Cultural Revolution were now punished. One afternoon, three workers from a nearby factory came to our school asking to speak to my friend Lan and myself.

Figure 27–6: Swan Song *1993, by Hung Liu. The artist survived the Cultural Revolution, and now teaches in California. The ballerinas are from the* Red Detachment of Women, *one of only eight operas that Madame Mao deemed "revolutionary" enough to be shown during the Cultural Revolution. Used by permission of the artist.*

"Do you know a former student by the name of Lucky?" they asked. "We are accumulating evidence regarding the evil deeds of Lucky. He has just been arrested by *Gong An Ju,* the Public Security Bureau (equivalent to the police), for fighting and unlawfully beating a fellow worker to death. He is now facing a possible death sentence, because he is over 18."

When Lucky was torturing me, I knew that as long as I kept myself alive, everything would turn out all right; but I did not expect that he, my torturer, would be the one to die.

Further Reading

Butterfield, Fox. *China—Alive in the Bitter Sea.* New York: Times Books, 1982.

Chang, Kuo-Sin. *Mao Tse-Tung and His China.* Hong Kong: 1978.

Chang, Jung. *Wild Swans.* New York: Simon & Schuster, 1991. I started to read Jung Chang's book solely to satisfy my curiosity. Her grandmother was the same age as my mother, her mother was born in the year I was born, and she and her siblings are the age of my children. The life experiences of the three generations in my family before the Cultural

Revolution couldn't have been farther apart from hers. Yet from 1966 on, the anxieties, the sufferings, and the shocks the two families experienced were very similar.

Cheng, Nien. *Life and Death in Shanghai.* New York: Penguin Books, 1986. Nien Cheng belongs to my mother's generation, and she and my parents had friends in common. Reading her book I acquired a more vivid account of what really happened to my family and my relatives in Shanghai during the Cultural Revolution. (I was living in Beijing at the time and only communicated with my family occasionally by phone. I dared not write letters, and I begged my parents not to put anything in writing.)

Heng, Liang, and Judith Shapiro. *Son of the Revolution.* New York: Random House, Vintage Books, 1984. Both this and the following book present authentic accounts of a generation younger than mine that survived the horrors of the Cultural Revolution. Literally millions of well-educated people who have nothing but love and enthusiasm for their native country suffered in the same way as Liang's parents and their friends.

———. *After the Nightmare.* New York: Macmillan, Collier Books, 1987.

Hinton, William. *Turning Point in China—An Essay on the Cultural Revolution.* New York: Monthly Review Press, 1972.

Rittenberg, Sidney, and Amanda Bennet. *The Man Who Stayed Behind.* New York: Simon & Schuster, 1993. Sidney Rittenberg is a long-time friend of mine and, for many years, my superior when I was working in Beijing. As a life-long friend of China he had no bitterness in spite of all the things the Chinese Communists did to him and his family.

Terrill, Ross. *China in Our Time.* New York: Simon & Schuster, 1992.

Part IV

Asian Pacific Culture

Diaspora

The Chinese Diaspora

A Selection from the Work of Evelyn Hu-DeHart*

EVELYN HU-DEHART

[*Diaspora*—accent on the second syllable—was originally the name given to the dispersion of the Jews throughout the Old World, first after the conquest of their homeland by the Babylonians in the sixth century B.C. and, in greater numbers, after the Romans laid waste to the country following the Jewish Revolt against them around 70 A.D. In recent years this useful term has been adopted for the less-than-willing migration of other peoples faced with grim financial need (and even for the totally unwilling dispersion of the Africans through slavery). This important migration phenomenon has spawned its own journal, *Diaspora*. The goals of *Diaspora,* according to editor Khachig Tölölyan, are to examine the evolution of the "term" and its "semantic domain." Acknowledging that 30 years ago "diaspora" was a term of "self-description" used only by Jews, Greeks, and Armenians, today the term is being "repeatedly appropriated by various disciplinary (and polemical) endeavors, and redefined along the way" (*Diaspora* 3:3 1994).

We don't rightly understand the Chinese arrival in America until we see it as one part of the great Chinese diaspora that has continued unceasingly since the mid-1800s. (The Japanese peasantry went through a diaspora on a smaller scale: Hidetoshi Ukawa, Japanese Ambassador to Brazil, estimated in a November 1994 speech at the Japanese American National Museum that there were by then 2.5 million "people abroad of Japanese ancestry.") We don't fully understand the Chinese immigrants struggling to get to the land of the "Flower Flag," America, despite all odds, until we know what stories of other lands they heard in their home villages. Dr. Hu-DeHart's chilling story of the Latin American "coolie trade" explains why even the racism of nineteenth-century America must have looked bearable by comparison.—Ed.]

*Abridged by George J. Leonard

From 1847 to 1874, as many as 225,000 Chinese indentured or contract laborers, almost all male, were sent to Cuba and Peru.[1] During this period, about 1.5 million Chinese went overseas, to Southeast Asia, North America, as well as South America and the Caribbean, and other parts of the world. This is no small number, considering the time span of just 27 years. Eighty percent or more were destined for the sugar plantations of both societies. In the case of Cuba, the Chinese were imported while African slavery was still in effect though undergoing "gradual abolition," and the Chinese worked alongside this traditional form of plantation labor. In the case of Peru, where slavery was abolished in 1854, the Chinese supplanted black slaves. Was coolie labor another form of slavery, or was it a transition to free labor? This paper will examine *"la trata amarilla"* (the yellow trade).

The International Coolie Trade

The British were the first to experiment with the exporting of first Chinese, then East Indian, laborers under contract to their overseas colonies. As early as 1806, at precisely the time when the British ended the slave trade, 200 Chinese were sent to Trinidad. Although this experiment was a failure, British entrepreneurs continued to press for the export of Asian labor, turning from China to India by the 1830s. By 1838, some 25,000 East Indians had been exported to the new British East African colony of Mauritius and successfully adapted to the plantation system there.

Thus was initiated a forced international labor migration of immense proportions, the official, recorded count totaling over half a million between 1842 and 1870, to Mauritius, Demerara (British Guiana), Trinidad, Jamaica, Natal, Réunion, and other small French colonies.[2] The British, who condemned slavery and pressured the French, Spanish, and Portuguese to follow their lead in ending the African slave trade, also led the way to develop, sanction, and profit from this new system of forced labor. The Spanish and Cubans, and the Peruvians, quickly followed their example, faced as they were with the same dilemma of the end of slavery when the plantation economy continued to flourish.

This became the infamous *coolie trade,* referring specifically to Chinese and East Indians bound under contract to provide service for a specified period of time—five years under the British system, eight in Cuba and Peru. The contract was a legal document between a free person and an employer and spelled out the precise obligations of both parties. The coolie [from the Chinese *ku li,*

"bitter labor"] was to be paid during the period of contract, usually a combination of wages and in-kind (food, clothing, lodging, and medical attention). After completing the term of indenture, the coolies were to regain their total freedom. However, there was an immense gap from the very beginning between theory and practice, which was probably unavoidable given the context in which the system developed.

British historian Hugh Tinker describes coolie labor as "the lowest layer of the industrial labor force," whose creation was directly linked "to the emergence of Western . . . economic exploitation of the raw materials of the tropics." The coolie system enabled the plantation industry "to draw upon a pool of cheap labour with the minimum of restrictions and the maximum of leverage against the workers." It emerged in direct response to the end of the African slave trade and of slavery as the preferred system of labor on plantations. At this time the plantations were becoming more mechanized and industrialized, so much so that one could speak of the plantation as "industrial agriculture," or "factory in the field."[3]

The Coolie Trade to Cuba and Peru

Between 1763, the year the British captured and occupied Havana for 10 months and opened up this Spanish colony to international trade and the emerging North American market, and 1838, when the Cuban industry mechanized significantly, Cuban society was transformed from "the relatively mixed economy based on cattle-ranching, tobacco-growing, and the small-scale production of sugar" to the "dominance of plantation agriculture based on the large-scale production of sugar and coffee."[4] It had surpassed her British West Indian neighbors to become the preeminent sugar producer in the world. Along with new markets, improved technology, capital availability, a responsive political climate, a modern, entrepreneurial spirit among the planters, and other factors, African slave labor was crucial to the success of the plantation economy. The slave population had grown from 38,879 (22.8 percent of the total population) in 1774, to 436,495 (43.3 percent of total population) by 1841. Despite British efforts already underway to end the international slave trade, Cuba continued to import large numbers of Africans during the early nineteenth century, reaching as high as 25,841 in 1817.[5]

The transformation of Cuban society was not just an economic phenomenon; it was social as well, for the population became not only increasingly slave and colored, but the planter class—often *hacendados* (landowners), *esclavistas*

(slave owners), and *negreros* (slave traders) all in one (e.g. Zulueta and Aldama)—reigned supreme, with their interests driving most policy-making, and their authority, particularly on their estates, largely unquestioned.

In Peru, the coastal sugar economy declined after independence, due to the ravages of war and the labor shortage brought on by the end of African slavery. The slave trade to Peru ended in 1810, and slavery itself was formally abolished in 1854. But the guano trade (nitrate fertilizer from bird droppings) of the 1840s generated new capital, some of which was transferred to agriculture and revitalized it. Together with the guano industry, the coastal planters went in search of cheap labor overseas, unable to find it among the small coastal peasantry or the faraway serranos. When slavery was officially abolished in Peru in 1854, there were only 17,000 slaves left. Even if they were willing to remain as salaried workers, it was hardly enough to meet the growing labor demand. Between 1839 and 1851, the Peruvian government paid out 450,000 pesos in premiums to encourage importation of foreign labor to replace slaves.[6] Two thirds of this money was directly invested in labor for the sugar plantations.

Free men and women in Europe were not attracted to working in a plantation society under near–slave labor conditions. So in 1844, when the British coolie trade was in full swing, the Junta de Fomento [trade association] sent an agent to China to study the possibility of importing Chinese coolies. The Spanish government was also familiar with Chinese agricultural labor in their Philippines colony. An agreement was sealed sometime in 1846 between Zulueta and Company in London and the British in Amoy, a treaty port in Fukien Province, South China. On June 3, 1847, the Spanish ship "Oquendo" docked in Havana with 206 Chinese on board, after 131 days at sea. Six died at sea and another 7 shortly after arrival. Nine days later, another British ship, the "Duke of Argyle," arrived with 365 on board, after 123 days at sea.[7] Thirty-five had died at sea. Both human cargoes were consigned to the Junta de Fomento, which proceeded to distribute the coolies in lots of 10 to a group which included the island's most prominent planters and one railroad company.

As the African slave trade wound down and ended with the last shipments in 1865 and 1866 of just 145 and 1,443 slaves, the size of the Cuban coolie imports rose markedly, reaching as high as 12,391 and 14,263 in 1866 and 1867. From 1865 to the end of the coolie trade in 1874, 64,500 coolies arrived, constituting more than 50 percent of the total number imported. During this period, sugar production climbed steadily, reaching a high of 768,672 metric tons in 1874. Coolies constituted the source of labor replenishment, delaying the crisis that would have set in with the end of the slave trade and making it possible

for the plantation economy to continue to prosper. It is also noteworthy that, after 1875, when both the slave and the coolie trade had ended, sugar production displayed a pattern of general decline, a crisis brought on certainly in large part by the shortage of available labor.

The Coolie Contract and Coolie Regulations

From the very beginning of the trade, Cubans and Peruvians rarely referred to the Chinese as coolies, or even as workers, but as "colonos asiaticos." Those who bought their contracts were referred to as "patrón" or "patrono," and, in Peru, sometimes as "amo," which can be translated as "master." (Significantly, however, the Chinese government itself preferred the term "employer," which certainly was more appropriate given the coolies' legal status.) The contract ("contrata") had the heading "Emigración China para Cuba" (or Peru), which probably explains the reference to the Chinese as "colonists." In Chinese, however, the heading can be translated as "Labor Employment Contract" (Gu kong he tong), making no allusion to immigration, but rather to work.[8]

All coolies were issued a contract before embarkation for Cuba and Peru. The contracts were essentially the same for both destinations; often the coolie did not know where he was heading until on board ship. Peruvian and Cuban planters even employed the same agents to handle the trade for them in Macao. The same Portuguese authorities in Macao oversaw the loading process and legalized the documents. The contract was to be read to the coolie in the appropriate Chinese dialect, so that he fully understood its terms, and by signing signified conformity with these terms.

The contract was printed in both Chinese and Spanish and issued in duplicate: one to the coolie to be kept on his person for the duration of his servitude, and one to the contracting agency, which transferred it to the patrono upon selling it. Printed in clear type in both the Spanish and Chinese versions, and usually on a fine blue paper, the contract included details such as the name, age, and home village of the coolie, the name of the on-site agent as well as the contracting agency in Havana or Lima, and sometimes the name of the coolie ship; it was signed by the Spanish consul and the local authorities (Portuguese in the case of Macao).

Throughout the years of the trade, some of the basic terms remained constant: the eight years of servitude almost never varied; the pay of one peso a week, or four a month, also remained constant; in addition to salary, coolies were paid in food and clothing—usually some specified amount of rice, meat or fish, yams

or vegetables, as well as two changes of garment, one jacket and one blanket a year. Housing was also provided. The contract specified three days off during New Years, and usually Sundays as well, although this was rarely honored even when stipulated. Furthermore, the contract provided for medical attention, although it also stipulated under what conditions the patrono could withhold pay until recovery. The patrono was also assured of fully eight years service, so that the coolie was obligated to make up for lost days by extending his service beyond the eight calendar years. In addition, the coolie was advanced 8 to 14 pesos at time of departure (for passage and a new change of clothing), which constituted a debt to the patrono to be repaid by deduction from his salary at the rate of one peso a month.

In Cuba, the initial contracts were reinforced by the first coolie regulations issued on April 10, 1849, entitled "Government Regulations for the Handling and Treatment of Asian and Indian Colonists."[9] In issuing these rules, Governor-General Conde de Alcoy bluntly stated the need—in addition to "protecting the rights of the colonists"—for rules that also assured their "subordination and discipline, without which they could hurt instead of benefit agriculture." Since nowhere in the contract was corporal and other forms of punishment mentioned, the 1849 Reglamentos clearly spelled out the conditions—insubordination and running away—under which corporal and other forms of severe punishment could be meted out, including floggings *(cuerazos),* leg chains or shackles *(grillete),* and confinement in stocks *(cepo).* Cuban historian Juan Pérez de la Riva, one of the severest critics of the coolie system, pointed out in his study of the legal condition of the coolies in Cuba, that the rules regarding corporal punishment were lifted almost verbatim from those designed to discipline and punish slaves.[10]

On the other hand, the 1849 regulations also contained two articles clearly implying distinctions between Chinese coolies and slaves. Article 10 stipulated that whenever there were 10 coolies on any one estate, the planter must assign a white overseer (mayoral blanco) to supervise and care for them and to help them with the work. Article 17 stipulated that only the white overseer could mete out corporal punishment and never in the presence of slaves *(los negros).*

When the trade was resumed in 1853, a new set of regulations were introduced in 1854, and the contract itself was modified. This was the "Regulations for the Introduction and Control of Spanish, Chinese, and Yucateco Colonists on the Island of Cuba."[11] Although the regulations included all colonists, it was clearly aimed primarily at governing Chinese coolies. First of all, in view of the violent reaction of the first coolie arrivals to corporal punishment, it was specifically

prohibited in the 1854 regulations and all subsequent ones. There is no shortage of evidence to demonstrate that this prohibition was largely ignored by the planters and their administrators.[12]

Coolies in Cuba and Peru

From the beginning, critics and cynics in both Cuba and Peru noted and decried the hypocrisy they perceived in the use of the term "colono." If "colonist" implied settling the land and working it independently, there is plenty of evidence to indicate that such was far from the minds of those who acquired Chinese coolies and who viewed them simply as "brazos" or cheap, unskilled labor. In practice and in some of the laws, the Chinese were denied most of their rights as free men under contract and after the contract period, and were hardly regarded by other members of either society as immigrants or colonists. Most of all, the critics of this system—both contemporary observers as well as historians examining it retroactively—have focused on the actual physical conditions of work and daily life on the plantations (in Peru the guano pits as well) for the Chinese coolies.

There of course, the Chinese were confronted with the tradition of slavery, their patronos seasoned slave owners. In the case of Cuba, the situation is even more concretely that of a slave regime, with the Chinese working alongside slaves, performing basically the same unskilled tasks, with some small number assigned to more skilled labor. In the case of Peru, in the early years, the Chinese likely worked under recently liberated slaves who became the "capataces" and "mayorales" (headmen or overseers), prompting one critic at the time to observe that "the *negros* under slavery suffered only the tyranny of the white; the *chinos* that of the white and the negros."[13] These former slaves, in short, acclimatized the Chinese into a continuing "tradición esclavista," which Chinese coolies introduced at exactly the time that slavery was abolished in 1854.

Coolie traders as well as the planters made little attempt to readjust the system or even to change the terminology. In South China, hapless Chinese, mostly poor young men, were "recruited" by force and deception by their own countrymen commonly called by the Westerners crimps or runners *("corredores")*—just as their counterparts in Africa were called. While waiting to be embarked in Macao, these recruits were housed in "barracoons." Many of the same ships and captains used in the African slave trade now transported Chinese coolies, packing them on board in the same way as slaves, across a "Middle Passage" that was even longer in distance and more arduous. Mortality rates on these coolie ships—

known also as "floating coffins"—were as high as 25 or 30 percent, and averaged 16 percent for Cuba.[14]

Upon their arrival in Havana, the coolies were locked up on the "depósitos" until they (technically their contracts) were auctioned off in lots in the same market used to sell slaves. In the plantations, the coolies were housed in the same quarters as slaves or former slaves, known as *"galpones"* in Peru. The administrators resorted to the same methods of control and punishment—stocks and metal bars *(cepo* and *barras),* leg chains *(grillete),* whippings *(azotes),* jails and lockups, even executions. Physical punishment was rampant, because this was the usual method Peruvian planters used to control the workers on the haciendas.[15] Notices appeared in the local newspapers regarding "chinos cimarrones" (cimarrones being a term that specifically applied to runaway slaves) or "venta de chinos" (chinamen for sale) although legally, of course, neither the contract nor certainly the person of the Chinese could be sold.[16]

In the actual treatment of coolies, it is clear that the patronos lived (in the case of Cuba) and inherited (in the case of Peru) the legacy of slavery: "They thought only in terms of a slave system; they could not think beyond that system, and they did not want to go beyond." The coolie system was erected upon the foundations laid by slavery. As with slaves, the planters enjoyed "absolute power" over the coolies.[17]

The coolies, for their part, also responded to the harshness of the plantation regime much as slaves did. They rebelled, individually or collectively; they protested to the authorities whenever possible though usually with little effect against the overwhelming power of the planters over the judicial system in spite of certain laws; they ran away; they resorted to suicide. They even joined insurrections (against Spain in Cuba's Ten Year War) and allied with foreign invaders (with Chile in the War of the Pacific) in order to bargain for their personal freedom.[18]

On the part of contemporary observers turned critics of the coolie system, as well as of twentieth-century historians examining the system, many viewed this treatment of legally free men, albeit under contract for eight years, as no different from chattel slaves, thus concluding that coolies were slaves or "semiesclavos," and the system another form of slavery. In many of the critics, an undertone of moral outrage is quite audible.

Extension and Adjustments to the Coolie System

When the coolie trade was cut off to Cuba and Peru in 1874, many of those already in these two countries still had to work off their terms of servitude. Moreover, in

both places mechanisms were put in place to extend the term of service, to force or otherwise entice the Chinese to continue working under some kind of contract primarily on the plantations, where demand for labor continued to be high.

In Cuba, forced recontracting began early, with the Reglamento of 1860 discussed above, which obligated those coolies who had completed their first eight years to recontract (for an unspecified period of time) or to leave Cuba at their own expense. Only those whose contracts expired before 1861 were exempt. To critics such as Pérez de la Riva, recontracting simply further confirmed his conclusion that the coolie system was slavery, in that compulsory and successive recontracting perpetuated servitude indefinitely to the point that the legal distinction between indenture and slavery became truly blurred by the practice.

There is no doubt that the Cubans issued the recontracting regulation in order to keep as many as possible of this captive alien labor force on the plantations, knowing full well that very few of the coolies could have saved enough from their meager wages to pay for their passage home. Equally undeniable a factor was racism, for the question of race definitely figured into this decision to keep the Chinese indentured. Cuban slavers and abolitionists alike had trouble dealing with a free nonwhite population. Recontracting succeeded well as a device to keep Chinese labor in agriculture for as long as possible. The 1872 Cuban census noted 58,400 Chinese, of whom 14,046 were "free," that is, men who had completed their original contracts. Nevertheless, of this number 10,044 remained in agriculture.[19] Records uncovered by historians in the People's Republic of China reveal that from 1880 to 1885, a period when many of the coolies sent to Cuba and Peru during the height (also the last thrust) of the coolie trade in the first half of the 1870s would have completed their original contracts, only 1,887 of the Chinese managed to make their way back home to China. This was an insignificant number, given the over 100,000 who left China in the 1870s for Cuba and Peru.[20]

In Cuba by the census of 1872, 14,064 coolies had completed their original contracts, had become naturalized, or had registered as a "foreign resident." Under contract were 34,408 coolies; 7,036 were runaways, 864 were captured runaways, and 684 were sentenced criminals. Awaiting recontracting in the depositos were only 864.[21]

As the decade of the eighties drew to a close, both Peru and Cuba saw the end of dependence on slave and coolie labor on the plantations. Very simply, after 1885, an aging Chinese population whose ranks were not being replenished by younger immigrants, was being increasingly replaced by Peruvian *"peones libres"*; they disappeared almost entirely from the plantations by the end of the century.

By then, Peruvian hacendados had learned how to entice and keep native Peruvian workers with the use of advance wages and debts, much the same way they had used to entice and coerce free Chinese to work for them. In Cuba, the old plantation system gave way to the colonos or independent small farmers who cultivated and supplied the newly modernized mills with the raw canes. Many of these colonos were new immigrants from Europe (mostly Canary Islanders and Gallegos).

Analysis and Conclusions

If one focuses strictly on the eight-year term of servitude that the Chinese coolies bound themselves to by signing the contracts—specifically the condition of the work; the actual physical treatment they received at the hands of planters, administrators, overseers; the denial of personal freedom; the spatial (in the case of Cuba) and the chronological (Peru) proximity to slavery—there is no escaping the conclusion that the coolie system very closely resembled plantation slavery.

Notes

1. See Arnold Joseph Meagher, "The Introduction of Chinese Laborers to Latin America and the 'Coolie Trade,' 1847–1874." Ph.D. dissertation, UC Davis, 1975, p. 55. (This is an excellent piece of research that should have been published as an important contribution to an aspect of the international migration of labor in the nineteenth century.)
The approximately 225,000 Chinese who went to Cuba and Peru were almost exclusively male. So few women went under contract that they were statistically insignificant. A few women went as prostitutes (possibly sent from California by enterprising California Chinese businessmen) or free women. The Cuban census of 1872 noted 58,400 Chinese, of whom only 32 were females, 2 under contract and 30 free. Of the 34,650 noted in the 1862 census, 25 were females. Of the 24,068 in the 1877 census, 58 were females (some possibly born in Cuba and Peru). These figures taken from C.M. Morales' papers, vol. 3, #19, Biblioteca Nacional José Martí, Havana: Vidal Morales y Morales, "Immigración de chinos en la Isla de Cuba. Datos que ha proporcionado el que suscrita a Mr. Sanger, Inspector General del Censo." (Collection of clippings n.d.) The Peruvian census of 1872, which is incomplete, notes 12,849 Chinese in the four coastal provinces of Pacasmayo, Trujillo, Chiclayo, and Lambayeque where the Chinese population was concentrated; only 15 of them were females. Censo de 1872. Archivo General de Perú (AGP).
2. Hugh Tinker, A New System of Slavery. The Export of Indian Labour Overseas, 1830–1920. London: Oxford University Press, 1974, p. 113. If Ceylon, Malaysia, the trade before 1842 and after 1870, and illegal exports were all included, Tinker estimates the number of East Indians taken overseas to be at least one million, possibly as high as two million; pp. 114–115.

3. Tinker, pp. xii–xiii, 20–21.

4. Franklin Knight, *Slave Society in Cuba During the Nineteenth Century.* Madison: University of Wisconsin Press, 1970, p. 6.

5. Ibid., p. 22.

6. Michael J. Gonzales, *Plantation Agriculture and Social Control in Northern Peru, 1875–1933.* Austin: University of Texas Press, 1985, p. 23.

7. Archivo Nacional de Cuba (ANC). Junta de Fomento, 147/7278. Also: Juan Jiménez Pastrana, *Los chinos el la historia de Cuba, 1847–1930.* Havana: Ed. Ciencias Sociales, 1983, pp. 13–17.

8. ANC. Gobierno Superior Civil, 635/20078, is a copy of an 1847 contract, signed in Amoy, China. A reproduction of a Cuban contract can be found in Jiménez Pastrana, "Materia gráfica" section between pp. 106 and 107. Many copies of Peruvian contracts can be found in the AGP.

9. "Reglamento del Gobierno para el Manejo y Trato de los Colonos Asiáticos e Indios." 10 de abril de 1849. Reproduced in Jiménez Pastrana, pp. 153–161.

10. Juan Pérez de la Riva, "La situación legal del culí en Cuba," in *El Barracón. Esclavitud y capitalismo en Cuba.* Barcelona: Ed. Crítica, 1978, pp. 111–140. Originally published in *Cahiers du Monde Hispanique et Luse Bresilien,* Carabille, no. 16, 1971.

11. "Reglamento para la Introducción y Régimen de los Colonos Españoles, Chinos o Yucatecos en la Isla de Cuba." Real Decreto de 22 de marzo de 1854. Reproduced in Jiménez Pastrana, pp. 161–174.

12. Pérez de la Riva, "Situación legal," p. 117.

13. Juan de Arona, *La immigración en el Perú,* 1972 edition, p. 93, cited in Humberto Rodríguez Pastor, *Hijos del celeste imperio en el Perú (1850–1900). Migración agricultura, mentalidad y explotación.* Lima: Instituto de Apoyo Agrario, 1988, p. 33. Arona was an abolitionist who also opposed the coolie trade, although this did not stop him from acquiring a few coolies from one of the earliest shipments for a relative.

14. Denise Helly, *Ideologie e ethnicité. Les Chinois Macao a Cuba, 1847–1886.* Montreal: Les Presses Universitaires de Montreal, 1979, p. 131. On Macao and the passage, see Watt Stewart, *Chinese Bondage in Peru. A History of the Chinese Coolie in Peru 1849–1874.* Durham: Duke University Press, 1951, pp. 25–76.

15. Rodríguez Pastor, pp. 34–35.

16. The *Boletín de Colonización* of Cuba in 1873 contains many lists of "chinos cimarrones" in various municipal depósitos or holding cells. In Peru, it was common to read notices in newspapers seeking help to recover a "chino prófugo," or seeking to buy or sell ("se vende un chino") coolies. *El Comercio,* 17 July 1851; 17 August 1870; 21 July 1871.

17. Tinker, pp. 2–3, making the observation about West Indian and Mauritanian planters via-à-vis East Indian coolies. On Peruvian planters, see Stewartt, p. 108–112; Gonzales, pp. 24–41. On Cuba, see Rebecca Scott, *Slave Emancipation in Cuba. The Transition to Free Labor, 1860–1899.* Princeton: Princeton University Press, 1985.

18. For Chinese response and resistance to the coolie system, see the Chinese Commission testimonies, scattered throughout the document; Helly, pp. 211–229, Jiménez Pastrana, pp. 81–128. For Peru, see: Rodríguez Pastor, pp. 83–112; Wilma Derpich, "Sistema de dominación: cimarronaje y fugas," in *Primer Seminario sobre Poblaciones Immigrantes,* pp. 79–90. Also, there are many expedientes in the ANC, Gobierno Superior Civil and Miscelánea de Expedientes (unclassified documents) on coolie runaways, suicides, assaults on administrators and overseers,

complaints, protests, and uprisings. Similar expedientes can be found in the AGP for Peru and in the correspondences between administrators and plantation owners in the Archivo del Fuero Agrario of Peru.

19. *Boletín de Colonización,* I:18, 15 October 1873. The Boletín, published in 1873 and 1874, was the official organ of the powerful Junta (or Comisión) de Colonización, which had jurisdiction over the coolie trade and the coolies, whom it always and consistently termed "colonos" or "immigrantes." The president of the junta was the prominent planter and international businessman, Julián Zulueta, the same who introduced the first coolie cargo to Cuba in 1847. Zulueta exemplified what might be termed "vertical integration" in the sugar industry of Cuba.

20. Zhang Kai ("Chinese Labor in Cuba and Establishment of Sino-Cuban Diplomatic Relations"), *Huagiao Huaren Lishi Yanjiu* (Overseas Chinese History Review) 4 (1988), pp. 3–11.

21. *Boletín de Colonización* I:18, 15 October 1873. By law, anyone residing in Cuba but not naturalized must be registered as an alien or foreign resident. As most Chinese in Cuba embarked from Macao, they registered generally with the Portuguese consul in Havana. Besides, there was no representation of the Chinese government in Havana at the time of census (1872).

Further Reading

Hugh Tinker. *A New System of Slavery: The Export of Indian Labour Overseas, 1830–1920.* London: Oxford University Press, 1974.

The Arrival of the Asians in California

The Six Companies

STEVEN A. CHIN

Chinese Community Organizations

In the early days of San Francisco's Chinatown—the largest in the United States, and in many ways the model for all later ones—several distinct types of organizations emerged. District associations, composed of men who had emigrated from the same region, took care of employment and community affairs, such as schools and medical services. In 1865, the major district associations in San Francisco took the further step of uniting to form the powerful Chinese Consolidated Benevolent Association, better known as the Chinese **Six Companies**. After lording over the affairs of Chinatown for a hundred years, the Six Companies is today a mere shadow of its former self. From 1882 to the late 1970s, however, the Six Companies reigned as the undisputed voice of Chinese America, exerting enormous influence through its network of traditional district and family associations. Most ethnic groups evolved parallel organizations. Compare the Japanese American *kenjinkai,* the Jewish *landsmanshaften.*

The Asian diaspora continues—in fact, the diaspora to the United States accelerates. The Six Companies continue to play a role, but a survey of what their role was, and how it has changed, will illustrate the way the Asian diaspora itself has changed.

The Six Companies must be distinguished from those family associations which brought together men of the same surname. These associations acted as substitute families for Chinese immigrants and sojourners, providing mutual aid, recreation, and social services. They exist to this day. One must also not confuse the Six Companies and the family associations with the *tongs.* Made infamous by a thousand sleazy books and movies, the tongs were voluntary fraternities open to men of all backgrounds. Although some were, indeed, secret societies that dealt in gambling and vice, others were legitimate business associations. (See Chapter 31.)

The Six Companies' Changing Role

Both inside and outside Chinatown, tales have persisted of a committee of powerful community elders who oversee the lives of Chinese Americans. Many are true. But its influence waned in the 1970s with the emergence of social service agencies and advocacy groups, as well as an explosion of the Chinese American population as a result of changes in U.S. immigration laws.

Until the passage of the 1965 Immigration Act, 95 percent of Chinese Americans came from a small area: the six provinces of the Pearl River Delta around Guangdong (Canton), a region no bigger than the San Francisco Bay area, or metropolitan New York.

The seven (not six) organizations that make up the Six Companies—the *Sam Yup, Ning Yung, Yan Wo, Yung Wo, Sue Hing, Hop Wo* and *Kong Chow* benevolent associations—represent the people from the various counties of this delta region. One of the most dramatic changes in the last two decades has been the increased diversity of the Chinese American community, once dominated by that fairly homogeneous group of villagers.

The Six Companies was founded by Chinatown merchants in 1882 to arbitrate community disputes. But with the passage of the Chinese Exclusion Act of 1882, which restricted Chinese from immigrating to the United States, the Six Companies took on the role of safeguarding community interests in an environment hostile to Chinese. Later it also served as a diplomatic arm of the Republic of China after it formed on Jan. 1, 1912. Among its significant contributions to Chinatown was establishing the Chinese Central High School in 1905 to teach Chinese language and culture to Chinese children. In 1925, it was one of 15 founding members of the Chinese Hospital.

Over the years, the Six Companies, along with the many other associations under its umbrella, bought up parcel after parcel of Chinatown property. Today, the associations together own up to 40 percent of prime Chinatown real estate in the heart of San Francisco. The Six Companies itself owns four Bay Area properties worth at least $10 million.

Before World War II, discrimination forced most Chinese to live and work in Chinatown. In those days, Lingchi Wang, a University of California, Berkeley, ethnic studies professor, says, "The Six Companies could claim to represent all Chinese, but this power base rapidly disappeared after the war." Chinese began moving to the suburbs and "lost contact with the traditional associations, leaving behind the older generation to hang on to control of these organizations."

Today, the 315,345 Bay Area Chinese include immigrants from Taiwan, Southeast Asia, South America, and numerous regions of China. These Chinese, most of whom cannot join the Six Companies because the bylaws exclude those from outside the seven districts, have started their own associations and schools. Many, such as the *Fukian, Tung Wa, Hakka, Fa Yuen,* Chinese Vietnamese, Shanghainese, and Taiwanese associations, have become powerful in their own right.

Since 1993, dissension within the Six Companies has mounted over the organization's handling of its fiscal crisis, which stems from an $800,000 wrongful death judgment against the Six Companies in 1990 that left the group $100,000 in debt.

Six district associations are challenging the dominance of the largest group, Ning Yung. Underlying the internal struggle, however, is the broader issue of what kind of organization the Six Companies will be as it heads into the twenty-first century. It can choose to accept its shrinking role in the Chinese community or it can become a source of real political power for Chinese Americans on the state and national level, a role currently filled by no one particular group.

Chinese Americans living in California more than doubled from 1980 to 1990, from 325,882 to 704,850, and now comprise 10 percent of the state's residents, according to the U.S Census. Still, Chinese Americans have been unable to translate numbers into significant mainstream political gains.

The Six Companies has the potential to "play a very influential role in promoting the welfare of the community and also in the political empowerment of the Chinese American community through its power in raising money," Lingchi Wang claims.

On the other hand, failure to reform could result in its member associations withdrawing financial support, which could lead to the demise of the Six Companies, leaving Chinatown's 150 family and district associations without any unifying structure.

Is There a Future for the Six Companies?

Lately, growing interest among Chinese Americans in China's affairs, along with the recent thawing of relations between China and Taiwan, have cut into one of the Six Companies' primary functions as the community's anti-Communist watchdog. "Chinatown is very different than before," said Six Companies board member Thomas Ng, a San Francisco fire commissioner whose affiliation with the Six Companies began more than 20 years ago. Adrift in a post-Cold War era, the

staunchly pro-Taiwan Six Companies faces an uncertain future. Confronted with internal disputes, financial problems, and a rapidly changing local and global political landscape, the Six Companies is under pressure to reform from all corners of the community. "The Chinese Six Companies, as it is presently composed, is not viewed as a respected organization by community and family associations because it has not changed with the times," admits lawyer Arnold Chin, who was presiding president of the Six Companies in 1989.

Many outside the organization say it is an ineffective group trapped in a feudal time warp—out of touch with this new community and fast losing its authority. "The Six Companies has a sound structure, particularly in respect to its networks that exist throughout the world, but it is trapped in an old body," says Chinatown lawyer Edward Liu. "It is led by old-guard leaders who lack vision."

Within the organization, reform-minded members say its outmoded politics and archaic bylaws, last revised in 1930, are hindering the Six Companies' ability to adapt to the rapidly changing needs of the community. For instance, the bylaws stipulate that the group's general counsel must be a *"sai yen,"* in other words, a Caucasian. And while the bylaws don't prohibit women on its board, a female has yet to hold a director's post. "If the Chinese Six Companies officially represents all Chinese in America, they should let other people join in," said Eddie Au, a member of the Sam Yup association. "I'd like to see it reorganize and open up."

From the 1940s to the 1970s, the Six Companies' leaders paid little attention to community issues, instead focusing on maintaining Chinatown's loyalty to the Nationalist Party. Communist sympathizers in the community were effectively isolated by Six Companies leaders. Those leaders "were old-fashioned," said Ng, whose involvement with the Six Companies began around 1970. "They only thought about the old country and how to control Chinatown."

Today, its letterhead still reads "Official Representative Association of Chinese in America," and it continues to be viewed by outsiders as the "mayors of Chinatown"—but the Six Companies wields only a fraction of the influence it once did. "People are leery of them and don't want to offend them. It's similar to the emperor with no clothes," scoffs Chinese American historian Him Mark Lai. Arnold Chin adds, "The larger community really still does not understand Chinatown dynamics and thinks the Six Companies is the spokesgroup for Chinatown—they're not."

Public criticism of the group, unheard a decade ago, has grown. A number of Chinese language newspapers have written editorials ripping the Six Companies over its latest problems. In a Sept. 5, 1993 editorial, *Sing Tao,* San Francisco's

largest-circulation Chinese newspaper, criticized the group for being undemo-
cratic, operating under an archaic system dating back to the Qing Dynasty. "In-
ternally, it is dominated by dictatorship politics. If it does not dramatically change
and continues to allow only several people to control it, it will deteriorate to the
point that it is completely disconnected from the community," the editorial stated.
"Its highhanded methods have created unprecedented opposition to the Six Com-
panies in the Chinese community never before seen."

Some would like to revise the 1930 bylaws to reduce Ning Yung's power.
Currently, Ning Yung is allotted 27 of 55 seats on the board—representation based
on Chinatown's population in 1930 when people from the districts of Taishan,
China, were the most populous group. The other six associations share the re-
maining 28 seats. The bylaws also set the president's term at two months, with
the Ning Yung president filling the post every other term for a total of six months
a year, while the other six association presidents rotate in one term apiece. "Ning
Yung doesn't want to change the bylaws to have less of a voice," said Ng. "Six
Companies is just like a corporation. If you have 51 percent, you have control.
The other 49 percent have to listen to the 51 percent." Any redistribution of
power or opening up to new voting members is complicated by the group's land
holdings, noted Ng.

During the early days of the organization, it was Ning Yung people who
worked hard to buy a lot of the group's buildings, he said. "The Six Companies
owns a lot of property and doesn't want to distribute the wealth to newcomers."
Change will not come easily or quickly. The Six Companies' reluctance to change
is similar to that of "the sleeping giant of China," said lawyer Arnold Chin.

"For many centuries, China didn't want to change and remained closed off
to the world," he said. "Then abruptly in the nineteenth century, they had no choice
but to change."

(For an account of the way the Japanese American *kenjinkai* evolved into
the Japanese American's Citizens' League, see Chapter 7.)

Further Reading

Chinn, Thomas W. *Bridging the Pacific: San Francisco Chinatown and Its People.* San Francisco: Chinese
 Historical Society of America, 1989.

The Early History of Chinese, Japanese, Koreans, and Filipinos in America

BRIAN NIIYA

The early history of Asian America does not make for a pleasant story. The Chinese were the first Asian immigrants to come to the United States in large numbers. While some Chinese had arrived as early as the late 1700s, the year historians give as the beginning of Chinese immigration is somewhere around 1850. For example in *The Asian in the West,* Stanford Lyman writes: "Chinese immigration to America effectively began in 1847. A coincidence of catastrophe in China and opportunity in California supplied the expulsive and attractive elements that linked the Middle Kingdom to the United States." The catastrophe in China included the Taiping rebellion of the 1850s which reduced much of southern China to rubble. Additionally, much of the area was hit with severe droughts during this time. Meanwhile, gold had been discovered in California in 1848, leading to stories of Chinese who had gone to California and become rich. Soon, Chinese immigration to America increased dramatically; according to Roger Daniels, "This economic attraction—what historians of immigration call 'pull'—coupled with the 'push' of Chinese peasant poverty and the existence of cheap and frequent trans-Pacific sail and steamship transportation produced a steady stream of Chinese migration to the United States"[1] By 1860 some 34,933 Chinese were in the United States. The figure rose to 105,465 by 1880.[2]

At first, the Chinese mainly concentrated in mining, working the claims left for dead by the white miners. Gradually, they moved into other fields, most notably into building railroads and starting such businesses as laundries or restaurants. This was not a matter of choice or inclination. For almost as soon as significant numbers of Chinese began to immigrate to America, anti-Chinese forces materialized to meet them. Organized labor often took the lead in these anti-Chinese groups, claiming that the Chinese took jobs away from American workers and lowered the standards of living for everyone. The attacks on the Chinese grew more racist in nature as they were

Figure 30–1:"Young Glory with Commodore Dewey." Pulp magazine for boys celebrating the liberation of Manila from the Spanish. Courtesy of George J. Leonard.

eventually criticized for everything from how they cut their hair to the squalid living conditions they were forced to adopt. Anti-Chinese sentiment soon began to manifest itself in the form of both physical violence and legislation. The violence involved such incidents as the complete removal of Chinese from several cities and mere riots and lynchings in other cities. The legislation varied from such harassing measures as an ordinance prohibiting queues (the ponytail-like hair appendage required by Manchu law to be worn by all Chinese men) to such debilitating economic attacks as the foreign miners' tax, which imposed a tax only on Chinese gold miners. Many other laws came up which sought to prevent the further entrance of Chinese to America, to prevent the Chinese who were here from entering certain fields of endeavor, or to simply make life more unpleasant for them. A popular song of 1877 ran

Twelve Hundred More

O workingmen dear, and did you hear
The news that's goin' round?
Another China steamer
Has been landed here in town.
Today I read the papers,
And it grieved my heart full sore
To see upon the title page,
O, just "Twelve Hundred More!"
O, California's coming down,
As you can plainly see.
They are hiring all the Chinamen
and discharging you and me;
But strife will be in every town
Throughout the Pacific shore,
And the cry of old and young shall be,
"O, damn, 'Twelve Hundred More!'"
They run their steamer in at night
Upon our lovely bay;
If 'twas a free and honest trade,
They'd land it in the day.
They come here by the hundreds—
The country is overrun—
And go to work at any price—
By them the labor's done.
If you meet a workman in the street

And look into his face,
You'll see the signs of sorrow there—
Oh, damn this long-tailed race!
And men today are languishing
Upon a prison floor,
Because they've been supplanted by
This vile "Twelve Hundred More!"
Twelve hundred honest laboring men
Thrown out of work today
By the landing of these Chinamen
In San Francisco Bay.
Twelve hundred pure and virtuous girls,
In the papers I have read,
Must barter away their virtue
To get a crust of bread.
This state of things can never last
In this, our golden land,
For soon you'll hear the avenging cry,
"Drive out the Chinamen!"
And then we'll have the stirring times
We had in days of yore,
And the devil take those dirty words
They call "Twelve Hundred More!"[3]

The anti-Chinese forces won their greatest victory in 1882 with the passage of the Chinese Exclusion Act. From this point on, Chinese laborers were prohibited from entering the country. The Chinese population fell consistently for the next few decades until the emergence of the second generation.

The next Asian group to immigrate in large numbers was the Japanese. With the supply of Chinese labor suddenly cut off, employers began to look to the Japanese to take their place. Daniels writes: "Immigrants from Japan . . . came to the United States for exactly the same kinds of reasons that other immigrants came: for economic opportunity and to escape severe economic and social dislocations at home."[4] Yamato Ichihashi expands this statement in describing some of the factors behind Japanese immigration:

> *Japanese labor emigration to this country and Hawaii was impelled by desire*
> *for improvement rather than by necessity of escaping misery at home; this*

was the fundamental, positive cause of Japanese emigration. But coupled with
this there was also a powerful negative cause: the military conscription law.
Neither religion nor politics constituted a cause for Japanese emigration. [5]

The first significant numbers of Japanese immigrants arrived after Chinese ex-
clusion in the 1880s; by 1900 there were 24,326 Japanese in America. This fig-
ure rose to 111,010 by 1920. Like the Chinese before them, the early Japanese
immigrants consisted mostly of young men who came to the United States to seek
their fortunes. Also like the Chinese, the Japanese were forced into such areas of
menial labor as agriculture, fishing, and similar types of businesses.

The anti-Chinese forces moved on to attack their new enemy: the Japa-
nese. For the same types of reasons, these groups agitated for action against the
latest threat to the "American" way of life. Legislation such as the Alien Land Law
of California prohibited "aliens ineligible for citizenship"—that is, the Japanese
and Chinese—from owning land. Most of the other western states soon followed
suit. Under intense pressure from labor interests, the Gentlemen's Agreement
of 1907 effectively cut off further immigration of Japanese laborers. The Immi-
gration Act of 1924 virtually ended all further Japanese immigration.

For a time in the early 1900s, Koreans were encouraged to come to Hawaii to
add to the diversity of the agricultural labor force there—it was hoped that they would
stop the disturbing trend of labor organization among Japanese immigrants. For vari-
ous reasons, most importantly opposition from the Japanese government that ruled
Korea by this time, this immigration was cut off after only a couple of years—only
around 8,000 Korean immigrants made it to Hawaii. Filipinos were the next source
of cheap labor targeted by employers. They began to arrive in significant numbers in
the early 1900s and were met by the now predictable protest from the various "anti-"
groups. The same combination of violence and legislation met the Filipino laborer.
Around 60,000 Filipinos were in Hawaii and another 20,000 were on the mainland
when the Tydings-McDuffie Act cut off Filipino immigration in 1934. This ended what
we might call the first wave of Asian immigration. Significant numbers of Asian immi-
grants would not come to these shores again until the mid-1960s.

Notes

1. Daniels, Roger. *Concentration Camps USA: Japanese Americans and World War II* (Hinsdale,
IL: The Dryden Press, 1971), p. 3.
2. United States Census figures from Rose Hum Lee, *The Chinese in the United States of
America* (Hong Kong: Hong Kong University Press, 1960), p. 40.

3. "Twelve Hundred More." *The Blue and Grey Songster* (San Francisco: S.S. Green, 1877). Quoted in Linda Porrin, *Coming to America: Immigrants from the Far East* (New York: Dell, 1980), pp. 32–34.

4. Ibid. p. 4.

5. Ichihashi, Yamato. *Japanese in the United States: A Critical Study of the Problems of the Japanese Immigrants and Their Children* (Stanford, CA: Stanford University Press, 1932).

Further Reading

Lai, H.M., and P.P. Choy. *Outlines: History of the Chinese in America.* San Francisco: Chinese-American Studies Planning Group, 1973. Among the earliest Chinese in America, the authors list three crewmen stranded in Baltimore in 1785, five servants in Philadelphia in 1796, and 50 colonists in Nootka Sound in 1788, among others.

Lyman, Stanford M. *The Asian in the West.* Reno, NV: Social Science & Humanities Publication No. 4, Western Studies Center, Desert Research Institute, University of Nevada System, 1970.

Melendy, H. Brett. *Asians in America: Filipinos, Koreans, and East Indians.* Boston: Twayne Publishers.

Chinatown, 1899

C.A. HIGGINS

[In 1899 the "Passenger Department" of the Atchison, Topeka, and Santa Fe Railroad published a paperback book, *To California and Back,* that it had commissioned by one C.A. Higgins, now otherwise unknown. The Santa Fe wished Higgins to advertise that a "comprehensive tour of the West" was possible over the "proprietary lines" of the company. The book is a frank attempt to solicit business by advertising the wonders the traveler will see, starting from and returning to Chicago. But *To California and Back* is no brochure. Higgins took the chance to write 175 closely observed, finely detailed pages about the West, just after the closing of the frontier. Victorianists will recognize John Ruskin's influence, but also the model of Henry Mayhew's carefully reported excursions into London's lower depths, *London Labour and the London Poor.* Higgins's book, now extremely rare, was printed on fine paper, almost every page of which was richly illustrated with line drawings by J.T. McCutcheon, otherwise as unknown as Higgins, many included here.

Higgins wrote poetically about the deserts and with special respect for the southwestern Indian cultures. Chinatown, however, was another story. His reaction is worth reading because it is not only detailed, but completely typical of American attitudes to Chinatown before Japan's attack on Pearl Harbor changed China's image to that of heroic ally. Before World War II, Chinatown filled the same place in American popular fantasies that the Mafia did afterward. Indeed, a Sin City populated by gangsters and slinky prostitutes smoking dope seems to be a necessity to American popular fiction.

Higgins' prose, precious even by the standards of the "Aesthetic Nineties," Oscar Wilde's decade, helps him keep a genteel tone while insinuating smut. He seems to have been under orders from the Santa Fe Railroad to let prospective customers know that, so to speak, there was the chance to stop in a kind of Oriental Vegas to see the gamblers and lap dancers. But in 1899, Higgins has to walk a moral

Figure 31–1: "An opium smoker, Chinatown," by J.T. McCutcheon.
From Higgins, C.A. To California and Back. *Chicago: Atchison, Topeka &*
Santa Fe Railway Company, 1899.

line. I love the way he works it out that the white tourist panting to see "genuine wickedness" and the "lowest spectacles" is somehow to be *praised* for superior "hardihood" in penetrating Chinatown. Higgins dangles Chinatown in front of the 1890s midwestern reader as a "peepshow" where he can safely see scenes of "irredeemable depravity" before regaining the familiar streets of "civilization." The piece would be no more than a fine example of "orientalism," of Westerners projecting popular fantasies on Asians, did not Higgins redeem it with hard work, constructing long catalogs of closely observed facts. I have added notes in brackets.—Ed.]

Chinatown

A few steps from your hotel, at the turn of a corner, you come at once upon the city of the Chinese. It is night, and under the soft glow of paper lanterns and

through the gloom of unlighted alleys weaves an oriental throng. Policemen doubt-less stand upon a corner here and there, and small parties of tourists pick their way under lead of professional guides; the remaining thousands are Celestials all. [Denotation of terms by editor: "Celestials" is a common ironic name for the ex-citizens of the Celestial Empire, as was "John Chinaman" in the following sentence.] The scene is of the Chinaman at home, very John, restored to authenticity of type by the countenance of numbers; and so in the twinkling of an eye you become a foreigner in your own land, a tolerated guest in a fantastic realm whose chief ap-parent hold upon reality is its substratum of genuine wickedness. It is a grotesque jumble, a panopticon of peepshows; women shoemakers huddled in diminutive rooms; barbers with marvelous tackle shaving heads and chins, and cleaning ears and eyeballs, while their patrons sit in the constrained attitude of a victim, meekly holding the tray; clerks, armed with a long pointed stick dipped in ink, soberly making pictures of variant spiders in perpendicular rows; apothecaries expound-ing the medicinal virtues of desiccated toad and snake; gold-workers making brace-lets of the precious metal to be welded about the arm of him who dares not trust his hoard to another's keep; restaurateurs serving really palatable conserves, with pots of delectable tea; shopkeepers vending strange foreign fruits and dubious edibles plucked from the depths of nightmare; merchants displaying infinitude of curious trinkets and elaborate costly wares; worshipers and readers of the book of fate in rich temples niched with uncouth deities; conventional actors playing interminable histrionics to respectful and appreciative auditors; gamblers stoically venturing desperate games of chance with cards and dominoes; opium smokers stretched upon their bunks in a hot atmosphere heavy with sickening fumes; lepers dependent upon occasional alms flung by a hand that avoids the contamination of contact; female chattels, still fair and innocent of face despite unutterable wrongs, yet no whit above the level of their deep damnation—such is the Chinatown one brings away in lasting memory after three hours of peering, entering, ascending, descending, crossing, and delving. A very orderly and quiet community, withal, for the Mongolian is not commonly an obstreperous individual, and his vices are not of the kind that inflame to deeds of violence. He knows no more convivial bowl than a cup of tea. If he quits the gaming-table penniless, it is with a smile of patient mel-ancholy. And his dens of deepest horror are silent as enchanted halls.

All except its innermost domestic life may be inspected by the curious. The guides are discreet, and do not include the lowest spectacles except upon request, although it is equally true that very many visitors, regarding the entire experience as one of the conventional sights of travel, go fortified with especial hardihood and release their conductor from considerations of delicacy.

Figure 31–2: "Balcony of Joss-House," by J.T. McCutcheon. From Higgins, C.A. To California and Back. *Chicago: Atchinson, Topeka & Santa Fe Railway Company, 1899.*

[Higgins visits a "temple" and to *his* credit realizes he isn't seeing the real thing. Enterprising guides seem to have concocted, by 1899, a Disneyish Chinatown-Land to take tourists through.]

The *joss* houses, or temples [joss, a garbling of the Portuguese word for god, *dios,* was wrongly thought to be a Chinese word] are hung with ponderous gilded carvings, with costly draperies and rich machinery of worship. The deities

are fearful conceptions, ferocious of countenance, bristling with hair and decked with tinseled tubes. A tiny vestal flame burns dimly in a corner, and near it stands a huge gong. An attendant strikes this gong vociferously to arouse the god, and then prostrates himself before the altar, making three salaams. A couple of short billets, half round, are then tossed into the air to bode good or ill luck to you according as they fall upon the one, or the other side. A good augury having been secured by dint of persistent tossing, a quiverful of joss-sticks is next taken in hand and dexterously shaken until three have fallen to the floor. The sticks are numbered, and correspond to paragraphs in a fate book that is next resorted to, and you are ultimately informed that you will live for forty years to come, that you will marry within two years, and, if your sex and air seem to countenance such a venture, that you will shortly make enormous winnings at poker. Whatever of genuine solemnity may cloak the Heathen Chinee in his own relations to his bewhiskered deities, he undoubtedly tips the wink to them when the temple is invaded by itinerant sightseers. The smooth, spectacled interpreter of destinies pays $5,000 a year for the privilege of purveying such mummeries, and hardly can the Heathen Chinee himself repress a twinkle of humor at the termination of a scene in which he so easily comes off best, having fairly outdone his Caucasian critic in cynicism, and for a price.

[Higgins's phrase "the Heathen Chinee" enrolls him in the extremely popular literary tradition dating back to Bret Harte's hugely famous comic poem, "The Heathen Chinee," in which a comic Irish immigrant, William Nye, whose sleeves are stuffed full with cards, keeps losing to a Chinese immigrant, Ah Sin. At last Nye tackles Sin, and turns him upside down, shaking twice as many cards out of his sleeves as Nye had been able to stuff up his. Nye roars self-righteously, "We are ruined by Chinese cheap labour." Harte's poem is more a joke on the anti-Chinese Irish-dominated workingmen's leagues, led by the likes of Dennis Kearney, than it is on the Chinese. See Chapter 30, "Early History."]

[Higgins faithfully and respectfully describes a visit to San Francisco's Chinese opera, and is aware he's in the presence of serious dramatic conventions he doesn't understand. For the truth, see Chapter 55, "Chinese Opera."]

In the theater he will be found, perhaps contrary to expectation, to take a serious view of art. You are conducted by a tortuous underground passage of successive step-ladders and narrow ways, past innumerable bunk-rooms of opium-smokers, to the stage itself, where your entrance creates no disturbance. The Chinese stage is peculiar in that while the actors are outnumbered ten to one by supernumeraries, musicians, and Caucasian visitors, they monopolize the intellectual recognition of the audience. The men who, hat on head, pack the pit, and

Figure 31–3: "A Street in Chinatown," by J. T. McCutcheon. From Higgins, C.A. To California and Back. *Chicago: Atchinson, Topeka & Santa Fe Railway Company, 1899.*

the women who throng the two galleries, divided into respectable and unrespectable by a rigid meridian, have been educated to a view of the drama which is hardly to be ridiculed by nations that admit the concert and the oratorio. The Chinese simply need less ocular illusion than we in the theater, and perhaps those of us who are familiar with the grotesque devices by which our own stage-veneer is wrought perform no less an intellectual feat than they. Their actors are indeed richly costumed, and, women not being permitted upon the stage, the youths who play female roles are carefully made up for their parts; and one and all they endeavor to impersonate. Almost no other illusion is considered necessary. The stage manager and his assistants now and then erect a small background suggestive of environment, and the province of the orchestra is to accentuate emotion—in which heaven knows they attain no small degree of success. It is highly conventionalized drama, in which any kind of incongruity may elbow the players provided it does not confuse the mind by actually intervening between them and the audience. The plays are largely historical, or at least legendary, and vary in length from six or eight hours to a serial of many consecutive nights' duration. There are stars whose celebrity packs the house to the limit of standing-room, and there are the same strained silent attention and quick rippling response to witty passages that mark our own playhouses; but such demonstrative applause as the clapping of hands and the stamping of feet is unknown. The Chinese theater-goer would as soon think of so testifying enjoyment of a good book in the quiet of his home. But as for the orchestra, let some other write its justification. Such a banging of cymbals, and hammering of gongs, and monotonous squealing of stringed instruments in unrememberable minor intervals almost transcends belief. Without visible leader, and unmarked by any discoverable rhythm, it is nevertheless characterized by unanimity of attack and termination, as well as enthusiasm of execution, and historians of music are authority for the statement that it is based upon an established scale and a scientific theory. Be that as it may, it is a thing of terror first to greet the ear on approach, last to quit it in departure, and may be counted upon for visitation in dreams that follow indigestion.

[At last Higgins must deliver what his employers and his audience have been waiting for: sin. Higgins gets his facts all wrong, but accurately recreates for us his era's stereotype of Chinatown as sin city, filled with Mafia-like tongs, hardboiled gangsters, and enslaved "sing-song girls," as prostitutes were called. To compare stereotype with reality, see Further Reading.]

The secret society known as the Highbinders was created two and a half centuries ago in China by a band of devoted patriots, and had degenerated into an organization employed to further the ends of avarice and revenge long before

it was transplanted to this country. Relieved of the espionage that had in some measure controlled it at home, and easily able to evade a police unfamiliar with the Chinese tongue, it grew in numbers and power with great rapidity. The greater portion of the people of Chinatown has always been honestly industrious and law abiding, but the society rewarded hostility by persecution, ruin, and often death. Merchants were laid under tribute, and every form of industry in the community that was not directly protected by membership in the society was compelled to yield its quota of revenue. Vice was fostered, and courts of law were so corrupted by intimidation of bribery of witnesses that it was next to impossible to convict a Highbinder of any criminal offense. A climax of terror was reached that at last convulsed the environing city, and by the pure effrontery of autocratic power the society itself precipitated its downfall. A peremptory word was given to the police, and a scene ensued which the astonished Celestials were forced to accept as a practical termination of their bloody drama; a small epic of civilization intent on the elevation of heathendom, no inconsiderable portion of which in a short space was blown skyhigh. The Highbinders were scattered, many imprisoned or executed, innumerable dives emptied, temples and secret council-rooms stripped bare, and the society in effect undone. Yet still, for one who has viewed the lowest depths of the Chinatown of to-day, the name will long revive an uncherished memory of two typical faces, outlined upon a background of nether flame. One is the face of a young woman who, in a cell far underground, leans against a high couch in a manner half-wanton, half-indifferent, and chants an unintelligible barbaric strain. The other is that of her owner, needing only a hangman's knot beneath the ear to complete a wholly satisfactory presentment of irredeemable depravity. And that is why one quits the endless novelties of the peepshow without regret, and draws a breath of relief upon regaining the familiar streets of civilization.

Further Reading

Barth, Gunther Paul. *Bitter Strength: A History of the Chinese in the United States, 1850–1870.* Cambridge, MA: Harvard University Press, 1964. A full-length and realistic study of the Chinatown Higgins visited 30 years later.

Lai, Him Mark, Genny Lim, and Judy Yung, eds. and trans. *Island: Poetry and History of Chinese Immigrants on Angel Island. 1910–1940.* Seattle and London: University of Washington Press, 1991. See Chapter 36, "The Beginnings of Chinese Literature in America." Here the San Francisco Chinese contemporaries of the people Higgins might have passed in the street speak out in their own voices.

Wong, Bernard P. *Chinatown: Economic Adaptation and Ethnic Identity of the Chinese.* New York: Holt, Rinehart and Winston, 1982. A brief sociological account of modern Chinatown.

Part V

Literature

Dialect, Standard, and Slang

Sociolinguistics and Ethnic American Literature

ROBERT A. LEONARD

She smiled, twisting a braid of hair around her finger and brushing her
lips with it. "Why Mr. Wah Gay, I'm only thirteen and much too young to
know the love of a man, you handsome rogue, you."

"Melly me, Eva, an' we liff happ fo'evah"

<div align="right">

("Cheap Labor," Jeffery Chan)

</div>

Our reactions to the characters in Asian American ethnic literature, as in all ethnic literature, will have everything to do with our reaction to the way they speak. That reaction will in turn depend on a number of theories, or perhaps just assumptions, that we have about speech in general and what it reveals about the speaker and his/her social status. An entire science studies those assumptions: sociolinguistics.

Mark Twain once said, "Most ignorance ain't not knowing things. It's knowing things that *ain't so.*" Our unexamined assumptions, combined with the myths we've learned from pop grammarians like John Simon, have put most people in the latter category when it comes to linguistics. Since ethnic literature contains a high number of characters who are not "standard" speakers, we can improve our reactions to ethnic literature and its speakers by availing ourself of what sociolinguists have learned about speech.

This chapter will present an overview and an introduction. Although I'll frequently use examples from foreign languages to illustrate concepts, that is only because such examples are often more clear-cut than those closer to home. Distance diminishes our emotional reactions, too, and leads to rational analysis. But all these concepts come home to the study of American ethnic literature, in scenes like the ones quoted above.

No Language Is Homogeneous

All languages are composed of different varieties. One variety usually acquires the most prestige and becomes known as the standard. Speakers often identify this standard variety as the very language itself, looking down on other varieties as corruptions of the "pure" standard: mere vulgar speech, patois, or dialect spoken by the common (not noble) person, by the uneducated, by people living "in the provinces," away from the center of power, influence, and refinement. Children get taught that the standard somehow "sounds better," is more "elegant"— even that it transmits thoughts more accurately and is somehow better suited for art, culture, law, and government. But scientific analysis cannot prove one dialect "better" than the others *as a language*—the reasons a particular dialect becomes the supposedly "pure" standard are accidents of history.

Even before widespread education taught students that they were supposed to speak a certain way, speakers wanted to identify themselves with the fashionable, powerful, and prestigious, and one way of doing this was to try to sound like them. That's clearer when we look at foreign examples. Standard Spanish, for example, comes from Castile in Spain not because the people there somehow invented a better brand of Spanish but because of the power and prestige of Ferdinand and Isabel, the king and queen who brought all of Spain under their rule in the fifteenth century. Castile was their capital and power base. Standard British English is based on London dialect because of London's great importance. Standard French is Parisian because it was Paris where a prestigious royal court, legal system, and religious center all developed. The literary Standard Italian is Tuscan because of the prestige of the writers Dante, Petrarch, and Boccaccio. In former colonies of the European powers, the standard was often chosen by the colonists: In what is now Kenya and Tanzania, British and German missionaries chose Zanzibar dialect as the basis for the official Standard Swahili not because it was more "pure," or "refined," but because they wanted to wrest power and attention away from the Lamu dialect that had a long history of written epic poetry—mostly in praise of Islam. Modern Lamu speakers take standardized Swahili tests and are marked wrong when they use their own dialect—once a great literary dialect—and are made fun of by outside teachers because they can't learn "pure" Swahili.

Even if you do grow up in Castile speaking Castile dialect or in Paris speaking Paris dialect, most likely you still will not speak standard Spanish or French, because it is only the upper class or educated variety of Castile or Paris dialect that is counted as the standard. In the United States, for example, Standard

American English is historically based on the Midwest dialect. But if you are a Midwesterner whose dialect includes words like *ain't*, then you do not speak Standard American English. If you are brought up somewhere, for example, the South, and you speak a Southern dialect, then you automatically do not speak the standard.

> [T]he music we loved and played and used was Negro music. It was something we could share in common, like a "lingua franca" in our "colored" community. And in our distorted reality of aliens and alienation, it even felt like citizenship. It seemed so very American—"un-foreign," on "un-foreign" instruments—and the words it used were English. Not "across town" or "Hit Parade" English, perhaps, but nevertheless an English that, in its own way, did the job. (And we were all criticized, continually corrected and ridiculed in school for the way we talked—for having accents, dialects, for misusing, abusing the language.)
>
> But the music spoke to us, and we spoke back—laughing and carrying on among ourselves in a quaint code of "jive" and "hepcat" talk about "boogie" and "bebop" and being "cool." Mexican, Negroes, Orientals—talking that talk! (Legends from Camp, Lawson Fusao Inada)

Distinct varieties of language are often confused and lumped together. For example, most schools will frown on their students speaking any of the following: dialect, slang, colloquial speech, broken English, pidgin, and creole. These have in common that they are non-standard; and society and its school systems teach us to look down on such speech and the people who speak it. Amy Tan writes of the English spoken by her mother, an extremely intelligent woman:

> I have described the kind of English my mother speaks as "broken" or "fractured." But I wince when I say that.
>
> It has always bothered me that I can think of no way to describe it other than "broken," as if it were damaged and needed to be fixed, as if it lacked a certain wholeness and soundness. It limits people's perceptions of the speaker. I know this because when I was growing up, I believed that my mother's English reflected the quality of what she had to say. That is, because she expressed them imperfectly, I considered her thoughts imperfect.
>
> And I had plenty of evidence to support me: the fact that people in department stores, at banks, and at restaurants did not take her seriously, did not give her good service, pretended not to understand her, or even acted as if they did not hear her. (Mother Tongue, Amy Tan)

Actually, anything other than the formal, written variety of Standard English runs the risk of being branded "bad" English. Many quite distinct types of speech are looked down on, although some, as we said, are linguistically very much the equal of Standard.

Dialect is normally used to mean the speech of a certain geographical area, for example New York dialect, or Midwestern dialect. If that area is not prestigious, then the speech is looked down on. Any dialect of French other than Parisian is a mere uncultured *patois;* any Italian not from Tuscany is a mere uncouth *dialetto,* and Southern American English is sometimes characterized by outsiders as sounding slow or dumb. The term dialect can also refer to other types of systematically differing speech. For example, linguists like Labov speak of Black English Vernacular dialect (called Ebonics in the press), and Tannen describes the different dialects spoken by men and women. Although Standard English is actually just another dialect of English, its prestige sets it apart and people often identify it as the very language itself and the other dialects as just dialects.

Sometimes the terms "accent" and "dialect" are confused. "Accent" refers to the pronunciation part of someone's speech, whereas the term "dialect" refers to all aspects of the language: pronunciation, grammar, vocabulary.

Slang may profitably be defined as a set of *informal* words and phrases whose meanings are *secret;* that is, knowledge of meanings is restricted to members of a certain group. Slang has several interesting features. It helps define groups by giving them a *secret language* unique to their group, an *informal insider vocabulary*. It has special words that help members talk more precisely about things that matter to them. More importantly, it *identifies group members and excludes non-members*. Notice how in Inada's remembrance the "quaint code of 'jive' and 'hepcat' talk" and the music (and lifestyle) it referred to gave a sense of belonging and unity in a "colored" community. Word coinage and usage can also demonstrate great irreverence, inventiveness, and skill in word play. *Slang is not only secret but informal.* This sets it apart from colloquial speech (like *cool* and *OK*) which is informal but not secret, and from jargon words, whose meanings are secret but not necessarily informal. Jargon will be further discussed. When slang is noticeable in the speech of a group, people sometimes seize on that as the prime characteristic of that speech, and quite erroneously claim that "all they speak is slang." If people don't understand the normal words or grammar of a dialect, they may think that it's because it's all secret slang; but slang is never more than a small percentage of total speech.

Many people mistakenly think slang is sloppy, lazy speech because it (quite intentionally) sounds like the opposite of "correct," formal, "teacher" type of speech. But slang is certainly no easier than any other vocabulary. Slang words

and meanings can change quickly, especially within groups that pride themselves on their uniqueness and exclusivity. It can be hard work to learn and keep current on what slang words mean, and what is "in" and what is "out" in the group where a speaker wants status. Some slang, however, is very long lasting, and survives as slang through generations. *Fin* for "five dollar bill" and *grub,* "food," are long-term survivors. *Slice* for "boyfriend or girlfriend," a slang term collected in New York in 1989, seems not to have survived more than a year.

A recurring theme in current slang is the use of negative words to mean positive attributes. One well-known current example is *bad* meaning "good, excellent at its task." Some other "bad" words meaning "good" in the New York City area as of the mid 1990s were: *stupid* as in *a stupid [wonderfully] cool car*; *grubby* as in *that MacDonald's hamburger was grubby [delicious]*; *evil* as in *what an evil [superb] movie—I loved it*; *sick* as in *that was the sickest [best] class I ever took.* Such reversal of meaning serves the secret language function in addition to being irreverent, unique word play. Returning to the question of laziness, notice that a member of a group using these slang words not only has to know when to use them with their "normal" meanings (to outsiders) but also must memorize which words can mean their opposite (not all negative words can, of course) and learn when to use them with their slang, insider meanings. This is clearly not less work than only knowing and using the normal meanings.

People who use slang often have mixed feelings about it. One 21-year-old African American speaker, echoing the negative judgments she must have heard all her life from teachers and parents, scorned slang as "sloppy, a bad habit, vague. Slang saves us the time and effort of speaking and thinking precisely." Yet the same speaker also explained that she used slang "to escape the familiarity of standard words, to escape from normal everyday life." Like most speakers, she knows that slang is supposed to be looked down on. Yet she realizes that slang can make speech, and interacting with other people, more lively and more satisfying than can the drab formal language that "everyone" knows. Another speaker hit the mark when he said, "People use slang because it sounds cool and is a code for friends to understand each other without anybody knowing what they are saying." This may well be the essence of slang.

While it is true that slang is the special province of younger speakers and other disenfranchised groups (doubtless because of its ability to build identity and communicate secretly), other groups most certainly use slang. For example, many older people retain much of the slang they learned as youths and use it regularly as well as picking up new slang. Some of it has become what we are calling merely colloquial because it has been used for so long that there is no secrecy left.

Jargon should be distinguished from slang, although the two are similar. Like slang, jargon is a special vocabulary used by a certain group (usually an occupational group such as lawyers, nurses, novelists, or the police). Unlike slang, *jargon can be used (like other non-slang speech) in either formal or informal settings. Slang can only be informal.* Slang cannot even be pronounced in a formal way or it ceases to be slang. For example, the slang terms *chillin'*, "relaxing," and *jonesin'*, "to crave," are not the same terms if pronounced "chilling" and "jonesing." Slang users do not accept them as the same words; they laugh at how funny "chilling" and "jonesing" sound. Such is not the case with jargon. Jargon words can have either informal or formal pronunciations. A judge may say to her husband at breakfast that she is looking forward to finally *chargin'* that jury; in open court she will announce her intent to be *charging* the jury by 2:00 P.M. Judges and other groups of people in the same occupation can of course have their own slang, as well, in addition to jargon words.

The definitions of "slang" and "jargon" given here are derived from actual speakers' comments as well as from field observations of how speakers really use what it is they call slang and jargon. There are many different definitions of slang and jargon given in dictionaries and other sources. Often these omit the "only informal" and "secret" aspects of slang. We find these are important in distinguishing jargon and slang, and especially in setting slang apart from other informal speech in speakers' minds.

Words may move around from category to category. Words can begin as slang, lose their secret aspect and become colloquial, and later even lose their informal, colloquial aspect. For example, the term to *dis* someone entered the speech of groups of whites from the speech of African Americans. White speakers originally reported to researchers that it was a slang term that meant to "stand someone up," that is, to keep a date waiting or not show up at all. It had a much wider meaning in the African American groups' speech, which was to *disrespect* someone, to "not show proper respect" in a variety of situations, only one of which was dating. (It is interesting to note that in the English of white speakers, *respect* would probably not be the first quality considered lacking in a date that stands someone up.) Since then, more and more white speakers have realized that *dis* has a wider range than simply dating, and that it is short for a quite useful verb, *disrespect.* Of course, the noun was already firmly established in white non-colloquial speech, as in *he showed him disrespect,* and this has no doubt helped the verb *disrespect* in its rather quick progress toward usage as a "normal" verb.

Usage of terms also can expand, but then shrink back again. "A sort of opposite of *dis,*" the African American term *props* means to give someone "proper respect." *Props* crossed over to the slang of white speakers, but unlike *dis* it stayed

slang, and never really caught on. Collections ceased to show it in our samples of white speakers, but it continued in the slang of some African American groups.

Other terms that have lost their slang status and become "normal," common words are *jazz* and *rock 'n' roll*, the names of two indigenous American musical styles. Both these terms began as slang for "sexual intercourse." Currently it is quite uncommon for a speaker to connect the music names with the old slang terms. Many other terms have, of course, since arisen to fill any void left by their change of meaning.

Broken English might be defined as the "language" that people speak who have not fully learned English. English is not their native language, and they make mistakes when they speak, like anyone trying to use a foreign language they have not yet mastered. Think of your high school French or Spanish and you will see what I mean. This is not anyone's native language. It is not the primary language of a human speech community. It's English overlaid on the person's first, native language. There is a lot of interference with the systems of grammar and pronunciation that are already in their heads, just like English got in the way of your trying to learn Spanish in high school. It's like trying to pour water into a bottle that is already full. No linguist would claim that these "languages" are not full of mistakes.

Unfortunately, a lot of what people call "broken English" is not. They are real, native languages for which linguists use the term creoles. Hawaiian Creole English (called "Pidgin" by most people in Hawaii) is not broken English. It is a different language that seems a lot like English because it has a lot of English words in it. These words are pronounced according to the sound system of Hawaiian Creole English, not English. Similarly, Haitian Creole, called Krio, is not broken French. It is a separate language that has many French words in it, again not pronounced according to the rules of French—because it's not French. Creoles come about from pidgins.

Pidgins are "languages" that arise when speakers of different languages have to find a common medium of communication. For example, if speakers of Hawaiian, Chinese, Japanese, and Tagalog find themselves on a sugar plantation in Hawaii and have to cut cane together, what language do they use? They couldn't assume that if they spoke their own language everyone would understand. The only language they could be sure that everyone knew at least a little of was the language of the overseer—English. So workers used what little English they knew with each other. But no one ever really taught them English, and they were really quite segregated from the English speakers. They had to use words from their own languages when they didn't know the English word. An example would be a

Hawaiian who wanted to ask a Chinese speaker if he was finished with some task. Not knowing the English word *finished* he might ask, "You *pau?*" The Chinese speaker, who assumes the Hawaiian is using the language they both know some of—English—assumes he has now learned a new English word. He next uses *pau*—a Hawaiian word—to a Filipino, who also assumes it must be English. And so *pau* becomes established as the pidgin word for "finished." Of course the actual situation was vastly more complicated, but this gives an indication of how pidgins arise. Notice that although many of the vocabulary words the pidgin uses are English, many are not. Also, everyone would use the pronunciation for a word that was possible to say given their own language's system of pronunciation. Further, a pidgin develops its own sort of simplified grammar that while not nearly as complicated or systematic as languages like English, is not random. Pidgin may be a form of broken English, in that it is mostly English spoken quite non-natively by speakers of other languages—but it is not "simplified" English, or "babytalk." You must learn the pidgin to speak it; knowing English does not give you instant access. When I was in Hawaii I heard the linguist John Reinecke tell how he was in the cane fields when a fresh strawboss from New England arrived for the first time. He spoke no pidgin and thus could not communicate with the cutters. In frustration, a Chinese worker went to another supervisor and demanded to know what was the matter with the **Haole** since "he no can talk *Haole*" (a Hawaiian word that originally meant "stranger," but by the time of this story in the 1920s had come to mean "white person" and by extension, their language). Reinecke points out this story also shows that the workers believed they were speaking English.

How do creoles arise from pidgins? The same way all languages come about. They are concocted in the minds of children. All humans have a virtually identical ability to learn a native language. This comes from having human genes. But, of course, which language a child learns is not genetically determined. It depends on the language they are exposed to during the critical learning period of early childhood. In Chinese-speaking Beijing, you learn Chinese. In English-speaking New York, you learn English. Children listen and observe people speaking to them and to others and they attempt speech; they find what works and what doesn't; they make mistakes and get feedback; they experiment and communicate and eventually they emerge as native speakers of a language.

Think what it means to have native speaker ability in a language. Let's assume you and I are both native speakers of English. You have probably never before read a sentence exactly like this one, but you are having no trouble understanding it. Although I have never written this exact sentence before, I am

having no trouble producing it. How? If we never heard it before, how do we understand it? We have not been exposed to every possible sentence we may ever read or produce, but we do not have to be. Learning the language means constructing the grammar, the communicative system of the English language, based on what we did hear and try out. But, and this is the important point, we constructed vastly more than we heard. Our human brains are specialized for language acquisition. Based on (relatively) mere bits and pieces of a language, you and I constructed a whole one. From our knowledge of the communicative system of English, we can produce or understand virtually an infinite number of potential utterances. Given how complicated and vast the system is that is being re-invented, it is inevitable that new generations invent at least slightly different versions of what the previous generations speak. This is how all languages change. This is the main reason that Old English is so different from modern English and why Latin evolved into Spanish and French. Each generation of children changes the language it re-invents.

This is what children do who are born into areas where the language is English, or French, or Chinese. What about children born into areas where the common language is a pidgin? The same thing happens, courtesy of the human brain. From bits and pieces comes a whole language. As far as re-inventing a native language goes, it makes little difference if the input is from an English with full grammar or a Pidgin English with a limited grammar because the most important input is from our brains. Anything that is not there in the limited grammar of the pidgin is filled in by the inborn linguistic ability of the children's brains. What the children invent is a complete language, with a (new) full grammar, capable of as rational and logical and emotional communication as any other language. We might say that with English it is more *re*-invention, and with pidgins more invention but the process is exactly the same. A complete language is created, just as good as French or English in terms of linguistic ability. It is not broken French or second-class English. It is a new language, which linguists call a creole. Unfortunately, its speakers will not be made to feel proud of their language—exactly the opposite. Creoles are usually spoken by populations who have little social or economic power. Further, to speakers of English or French the creole often sounds like someone is trying, but failing to speak their languages. The result is that creoles are, quite unjustly, looked down on.

A next possible stage is called decreolization or standardization. Given the low status of creoles, speakers quite reasonably want to learn Standard English or French and will try to do so if they have access to it. While most Haitian Krio speakers have little access to French, in Hawaii an excellent school system makes

targeting Standard English quite possible. Many residents of Hawaii I knew were bilingual in both Hawaiian Creole English (this name means the creole came from a pidgin based on English) and English. Bilingual ability has its advantages, for there are many things you can express and appreciate in one language that are difficult to express in the other; the languages represent different worlds of experience. In situations where many in your community know both languages, a speaker often has the choice which to use. One can make quite eloquent statements of social, familial, and political identity and solidarity simply by choice of language. (Linguists call such situations—common around the world—diglossia. There is a very interesting literature on the subject. See Wardaugh and Trudgill.)

Most children—not just in creole areas—grow up speaking something other than the standard. In the United States these days, schools attempt to teach the standard, and we learn it as an addition to the kind of speech we already have. Teachers often link not speaking the standard with laziness, bad habits, and a rejection of what is "correct" and "right." Similarities with morality do not stop there. That "Standard is Good" is taken as an article of faith. It must be taken on faith, since it is not provable in any scientific sense. There are indeed good reasons to learn Standard, but they stem from the *self-fulfilling prophecy* that good, cultured, educated people will speak the standard language. If you want to be seen as one of those people then you will try to speak the standard. This will be discussed more fully below.

Often prescriptivists—that is, grammarians who "prescribe" that people follow the rules of the standard—attempt, and fail, to "prove" that standard is better by appealing to some objective measure outside of language; by appealing to logic, for example. They claim that standard is better because it is more "logical." A common argument of this kind is that double negatives are wrong because they are illogical, since, as everyone is said to know, "two negatives make a positive." Thus, *He don't know nothing* is said to be wrong because it "really" would mean "he knows something." This ignores the fact that French, Italian, and many other languages routinely use exactly the same type of double negatives, and they mean negative: for example, French *Il ne sait rien,* "He doesn't know anything" is literally "he not know nothing." These same grammarians do not accuse French of being "illogical," because French is a high-prestige language to most English speakers.

Another measure is "clarity." It is quite true that poor, murky writing or speech is very unclear and counterproductive; however, the decidedly nonstandard *He don't know nothing,* to use the example from before, is clear in the extreme.

Perhaps the least defendable of all is that certain speech is incorrect because it has changed over time from some original, perfect state. This is the "change equals decay" argument. This is a popular attitude regarding many aspects of culture, not just language: everything was better "in the old days." With language, most certainly, it is an absurd position, yet many people seem to make a name for themselves by condemning change. One of them, for example, is John Simon. Simon is a theater critic as well as a pop grammarian.

Simon shows just what *he* thinks of linguistic change in his typical bombastic style.

> "Language has always changed," say these people, and they might with
> equal justice say that there has always been war or sickness or insanity.
> But the truth is that some sicknesses that formerly killed millions have
> been eliminated, that some so-called insanity can today be treated, and
> that just because there have always been wars does not mean that someday
> a cure cannot be found even for that scourge. And if it cannot, it is only by
> striving to put an absolute end to war, by pretending that it can be licked,
> that we can at least partly control it. Without such assumptions and ef-
> forts, the evil would be so widespread that, given our current weaponry, we
> would no longer be here to worry about the future of language.

Notice that Simon begins the passage actually equating language change with "sicknesses that formerly killed millions," and winds up even further off the deep end, talking in the same breath about the annihilation of humanity.

Simon does not like the language of the underprivileged, which he intimates comes about through language change, and he does not like educators who allow it,

> professors who—because they are structural linguists, democratic respect-
> ers of alleged minority rights, or otherwise misguided folk—believe in the
> sacrosanct privilege of any culturally underprivileged minority or major-
> ity to dictate its ignorance to the rest of the world. For, I submit, an En-
> glish improvised by slaves and other strangers to the culture—to whom my
> heart goes out in every human way—under dreadfully deprived condi-
> tions can nowise equal [Standard English].

I devote so much time to Simon because many otherwise well-informed people actually accept such nonsense as true. Statements such as these on change and

"underprivileged" English are about as absurd as if an amateur astronomer claimed that the sun revolved around the earth. It is unfortunate that someone who sets himself up as a language authority can reveal so dismal a knowledge of language. Simon's every position runs counter to the body of evidence discovered by linguists, scientists who study language.

Linguists have analyzed a great many languages around the world. Virtually all linguists believe that there is no superiority of one language over another among any of the thousands of languages spoken as the native tongue of a group of humans. We might say, *"All languages are equal"* in linguistic ability. No linguist has ever found a deficient language that was serving as the native, primary language of a human speech community. This is *a function of the common genetic makeup of humans.* There is no such thing as a language that is less good, defined by linguistic criteria. Social criteria, however, are something else again.

Many languages and varieties of languages have low social status. The prejudice against them does not come from something internal to the language, but rather is something you must specifically learn. A favorite dialect of American ethnic literature has been New York-ese. New Yorkers themselves look down on certain New York pronunciations. If someone "toiks like dis," in New York, people think the speaker sounds dumb and sloppy. In New York, it sounds bad to call a Chevy a "caw," without an *r,* instead of a "car" with the final *r.* But is this because the lack of *r* sounds bad in and of itself, or because what we have actually learned is that the lower socioeconomic classes, with whom we associate a lack of *r,* sound bad?

In English cities like Bristol and Reading, a lack of *r* sounds *good.* If you pronounce your *r*'s you are looked down on. The highest prestige dialect of England is marked by lack of *r:* The Queen says "cah."

So the lack of intelligence that New Yorkers say they associate with someone who says "caw" must not be because of the language itself but because of what the New Yorkers have additionally been taught about such people. You must be taught what language sounds good and bad; the information is not there and obvious in the language itself.

A good example of this comes from a superb video called *American Tongues,* which explores various dialects of the United States. In one segment, a woman from Cincinnati is shown. She explains how in that city if you have a bad accent, it is difficult for you to get ahead. Yet New York college students shown the video consistently could not tell whether the woman herself has a "bad" accent or not (she does).

If there were some universal, immutable standards for good speech, this would not be the case. But it is the case. Standards of proper speech are relative because they are *defined by culture,* not by nature.

We will discuss below the principle of language that Ferdinand de Saussure, the founder of modern linguistics, called the *"arbitrariness* of the linguistic sign." For now let us note that the principle makes clear that there is nothing inherently better or worse in using, say, one pronunciation or another to signal a certain meaning.

One of the most serious criticisms we can level against know-nothing "experts" such as the pop grammarian Simon, and this is an important point, is that they encourage people to use language differences as a basis for negative moral judgments against those who speak a low-status language or dialect. That is, *they encourage using language differences to reinforce and justify nonlinguistic prejudices.*

This means that we learn prejudices against groups, and then learn to dislike that group's language as a way of reinforcing and justifying the attitude toward the group. We are not aware this is what happens; we truly think the group's speech is "bad," and evidence of laziness or poor upbringing or ignorance. But as discussed above, we must be carefully taught which group's speech is bad or good—it is not inherent in the speech itself.

The implications for ethnic literature are obvious. The reader may not have reacted to the nonstandard speakers in the quotations above by simply thinking them nonstandard speakers. The reader may also have assumed they were stupid, or at least illogical, messy, lazy, "bad."

A devastating study shows how people can deceive themselves once they have internalized American society's view of what groups are low prestige or nonstandard. Frederick Williams and his associates presented white student teachers with videotapes of children speaking. The teachers rated black, Mexican American, and white Anglo children as having markedly different levels of fluency and ability to speak standard English. However, the videotapes were specially done so that even though the visuals showed different children, they all had exactly the same speech dubbed in, that of a speaker of standard English. So when teachers heard a black or Mexican American child speak standard, they rated that child as having lower fluency and their speech more nonstandard than a white child speaking the very same words—there was only one voicetrack.

Obviously, these prejudices against languages and groups have grave consequences for the educational system, even for the quality of life in America. One more consequence is to make it all but impossible for some of us to respond positively, or even objectively, to the speakers in ethnic literature.

I have never read a pop grammarian who understands about home languages. Linguists defend the home languages—Black English, New York English,

or Standard English, whatever you learn at home—because they are perfectly good languages and if that is what you were trying to speak, then you *are* correct. Understand it or not, pop grammarians cannot embrace this principle since it would rob speaking a home language of the moral turpitude they now claim it evidences.

Other evidence of moral turpitude, they allege, is language change. Remember that we have seen John Simon rather ponderously equate language change with war, sickness, and insanity. Change in language is viewed by the pop grammarians as especially bad if it comes about because of input from "debased" sources like minorities or feminists. Change is seen as bad in itself. Change is equated with corruption. Does change ruin language? In a word, no.

Languages change all the time for a great variety of reasons. Old English became Middle English. Middle English became Modern English. Would we be communicating better if we all still spoke Old English? Would we be morally purer speaking our language family's Late Stone Age ancestor Proto-Indo-European?

Knave once simply meant "boy." *Silly* used to mean "timely." *Thing,* several hundred years ago, meant "a public meeting or court of law." Are the modern uses of these words wrong? Are speakers debased by using other-than-original meanings? Clearly the answer is no.

When the Declaration of Independence was being written, the word *enthusiasm* meant "divine inspiration" and "spirit possession." Adam Smith, Hobbes, and Locke all wrote warnings against enthusiasm's influence and attacking its superstitious power against reason. Is English nowadays more corrupt in that the meaning of *enthusiasm* has changed?

Many complaints by the pop grammarians like Simon have underpinning them a misunderstanding of the basic nature of language, especially the principle the linguist Saussure called the "arbitrariness of the linguistic sign." "The hierarchical place of this [principle]," Saussure said, "is at the very summit. It is only little by little that one recognizes how many different facts are but ramifications, hidden consequences of this truth."

The elemental structure of language is signals paired with meanings. A signal-meaning pair is a sign. The relation of signal to meaning is arbitrary. In English we call a cat a *cat;* in French a cat is *chat,* in Spanish *gato,* and in Swahili *paka.* There is no natural connection between the sounds in *cat* or *gato* or *paka* and the animal those sounds signify. The relationship between the word and the meaning is *arbitrary.*

All that matters is that the speakers of the language *agree* that a word means what it does: meaning in language is a social contract. There is a very good reason for this, of course. We would soon run out of things to say if we could only say what we could imitate. We could say *plop*, we could say *fizz*, we could say *maew* to mean "cat," as we do in Thai, and we could say *ng'ombe* to mean "cattle," as we do in Swahili. But how do you make a sound that imitates "red" and "green," let alone "truth" and "justice"? How could we represent the sound made by the present, past, and future?

The vast majority of signals in a language—in all languages—mean what they do because they are *arbitrarily* attached to their meaning by the agreement of the speakers of the language. But the sign is arbitrary in more than just the relationship between signal and meaning. Extremely important to our discussion is that there is an *arbitrary relation among meanings* as well.

Anyone who has ever tried to translate between two languages knows that language is not just a set of names for a universal, preexisting set of meanings. If this were the case, we could translate simply by replacing the French signal for a certain meaning with the English signal for that same meaning. To further translate it, we could replace it with the Chinese signal for that same meaning. But there is no universal set of meanings for which all languages have signals. Each language has its own set of meanings, independent of other languages and independent of "reality." If language actually represented "reality" we would, perhaps, find in all human languages the same semantic atoms. But *language invents reality*, and each language invents its own. It is scary to realize this, and so we resist. We want to believe that what we perceive is objective reality. But as the linguist Edward Sapir said, "The worlds in which different societies live are distinct worlds, not merely the same worlds with different labels attached."

We could find examples in American speech but we would immediately run into our own perhaps heated involvement with American cultural politics. So, to give ourselves a relatively neutral example, let's consider the East African language Swahili. The structure of Swahili is markedly different from English. Swahili utilizes more than 15 noun classes, the equivalent of a Romance language (like French or Spanish) having 15 genders. Three noun classes are devoted solely to different aspects of space and time. Like other Bantu languages, its grammar, by European standards, is exceedingly complex.

Let us look not at grammar now, but at kinship terms, and compare the different realities created by English and Swahili in regard to the individuals who populate one's family. Let us imagine an English-speaking American family.

Susan has a mother, Anne, and a father, Sam. Mother Anne has a sister Sarah and a brother Frank. Father Sam has a brother Louie and a sister Alice.

Frank—Sarah—Anne =_= Sam—Louie—Alice

—

—

Susan

	English
Anne is Susan's	mother
Sam is Susan's	father
Alice is Susan's	aunt
Frank is Susan's	uncle
Sarah is Susan's	aunt
Louie is Susan's	uncle

In Swahili, things are a bit different:

	English	*Swahili*
Anne is Susan's	mother	mama
Sam is Susan's	father	baba
Alice is Susan's	aunt	shangazi
Frank is Susan's	uncle	mjomba
Sarah is Susan's	aunt	mama
Louie is Susan's	uncle	baba

Your mother is your *mama;* your mother's sister is also your *mama.* Your father is your *baba;* your father's brother is also your *baba.* How shall we translate *uncle* into Swahili? How do we translate *baba* into English? In both English and Swahili the same Anne and Sam gave birth to Susan. English and Swahili eyes all see the same Anne and Sam and Alice and the rest. But there is no one-to-one correspondence of Swahili and English meanings. The two languages divide up the world in different ways. They construct different realities.

The first moral here—one we can apply back to our discussion of American ethnic speech—is that while the English and Swahili meaning systems are quite different, there is no principled way of declaring one right and the other wrong. They are equally valid. This illustrates that there is no natural set of meanings that must be in a language; a language is free to reflect the semantic needs of its speakers.

An extension of this point concerns change. If there were preexisting, universal meaning categories then regardless of other evolution in a language, those meanings would not change. But because the meanings are arbitrary they are free to change as, of course, we have observed they do. (We have not discussed this, but the signals, being an integral part of the arbitrary sign, are as free to change as the meanings.) What the pop grammarians misunderstand is that language is (and only is) a social contract, an arbitrary agreement by the speakers. This fact underlies the equality of different languages and of the different varieties of a single language. This fact underlies also that change in itself is not decay.

There is a second moral. Let us end by looking back, with sharpened vision, at the quotation with which we began. An Asian American young woman was—with sarcasm—fending off the amorous advances of a foreign-born man. Great attention is drawn to their different accents, to his nonstandard speech. She continues on, "I could never marry a coolie," and someone comments, "Damn American-born girls." A constant topic of American ethnic literature will be the tension between the foreign born and the American born.

Sociolinguists can give at least one important reason for this from among the many available. The foreign born have had their reality organized by a foreign language. The two languages have divided up the world in different ways, organized two separate realities. The clash between these two realities—each looking like no more than "common sense" to the holder—generates the anxiety that, in its turn, generates so much of ethnic American literature. On the very first page of Amy Tan's *The Joy Luck Club,* she records an exchange between a foreign mother and an English-speaking daughter that prefigures everything she'll write thereafter:

> "*Don't show off,*"*I [the daughter] said.*
>
> "*It's not showoff.*" *She said the two soups were almost the same,
> chabudwo. Or maybe she said butong, not the same thing at all. It was one
> of those Chinese expressions that means the better half of mixed intentions.
> I can never remember things I didn't understand in the first place.*

It's one thing when a foreigner holds a separate view of reality. It's another thing when it's your mother. In that Aristotelian conflict can be found the plots of perhaps the majority of American ethnic literature.

[For that reason, this volume devotes a long chapter to a social analysis of the Mandarin expressions in *The Joy Luck Club.* See Chapter 44. We also include a "Cultural Lexicon," Appendix B.—Ed.]

Further Reading

Alvarez, Louis, and Andrew Kulker, directors. *American Tongues.* Center for New American Media, 1987, video. A superbly entertaining and informative look at American dialects on video.

Bickerton, Derek. *Dynamics of a Creole System.* Cambridge: Cambridge University Press, 1975. First-rank theoretical linguist and expert in pidgin and creole studies. I saw this when I studied with Bickerton at the University of Hawaii, accompanying him on fieldwork, interviewing and recording former sugarcane workers.

Culler, Jonathan. *Saussure.* Glasgow: Wm. Collins & Sons, 1976. A readable and informed introduction to Saussure, the founder of modern linguistics and semiotics.

Dickson, Paul. *Slang!* New York: Pocket Books, 1990.

Fasold, Ralph. *The Sociolinguistics of Society.* Oxford: Basil Blackwell, 1984. A superb book for a more advanced reader, it discusses the Williams' study and many others.

Goshgarian, Gary. *Exploring Language.* New York: HarperCollins, 1992. A sourcebook with short readings from many different authors, including Simon, aimed at high school and college students. The Simon examples come from pp. 343 and 344.

Holm, John. *Pidgins and Creoles.* 2 vols. Cambridge: Cambridge University Press, 1988, 1989.

Inada, Lawson Fusao. *Legends from Camp.* Minneapolis: Coffee House Press, 1992.

Labov, William. "The Logic of Nonstandard English." In Labov's *Language in the Inner City.* Philadelphia: University of Pennsylvania Press, 1972. A renowned linguist's classic debunking of non-standard "inferiority" and some reasons certain dialects fall prey to this undeserved reputation.

Tan, Amy. "Mother Tongue." *Threepenny Review,* 1989.

Trudgill, Peter. *Sociolinguistics: An Introduction to Language and Society.* London: Penguin, 1974, rev. 1983. An excellent, lively, readable general introduction to the branch of linguistics that deals with issues such as the ones discussed in this article.

Wardaugh, Ronald. *An Introduction to Sociolinguistics.* Oxford: Basil Blackwell, 1986. Useful and readable.

Dialect Literature in America

Theory

JAMES J. KOHN

[In 1981 James J. Kohn became one of the first American scholars allowed back into China after the Cultural Revolution. He taught English for a year at Shandong University and studied Mandarin. As Kohn notes, much American literature, particularly ethnic literature, routinely represents accents and dialects. Asian American literature continues this tradition. Kohn—not only a Mandarin speaker but a Columbia graduate with a specialty in linguistics—points out that the literary representation of dialects, so characteristic of American literature, has philosophic implications and problematic overtones. He reviews half a century of research and offers conclusions of his own.—Eds.]

> *Perhaps, also, in America, since the period of national independence, there has always been in the literary consciousness a background of hope that the popular native style might turn out to be the prince in disguise after all, that America might have in its immediate possession an original and unique literary medium of expression which when illustrated by the writings of genius would take its place among the perfected languages of the world. Certain it is that few American authors have been able to resist the temptation to experiment in the literary possibilities of the popular speech.*—George Philip Krapp, The English Language in America, *Vol. 1., p. 225 (New York: Ungar Publishers, 1966).*

From Regional to Ethnic Dialect Literatures

Showing the sound of our native language has always been a goal of writers of American English. From the earliest writings on this continent until the present

day, writers have been sensitive to the differences between the voices they hear and the way the language is represented on the page.

Those differences, in earlier days, were largely regional differences: the "Southerner," the "Hoosier," the rough but democratic "N'Yawker," the proper Bostonian pontificating from "Havad Yad." What has begun to take the place of *regional literature,* it seems to this writer, is the ascent of American *ethnic literature.* Social minority groups in America have found powerful literary voices, heard in the work of African-, Asian-, Hispanic-, and Native-American writers. And the dialect literature tradition now flourishes there. To understand its rhetoric fully—and its implications, both intended and unintended—we must understand the older regional dialect literature it grows out of. Happily, that literature has been much discussed by linguists and critics.

The American Dialect Society, a group of linguists who studied oral language variation, dedicated its efforts to describing the varieties of American English. Journals such as *Dialect Notes* and *American Speech* present the scholarly description of these various kinds of English. But a more accessible and attractive channel to the American reader is open to writers of American fiction. Over the past two centuries, they have presented their interpretations of the languages they heard, from the English of Native Americans, to the regional variations in New England, the Midwest, the South, and the West, to the social variations of Black English vernacular and the wide variety of immigrant Englishes. In this work, the writer can only indicate the sources of reference to this sprawling collection of attempts at literary descriptions of American English, and to suggest some of the problems and trends concerning its future.

There are several writers who have attempted to describe the scope of American dialect literature. Of these, I have selected three prime sources for commentary and reference: George Philip Krapp, *The English Language in America,* Sumner Ives, "A Theory of Literary Dialect," in Juanita V. Williamson and Virginia M. Burke, eds., *A Various Language,* and Eva M. Burkett, *American English Dialects in Literature.* Of these, the latter, published in 1978, offers the most complete and recent annotated listing of literary works that included passages of American dialects. For a comprehensive, recent list of works in American dialect literature, the work by Burkett serves very well.

All of these writers agree that Americans have tried consistently throughout our history to represent our oral dialects in fiction, with varying success, and using a wide variety of techniques.

George Philip Krapp's School of Thought

George Krapp differentiates several kinds of attempts at dialect representation in American fiction. One sort of representation is "eye dialect," in which the sounds of the language are hinted at through a variant spelling:

> Thus a dialect writer often spells a word like front as frunt, or face as fase, or picture as pictsher, not because he intends to indicate here a genuine difference of pronunciation, but the spelling is merely a friendly nudge to the reader, a knowing look which establishes a sympathetic sense of superiority between the author and the reader as contrasted with the humble speaker of the dialect. (Krapp, p. 228)

Krapp includes varieties of immigrant English as another form of class dialect, in which "there is probably present some sense of amused superiority on the part of the conventional speaker as he views the forms of the dialect speech," but in which "the American seems always to have experienced an unusual degree of exaltation and self-satisfaction" (Krapp, p. 229). Krapp goes on to include several forms of "local dialect," such as southern mountain dialects and New England dialect varieties. He devotes much attention to an analysis of James Russell Lowell's *Biglow Papers* for New England speech, John Hay's *Little Breeches* in *Pike County Ballads*, and Joel Chandler Harris' *Mingo*, a "self-respecting well-to-do woman of democratical central Georgia." But from his analysis, Krapp concludes

> that all local dialects of this kind are at bottom merely general colloquial American English, with a slight sprinkling of more characteristic words or pronunciations, some of which suggest fairly definite local associations, often in the case of words by connection with some peculiar local occupation or activity. A person who speaks a low colloquial English in plantation surroundings is readily interpreted to be a Southerner of some degree, but essentially the same language spoken on the range would establish the speaker as a cowboy, or in the gold region as a miner. The statement quoted earlier in this chapter, that there are no true dialects in America, is thus seen to be in the main defensible, so far as dialects have been utilized for literary purposes. One may say that there have been only two forms of speech in America, the more or less formal standard and the more or less informal colloquial. (Krapp, p. 242)

Krapp continues his analysis of such writers as Bret Harte, James Whitcombe Riley, and Joel Chandler Harris, attempting to show that these writers make relatively minor adjustments in style and diction to represent what Krapp labels "General Low Colloquial," which he describes as "the speech of the careless or uneducated English speaker everywhere," and which he claims is not much different from "General Colloquial," and differs only slightly from "Local Dialect," a designation for regional features in speech.

One noteworthy application of these general remarks seems to be in his discussion of Gullah, a dialect of African-American English of the Southeast. Krapp cites several representations of Gullah in literary works, commenting that "There are no African elements in these transcriptions, no survivals of an original speech which make the English of negroes seem like the speech of foreigners who have imperfectly assimilated English," and that representations of this African American dialect are like other representations of "Low Colloquial English," with sprinklings of words or phrases associated with "negro speech." Krapp further remarks that

> The question of African origins is of very little importance, however, since there is practically nothing in the recorded forms of Gullah speech which cannot be derived from English. Like the negro English of Harris and Page, Gullah is merely a debased dialect of English, learned by the negroes from the whites. The English speech which the whites probably used in addressing their savage slave captives was the much simplified, infantile English which superiors sometimes assume in addressing inferiors, or which with repetition and vociferation is used in trying to communicate with people who do not know the language. (Krapp, p. 253)

Subsequent generations of linguists have refuted such claims about the origin of Gullah, and an entire branch of linguistics has since evolved to study the derivation of pidgin and creole languages. Krapp's claims are no doubt based on the ignorance of contemporary scholars who had not yet studied such languages. No reputable scholar could dare make the sweeping and unsubstantiated claims that Krapp makes here. But at least we see in Krapp a critical view of the representations of American dialects in literature.

Sumner Ives' "Theory of Literary Dialect"

Another well-known writer on American dialects is Sumner Ives, whose article, "A Theory of Literary Dialect," appeared in *Tulane Studies in English II* in 1950, and

has since been included in a very useful anthology, *A Various Language: Perspectives on American Dialects,* edited by Juanita V. Williamson and Virginia M. Burke (New York: Holt, Rinehart, 1971). *A Various Language* includes a wide range of writings on dialects of American English, ranging in level of discussion from general to technical. The article by Ives is located in a section of the book, "Literary Representations of American English Dialects," which also contains articles on eye dialect, on Negro dialects, on dialects in *The Adventures of Huckleberry Finn,* and on dialects in Eugene O'Neill's plays.

In his article, Ives deals with the problem suggested in Krapp's work, that literary representations of dialects do not always differ greatly from colloquial speech:

> *Nearly all examples of literary dialect are deliberately incomplete; the author is an artist, not a linguist or a sociologist, and his purpose is literary rather than scientific. In working out his own decision between art and linguistics, each author has made his own decision as to how many of the peculiarities in his character's speech he can profitably represent; consequently, examples of literary dialect vary considerably in the extent to which they are "dialectal," and no very definite rules can be given regarding what to consider in that category. (Ives, p. 147)*

Ives points out that Krapp's analysis is based on the assumption that there was a uniform standard for all American speech, a misconception that many laymen hold today. He further notes that Krapp's method was to choose small samples and compare them to nonstandard forms: "When he discovered that these forms appeared more or less consistently in his samples, he concluded that the dialect writers did little more than draw on this common 'low colloquial'" (Ives, p. 148). Ives' alternative theory of dialects is that the American language is fluid, and subject to many changes:

> *Furthermore, people move about and carry the speech with them, and even without such movement the speech of one group affects the speech of adjoining groups. All these factors contribute to the formation of dialects of the language, and all users of a language speak some dialect rather than the "language" itself. So far as known, no language, not even if we include modern Latin, exists in a "pure" or non-dialectal state. (Ives, p. 150)*

Ives' description of dialects is much closer to modern dialectologists' perceptions, who speak of varieties of speech, which may vary not only by region,

but by social class, ethnic group, or even contextual situation (see D. Hymes, W. Labov). Ives goes on to point out that, for literary purposes, an author may wish to exaggerate the frequency of occurrence of dialect features in a character's speech, or to use "eye dialect," which may "overstate the ignorance or illiteracy of his characters."

He notes that authors must eventually reach a compromise with the readability of the text for their readers and that "a literary dialect based on the speech of the Gullah Negroes of South Carolina and Georgia coast is necessarily a less complete representation of the actual speech than a literary dialect based on the speech of southern Indiana or eastern Massachusetts" (Ives, p. 155).

In this article, Ives makes a close study of specific instances where authors represent the regional speech of their characters, including passages from Joel Chandler Harris' *Uncle Remus* and James Russell Lowell's *Biglow Papers*. Ives makes the point that the spelling of words to represent dialects is relative to the author's own spoken dialect. One example is his discussion of the spelling of words with 'r' in John Greenleaf Whittier's poem, "Skipper Ireson's Ride":

> It is probable that Whittier, like Lowell, spoke an "r-less" dialect; hence he would be likely to use some phonetic spelling device to indicate the presence of an [r]-like sound that he would not use himself. In this poem, the words hard, heart, and cart sometimes appear as HORRD, HORRT, and CORRT. The spelling with RR is certainly an indication to the readers that, actually, the women of this town do pronounce an r in these words, contrary to the practice of most other inhabitants of eastern New England.
> (Ives, p. 161)

Ives also points out that such regional morphological forms as "clum," "clam" or "clim" for *climbed,* or "driv" for *drove* or "cotch" for *caught* or "hold" for *helped* are all regional variants which have disappeared over time, but which reflected a more lively variation in early periods of American writing.

Ives concludes his essay by noting that literary representations of dialect are not always the most reliable recordings of the details of dialect, although they may bring out details that may be missing from a linguistic description: "the analysis of those literary dialects for which verifying evidence is available can quite possibly bring out clues to a more certain interpretation of evidence on historical developments" (Ives, p. 177). But for a fiction writer, nothing so clearly can identify a character as his or her speech; literary dialects are an important tool in characterization.

Eric Stockton

For a detailed examination of the way in which an American author has used literary dialect representation to achieve characterization, one can turn to Eric Stockton's article, "Poe's Use of Negro Dialect in 'The Gold Bug,'" in Williamson and Burke's *A Various Language*. Stockton assesses Poe's use of Negro dialect features was "to show low social status, not regional *mise en scène*." Thus Poe did not intend the dialect as an accurate representation of Southern speech, but rather as a social comment. Stockton points out that Poe's own speech was Southern, so that more accurate representations of regional variations between characters would be pointless; they all speak Southern. The bulk of Stockton's article is a thorough analysis of the linguistics of the speech of Jupiter, a main character in Poe's story. Stockton describes the phonology of stressed and unstressed vowels, of consonants, of stress, and varieties of morphology, syntax, and vocabulary. He concludes that the character Jupiter is not represented accurately as a speaker of Gullah, or any specific Southern dialect:

> This analysis has attempted to show that Jupiter's phonology, morphology, syntax and vocabulary form an excellent contrast with Poe's conception of his own 'standard' Southern speech. The primary contrast emerges as social; Jupiter's speech is as much substandard as it is Southern Negro. The author, however, took race and the story's locale into consideration successfully. Save for two or three humorous folk etymologies, Poe invented no linguistic features for him; they are all duplicable elsewhere, and the overall dialect is enjoyable. (Stockton, p. 213)

Thus, the reason for using literary dialect representations was for Poe, and remains for most, their value as a literary device to entertain and inform the reader, and only secondarily as an accurate recording of the actual speech of the characters.

Eva Burkett and James B. McMillan

More recently, two annotated bibliographies of dialect description and dialect literature have appeared. James B. McMillan's *Annotated Bibliography of Southern American English* (Coral Gables, FL: University of Miami Press, 1971) contains a wealth of references to descriptions of Southern speech, and a chapter on

literary representations of that speech. But by far the most complete survey of American dialect literature is Eva M. Burkett's *American English Dialects in Literature* (Metuchen, NJ: The Scarecrow Press, Inc., 1978). Burkett identifies four dialect areas for American literary works—New England, Middle Atlantic, Southern and Western. Each area's writings are listed and annotated in a separate chapter. In addition she includes a chapter of "Dialects Used by Writers of English as a Second Language," devoted to representations of ethnic dialects of American English. The chapter on Southern dialects is subdivided into several divisions, including "Southern Lowlander," "Southern Mountain," "Louisiana French Creole and Cajun Dialects," and "Negro Dialects," which is further divided into subsections—"By White Writers," "By Negro Writers," and "The Gullah Dialect." Burkett includes a very useful introductory chapter, in which she reports on the work of American dialectologists, including an annotated bibliography of works on American English Dialects. Each of the succeeding chapters of the book begins with a discussion of the historical background of the regional dialect, followed by an annotated bibliography of specific works for that region, and of literary works that represent that region or social group. One notices that entries for these chapters begin with nineteenth century works and continue to the early twentieth century; it would be useful to know if the paucity of entries post-1950 reflects the lack of newer material written to represent dialects, or the lack of publishers' interest in such material.

In any case, Burkett's work is surely the most complete modern reference to such material. She also includes an appendix with a sample of southern rural Florida dialect, a list of dialect features that appear in literature, and an index by title of works on dialects in American English. For students beginning work on American dialects and their literary representations, this text makes an excellent place to begin.

From Regional to Ethnic

One of the social forces that continues to affect the American dialect literature is the steady influx of immigrants from other countries. Depictions of the lives of these immigrants has always included representations of their speech. All the dialect theorists just discussed have grappled with these representations, in their different ways. Each approach throws valuable light from a different angle.

There is a long history of the representation of ethnic minority speech in American writing. George Krapp cites an example taken from the writings of a Boston merchant in 1675, describing an encounter with "about three hundred Indians":

> *all being ready on both sides to fight, Captain Mosely plucked off his Periwig, and put it into his breeches, because it should not hinder him in fighting. As soon as the Indians saw that, they fell a Howling and Yelling most hideously, and said, 'Umh, umh, me no stawmerre fight Engis mon, Engis mon got two hed, Engis mon got two hed; if me cut off un hed, he got noder, a put on beder as dis.' (Krapp, p. 268)*

One must wonder whether the writer actually heard this speech, since the story has an apocryphal ring to it. But it is early evidence of the attempts to transcribe the speech of those learning English. Krapp includes several other citations of transcriptions of Native- and African-American English from the eighteenth century. As the great waves of immigration in the nineteenth century brought increasing numbers of European immigrants to America, their voices began to appear in literature, first as the subject of ridicule in dramas of the period and later as characters in more serious drama. As Ruth M. Blackburn reports in her article, "Dialects in Eugene O'Neill's Plays," Eugene O'Neill attempted to recreate the speech of Irish and Cockney sailors in his early plays, such as Burke in *Anna Christie* and Paddy in *The Hairy Ape:*

> Burke: *'Is it losing the small wits ye iver had, ye are?' '. . . aisy for a rale man with guts to him, the like of me.'*

> Paddy: *'Ho-ho divil mend you? Is it to belong to that you're wishing?'* *'Me back is brok. I'm bate out—bate.' (Blackburn, p. 236)*

In her chapter on "Dialects Used by Writers of English as a Second Language," Eva Burkett lists several works in which immigrant dialects are used, including Thomas Daly, *Selected Poems* (1936), containing Irish and Italian immigrant English, Sidney Howard's *They Knew What They Wanted* (1924), about Italian immigrants in the Napa Valley of California, and of course Leo C. Rosten, whose book of short stories, *The Education of H*Y*M*A*N K*A*P*L*A*N,* is an enduring favorite. Among contemporary writers, the masters of Yiddish-American English are Bernard Malamud, *The Magic Barrel* (1958), and *Idiots First* (1963), and Isaac Bashevis Singer, author of many short stories.

American Ethnic Literature

What has begun to take the place of regional literature, I began by saying, is the maturing of American ethnic literature. Social minority groups in America have found powerful literary voices. Anthologies that focus on Asian American writings have appeared, such as *The Big Aiiieeeee!* (edited by Jeffrey Chan, Frank Chin, Lawson Fusao Inada, and Shawn Wong [New York: Penguin Meridian, 1991]) and *Here to Stay* (edited by Sylvia Watanabe and Carol Bruchac [Greenfield Center, NY: The Greenfield Review Press, 1990]). These include short stories, passages from novels and plays written by or about Asian Americans. It is not usual to find dialects represented in these works, but the topics and settings are clearly specific to the experiences of members of the Asian American communities. An excellent resource for Asian American literature is the MLA publication, *Asian-American Literature: An Annotated Bibliography* (1988), edited by King-kok Cheung and Stan Yogi.

Similarly, a recent anthology of Mexican American fiction, *North of the Rio Grande* (1992), edited by Edward Simmen, contains many stories written by and about Mexicans in America, starting from about 1900.

As noted, African American English has long been re-created in American literary works. In the work of Langston Hughes, Zora Neale Hurston, and other African American writers of the period of the "Harlem Renaissance," the dialects of speakers in the New York African American community are represented. But in more recent works, like Ralph Ellison's *Invisible Man,* the region from which the characters come is not as relevant as their identification as members of the African American community. That the characters in such a novel as Alice Walker's *The Color Purple* speak a variety of different versions of American English is evidence that regionalism is not as important as ethnic identification.

It is not within the scope of this article to detail the broad scope of newly emerging ethnic literature in the United States, merely to point out that the emergence of such literature is replacing the attention given to regional and social dialects seen in the writings of previous generations.

The Future of Dialect Literature in American Literature

As noted above, there has been a decrease in the number of fictional representations of dialects in American literature in recent years, which may continue in the years to come. As attractive a means of representing the true nature of the

characters they helped portray in earlier times, it may now be the case that dialects no longer play such an important role. The reasons for such a decline have to do with the social facts about dialect variation, as much as the nature of fiction in America. That there are still representations of dialect in American fiction is clear. One need look no farther than such recent titles as Tom Wolfe's *Bonfire of the Vanities* to hear Southern English parodied ("Shuh-man!"), if not accurately portrayed. Novels of the African American experience, such as the work of Toni Morrison and Alice Walker, convey the sound of their characters with the same accuracy as earlier writers recorded Middle Atlantic or Western dialects. But social forces are at work against the growth of such representations.

The spread of regional dialects that characterized the first 300 years of European settlement in North America has now stopped and begun to double back on itself. Large social movements sponsored by the two World Wars brought many residents from the South and East to cities in the West. In the past decade, while Eastern cities have lost population, Southern and Western cities have gained. With so much movement from previous dialect areas to new ones, there is no longer the firm base of regional location that would enable writers to identify characters to their readers on the basis of how they would sound in speech. No longer can a Southwestern dialect feature typify Oklahoma or Texas, since the same sounds could come from central California residents. Even the "Valley Girl" speech made famous by Moon Zappa cannot be localized to southern California, but might be found in the speech of teenagers across the country. As the economy changes and as jobs attract more transnational migration, writers are just as likely to hear Eastern accents in Southern states. The regional vocabulary expressions that once brought "local color" to the work of such writers as Bret Harte, Mark Twain, and many others has given way to mostly national usage, shared by readers all over the country, and thus not easily identifiable as representative of a single region. The influence of radio, television, and films in the spread of a national colloquial language is often identified as one important influence in the decline of regional dialects and the spread of an amalgamated American English. But equally important is the change of lifestyles in America and the advent of so much greater mobility. Just as people are said to move three or four times in their lives to remote cities, families are now routinely spread to all corners of the country. Easy access to long-distance telephoning makes proximity at once as near as the nearest instrument, but physically as remote as the past.

The success of such ethnically grounded novels as those of Maxine Hong Kingston, Amy Tan, Alex Haley, Alice Walker, Toni Morrison, Louise Erdrich, and Leslie Marmon Silko is a clear demonstration that American readers are now in-

terested in reading about the lives of people of color and of their histories. With the amalgamation of American dialects into a mosaic of mutually acceptable varieties, it may be that new energy in representing American dialects will come from ethnic communities. As Leo C. Rosten says, "There is a magic in dialect which can liberate us from the prison of the familiar."

Further Reading

Blackburn, Ruth M. "Dialects in Eugene O'Neill's Plays." In J. Williamson and V. Burke, *A Various Language*. New York: Holt, Rinehart and Winston, 1971, pp. 230–244.

Burkett, Eva M. *American English Dialects in Literature*. Metuchen, NJ: The Scarecrow Press, 1978.

Chan, Jeffrey Paul, Frank Chin, Lawson Fusao Inada, and Shawn Wong. *The Big Aiiieeeee!* New York: Penguin Press, 1991.

Cheung, King-kok, and Stan Yogi. *Asian-American Literature: An Annotated Bibliography*. New York: The Modern Language Association, 1988.

Ives, Sumner. "A Theory of Literary Dialect." In J. Williamson and V. Burke, *A Various Language*. New York: Holt, Rinehart and Winston, 1971, pp. 145–177.

Krapp, George Philip. *The English Language in America*. Vol. I. New York: Frederick Ungar Publishing Co., 1925.

McMillan, James B. *Annotated Bibliography of Southern American English*. Miami, FL: University of Miami Press, 1971.

Simmen, Edward. *North of the Rio Grande: The Mexican-American Experience in Short Fiction*. New York: Penguin Books, 1992.

Stockton, Eric. "Poe's Use of Negro Dialect in 'The Gold Bug.'" In J. Williamson and V. Burke, *A Various Language*. New York: Holt, Rinehart and Winston, 1971, pp. 193–214.

Watanabe, Sylvia, and Carol Bruhac. *Home to Stay: Asian American Women's Fiction*. Greenfield Center, NY: The Greenfield Review Press, 1990.

Williamson, Juanita V., and Virginia M. Burke. *A Various Language: Perspectives on American Dialects*. New York: Holt, Rinehart and Winston, 1971.

Roots

The Journey to the West

MARY SCOTT

One of the most beloved characters of the Chinese stage is the Monkey King, whose spectacular leaps and somersaults and irreverent humor have delighted theater audiences for centuries. Some of the finest actors in the traditional theater have specialized in this role, which requires extraordinary comic timing, acrobatic perfection, and a brilliant miming of real monkey behavior. The Monkey King and his friends turn up in children's cartoons and comic books, in advertising, and in ordinary conversation throughout East Asia. They are an enduring part of Chinese and Chinese-diaspora popular culture, part of the fund of shared childhood experience on which many Chinese American writers have drawn. Maxine Hong Kingston's *Tripmaster Monkey: His Fake Book* takes the story of the Monkey King as its starting point, and in the mishaps of its protagonist, Wittman Ah Sing, there are many echoes of the Monkey King's adventures.

All of the modern stage, screen, print, and television versions of the Monkey King's story derive from the late sixteenth-century *Journey to the West,* a hundred-chapter chronicle of a pious monk, his motley animal disciples, and their quest to obtain the Buddhist scriptures. Although most audiences have loved the stories about the befuddled monk and his disciples for their inspired fun and silliness, thoughtful readers of *Journey to the West* have always acknowledged its religious and philosophical dimensions. The book was written at the turn of the seventeenth century, during the high tide of late Ming religious syncretism which believers summed up in the phrase *san jiao gui yi,* "the Three Teachings (Confucianism, Buddhism, and Taoism) are One." Its anonymous author—some believe his name was Wu Cheng'en—was clearly a scholar, trained in Confucian doctrine but also familiar with the ideas and language of Mahayana Buddhism and popular Taoism. From the sixteenth century to the twentieth, readers have tended to find in the text an emphasis on whichever

of the Three Teachings suits them best, while also generally acknowledging at least the corroboratory value of the other two.

The pilgrims' quest for the scriptures is distantly based on the journey of an actual eminent Buddhist monk, Xuanzang, who in the seventh century C.E. made a long, perilous journey from China to India through many now-forgotten Central Asian kingdoms. His goal was to bring back the scriptures of an idealist branch of Mahayana Buddhism that until then had been little known in China.[1] Early accounts of Xuanzang's travels attributed his survival of the journey's terrible hardships to the Mahayana deities' grace. Although subsequent versions of the story were far more playful and fantastic than Xuanzang's own sober account and in fact have very little connection to the historical Xuanzang, at their core is still the idea of a quest for wisdom attainable only through the travails of experience and steadfast reliance on the Mahayana deities. In the popular Chinese tradition, the learned and intrepid Buddhist prelate of the historical accounts is transformed into a naive, timid, and literal-minded young monk whose consistent spiritual ordinariness makes him the perfect Buddhist "Everyman."

Even in the earliest surviving remnants of this group of tales, the pilgrim monk was provided with marvellously powerful animal disciples. Among the disciples, the Monkey King consistently upstages his hapless master to emerge as the real hero. Almost equally prominent is Pig, whose endless conflicts and reconciliations with Monkey are still a feature of this entire group of stories and plays. There is also a magical white horse (a transformed dragon) and a mild-mannered but monstrous-looking creature called the Sand Priest, who wears a necklace of human skulls. All the disciples are immortals who have transgressed against heaven in one way or another and have been sentenced to redeem themselves by helping the monk on his quest.

The opening chapters of *Journey to the West* tell the individual histories of the monk and his disciples and explain how each of them embarked on the pilgrimage. Monkey's history, given first and in greatest detail, defines the concerns of the whole book by emphasizing Monkey's cleverness, his extraordinary powers of self-transformation, and his outrageous egocentrism.

The Monkey is miraculously born from a stone egg and sets himself up as king of the monkeys at the idyllic Flower and Fruit Mountain. Realizing one day that he is mortal, he sets out in search of someone who can teach him the secret of eternal life. He finds a teacher, but although he proves to be an apt student, he is eventually dismissed for making an unseemly display of his unusual powers of mind. After he acquires cloud-stepping shoes and a magical staff that can shrink or expand as he wishes, he returns to the monkey kingdom, arms

the little monkeys, and challenges the ruler of the Taoist heaven, the Jade Emperor himself.

The Jade Emperor is first alarmed, then amused at this upstart who styles himself the "Great Sage, Heaven's Equal." He offers Monkey a position at court: Janitor of the Royal Stables. When Monkey finds out how lowly a job this is, he runs amok in the Jade Heaven, stealing the Peaches of Immortality and eating in one gulp all the immortality medicine that the Taoist sage Laozi has created by alchemical means. Having done this, Monkey is not only ungovernable but indestructible. Even heaven's greatest warriors are helpless: Monkey confuses them by magically becoming frighteningly large or absurdly small, deludes them with multiple illusory versions of himself, or hides from them by transforming himself into something altogether different. After the Jade Emperor has seen several heavenly armies defeated by Monkey, he turns in desperation to Amitabha, the Buddha of the Western Heaven, who takes Monkey in hand and imprisons him for 500 years under the Mountain of the Five Elements.

Monkey's imprisonment under the Mountain of the Five Elements or Five Phases, a name redolent of Taoist lore, speaks of the beginnings of both Buddhist and Taoist wisdom: the human mind must come to terms with its own limits, recognize its assumption of its own omnipotence and immortality as a delusion, and come to understand that it is only a small part of a larger pattern of cosmic flux. Significantly, after Monkey's release from the Mountain of the Five Elements, the compassionate Boddhisattva Guanyin underlines the necessity of perpetual vigilance over the wayward mind by fastening a metal band around Monkey's head, which the monk can tighten with a magic spell whenever Monkey misbehaves.

This summary of *Journey to the West*'s famous opening chapters shows how seamlessly Taoist and Buddhist images are intermingled in the book.[2] Although the Mahayana Buddhist deities generally turn up in moments of narrative crisis, the Taoist imagery of the Five Elements, or Five Phases, is more pervasive at the level of textual detail.[3] The Five Elements—Fire, Water, Earth, Wood, and Metal—are the constituent qualities of the world, which can be arranged in cycles of mutual engendering or mutual destruction. It is a set of terms that can be used to describe the interrelatedness, complex, and nonlinear causality and perpetual changeability of experience. The Five Elements correspond with the four points of the compass plus the center: water in the north, fire in the south, wood in the east, metal in the west, earth in the center. This set of correlations extends to an almost infinite number of other phenomena. Water, for example, is associated with the north, the color black, and the tortoise, among other things.

Five Elements theory was one of the several interlocking classificatory systems used by early Chinese cosmographers to explain what they saw as the complex but ultimately unitary nature of phenomena, and it has continued to be part of the language of many aspects of traditional Chinese life, from calendrical terms to *fengshui* (geomancy) to acupuncture and other medical therapies. Five Elements terminology is still used to describe the harmony or imbalance among the functional systems of the body: what a Western-trained doctor might call a disorder of the respiratory tract, for example, is explained as an excess or insufficiency of the metal element, while a kidney ailment may be described as an imbalance in the water element. Five Elements terminology may also be used metaphorically to refer to aspects of the process of meditative discipline and integration of mind and body known as *qi gong*, "mastery of *qi*," or Taoist internal alchemy. (*See* Chapter 23, "Fengshui, Chinese Medicine and Correlative Thinking.")

Each of the disciples in *Journey to the West* is imaginatively linked to particular aspects of the cycle of the Five Elements: Monkey, with his quick temper and fiery eyes, is associated with fire, while the backsliding, sensual Pig is associated with water, and the Sand Priest with earth. (No one is quite sure about the dragon-horse, who is not terribly important in the story.) Together they undergo 81 tribulations, 81 being the emblematic number of Buddhist wholeness (9 x 9) and the number of steps required for the Taoist alchemical synthesis of mercury (associated with water) and cinnabar (associated with fire).

Many of the pilgrims' tribulations involve their ensnarement by various demons in sympathetic and appealing disguises that only Monkey can see through. In the famous episode of the White-Bone Demon, for example, Pig and the others are tricked by a demon who disguises herself as a beautiful woman. When Monkey pronounces her a demon and proposes smashing her to death, the others—piously invoking the Buddhist prohibition on taking life—drive Monkey away in disgrace, with temporarily disastrous consequences for the pilgrimage. In this episode as in many others, the pilgrims finally resolve their collective predicament through cooperation on the part of Monkey and Pig, for there are some things (venturing into water, for example) that only Pig can do. In other episodes, however, they may be saved from disaster only by the timely intervention of Guanyin, the Boddhisattva of Compassion.

Monkeys, with their tireless agility, their mischievous ingenuity, and their almost human intelligence, are a very old Buddhist image for the restless and ungovernable human mind. The Monkey King's name, Sun Wukong, "Monkey

Aware-of-Emptiness," suggests that a Buddhist understanding of the emptiness *(sunyata)* of phenomena is essential to any reading of *Journey to the West*. In fact, in the opinion of many traditional commentators, the text's combination of lively verisimilitude and ultimate fictionality make *Journey to the West* a means of acquiring that understanding. Monkey himself has a habit (which he shares with many of the demons that haunt the pilgrims' path) of materializing in illusory dual and multiple versions of himself. This is a playful illustration of the Heart Sutra's assertion of the emptiness and nondualism of phenomena, a famously abstract piece of Mahayana Buddhist teaching that *Journey to the West* often quotes. The pilgrims' task—and the task of the pilgrim reader in turn—is to cultivate an intuitive grasp of nondualism through the mindful experience of the illusions of dualism.

Pig's name, *Zhu Bajie*, "Pig the Eight-Preceptor," is a joking reference to the tension between Pig's sensual nature and the Buddhist novice's eight vows of self-restraint. Monkey's constant feuding with Pig—who is given to the gluttony, lust, and sloth of the body—and their sporadic reconciliations for their master's sake thus speak of the difficult necessity of disciplining both mind and body to the pursuit of enlightenment, avoiding the extremes of asceticism and self-indulgence.

The vast bulk of *Journey to the West* is concerned with the perils of the road, which the pilgrims face as a group. Collectively the disciples evoke an ideal harmony and integration of the various aspects of the self—an ideal common to Buddhism, Taoism, and Confucianism, but an ideal that the monk and his disciples only occasionally and briefly achieve. This harmony, not the sutras themselves, constitutes the enlightenment that is the real goal of their quest. Near the end of *Journey to the West,* the pilgrims do obtain the scriptures. Predictably, they turn out to be nothing but blank pieces of paper, though the Buddha in his mercy does eventually provide some written sutras for the consolation of those in China— or anywhere—who have not yet awakened to the understanding that enlightenment is neither attainable nor expressible through words.

Notes

1. For a discussion of the historical Xuanzang, see Arthur Waley, "The Real Tripitaka," in *The Real Tripitaka and Other Pieces*. London and New York: Allen, 1952.

2. For a discussion of Buddhist and Taoist ideas in *Journey to the West*, see Anthony C. Yu's introduction to his translation.

3. For a full discussion of the significance of Five Elements imagery in *Journey to the West*, see A. Plaks, "Allegory in *Hsi-yu chi* and *Hung-lou meng*."

Further Reading

Ch'eng-en, Wu. [Attributed to] Arthur Waley, trans. *Monkey.* New York: Grove Press, 1944. Arthur Waley's partial translation is still worth reading for its liveliness and general accuracy, but its lack of notes obscures the allegorical dimensions of the text.

Dudbridge, Glen. *The Hsi-yu chi: A Study of Antecedents to the Sixteenth-Century Chinese Novel.* Cambridge: Cambridge University Press, 1970. An excellent discussion of the relationship between the sixteenth-century version and earlier texts of *Journey to the West.*

Hsia, C.T. "The Hsi-yu chi." In *The Classic Chinese Novel.* New York: Columbia University Press, 1965. An important and accessible critical discussion of *Journey to the West.*

Plaks, Andrew H. "Allegory in Hsi-yu chi and Hung-lou meng." In Andrew H. Plaks, ed. *Chinese Narrative: Critical and Theoretical Essays.* Princeton, NJ: Princeton University Press, 1977. An important and accessible critical discussion of *Journey to the West.*

———. "Hsi-yu chi: The Transcendence of Emptiness." *The Four Masterworks of the Ming Novel.* Princeton, NJ: Princeton University Press, 1987. An important and accessible critical discussion of *Journey to the West.*

Shuen-fu, Lin, and Larry Shulz, trans. *Tower of Myriad Mirrors.* Berkeley: Asian Humanities Press, 1978. English translation of a fascinating seventeenth-century work of philosophical fiction, a kind of sequel to *Journey to the West,* in which the Monkey King is the leading character.

Waley, Arthur. *The Real Tripitaka and Other Pieces.* New York and London: Allen, 1952. Good introduction to the historical Xuanzang.

Wang, Jing. *The Story of Stone.* Durham, NC: Duke University Press, 1992. A very interesting examination of Chinese stone lore that includes some discussion of *Journey to the West.*

Yu, Anthony, trans. *Journey to the West, Vol. 1–4.* Chicago: University of Chicago Press, 1977–1983. An outstanding, completely annotated English translation of *Journey to the West,* with a lengthy, scholarly introduction by the translator.

Yu, Anthony. "Liu I-ming on How to Read the Hsi-yu chi *(Journey to the West).*" David Rolston, ed. *How to Read the Chinese Novel.* Cambridge: Cambridge University Press, 1970. A translation and discussion of an illuminating later eighteenth-century critical preface to *Journey to the West.*

Roots

Japanese Haiku and Matsuo Basho

GEORGE J. LEONARD

Furuike ya
Kawazu tobikomo
Mizo no oto.

Old pond
Frog jumps in
Water-sound.
　　　　—Basho

Classical Japanese literature's most famous gift to the West, and to American literature in particular, has been an unlikely one for our democracy to embrace, the poetic form—austere even by Japanese standards—called "haiku." A haiku (the word is both singular and plural) is a poem only 17 syllables long, written in three lines of five, seven, and five syllables.

The name is pronounced *ha-i-ku,* in three syllables, because in Japanese there are no diphthongs; but English speakers normally say it in two syllables, "hai-ku." Any other pronunciation would be, by now, pedantic. Donald Keene, in his definitive account of Japanese poetry, resolutely uses the word *haikai.* Keene argues, no doubt rightly, that the "word and the concept" of haiku, the idea that the three lines stood by themselves as a separate poem, dated only from the late 1800s. Be that as it may, Western culture has already embraced the word "haiku," and we will not use the right word anymore than we will correctly call Rome, "Roma." During the 1960s, Harold G. Henderson's excellent translations of haiku became a kind of beatnik/hippie bible, resting on the living room table next to the copy of Hesse's *Siddhartha* and the water pipe. Since the turn of the century, moreover, poetry called haiku had inspired Western poets, first in France, and then among

the important poets affiliated with Ezra Pound. Pound's famous attempt at a haiku equivalent is one of his best poems. He captures a scene on London's Underground (subway):

> *Faces in the crowd*
> *Petals on a wet, black bough.*

The example of haiku (among other forms) licensed Pound, Amy Lowell, and certain other "Imagist" poets to write the kind of poetry they longed to write anyway. They knew little of Japan; few Westerners did, at the time; and much of what they "knew" was "orientalist" fantasy. Perhaps they didn't even care. They were using haiku's example to excuse themselves from the tyranny of English rhyme and to destroy the traditional English esteem for poetry that was—like so much English poetry, from Ben Jonson to Tennyson—a versification of arguments. In its place they elevated the idea (perhaps the mistaken idea) of an Asian lyric poetry that communicated by images alone. "No ideas but in things." Haiku's frequent obscurity and suggestiveness also helped Pound and company create the twentieth-century poetic convention that a poem need not be understandable on the first reading—or even the fifty-first. Poets as distant from Pound as Wallace Stevens have taken advantage of that once-controversial permission.

Asian American artists have been justifiably proud of haiku's prestige in the West. For instance, Hisaye Yamamoto's short story collection, *Seventeen Syllables,* which Jeffery Chan considers the finest by a Japanese American so far, takes its name from haiku, the art of creating a poem in 17 syllables.

The Evolution of the Haiku Form

Why base a poetic form on syllable count, rather than on rhyme, as so much of Western poetry does? All Japanese words end either in a vowel or an "n" which makes rhyming too easy. It's almost as easy, in Japanese, to rhyme as not to rhyme. The history of Japanese poetry—at least the history that leads to the invention of the haiku—shows a growing fascination with the beauty of concision, of understatement, and with the power of suggestion. As far back as the Heian era (794–1191) a 31-syllable form (called "tanka" and also "waka") was being written among the idling nobles at court, often answered by a similar poem. These linked verses— up to 100 verses long—were called "renga." We are told that they were sometimes written by courtier poets sitting together almost like jazz artists, listening

to each other's poems and, on the spot, answering riffs, altering and extending the themes. (A great theme for an on-line chat room?) The themes were typical of court poets in all cultures: ennui and dalliance, the brevity of love, youth, life, conveyed in ritualized melancholic allusions to fading blossoms, vanished summers, and such.

This friendly but competitive atmosphere led to a gradual tightening of the rules-of-play and a growing sense of seriousness. Teitoku (1571–1653), though his work stayed on the level, Keene tells us, of "witticisms," was the dominating poet of his age, and his seriousness about his *haikai* lent the genre his prestige. Soin (1605–1682) and Saikaku (1642–1693) are credited with keeping the 31-syllable tanka form's colloquial language and wit, but investing the genre with a new seriousness. They developed certain tactics that classic haiku would later employ: a fondness for images rather than for explanations, and for jumpcuts between those images that cause interesting and suggestive clashes. The poems work, at their best, the way film works, by a rapid montage of images that generate a meaning of their own.

By Soin's time, the 1600s, the 31-syllable tanka had, for several hundred years, begun with a three-line starting verse, using the first 17 syllables. The Japanese for "starting verse" is *hokku*. Gradually, that starting verse became the whole poem, called "haiku" (and as we have noted, in scrupulous texts, *haikai*).

Interest in upping the ante and showing you could do in 17 syllables what some other courtly poet needed 31 to do, dates back at least to the mid 1200s. These early haiku examples are very primitive—almost like greeting card verses. The poets are still essentially courtly wits. You can usually paraphrase what these early haiku mean in ordinary prose—a bad sign.

Soin's new artistic school ended that. In 1660, the same year as the English Restoration, Soin founded the "Damrin school," and haiku rose toward high art while it simultaneously became intimately connected with the Zen Buddhist vision. (For a full discussion of Zen, see Chapter 37.) No one disputes Soin's historical importance. However, all authorities agree that Soin's student, Matsuo Basho (1644–1694) is the genius who perfects haiku.

Matsuo Basho

To understand Basho's relationship to all subsequent haiku, one has to think of Shakespeare's relationship to all subsequent English poetry. I could stretch the

parallel and claim Soin as Basho's Christopher Marlowe, a great innovator who sows many of the seeds Shakespeare will harvest. Marlowe began writing verse dramas in English iambic pentameter—"Marlowe's mighty line"—lifting the form to high art. Shakespeare, his younger contemporary, perfects English iambic pentameter and the drama based on it.

Indeed, as the critic Harold Bloom has pointed out, Shakespeare, in a way, succeeds too well. Who, after all, would want to write a verse drama now? Shakespeare so fully exploited the form's possibilities that his followers have been reduced to imitation, veneration, or flight. Similarly, Basho not only perfected haiku, he put such a strong stamp on it that to this day haiku poets cannot escape him. The difference is that English verse drama was virtually given up within a century of Shakespeare's death, but haiku continues to thrive in Japan.

The poem quoted at the beginning of this article is Basho's masterpiece and still his most famous. (Japanese grammar is so different from English that my translation is merely one of a hundred possible.) It was published in 1686, when Basho was already 42 years old, well known, and surrounded by disciples. The child of minor samurai (the knightly or warrior class), he had rebelled against his parents, traveled restlessly around Japan enduring spiritual trials—sometimes sampling the fleshly pleasures of the geisha's "floating world"—and writing poetry. In 1675 he was well enough known for the great Soin to invite him, among others, to compose renga, the linked form. Basho was deeply honored and adopted a new pen name to signal his transformation. He becomes, for a time, almost too respectful a disciple, writing Soin-like verses. But his personal spiritual crises returned: in his poems black crows descend on him, his "guts freeze," he weeps through the black night. His spiritual trials, so familiar to Western poets and their readers since the Romantics, made his poetry feel accessible to American poetry readers later.

At last, Basho sought solace in Zen meditation. After the "Zen boom" of the beatnik fifties, that solution was familiar to American poetry audiences too. After several years of sitting in meditation, trying to erase his personality, to simply *be* and *see* the scene in front of him, Basho escaped the torments of his middle years and entered a calm visionary place he never left. Haiku becomes, in his hands, a door through which others reach his contemplative visions, achieve his sensation of ultimate reality in even the most commonplace things. Harold Henderson, in an incisive passage, summed up how Zen perfected Basho's character and his poetry. After Zen his poems showed a "great zest for life; a desire to use every instant to the uttermost; an appreciation of this even in natural objects; a feeling that nothing is alone, nothing unimportant; a wide sympathy; and an acute awareness of relationships of all kinds, including that of one sense to another."

Figure 35-1: Teahouse and lake, Katsura Imperial Villa, Kyoto, Japan. Early 1600s. Basho and his disciples were reclining in such a pavillion when a frog leaped into the lake, leading Basho to compose his most famous haiku. Photo by George J. Leonard.

Comparisons with Wordsworth and other "natural Supernaturalists" are frequent, and valid, but considering Basho's poems' sheer intensity, comparisons with Van Gogh would be better. Van Gogh does not paint scenes; he paints his *experiences* of scenes. Millet paints a Starry Night and we know how it *looked*. Van Gogh paints a Starry Night, and we know how it *felt* to be Van Gogh, standing there in holy awe. The painting is still of stars, not of angels; but the stars seem to pinwheel with the joy of sheer being, while beneath them, cypresses twist and burn in the ecstasy of being alive. In Van Gogh's paintings, ordinary trees and fields take on a holiness and awesomeness, without his having to add supernatural elements. In Basho's work, too.

Such moments have been called, since James Joyce, "epiphanies," moments when the holiness shines through commonplace things. The more commonplace, the better—we need help with those the most. There is no way to write a prose paraphrase of the Basho poem quoted above. How to explain the mystical quality that centuries of readers have agreed Basho successfully gives that moment? Even in translation, much comes across:

Old pond
Frog jumps in
Water-sound.

A disciple has left us a memory of the instant the poem was written. Basho was deep in meditation, sitting in a covered area outside his riverside house, listening to the silence, to some pigeons cooing faintly, to a gentle misting rain. Now and then came the sound of a frog leaping into the water. Basho suddenly recited the last two lines. But he had no opening line. A disciple then suggested a showy opening line, something about all this happening in the midst of yellow roses. Basho quietly refused, and added "Old pond." Some translations try to explain the poem ("Breaking an old pond's holy silence," and so forth) but Basho's simplicity needs no help.

One critic uncovered some of Basho's concealed craft by remarking that much of the effect would vanish if Basho had just written

Pond
Frog jumps in
Water-sound.

Basho's slight but significant addition to the visual and auditory facts—"*old pond*"—wafts just enough feeling of age and peace over the scene to make it work. Yet, I must insist that, as with Van Gogh's paintings, if we really knew how he did it, we could do it too. We don't and we can't.

Basho's ability to create this effect in only 17 syllables gives his haiku a power that Western aesthetics has long recognized. That which strikes in an instant has more force than that which takes two hours to produce its effects. Thus Western historical painting argued its superiority, since Horace's time, to works written down on paper. Basho's poems work on us as rapidly as a painting, and they strike as hard. They are not little, they're brief, and that is power. Hemingway (writing in praise of his own understated art) said that "the dignity of an iceberg lies in its being nine-tenths beneath the water." You sense, in Basho's poems, that you have glimpsed only the tip of a stately vastness beneath.

Basho was master of another form as well. In "travel diaries" like *Oku no Hosomichi (The Narrow Road to the Deep North),* he wrote introspective prose which rises, when it needs to—like an opera rising from recitative to an emotional aria—into lyrical haiku. These are no mere travel diaries, of course. As Henderson points out, the ambiguous title could almost be translated, "the difficult path to the interior"—of the self? of Japan? of being? Basho's art is an art of infinite suggestion.

Haiku After Basho

After Basho, the form does not lack for great names, but this is a book to be used as background by the West, not a study of Japanese poetry in itself; and for the West, Basho has, historically, been haiku itself. The interested reader certainly should go on to read Onitsura (1660–1738) who studied with Soin's school. He is sometimes as visionary as Basho. Onitsura once said, "Outside of truth there is no poetry." The melancholy, gentle Issa (1762–1826) reminds one of the French painter Watteau, and like him, works on the edge of sentiment. At times he goes over the edge into sentimentality. Buson (1715–1783) is a great craftsman, but he is as different from Basho as the worldly Parisians Manet and Degas are from the devout Van Gogh. Buson's sophisticated poems about prostitutes, for instance, are the work of a *boulevardier,* as are Manet's wry paintings of cafe life. Shiki (1867–1902) who lived during the frantic attempt to Westernize Japan, writes as religiously as Basho does, but militantly rejects Buddha ("I'll have no gods or Buddhas!"). He wants to kick the priests and clerics out and show people they can see the world as a miracle without buying into a lot of theological bureaucracy. Like the similarly militant atheist Percy Shelley, he even writes a poem about a skylark. Like Monet, he embraces the new industrial world, and tries to include not only nature in his poems, but the beauty of railroads and modern industrial objects.

For all that, none ever equals Matsuo Basho. As with Shakespeare's case, no one is expected to.

Further Reading

Basho, Matsuo. *The Narrow Road to the Deep North, and Other Travel Sketches.* Trans. by Nobuyuki, Yuasa. New York: Penguin, 1966.

Henderson, Harold G. *An Introduction to Haiku.* Garden City, NY: Doubleday, 1958. Popular, unsurpassedly lyrical translations, by Donald Keene's predecessor at Columbia. The best and most familiar English versions of the most famous haiku.

Keene, Donald. *World Within Walls: Japanese Literature of the Pre-Modern Era, 1600–1867.* New York: Holt, Rinehart and Winston, 1976. The definitive work (600 pages) by Columbia University's master scholar and translator. Nearly 300 pages on haiku and its related forms alone.

The Beginnings of Chinese Literature in America

The Angel Island Poems: Two poems by Xu of Xiangshan

SIMEI LEONARD AND GEORGE J. LEONARD

You've seen Angel Island. It appears in the middle of every postcard of the San Francisco Bay, to the side of Alcatraz, another beautiful green hill in the middle of the blue. The early San Franciscans were fond of using their most beautiful real estate as prisons and detention centers.

Angel Island was *not* the "Ellis Island of the West," though there were intentional similarities of design. When it opened in 1910 immigration from China had been illegal for years. Nonetheless, between 1910 and 1940, when Angel Island closed, nearly 150,000 enterprising Chinese managed to find provisions in the law which allowed them to enter the country through Angel Island. That number does not include those detained on the island who were ultimately turned away, on many grounds.

Angel Island became the scene of complicated games of strategy that lasted sometimes more than a year, as **paper sons** claiming to be relatives of American Chinese dueled with immigration officials. The paper sons were armed with coaching papers; the government officials armed with books of clever questions. We are told that the Chinese kitchen staff smuggled information through to the candidates from supporters on shore.

Reading the questions asked will bring a shock of recognition to anyone who marries a foreign national today, for many are still asked. In today's brief, benign version you are asked which side of the bed each of you sleep on, and whether you wear pajamas and what kind. (Precisely the details the coaching papers once provided the paper sons about their paper in-laws.) At one point in our first hearing, my wife was made so nervous by the questions I patted her arm. The agent asked sharply, "Is that a code?" We were astonished, realizing he meant Two Pats: Say yes / One Pat: Say no, or something of the kind.

The Angel Island poems run the gamut from doggerel complaints about being checked for hookworm, and dreams of revenge, to learned ruminations on life's disappointments, filled with allusions to classic literature, like school themes. Although the men were primarily laborers, they were not unlettered. Almost all the poems are anonymous. Two that stand out are signed with the same name, one Xu of Xiangshan, or even Mr. Xu Xiangshan. The name can be translated different ways.

Xiangshan is a famous suburb of Beijing, but the name, Fragrant Hill or Mountain, is not confined to that place. If Xu was from the capital, however, it might explain his breaking with the anonymity of the other poems and proudly signing his work. Ninety-five percent of American Chinese are from the six counties outside Canton and speak Cantonese. As a Mandarin-speaking northerner, Xu would have stood out, or been held out, to begin with. There is no way to know, since Cantonese and Beijingese alike use the same characters, though they speak different languages.

My wife, reading the Angel Island poems with me, was moved by Xu's, and remembered her own first emotions coming here. Xu had really caught the mood, she felt. They recalled to her the nightmare she had, her first night in America. There was a horse and a wagon and she jumped on the wagon as the horse started to run away with it. The horse ran, and she held on for dear life. She was here now. There was no going back. You had to hang on, had to fight like hell just to hang on.

In his first poem, the "Flower Flag" was a familiar term for the American flag. Almost all Chinese terms for America were positive. The word for America, *Meiguo,* means The Beautiful Land, and the Cantonese slang term for us, *Gum Shan,* **Gold Mountain**, is no less hopeful.

We've chosen Xu to translate because of his merit, but also because he wrote a poem about the poems themselves, covering the walls of the Island.[1]

One

Just talking about the Flower Flag,
Happiness comes over his face
Give him a thousand liang of gold, you can't stop him.
The relatives left behind.
So much to say but the throat knotted up first.
His Wife. The goodbyes. All the feelings. The tears, face to face.

Waves: big as mountains, scaring away the stranger
Laws: vicious as tigers, waiting to taste the animal
Don't forget this day when you step on the land.
Hurl yourself into work. Fight for your future. Never slacken.

Two

On the wall, poems, more than a hundred.
Looks like all are one long sigh.
Worried people to worried people complain
The stranger with the stranger sympathizes.
Get, lose: how do you know it's not your fate?
Rich, poor: who can say it's not because of Heaven?
Now we're stuck here. Why must you complain?
It's always been this way: Heroes must face difficulties first.

Note

1. Translated by Simei Leonard and George J. Leonard. We translated from the Chinese versions of Xu's poems. Our first poem is *Island's* #1, on page 43; our second is #27 on page 63. Chinese differs so greatly from English that translations that vary greatly may all be plausible. Ours tries to emulate the concision of the original text.

Further Reading

Lai, Him Mark, Genny Lim, and Judy Yung. *Island: Poetry and History of Chinese Immigrants on Angel Island, 1910–1940*. Seattle and London: University of Washington Press, 1993, reprint of 1980. The definitive book, *Island* provides a detailed scholarly history, with the Chinese texts of the poems, facing translations.

D. T. Suzuki and the Creation of Japanese American Zen

GEORGE J. LEONARD

No part of Japanese culture has impressed and affected American literature, art, and even, for many Americans, their daily spiritual practice, as much as the Japanese Buddhist sect called "Zen." Zen, the philosopher Arthur Danto was marveling by 1972, "has become a household word."

To this day, what the West considers Zen has come to it primarily through Zen's famous apostle to the West, D. T. Suzuki. Suzuki's lecture series at Columbia University in the early 1950s led to the conversion of the ultra-influential avant-garde composer/philosopher John Cage and of Cage's student Allan Kaprow (father of the "Happenings") and triggered Zen's triumphant sweep through the 1950s art world, a phenomenon now remembered as the "Zen Boom." Other Suzuki-inspired Columbians like Allen Ginsburg and Jack Kerouac took Zen west to San Francisco, ushering in the glory days of Beatnik Zen. By the 1960s students and intellectuals all over America were seeking *satori,* enlightenment, like Kerouac's romantic Dharma Bums. In significant ways the phenomenon parallels American's fascination, since the late 1980s, with the Confucian family system. This article complements Chapter 5 on that philosophy. I'll return to this point at the end.

Yet this book's discussion of Suzuki's Zen appears here, with the Japanese American writers, rather than in the section on Asian culture. By the 1970s, American religious scholars had become aware—and at first, painfully aware—that what the West considers "Zen" was, to an unsuspected degree, D. T. Suzuki's own poetic creation. Back in Japan he hadn't been a Zen master. He hadn't even been a Zen monk. He had been a high school English teacher. Suzuki reached his own enlightenment not in Japan, but riding his bicycle through the fields outside Chicago.

His particular love, as he wrote later, was American literature. In the sixties, when the new American Zen converts returned to Japan for serious study,

they were scandalized to realize that it was only after he was in Chicago, far from Japan, that the young English teacher, having become not only the first but the sole Zen Buddhist living in America, became Zen's apostle to the gentiles.

In short, D. T. Suzuki's story is a classic American immigrant success story. The colonial gentry of Massachusetts and Virginia hadn't been such nabobs back in the Old Country either. Real nabobs don't have to come to America. They are, after all, doing fine where they are. Suzuki's Zen is the brilliant spiritual creation of a young genius making the most of the New World's opportunity.

His Zen is a Japanese American creation, and like other Japanese American cultural creations—see Chapter 25—it melds the best from the old culture and the new. Suzuki arrived in America at 27, and when he left, at 38, his most creative period was over, and his personality, philosophy, and mission had formed. He returned periodically and had his greatest success here in old age. His philosophy, with its conscious and candid debts to Emerson's transcendentalism, to Thoreau's cult of simplicity, to John Dewey's pragmatism (he probably attended Dewey's University of Chicago lectures and certainly helped edit and publish several of them) is a classic American hybrid.

But it is not just a matter of place: Suzuki's Zen is Japanese American the way Van Gogh's art is French, not Dutch. It is for that reason that Suzuki's greatest convert, John Cage, later wrote with amazement that he had found all the best parts of it in Thoreau. No miracle: not a few of those ideas had *started out* in Thoreau, whom Suzuki admired in college. Suzuki's detractors now imply that Suzuki merely hung some Japanese lanterns on Emerson and Thoreau and handed them back to Americans, suffused with a picturesque "oriental" glow. He is called a "popularizer." But Suzuki's "satori Zen," the Zen of John Cage's avant garde piece 4'33" and of the beatniks and the hippies, is as valid a religious creation as the Christianity created by St. Paul, who never met Christ and who began his career leading a persecution of the Christians. Suzuki, we shall see, carefully studied Paul's radical daring, how Paul accepted his role as apostle to the gentiles. Fashion a Christianity that would "lay no stumbling blocks" before the new converts, that was Paul's task. Suzuki worked to fashion a Zen for Americans. The spiritual vehicle he created has become so important it "suffused," in Martin Marty's phrase, mainstream American religions, turning them from their historic obsession with sin and punishment to a devout contemplation of the natural world that sometimes, to the alarm of the Vatican, seems indifferent to the existence of a God or an afterlife. Perhaps a majority of college-educated Americans have, by now—however unwittingly—made some part of Zen a part of their own pluralistic, nontheistic, ecologically oriented spirituality.

The Un-Making of a Master

By the 1950s, D.T. Suzuki's stature in the Western religious world was second to none. Historian Lynn White, Jr., would write of Suzuki's *Essays in Zen Buddhism, First Series,* that their publication in 1927 "may well seem to future generations as great an intellectual event as William of Moerbeke's Latin translations of Aristotle in the thirteenth century or Marsiglio Ficino of Plato in the fifteenth. But in Suzuki's case the shell of the Occident has been broken through." Carl Jung wrote a foreword to Suzuki's *Introduction to Zen Buddhism,* Erich Fromm organized a workshop with him, later published as *Zen Buddhism and Psychoanalysis.* When the prestigious journal *Philosophy East and West* was founded, the first number contained two articles on Suzukian Zen, the second and third, articles by Suzuki. Catholic theologian Thomas Merton wrote, in a typical passage, that "though less universally known than Einstein and Gandhi," Suzuki was "no less remarkable," a man who embodied "all the indefinable qualities" of the Asian religious tradition's "'Superior Man' the 'True Man of No Title' . . . and of course this is the man one really wants to meet. Who else is there?" Meeting Suzuki was "like arriving at one's home." Christmas Humphreys, the ubiquitous president of the Buddhist Society, London, summed up the contemporary attitude toward Suzuki in a preface added to each Rider volume of his work: "To those unable to sit at the feet of the Master his writings must be a substitute." Suzuki's prominence in the art world is unchanged to this day.

Not so in the American Buddhist community. By 1985, when his disciple Masao Abe edited a *festschrift* (a collection of articles in honor of a scholar, written by his students) for Suzuki, he had to defend him against charges he conceded were "to an extent . . . undeniably correct." Many Americans converted during the Suzuki-inspired "Zen boom" of the late 1950s had by then managed to study in Japan. They had discovered how different Japanese Zen actually was from what Suzuki had said. (Alan Watts predicted their disillusionment, in his 1959 essay, "Beat Zen, Square Zen and Zen.") First the Americans discovered, Abe acknowledged, that Suzuki had presented only the Rinzai sect of Zen, "neglecting the important stream of Soto Zen."

Most startling, however, for those brought up in the "sit at the feet of the Master" adulation that surrounded Suzuki (through no fault of his own) was the realization that "the Master" was, in fact, *not* a Zen Master, not a *roshi.* When he was sent to Chicago in 1897 by a genuine Zen master, Soyen Shaku, Suzuki was not even a Zen monk. He was Soyen's translator. Soyen got him a job in Chicago translating for Dr. Paul Carus' Open Court Publishing. Back in Japan, young Suzuki had been an English teacher.

Suzuki, it need hardly be said, never misrepresented himself to anyone. Yet the adulation surrounding Suzuki had been uncontrollable and uncontrolled, and the reaction came. Today, the researcher trying to discuss Suzuki with American Buddhist scholars encounters a lot of embarrassed silences, like a sophomore asking his professor what the art world thinks about Andrew Wyeth.

At the same time no one denies that Suzuki's "satori Zen," the Zen of John Cage's 4'33", has been enormously important to American spiritual life. As Martin Marty and many others have pointed out, by the 1990s one might *think* one was a Catholic or a Presbyterian—yet actually be doing something more like Zen, right there in the church. In 1990, for instance, the Episcopal Bishop of San Francisco led congregations on Earth Day's twentieth anniversary to link hands and chant "Om!" Indeed, one might even think one was a Baptist who believes in biblical inerrancy—yet piously celebrate Earth Day, an idea of humanity's relation to nature that has nothing to do with a sense of this world as "fallen," or a giant snare of sin. One might think oneself a Catholic—yet now believe in a sanctity of the body nothing in St. Augustine allows. So the Vatican feared when it issued, in 1989, a 23-page document approved by John Paul II warning hip American Catholics that their fascination with Zen and yoga wasn't harmless, that it could "degenerate into a cult of the body" and lead to "moral deviation" and "mental schizophrenia." When the nuns at St. Catherine's School in Martinez, California taught my future students to write contemplative Zen haiku back in the fourth grade, they were leading them far astray from St. Augustine's picture of this world as a "vale of tears," no more than a giant college entrance exam for Heaven—and a painful one.

But now we see the scope of the problem: when the Pope warns Americans against what he calls "Zen," we now know he is really speaking of D. T. Suzuki's Zen. Quite an achievement for a writer—the creation of a successful new religion! The temple-going Zen religious sects which have grown up in the last 20 years, more faithful to the East Asian tradition, really *are* Zen, and so they matter to ten or twenty thousand American devout. On the other hand, some version of the bastard, compromising spiritual philosophy that Suzuki fathered may already, by suffusion, be the spiritual life of a *majority* of educated Americans. Nevertheless, even perceptive writers on American Zen like Harvey Cox and Helen Tworkov, and the adherents of more conservative Zen traditions (such as Shunryu Suzuki's) continue to write as if Daisetz Suzuki had made some kind of error.

Americanists will recognize a more complex reality. American culture is perpetually a story of ethnic encounters, a fascinating drama of creative

misreadings, religious improvisations, and cultural cross-fertilizations. Suzuki's personal drama gives us the only-in-America spectacle of a Japanese Buddhist and a German theologian designing a new World Religion in a small Illinois town. "I'm amazed," Suzuki's student Cage later wrote, "that in reading Thoreau I discover just what I've been saying in my books all along." In later life Cage seemed genuinely surprised to discover what he considered "Eastern" thought in an American transcendentalist—what he called "all of those ideas from the Orient there" Cage's explanation was that Thoreau "actually got them, as I did, from the Orient."

But in Cage's case, the "Orient" he got the ideas from was Dr. Suzuki, primarily. (Cage confirmed this many times and again to me when I was writing this.) What if Suzuki got them from Emerson and Thoreau? After all, Suzuki once wrote, "I am now beginning to understand the meaning of the deep impressions made upon me while reading Emerson in my college days." Does he mean in Japan or at the University of Chicago? Letters still on file at Open Court, his first employer, show Suzuki in the late 1890s investigating University of Chicago courses, considering John Dewey's, studying at the Newberry Library. Reading Emerson, Suzuki said he was actually "digging down into the recesses of my own thought That was the reason why I had felt so familiar with him—I was indeed, making acquaintance with myself then. The same can be said of Thoreau."

A frank discussion of Daisetz Suzuki's brilliance and audacity will help us understand why his Zen was so accessible to Cage and to the West. If we now know that Suzuki's wasn't "good" Zen, all is not lost; in fact, everything is gained. Here the spirit of Harold Bloom's work is also helpful. Rather than write off Suzuki as a "subjective" popularizer, making "unscholarly" mistakes, a contemporary literary critic immediately wonders if he has encountered a "strong" poet creatively misreading some text to breathe new life in it. Suzuki's Zen, "satori Zen," is no "blasphemy" but a splendid religious creation, not a corrupt variant of Eastern Buddhism. Suzuki's first published essay, the year before he began his 11-year residence in Illinois, was "On Emerson."

Since we've mentioned Emerson, consider, for a start, that Suzuki writes, "Zen is the religion of *jiyu (tsu-yu)*," and translates that as "self-reliance." Zen the religion of self-reliance?—how Emersonian, how accessible. But the usual translation of *tsu-yu* is "freedom." "Freedom" certainly implies self-possession or self-reliance so the translation isn't exactly a fib—but it's a stretch. By translating *tsu-yu* as "self-reliance," Suzuki casts over Zen a friendly Emersonian glow. It's a rhetorical technique worthy of Emerson himself.

From Meiji Japan to Chicago Zen

Teitaro Suzuki, later given the honorific name "Daisetz" ("great simplicity") by his teacher Soyen Shaku, was a young man from a good but impoverished family— his father died when he was 6—who had taught himself English from books. Born in 1870, he died in 1966. Though one mentally associates him with the "Beat" generation, he was 10 when Thomas Carlyle died, and near 30 when Queen Victoria died. His famous lectures at Columbia (1951–1957) concluded when he was 87 years old. Getting that right matters, because Suzuki's life effort was typical of his Japanese generation. He was born only two years after the Meiji Restoration abruptly ended Japan's 250 years of paralyzingly successful seclusion—with effects, Arthur Koestler once commented, "as explosive as if the windows of a pressurized [airplane] cabin had been broken." In the space of a decade, the Japanese were thrust out of the feudal Middle Ages into the late Industrial Revolution, scrambling to catch up after the centuries they had lost. There was no time to reinvent what the West knew; it was quicker to capture it and import it. To become a scholar of American language and culture was to become no pedant but a hunter on Japan's great safari into the West, an exciting expedition that drew many of the most adventurous talents.

Suzuki's lifelong mental effort is typical of the Meiji. His generation combed the West's culture for social customs to replace those of the vanished feudal caste system. When Suzuki's religious bent showed itself, he naturally carried on that search into the sphere of religion. His good fortune was to meet, in Chicago, a small group of Western thinkers who, in the wake of Darwin's and Lyell's shock to Western religious culture, were wandering through as new and confusing a mental landscape as the Meiji Japanese were. They had trekked into Eastern spiritual culture hunting for new solutions as eagerly as the Meiji Japanese were hunting through Western material culture and political culture.

For a while Suzuki survived as a primary school teacher, taking nondegree courses whenever he could at Tokyo's Imperial University. He never earned a college degree. His doctorate came *honoris causa* at the age of 63. His family, like most good families of the abolished samurai (knightly) class, had belonged to the Rinzai Zen sect, as a matter of course. Suzuki, like many laymen, took advantage of Abbot Kosen's reforms to attend Zen lectures, then lived at the monastery as a lay brother. Kosen, Helen Tworkov writes, was a radical Zen protestant, who had made the "heretical move" of opening the bureaucratized Rinzai sect's temples to sincere lay pupils, trying to turn interest away from the letter of the law back to the "spirit of Zen." Suzuki, the young English student, was one of those laymen.

When Kosen's successor, Soyen, helped him find a position in Chicago, Suzuki had not even been, as it were, ordained. Suzuki's "lack of pedigree," Tworkov says politely, made him a "perfect first emissary to the United States, itself a product of disrupted lineages."

The speech so impressed Dr. Paul Carus, editor of Open Court Publishing, that he invited Soyen to spend a week at his home in the nearby Illinois town of La Salle. Their conversations led Dr. Carus to compile *The Gospel of Buddha,* which Suzuki remembered led to his coming to America at Carus' request, to be a translator. Unpublished letters, however, show Suzuki, after translating the *Gospel,* asking Carus if he could come to Illinois to learn from him. Soyen writes Dr. Carus on his behalf: "[Suzuki] tells me that he has been so greatly inspired" by Carus' books, "that he earnestly desires to go abroad and to study under your personal guidance" (15 January 1896). Suzuki writes Carus that his new booklet on religion is "your philosophy plus Buddhism plus my own opinions. The amalgamation of the three will become the initial feature of my book" (14 May 1896). What Carus could teach Suzuki wasn't Zen, obviously. What Suzuki wanted to learn, and did learn, was the unusual *methodology* he saw Paul Carus use in *The Gospel of Buddha* (discussed below). Soyen promised Carus that Suzuki was "an honest and diligent Buddhist, though he is not thoroughly versed in Buddhistic literature, yet I hope he will be able to assist you."

So Suzuki, 26 years old, despite four years of Zen study, was no master, no monk—indeed he still had not even achieved satori, enlightenment. The dedicated new Zen practitioners of the 1980s knew it was no mere technicality to learn Suzuki was not a true master, a roshi, and had received no "direct dharma transmission" from an established master—particularly once his Zen was discovered to be so odd. For good doctrinal reasons, one can no more ordain oneself a Zen master than one can elect oneself Pope.

Zen deals with an experience that *can be known,* but *not* through words. Since one cannot "get it" from words, or from books, one must get it through various *practices,* supervised, logically enough, by a master. He alone—and in Japan it was always "he"—will certify when one has gotten it. But the only way to know that he *himself* has gotten it, and is therefore qualified to tell his student likewise, is if a qualified master told *him* so. Therefore, somewhat the way the special authority of the latest pope depends on the authenticity of the line all the way back to Peter, lineage matters philosophically to Zen. Hands must be laid on. Verses traditionally attributed to the circle of Bodhidharma, the mythic Indian missionary who in the sixth century A.D. became China's first Zen patriarch, underscored transmission's centrality:

A special transmission outside the scripture
No dependency on words and letters,
Pointing directly to the mind of men,
Seeing into one's nature and attaining Buddhahood.

Helen Tworkov notes that Bodhidharma's dispensing with the scriptures was as presumptuously "heretical" as it sounds. It was instantly attacked. The Roman Catholic Church bases its special claim for the pope on the special transmissions to Peter. Bodhidharma's sect was advancing a parallel claim to a "special transmission" from the historical Buddha himself to the disciple Mahakasyapa. A thousand years before, Mahakasyapa alone had understood Gautama Shakyamuni Buddha's "flower sermon," in which, unwilling to speak the ineffable, the Buddha simply held up a "golden colored lotus flower" for the disciples to contemplate. Only Mahakasyapa did not violate this wordless sermon with feeble words. He simply smiled, and the Buddha noticed.

Suzuki, in his later writings, tried to dismiss Bodhidharma as little more historical than many early Christian saints, and this document in particular as a late forgery. "There must have been some necessity to invent a legend for the authorization of Zen Buddhism" The tradition, however, leaves no doubt that the concept of "transmission" was woven into Zen's core; and Suzuki never received it.

Suzuki's decision to leave Japan for Chicago caused an emotional and intellectual "crisis," Suzuki later recalled, which pushed him to "extremity" in the final seven-day *sesshin,* meditation retreat, he attended before leaving. On the fifth day he had what he termed the "first glimpse of satori," *kensho,* "Seeing into the Self-nature"

Suzuki went to America. For the next 11 years he lived with Dr. Carus in La Salle, paying for his room and board by doing everything that needed doing at a small press which published not only books, but two important learned journals: translating, editing, typesetting, taking photographs; and, in his capacity as boarder, even cooking and running errands. Riding his bicycle through the fields, reading in the countryside south of Chicago, Suzuki at last had the transfiguring spiritual experience that had eluded him for years and on which he would found his theology. In Illinois, he records, meditating on the Zen phrase "the elbow does not bend outwards," he finally reached satori.

Suzuki, 27 years old, who had had little college, who was not even "thoroughly versed" in Buddhism, found himself thrown into a den of ferociously erudite nineteenth-century German religious scholars, heirs to the Higher Criticism

in general and the famous Tübingen School in particular. A Tübingen Ph.D., Carus was 18 years older than Suzuki and, when they met, had written half of the 1,500 titles his bibliography finally contained. (Not a typo: fifteen hundred titles!) Carus had married the daughter of his friend, philanthropist Edward Hegeler, a German zinc millionaire financing a scholarly publishing house devoted to the reconciliation of religion with modern (Darwinian) science. In their two learned journals, Carus regularly published articles by the world's most famous philosophers—John Dewey, Bertrand Russell, Charles Peirce. The press, which always lost money, published inexpensive editions of philosophic classics and new work by Boole, Binet, and other internationally prominent scientists. Carus himself produced perhaps 74 books. Tolstoy translated Carus' *Nirvana: Two Buddhist Tales* into Russian and wrote to apologize when reprinters credited him with its authorship.

From age 27 to age 38, Suzuki—literally—ate, slept, and drank Open Court and its unusual mission of creating a new religion from the best of East and West. Suzuki's generational and personal interest in culling the West found its match in Carus' interest in culling the East. Suzuki had courage and genius, but Suzuki's formal education had been slight. Carus' was prodigious, and he and Suzuki together corresponded with and edited the finest minds of the time. Open Court was Suzuki's graduate education. He could have found no finer.

Hegeler had founded Open Court to reconcile science and religion, but Paul Carus believed Western anthropomorphic religion too damaged by science to reconcile. He had a bolder plan—so bold that when he died in 1919 he must have seemed almost a crank. Carus' idea was that some distillate of Asian religion, particularly of Buddhism—its tenets only recently distinguished in the West from those of Hinduism—might prove genuinely compatible with science and provide the rationalistic West with an outlet for its spiritual energies. "Buddhism is a religion which knows of no supernatural revelation," Carus argued. "The Buddha bases his religion solely upon man's knowledge of the nature of things, upon provable truth."

Carus' daring attempt at *Weltreligion*, called *The Gospel of Buddhism*, fired his young Japanese translator's imagination and showed him his lifework. *The Gospel* models Suzuki's mature methods. Carus fashions a Buddhism for the West by selecting from the gigantic Buddhist canon only certain accessible texts and arranging them in a format parallel to the familiar Christian gospels. His new Buddhist "Gospel" would engage the Christian gospels in an Hegelian dialectic, an argument leading to a higher synthesis—"a nobler faith which aspires to be the cosmic religion of universal truth," Carus wrote. That became his young translator's goal.

The new American Zen converts, were they to read Carus, might misunderstand him too as "subjective" and "unscholarly." That would be a mistake. Carus' sophisticated methodology comes, like his doctorate, from the famous Tübingen School of Pauline criticism. When the researcher learns that Carus took his doctorate at Tübingen, much of Carus, Suzuki, and even Cage falls into place with a click. Contemporary scholarship on St. Paul begins with the Tübingen School's famous founder, Ferdinand Christian Baur (1792–1860). Baur shifted scholarly interest from Jesus to Paul, whose true glory, Baur argued, was his audacious revision of Christianity into "Paulinism," a "religion for the world." Carus too wrote, honestly, that he was revising Buddhism into a "cosmic religion."

Suzuki, translating Carus, saw him willing to go so far as to add his own verses to the *Gospel of Buddha*, and tell you frankly he'd done so! Besides rearranging material, even adorning it with pictures (in the 1915 edition) of a thin, haloed Buddha with a Caucasian face like a Durer Jesus, Carus had made, he admitted, "additions and modifications." No matter: these additions "contain nothing," he calmly assured the reader, " but ideas for which prototypes can be found somewhere among the traditions of Buddhism, and have been introduced as elucidations of its main principles this book characterizes the spirit of Buddhism correctly."

That's the crucial difference: the spirit. For the Tübingen school, the *spirit* was all that mattered. Baur had argued that "Paulinism's" central "principle" was "For the written code kills, but the Spirit gives life" (2 Cor. 3:6). Great religious figures (strong poets?), to convey the living "spirit" of a religion, are authorized to modernize, revise, or otherwise rewrite traditions. In his new *Gospel,* Carus didn't hesitate to "cut out . . . apocryphal adornments" or "prune away the exuberance of wonder" that would alienate a Western rationalist. He frankly said he translated passages "freely in order to make them intelligible to the present generation." Suzuki, later his translating partner, wouldn't hesitate to translate *tsu-yu* as "self-reliance," or, translating the concept of *wabi,* write, "*wabi* is to be satisfied with a little hut, a room of two or three tatami mats, like the log cabin of Thoreau."

Suzuki, following Carus, was equally frank about his goals. He himself asked us to understand his work as creative misreading, not as error, in the *Essays on Zen Buddhism, First Series.* Readers must find it odd that the start of this, his central work on Zen, should be a long meditation on Pauline, post-Jesus theology, but given his training we see the connection. Suzuki had identified with the Tübingen School's Paul beyond what Carus could. Paul was, unlike the Hebrew Christians back in Jerusalem, a Roman citizen whose outlook made the original sect's willingness to fight only on the Jewish battlefield seem unambitious and

parochial. Suzuki, now a master of Western language and literature, looked similarly outward from Asian culture. He had begun to see himself as Zen's apostle to the Western gentiles—as Zen's "Paul."

"How much Christianity," Suzuki echoed Bauer at the start of his central work, "as we have it today is the teaching of Christ himself? And how much of it is the contribution of Paul, John, Peter, Augustine, and even Aristotle?" Christianity was "not the work of one person, even Christ." The "great mistake" of the conservatives is "to think that any existent religious system was handed down to posterity by its founder as the fully matured product of his mind" The central lesson Suzuki had learned from Open Court, the light by which his work must be understood, is the principle Baur enunciated and Carus acted upon. "Historical facts," Suzuki also writes, are not as important as the "religious truth of Christianity: The latter is what ought to be rather than what is or what was. It aims at the establishment of what is universally valid, which is not to be jeopardized by the fact or nonfact of historical elements . . ."

Suzuki must have noted one further resemblance between himself and Baur's picture of Paul. Paul, Baur argued, was freed from doing petty historical reconstructions because he had had direct revelation of Christ in the spirit. Baur declared of Paul, "Why should he go to eyewitnesses of Christ's life to ask what he was according to the flesh, when he has seen himself in the spirit?" Suzuki had had satori. What did Suzuki need from the confused, corrupt sutra-traditions of the fleshly Buddha's sayings when he had experienced satori himself and knew not what the Buddha said but what the Buddha *meant*?

Like Baur's Paul, then, Suzuki did not hesitate to revise doctrine so as not to lay "unnecessary burdens" upon his new converts. The letter only kills; the spirit gives life. One could not make any change more radical than the one Paul made at Antioch when he announced to the hostile Jews that, though Jesus' message had had to be offered to them "first," "we turn now to the Gentiles" (Acts 13:46). Suzuki's changing Zen from a variant of Buddhism into an American Emersonian transcendentalism is a parallel audacity. (No wonder Cage discovered it later in Thoreau!) Paul decided not to dishearten his prospective converts with circumcision and was called on the carpet for it by the original sect. Suzuki, Helen Tworkov says gently, did not "dishearten his enthusiastic audience with alien rituals"; his "concern" was to "alleviate cultural impositions for his Western readers." Transmission went the way of circumcision. Suzuki, the Emerson scholar, built on the West's existing cultural disposition—a *Weltanschauung* by then steeped in a hundred years of Natural Supernaturalism dating back through Emerson to Carlyle and William Wordsworth. When Western artists discovered that Zen (at least,

Suzuki's Chicago Zen) made a good deal of sense to them, they paid unwitting tribute to that great scholar's creative religious genius.

The Pauline gospel that Paul's fellow traveler the Lucan author produced for Roman ears omits the Roman soldiers flogging Jesus in the praetorium; Suzuki's Zen also selects. Zen was the samurai's religion—often violent, militaristic. In the 1930s Japan's General Tojo himself had been one of Suzuki's university students. (Suzuki had returned with honors from the West, to teach.) During the 1950s, the underrated French concept artist Yves Klein, a Judo champion, tried to bring this violent side of Zen West. The West shunned it. Suzuki, while acknowledging that "people of the West may wonder how Zen came to be so intimately related to the art of killing," tries to neutralize the topic. He makes an incomprehensible distinction between "the sword that kills and the sword that gives life."

Suzuki deals similarly with Western stumbling blocks like Zen's belief in reincarnation and the transmission of souls. "What is it that migrates, then?" By the time Suzuki finishes, only *trisna,* a formless principle that "lies at the back of Schopenhauer's Will [to live]."

Nor, as his defender Masao Abe had to admit, though Zen's very name means "the practice of sitting meditation," did Suzuki think that the grueling practice of "zazen" was "absolutely necessary for the attainment of enlightenment." In Japan the monks were sitting seven-day *sesshins.* Suzuki had himself. But in Suzuki's Western Zen, one no longer need even sit Zen.

Suzuki moved to his *weltreligion's* heart one value, one experience: satori. Of the three main Zen sects back home, only Suzuki's sect, Rinzai, had been interested in satori. When Soto sect's leader, Shunryu Suzuki (no relation) arrived in America and published his ideas *(Zen Mind, Beginner's Mind),* his disciples pointed out that the word *satori* never appeared in the book. Even for Rinzai it was only a starting place en route to the kind of utter negation of personality that the *sesshin* was supposed to encourage. In the West, however, an analog to satori had been a major cultural concept for a long time: Suzuki's satori is largely identical to Wordsworth's, Emerson's, Thoreau's, Carlyle's, Ruskin's, Joyce's vision of the supernatural hidden in the natural, of the sacredness of ordinary things—what some call "Natural Supernaturalism," and the philosopher Arthur Danto has termed the "transfiguration of the commonplace." "Satori finds a meaning hitherto hidden in our daily concrete particular experiences." Suzuki explains, regarding the world from the "religious aesthetical angle of observation" The "artist's world," therefore "coincides" with that of the Zen-man himself, but he is the higher artist, for he has no need of art objects. "While the artists have to resort to the

canvas or brush or mechanical instruments or some other mediums to express themselves, Zen has no need of things external The Zen-man is an artist," but he "transforms his own life into a work of creation!"

When Suzuki moved his own, thoroughly Emersonian version of "religious aesthetic" satori to his Zen's center, he thereby, Helen Tworkov wrote, "provided a powerful—and romantic—attraction" for Westerners. Satori was a "concept of spontaneous liberation" that "triggered an image Americans could grasp." Though Suzuki "captivated" Americans with this promise of spontaneous liberation, his and his followers' work "contains little about the formal discipline of Zen that generates and grounds this experience."

One does not fault Paul, however, for changing Christianity. That's what a Paul does. Suzuki too.

Suzuki's is an archetypal Asian American journey—his new Zen is a fascinating counterpart to the new American Confucianism that I have described in Chapter 5. Asian Americans, I argued, have had greatness thrust upon them, so to speak. It falls on all American immigrants, in the course of their daily lives, to salvage the best of their home culture and combine it with the new. Asian immigrants have had the hardest, but also the greatest possible task thrust on them: to salvage what works from the Asian system and graft it onto what works from the American. Suzuki and his German American teachers thought that the fruit from such an extraordinary hybrid could spiritually nourish the world. Though Confucianism lacks a conscious apostle, a Suzuki preaching to the West, the same work of hybridization goes on in a million Asian American homes. Yet those Confucian families have preached by example so surpassingly well that the whole "model minority" question has arisen. The reinvigoration of these two historic strands of Eastern religion—one mystical, the other humanist—is one of the most important spiritual developments in modern American culture.

Notes

1. Arthur Danto, *Mysticism and Morality: Oriental Thought and Moral Philosophy* (New York: Columbia University Press, 1987; repr. of 1972), pp. 16–19.

2. "The Changing Canons of Our Culture," quoted in Masao Abe, *Zen and Western Thought*, edited by W.R. LaFleur (Honolulu, HI: University of Hawaii Press, 1985), p. xi.

I thank Open Court's Mr. Blouke Carus for generously making D.T. Suzuki's unpublished letters available to me.

Earlier versions of some passages in this article appeared in George J. Leonard, *Into the Light of Things: The Art of the Commonplace from Wordsworth to John Cage* (Chicago: University of Chicago Press, 1994), and are reprinted by permission.

Further Reading

Abe, Masao. "The Changing Canons of Our Culture." *Zen and Western Thought.* W.R. LaFleur, ed. Honolulu, HI: University of Hawaii Press, 1985.

Ames, Van Meter. *Zen and American Thought.* Honolulu, HI: University of Hawaii Press, 1962. This remains the most scholarly and forgiving book on the subject.

Baur, Ferdinand Christian. "Hebraists, Hellenists, and Catholics." *The Writings of St. Paul.* Wayne A. Meeks, ed. New York: Norton, 1972.

Bielefeldt, Carl. *Dogen's Manuals of Zen Meditations.* Berkeley, CA: University of California Press, 1988.

Blofeld, John, trans. *The Zen Teaching of Huang Po on the Transmission of Mind.* New York: Grove, 1958.

Carus, Paul. *The Gospel of Buddha.* Chicago: Open Court, 1915.

Danto, Arthur. *Mysticism and Morality: Oriental Thought and Moral Philosophy.* New York: Columbia University Press, 1987.

Fields, Rick. *How the Swans Came to the Lake: A Narrative History of Buddhism in America.* Boston: Shambhala, 1986, rev. ed. Contains an excellent, brief account of Suzuki's career.

Fromm, Erich, D.T. Suzuki, and Richard de Martino. *Zen Buddhism and Psychoanalysis.* New York: Harper, 1960.

Leonard, George J. *Into the Light of Things: The Art of the Commonplace from Wordsworth to John Cage.* Chicago: University of Chicago Press, 1994. Contains a full length, advanced explanation of the points in this essay, showing the use made of Suzuki by his great disciple, John Cage, and explaining the impact of Suzuki's Zen on American art of the 1960s.

Marty, Martin. *A Nation of Behavers.* Chicago: University of Chicago Press, 1976.

Suzuki, D.T. "Preface." *The Zen Doctrine of No-Mind.* London: Rider, 1949, 1969.

_____. *Zen and Japanese Culture.* Princeton, NJ: Princeton University Press, 1970.

Tworkov, Helen. *Zen Buddhism in America: Profiles of Five Teachers.* San Francisco, CA: North Point, 1989. The essential work on Zen in America.

Watts, Alan. "Beat Zen, Square Zen and Zen." *The World of Zen.* Nancy Wilson Ross, ed. New York: Random House, 1960.

Asian American Literary Pioneers

Jeffery Paul Chan and George J. Leonard

We eastern spawn
fermented in the West,
dipped in salt, vinegar, pig's blood,
sugar, alcohol, ashes, lime
claim ourselves.

—From *Disarmed / 1968–1987 / San Francisco State College* by
Russell Leong

[Prefatory note by George J. Leonard: What follows is the record of an education. For better than five years Jeffery Paul Chan and I have have passed this ever-lengthening manuscript back and forth between us, as he educated me about a canon he helped create. To recapture that process, it is told in my voice, with Chan in quotations, responding to questions. Diane Rosenblum, Christine Owens, Jenny Stern, Sonja Hird, Amy Feldman fact-checked and suggested questions over the years. Professor Chan corrected the finished article.]

"Asian American studies," Cornell's Gary Y. Okihiro once wrote, "was built with the stones hurled through closed windows at San Francisco State in 1968" during the epochal San Francisco State Strike. Nationally televised, nationally discussed by every Ted Koppel of the day, the strike ended with various concessions, among them the creation of the nation's first department of Asian American studies, headed by a young writer, Jeffery Chan. "For Asian Americans," Shirley Hune has commented, "San Francisco State will always symbolize the beginnings of the Asian American Studies Movement . . ."

If Chan and his associates are sometimes controversial in the rarified atmosphere of campuses today, their significance is never disputed. Any comprehensive work—like the critically sophisticated and gender conscious *Reading Asian American Literature: From*

Necessity to Extravagance by Sau-ling Cynthia Wong (Princeton: 1993)—must acknowledge Jeff Chan and friends in the first pages.[1] He, Frank Chin, and others of their old gang sometimes seem, to me, to have lived on into the feminized world of 1990s scholarship like a group of Dodge City gunfighters living on into the twentieth century. That gentler world retains a gratitude to them, born partly from the knowledge that, at a certain violent historical moment—America, 1968—if Chan, Chin, and company hadn't been exactly the tough guys they are—indeed, a bunch of windowbreakers—Asian Americans might still be "Orientals," and there might not be ethnic studies at all.

The problems of victory, Winston Churchill once said, are preferable to the problems of defeat, "but still problems." As Jeff Chan remembers, "They told us, 'Ok, you win. Here's your department. You can teach courses on Asian American literature.' And when we were alone we looked at each other and said, '*What* Asian American literature? Who's that?"

Thus began what now looks like an heroic age of scholarship, as Chan and his friends had to "scramble around and find some." Great stuff was out there, they were sure, undiscovered. Asian American studies will always be grateful to Chan for uncovering books now considered classics—books that sometimes existed, when he found them, only in a few worn copies. Lawson Inada, the poet, re-creates the mood, the adventure of those days:
"It was 1974," he writes, and

> *We were talking about the book [John Okada's* No No Boy*]. We had been talking about the book . . . ever since Jeff Chan discovered it in some J-Town San Francisco bookstore in 1970. The book had been published in 1957 and gone practically unnoticed. We discovered it, then, and were passing it on.*
>
> *Tonight, it would reach my hand, my life, and the story would continue. So we were talking about the book, in the long Oregon dusk, over a bucket of steamed clams Frank Chin and David Ishii brought down from Seattle. With the book. . . .*
>
> *We were going to do something about the book. We knew, we felt, we owed it to us, to John [Okada, the author]: the world had been deprived too long. A book this true and strong was our very substance. So we got as many copies as we could and spread the word, bringing the book to campuses and communities.*

In scenes reminiscent of Kerouac, the young writers drove through California, spreading the word, meeting other writers who would become famous, finally driving to meet, and tape-record, John Okada's widow, Dorothy:

It hurt to have her tell us that "you two are the first ones who ever came to see him about his work." It hurt to have her tell us that she recently burned his "other novel, about the Issei, which we both researched, and which was almost finished." It hurt to have her tell us that "the people I tried to contact about it never answered so when I moved I burned it, because I have him in my heart." . . . *It hurt to have her tell us that "you really didn't miss meeting him by very long."*

That's how near to extinction *No No Boy* and other classics almost came. In 1974 Chan, Lawson Inada, Frank Chin, and Shawn Wong published a sampler of what they'd found, *Aiiieeeee!: An Anthology of Asian American Writers*—"the catalytic and seminal anthology of the new Asian American literary consciousness," poet Garret Hongo called it 20 years later, introducing his own admirable anthology of Asian American poetry. Furthermore, Chan, Chin, Inada, and Wong "identified and argued for, in a strongly worded and hectoring introduction, a native-born Asian American literary *language* and sensibility that was not Oriental or Western European, but a native development of American culture." This vision "liberat[ed] a younger generation of writers"

In this section we review—with comments by Professor Chan—some (not all) of the early milestones of Asian American literature, including works he and his friends discovered during those exciting days. We also include his comments on the mainstream representations of Asian Americans in those days and how they played a role in Asian America's evolving picture of itself. Chan is still a windowbreaker, never orthodox, and his opinions of works like *Flower Drum Song* may surprise the reader.

Pardee Lowe

Pardee Lowe was born in 1905, and Lowe's *Father and Glorious Descendant,* 1943, was the first published book-length literary piece to come out of Chinese America and become a mainstream success. Lowe's book's success coincides with America's wave of affection for the heroic Chinese people, America's allies, who had been fighting off our mutual enemy, the Japanese, since the mid 1930s. Henry Luce, the uniquely powerful publisher of *Time* and *Life* was China's greatest cheerleader (before television, *Life*'s weekly photospreads were how ordinary Americans got their pictures of the world). Luce was a personal friend of Generalissimo and Madame Chiang Kai-shek.

In 1942 the American government despatched General "Vinegar Joe" Stilwell to lead part of Chiang's army, keeping the Japanese pinned down in China,

unable to reinforce their Axis partners elsewhere. As Barbara W. Tuchman described in her excellent biography of Stilwell, America's fondness for the Chinese people, fueled by Luce's war propaganda about their heroics against the Japanese, reached a level never equaled before or since.

Contemporary critics like Elaine Kim and Sau-ling Cynthia Wong argue that Lowe's story reveals his need for acceptance by the white society, an acceptance contemporary Asian writers are in a position to do without. Kim thinks Lowe's autobiography's importance for modern times is only as "a record of the psychological responses" Lowe had to make to "race discrimination."

Jeff Chan makes a different point about the book:

> *Pardee Lowe's book is an autobiography, which is the most common genre in Asian American literature. The autobiography was the first writing lesson that every immigrant who came into the country learned. It's part of the process of Americanization. You're writing your autobiography from kindergarten on, or from whatever age you walked in. You keep telling people who you are and why you are. The process distances you from your experience, makes it objective, and also forces you to put your experience into the language that you have to learn to see your past experience in.*

This volume's editors, noting that Frank Chin and Jeffery Chan often underline that these autobiographies are Christian, asked Chan, "Christian autobiographies, since Augustine's *Confessions,* follow a pattern of past sin leading to confession and present redemption. In early American ethnic biographies the sin seems, in a way, to be ethnicity. The redemption is Americanization. 'Up from Irish-ism,' 'Up from China-ism,' so to speak. Is that part of what you're criticizing here?" Chan agrees, but explains that the power of the free marketplace practically guarantees that those books predominate. "I mean, who would publish this stuff otherwise?" It has to sell. These flattering accounts of how the immigrant has aspired to be exactly like the reader are "what the broad American audience wants to hear." Such books sell, so such books get published. "And you use it as a naturalization technique."

But Chan has much more respect for Lowe's achievement than Kim or Sucheng Chan has. These younger critics, he notices, grew up in, and write from, a secure post-1965 Civil Rights Bill consciousness of their safety; indeed they mostly write from tenured havens. No one fought harder than Chan to bring that safer world about, but he remembers too clearly how it was before. "Don't knock Pardee Lowe. Think of how Asians had always appeared before Pardee Lowe. Think

Figure 38–1: Pulp Fiction: a 1930s Dragon Lady and her prey.
Courtesy of George J. Leonard.

of what the image of the Asian and Asian American had been! Fu Manchu! Known as 'the insidious Doctor Fu Manchu' [in the Sax Rohmer novels]. Dragon Ladies in slinky dresses! And (though I personally have no problem with him) even think of a supposedly 'good' Chinese American, the sexless Charlie Chan.

Figure 38–2: Pulp Fiction: the representation of the Chinese in popular literature. Courtesy of George J. Leonard.

"So at that moment in history," Jeff Chan says, Pardee Lowe's kind of work "is *not* a problem! You *want* to see something get published that's slightly better than Charlie Chans and Fu Manchus. Something! Anything!" You want the general public to hear something about Chinese Americans that doesn't have them

throwing axes in Tong wars or twisting their evil mustaches. And the most palatable realistic thing to the general public will be these confessional autobiographies.

"I'm *ABC*," Professor Chan continued, "American-born Chinese. My father's from Nevada, and his grandmother was a Southern Ute Indian from Colorado. My mother's family is here an equally long time. Believe me, in 1943 Pardee Lowe's *Father and Glorious Descendent* spoke to me and my friends." Chan's entire generation of Asian Americans "had grown up with nothing but Fu Manchu and Charlie Chan. Whether you hated it or loved it you were moved by Lowe, because it was the first glimmer of recognition of your individuality."

Lowe's book *Father and Glorious Descendent* is a loving, comic memoir of his old-fashioned father, written by the American son who had to live up to being the "Glorious Descendent," in the formal Chinese phrase. It should be read intertextually against the other American best-sellers of its time. The title was probably meant to position it as a Chinese American version of Clarence Day's mega-bestselling *Life With Father* (1935) which, when Lowe wrote, had been made into the longest-running play ever on Broadway. The book began as Day-esque vignettes soon after Day's novel appeared. The loving but humorous tone of Lowe's anecdotes also places it in the genre of midcentury ethnic hits like *The Goldbergs,* which took radio audiences inside a contemporary Jewish home, and the contemporary *I Remember Mama,* John Van Druten's Broadway success based on Kathryn Forbes' 1943 *Mamma's Bank Account,* about growing up Norwegian.

Lowe's book strikes a note of admiration and irreverence in the first two sentences: "I strongly suspect that my father's life is a fraud. But if it is, it is a magnificent one." The stories are simultaneously funny, accurate and perhaps more revealing about early twentieth century Chinatown than some critics like. Besides comic stories like the one about Lowe's grandfather's attempt to make wildcat soup, are moving ones about his father tackling an armed Tong gunman who had shot a man in his father's store and about his father coping with Lowe's marriage to a Caucasian. Lowe does not hesitate to criticize "the inhumanity of this country's immigration laws," and describes his losing battle to support three Chinese orphans in this country, who are eventually deported to China where they vanish in the Japanese invasion. Asian American literary criticism should give Lowe a second look.

Jade Snow Wong

Like Pardee Lowe's book, Jade Snow Wong's *Fifth Chinese Daughter* (1945) was published before the war in Asia ended, and helped cement in the American

consciousness the new image of our brave allies, the Chinese people, who were battling against our common foe. There was a consequent spillover of affection for the Chinese Americans one saw here.

Jade Snow Wong was born on January 21, 1922 in San Francisco's Chinatown. Her autobiography, *Fifth Chinese Daughter,* speaks of her Chinese upbringing in a fearful white society. Elaine Kim believes that Wong's attitude is a reaction toward familial and community oppression. Her education and life at exclusive Mills College (a women's school in Oakland, California) afforded her an opportunity to expand beyond normal restrictions. Choosing not to reject her Chinese identity, she accepts, instead, the role of interpreter and educator for the Westerners. Jade Snow Wong writes of the difficult and delicate balance of the Asian and American cultures. She writes of her battle to discover a personal balance.

Wong takes a step beyond Pardee Lowe, for she dared to embarrass her American readers by frankly telling them she had faced prejudice from them. "There is no escape from race prejudice; one must simply decide how much to accept and then utilize it." She tries to achieve a personal success in a society that continues to see her as an outsider. She feels it is her "responsibility to try to create understanding between Chinese and Americans"—writing as if those were inevitably two different things.

However retrograde that attitude seems now, Jeff Chan refuses to deny Wong's value at that historical moment. "I would say much the same of Jade Snow Wong's book as I said of Lowe's." One has to remember *Fifth Chinese Daughter* was written a half century ago and be realistic. She went as far as the publishers, constrained by the market, would allow. And Asian Americans devoured her book with the same eagerness they had Lowe's. "Her book played, for my friends and myself, a role similar to Pardee Lowe's book. A welcome role. Her son, by the way, is a writer, an explicator of Taoist thought to the United States."

C. Y. Lee

Chin Yang Lee was born December 23, 1917, 30 miles from Changsha, the capital of Hunan province. He lived his early childhood as a Mongolian nomad, never settling in one town and wandering the countryside with his family. At age 11 he was sent to Peking to study at the Western schools. After college he wrote as a journalist for several Chinese newspapers and magazines. In 1942 he escaped to the United States and studied drama at Yale Drama School—surely the first Mongolian nomad to do so.

C.Y. Lee's first novel, *The Flower Drum Song* (1957), appeared 12 momentous years after Jade Snow Wong's novel. The Warren Court had delivered

segregation's death knell, the South was being forcibly desegregated, and American commitment to "minorities" was a newly popular cause. The time was right for a sympathetic portrayal of Chinese life in America. The book was an enormous mainstream hit. It received the ultimate accolade of 1950s American popular success: translation into a Broadway musical by Rodgers and Hammerstein.

With a publishing history like that, one almost assumes that *Flower Drum Song* is bogus, if not worse, and that a rock-throwing radical from 1968 like Chan would hate it. Quite the reverse.

First, the book had a great deal of historical accuracy. "*Flower Drum Song* catches a certain moment in the 1950s, during a new era in Chinatown that began with Mao taking over China in 1949." Starting with the Exclusion Act of 1882, America had shut the door tighter and tighter against Chinese over the decades. "The Chinatown that I grew up in, from 1942 to 1950, was all ABC, American Born Chinese, English speaking. No new Chinese immigrants had been allowed in America for generations. Then the American attitude to China began to change, slowly, because of the Chinese stand against the Japanese. Some war brides were allowed in after World War II, but the big event came in 1949, when Mao captured China."

Henry Luce (through *Time* and *Life*) had spent the 1940s convincing the American public that Chiang Kai-shek had the Chinese people's affection. Mao stunned America. In 1949, when the Communists took over, America opened its doors. "All these refugees (they had been our allies, and they were fleeing Communism) were allowed into the United States. Suddenly, Chinatown became this foreign country. And we ABCs moved out. *Flower Drum Song* accurately captures that moment. It takes place in a Chinatown bifurcated into a Chinese part and an English-speaking part, which I grew up in and belonged to."

C.Y. Lee has been called a "Chinese Saroyan" for his "compassionate view of life." Lee says he "has no patience with the intellectual approach to literature"; literature, he believes, is really an "emotional business that cannot be calculated or tabulated." Although many Asian American writers today think Lee's work refuses to explore political issues, *The Flower Drum Song,* with its picture of life in 1950s Chinatown, holds a special niche in Asian American literature. The work was—comparatively—a breakthrough in the representation of Asian Americans and was deeply admired as such.

Nor can we underestimate the importance for Asian Americans at that time of the musical version by Rodgers and Hammerstein, two Jewish liberals who had graduated from Columbia University. They already had attacked racial prejudice against Asians in *South Pacific* ("You've got to be taught/ To hate and fear/ It's got to be drummed in your dear little ear/ Before you are six or seven or eight/ To hate all the people your relatives hate/ You've got to be carefully taught").

Of the Rodgers and Hammerstein musical, Jeffery Chan simply says: "My God, it was everything. It was the very first time that I had ever seen Chinese American actors being *American*. They could sing! They could dance! It was glorious. The two biggest movies of my youth were *Flower Drum Song* and *Sayonara,* with Marlon Brando."

Sayonara was not by an Asian American, but was, Chan notes, an important cultural event for Asian Americans, and so deserves mention. Brando, then America's reigning superstar, guaranteed the film's success by his presence alone. He plays a southern American officer engaged to a general's daughter, then posted to Japan. He befriends a soldier (Red Buttons—Oscar performance) who has happily married a Japanese. Intrigued, Brando meets and falls in love with a Japanese himself. His southern heritage makes him fight against his love as "miscegenation," and during that fight he relays to Buttons an official—and racist—command to leave his wife and move on. Rather than part, the soldier and his Japanese wife commit suicide. Brando, in revulsion at the racism that has caused this tragedy, overcomes his southern upbringing, throws away the general's daughter (and his career, it seems) to defy the order and marry his love.

Jeff Chan comments, "*Flower Drum* and *Sayonara* were romanticizations, they were 'orientalism'—absolutely! But they meant so much *at that time.* You have to understand we'd never been exposed to anything good before—I once went to the library and looked up Jung, because, from the sound of his name, I hoped he was Chinese. I can still see Brando at the end of *Sayonara*—the title means, 'Goodbye'—walking away with his Asian wife, as the press yells at him, 'What will we tell the generals? What will we tell America?' And he says, 'Just tell them: *Sayonara.*' I said, 'All *right!* Get *down!*'—or 1950s words to that effect. In that sense both works were very timely. I was thirteen or fourteen and they finally gave me a way, as a young man, to think about myself."

In the 1990s C. Y. Lee, in his seventies, was still publishing, most recently about the 1989 Chinese Communist massacre in Tiananmen Square. During the 1970s he had written about Tong wars in California. "Lee's daughter is also a writer," Jeff Chan adds.

Toshio Mori and Hisaye Yamamoto

Toshio Mori (1910–1980) and Hisaye Yamamoto (b. 1921) are two Japanese American short story writers of the Nisei (American-born generation) experience. Mori was born in Oakland, California, Yamamoto in Redondo Beach, near

LA. Each is best known for one brief work that went unnoticed when first published. Both were showcased in Jeff Chan's canon-making 1974 anthology and are now considered classic writers of the Japanese American experience.

Mori's stories, collected in Yokohama, California, evoke the northern California "J-towns" of the 1920s and 1930s. He was interned in the Topaz concentration camp, where he started a magazine, *Trek*.

Hisaye Yamamoto's work consists of only seven short stories published between 1948 and 1961. As a body of work, it is a veritable *haiku,* and the title of her one collection, *Seventeen Syllables and Other Stories* alludes to that terse 17-syllable poetic form. In 1961 she made a decision to stop writing and give all her time to her family. There is something in that decision that seems both characteristic of her generation, and characteristic of an artist so in love with haiku-like concision, she has decided that adding another word to her *oeuvre* will diminish it. (See Chapter 35, "Roots: Japanese Haiku and Matsuo Basho.")

Of Yamamoto, Jeff Chan exclaims, "She's the real thing! She's the best Japanese American short story writer, surely. Her stories, I've often said, are remarkable for their range and their gut understanding of Japanese America—among the most highly developed of *all* Asian American writing. Her greatest story is 'The Legend of Miss Sasagawara.' It's also the only story that takes place inside the concentration camps written by a Japanese American who was of age—not a child—at the time.

"Yamamoto's story is told from the point of view of a 19-year-old who thinks that life is wonderful. She's about to go to college. And she's confronted by this character Miss Sasagawara who apparently had been a very successful ballet dancer, but now, at the end of her career, age 39, finds herself in a concentration camp. Parallels are being drawn between the teenager at 19 and the ballet dancer, who apparently never married and whose mother has just died. The teenager thinks life is wonderful and the whole world's before her. The ballet dancer finds herself at 39 in a concentration camp having a nervous breakdown. The question asked is 'Which one of them is crazy?' A great story. You can find 'The Legend of Miss Sasagawara' in *Seventeen Syllables*.

"What's wonderful about Yamamoto's writing is that she remembers perfectly how it feels to be 19, feeling absolutely free and the world is open to you. As soon as the war will be over—*no problem!* Yet you read the tension behind that, the illusion, and it just undermines it. Ironically, all the writers that are younger than she is, exaggerate the whole thing: here's the camp, it's a terrible place and all these terrible things happen—which they did, of course. But they don't know these events as participants that actually experienced them." (See Chapter 7.)

Monica Sone

A good complement to Yamamoto's short stories would be the fuller treatment of the camps in Monica Sone's *Nisei Daughter,* which was first published by Little, Brown, in 1953, but made little impact then. The University of Washington Press brought out a new edition in 1979, at a time when the Japanese American community was embarked on its campaign for "redress," an apology and a payment to all Japanese Americans who had been put in the camps. **Redress** came at the end of the 1980s. (See Appendix A and Chapter 7.)

Sone's memoir is set in the Seattle Japanese community. She writes with a light and humorous touch, but she grew up to be a clinical psychologist, and she writes of her characters with a professional incisiveness. The first paragraph gives the book's flavor:

> *"The first five years of my life I lived in amoebic bliss, not knowing whether I was plant or animal, at the old Carrollton Hotel on the waterfront of Seattle. One day when I was a happy six year old, I made the shocking discovery that I had Japanese blood. I was a Japanese."*

The portrait of a little girl living in "amoebic bliss" inside a strong, loving family—bliss, even though that family lives in a "Skidrow" residential hotel between a bar and a burlesque theater—is both charming and troubling. Later, the little girl is taken back to Japan to be shown off to her grandparents. The family is taken sightseeing and is told that a certain bridge, the Shinkyo Bridge, is "sacred to the gods," and only the emperor may walk on it. Monica, like any self-respecting American kid given such a challenge, sneaks away from her family and climbs up on the sacred bridge herself, to the horror of the 1930s emperor-worshipping Japanese. It's a wonderful scene, which captures in an instant the distance between the Japanese psyche and the Japanese American child's.

Sone's wartime incarceration gets only 70 pages. The powerful family that enabled her to live on Skidrow in "amoebic bliss" cushions her during this ordeal as well. She remembers anger and fear, remembers Tommy guns and barbed wire; but Sone may have been just too well-loved and well-balanced a person by then to have been as deeply affected by it as other people were. Nor did it play a large role in her mental economy. After the war, she went on happily with her life. Sone's personal strength is, therefore, her work's weakness. This naturally sunny person, miraculously stabilized by her personal internal gyroscope, is not the ideal reporter of what was, to most, a dismal experience.

Sone's book is sometimes proposed as a more authentic document for classes than Jeanne Houston's camp narrative, discussed next.

Jeanne Wakatsuki Houston

Jeanne Wakatsuki Houston wrote only one book, the famous *Farewell to Manzanar*, a perennial bestseller about the Japanese concentration camps that has been called a Japanese American *Diary of Anne Frank*. It is much assigned. Back in the 1970s some militants challenged the book's authenticity, since it was coauthored with the writer's husband, a famous (white) writer. Jeff Chan told the editors of this volume that all that was a dead issue, noting that the Houstons gave the Redress movement (which led to the federal government apologizing to all former internees and paying each $20,000) great and needed support—and so did, no doubt, the consciousness raising novel, *Farewell to Manzanar*.

"Jeanne Houston and her husband, a renowned writer, went into it together, but there's no reason to question Jeanne's contribution," Chan shrugs. "You have so many different points of view in the camps. All the most popularly accepted portrayals of the camp experience were written or scripted by the next generation, Jeanne's generation. The loss of the immediate experience of the camps always changes the portrait of it. The different generations would have different reasons for portraying the evacuation, different points of view. The only Japanese American writer who wrote a fictional piece that happens in the camp—and who was old enough to experience it—is Yamamoto. (Monica Sone's book is not fiction.) Even Toshio Mori, another fine fictionalist, didn't write a piece that was set in camp. It's the weirdest thing, that no more was written than that."

Critics generally agree that Houston's goal, writing, was to create a Japanese American version of Anne Frank's autobiography. That Houston actually did write a work of comparable emotional power is no small feat! Chan feels, however, an emotional distance between writer and subject, noting that Jeanne was little more than a toddler when interned, and she must be *reconstructing* a great deal, which is different from actually *remembering*.

Chan has nothing but praise, however, for certain post-camp scenes, which involve a topic the writer does remember and is in full emotional contact with: what it means to be an Asian American woman. It is surprising that 1990s feminist criticism has overlooked these scenes. From the time Jeanne reaches puberty, in camp, much of the book involves her immigrant father's attempts to push her toward *odori* school, with its lessons in how to be what Japan considered feminine—

and Jeanne's rebellious efforts to become as American as possible. After camp, when a catty group of Girl Scouts exclude her she discovers she can use her budding "sexuality" to become, instead, a drum majorette for the Boy Scouts. "I was too young to consciously use my sexuality or to understand how an Oriental female can fascinate Caucasian men . . . but I knew intuitively that one resource I had to overcome the war-distorted limitations of my race would be my femininity." Jeanne's efforts culminate in her election as high school Spring Carnival Queen, which she wins by "going exotic," appearing at the contest submissively barefoot, in a sarong, with a flower behind her ear. The victory turns to ashes when she tries to dress "respectable" at the ball, in a formal white dress. People are confused. "It wasn't the girl in this old fashioned dress that they had voted for. But if not her, who *had* they voted for?" Houston's stories raise fascinating questions. The price of transforming yourself into someone's fantasy turns out to be losing your reality.

Louis Chu

Louis Chu was born in Toishan, China on October 1, 1915, and immigrated to Newark, New Jersey in 1924. Chu was a well-known figure in the Chinatown of his day, an important public official in the Department of Welfare, a man with an advanced degree from New York University, executive secretary of the powerful Soo Yuen Benevolent Association, and even the host of a radio program called "Chinese Festival."

He published *Eat a Bowl of Tea* in 1961, a satire set in the Chinese "bachelor community" of the 1940s. Elaine Kim calls *Eat a Bowl of Tea* a "compassionate portrait of daily life, manners, attitudes, and problems in the Chinese [1940s] community from the viewpoint of laundrymen and waiters." The novel—made into a feature film by former San Francisco State student, the director Wayne Wang—is indeed our best portrait of that vanished world. Jeff Chan rediscovered the book as he did John Okada's, and he remembers how close *Eat a Bowl of Tea* came to being lost.

"After the strike, after we were given our own Asian American studies department, the first course we were allowed to teach was an "Asian American literature" class. And we were desperate. We *had* no literature. At first, people who were political activists enrolled in the course to make sure that we had enough heads so they couldn't cancel it. Then other kids—genuinely interested in literature—started coming out of the woodwork. Very quiet kids like Herbie Chu.

"Herbie brought this book in that his aunt, who was the assistant fiscal officer at San Francisco State at the time, gave him. She had always had an interest in Chinese American literature. She said, "Take this to them. I'll bet they never saw anything like this before." And she was right.

"*Eat a Bowl of Tea* was our first book. We had nothing else. And we only had one copy of *that*. We immediately took it and made photocopies of it. It was out of print. We couldn't find it. Couldn't order it. It had been published, you see, by a very odd publisher: Lyle Stuart. Stuart usually published gambling books and soft core porn. But when he was a young man in New York first assigned to publish books, his best friend was a Chinatown social worker named Louis Chu. They would eat lunch together. Well, Louis had a book he had written, and he showed it to Stuart. It had to do with gambling. It had to do with prostitution in Chinatown. In 1961 Lyle Stuart published it.

"I finally caught up with Stuart and discovered he did have some copies left. He had taken home the left-over from the tiny original edition and had them sitting in his basement. So for two semesters, until the paperback came out, the kids were buying for $2.95, hard bound first editions of *Eat a Bowl of Tea*.

"Stuart didn't make money on the book until 20 years later when Wayne Wang based his second movie on it. He read the book in that class! You see how it happens. Wayne came from Hong Kong, was a student in San Francisco State's Ethnic Studies program, and took our class. But he always wanted to be a film maker. (See Chapter 57.)

"*Eat a Bowl of Tea* is set in the 1940s Chinese **bachelor society.** The 'bachelor society' was a community that lay moribund at the close of World War II, enclaves of old men trapped by racist immigration laws to live out their days in San Francisco, Seattle, Los Angeles, Boston, and New York City. With allegiances tied to wives and family barred from entering the United States, they found refuge in the back rooms of barbershops and restaurants, at the local tong, in the repartee and rivalries exchanged over a game of mah jong. Louis Chu captures their vanities and illusions."

That being said, Jeff Chan sharply disagrees with scholarly attempts to reduce the novel to sociology and read it as a story of old Chinatown restaurant life. Chan points out that "the two main characters are gamblers—also prominent figures in Chinatown's daily life during that era." Chan sees the novel as a "biting satire with a powerful subtext. A Cantonese speaker or someone versed in Chinese literature will be aware of all the puns. The characters' names, for instance, pun on the roles they play in the novel. The female lead, Mei Oi, is nicknamed Moi Moi. A *moi* is the plum that the Chinese herbalist gives you after you

take bitter medicine. The bitter medicine she shells out is that she's going to have an illegitimate child that her husband will have to legitimize. Her husband, Ben Loy's name, is really subtle. If, in Chinese, you change the tone slightly, it means 'a sickness is coming' in Toishan dialect, much used in the Chinatown of that era. That foreshadows his impotence. His whole name, Wang Ben Loi, actually means 'King of Internal Illness.'

The novel, therefore, is no simple social realist tract, but something Joycean in its complexity, a puzzle of mathematical games as well. The address of the bachelor headquarters is 45 Catherine Street and where they live is 87 Mott Street. One address counts up to the number 6 and the other, down to 6. The word "six," in Cantonese, is a pun on the word for green—and 'to wear a green hat' in Cantonese means you're a cuckold, which is exactly what happens to Ben Loy. Six is the cuckold's number. When Mei Oi's bracelet is being examined by a potential lover, Louis Chu works it so the number six pops up again. Joyce demanded you know Dublin and sometimes Gaelic to understand his jokes. Here too there's an enjoyable subtext that speaks to the knowing, particularly to Toishan speakers, where the puns work best. Yet it wasn't Joyce who influenced Louis Chu the most, it was Shakespeare. The character who is going to be cuckolded, for instance, has a birthday on March 15th: Beware the ides of March! which we all remember from *Julius Caesar*."

In sum, Prof. Chan's point is that Chu's novel is anything but the quasi-documentary, social realist work that Elaine Kim and others would make it. "It is true that Chu was a highly respected social worker and the novel is grounded in reality. But he's not writing a documentary about Chinatown. It's a black comedy about a gambler, full of puzzles and wit."

John Okada

Jeff Chan writes: "John Okada's *No-No Boy* (1957) was a forgotten, neglected, and rejected novel about Japanese America that every Japanese American knew about but never read during Okada's lifetime. In the 14 years that John Okada lived with his book, he saw it slip into obscurity and fail to sell out an edition of 1,500 copies. Japanese Americans out to prove to America that they were loyal and perfect Americans after the war sidestepped Okada's fictional community full of pain, depression, suicide, anger, bitterness, and guilt.

"Okada was born in the old Merchants' Hotel in the Pioneer Square area of Seattle with the help of a Japanese midwife. He received two bachelor's degrees from the University of Washington, one in library science and the other in

English, and later received a master's degree in English at Columbia University, where he met his wife Dorothy. He served as a sergeant in the U.S. Air Force during World War II.

"Five years after Okada's death of a heart attack in 1971, the Combined Asian American Resources Project reprinted his landmark novel, back then the *only* novel written by a Japanese American writer. Its time had come. The book sold out two printings of 3,000 each, mainly to Japanese American readers who were ready to look back at themselves. The University of Washington Press has continued to publish *No-No Boy* with two additional printings."

With Okada's work, we have reached the threshold of modern Asian American literature: post-sixties, post-Civil Rights movement, post-1965 Immigration Act, and the arrival of the "new wave" of Asians.

Shawn Wong

Shawn Wong is, perhaps, the last Asian American writer—and surely the last Chinese American writer—who can be called a "pioneer." "Amazingly Shawn's 1982 novel *Homebase* is the first novel published by an American-born Chinese American. We could quibble about what is and what is not literature, what is a novel, and the like; but I remember Ishmael Reed (who published it, I. Reed Books) making that assertion good at the time of publication.

"Shawn Wong was born in Oakland, California and raised in Berkeley. *Homebase*, won the Pacific Northwest Booksellers Award and a Washington State Governor's Writers' Day Award. A German edition of *Homebase* was published in 1982. In addition to coediting *Aiiieeeee!* and *The Big Aiiieeeee!*, he has edited two other volumes of Asian American literature. Wong is also a recipient of a National Endowment for the Arts creative writing fellowship. A graduate of the University of California at Berkeley and San Francisco State University, Wong has taught at Mills College, University of California at Santa Cruz, and San Francisco State University. He is a former chairman of the Seattle Arts Commission and is presently the chairman of the English Department at the University of Washington.

"Shawn scored a major success with his 1995 novel *American Knees*. For a general audience, it's a spritely sex comedy, a twisty tale of love, marriage, divorce—modern coupling, Asian American style. For those of us familiar with the themes he works, the immigrant scion as orphan, the history embedded in indecipherable glyphs, anonymous figures we translate as father and mother, Wong treads a familiar and a welcome landscape in this new work."

Conclusion

This section in particular could have been infinitely longer. Other fine authors, and selections from many of the "pioneer" figures quoted, may be found in the enlarged version of Professor Chan's anthology, itself a milestone in Asian American literature. See *The Big Aiiieeeee!: An Anthology of Chinese American and Japanese American Literature,* edited by Jeffery Paul Chan, Frank Chin, Lawson Fusao Inada, and Shawn Wong.

To research a new author, one should not overlook *Contemporary Authors* and *Contemporary Literary Criticism,* reference works that almost all public and college libraries carry.

The best introductory bibliography for Asian American literature was compiled by Amy Ling, a contributor to this volume, for the standard reference work, *Redefining American Literary History* (New York: Modern Language Association, 1990), pp. 353–362. Ten pages of fine print organized by genre and by ethnicity.

Further Reading

Chu, Louis N. *Eat a Bowl of Tea.* Seattle, WA: University of Washington Press.

Houston, Jeanne Wakatsuki. *Beyond Manzanar: View of Asian-American Womanhood.* Santa Barbara, CA: Capra, 1985.

————, and James D. Houston. *Farewell to Manzanar.* San Francisco, CA: San Francisco Book-Houghton, 1973.

Lee, Chin Yang. *Flower Drum Song.* New York: Farrar, 1957.

————. *Lover's Point.* New York: Stratford, 1958.

Lowe, Pardee. *Father and Glorious Descendant.* Boston: Little, 1943.

Mori, Toshio. *The Chauvinist and Other Stories.* Los Angeles: Asian-American Studies Center, University of California, 1979.

————. *Yokohama, California.* Caldwell: Caxton, 1949.

Okada, John. *No-No Boy.* Rutland: Tuttle, 1957; Seattle, WA: University of Washington, 1979.

Sone, Monica. *Nisei Daughter.* Boston, MA: Little, 1953; Seattle: University of Washington Press, 1979.

Wong, Jade Snow. *Fifth Chinese Daughter.* New York: Harper, 1945.

————. *No Chinese Stranger.* New York: Harper, 1975.

Wong, Shawn. *Homebase.* New York: Reed, 1979.

Yamamoto, Hisaye. *Seventeen Syllables.* Introd. King-Kok Cheung. Latham: Kitchen Table-Women of Color, 1989.

Asian American Literature

The Canon and the First Generation

S.E. SOLBERG

In one very real sense the first generation of Asians, those intrepid adventurers who first broached the Pacific shores of America, have been the forgotten ones in the study and teaching of Asian American literature. Not that they do not appear in the accepted canon, they must and do, but rather, they do not appear as authors rather than subjects, with two outstanding exceptions, Carlos Bulosan and Younghill Kang. It is important to understand the reasons for this, for therein lie both the constraints and the stimuli that defined the field through its first decade, and, in good part, its second. It is my sense that the past several years have marked a turning point and expansion into broader concerns, many of which are more closely linked to the traditional aims of literary scholarship and the field of Asian Studies.

Asian American literary studies as a formal literary field can be dated roughly with the publication in 1972 of Kai Yu Hsu and Helen Palubinskas' *Asian-American Authors,* which, while it took the form of a secondary school social science textbook, was indicative of the foment and excitement that was soon to bring forward other anthologies and, more importantly, a whole generation of new Asian American authors. I take a certain pride in having been in the field almost from those beginnings. In 1973 I received a National Endowment for the Humanities post-doctoral fellowship for the study of Asian American literature; in the 1974 academic year I initiated the course in Asian American literature at the University of Washington. That course, and the many like it that were developed in those years of foment, constituted a recognition of the importance of a literary tradition to validate the history and experience of a minority population. There were problems, however. Unlike Black, or African-American, and Chicano literatures, which can be seen as growing from a reasonably homogeneous source, Asian Americans were a variety of peoples from widely divergent immigrant roots:

Chinese, Japanese, Filipino, the core group, by virtue of numbers and chronology, plus Korean, Southeast Asian, but not usually, at that time, South Asian or Pacific Islanders, Hawaiian, and Samoan. How from either an intellectual or pedagogical standpoint, could one assume any unity in such a diversity?

Practically, in those early years, the problem resolved itself: a course had to be built around the few texts available. The Hsu text had been developed for secondary schools, and while the selection and presentation were appropriate to that level, the study seemed condescending and jejune to a college class—representing precisely the attitudes they were (so far as they were Asian American, and most were) fighting to destroy. The rest was library reserve shelf and photocopies. The bulk of the material, Chinese, Japanese, and Filipino. Then in 1974 and 1975, two new anthologies appeared representing widely divergent approaches to the question, what is Asian American literature? The lines were drawn for a highly emotional critical battle that continues on down to the present, representing in part a divergence in point of view of the east and west coasts, in part the differences in perception between those who belong to the established Asian American communities and the more recent, more middle class, immigrants.

The two anthologies were *Asian-American Heritage: An Anthology of Prose and Poetry*, 1974, edited by David Hsin-Fu Wand, and *Aiiieeeee!*, 1975, edited by Frank Chin, Jeffery Paul Chan, Lawson Fusao Inada, and Shawn Wong. The first was published as a paperback by Pocket Books under the Washington Square Press imprint; the second, in hard covers, significantly, by Howard University Press. David Wand was Chinese-born and educated, coming to the United States for his higher education and pursuing a career in college teaching. The editors of *Aiiieeeee!* were American-born, second, third, or more generations, and established or aspiring writers themselves. It was clear that the focus of the two books would be different.

The selections in *Asian-American Heritage* represent what might be called the eclectic approach: the only justification, critical or otherwise, adduced is that these are works by Asian Pacific Americans, another of those minority groups that have been sadly neglected in the past. When any critical judgments are made, they are couched in the careworn phrases of traditional literary studies. The criterion for selection would seem to have been only the ethnicity of the author. While this made it possible to include both Korean and Polynesian materials, it ignored the question: what in the literature itself might serve to give it coherence? The result was the anachronism of the inclusion of traditional Hawaiian and Samoan chant in translation while ignoring original materials in Chinese or Japanese, or the inclusion of two Korean authors, both fine writers, who more properly belong to

the category of Korean writers in English, and whose American experiences were at best incidental to the central concerns of their writing. There is also a good deal of comparatist befuddlement seeking roots for Asian American writing in Asian literary traditions. The dominant emotional and intellectual values remain those of the European/American academic traditions of literary study. The raw core of experience as formed by literature is transmuted into stale academic formulae. This is not to depreciate the value of such formulae; it is only to say they have little or no meaning when they are raised prior to grappling with the raw material of the works themselves.

By way of contrast, the editors of *Aiiieeeee!* work from a central premise: the only valid works of Asian American literature are those that are defined by a particular sensibility that reflects the position of the Asian American in relation to the majority society. This has the obvious advantage of defining the field in terms of the works themselves while at the same time allowing considerable latitude. (The inclusion of an American-born Chinese Eurasian writing about World War II Shanghai would suggest how much.) The specificity of the definition was also positive: it was a call and a program for more Asian American writing. It was an angry statement, yes, and threatening in its attack on the pretensions of middle-class liberals (not WASPs alone by any means).

> *Our anthology is exclusively Asian American. That means Filipino, Chinese, and Japanese Americans, American born and raised, who got their China and Japan from the radio, off the silver screen, from television, out of comic books, from the pushers of white American culture that pictured the yellow man as something that when wounded, sad, or angry, or swearing, or wondering, whined, shouted, or screamed "aiiieeeee"! Asian America, so long ignored and forcibly excluded from creative participation in American culture, is wounded, sad, angry, swearing, and wondering, and this is his AIIIEEEEE!!! It is more than a whine, shout, or scream. It is 50 years of our whole voice.*

This is, in other words, a literary threading that validates our humanity, that establishes our identities as Asian Americans rather than as stereotypes foisted on us by the white imagination. (It should be noted in passing that one did not have to be white to create with a white imagination.) By editorial fiat many of the names that up to that point had dominated as the literary interpreters of Asian America were deposed in favor of a selection of mostly, in 1975, little-known writers.

The results of the publication of *Aiiieeeee!* were electrifying. A viable literary tradition had been established for the aspiring Asian American writer, and the lines had been drawn for what was to become a fruitful, if sometimes acrimonious, critical debate. *Aiiieeeee!* dominated the market. The hardcover edition remained in print for over a decade. The Doubleday Anchor paperback issued soon after the hardcover went out of print in the early 80s, but was quickly replaced with a Howard University Press paperback. The tradition continues as well with Penguin issuing *The Big Aiiieeeee!: An Anthology of Chinese American and Japanese American Literature* in 1991. The works and authors represented in the original *Aiiieeeee!* became the core of a viable Asian American canon, and this has had profound implications as to how the works of the first generation have been regarded.

The definition by sensibility, as used by the editors of *Aiiieeeee!* has this apparent defect, that it seems to essentially rule out first-generation writing, despite the flexibility:

> Asian American sensibility is so delicate at this point that the fact of Chinese or Japanese birth is enough to distinguish you from being American-born, in spite of the fact that you may have no actual memories of life in Asia. However, between the writer's actual birth and birth of the sensibility, we have used the birth of the sensibility as the measure of being Asian American.

The point that has often been overlooked in the past and has been in part remedied in *The Big Aiiieeeee!* is that this particular sensibility could have been engendered by the immigrant experience as well. One reason for that oversight was the powerful underlying assumption that Asian American literature would be written in English; the other was that few, if any, of those involved in the academic study and teaching of Asian American literature in those days had the language competence to go back to original language sources.

This is an area where Asian American studies in general, and literary studies in particular, begin to develop in ways that are also the legitimate concerns of more traditional Asian studies. It is an area where, if we categorize less, we are concerned more with process than with type, more with the making of a literature than its deconstruction, we see in the most dramatic terms the growth of that sensibility that the editors of *Aiiieeeee!* two decades or so ago too quickly labeled as being the mark of the native born. *The Big Aiiieeeee!* goes a long way toward alleviating that difficulty, the editors seeing more clearly in retrospect, the solid rooting of their tradition in the ways of their immigrant forebears, both folk and learned. What once was frequently relegated to a category of "cultural

heritage" now is seen as intrinsic to the growth of the Asian American tradition and the establishment of the canon. The question of authenticity still haunts the search, and the question of who represents the "real" tradition, and who is excluded by this reading should again stir up the critical waters on the most fundamental level.

Another view of the matter, more particularized and regionalized, underlies Stephen H. Sumida's recent invaluable *And the View from the Shore: Literary Traditions of Hawai'i*. Here the view is indeed and determinedly that "from the shore" and the materials dealt with Hawaiian language, song, and chant, the impact of Hawai'i, and by implication all of America, on the immigrant as illustrated through Japanese language haiku and Bon Odori chant. The maintenance and growth of a heroic tradition always, as Sumida sees it, in conflict with the exoticising, stereotyping pressures of the pastoral.

Yet despite the translations from the Chinese by H. Mark Lai of the Angel Island poems and of Marion Hom of the Cantonese *Songs of Gold Mountain* plus a scattering of hard-to-find translations of Japanese language poems, nothing of the immigrant generation has yet captured a place in the canon in the way of, say Rolvaag's Norwegian-written novels of the Dakota plains. Clearly what we have is only a beginning: there remains a wealth of material in the ephemeral yearbooks and other community publications, the vernacular press, the output of poetry clubs, and, no doubt, in manuscript in both private and public collections. This is important material, for it presents in its whole human dimension the experience of an increasingly important segment of America. It also becomes of more and more concern as we are faced with a continuing first-generation presence, a constant flow of immigration that maintains the home language and contacts with the homeland much closer than could have been envisioned in the past. The meeting edge of language, culture, and individual are again being recorded in two languages while curiosity grows as to how similar in their variousness these many experiences recorded through literary devices may be.

When the second paperback edition of *Aiiieeeee!* was in the making, I was asked by the editors if I would supply an essay on Filipino American literature to take the place of the original. In the original formulation it had been suggested that Filipino American literature was so different in its origins that it had to be treated separately from that of Chinese and Japanese America. There are good reasons for this; however, the original essay by another hand had fallen short of the mark on several grounds. In the case of the Filipino American writers represented in the anthology, all were first generation, yet certainly, particularly in the case of the major selection from Carlos Bulosan, the extended definition

by sensibility applied. He was born and educated in the Philippines, yet, when he arrived in the United States and began writing, his works, insofar as they dealt with the American experience, exhibited the same sort of painful attempts to formulate a particularly Filipino American sensibility outside the constraints of an imposed mainline white American point of view. Easy answers come easy: Filipinos never knew who they were to begin with; it was his radical political stance that set him apart. Neither is very satisfactory: it is considerably easier to change politics than it is race; politics is a matter of choice, not birth; as to the generalizations about Filipino identity either here or in the Philippines, there may be a germ of truth, for the Filipino was a colonial emigrating to the metropolitan center. He had already had his taste of the relationship to the existing system; she had also been educated in schools that inculcated her with that textbook idealism of an earlier decade that posited the American dream as attainable by all. The confrontation with an indifferent American culture, which, for the Japanese and Chinese, had been posited as an experience on American soil, had already begun in the Philippines.

This raised an interesting question. The editors of *Aiiieeeee!* had used the colonial model to explain the impact of racism and the structure of American society upon the authors while studiously avoiding any larger generalizations that would have suggested an identification with Third World literature. Bulosan had been the subject of a well-reasoned dissertation by Susan Evangelista at the University of the Philippines entitled "Carlos Bulosan and the Beginnings of Third World Consciousness." The fundamental difference in approach, however, is that Evangelista argued from content and the Asian Americans argued from sensibility. This may seem like hair splitting, but in fact the two are very different things, though certainly not mutually exclusive. The Third World argument would, in its simplest form, be that similar situations in minority-majority relations lead to similar sensibilities. The argument from sensibility would be that the American confrontation leads to an exposure and rawness of certain psychic nerves that is specific to the situation of the Asian American author. Betrayal and selling out are constant themes in both settings, but in the Third World the betrayal is more frequently in the moral lapses generated by the quest for power; in the Asian American world it is seen as that ultimately fatal moral weakness that sells a rich racial and ethnic heritage for the warmed-over pottage of a white fairy tale.

The point of this peregrination is simply that there clearly is a place for the first generation in the canon of Asian American literature as it has been constituted without lapsing into the unfocused eclecticism that was typified by Wand's early anthology. The academic challenge is to find these works and make them

available, both for scholarship, teaching, and the common reader (which may re-
quire a bit of translation). It is important to understand as fully as possible the
feeling and the aspirations, the frustrations and triumphs, that have gone into the
making of all Americans, for that is the way to understanding, self-respect, and a
reaffirmation of the dedication to the fundamental ideals of America that have been
kept viable by the continued attempts of the neglected and excluded to achieve
their promise.

This is but to say that the canon of Asian American literature as it is pres-
ently conceived does not serve that first generation well. The second-generation
author is apt to see the older generation in terms of both generational and cul-
tural conflict, though some of Steve Sumida's readings have pointed out that that
interpretation is, in many cases, a misreading, or reading of preconceived notions
of cultural and generational change and relationships into texts that are doing
something else entirely. (This suggests that one of the challenges to teachers is to
see to it that students know how to read a text before they start attempting all
the fancy footwork current literary theory requires.) Still, the fact remains that
the second-generation author is more apt to see the older generation in terms of
the generational and cultural conflicts that shaped his growing up rather than in
terms of that older generation's hopes, fears, and aspirations. Still those insights
do come through. In John Okada's *No-No Boy,* a Japanese American novel set in
Seattle, the Nisei protagonist notes with a kind of wonder that the Issei are set-
tling back in Seattle after the dislocation of the World War II concentration camps
as if they intended to stay. It is usually by suggestions such as this that the first
generation's heroic struggle for survival in a hostile society, where they were de-
nied the rights to citizenship and property ownership, comes through. The re-
lated, but more insistent problems of the younger, American-born, and hence
American-citizen generation dominate, for it is their sensibilities that inform the
works—sensibilities neither Chinese, Japanese, Filipino, nor white American.

It should be noted in all fairness, however, that it has been very largely the
third generation who have begun the attempt to resurrect their grandparents,
anachronisms and all. (Another confirmation, if one were needed, of Hansen's
third-generation hypotheses.) On the academic side we can expect a good deal
of excitement yet to come once this critical flurry of mostly, except in the most
expert hands, obfuscating snow blows over.

Yet even beyond that encouragement to stay with the field there is another
side to the teaching of Asian American literature which I find as, if not more, stimu-
lating than the research and the opening of new vistas and new perspectives in
the classroom. There is what I at least conceive of as the duty to nurture and

encourage the younger generation of potential writers. The fledgling ethnic writer, even an English major, often feels at sea, finds it hard to see where her experience, which is, after all, the core from which any serious writing must emerge, can be fit to the mainstream models she has been asked to accept. It is at this point that the canon of Asian American writers becomes important as representing an established tradition to work with or against as he or she may choose, but at the least, to supply an orientation of the sort the core English curriculum neither can nor should in the detail and richness we are suggesting here. There are canons and canons, and the canon for the department of English will of necessity be different than those of the department of Romance Languages, yet both departments clearly have a stake in, and a responsibility to provide, an introduction to specific ethnic American literatures, and to be clear that those literatures are distinguished among themselves. (The current nastiness about multicultural curriculums too will pass; there is no known civilization that has been destroyed by a change in its school curriculum and reason, or at least reasonableness, will in time prevail.) But to work its magic a tradition must appear living and productive; it cannot be created from yellowed magazines and out-of-print books. One way to achieve this is with warm bodies, living authors; the other, and ultimately more effective because more permanent and further reaching, is to have a body of works in print, books that can be purchased at the book store, read in the library, used as texts—their persistence in time and space validating their worth. A canon, in other words.

Live bodies are frequently available for the classroom, particularly today with the current publishing fad for Asian American subjects having put a covey of authors on the promotion circuit. Fourteen or fifteen years ago things were not that easy. When I was preparing to teach my first course in Asian American literature some 14 years ago I was reminded of the courses I had taken in Korean literature some 14 years before that where the only texts were mimeographed, scrounged out of library stacks, or retrieved by interlibrary loan. *Aiiieeeee!* was late from the press; I was, however, able to produce two of the editors, Frank Chin and Shawn Wong, for my class.

There is another way to get things started on the creative line. Bring the writers together with others who are interested, academics, students, prospective writers. In a conference such as that, the excitement and intensity generated continue to work long after the meetings are over. There were three such conferences in the first decade of Asian American literary studies (Oakland, Seattle, and Honolulu); conferences in which the remaining "old timers," makers of the canon, were able to come together with their aspiring and admiring juniors.

All three were frequently emotional occasions where writers and writing took precedence over academics and analysis. There was a sense of commonality of purpose and shared point of view that could not help but encourage new efforts, new writing. The final accounting for the work started by those three conferences has yet to be made. Certainly a good part of the impetus driving Asian American literary studies, even today, is in part a result of those conferences.

But conferences do not get books published, particularly out-of-print "classics," with what seem to be predictably small readerships. That requires a different kind of commitment. In 1973 when I was first surveying the books in the Asian American literary field I had suggested to the University of Washington Press that they might consider a reprint of Carlos Bulosan's *America Is in the Heart*. The suggestion was received favorably, and all involved were gratified, and perhaps somewhat surprised, by the favorable reception of the book. In the years since the editors at the University of Washington Press have shown a growing commitment to the reprinting of the canon of Asian American literary works as they are now conceived as well as developing an impressive list of scholarly Asian American titles.

This has evolved into a rather lengthy discourse, more about the status of Asian American literature than about the first generation. That is, in part, because those in the field at present are only beginning to pay real attention to the literary statements and accomplishments of that generation.

It only remains for me to quickly run down the existing canon of Asian American literature as I see it. In a way these works represent a first generation also, the first generation of works in the tongue of the new land that makes none of the fatal compromises with the mainstream, language, or tone. I have included only full-length prose works; poetry remains problematic, even now, though Lawson Fusao Inada's *Before the War: Poems as They Happened* stands high on the list, and not only because it was first. The same is true of drama, but again, Frank Chin's *Year of the Dragon* clearly belongs; it would be premature to attempt a sorting out of the increasing number of Asian American plays that are being produced. In fiction, autobiography, and that no-man's-land in between, then, these are the works that stand, upon which the new generations have drawn, across the whole spectrum from shameless imitators to rebellious adolescents. This is the canon then, in no particular order:

Further Reading

Bulosan, Carlos. *America Is in the Heart*. First published 1946, in print, University of Washington Press.

Chu, Louis. *Eat a Bowl of Tea*. First published in 1961, in print, Lyle Stuart.

Holt, John Dominis. *Waimea Summer.* First published in 1976, in print, Topgallent.

Kang, Younghill. *East Goes West.* First published in 1937, reprint 1965, out of print.

Miyamoto, Kazuo. *Hawaii: End of the Rainbow.* First published 1964, in print, Tuttle.

Mori, Toshio. *Yokohama , California.* First published in 1949 but written before World War II, in print, University of Washington Press.

Murayama, Milton. *All I Asking for Is My Body.* First published in 1975, in print, University of Hawaii Press.

Okada, John. *No-No Boy.* First published 1957, in print, University of Washington Press.

Santos, Bienvenido. *Scent of Apples.* Short stories, most first published in the Philippines in 1955, some new, in print, University of Washington Press.

Sone, Monica. *Nisei Daughter.* First published 1953, in print, University of Washington Press.

First-Generation Writings

Younghill Kang and Carlos Bulosan

S.E. SOLBERG

This is a simple story. So long as there is immigration from Asia there will be a first generation serving both as creator and subject for Asian-American literature. Call them *F.O.B.s,* F.O.J.s, or borrowing a term from an earlier generation, greenhorns, these are the peoples whose stories are frequently, and rightly, lumped under such innocuous titles as "the new Americans" or "becoming American." But the stories are seldom innocuous for they all constitute variations on the epic immigrant theme: uprooting, removal, and the new life in the promised land.

The typical story begins in an Asian village from which the promise of America is seen through an awareness of the modern world of canned foods, simple technology, and, frequently, missionaries. The next step is the break with tradition, which may or may not be equated with departure for foreign, or American, shores. Then follows the record of the hardships encountered on this new soil leading to an affirmation of accomplishment, no matter how ambiguous. For the more contemporary experience, the story will probably begin in an urban setting, indifferently slum or middle class, in countries well past that initial break with tradition that marked their entry into the modern industrialized world. The rest of the story remains the same.

These first-generation stories are, after all, success stories. To suggest a spectrum, they range from the simple, or simplistic, Horatio Alger pattern to the heroic quasi-tragic pattern of a *Giants in the Earth*. In the end it is the author's vision and literary skill that makes the lasting work, whether in his native tongue or borrowed English. We have, I hope, moved beyond the point where the mere fact of ethnicity of author and subject supersedes simple literary skill. There is a large body of literature out there that is primarily of interest to the specialist (and, in its own way, to the ethnic community), but

which fails to be an adequate account of the immigrant, first-generation experience for lack of adequate vision or skill. This is a loss, but a small loss, given the major works that have been written.

The naming of generations in America is most clear in the Japanese and Korean communities, but what is first for one is second for the other, that is, Japanese Isei is first generation, Korean Isae is second generation; Japanese Nisei is second generation while Korean first generation is Ilsae. The terminological confusion is minor, however; the first generation will continue to be whatever it is, making only the necessary adjustments for survival in America. For this is the generation of divided hearts, of exiles (as Ben Santos or Paul Tabori would have it), of men caught between loyalties and opportunities, between politics, war, and chance, who always are going back, yet never or seldom do. The second generation are another story, beginning in America. The one-and-a-half generation, as the Korean-born, but mostly American-educated children of present-day Korean immigrants have been characterized, are themselves another story: Eurasian complexities without the mixing of bloods. This is, of course, not a Korean story alone; it belongs to all our rapidly growing immigrant and refugee communities.

Of the immigrant stories written by the first generation in English, two, at least, stand out as major works in the canon of Asian American literature, Younghill Kang's *The Grass Roof* and *East Goes West,* and Carlos Bulosan's *America Is in the Heart.* Kang's work predated Bulosan's by about a decade, and Bulosan gives Kang credit for being one of his models when he began to write (also for helping him understand "the Korean revolutionary movement," whatever that may have meant). Yet, while Younghill Kang enjoyed both international and national acclaim in the 1930s, somehow, in the reification of the Asian American literary tradition that began in the late 1960s and early 1970s he has been, if not ignored, at the least, slighted. This is really too bad, for the only other Korean we find in the old immigrant generation is Philip Jaisohn, whose self-published *Hansu's Journey* was hardly a best-seller (and seems to exist only in the Library of Congress' depository copy today). The story both Kang and Bulosan had to tell was the immigrant epic.

Younghill Kang took two roughly autobiographical novels to tell his story: *The Grass Roof,* which details his growing up in traditional Korea, the break with tradition that occurred, for his characters, with the occupation of Korea by Japan in the first decade of the twentieth century, and ends with the protagonist on his way to America after the abortive March 1, 1919 Independence movement in Korea. The themes of modernization (Westernization) and the conflict with tradition and traditional values are dramatized against the backdrop of Korea's struggle to maintain and regain independence from Japan.

The second volume, *East Goes West,* carries the story from arrival to happiness of a sort with impending marriage, to a white. The hurdles of discrimination in jobs and opportunities are overcome, so far as they can be, by the usual hard work, hard study, and determination. There is a constant contrast between the traditional Korean way of life and modern (1920s New York) America: the depersonalization of individual life in an aggressively capitalist society, the conflict of the idealized America with the fact, the continued criticism of Western civilization for not acting as it preaches (begun in *The Grass Roof*) inform the work.

The pattern is clearly preserved in Bulosan's *America Is in the Heart*: the opening sections in Pangasinan, the clash of modern (Western) values with tradition, the breakdown of traditional values under the hands of the colonialists (American rather than Japanese in this case), education and the dream of America, and, in this instance, the quintessential picture of America as "vamp," to use a somewhat dated but very exact expression. As P.C. Morantte has described this relationship, both in Bulosan's life and his writing, America is the woman who promises but never gives, yet whose allure is strong enough to maintain the idealized America that is in the heart that continues to entrance and entrap the immigrant despite the day-to-day record of rejections and withdrawals. This is, is it not, the image behind all immigrant sagas, the image of America as siren or Lorelei?

Both Bulosan and Kang write straightforward narrative, putatively autobiographical, chronological, and clear. What happens when the author strays into more complex literary forms? An instructive example is Louis Chu's *Eat a Bowl of Tea,* a book we do not commonly think of as constituting an immigrant saga, for it is a novel set in an existing Chinatown (New York). Yet, regardless of generation, the bulk of the characters are immigrants due to the racist vagaries of American immigration law forcing the older generation of males to father their sons and daughters during brief interludes back in the home village in China. Despite fathers living in the United States, both Ben Loy and Mei Oi were born in the village and reared by their mothers until they came of an age when they could join their fathers in American Chinatown, the son when he became old enough to work, the daughter when she came of marriageable age.

Behind the more sophisticated trappings of the comedy of manners that *Eat a Bowl of Tea* is, lies the same tale of traditions in conflict, of the struggle to overcome hardships in the new land, the ultimate triumph over adversity, or, at least, that part of adversity necessary to the plot. The promise of the future may be ambivalent or ambiguous, but it remains a promise nevertheless. Anything less would be travesty.

Asian American Autobiographical Tradition

BRIAN NIIYA

Asian Americans publish a lot of autobiographies. No matter how one defines "Asian American" and no matter how one defines "autobiography," there are plenty out there. In *Asian American Literature: An Annotated Bibliography,* there are at least 50 books that are unambiguously autobiographies. This number does not include nonfiction works containing biographies or oral histories of Asian Americans, non–book length or unpublished autobiographical works, or the numerous autobiographical novels by Asian American authors. In proportion to the total number of Asian American literary works, 50 is a sizable number, enough for us to talk about an Asian American autobiographical tradition.

Why do Asian Americans publish so many autobiographies? The question becomes even more interesting when we discover that in the Asian countries from which Asian immigrants originally arrived, there seems to be little auto-biographical tradition. China, Japan, and Korea share a Buddhist/Confucian/Taoist tradition that reflects itself in literature. Virtues such as loyalty to the king/emperor, filial piety, and respect for seniority abound. Additionally, Asian cultures tend to place less importance on individual achievement than on com-munal or familial welfare. According to Marie Ann Wunsch:

> Some of the reticence to use personal experience as the subject for litera-
> ture clearly springs from the Asian cultural subject for heritage. With the
> Chinese, for example, literary and social tradition are frequently interwo-
> ven. Unlike much of Western literature, the thematic concern is more often
> on what the characters do in their social roles rather than what they do
> and feel as individuals.

It was out of the value placed on the individual that the Western autobiographical tradition arose with the confessionals of the Renaissance period. No comparable tradition arose in the Asian countries.

There were certainly literary differences among the Asian countries. In Japan, for instance, there was a genre called the *watakushi shosetsu*—literally, the autobiographical novel. However, these works were the exclusive territory of the Japanese elite. The genre is not shared by the poorer classes that made up the bulk of American immigrants. Perhaps because of Korea's turbulent history, there were autobiographical writings by poor people such as Gyun Ho, seventeenth century revolutionary and the author of the autobiographical novel *The Story of Gil-dong Hong*. One critic, In-sob Zong, writes that this work "is considered generally to be the first Korean work of fiction and so may be regarded as epoch-making." Ho's book tells the story of a Robin Hood figure who tried to reform the class structure. Because Korea was constantly being invaded, there was more opportunity for writers to use the autobiographical form for political purposes, though not many did. Ho's execution may have had something to do with the scarcity.

However, the Asia that the early immigrants to America left was not the Asia of tradition. By the late nineteenth century, the Western invasion of Asia left China, Japan, and Korea in a state of transition. Christianity and modernization brought with it a new emphasis on individualism. Irena Powell writes: "Japanese literary historians generally agree that the rise of individualism—the subjective, individualist and private orientation of life and literature which has taken place in the last two hundred years in Europe, occurred in Japan only at the beginning of the century" In the Philippines, because of colonization the Western influence was even greater. Once the Western influence began to take hold, we begin to see the rise of autobiography in Asia. By the 1930s, the most prominent literary style in Japan would be the "I-novel," a transparently autobiographical genre.

The point here, however, is that in looking for an answer to the question of why there is so much Asian American autobiography, we need not look too far into Asian culture. Autobiography is not found in Asian peasant culture and became prominent in Asia only after the infiltration of Western ideas. Elaine Kim writes:

> Then, too, autobiographical writing and popular fiction were not in the tradition of the Asian cultures that produced the first immigrants. Even in the Philippines . . . the majority of peasants had not the privilege of schooling, and most of the Filipino immigrants were illiterate. In China and Korea, writing and literature were the domain of the literati, who

traditionally confined themselves to poetry and the classical essay. Autobi-
ography as such was virtually unknown, since for a scholar to write a book
about himself would have been deemed egotistical in the extreme.

In looking for clues about the Asian American autobiographical tradition, then, we must look not at Asia but at America. In this introduction, we will take a different approach to Asian American autobiography, one which takes into account the social and historical context of Asians in America.

The Collective Self

I believe that the idea of the "collective self" provides the key to understanding the Asian American autobiographical tradition. Most of the time, autobiographies tell the story of only one life and are read with the realization that they speak for no one but the author. Generally, the autobiographer is a person who is already famous for other reasons and whose unique life experiences do not encourage the readers' identification. Such autobiographers can write with the knowledge that they speak only for themselves and that their works will be read that way. In such cases, we might call the self in these autobiographies an "individual self."

Many autobiographies, however, are written not by famous people, but by people who are for all intents and purposes unknown. Such autobiographies are published and read presumably because they tell us something not only about the individual author but also about some group to which the author belongs. For example, we read Claude Brown's *Manchild in the Promised Land* not because we care about Brown per se, but because we want to know how the black poor in the urban ghettos think. Naboth Mokgatle's *The Autobiography of an Unknown South African* serves as a more blatant example since its title even tells readers that they have no reason to know about the author as an individual. The selves in these autobiographies are what I mean by a "collective self." Such books are written with the knowledge that people are reading to get insight about a group. Such books consciously speak not only for the author but for that group. As is true in the above examples, the collective self is often employed by members of a minority or alien group writing to members of a majority or ruling group.

The vast majority of published Asian American autobiographies have one thing in common: they are written by people known for little else except their autobiographies. In fact, of the 50 plus Asian American autobiographies I could find, only one was written by a person famous outside his

immediate community. The one is *Journey to Washington* by Hawaiian Senator Daniel
K. Inouye. Although many other autobiographies have been written by such com-
munity leaders as Mike Masaoka or Manuel Buaken, Inouye is the only Asian
American figure of national prominence to write such a book. In the majority of
these cases, the collective self operates: people read these books as if they speak
for some group. But there is something a little different going on here. For un-
like most unknown autobiographers, unlike Claude Brown and Naboth Mokgatle,
most of these Asian Americans *were not writing books intended to speak for their group.*
The story of the Asian American autobiography is the story of the collective self
imposed on writers who never intended it. For years, publishers turned out auto-
biographies that presented a one-dimensional picture of the Asian American ex-
perience, knowing that the public would read these books as the "truth" about
Asian Americans. They did so because they had a preconceived notion of what Asian
Americans should be like and an interest in conveying a particular political mes-
sage. And what better way to get this message across than to have it come from
the pens of the people it would most affect? By looking at the historical context,
we can see what message was being presented and why.

Publishing Optimism

One other element that practically all Asian American autobiographies written
before 1976 have in common is optimism. The impression one gets from reading
these books is of a happy population. Given the not-so-happy history of Asians in
America, this optimistic view is somewhat puzzling. But if these autobiographies
were selected by the publishers to convey a particular message, this optimism is
less puzzling. During World War II, while Japanese Americans on the West Coast
were being held in concentration camps, happy autobiographies by two Chinese
Americans, Jade Snow Wong and Pardee Lowe, were written and published and
Wong's was to become the most widely read piece of Asian American literature
until the 1970s. During the mid-1960s, while ghettos burned and racial minori-
ties took to the streets, more happy autobiographies such as those by Daniel
Inouye and Daisuke Kitagawa appeared, illustrating the virtue of hard work and
belief in the system. Until the mid-1970s, nearly all published Asian American
autobiographies were books that supported the status quo. The periods when
the most, and the most popular, books appeared coincided with periods when
the status quo was questioned the most. Only with the advent of ethnic studies
in the universities in the 1970s did autobiographies supporting alternative points

of view begin to emerge, often published by the universities themselves. But the years of happy autobiographies had certainly taken its toll.

There have been few exceptions to this story of optimism, an imposed collective self, and the presentation of only a limited viewpoint. A few do exist, however. In the late 1930s and early 1940s, a number of books appeared that took a hard hitting look at a society and seriously questioned its militaristic and imperialistic tendencies. Not surprisingly, the object of this scrutiny was Japan and not the United States. In the mid-1940s, two other books appeared that presented a less than rosy view of this country—*America Is in the Heart* by Carlos Bulosan and *Citizen 13660* by Mine Okubo. Okubo's book presents an honest view of America's concentration camps through drawings and text. However, it never directly criticizes the treatment accorded Japanese Americans and emphasizes the humor and resourcefulness of the internees over the anger and bitterness. Bulosan's book is remarkable for its intense look at the dark side of the American dream and at the treatment accorded America's Filipino immigrants and farm workers. Bulosan clearly writes this book with the purpose of inducing reform. But for all its criticism of America, optimism dominates even this book. No matter what happens to Bulosan in the book, he never loses faith in the idea of America. Additionally, parts of *America Is in the Heart* first appeared during World War II. It is interesting to note that the book ends with the Japanese invasion of the Philippines and the volunteering of Bulosan's brother for the U.S. military. So even a book that has a conscious reform motive carries a propaganda message against the Japanese and actually gives a ringing endorsement to the American system. Perhaps the muted nature of the protest in these books and their general optimism were prerequisites for their being published.

Other Publishing Trends

When we look at the first "Asian American" autobiographies—those written by Asian visitors and immigrants to the United States, a great number of which appeared in the 1960s—we notice other striking trends. One is the profusion of women autobiographers, given that the number of Asian immigrants who were women was minuscule compared to the number of men at the time. Yet more women than men published autobiographies. Assuming that publishers reflect public taste, it seems safe to say that this phenomenon reflected the American public's preference for autobiographies by Asian women over those by Asian men. This preference may be a foretaste of the public's embrace of Asian American women novelists, like Kingston and Tan.

Part of this is no doubt a natural inclination on the part of Americans to feel more sympathetic to the "weaker sex" than to the one seen as posing more of a threat. Certainly this phenomenon has not been limited to Asians—consider the stereotypes of Native American or African American women vis-à-vis the men. The negative stereotypes that Asian men had acquired by the onset of World War II also no doubt fueled this tendency. Beyond this inclination, however, these books by Asian women appealed in different ways to male and female readers or perhaps to liberal and conservative audiences. Practically all of the women autobiographers address feminist issues to some extent. Practically all of them attack their traditional cultures for repressing women and praise the West for allowing women more freedom. To the more liberal American women of the middle and upper classes, such stories were no doubt ones they could identify with.

But more conservative and/or male readers could also enjoy these books. Although most of these books support a generally liberal point of view, it is certainly possible to read them in such a way as to bear out the prevalent stereotype of Asian women as the exotic and deferential Oriental beauty. If the reviewers are in any way typical, such a perspective may have been typical. For example, about Shidzue Ishimoto's *Facing Two Ways,* Rose C. Feld writes "Labor reform, feminism, birth control—these are strange subjects to come from the pen of one who looks like a lovely print by an old Japanese master of the brush." In one review of Haru Matsui's *Restless Wave,* Bradford Smith uses the words "charm" or "charming" no less than three times. It is striking that in the reviews for the especially political books by Baroness Ishimoto, Haru Matsui, and Yoko Matsuoka, reviewers repeatedly praise the early parts of these books—the parts that describe childhood and Japanese culture and customs—over the later, far more political parts. For example, in her review of Ishimoto's *Facing Two Ways,* Feld writes that "it is the pages that deal with her childhood and youth that will bring the greatest delight to her American readers." In another review of this book, Amy Loveman writes, "It is to her visits to America and Europe, her Western friends, and her feminist activities that the second half of Baroness Ishimoto's book is devoted. Less picturesque than the first, it is still interesting and revealing." Harold Henderson's review of *Restless Wave* echoes this sentiment: "The later part is both interesting and important, but it is not confined to personal experiences, and hence lacks the vividness and the direct simplicity that make the earlier Japanese scenes a part of the reader's own life." Two more reviews of *Daughter of the Pacific* continue this theme. Trudi Osborne writes, "Miss Matsuoka is most successful in the first two-thirds of her book where our interest is focused on her personal reaction to events." The review in *The Booklist* is more blunt: "The picture of her girlhood is interesting,

but her interpretation of Japanese thinking is not convincing." These reviews had a tangible effect in one case: the first half of Ishimoto's book was republished by itself a few years later under a different title, effectively gutting the book's main argument. All these review excerpts suggest the idea that the "charming" Asian woman loses her charm if she gets too political.

The second commonality is Christianity. To differing degrees, every author discussed in this chapter has been a Christian. The importance of Christianity varies greatly in each book: in both pairs of books by Kiyooka and Mishima, Christianity is hardly a factor; in Jade Snow Wong's book, an entire section (consisting of three chapters) is entitled "Why We Became Christians." To the predominantly Christian American readers, the uniform Christianity of these authors serves to reinforce the cultural bridge idea and to subtly suggest the superiority of Western thought.

The third trend in these books is that in an era marked first by large scale labor migration from Asia and later by settling of these immigrants (overwhelmingly male) in largely poor ethnic ghettos or in migrant farm worker camps, the majority of published English-language autobiographies by Asians that got published were those that reflected the perspective of rich female visitors.

Hence we may say that the publishers, through selection, appealing to the audiences taste, inadvertently but inevitably imposed a false "collective self" on Asian Americans of that time. The people who read only those books learned nothing about the experience of those people whom we would today call "Asian American."

Further Reading

Cheung, King-Kok, and Stan Yogi. *Asian American Literature: An Annotated Bibliography.* New York: Modern Language Association, 1988.

Feld, Rose C. "A Woman of Old and New Japan." Review of *Facing Two Ways: The Story of My Life* by Baroness Shidzue Ishimoto. *New York Times Review,* 25 (Aug 1935): 5. She goes on to add that people "will welcome a narrative that holds the magic charm of an exotic land of moonlight and lotus blossoms."

Henderson, Harold. "Japan from Inside." Review of *Restless Wave* by Haru Matsui, *Saturday Review of Literature* (Jan. 27, 1940): 6.

Ishimoto, Shidzue. *East Way West Way: A Modern Japanese Girlhood.* New York: Farrar & Rinehart, 1937.

Kim, Elaine H. *Asian American Literature: An Introduction to the Writings and Their Social Context.* Philadelphia: Temple University Press, 1982.

Loveman, Amy. "Born to Change." Review of *Facing Two Ways: The Story of My Life* by Baroness Shidzue Ishimoto. *Saturday Review* (Aug. 31, 1935): 13.

Osborne, Trudi. "A Lady of Japan." Review of *Daughter of the Pacific* by Yoko Matsuoka. *New York Times Book Review* (Mar. 2, 1952): 16.

Powell, Irena. *Writers and Society in Modern Japan.* London: The Macmillian Press Ltd., 1983.

Review of *Daughter of the Pacific* by Yoko Matsuoka. *The Booklist* (Apr. 1, 1952): 245.

Smith, Bradford. "The Japanese Woman." Review of *Restless Wave* by Haru Matsui. *New York Herald Tribune Books* (Mar. 31, 1940): 4. (1) "Any one who has lived in Japan remembers the charming combination of delicacy and strength which characterizes the Japanese woman." (2) "For this book has the charm one feels in the quiet presence of a Japanese lady." (3) "And it must be admitted that this restraint is a part of her charm."

Wunsch, Marie Ann. "Walls of Jade: Images of Men, Women and Family in Second Generation Asian-American Fiction and Autobiography." Diss., U of Hawaii, 1977.

Zong, In-sob. *An Introduction to Korean Literature.* Seoul: Sam Young Printing Co., Ltd., 1970.

Frank Chin

First Asian American Dramatist

JEFFERY PAUL CHAN

Frank Chin (b. 1940) presents without doubt the most perceptive, most inventive literary sensibility to emerge from the post Exclusion Act Chinatown communities at the end of World War II. Novelist, playwright, essayist, actor, teacher, polemicist, raconteur, he has laid the foundation for the first critical appreciation of Asian American writing and established the terms for its definition, for its critical measure in America's literary canon, beyond the Christian missionary autobiographies and Chinatown tour guides that represent the accepted English language descriptions of Asian American culture of the day.

In the essay "Racist Love" (*Seeing Through Shuck*, ed. Richard Kostelanetz. New York: Ballantine Books, 1972), Chin dissects the anatomy of the positive white racist stereotypes of the Asian American minority reflected in white popular culture, exotic immigrants, their well-behaved American-born offspring, dismissing the illusion of acceptance as a racist pathology that infects a self-contempt to encourage their cultural assimilation qua extinction. In a second essay to introduce *Aiiieeeee!* (*An Anthology of Asian-American Writers*, ed. Chin et alia. Washington, D.C.: Howard University Press, 1974), he begins an historical survey of Chinese and Japanese American writing in which he requires readers to consider the mix of Asian American histories, issues surrounding the use of language, the authors' points of view, the intended audience, the particular sensibilities that are shaped by the American minority experience as introductory criteria by which Asian American literary works might be compared to each other, and to distinguish them from other American literatures. In a third essay, "Come All Ye Asian American Writers of the Real and the Fake" (*The Big Aiiieeeee!*, ed. Chan et alia. NY: New American Library, 1991), Chin requires that the serious writer as well as the serious reader be familiar with the basic myths, legends, and histories that inform East Asian cultures if Asian American writing is

to distinguish the "real" from the "fake"; that is, to know the difference between what is in fact Asian and what is not.

Chin counts himself a fifth generation Chinese American, the son of a Chinese immigrant father and a fourth generation Chinatown mother whose father worked as a steward on the Southern Pacific Railroad. He proudly claims that he was the first Chinese American brakeman for the Southern Pacific since the early Chinese built the Central Pacific over the Sierras in 1865. After graduating from University of California, Santa Barbara in 1966, he wrote and produced documentaries for the King Broadcasting Company in Seattle, Washington. Then, in 1973 and 1974, the American Place Theatre of New York produced *The Chickencoop Chinaman* and *The Year of the Dragon* (University of Washington Press, 1981), both of which found broad critical attention for his controversial portrayal of the Chinese American experience. At the same time, the American Conservatory Theatre of San Francisco invited Chin to help form the Asian American Theatre Workshop which he directed until 1977.

Chin has also written extensively on Japanese American history, in particular on issues pertaining to the World War II Japanese American internment. He helped to organize the first "Day of Remembrance" in Seattle, Washington, during which thousands of Japanese Americans reenacted their imprisonment at the Puyallup County Fairgrounds, which had been converted into concentration camps for the **Nikkei** in 1942. Public demonstrations such as these focused public attention on the several issues of injustice that mark this historical infamy and would lead to public apologies and financial compensation in the decade to follow. Inspired by the work of Nikkei author John Okada (*No-No Boy,* University of Washington Press, 1976) he maintains a particular interest in the draft resistors, *"no-no boys,"* who dramatized the injustice of the incarceration by refusing to serve in the American military during World War II.

Chin has taught Asian American history and ideas at several schools and universities, and he helped to organize the first Asian American literature curriculum at San Francisco State University in 1970. His most recent efforts focus on the retelling of popular stories and operas from the Chinese fairy tale and heroic tradition for the multicultural classroom that have been published in comic book format traditional in Chinese popular culture. (See "Rescue at Wild Boar Forest" and "Ling Chong's Revenge" from Shi Na'an's *The Water Margin,* Water Margin Press of Canada, 1988–89.)

A collection of Chin's short fiction, *The Chinaman Pacific & Frisco R.R. Co.* and a novel, *Donald Duk* (both published by Minneapolis, MN: Coffee House Press, 1988, 1991), and a second novel, *Gunga Din Highway* (1994), provide the best and

most compelling evidence signaling an original American literary voice. Their texts writhe and snap demanding close attention to a generation of Asian Americans whose histories were shaped by racist immigration laws that severed Asian immigrants and their progeny from their homeland and forced an assimilation process as insidious as Christian settlement houses and as demonstrably genocidal as the World War II internment camps. The eclectic cultural geography that informs his unique literary landscapes includes the gypsy flamenco enclaves of his native North Beach district of San Francisco, which he compares to his own Chinatown community, his Cantonese heritage peopled by traditionally contentious rebels, individualistic, arrogant, and above all, loyal to the history, language, and culture from which they descend. His characters are Taoist warriors, the philosopher strategists who ply the rise and fall of kingdoms, the stars of the Cantonese opera, railroad workers, the cooks, the gamblers, musicians, all of them in the guise of immigrants minding one another and, inevitably, their American-born children who so often believe that they must forget the language and history of their parents in order to become acceptably American. Chin's Asian American heroes warn against cultural amnesia and the racist promise of acceptance America proffers.

Works by Frank Chin

Fiction

"The Chinatown Kid," short story, in *Cutting Edges*, ed. Jack Hicks. Holt, Rinehart & Winston, 1973.

"A Chinese Lady Dies," novel excerpt, *Carolina Quarterly*, vol. xxiv, no. 1.

The Chinaman Pacific & Frisco R.R. Co. Short stories. Minneapolis, MN: Coffee House Press, 1988.

Donald Duk, a novel. Coffee House Press, 1991.

"The Eat and Run Midnight People," short story. *Chouteau Review*, vol. 1, no. 3, Fall/Winter 1976, Kansas City, MO.

"Food for All His Dead," short story, *Contact*, vol. 3, no. 3, San Francisco, 1962. Anthologized in *The Young American Writers*, ed. Richard Kostelanetz, Funk and Wagnalls, New York, 1967; *The Urban Reader*, Prentice Hall, 1971; *Asian American Authors*, ed. Kai-yu Hsu, Houghton Mifflin, 1972; *Psych City*, ed. Robert Cohen, Pergamon Press, 1973.

"Goong Hai Fot Choy," short story, in *19 Necromancers from Now*, ed. Ishamael Reed, Doubleday, 1970.

Gunga Din Highway, a novel. Coffee House Press, 1994.

"I Am Talking to the Strategist, Sun Tzu, About Life When the Subject of War Comes Up," short story, *Amerasia Journal*, vol. 17, no. 1, Los Angeles, 1991.

"The Most Popular Book in China," short story, in *Quilt 4*, Berkeley, 1984.

"Railroad Standard Time," short story, *City Lights Journal*, Spring 1978, San Francisco.

"Yes, Young Daddy," short story, in *Panache*, Princeton, New Jersey, 1971. Anthologized in *In Youth*, ed. R. Kostelanetz, Ballantine Books, 1972.

Plays

The Chickencoop Chinaman and *The Year of the Dragon,* introd. by Dorothy Ritsuko McDonald, University of Washington Press, Seattle, 1981. "The Chickencoop Chinaman" was first presented by the American Place Theatre, New York, 1972. Jack Gelber directed. "The Year of the Dragon" was first presented by the American Place Theatre in 1974. Russell Treyz directed. It was also produced by the *Theater In America* series and first aired on PBS in 1975.

"Flood of Blood," a play in one act. *Seattle Review,* vol. xi, no. 1, Spring/Summer 1988.

"Gee Pop!" first presented by the American Conservatory Theatre, San Francisco, in 1974. Edward Hastings directed.

Anthologies

Aiiieeeee! An Anthology of Asian-American Writers. Howard University Press, Washington, D.C., 1974.

Yardbird Reader. vol. 3. Yardbird Publishing Cooperative, Inc. Berkeley, 1974.

The Big Aiiieeeee! New American Library, New York, 1991.

Comic Books

Rescue at Wild Boar Forest. Water Margin Press, Calgary, 1988.

Lin Chong's Revenge. Water Margin Press, Vancouver, 1989.

Selected Nonfiction

"Bus to America." *The San Francisco Fault,* vol. 1, no. 1, 9/28/71.

"Chinamen, Chinks & the CACA." *East/West Chinese American Journal.* San Francisco, 2/11/70.

"Confessions of a Chinatown Cowboy." *Bulletin of Concerned Asian Scholars,* Fall 1972, vol. 4, no. 3, San Francisco.

"Confessions of a Number One Son." *Ramparts,* vol. 11, no. 9, 3/93, San Francisco.

"Don't Pen Us Up in Chinatown." *The New York Times,* 10/8/72.

"From the Chinaman Year of the Dragon to the Fake Year of the Dragon." *Quilt* 5. Berkeley, 1986.

"In Search of John Okada." *The Weekly of Seattle,* vol. 1, no. 14.

"James Wong Howe: The Early Years 1899–1936; The Marriage, 1941–1970." *Yardbird Reader,* vol. 3, with Shawn Wong.

"Kung Fu Is Unfair to Chinese." *The New York Times,* 3/24/74.

"The Last Charlie Chan of the Movies." *Amerasia Journal,* vol. 2, Fall 1973, Los Angeles.

"Our Life Is War." *The Weekly,* 5/4–5/20/83.

"Racist Love," Chin and Jeffery Paul Chan in *Seeing Through Shuck,* ed. Richard Kostelanetz. Ballantine Books, 1972.

"This Is Not an Autobiography," *Genre.* University of Oklahoma, vol. xvii no. 2, 1985.

"Yellow Seattle," *The Weekly,* vol. 2, no. 45.

Maxine Hong Kingston

AMY LING AND PATRICIA P. CHU

Of all Asian American writers, Maxine Hong Kingston is undoubtedly the best known, best loved, and most widely respected. Her books are accomplished works of art, and her public positions on pacifism and bilingual education in the face of powerful opposition are both selfless and courageous. Her first book, *The Woman Warrior*, won the National Book Critics Circle award for the best nonfiction of 1976, after which Kingston was showered with numerous other awards, including the rare title of Living Treasure of Hawaii bestowed by a Buddhist group in 1980. *China Men* (1980) won the American Book Award for 1981; her novel *Tripmaster Monkey* (1990) received the Pen West Award for fiction. She holds honorary doctorates from universities throughout the United States. Numerous interviews with her have been printed in national and local newspapers and journals; she has been televised and filmed. The best film is *"Maxine Hong Kingston: Talking Story"* (1990), directed and edited by Joan Saffa and available through CrossCurrent Media in San Francisco. In the 1980s her first two books were the most frequently taught texts on college campuses by any living American writer. In 1991, recognizing her popularity in the curriculum, the Modern Language Association published *Approaches to Teaching Maxine Hong Kingston's The Woman Warrior*, placing her in a series that includes such authors as Homer, Shakespeare, Chaucer, Dante, Goethe, Milton, and Camus. As a final measure of her stature, *The Woman Warrior* may now be found on doctoral reading examination lists, including those at the University of Wisconsin.

Maxine Ting Ting Hong Kingston was born on October 27, 1940 in Stockton, California, the eldest of six children. Her mother, Ying Lan Chew, a respected doctor/midwife in China, had to be resigned to working as a laundress and field hand in the United States. Her father, Tom Hong, a scholar/teacher in China, struggled for a living as a laundryman and gambling house manager in the United

States. Kingston majored in English Literature at the University of California, Berkeley, graduating in 1962 and marrying classmate Earll Kingston, an actor, in the same year. She earned a secondary teaching credential in 1965 and joined in the marches against the Vietnam War. The couple have one son, Joseph, born in 1963. In 1967, the young family moved to Honolulu, where they lived for 17 years. In 1984, Kingston and her husband returned to California, leaving behind Joseph, who preferred to remain in Hawaii. In the fall of 1991, Kingston's house and almost 200 pages of manuscript were burned in the Oakland fire. She is now professor of creative writing at the University of California, Berkeley.

At its appearance, *The Woman Warrior: Memoir of a Girlhood Among Ghosts* created a sensation in literary and scholarly circles. Prepared by the Civil Rights and the Women's Liberation movements, readers could appreciate Kingston's voice and her themes. The Civil Rights and Women's Liberation movements, seen retrospectively, were major social and political revolutions of the 1960s and early 1970s during which African Americans (joined by other racial minorities) and feminists asserted, demanded, and demonstrated for equal rights, opportunities, and salaries in the workplace and shared labor in the home. Though Kingston's book spoke of being physically weak because of continual devaluation, both by a patriarchal Chinese culture and by the white-dominated society, her voice was strong and angry in its protest against sexism and racism. *The Woman Warrior* was an experiment in genre, an autobiography that crossed into fiction without recognizing boundaries. It recounted seemingly outlandish Chinese stories and superstitions as well as made easy reference to Anglo-American authors and traditions. It mixed American slang and striking poetic metaphor. It was a personal sorting out of the author's particular Chinese American female identity as well as the story of every second-generation immigrant experience. It was a voice that was simultaneously exasperated by and proud of its Chinese American heritage, the voice of a daughter both angry and loving toward her mother. "I learned to make my mind large, as the universe is large, so that there is room for paradoxes," wrote Kingston, and her text itself is composed of such paradoxes.

Readers' responses to Kingston's work provide an informal sample of the public's ideas about Asian Americans and Asian American writing. As Kingston has noted, many mainstream reviewers of *The Woman Warrior* were quick to talk about the book's "exotic" oriental qualities, to assess whether it fit their existing impressions of Chinese or Chinese Americans, or to view it as a handy and reliable window into Chinese culture or psychology. These responses, which are still typical responses to Asian American texts today, are all problematic. By calling someone an exotic, inscrutable, or mysterious oriental, one implies that he or she is in es-

sence inexplicable, and one excuses oneself from recognizing the full complexity and humanity of that person. Hence, reviewers who praised the text as exotic, or criticized it as not so, were insisting that it conform to a belittling orientalist stereotype. (See Chapter 45 for a full discussion of orientalism.) The other responses are also problematic because one text could not fairly be expected to represent so many people, and because these responses do not fully recognize the author as an artist, rather than a historian or ethnologist.

Equally interesting have been Chinese responses to Kingston's books, which have undergone multiple Chinese translations. Zhang Ya-jie and Quin-yun Wu, two scholars from the People's Republic of China (PRC), have published thoughtful responses in American journals. Zhang, reading *The Woman Warrior,* was at first put off by Kingston's revisions of traditional Chinese stories, which she felt were "somewhat twisted, Chinese perhaps in origin but not really Chinese any more, full of American imagination"; she was also jarred by the narrator's disclosure of family secrets, seeming bitterness toward her mother, and generalizations about the Chinese. However, she later came to see these as valid elements of a Chinese American's coming-of-age story, rather than flaws in a Chinese story. Quin-yun Wu, another Chinese-born reader, records excitement at learning how to interpret *China Men*'s imaginative retelling of beloved stories from Chinese folklore and classical literature; respectful dissent from Kingston's mixed, but predominantly negative, portrayals of Communist China; and growing respect for the Chinese American men whose history is mythologized in *China Men.* For these and many other Chinese, Kingston is a distinctly American writer with Chinese roots. Yet, Wu observes, Kingston seems more interested in Chinese culture than some PRC writers who, in an effort to shake off the burden of their 5,000-year history, have recently been seasoning their work with references to Greek mythology, the Bible, and Shakespeare. Other Chinese writers, according to Kingston, feel cut off from their cultural roots by the PRC's Cultural Revolution (a period in the 1960s when violent political upheaval, combined with state-sponsored attacks on traditional culture, resulted in the loss of much traditional learning). These writers are creating a new Chinese "roots literature," in which they include Kingston's work. Perhaps the most interesting Chinese-educated reader, however, is Kingston's scholar father, who has literally inscribed his own comments, in Chinese, on personal copies of his daughter's books.

In the United States, literary scholars have extensively explored Kingston's feminist themes and innovations in the genres of fiction and autobiography. Many Asian American women have identified with Kingston's girlhood struggles, and some Asian American scholars, notably Elaine Kim and Amy Ling, have placed

Kingston's work in the contexts of Asian American or Chinese American history, sociology, and literary history. Most recently, Patricia Lin has demonstrated that *Tripmaster Monkey* reverses the traditional Eurocentric, or European-centered, gaze of anthropology—a stance in which white anthropologists study people of color from a European point of view. Reversing this gaze, Kingston explores how some Chinese Americans see American culture. For Lin, Kingston's work is a new kind of ethnographic document: instead of treating readers to a conventional literary tour of Chinese culture, her text asks mainstream Americans to see *themselves*— or at least mainstream American culture—through the unfamiliar lens of a Chinese American consciousness.

Finally, Kingston has become the center of debates about the responsibility of Asian American artists to portray their communities "authentically." This can mean "accurately," "favorably," or both. As critic Sau-ling Wong notes, requiring both accuracy and positiveness is contradictory and inimical to literary excellence, since life itself is not limited to favorable experiences and desirable role models. In particular, author Frank Chin has vociferously denounced Kingston's work as unfaithful to Chinese legends and assimilationist in tone, while others rejoice that at last someone speaks for them. At stake in the authenticity debate is a central question for all minority writers: who should have the right to determine what a community's "authentic" experiences are and how they will be represented to outsiders? Broadly speaking, Kingston's critics tend to define Chinese American authenticity more narrowly than her defenders. The latter group—an overwhelming majority in academic circles—tends to celebrate a broader range of experiences, opinions, and modes of representation as acceptable representations of Chinese and Chinese American experience. The authenticity debate is also rooted in gender conflicts that Asian Americans seem to share with other minority communities. Like others, Asian American men and women encounter both opportunity and discrimination in different forms. As a result, they respond differently to texts like *The Woman Warrior,* in which women publicly criticize male sexism within their community. They argue about whether such criticism is disloyal and harmful to the men or to the community as a whole.

This wide spectrum of responses reveals the difficulties Asian American authors face in negotiating others' expectations when so few writers are perceived to be representing so many. Both Kingston's critics and her supporters agree, however, that the dangers of misrepresentation are best overcome by exposing the public to many, many more Asian American writings, rather than relying on the voices of a privileged few.

Kingston herself, in *The Woman Warrior,* sought to come to an understanding of her own youth and upbringing, beset by conflicting standards of behavior: the independence and self-fulfillment promised to American children versus the self-sacrificial filial obligations demanded of Chinese girls. **Filial piety** refers to the respect that Chinese children are expected to pay their parents and everyone in older generations. How was she to fit the Chinese ghost stories and legends her mother funneled into her imagination with the American world of neon and plastic in which she was growing up? How was she to find her own voice and realize her worth with a mother who claimed to have cut her daughter's frenum and in a society that devalued daughters? How was she to develop her own storytelling powers when faced with a mother whose own storytelling powers and domineering spirit were so formidable, even threatening?

In *China Men,* Kingston presents an alternate version of the Founding Fathers of America. Not only does she shift the geographical locale from New England to Hawaii and California but she boldly shifts the ethnicity from Englishmen to "China Men." She makes founding fathers of the Chinese men whose back-breaking labor cleared jungles to create sugar plantations and broke through mountains to lay tracks for the transcontinental railroad; who, though scholars, took in laundry to support their families; who, though pacifists, served as soldiers in Vietnam. Again, her text is a collage, mixing myth and history, fictional elaboration and biographical fact. Hers are composite, communal stories, as well as stories of her own family. To set the context and provide a contrast for her tales of heroism, she gives a central place in her book to "The Laws," a chronological, factual list of America's legislation dominated by discriminatory statutes against the Chinese.

Kingston's most recent work, *Tripmaster Monkey* (1990), is an ambitious, brilliant novel about a sixties Berkeley graduate, a loud-mouthed, raging Chinese American playwright, Wittman Ah Sing. An Asian American *Ulysses,* the novel is richly textured, interweaving literary allusions from Euro-American traditions as well as from three Chinese classics, Wu Ch'eng-en's *Journey to the West* or *Monkey* and Luo Kuangzhong's two novels *The Romance of the Three Kingdoms* and *Outlaws of the Marsh,* also translated as *The Water Margin.* (See Chapter 34, "Roots: *The Journey to the West.*") *Tripmaster Monkey* is a comic/tragic/surrealistic portrait of a complex young spokesman for a developing Asian American consciousness. Fully aware of racism and its humiliations, Wittman Ah Sing screamingly asserts himself, uninhibitedly voices his contempt for conventions, seeks validation in personal relationships, and finally expresses himself by directing an extravaganza that incorporates all the people of his acquaintance and all the passion and fury of

· 443 ·

his person. At the very end of the novel, he is transformed from his hitherto militant self into a pacifist by the unnamed narrator, Guan Yin, the Goddess of Mercy. Like *Ulysses* or *The Invisible Man,* however, this book is as much a satiric portrait of a society as of one person.

The cultural world of Kingston's childhood is that of the Chinese immigrant from Canton province (also spelled Kwangtung and Guangdong), a region of southern China. Part of the narrator/daughter's impatience with her mother in *The Woman Warrior* is due to the mother's insistence on inappropriately following Cantonese beliefs and superstitions in the United States. The major belief protested against in this feminist text is the Chinese tradition of valuing sons above daughters. "Feeding geese is better than feeding girls," the traditional Chinese thinking goes, because girls grow up to marry into another family. They then belong to their husband's family; their responsibility and duty is to serve the husband and his parents. When the parents die, the parents' spirits are invoked by their sons and daughters-in-law to intercede with the gods to bring good fortune to their children on earth. In reciprocal manner, the sons are to burn incense and paper money and bring food to the parents' graves in order to care for them in the spirit world. This practice is known as ancestor worship. Furthermore, sons carry on the family name, ensuring a long life for the clan. Thus, the birth of a daughter is called a "small happiness" while the birth of a son is a "great happiness." Under severe conditions, such as a famine, when a family has too many mouths to feed, a daughter may be sold as a servant or slave to a wealthy family or a female infant may be killed at birth.

In *The Woman Warrior,* Kingston expresses her annoyance that girls are constantly reminded of their lack of worth, through the common misogynist sayings her parents quoted. Instead of receiving the story of the No Name aunt as a warning, as her mother, speaking for the patriarchy, intended, Kingston seeks in this rejected aunt a model for her own rebellious nature and elaborates extensively on her mother's terse narrative. In thus embroidering on the aunt's story, Kingston shows her own ability to talk-story, Hawaiian pidgin for storytelling, a way to display her power. Elsewhere, Kingston speculates that perhaps women's feet used to be bound in China because women were too strong and would otherwise run away.

Though chastened by misogynist sayings and berated for her "pressed-duck voice," Kingston, the growing girl, also had ever before her the strong model of her own mother. This mother, aptly named Brave Orchid, was a bold eater, a hardworking medical student, a ghostbuster, and a strong worker who could "carry a hundred pounds of Texas rice up- and downstairs," who "could work at the laundry from 6:30 A.M. until midnight," and who bore six children after the age of

45. By the end of the book, the young narrator realizes that the same mother who confused her with stories, also gave her a legacy—these same stories that the daughter has shaped into the present book.

One of the most controversial revisions of history in *The Woman Warrior* occurs in the "White Tigers" chapter. Fa or Hua Mulan is a legendary heroine, a model of filial piety, who showed consideration and love for her father by disguising herself as a man and serving in the army in his place. A popular ballad about Mulan is commonly sung by mothers to their children. (For a translation, and the Disney movie's debt to Kingston, see **Mu Lan** in "Cultural Lexicon.") However, in her text, Kingston combines two Chinese stories: the legendary Hua Mulan, the Chinese Joan of Arc, and Yueh Fei, a historic figure, the general who had Chinese words tattooed on his back. Chinese historians take issue with Kingston's conflation of the two stories and are also struck by the *carving* of the characters on the woman warrior's back. Feminist and literary critics, however, assert an author's right to adapt and change stories for artistic purposes and praise Kingston's creation of a symbol to emphasize the burdens painfully imposed on women.

Another detail of *The Woman Warrior* that has elicited some discussion is Kingston's translation of the Mandarin word *gwei* as "ghost." The word has a variety of meanings from "foreign devil," to "demon" to "ghost." In what might be considered Sinocentricism, the Chinese call their own country Zhong Guo, or Middle Kingdom, and consider everyone else "barbarians," or lo fan (Cantonese) or wai guo ren (Mandarin), both words meaning "foreigner," even when they themselves are living in the foreign land. The term "gwei" is generally reserved for insults and curses, while the "polite" term for anyone other than Chinese would be "foreigner." In generalizing the term "gwei" to refer to all kinds of people ("Newspaper boy ghosts, Garbage man ghosts"), Kingston is purposely, but playfully, indulging in a kind of inside joke. At other times ("Noisy Red-mouthed Ghost," "Ho Chi Gwei!"), she clearly intends the term to be a curse. Though she consistently uses only the word "ghost," the shifting definitions create a fluid quality that is of a piece with this text that itself flows across the boundaries that separate genres, languages, and cultures. When the mother complains that her children have become half-ghosts, she is lamenting their assimilation into American culture. However, in the final chapter, "Song for a Barbarian Reed Pipe," Kingston implies a resolution between mother and daughter in the realm of talk-story. The story of T'sai Yen is begun by the mother and finished by the daughter. It's a story with a happy ending about a woman living among "barbarians" whose own "barbarian" children finally come to understand her and to sing along with her despite their difference of language, a song that "translated well."

Further Reading

Cheung, King-Kok. *Articulate Silences: Hisaye Yamamoto, Maxine Hong Kingston, Joy Kogawa*. Ithaca, NY: Cornell University Press, 1993. An outstanding feminist essay.

Chin, Marilyn. "A *MELUS* Interview: Maxine Hong Kingston." 16 *MELUS* 4 (1989–1990): 57–74. Lively and wide-ranging. Also the best background reading on *Tripmaster Monkey* at the present.

Kim, Elaine H. *Asian American Literature: An Introduction to the Writings and Their Social Context*. Philadelphia: Temple University Press, 1982. Dated, but still the definitive book-length introduction to Asian American literature. Readable, historically informative, and central to the field.

Kingston, Maxine Hong. "Cultural Mis-Reading by American Reviewers." *Asian and Western Writers in Dialogue: New Cultural Identities,* by Guy Amirthanayagam, ed. London: Macmillan, 1982. A smart, sensible review of mainstream misconceptions.

———. *The Woman Warrior: Memoirs of a Girlhood Among Ghosts*. New York: Vintage, 1984.

Lim, Shirley, ed. *Teaching Approaches to Maxine Hong Kingston's The Woman Warrior*. New York: Modern Language Association, 1991. The best single introduction to teaching *The Woman Warrior*.

Lim, Shirley, Geok-lin, and Amy Ling, eds. *Reading the Literatures of Asian America*. Philadelphia: Temple University Press, 1992.

Ling, Amy. *Between Worlds: Women Writers of Chinese Ancestry*. New York: Pergamon, 1990. (Now at Teacher's College Press.) Useful literary and historical context for Kingston.

Luo, Guanzhong. *Three Kingdoms*. Abridged and trans. by Moss Roberts. New York: Pantheon, 1976.

———. *Outlaws of the Marsh*. Abridged and trans. by Sidney Shapiro. Hong Kong: Commercial, 1986. *Outlaws* or *The Water Margin* is a second major source.

Shih, Shu-mei. "Exile and Intertextuality in Maxine Hong Kingston's *China Men*." In *The Literature of Emigration and Exile*. Ed. by James Whitlock and Wendell Aycock. Lubbock, TX: Texas Tech University Press, 1992. A lucid reading explaining some of the Chinese sources.

Takaki, Ronald. *Strangers from a Different Shore: A History of Asian Americans*. Boston, MA: Little, Brown, 1989. A highly readable introduction for the general reader.

Wang, Alfred S. "Maxine Hong Kingston's Reclaiming of America: The Birthright of the Chinese American Male." *South Dakota Review* 1 (1988): 18–27. Short, accessible, historically informative reading of *China Men*.

Wong, Sau-ling Cynthia. *Reading Asian American Literature: From Necessity to Extravagance*. Princeton, NJ: Princeton University Press, 1993. One of the best essays on *The Woman Warrior*.

Wu, Ch'eng-en. *Monkey: Folk Novel of China*. Trans. by Arthur Waley. New York: Grove Press, 1988. This abridged translation (320 pages) of Wu's Chinese classic is a delightful introduction to the Chinese folk hero named in *Tripmaster Monkey*.

A Reader's Guide to Amy Tan's The Joy Luck Club

MOLLY H. ISHAM

[In Chapter 32, Robert Leonard, general linguistics editor for this series, wrote, "A constant topic of American ethnic literature will be the tension between the foreign born, and the American born. Sociolinguists can give at least one important reason, from the many available. The foreign born have had their reality organized by a foreign language. The two languages have divided up the world in different ways, organized two separate realities. The clash between these two realities—each looking like no more than "common sense" to the holder—generates the anxiety which, in its turn, generates so much of ethnic American literature. On the very first page of Amy Tan's *The Joy Luck Club,* she records an exchange between a foreign mother and an English speaking daughter which prefigures everything she'll write thereafter:

> "*Don't show off,*" *I [the daughter] said.*
> "*It's not showoff.*" *She said the two soups were almost the same,* chabudwo. *Or maybe she said* butong, *not the same thing at all. It was one of those Chinese expressions that means the better half of mixed intentions. I can never remember things I didn't understand in the first place. (p.19)*

It's one thing when a foreigner holds a separate view of reality. It's another thing when it's your mother. In that Aristotelian conflict can be found the plots of perhaps the majority of American ethnic literature."

For that reason, this volume devotes this chapter to a social analysis of the Mandarin and Shanghainese expressions in *The Joy Luck Club.* Molly Isham, born in Beijing and a graduate of Mills College, was director Wayne Wang's interpreter during the filming of *The Joy Luck Club* on the set, and had several conversations

with Amy Tan about her novel. Many critics have, like Frank Chin, made Tan's knowledge of Chinese culture the center of their criticisms. Molly Isham is arguably the person most familiar with Amy Tan's highly personal version of Mandarin and Tan's use of Chinese adages and cultural expressions. This article is intended for the advanced researcher as well as those simply trying to explicate a puzzling phrase. It is perhaps significant that later, as Tan familiarized herself with the mainstream audience's tastes, Mandarin all but vanishes from her works.—Eds.]

The phonetic system shown in parenthesis in this article is the official *pinyin* system (P.Y. for short) used in the People's Republic of China (PRC) since 1958. Six of the unfamiliar symbols are explained as follows: *Q* like "ch" in "*ch*eese"; *X* like "sh" in "*sh*eep"; *C* like "ts" in "ca*ts*"; *Z* like "ds" in "be*ds*"; *Zh* like "dg" in "e*dg*e"; and *E* like the "e" in th*e* preceding a consonant.

Pinyin, phonetic spelling, also called **Hanyu pinyin**, the Han dialect phonetic spelling, is a set of symbols using the 26 letters in the English alphabet to give the sounds of Chinese characters. Prior to 1958, a set of old phonetic symbols called *zhuyin Fuhao* were used both in the People's Republic of China and Taiwan. They were based on ancient Chinese characters, and looked like radicals of the characters. In 1958 the government of the People's Republic of China encouraged the spread and use of the Hanyu pinyin system; from then on all elementary school textbooks and children's story books used the pinyin phonetic symbols to help facilitate the learning process. All the proper names, when they appeared in the PRC-published English-language newspapers, official documents, or other publications, were also spelled according to the new phonetic system.

In Taiwan zhuyin Fuhao, the old phonetic system, is still being used in elementary schools to help children learn to read. Names of persons and places are spelled according to the Wade-Giles phonetic systems.

Some Chinese language textbooks published outside of the People's Republic of China use both the pinyin and Wade-Giles phonetic systems. For more on the difference between pinyin and the Wade-Giles systems see Chapter 1.

Feathers from a Thousand Li Away

Feathers from a Thousand Li Away (P.Y. *Qian li song emao, li qing qingyi zhong*): To give a present of a goose feather from a thousand "li"—Chinese mile—away, the gift may be light, but the sentiment is strong. This expression is often used when a person wants to show modesty when giving a gift.

P. 5

Mah jong (P.Y. *Majiang*): A Chinese gambling game played by four persons—very often women—using colored chips and 128 bone or ivory tiles. A mah jong party is a good excuse for friends to get together, socialize, talk, and eat tasty food. Mah jong is a popular game in Chinese communities all over America, especially in the San Francisco Bay Area and many big cities On the East coast. In China mah jong was widely played until 1949 when the government of the People's Republic disallowed all forms of gambling. Since the early nineties, however, mah jong has again become a popular game among the people in mainland China.

Red bean soup (P.Y. *Hong dou tang*) Black sesame-seed soup (P.Y. *hei zhima tang*): The red bean soup and black sesame-seed soup are sweet snacks with medicinal functions. The red bean soup nourishes the blood and is usually consumed in cold weather. The black sesame-seed soup nourishes the kidneys and the eyes. Two other soups, the mung bean soup (P.Y. *lu dou tang*) and the lily bulb soup (P.Y. *baihe tang*), also have medicinal functions. They are, however, served as snacks in hot weather.

P. 6

Chabudwo (P.Y. *Chabuduo*): Often means "nearly" or "almost." The character *cha* means to fall short of, or to differ from, and *buduo* means not much. Example: It's *chabuduo* (nearly) five o'clock. Sometimes this expression is also used in lieu of an answer when a person is reluctant to be specific. For example when a person asks: "Did I do this correctly?" Answer: *"chabuduo"* meaning, not absolutely satisfactory, but it's O.K. Butong (P.Y. *butong*): Different. It has the same meaning as *bu yiyang:* not the same.

P. 7

Kweilin (P.Y. *Guilin*): Name of a city in southwest China. Guilin is located in the northeastern part of Guangxi province, about 300 kilometers northwest of the city of Guangzhou, which is known to Westerners as Canton. The scenic Li River runs through Guilin. There is a saying: *"Guilin shanshui jia tian xia,"* which translates, "the mountains and waters in Guilin are number one under Heaven." There are more than 30 scenic places in Guilin that are frequented by tourists, both domestic and international. Many artists, inspired by the beauty of Guilin, have painted its domelike mountains and peaceful rivers.

P. 10

dyansyin (P.Y. *dianxin*): Literally means "dotting the heart"—to eat a little bit and keep a person from getting too hungry between meals. Dianxin is the general word for finger food or snacks, usually referring to various kinds of pastry, including steamed or baked cakes, meat or shrimp dumplings, fried egg rolls or steamed buns stuffed with meat or vegetables. The well-known Cantonese word carrying the same meaning is *dimsum.*

P. 11

hongmu (P.Y. *hongmu*): The two Chinese characters *hong* and *mu* respectively mean "red" and "wood"; however, this wood is very different from the redwood we find in California. *Hongmu* is a very hard and very expensive wood used to make furniture. In English it is known as rosewood, and is found in Asia and Africa.

pai (P.Y. *pai*): The tiles in a Chinese mah jong set are called "pai." See above p. 5 under mah jong.

pung (P.Y. *peng*): This is a sound or word spoken by one of the four mah jong players when she/he needs to take in a tile, thrown out by any one of the other three players, to form a set.

chi (P.Y. *chi*): A sound or word spoken by one of the four *mah jong* players when she/he needs to take in a tile, thrown out by the player to the right, to form a set.

P. 12

Yuan: The monetary unit of China, one yuan equals 10 *jiao* or 100 *fen.* The yuan mentioned in the story refers to the old money whose value was depreciating every day in the 1940s. In 1949, after the Communists took over, the new money was called *ren min bi,* the people's money. The basic units were still yuan (comparable to the dollar), jiao (comparable to the dime), fen (comparable to the penny) . The exchange rate in the early 80s was 1.5 yuan to one U.S. dollar; in the early 90s it was 5.80 yuan to one U.S. dollar; and in 1995, it was 8.4 yuan to one U.S. dollar.

P. 18

Wonton (P.Y. *huntun*): Boiled wontons are served in a soup. Fried wontons are served as hors d'oeuvres. To make wontons you chop up meat and vegetables and put a teaspoonful in each ready-made wrapping, then boil or fry before eating. In China this is a popular mid-afternoon or midnight snack.

P. 19

Five Elements (P.Y. *Wu Xing*): It was the belief of the ancient Chinese that the Five Elements—metal, wood, water, fire, earth (P.Y. *Jin, Mu, Shui, Huo, Tu*), were indispensable in the composition of our physical universe. It was also believed that these five basic materials were continuously interacting and changing, enabling them to enhance each other as well as restrain each other. For example, on the one hand, water generates wood, and wood generates fire, while water restrains fire, and fire inhibits metal. This ancient philosophical concept was later used by doctors practicing traditional Chinese medicine to explain various medical problems, in other words, the physiological and pathological relationship between the patients' internal organs. Wood represents the liver, and fire, the heart; and in the same way, earth, the spleen, metal, the lung, water, the kidney. When there is excessive liver (wood) fire, the lung (metal) may be damaged; but a lack of wood (depressed liver) will generate wind, and wind represents unsteadiness and symptoms of wandering uncertainty. The traditional Chinese doctor believes an imbalance of the five elements could even affect a person's behavior or character.

P. 23

Aii-ya (P.Y. *ai-ya*): An exclamatory expression showing surprise, disappointment, or disgust depending where the stress is and which tone mark (a Chinese sound has four tones) it has. For example: (1) Ai-'ya! You scared me (surprise). (2) 'Ai-ya, you disappoint me. (3) 'Aii-'ya, look what a mess you have made!

P. 24

chiszle (P.Y. *qisile*): *qi,* means angry; *si,* means to die, or death. The two combined means extremely angry, enraged; however, it sometimes can be used jestingly. For example, an adult would say qi sile to a baby when it has inadvertently done something wrong, but that does not mean real anger. The expression Sile, with the function of an adverb, is often preceded by an adjective to show extremity. The adjectives most frequently used with sile are as follows: (1) Hungry (P.Y. *e* /pronounced "uh"). E sile means to be dying of hunger. (2) Thirsty (P.Y. *ke* /pronounced "kuh"/). Ke sile means to be dying of thirst. (3) Busy (P.Y. *mang*/pronounced "mung"). Mang sile means extremely busy. (This expression appeared on p. 17 of Amy Tan's *The Kitchen God's Wife*). (4) Tired (P.Y. *lei*). Lei sile means to be dying of fatigue. (5) Hot (P.Y. *Re*). Re sile means extremely hot. (6) Cold (P.Y. *Leng*). Leng sile means extremely cold. (7) Dirty (P.Y. *Zang*). Zang sile means extremely dirty, or dirty beyond endurance. (8) Stinky (P.Y. *Chou*). Chou sile means extremely stinky or stinky beyond endurance. (This last expression appeared in Chapter 2 on p. 184.)

P. 25

Hangzhou: Also known as Hangchow, which was the spelling used before 1958. Hangzhou is in Zhejiang province, southeastern part of China. It is about 150 kilometers southwest of Shanghai. Hangzhou is considered the most beautiful city in the whole country; it has more than three dozen scenic spots for travelers and tourists to visit, including the West Lake, the Six Harmony Pagoda, the Jade Spring, the Temple of the Hidden Spirit, etc. As the old Chinese saying goes: "*Shang you tiantang, xia you su hang.*" Translation: "Above, there is Paradise; below, there are Suzhou and Hangzhou." During the Song dynasty (960–1279 A.D.) the Mongolian invasion from the north caused the capital to move from Kaifong in Henan province to Hangzhou (1127 A.D., the beginning of Southern Song); thus, the dialect spoken there is a mixture of northern and southern Chinese dialects.

Ningbo: A city in Zhejiang province, southeastern part of China. Ningbo is just south of the Hangzhou Bay, about 100 miles east of the city of Hangzhou.

P. 33

Ghost (P.Y. *gui*): There are many kinds of ghosts in Chinese legends and stories. As a child I loved to listen to grown-ups tell *Gui Gushi,* ghost stories, and very often the ghosts they talked about were right there in our house. I was living with my grandparents in a huge traditional courtyard style house in Peking, now known as Beijing. My cousins and I loved to explore every mysterious, uninhabited part of that house, but it turned out there was an anecdote behind each one. Those rooms, according to my uncles and aunts, were either "frequently visited by *huli jing,* the fox spirit," or "haunted by *diaosi gui,* the ghost of a person (usually a woman) who hanged herself," or *nisi gui,* the ghost of a drowned person. They described the ghosts so vividly, a lot of the times I really thought I saw them in the dark of the night. The fox spirit, which appeared in the form of a beautiful lady, legendarily, was a fox that cultivated its character, and piously prayed its way to a human form. Its motive was to seduce and mislead young men until their marriages were broken up, their money ill-spent, and they themselves fell into a sensual degeneracy.

In *Tales of Liao Zhai,* a collection of short stories written in classical Chinese, the author Pu Song-Ling (1640–1715), on the one hand, exposed the dark side of feudal ethics, and, on the other, showed sympathy for true love through his protagonists. In his stories the fox spirits and ghosts took the forms of young human females. They were extremely pale, sometimes pretty, with long, straight

black hair, randomly falling over the faces. This has always been the image of Gui in Peking opera and other traditional Chinese operas.

It was a Chinese belief that if a diaosi gui or nisi gui had been unjustly treated in his/her lifetime, and eventually died a wrongful death, it would grab the first opportunity to find a *tishen,* substitute (take the life of a living person the same way it died), in order to free its spirit. With my head stuffed with these stories as a young child, for many years I feared I might be taken as a substitute by a ghost.

Other kinds of ghosts or fox spirits were actually human beings, referred to as ghosts by the community or by public opinion. In China's feudal society women who eloped or committed adultery, widows who remarried, and women who lost their chastity before they were formally married, were regarded as gui, ghosts and not ren, human beings. The public opinion was so much against women that even in the case of a rape or sexual assault, the woman, and not the man, was severely punished. Once a woman was labeled a gui, she would be looked down upon by everybody. Her own family and relatives would be so ashamed of her that they sometimes chased her out of the house, or ordered her to end her own life. (For better understanding of this situation please also read Maxine Hong Kingston's *The Woman Warrior,* Chapter 1, "No Name Woman.")

Popo: A woman addresses her mother-in-law as popo, and her father-in-law as gong gong. In south China a child calls his/her maternal grandmother popo, *ah po* or *waipo.* In the Shanghainese dialect the sounds are: *bubu, ah bu,* or *nga bu.* On p. 10 of *The Kitchen God's Wife* the granddaughter addressed her maternal grandmother "ha-bu"; that probably was the child's version of "ah bu" or "nga bu." In northern China, maternal grandparents are *lao lao,* grandma, and *lao ye,* grandpa. Paternal grandparents are *nai nai,* grandma, and *ye ye,* grandpa.

P. 35

Shou [sic.] (P.Y. *Xiao*): Filial piety—to respect and obey one's parents or elders. A disobedient or disrespectful child is considered *bu xiao,* not filial. The same character *xiao* also means mourning; therefore, *xiao zi* could mean a filial son or a son in mourning. (The phonetic sound *shou* is closer to the Shanghainese pronunciation.)

P. 36

ni: To disobey, to betray. *Ni zi,* an unfilial son, is the opposite of *xiao zi* (see shou).

Lose face (P.Y. *diu lian* or *diu mianzi*): Diu, to lose, lian or mianzi, face. To have face (P.Y. *you mianzi*) is a very important thing in the Chinese culture. If a child wins an honor at school, then the parents will "have face" and all their friends and neighbors will regard them with admiration and respect. If a family member does something disgraceful, like flunking in school, or eloping with someone the parents disapprove of, then the whole family will feel they have lost face, and most likely will punish that person severely. When a person is described as having no face (P.Y. *mei lian*) or don't want face (P.Y. *Bu Yao Lian*) it means the person is shameless or has done something disgraceful. *You Lian* also translates as have face; however, it is a derogatory expression; that is, he insulted me in public so many times, now he actually you lian (has the nerve) to come and ask a favor of me.

P. 37

Nuyer (P.Y. *nu'er*): In speaking to a parent, a daughter refers to herself as *nu'er*—daughter—when she blames herself for something bad that has happened. The same explanation applies when a son refers to himself as *erzi*.

P. 38

Ching (P.Y. *qing*): Translates as "please" or "to invite." This is a polite expression inviting people to come in, to sit down or to eat and drink; it can be used with or without the verbs. For example, a host may point with his hand, palm up, at his dining table and say: "Qing, qing." That means please come and have dinner.

No face (P.Y. *mei lian*): See lose face.

P. 43

Matchmaker (P.Y. *meipo*): Up until the middle of the twentieth century, professional matchmakers were fairly common in the rural parts of China. When a young man's parents had taken a fancy to a girl and wanted her for their daughter-in-law, they would go through a matchmaker. Matches were made to the advantage of the two families, based on birth, wealth, or convenience. The feelings and opinions of the young couple played no part in making the decision, and, more often than not, the bride and groom only saw each other for the first time on the night of their wedding. During the past two to three decades, with the exception of some very remote villages, the matchmaker has gradually disappeared, but people still depend on friends and relatives to make matches.

Whenever people think about a meipo, immediately they envision an old woman, short but not overweight (she keeps slim by getting a lot of exercise run-

ning from one household to another), wearing heavy make-up (like the ones in the film *The Joy Luck Club*), and, of course, extremely talkative. During the 10 years known as the Cultural Revolution (1966 to 1976), many people lost their spouses as a result of violent beatings or suicides. Among my friends and relatives, there was at least one death in every family I knew. Whenever a single person came to me for help, I would try my best to introduce someone compatible to him/her. Even though I enjoyed being a matchmaker, I did not want to be remembered as a meipo.

In the early 80s the Chinese government established a matchmaking agency in Beijing. To be eligible for consideration one had to pay *ren min bi* (see explanation under *yuan*), two yuan registration fee (a lot of money for a young worker making 60 yuan per month), submit two recent photographs, bring the census book to show residency, and present a letter of recommendation from the person's work unit. That agency got so popular they had to hire guards to stop the onlookers from blocking the entrance. The oldest couple the agency successfully matched were a 78-year-old retired professor, who lost his wife during the Cultural Revolution, and a 72-year-old retired middle school teacher.

Shrrhh shrrhh (P.Y. *shi*): With the strong "rr" sound, this means "yes" in the Mandarin dialect spoken in Beijing. I believe Amy Tan was giving a description of the "er" suffix which is added to many nouns and verbs, a typical sound heard in the Beijing area. For example *gongyuan* means park, but a native of Beijing would, by habit, say: "gongyuar," changing the "n" sound to an "r" sound; and *xiao hai* (child/ children) is always pronounced as "xiao har" in Beijing.

Taiyuan: A city in north China, about 390 kilometers southwest of Beijing, China's capital. Taiyuan is the capital of Shanxi province and is well-known for the artistic carvings in the grottos, mostly created during the Tang dynasty (618–907 A.D.). Bing is another name for Taiyuan. In China each city and each province has a one-character name, often used in place of its two-character or three-character name in writing. For example, the one-character name for Beijing is Jing, that for Shanghai is Hu. These one-character names are often seen in official documents, newspaper articles, and railway schedules. The train from Beijing to Shanghai advertised as Jing-Hu Xian, the Jing-Hu Line instead of Beijing-Shanghai Line.

Huang Taitai: Mrs./Madame Huang. Huang is a fairly common Chinese last name, meaning "yellow." The Cantonese spelling of this last name is "Wong," and the character is written differently from the last name "Wang." In speaking or

writing Chinese the family name always precedes the words Mr., Mrs., Miss, Dr., Prof., etc. *Taitai,* when used without the family name, means "wife" or "mistress of a household." The latter meaning applies only when servants are addressing the mistress of the house. In mainland China, since 1949 the word "taitai" was substituted by "airen," literally meaning "lover" or "loved person." When a man introduces his wife to friends, he would say: this is my airen instead of this is my taitai. Not understanding the Western connotation of the word "lover," Chinese people have said embarrassing things about themselves, such as this true story.

> *A young biology teacher in Beijing was having an open class where a group of American visitors sat in to observe it. That was after Nixon's visit in the 70s, when China first opened up to foreign tourists, and people were very curious about the Chinese way of living. During the question & answer session somebody asked her about her family.*
>
> *"I have a family of four," she said in good but rusty English, "I live with my mother, my little son, and my lover."*
>
> *"You have a . . . lover?" asked one American woman, her brows lifted, her eyes wide open.*
>
> *"Yes, I do," she said in a matter-of-fact voice, not the least embarrassed.*
>
> *"You live with your lover?"*
>
> *"That's right."*
>
> *"And you have a son by him?" ventured another American visitor.*
>
> *"Yes, my son is six years old now."*
>
> *By then everybody's eyes were wide with surprise and curiosity.*
>
> *One American man had a generalized question: "Do many Chinese women have lovers?"*
>
> *"Oh, yes, most of the women in my school have lovers, and children, too."*
>
> *The American visitors exchanged remarks among themselves that the biology teacher did not understand. She began to sense that something she said might not have been appropriate, but she was too timid to ask. Not until two days later when she mentioned this conversation to her friend, an English teacher, did she realize what a fool she had made of herself. This was the first group of Americans she had met in many, many years, and she wanted so much to impress them with her English!*

P. 44

Pichi (P.Y. *piqi*): The word piqi, meaning "temper," can be used with adjectives such as "bad," "good," "big," "small," to describe the disposition of a person; that is, *Piqi*

hao: good-natured; *piqi da:* hot-tempered. Da means "big." It is the Chinese belief that if a person has too much wood of the five elements that represent the inner organs, and not enough water, that person is likely to have a hot temper.

Tyan-yu (P.Y. *tian-yu*): Tian means "sky" or "heaven" or "day" and yu means "surplus" or "remaining," and when speaking of food, it means "leftovers." Western names are usually chosen from a reservoir of traditional names, while Chinese names are made up from any of the tens of thousands of Chinese characters in order to designate specific qualities or meanings. A Chinese name usually has three characters: the first character is the last name, and the second and third characters, the given name. Some characters are only used in masculine names, and others only in feminine names. Generally speaking, there are no rules as to what character or what two characters should be used for a first name; however, when there are many sons in a family, they usually share a common middle character, to show that they are brothers. For example, if Huang Tian-Yu had two brothers, they could have been given the names Huang Tian-Ming and Huang Tian-Li.

P. 45

Taiyuanese (P.Y. *Taiyuan Ren*): The residents of Taiyuan. Please see p. 43, under Taiyuan.

P. 46

Red-egg ceremony: A celebration taking place when a baby is a month old. The egg is a symbol of fertility, and red is the color for happiness. When a baby is born, the family will present relatives and friends with red eggs, but not necessarily give a party. When the baby is a month old, there will be a big banquet, and, very often, the whole village is invited to have *manyue jiu,* the full-month banquet.

Fen River: A river running through the central part of Shanxi province. Taiyuan is just to the east of the Fen River.

P. 47

Syaumei (P.Y. *shaomai*): A kind of afternoon snack or dimsum with meat in a wrapping, and steamed before eating.

Chang (P.Y. *zhang*): A jade tablet worn for good luck.

Wushi (P.Y. *Wuxi*): A city in southern Jiangsu province, eastern China. Wuxi sits on the north bank of Lake Tai, a freshwater lake that is shaped like a half

moon. Lake Tai is a popular boating place in the summer and, due to the warm climate and an abundance of rain in the area, it plays a significant role in agriculture as well.

Shanghai: Located in Huadong, eastern China, it is the largest industrial and commercial city of that country. The Shanghai Harbor is at the mouth of Chang Jiang, the Yangtze River, and plays an important role in foreign trade. In 1842, after China lost the Opium War in Canton (now Guangzhou), British battleships came up the east coast and occupied Shanghai by force. The Qing emperor, Dao Guang, signed the Nanjing Treaty with the British and within the next 10 years divided Shanghai into the Chinese controlled area and foreign concessions. Besides Ying Zujie, the British Concession, there were Fa Zujie, French Concession, Ri Zujie, Japanese Concession, and Gonggong Zujie, International Settlement, jointly managed by Britain and the United States. In 1949, when the People's Republic of China was established, the Communist government put an end to that situation.

P. 50
Shemma [sic] *bende ren* (P.Y. *Zhenme bende ren*): "Such a stupid person." Ben, foolish, stupid; Ren, human being, person. This is a very strong criticism.

P. 52
Shansi province (P.Y. Shanxi province): West of Hebei province in the northern part of China. See Taiyuan.

Palanquin: Also known as palenkeen *(jiaozi)*. A sedan chair carried by four to six men. An old fashioned Chinese marriage would require the bride to be carried to her husband-to-be's house in a jiaozi or hua jiao, a bridal sedan chair, decorated in red and gold.

P. 57
Tounau (P.Y. *Dounau*): A soup made of very tender bean curd (also known as tofu) with various ingredients added to make it tasty and nourishing.

P. 59
Deficient in metal: See Five Elements.

Festival of Pure Brightness (P.Y. *Qing Ming Jie*): The fifth of the 24 solar festivals, usually falls in the middle of the second month of the Lunar calendar, which is

the first part of April in the Gregorian calendar. By this time the temperature around the central and lower reaches of the Yellow River has risen to above ten degrees Centigrade, which indicates that farmers are to get ready for spring ploughing and spring sowing. Qing Ming Jie lasts 15 or 16 days, and on the first day of this festival, family members get together to sweep the ancestral tombs and pay respect to their ancestors; therefore, it is also known to some as "Festival of the Dead." For more information on the 24 solar terms, please refer to p. 247, under Cold Dew.

P. 65

Amah: The word Amah was used mostly by Westerners living in China to call their maids. The Chinese word for Amah is *Lao Mazi* meaning old maid-servant. Ma is a word meaning mother. If a maid servant is very young, the family members would call her by her name; if she is elderly, they would call her by her last name plus Ma, that is, Wang Ma, Liu Ma or Lao Li Ma, old Li Ma.

P.66

The Five Evils (P.Y. *Wu Du*): Wu is "five," and du is "poison"; wu du refers to the five poisonous creatures, namely the scorpions, snakes, centipedes, lizards and toads. To avoid children being harmed by these five poisonous creatures, often times they are painted onto children's tee-shirts, embroidered onto shoes, or hung as a pendant on their necks.

Wu du carried another meaning in mainland China between 1952 and 1953. When a political movement targeting the capitalists and private enterprises began in spring of 1952, the Five Evils referred to bribery, tax evasion, stealing of government property, dishonesty in signing government contracts, and theft of economic information.

Moon Festival (P.Y. *Zhong Qiu Jie*): Zhong, middle; Qiu, autumn; Jie, festival; thus it is the Mid-Autumn Festival. On the Lunar calendar it is the 15th of the eighth month, which usually falls in the latter part of September on the Western calendar. That evening people stay outdoors to enjoy the perfectly round moon and eat moon cakes. (See Chapter 24.)

Frog clasp (P.Y. *pan kou*): A set of pan kou is a button and a loop made of the same fabric as the jacket or Chinese sheath they are sewn onto. They are frequently used on men's and women's cotton, silk or padded jackets and gowns. They are also known as frog buttons.

P. 67

Dajya (P.Y. *dajia*): All the people; everybody.

Moon Lady: Known to the Chinese as *Chang E*. Please see p. 68 under Chang O.

Tai Lake (P.Y. *Taihu*): Also known as Lake Tai. Please see above p. 47 under Wuxi.

P.68

Chang O (P.Y. *Chang E*): "*E*" is pronounced "ehr." The Goddess of the Moon, the legendary lady who swallowed the elixir of immortality stolen from her husband and fled to the moon. People can see her silhouette in the full moon on the 15th of the Lunar month.

Baba: Daddy or Papa.

P. 69

Sour painful (P.Y. *suan teng*): When one is treated by an acupuncturist, as soon as the needle goes in, one feels a pulling pain, and that is called suan teng in Chinese.

Moon cake (P.Y. *yue bing*): A sweet pastry with fillings, made into a round shape, like that of a puck used in ice hockey, the size varies from two and a half to three and a half inches in diameter and about two inches high. The most popular fillings are bean paste, lotus seed paste, mixed nuts, and salted duck egg yolks. People eat it during the Moon Festival (also see p. 66, Moon Festival).

P. 70

Syin yifu! Yidafadwo! (P.Y. *Xin Yifu*): New clothes (P.Y. *Yitahutu*): All messed up; a complete mess. The phonetic spelling used in *The Joy Luck Club* reflects the Shanghainese pronunciation.

P. 71

My father's concubines (P.Y. *Yi Taitai*): Concubine. Up until 1949, it was fairly common for rich men in mainland China to take in concubines. Sometimes the lawfully wedded wife would take the initiative to help find a concubine for her husband when she failed to give him a son. For a couple to not have a male descendent to carry on the family name was considered most unfilial. For better understanding of the concubine situation, please refer to Chapter 6.

Zong zi (P.Y. *zongzi*): A pyramid-shaped dumpling made of sweet rice and wrapped in bamboo or reed leaves, then boiled in water for two to four hours depending on the size. It can be with or without a filling. When a filling is used, it is either sweet (bean paste) or salty (pork). The Chinese people customarily eat this food on *Duanwu Jie,* the Dragon Boat Festival, the fifth day of the fifth Lunar month.

Kunming: A city in the southwestern part of China, the capital of Yunnan province. The climate in Kunming is mild and pleasant. The Chinese use the words "*Siji Ru Chun,*" all four seasons are like spring, to describe Kunming. People who have lived in Kunming for many years tell me it is "the San Francisco Bay Area of China."

P. 81

Hou Yi (P.Y. **Hou Yi**) The name of a legendary figure in Emperor Yao's time, which was before 2,200 B.C. As the legend went, there were 10 suns in the sky and all trees and plants were dying; monsters became a menace to people. Hou Yi the Archer shot down 9 of the 10 suns, killed the monsters, and saved humankind.

P. 82

Yin, Yang: Please see p. 125, Yin and Yang.

The Twenty-Six Malignant Gates

P. 87, P. 131

The Twenty-Six Malignant Gates (P.Y. *Er-Shi-Liu Guimenguan*): Also Gates of Hell, a passage that no one can go through and come back alive.

P. 91

Meimei: A younger sister. When there are many children in a Chinese family, it is the custom to call the younger or youngest daughter meimei, younger sister, or xiao mei, little sister. The same applies to a male sibling; everyone, including the parents, would call the youngest brother didi, younger brother, or xiao di, little brother. Some families prefer to call the youngest son Xiao Bao, little precious, or baobao, precious darling, instead of xiao di, but no one would call a girl that. (Please refer to Amy Tan's *The Kitchen God's Wife,* p. 3.) In China, sisters and brothers seldom address each other by names; instead, they use ge (pronounced "guh"),

older brother, or *jie,* older sister, plus the number showing the seniority. This is an old custom that still prevails today in mainland China as well as Taiwan. For example, in my father's family (the small family) I am the oldest. I have two didi, younger brothers, and four meimei, younger sisters. Everyone calls me Da Jie, oldest sister, and the two boys are da ge, oldest brother, and er ge, number two older brother. The three older siblings address the four younger girls as da mei, er mei, san mei and si mei, which, in English, respectively mean big younger sister, second younger sister, third younger sister, and fourth younger sister.

P. 101

Aiii-ya: A sound of anger and disgust (see p. 23 under Ai-ya).

P. 107

Dragon instead of tiger: The Chinese zodiac, instead of going by the 12 months, repeats the cycle every 12 years, with one animal representing each year. They are arranged in the following sequence: Rat *(Shu),* Ox *(Niu),* Tiger *(Hu),* Rabbit *(Tu),* Dragon *(Long),* Serpent *(She),* Horse *(Ma),* Ram *(Yang),* Monkey *(Hou),* Rooster *(Ji),* Dog *(Gou)* and Boar *(Zhu).*

For example, 1914 was the year of the tiger, and 1916 was the year of the dragon; when, in Amy Tan's story, the year of birth was mistakenly changed from 1914 to 1916, the animal sign would become different also.

1993 was *ji nian,* year of the rooster, and on February 10, 1994, the Chinese people celebrated *gou nian,* Year of the Dog. 1995 is the year of the boar, the end of the cycle. Then, in 1996, we start from the rat again.

P. 108

Shwo Buchulai (P.Y. *Shuo Buchulai*): "Don't know how to say it."

P. 109

Shemma yisz (P.Y. *Shenme Yisi*): "What is the meaning?" or "What do you mean?" This expression is also used when two Chinese persons are about to start a quarrel, one or the other often starts with "Ni shenme yisi?" (What do you mean?) or "Ni yao gan shenme?" (What do you want to do?).

P. 117

Mei gwansyi (P.Y. *mei guanxi*): A frequently used expression meaning, "that's all right," "it doesn't matter," or "never mind." It is used in answer to an apology, that is, "Dui Buqi" (Sorry), answer: "mei guanxi" (That's all right).

P. 123

Tientsin (P.Y. *Tianjin*): Tientsin is the old spelling known to Westerners. After 1958 it was spelled Tianjin in Chinese newspapers and major publications. Tianjin is situated in Huabei, northern China, about 130 kilometers southeast of the Chinese capital, Beijing. Like Shanghai, Tianjin was a Westernized city, and after the Boxer Rebellion was suppressed in 1990, Tianjin, too, was divided into *zujie,* concessions. There were the British Concession, French Concession, German Concession, Italian Concession, Japanese Concession, Russian Concession, and the Chinese Controlled Area. The difference between Tianjin and Shanghai was that in Tianjin the residential and park areas, including the Racecourse, were all under British control, while the commercial area was the French Concession. In Shanghai the residential area was within the French Concession, while the downtown area where all the big hotels and foreign businesses were located was within the British Concession. (Please refer to p. 47 under Shanghai.)

P.124

Waigoren (P.Y. *waiguo ren*): A foreigner; a word used to describe anybody that is a non-Chinese, usually of European descent. The other words frequently used to describe Westerners are da bizi, big nose, yang ren, foreign person, yang guizi, foreign devil.

P. 125

Yin and Yang: These characters are used a lot in Chinese philosophy and medicine. Yin, literally shadiness, signifies the feminine, the earth, the moon, the weaker, the darker, the passive, the negative principle in nature, and Yang, literally brightness, stands for the masculine, the heaven, the sun, the stronger, the brighter, the active, and the positive principle in nature. The Chinese believe that Yin and Yang together constitute the *Dao* (also known as Tao), the Way or the principles of Heaven and Earth; therefore, Yin and Yang must always balance and supplement each other. If unbalanced in a human body, then the person gets sick; if unbalanced, a society falls into chaos; if unbalanced, Heaven and Earth shall be destroyed.

P. 130

Dangsying tamende shenti (P.Y. *dangxin,* to take care of or be careful, *tamende,* their/theirs; *Shenti,* body/health): A fairly common phrase to say at parting is "Ni Dangxin shenti" or "Ni duo baozhong." These are the equivalent to the American phrase "You take care."

Yiding (P.Y. *Yiding*): Definitely; must. This expression can also be used to confirm a promise, as in: "When you leave Yiding, be sure to, lock the door." Answer: "Yiding," (I) definitely (will).

P. 132, 134, 135
Nengkan (P.Y. *Neng Gan*): Capable; efficient. The two characters literally mean "able to work." They are often used to pay someone a compliment. For example: "Her husband is really neng gan, he can do everything from gardening, to fixing a car, cooking a Chinese meal, or write a computer program."

P. 137
Nale (P.Y. *Nali*): With Na in the fourth tone, nali means "over there." When na is in the third tone, nali means "Where?"

Nali nali: Used repeatedly, is an expression showing modesty. Example: "You are the best teacher in the whole country." Answer: *"Nali nali,"* meaning: "I'm not, you overpraise me."

Chu Jung (P.Y. *Zhu Rong*): A legendary monarch in 2689 B.C., who ruled over the elements of wood and fire. He was recorded by some to have brought light and harmony to Heaven and Earth. He was later named the God of Fire.

P. 142
Ni kan (P.Y. *Nikan*): Look! The speaker uses this expression to call somebody's attention to an object or person.

American Translation

P. 159
Wah (P.Y. *Wa*): An exclamatory sound showing surprise. It was initially used by Mandarin-speaking people from Taiwan. One can frequently hear the expression used in the San Francisco Bay Area and in New York, but not in mainland China.

Haule (P.Y. *Haole*): O.K. In different situations this expression carries different meanings, such as, "It's O.K. now," or "It's good now" (if you are fixing something). "I'm ready" (if someone has been waiting for you). Haole, Haole repeated, shows

the speaker is (1) getting impatient or (2) trying to comfort someone or stop that person from crying.

Peach-blossom luck (P.Y. *Tao Hua Yun*): The good luck to have someone fall in love with you or make love to you. In China when they say a person has *tao hua yun*, they mean that person is likely to get married soon. It is used with the verb *Zou*, to go, to get.

P. 161

Chunwang chihan (P.Y. *Chun Wang Chi Han*): Chun: lip or lips, Wang: dead or gone, Chi: tooth or teeth, Han: cold. Meaning, if one of two interdependent things falls, then the other is in danger. This is one of the three Chinese idioms using lips and teeth as metaphors. The other two are: *Chun Chi Xiang Yi*, as close to each other as lips and teeth; *Chun Chi Zhi Bang*, states depending on each other as lips and teeth.

P. 183

A Horse, A Rabbit (P.Y. *ma*, horse; *tu*, rabbit): Here "a horse" refers to a person born in the year of the horse, and the same explanation for the "rabbit." Please see above p. 107, under dragon instead of Tiger. For more information see Chapter 24.

P. 184

Choszle (P.Y. *Chou Sile*): See above p. 24, under Chiszle.

P. 195

Red-cooked eggplant (P.Y. *hong shao qiezi*): Any meat or vegetable simmered in soya sauce with a pinch of sugar is called *hong shao*, red-cooked. The other common red-cooked dishes are: hong shao pork, hong shao beef, hong shao fish, hong shao tofu, hong shao duck, and hong shao lion's head (big meat balls).

P. 200

Shemma (P.Y. *shenme*): What? It is also used like the English phrases "I beg your pardon?" or "Excuse me?" when one did not hear clearly.

Meimei-ah: A Chinese person answers the phone by saying, "Wei?" which is equivalent to "Hello?" In addressing the person at the other end of the line (we suppose she's Judy) one would say: "Judy, ah," which is like saying: "Is that you, Judy?" or "Eh, Judy." So *Meimei-ah* is " Eh, Meimei."

Jrdaule (P.Y. *Zhidaole*): I know or I heard you. This phrase said in a very polite tone is in lieu of "Yes." For example, "Don't be late for the lecture, or you won't find a seat." "Zhidaole."

P. 201
Ai-ya (P.Y. *'Ai-ya*): With the stress on the first syllable it is equivalent to a sigh.

P. 202
Sun Yat-sen (P.Y. *Sun Zhong-shan*): 1866 to 1925, aka Sun Wen, a great revolutionary leader of China. He overthrew the Qing government in 1911 and was elected Temporary President of China on December 29, 1911. He was known as the Father of the Chinese Republic.

Sun Wei (P.Y. *Sun Wei*): 1183 to 1240, official and famous armor maker of the Yuan dynasty. He was a native of Shanxi province.

Genghis Khan (P.Y. *Cheng Ji Si Han*): 1162 to 1227, he was the first emperor of the Yuan dynasty.

P. 203
Taiyuan: Please see p. 43, under Taiyuan.

Taiwan (P.Y. *Taiwan*): In 1949, when the Communist troops won victory in mainland China, the Republic of China moved to the island of Taiwan, off the coast from Fujian province. In Chinese the pronunciation of Taiyuan and Taiwan sound close, especially in Shanxi dialect (see p. 43, Taiyuan).

Ai (P.Y. *Ai*): An exclamatory sound which has four different meanings under the four tone marks. Ai with the first tone is calling somebody's attention, like "hey" in English. Ai with the second tone shows surprise, almost like "how come?" in English. Ai with the third tone means "no" or "not so." Ai with the fourth tone is a sigh. It also shows disappointment. Here on p. 203, according to the context, Ai is in the third tone.

P. 204
Beijing: The capital of People's Republic of China since 1949. Prior to that it was called Peiping, and also known to Westerners as Peking. For more information

please read *The Names of the Historical City Beijing*. The one-character name for Beijing is Jing. Also see p. 43, under Taiyuan.

P. 210
Hulihudu (P.Y. *hulihutu*): Confused, not clear-headed, often forgetful. The Chinese sometimes refer to a person comparable to the American "absent-minded professor" as *Hulihutu*.

Heimongmong (P.Y. *heimengmeng*): Darkness, or misty darkness. This is also used to describe a person's feeling when he/she has a blackout.

P. 213
Without wood (P.Y. *Que Mu*): Please see p. 19, Five Elements.

P. 235
Nala, nala: Trying to convince a person to accept a present.

Queen Mother of the Western Skies

P. 239
Hwai dungsyi (P.Y. *Huai Dong Xi*): You bad thing. When used in speaking to an infant, the person is lovingly teasing the baby.

Syi Wang Mu (P.Y. *Xi Wang Mu*): A legendary figure; also known to the Chinese as *Jin Mu*, Golden Mother, or *Wang Mu Niang Niang*, the Queen Mother. From ancient sayings she is the highest Goddess among the Chinese deities and is the symbol of immortality. According to the *Palace Anecdotes of Emperor Wu in the Han Dynasty* the Queen Mother, who took the form of an unrivaled beauty in her thirties, appeared before Emperor Wu one day, and presented him with a *pan tao*, Peach of Immortality. That was a flat peach grown on a tree that only had flowers and fruit every 3,000 years.

P. 241
Eat Bitterness (P.Y. *Chi Ku*): To eat bitterness means to endure great misery and hardship. Most Chinese children, from their very young days, were taught by their parents and their teachers how to temper their characters, so they would be able to *chi ku* and *nai lao*, endure hard labor when they grew up.

P. 245

Swanle (P.Y. *Suanle*): It can be translated into many different expressions. Here it means: "Let it be!" or "Let her go!" Here are a few examples of its usage:

> A: *"I'm terribly sorry. I know I promised to see you today, but I really can't."*
> B: *Sulkily,* "*Suanle!*," *"Forget it!"*
> A: *"I really can't give you any more help. This is all I can do."*
> B: *"Suanle, Suanle."* *"Don't bother, don't bother."*

P. 247

Period of Cold Dew (P.Y. *Han Lu*): The 17th solar term, which is usually the eighth or ninth of October on the Western calendar. A Lunar year is divided into 24 parts and each part is given a name; they are the 24 solar terms. The solar terms reflect the position of the sun and the changes in the climate. To get best results in agriculture the Chinese peasants find it very important to refer to the 24 solar terms. They are as follows: First Solar Term—*Li Chun*, Beginning of Spring; Second—*Yu Shui*, Rain Water; Third—*Jing Zhi*, the Waking of Insects; Fourth—*Chun Fen*, the Spring Equinox; Fifth—*Qing Ming*, Pure Brightness; Sixth—*Gu Yu*, Grain Rain; Seventh—*Li Xia*, the Beginning of Summer; Eighth—*Xiao Man*, Grain Full; Ninth—*Mang Zhong*, Grain in Ear; Tenth—*Xia Zhi*, the Summer Solstice; Eleven—*Xiao Shu*, Slight Heat; Twelfth—*Da Shu*, Great Heat; Thirteenth—*Li Qiu*, the Beginning of Autumn; Fourteenth—*Chu Shu*, Rid of Heat; Fifteenth—*Bai Lu*, White Dew; Sixteenth—*Qiu Fen*, the Autumn Equinox; Seventeenth—*Han Lu*, Cold Dew; Eighteenth—Shuang Jiang, the Descent of Frost; Nineteenth—*Li Dong*, the Beginning of Winter; Twentieth—*Xiao Xue*, Slight Snow; Twenty-first—*Da Xue*, Great Snow; Twenty-second—*Dong Zhi*, the Winter Solstice; Twenty-third—*Xiao Han*, Slight Cold; Twenty-fourth—*Da Han*, Great Cold.

P. 250

Paima Di (P.Y. *Paoma Di*): Racecourse, located in the former British Concession of Tianjin (spelled Tientsin prior to 1958). It was no longer used for horse races when the Japanese occupied the city in the late thirties. Now an industrial exhibition hall stands on the site. Older residents of Tianjin still refer to that area as Machang, another name for the racecourse.

P. 251

Taitai: Please see p. 43, under *Huang Taitai*.

P. 255

Houlu (P.Y. *huo lu*): Also called *luzi,* a coal-burning stove, common in northern China. Most of the Peking-style courtyard houses did not have central heating, so people used coal-burning stoves for both heating and cooking.

Yi Tai, Sz Tai (P.Y. *yi tai, si tai*): The character "yi" in the first tone means "one" or "first," so Yi Tai can mean "first wife." However, the first wife, which is the lawfully wedded wife, is more often referred to as *da taitai,* big wife; subsequently, a man's concubines are numbered as *er taitai,* second wife, *san taitai,* third wife, *si taitai,* fourth wife, and so on. The character yi in the second tone means aunt, and *yi taitai* means concubine or concubines. Thus, a family can also decide to have the servants address the second wife as *da yi tai,* the big concubine or number one concubine. According to that rule the third wife is called *er yi tai,* the second concubine, and the fourth wife, the third concubine, and so forth. On this page, sz tai is the third concubine.

P. 259

Syaudi (P.Y. *xiao di*): Little brother; within the family, *xiao di* or *xiao mei,* little sister, have become nicknames for the younger of youngest siblings. See p. 91, under Meimei.

P. 262

Tyandi (P.Y. *Tian Di*): In an old-fashioned Chinese family, when a couple gets married, the bride and groom are required to kowtow to their ancestors' portraits, their parents, and to Heaven and Earth. This has a sacred meaning in the bond of their marriage. For further information please read Chapter 6.

Tsinan (P.Y. *Jinan*): The capital of Shandong Province, which is located on the east coast of the People's Republic of China.

Thousand Buddha Cliff (P.Y. *Qian Fuo Shan*): A scenic tourist attraction in the suburban area, just south of the city of Jinan, Shandong province.

Bubbling Springs Bamboo Grove (P.Y. *Bao Tu Quan*): A popular recreation spot in Jinan, Shandong province not far from Thousand Buddha Cliff.

P. 263

Petaiho (P.Y. *Beidaihe*): A popular summer resort by the Buo Hai Sea in northeast China. It has a small residential community and a nice beach. Geographically it is about 400 kilometers due east of China's capital, Beijing.

P. 264

Shantung (P.Y. *Shandong*): A province on the east coast of China. The historical cities in Shandong are Jinan and Qufu, the birth place of the ancient sage Confucius. The well-known coastal cities are Qingdao (used to be Tsingtao), famous for its beer, Weihai (used to be Weihaiwei), and Yantai, famous for its pears. See p. 262 under Tsinan.

P. 266

Six Harmonies Pagoda (P.Y. *Liu He Ta*): A famous tourist attraction in the city of Hangzhou (also known to Westerners as Hang Chow). The Six Harmonies Pagoda was first constructed in 970 B.C during the Northern Song dynasty. Due to its height (more than 600 feet, or 184 meters) it served as a lighthouse for the ships sailing the Qiantang River. Later it was destroyed by fire during a battle. The present one was rebuilt in 1900 A.D., a seven-storied octagonal pagoda, 59.89 meters in height.

Monastery of the Spirits' Retreat (P.Y. *Ling Yin Si*): Built during the East Jin dynasty (317 B.C.–420 B.C.) according to legendary sayings. This is one of the oldest and largest of China's Buddist/Zen monasteries.

P. 275

Lihai (P.Y. *lihai*): When used to describe a person's character this adjective means sharp, energetic; such a person has the ability to manipulate people.

P. 277

Kai Gwa (P.Y. *kai gua*): Literally it means "open the melon," here in the story the man is referring to breaking a girl's virginity.

P. 284

Kechi (P.Y. *keqi*): Polite, courteous; the two characters mean "guest air," so, often when the speaker says: *"Buyao keqi"* he/she is asking the other person not to behave like a guest. For example, when guests first arrive, the host would say: "Please sit down, don't be keqi," meaning "make yourselves at home or don't stand on ceremony." At a dinner party the hostess may indicate the food and say: "don't be keqi" meaning "Please help yourself." When A is given an expensive gift, the polite thing for A to do is, initially try to refuse to accept it; and if B, the giver, insists, A would say: *"Ni tai keqi,"* "You are too generous." The expression *bu keqi* means "don't mention it" or "you're welcome"; it is used as an answer to "Thank you."

P. 285

Chi (P.Y. **Qi**): Air, breath; when a traditional Chinese medical doctor talks to a patient about qi, he is referring to a person's intrinsic energy or energy of life. Many Chinese practice the *qigong,* a breathing exercise similar to meditation. If done with perseverance, it will build up the qi in the body and, in turn, strengthen one's immune system and keep a person free from diseases. (For more information on qi, please read Dr. David Eisenberg's *Encounters With Qi,* Penguin Books, 1985.)

P. 289

Houche (P.Y. *Huoche*): Train. The word *huo* means fire, and *che* is a vehicle. Interestingly, a fire engine is *Jiu Huoche,* a "rescue fire vehicle."

Chr fan (P.Y. *Chi fan*): Eat or have a meal. If one wants to specify which meal, certain words need to be added; for example, to have breakfast is *chi zao fan,* to have lunch is *chi wu fan,* to have dinner is *chi wan fan.*

Gwan deng shweijyau (P.Y. *guan deng shuijiao*): Guan is to turn off, deng, a light, shuijiao, to go to sleep.

P. 297

Syaujye (P.Y. *Xiao Jie*): Miss; the two characters mean "little" and "sister." One may address a young female stranger as *xiao jie.* In mainland China, after 1949, it is considered a bourgeois habit to address young ladies this way; everybody is addressed as *tong zhi,* comrade. In the rural parts of the country people would use *da jie,* big sister, in addressing a young woman.

P. 301

Mangjile (P.Y. *mang jile*): Extremely busy. The expression jile, extremely, has the same function as the expression *sile,* dying of, when it is used with adjectives. Please refer to p. 24, under *Qisile.*

P. 310

Jyejye (P.Y. *Jiejie*): Older sister. *Meimei* is younger sister, *gege,* older brother, and *didi,* younger brother.

P. 315

Jandale (P.Y. *Zhang Dale*): Zhang is to grow, with *dale* added, the expression means "already full grown."

Further Reading

de Bary, William Theodore, *et al.,* eds. *Sources of Chinese Tradition.* New York: Columbia University Press, 1960, revised edition 1998.

Ebrey, Patricia Buckley, ed. *Chinese Civilization and Society.* New York: The Free Press, 1981.

Tan, Amy. *The Joy Luck Club.* New York: G.P. Putnam's Sons, 1989.

David Henry Hwang

PATRICIA P. CHU

Work

Chinese American playwright David Henry Hwang is best known for his eighth play *M. Butterfly,* which won a 1988 Tony Award for "Best Play" and many other prestigious awards (Outer Critics Circle, John Gassner, Drama Desk). In addition, theaters in two dozen countries have optioned productions of the play, and a film version starring Jeremy Irons, with a screenplay by Hwang, was released in the fall of 1993.

In *M. Butterfly,* Hwang uses a French espionage trial and an Italian opera to explore *orientalism,* a kind of stereotyping described by scholar Edward Said. According to Said, Europeans and Americans have historically justified their imperialist ventures into other continents, and their often unfair treatment of people of color, by stereotyping them as exotic, primitive, feminized "others" who by nature require the paternalistic domination of whites and their institutions. Hwang's play dramatizes the idea that such stereotyping contributes to Western attitudes equating masculinity and success with the power to rule and harm, both in personal relations and in international policy.

In terms of plot, Hwang's premise was taken from an espionage case briefly reported in *The New York Times* (May 11, 1986). In the article, a former French diplomat, Bernard Boursicot, confessed to passing information to his lover of 20 years, a Beijing opera singer whom he had mistaken for a woman; indeed, the singer, Mr. Shi Peipu, claimed to have borne a son by M. Boursicot. Pressed about his error, Boursicot reportedly said that Shi, the first love of his life, "was very shy . . . I thought it was a Chinese custom." Hwang took this as a sign that the Frenchman had been seduced by his own stereotypes of Asian women as demure and submissive. For Hwang, the epitome of these stereotypes

was the masochistic Japanese heroine of Giacomo Puccini's 1904 opera *Madama Butterfly*. In this popular opera, "Butterfly" lives and dies for her supposed husband, an American; in return, he openly treats her and their marriage as disposable, because of her race. According to Hwang, the hero's cynicism and personal mediocrity are central to Western fantasies about the East: the opera, though critical of the man, nonetheless creates a world that affirms that even a lowdown cad can purchase the lifelong love of a beautiful, cultured Asian woman, merely because he is white; she, on the other hand, will demand nothing in return because she is stereotypically Oriental. Puccini's heroine even announces, "I come from a people/ Who are accustomed to little/ Humble and silent."

Hwang took his central premise from the newspaper report, but constructed a fantasy rather than a documentary. In it, a fictitious French diplomat named Gallimard, stationed in Peking in the sixties, reveals how his own orientalism leads him to ruin. Duped by a male opera singer's impersonations of femininity and submissiveness, Gallimard dreams that he has found the perfect woman, a modern Chinese "Butterfly." Lulled into a false sense of superiority over all Asians, he not only misconstrues the basic power relations within his own love affair; he also misjudges them in Southeast Asia. There, his advice to the Americans, "Orientals will always submit to a greater force," proves disastrous. The play's revisionist title, *M. Butterfly,* points to the spectacular gender reversal by which the narrator comes to understand that he, not his lover, has been the exploited "butterfly" of his own story.

Students of Chinese American experience, however, may be more interested in Hwang's early trilogy about Asian American issues. (Many Asian Americans prefer the term "Asian" to "Oriental" because the latter term is now associated with orientalism.) *F.O.B.* (1979) uses the occasion of a "date" among three modern California college students to explore how racism can be internalized by American-born Chinese *("ABCs"),* also known as Chinese Americans. Dale, the central character, is a Chinese American who copes with anti-Asian racism by identifying uncritically with American popular culture and adopting racist attitudes toward Chinese who are "fresh off the boat" *("FOB").* Dale's assimilationist attitudes are extreme but not unique among Asian Americans. Grace, his foreign-born cousin, represents more positive and flexible responses. (As the play makes clear, "FOB" is a derogatory term. "ABC" is regarded as neutral, but is usually used only informally among Chinese and Chinese Americans, because it implies that a person born in the United States is still Chinese and foreign, a view most Chinese Americans would contest.) *The Dance and the*

Railroad (1981) develops the theme of resistance to racism and exploitation through art and activism; it is set during an American railroad strike that actually did take place among Chinese workers in 1867. Finally, *Family Devotions* (1981) portrays a wacky upper-middle-class California clan founded by two sisters born in mainland China. Beneath its farcical surface, the play exposes the destructive influence of the sisters' "born-again" fundamentalism and the second generation's craving for material success and recognition. A similar but not specifically Asian American family is satirized in Hwang's *Rich Relations* (1986).

Hwang's next three plays retained some Asian motifs but did not focus explicitly on Asian American issues. The first pair of plays, set nominally in Japan, were written to be performed together. *The House of Sleeping Beauties* (1983), inspired by Yasunari Kawabata's novella of that name, depicts an elderly male writer's encounters with the female proprietor of an unusual brothel. *The Sound of a Voice* (1983), based on Japanese ghost stories, introduces a male traveler to a beautiful woman in the woods; his fear that she may be a witch is inextricable from his more fundamental distrust of her as a woman. These two plays are Hwang's most naturalistic and offer Hwang's most delicate explorations of the difficulties of establishing trust between men and women. *As the Crow Flies* (1986), written as an alternative companion to *Voice,* explores the affinities between two old women in contemporary California, a Chinese immigrant and her African American housekeeper.

In collaboration with composer Philip Glass and designer Jerome Sirlin, Hwang has written the script for a science-fiction music drama about a human's apparent encounter with extraterrestrial life, *1000 Airplanes on the Roof* (1988). *1000 Airplanes,* commissioned jointly by festival organizers in three countries, premiered in Vienna. Hwang also wrote the libretto for Philip Glass' opera, *The Voyage* (1992), which draws upon the theme of space travel to commemorate Columbus' voyage to the New World. The opera was commissioned by the Metropolitan Opera and premiered there. While Asian and Asian American motifs are absent from these musical collaborations, they are nonetheless marked by Hwang's characteristic preoccupation with the themes of identity, cross-cultural contact, and cultural memory. Hwang's most recent work has explored interracial love and stereotyping. *Bondage* (1992) was staged in Louisville, and *Face Value* (1993) ran briefly in Boston and New York. In addition, Hwang contributed the screenplay for *Golden Gate,* a recent movie about an FBI agent's obsession with the daughter of a Chinese American man he hounded during the Communist purges of the 1950s.

Biography

David Henry Hwang was born in 1957 to a Chinese immigrant father and a Chinese-Filipino mother. He grew up in a suburb of Los Angeles, in a "born-again" Evangelical Christian family that superficially resembles the clan in *Family Devotions*. Hwang graduated from Stanford University in 1979. Within a year his first play, *F.O.B.,* was produced by Joseph Papp at the New York Shakespeare Festival Public Theater, where it was a hit, and his work and reputation have continued to grow since then. In 1985 Hwang married Ophelia Chong, a Chinese Canadian, to whom *M. Butterfly* is dedicated; the marriage broke up, however, during the New York production of the play. Hwang, who has residences in both Los Angeles and New York City, has received playwrighting fellowships from the Rockefeller Foundation, the Guggenheim Foundation, and the National Endowment for the Arts. He currently serves as co-dramaturge (with Philip Kan Gotanda) of the Asian American Theatre Company in San Francisco.

Reading Hwang's Plays

As a student, Hwang was fascinated with the plays of Harold Pinter and Sam Shepard. He studied with Shepard and dedicated *Family Devotions,* his most Shepardesque play, to his teacher. Pinter's and Shepard's stylized, often perverse dramas provide one useful context for understanding Hwang's plays, which often mix everyday settings and naturalistic dialogue with fantastic events or nonrealistic behavior.

Hwang is often classified as an Asian American playwright, and his best plays present serious ideas about race, gender, and cross-cultural understanding. Yet his plays rarely seek to present psychologically rounded, realistic life stories, to explain or introduce Asian or Asian American cultures to Westerners, or to document historical events. Rather, his imagination and method are satirical, fantastic, and highly theatrical. A typical Hwang play involves complex acts of narration and dramatization in which several layers of fiction-making resonate to develop a central idea or paradigm. Within these layers, Hwang often blends historical facts, familiar and unfamiliar cultural references, elements of pure fantasy, and dialogue that appears to represent ordinary speech, but is in fact funnier, faster paced, or more complex.

M. Butterfly, for instance, uses the central story about Gallimard's affair as a vehicle to discuss how *Madama Butterfly* and orientalism tie in with an educated

white man's feelings about masculinity. Brief but crucial references to China's Cultural Revolution and the U.S. intervention in Vietnam are used to imply that orientalism still colors American foreign policy. Hwang does not prove this with historical documentation or analysis. Instead, he creates a fantasy in which characters spell out how stereotypes operate in ways that are powerful, but ignored or denied in real life. In life, such prejudicial motives are usually masked by others, in ways that Hwang's play does not seek to portray. Similarly, the characters of Hwang's most brilliant satirical work tend to be caricatures, because they are pure or stylized representations of the traits being satirized. Even so, these characters are lively and engaging. For instance, some people might consider Gallimard a caricature, but some have found his story moving or deeply distressing.

In addition, Hwang revels in witty exchanges among characters talking on several levels at once. In *M. Butterfly,* the singer Song Liling repeatedly refuses to reenact Gallimard's memories the way he wants to present them to the audience. He has to keep arguing with "her" (Song, the female impersonator) and reminding her that she is a character in *his* narrative. Song's refusal of Gallimard's narrative authority not only amuses; it illustrates her refusal of his domination in other areas as well. The sharp satire, quick pace, and multiple levels of reality favored by Hwang would be compromised by a more naturalistic approach emphasizing strictly chronological narration and psychological realism. (See, for example, the film adaptation of *M. Butterfly.*)

Asian Americans' responses to Hwang's work have varied. In the case of *M. Butterfly,* some appreciate the play's sharp criticism of how men treat Asian women; others are understandably concerned that the play may perpetuate both the Butterfly stereotype and that of the "clever weakling," the image of Asian men as clever, devious, and effeminate. Unfortunately, the long history of both these stereotypes makes this concern a valid one, but it would be simplistic to suppose that the play simply reinforces such stereotypes in the minds of all its viewers. The play also demands, and seems to have found, a more thoughtful and sophisticated audience. To such viewers, it is clear that, just as Gallimard is not particularly French in sensibility, Song and "her" co-conspirator, Chin, are not particularly Chinese or Asian in temperament. In particular, Song's language, manners, and ideas are so obviously American, "her" story so obviously unique, that it is hard to imagine how this highly theatrical, cross-dressing, homosexual spy could be consciously mistaken as representative of Chinese manhood or culture. While the full range of audience perceptions is too complex to analyze here, the play's critical and commercial success reflects a substantial degree of acceptance of its central message, the critique of orientalism. Whatever the play's limitations, its

success in getting white audiences thinking about such fundamental prejudices must be reckoned as a positive contribution.

In the United States, a writer of Asian descent such as Hwang must always choose how much to explain Asian and Asian American cultural references. *M. Butterfly*'s mainstream success is due in part to its reliance on a white, middle-class frame of reference: everything unfamiliar to ordinary American theatergoers, including the plot of Puccini's opera, is explained. Hwang's early plays, however, took the opposite approach: they drew upon some specifically Chinese American sources that they purposely left unexplained, as a challenge to theatergoers to broaden their own knowledge. Of these, *F.O.B.* is the most allusive.

In *F.O.B.* and *The Dance and the Railroad*, Hwang alludes to two heroes he had encountered in the works of other Chinese American writers: Gwan Gung, the god of warriors, writers, and prostitutes; and Fa Mu Lan, a legendary woman warrior. Although both characters appear in Chinese culture, Hwang's play does not allude to Chinese sources but to references in Frank Chin's play *Gee, Pop!* and Maxine Hong Kingston's book, *The Woman Warrior*. Hwang identified these two writers as key figures in an emerging Chinese American literary tradition and paid tribute to them by using their characters in his plays. Chin and others subsequently criticized Hwang, along with Kingston, for distorting these heroes' stories and misrepresenting Chinese culture as exotic, misogynist, and barbaric, a criticism that is best evaluated by reading the plays.

One should realize, however, that both characters are ancient Chinese figures who, like England's King Arthur, have enjoyed many artistic incarnations over the centuries. As Robert G. Lee has noted, Gwan Gung (also spelled Guan Gong and Kwan Kung) is based on a historical Chinese hero, Guan Yu, who lived between 162–220 A.D. The title of *gung,* duke, was the first of many bestowed on Mr. Guan posthumously. In the late thirteenth century, Guan Gung, having already been declared both a Buddhist and a Daoist protector deity, was further mythologized in vernacular novels and plays. The most famous of these is *The Romance of Three Kingdoms* by Luo Guan-zhong. In the late nineteenth century, Gwan Gung came to be considered the most popular and powerful of several deities honored by Chinese in California, who celebrated his exploits in Cantonese opera productions. Since *F.O.B.* and *Dance* were first produced, Gwan Gung has been revived in several Chinese American works, including Frank Chin's novel *Donald Duk* and Maxine Hong Kingston's novel *Tripmaster Monkey*. The legend of Fa Mu Lan (Hua Mu Lan, Mu Lan) is a short, ancient ballad familiar to many modern Chinese children, which has also been treated in operatic and other forms. (See Chapter 43.)

F.O.B. also alludes to the treatment of Chinese immigrants in America. One speech evokes the interrogations faced by Chinese seeking entry to the United States throughout the first half of this century. In accordance with severe immigration restrictions against the Chinese from 1882 through 1943, these interrogations, designed to weed out impostors claiming false identities, sometimes included minute details such as the number of steps to the house, or the location of the rice bin. They have been well documented by Him Mark Lai, Genny Lim, and Judy Yung in *Island: Poetry and History of Chinese Immigrants in Angel Island.* Another monologue in *F.O.B.* evokes this country's history of anti-Chinese harassment and violence, which began with the arrival of Chinese in the 1850s and became particularly pronounced in the 1870s and 1880s throughout the American West. During this period Chinese were repeatedly threatened, attacked, expelled from their homes, and murdered by whites who had little fear of being tried and punished. This history, along with similar conflicts encountered by other Asian Americans, is recounted by Sucheng Chan in her book, *Asian Americans: An Interpretive History.* Through these mock-historical monologues, *F.O.B.* links the seemingly isolated problems of contemporary Chinese Americans with a little-known history of systematic anti-Asian discrimination in the United States.

One final example may illustrate Hwang's canny use of historical information as a springboard for his imagination. *The Dance and the Railroad* is set during a railroad workers' strike that actually took place and has recently been recounted by Ronald Takaki in *Strangers from a Different Shore.* To expedite construction, the Central Pacific railroad forced Chinese laborers to continue railroad construction across the mountains throughout the winter of 1866. Despite snowdrifts more than 60 feet in height and lethal snowslides, the Chinese labored on, living and working in tunnels under the snow. In the spring of 1867, the 5,000 workers struck, demanding a 14-dollar-a-month raise and an 8-hour workday, which white workers already had. Hwang made this strike the setting for his play, in order to combat stereotypes of the immigrants as passive victims of exploitation. In Hwang's play, the strikers, having made the same demands, accept a pragmatic compromise that improves their conditions and returns them to work: they win an eight-dollar raise and an eight-hour workday. In real life, the white authorities were less humane. After offering only a three-dollar raise, which the strikers rejected, and checking to see that an alternative workforce could be supplied (they sought 10,000 blacks), they simply cut off the workers' food supplies. Geographically isolated and faced with certain starvation, the strikers returned to work within the week. By departing from the historical record, Hwang has created a fiction that more clearly celebrates the men's valor and resistant spirit. However,

critics have neither noted nor attacked this blatant case of revisionism, nor have scholars debated the authenticity of Hwang's artistic, modern American railroad workers. No one minds, it seems, when poetic license is invoked in order to affirm Chinese American manhood and culture.

Further Reading

"As the Crow Flies" and "The Sound of a Voice." In *Between Worlds: Contemporary Asian American Plays.* Ed. by Misha Berson. New York: Theatre Communications Group, 1990.

Bernstein, Richard. "France Jails 2 in Odd Case of Espionage." *New York Times* (May 11, 1986).

DiGaetani, John Louis. "*M. Butterfly:* An Interview with David Henry Hwang." 33 *TDR: The Drama Review* 3 (1989): 141–153. Includes illustrations and gives a sense of how the play was first staged.

Glass, Philip. *1000 Airplanes on the Roof.* Beverly Hills, CA: Virgin Records, 1989. Sound recording of Glass's music, without Hwang's dialogue.

Glass, Philip, David Henry Hwang, and Jerome Sirlin. *1000 Airplanes on the Roof, a Science Fiction Music Drama.* Salt Lake City: Peregrine Smith Books / Gibbs-Smith Publisher, 1989. Illustrated text. Gives text with photographs of the set designs.

Hwang, David Henry. *FOB and Other Plays.* New York: Penguin / New American Library, 1990. Includes *F.O.B., The Dance and the Railroad, Family Devotions, The House of Sleeping Beauties, The Sound of a Voice,* and *1000 Airplanes on the Roof.*

———. *M. Butterfly.* New York: Penguin / Plume, 1986.

Hwang, David Henry, and Philip Glass. *The Voyage: An Opera by Philip Glass, Libretto by David Henry Hwang.* New York: Metropolitan Opera Guild, 1992. Libretto.

Street, Douglas. *David Henry Hwang.* Boise, ID: Boise State University Press, 1989. A readable 45-page narrative of Hwang's career emphasizing biography, plot summary, and critical reception of each play.

A Reader's Guide to Cebu and Dark Blue Suit Based on Interviews with Its Author, Peter Bacho

GEORGE J. LEONARD

DIANE ROSENBLUM

The Classroom Books of Choice—The Reasons Why

When I first started teaching my course in multicultural American literature, I naturally assumed that Jessica Hagedorn's lyrical, comical, wonderful *Dogeaters* would be the assigned text. When Diane Rosenblum and I questioned our Filipino advisors, however—critics who have a quarter century of experience with Asian Pacific American literature, and who supervise all Filipino materials in this book—they informed us that the book they themselves assigned was the American Book Award–winning *Cebu* by Filipino novelist Peter Bacho, then unknown to Diane and me. They admired Hagedorn. Everyone does. But they raised interesting pedagogical questions.

Dogeaters is a wonderful book, they agree. The Filipino American scholarly community is remarkably appreciative of all its authors and has not divided over any issue the way the Chinese American scholars divide over the Chin–Kingston debate. In that respect, the Filipinos are unique. The Latino scholars are dividing over feminist issues, and other ethnic communities look likely to follow. The Jews had divided over "neo-conservatism" by the end of the seventies. In the Native American community, Hagedorn's status as a "mestiza" might affect the issue, but not here.

If the multicultural course's purpose is to introduce students to ethnic *American* cultures through their artworks, Hagedorn's book isn't what Filipino scholars would choose. For one thing, *Dogeaters,* which brilliantly recreates the atmosphere of upper class life during the Marcos dictatorship, has become, since his 1986 fall, a novel of *le ancien regime,* slightly dated now. But the big reason for not assigning it, is that it is set entirely in the Philippines and tells you almost nothing about Filipinos—that is, Americans of Filipino descent. If students who knew little about contemporary Jewish American culture were given *Fiddler on*

the Roof, set back in Russia, as their sole assignment, it might mislead them. And so would *Dogeaters.*

In Bacho's *Cebu* an American-born Filipino encounters the Philippines for the first time, and a foreign place it is to him. The encounter underscores the difference between Filipinos (Filipino Americans) and Pilipinos, the citizens of the Philippines. Then Bacho's hero, Ben Lucero, returns to the United States, where—as a priest—he must contend with the world of Filipino youth gangs. Novelists, usually middle class, "interpret" their poorer ethnic counterparts, but not Bacho, who lived in migrant worker camps as a child. *Cebu* is written with unusual authority.

I was so impressed by *Cebu* that when, later, I had the chance to retain Bacho as an advisory editor for this volume I was eager to do so. What I've written about these two books' strengths and weaknesses as teaching devices, however, anyone can verify for themselves.

This reader's guide is based on taped interviews Diane Rosenblum and I conducted with Peter Bacho, with Prof. Dan Gonzales facilitating. Mr. Bacho also very kindly spoke to my class. The many papers my classes have written on *Cebu* over the last four years and the questions they asked have shaped what the guide includes. When *Dark Blue Suit* appeared, I added that section. Finally, Mr. Bacho reviewed it for factual accuracy, though he did not influence critical statements.

Bacho Against the Background of the Filipino Novel Tradition

Given the small number of Filipinos before 1965 and their relative lack of education, the group has already produced an astonishing number of highly regarded novelists. Bacho is very forthcoming about his admiration for the older generation of Filipino novelists. This volume deliberately chooses not to spend equal time on all deserving writers, but to concentrate on what is most likely to appear in the new multicultural courses. Excellent works like Sau-ling Cynthia Wong's *Reading Asian American Literature: From Necessity to Extravagance* treat Carlos Bulosan and Bienvenido Santos in detail. (See also Chapter 40.) Historically important as they may be, they are not the authors of choice for the first multicultural course. Asian America has changed so rapidly since the 1965 Immigration Act began letting great numbers of Asian Americans into this country—and Asians from a very different economic class than the earlier immigrants—that there has been, as Peter Bacho says, a "generational split in experience." Bulosan and

Santos offer visions of worlds that vanished with the Chinese American "bachelor society." In his new collection, *Dark Blue Suit,* Bacho pays what in essence is homage to those early immigrants; he tells readers what happened to those men—first introduced by Bulosan and Santos—at or near the ends of their lives.

This doesn't diminish their books' value as literature, of course! I asked Peter Bacho to briefly evaluate his predecessors, and he offered this respectful reply:

> *Ben Santos's and Bulosan's central works are bookends of an historic era, the 1930s through the early 1950s, though Santos continued writing well after that. There is a difference between the characters Santos writes about and the characters Bulosan writes about. Santos was part of an East Coast crowd, which gives him a very different perspective from the West Coast and Bulosan. The men Santos associated with were well-to-do, the kind of person most Filipinos then would only dream of associating with. They attended private schools, Harvard, Yale. Santos himself wasn't from the upper class, but the upper class, because of his brilliance, pretty much regarded Ben as a peer. (His best known work is* The Scent of Apples, *1955.)*

This social difference creates the difference between the characters Santos writes about and the characters Bulosan writes about. Santos may write about the sugar baron's sons and daughters, people like Val in *Quicker than Arrows.* Such people never appear in Bulosan's narratives.

Bulosan educated himself in a sanatorium, reading Gorky, Jack London, Steinbeck, Saroyan—all Socialists or Communists. Chris Mensalvas, the great Filipino union leader, said Bulosan was a card-carrying Communist; Bulosan described himself as a second-generation West Coast Communist. Mensalvas, a great union organizer, became the hero, Jose, in Bulosan's best-known work, *America Is in the Heart* (1943). Bulosan—who was physically frailer than the union organizers he writes about—depicts labor and its affiliation with the Left well. The connections he makes between the Spanish Civil War and the Filipino community, between fascism in Europe and in the United States—a huge jump from a racial connotation, of course—were connections that the community itself made at that time.

Otherwise, their sensitivities and sensibilities are very much the same. Neither writer had any writer-hero from his nationality available to him. The writers of few nationalities are entirely self-contained (the Americans of this

century have looked to the French or the Irish) but neither Bulosan nor Santos has any obvious foreign models. That's interesting.

Both were born in the Philippines, but write here. Both seem to have admired the Manila writer, F. Sionil Jose, though he was younger than either of them. They were aware, too, of Juan Dionisio. Yet their writing remains hard to categorize or even to characterize. Santos tells very evocative and subtle stories. Bulosan's style is very primitive, rougher even than a John Dos Passos. His storytelling is not well-paced. But it has an emotional honesty, and his tale is worth telling.

The Old Country: The Philippines and the Island of Cebu

Part One of *Cebu* is set in the Philippines, as Ben Lucero, the hero, a priest, takes his mother Remedios home to Cebu for burial.

Peter Bacho gives Cebu an exotic atmosphere by starting with Ben's arrival on a rickety plane flight, like something out of *Raiders of the Lost Ark*. We get the feeling of a trip back in time to the 1940s. That's the novelist's art. You'd never guess from this book that Cebu City is the third largest city in the Philippines, with 600,000 people, and is second in commercial activity only to Manila. Cebu has the second largest international airport, servicing the hordes of Japanese tourists who cover the beaches. The city has a large Chinese community with a long history in the Philippines, most of whom finance import-export businesses and live in the "Beverly Hills" type suburb—a quaint "Miami Beach." Cebu is one of the Visayan islands, which are famous for being more Polynesian in feel—laid back, tropical, slow lilting speech—than Manila.

Cebu is one of the main islands of the Philippines. The Philippines received its name from King Philip II of Spain (reign 1556–1598). The United States immigrants and U.S.-born children call themselves Filipinos (Filipino Americans) while in the Philippines they call themselves Pilipinos (there is no letter "F" in the Philippine alphabet). Newspapers use "Filipino-American," and "Am-boy" or "American boy" is also used as a slang term. No one agrees on the proper term. **Pinoy** and **Pinay** are also widely used slang; some younger people think the terms derogatory, according to my classes.

The Philippine Islands were part of an enormous mountain range, a million years old, which included Taiwan and which sank beneath the Pacific as they were shoved out into it on the Pacific plate. The tops of this mountain range make up the 7,107 Philippine Islands today. Only 7 or 8 percent are bigger than a mile across; only 7 or 8 percent are inhabited. The two biggest islands, Luzon and Mindanao,

have 65 percent of the land area and 60 percent of the population, dwarfing the other islands. Luzon is to the north, Mindanao in the south, and the middle cluster of islands—Cebu among them—is called the Visayas. (A popular Tagalog woman's name links the islands, Bacho tells me: Luzvimin. "It's sort of a nationalistic statement. Very popular in Tagalog and Visayan. I've seen it without the 'z,' too.") Anthropologists have found fossil species there linked to those in Asia. The Philippine Islands have 12 active volcanos and lie in a monsoon belt, enduring heavy weather.

The islands have a population of about 63 million—a number that grows annually at an astronomic 2.4 percent, making it the fourteenth most populous country in the world. (It is not a coincidence that the Philippines is considered the most Catholic country in the world. Bacho made his hero a priest—a central figure in the community.) In comparison to the Philippine's 63 million, the United Kingdom has only 57 million people and France has 56 million. Although Quezon City is the capital, Manila is the twelfth biggest city in the world with 12.8 million people in 188 square miles—ahead of Los Angeles, which ranks thirteenth and has 10.7 million in 1,110 square miles. Compare Manila to Calcutta, which jams 14 million people into 209 square miles. Bacho's novel, though set in Cebu, for the most part, must be pictured taking place against background scenes of Calcutta-like misery and inequality. Cebu itself is a middle-sized island nestled in the central Visayas. In 1521 Ferdinand Magellan landed in Cebu, discovered the Philippine Islands and claimed it for Spain—a month later a local chief killed him.

Malaysia, Borneo, Java are the neighboring countries. China is, at one point, only 994 miles away. These sparsely populated islands lent themselves to constant small-scale exploration, colonization, and rule by dozens of tiny kinship groups. As a result, today there are over 100 recognized ethnic groups and languages in the Philippine Islands as well as extreme tribalism, much like sub-Saharan Africa—10 percent are actually primitive groups living in the stone age, like the Negritos, who are most likely kin to the Australian aborigines.

As a result, the Philippines has never been more than a political entity, and that only recently, gaining its independence from the United States in 1946. Ten hours after the Japanese attacked Pearl Harbor they attacked the Philippines, forcing U.S. General Douglas MacArthur to retreat to Corregidor, then later to Australia. Before MacArthur left he promised, "I shall return"—which he did in February 1944, finally defeating the Japanese forces. To this day, MacArthur and the American Army of World War II are great heroes among mainstream Filipinos.

Before the Philippine independence, however, the United States had established the Tydings-McDuffie Act of 1934, which gave the Philippines a "ten-year transition period to independence" and which lowered the numbers of Filipinos who

could immigrate to the United States to 50 per year—although Americans could enter and live in the Philippines unrestricted.

Finally, on July 4, 1946 the Philippines elected Manuel Roxas as its first president of the independent Republic of the Philippines.

The official national language is Tagalog, which the state calls Pilipino. Though there are three major languages: Tagalog, Visayan, and Illocano (from the Ilocos region in Luzon), people who work and live around Manila and Quezon City speak Tagalog. People in Cebu speak Cebuano or Visayan. Although Tagalog adopted quite a few Spanish terms, it is its own language.

Miguel Lopez de Legazpi established the then-capital of Manila in 1565. The Philippines was founded to be a halfway point for "the Manila Galleon." The gold looted from Mexico and Peru was sent every year, on a galleon, to the Philippines, where the Chinese met the Spaniards to sell them furniture and fine goods. In 1899 the Philippines passed to the United States. (See Appendix A.)

The following is a reader's interpretive guide to the novel, *Cebu*.

Page 7 Clara Natividad

When Ben returns, he seeks out the woman he calls "Aunt Clara." This beautiful, powerful personage was not his aunt but his mother Remedios's closest friend and a sort of godmother to Ben.

Thus begins the theme of *utang na loob*—obligation, debts of honor—that Filipinos take as seriously as Sicilians. Two themes unite the novel's far-flung events: Utang and Barkada: debt, loyalty, and revenge. Debts of obligation and loyalty to one's group are not confined to a kinship group like the Chinese filial piety—these debts often extend to one's *barkada,* one's friends, business associates, or in this novel, gang members.

San Francisco State professor Dan Gonzales names four values usually cited by sociological texts as the central elements of Filipino culture. In Tagalog, these terms are:

1. *Pakikisama:* from *kasama,* constant companion: your in-group, peer group
2. *Utang na loob:* the words mean "debt" and "character"
3. *Amor proprio:* extreme sensitivity to personal insult
4. *Hiya:* propriety, etiquette "shame" in the social sense

These four values comprise what sociologists have called "the search for SIR, smooth interpersonal relationships." This value web, so to speak, creates many

secondary characteristics, for instance, the Filipino's great reluctance to give a negative message. If people find they can't make a dinner date, Peter Bacho notes, rather than tell you that unpleasant fact to your face, they may simply not call. Filipinos are said to subscribe to the fatalistic ethic of *Bahala na,* meaning "leave it to God" or more exactly, "Let it be." Filipinos paradigmatically show distaste for confrontation or attitudes that may "rock the boat."

(But Professor Dan Gonzales challenges these values as portraying Filipinos in too negative, too passive a light. See Chapter 12.)

Page 8

The cabbie in the United States calls Clara a "Chinese bitch." That is, he doesn't recognize that she's a Filipina. Filipino scholars call themselves "the forgotten Asian Americans," so little-known is the group even by the mid 1990s. Yet the 1990 census showed that Filipinos had surged ahead of Japanese Americans to become, after Chinese Americans, the second most populous Asian American group. In 1980 there were 781,000 Filipinos; nearly 473,000 arrived in that decade, for a total of 1,254,000.

Page 10

Clara Natividad's wealthy lifestyle exemplifies the extremes of rich and poor in the Philippine Islands. Clara has done very well under the Marcos regime. She could move easily in the corrupt upperclass world Jessica Hagedorn describes in *Dogeaters.*

Ferdinand Marcos became president in 1965 and immediately ordered successful public works projects. In 1969 in "one of the most dishonest elections in Philippine history" Marcos became the first president of the independent republic to be reelected to a second term. However, unlike the success of his first term, the country suffered economic stagnation and violence from Communist insurgency and from battles between Muslims and Christians in Mindanao, the southernmost island. The 1935 Philippine Constitution, which the U.S. helped frame, limited the president to two terms. Rather than step down, on September 21, 1972 Marcos declared martial law over the Philippine Islands. He confiscated weapons, shut down newspapers, dismantled business conglomerates and redistributed them to his allies, nationalized the Philippine Airlines, charged and arrested his arch-rival Benigno "Ninoy" Aquino on subversion. Marcos was no longer president, but dictator. Marcos allowed Aquino and his wife, Corazon, to go to the United States for medical treatment after eight years in prison.

On January 17, 1981 Marcos finally lifted martial law. Benigno (or Ninoy) Aquino led Marcos' opposition from the United States and in 1983 returned to the Philippines. When he tried to get off the plane, on August 21, 1983, soldiers of the Aviation Security Command shot him dead. It was all caught on videotape. There was worldwide outrage. Aquino's assassination martyred him and the Philippine people demanded Marcos' overthrow. General Fidel Ramos, then commander of the Philippine Constabulary, called for Marcos' resignation. Backed by the powerful Cardinal Jaime Sin—a religious/political figure comparable at times to Martin Luther King, though deeply conservative—the Filipinos took to the streets and staged "an almost bloodless revolution." In 1986 the martyr's wife, Corazon Aquino, became president of the Republic of the Philippines. General Fidel Ramos succeeded Corazon Aquino as president with her blessing.

The novel takes place after the fall of Marcos but Clara's class is still very rich and very much in power.

Pages 16–17

Aunt Clara finally gives Ben, the protected second-generation American, the family secrets. It's a standard scene in American second-generation immigrant novels. Compare Michael Corleone being let into his father's criminal secrets in Mario Puzo's *The Godfather,* or the daughter Jing Mei in Amy Tan's *The Joy Luck Club* learning her mother had abandoned two babies in China. Aunt Clara reveals to Ben, the American, how truly awful life in the Old Country was—contrary to what his mother, Remedios, had told him because she wished to protect him.

The second-generation novel follows the larger mythic formula of Oedipus unearthing his past and his identity—like Luke Skywalker discovering Darth Vader is his father at the end of George Lucas' *Star Wars Trilogy.* In the second-generation novel, the secrets involve the gap between the horrors the parents had to survive in the Old Country and the protected American present.

One of Clara's investments, we will learn, was in organized prostitution—a theme that relates to the American bases in the Philippines and the notorious sexual slums that grew up to serve them; as well as to the Japanese sex tours (unlike the bases, still current) and the forced sexual services of Filipinas abroad. Sex is a major economic theme in the economic survival of the Philippines, and an explosive one.

Pages 18–19

Clara's Uncle Pabling—who may be *bakla,* gay—became rich during World War II selling to the Japanese.

Pages 20–21

Clara steals jeeps, invents the *jeepney* and gets rich. The jitney-jeep, or jeepney, has two long cushioned seats on both sides, an open back entrance, and is the prime mode of transportation in Manila.

Pages 27–29

The Japanese raped Remedios. Clara kills one in order to rescue her.

Bacho deliberately incorporated "slambang" action into *Cebu* from the Filipino pop fiction and movies he loves. More recently, American director Quentin Tarantino copied the very similar Chinese-language action movies to create his film, *Pulp Fiction.*

Page 31

Notice that Bacho tries to give an oral quality to the narrative, to make it more like a told story, a tale.

The Japanese occupation—known in the Philippines simply as "the Occupation"—has a place in Filipino memory comparable to the Holocaust for the Jews, and was the formative event for contemporary Filipinos and their generally grateful attitude to the United States. Bacho depicts some of the horror in the scene where the Korean soldier bayonets the child. (Korea had been forcibly absorbed into Japan at that time. This Korean, fighting in his Japanese masters' army, is a kind of Uncle Tom, albeit a vicious one. Bacho explains that historically, the rare Korean soldiers trying to prove themselves to their disdainful Japanese masters were even crueler to the Filipinos than the Japanese were.)

Bacho's book helps Americans get over any naive idea of "Asians" as some kind of monolith. The relationship of the Chinese, Japanese, and Filipinos in this century has been as bloody as the relationship of French, Germans, and Russians. Bacho's characters (who are not identical with the author, and do not speak for him!) generally regard the Chinese as tricky, colonizing businessmen and have not forgiven the Japanese and Koreans. Contemporary Japanese prosperity only deepens the rift between Filipinos and Japanese (not to be confused with Japanese Americans). The Filipino term "Japayuki" normally refers to impoverished Filipinas who go to Japan and become sex slaves. One sometimes sees it extended to cover Japan-bound Filipino engineers. Japanese salary-men use the Philippines as a regular stop on the Japanese "sex tour" circuit. Every issue of *Filipinas,* the most important American magazine for Filipinos, has stories on how the Japanese treat their Filipino maids as less than human.

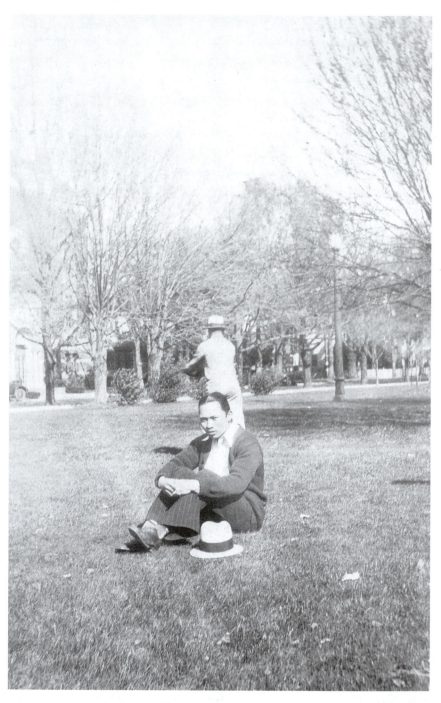

Figure 46–1: An elegantly dressed manong poses in a park on his day off. Seattle, Washington, 1950. Photo by Reme Bacho. Courtesy of Reme Bacho.

The popular attitude to America, by contrast, can only be called "reveren-tial," even if one takes it as evidence of a "colonial mentality." In the history books, the Americans are still the heroic good guys, first rescuing the Philippines from the Spanish in 1898 (despite the war of rebellion afterwards), then keeping their promise to rescue them from the Japanese (when it would have been possible to leapfrog over the islands, en route to Japan), and finally keeping the promise to grant the Philippines independence. (American students, unused to hearing any-thing good about America in college, let alone in an ethnic literature class, are almost comically amazed by this.)

Page 49–67
The theme of **utang**: Sitoy repays part of his *utang* to Clara when he obeys her orders to bandage up her Korean prisoner, so that Clara can take the Korean back to the village to kill him by cuts. She is paying her debt to Remedios, too. Sitoy refers to his patrol leader, or older brother, as **manong**—an important term of respect.

Page 66–67
Carlito's crucifixion is performed where the Korean was killed. Crucifixion is, among zealots, a popular Easter ritual in the Philippines to this day.

The Philippines is the only Christian country in Asia, and the most Catho-lic country in the world: 83 percent Roman Catholic, 9 percent Protestant, 5 percent Islamic, and 5 percent Buddhist. Cardinal Jaime Sin was such a great power that he helped end the Marcos dictatorship. The Church has fought con-traception and made abortion illegal, giving the country its frightening 2.4 percent annual growth rate.

Page 70
Marites, Carlito's granddaughter goes to Clara in this Godfather-like scene. No-tice that *salamat* is "thank you." It is a form of *salaam,* and shows the Muslim influ-ence from the south, where the Muslims colonized the Malays.

Page 75
Tagalog is essentially Malaysian, but it borrows a lot from all the cultures that have thronged to the islands. *Lolo* means "grandfather." For "Uncle," however, they use the Spanish "tio." "How are you?" is *kamusta,* an adaptation of the Spanish "Como esta?" Village is the Spanish word **barrio** (which really meant neighborhood) but the word for town is the Tagalog *bayan.* For beach and hotel they say "beach" and

"otel," borrowed from English. Yes is "oo" to a colleague and "opo" to an older person, but no is Hindi, "po." Po is a term of respect, like sir or ma'am.

Pages 95–98

Ellen Labrado, one of Clara's callgirls, becomes Ben's lover. Notice Ellen's obsession: move to the United States, to San Francisco, where, in the suburb of Daly City, the largest number of Filipinos in the U.S. congregate. It has been rightly said that the Philippines' biggest export is Filipinos, and mainly Filipinas, who send home the equivalent of one billion American dollars home to the Philippines each year. People coming home with money earned abroad to give out to relatives and friends are said to be making their **balikbayan,** an enormously important cultural ritual (and one filled with *utang,* debt). Stores in Daly City sell boxes marked balikbayan. All American immigrant cultures know this ritual, and it's nice to finally have a word for it!

Page 107

The working-class and criminal-class Filipino characters in the book show no sense of identification with Chinese Americans or Japanese Americans. The "Asian American is a political myth," Professor Dan Gonzales has written. Great differences are put aside for political purposes because "in unity there's strength." When in the 1930s the Japanese invaded China, the Japanese Americans and Chinese Americans became very cold to each other. When Japan invaded the Philippines, Filipinos rushed to join the American Army to fight them. When Japanese Americans were put in camps, the Chinese Americans just put on buttons saying "I'm Chinese!" so as not to be confused with them. Chinese American status in the United States suddenly soared, now that they were fighting our common enemy. They were even given new immigration quotas, in gratitude.

Most of the Filipinos of that first significant immigration wave came to the United States late, in the 1920s. They were housed with Mexicans who arrived to do fieldwork at the same time, and who shared their intense, emotional Roman Catholicism and their Spanish heritage. They intermarried with them and with African Americans. Bacho's father, a migrant worker who became a foreman, knew that life. As a child, so did Bacho, who lived the family's migrant life until he was five.

The largest number of Filipinos in the United States arrived since 1965, however, and they are another group entirely from the rural, agricultural workers who came before that. This educated, professional group (many of them women, many of them in health care) are not represented in this novel. The older

working class Filipinos complain they have nothing in common with the new professionals now coming in great numbers. "They just want to forget us," Bacho says.

Pages 148–149
Johnny Romero is part Indian. Johnny is shown rather cynically playing his affirmative action card to get into the police force. Since 1992, however, Filipinos have not been eligible for Affirmative Action preferences, since, like other Asian Americans, they have been very successful in school and the professions. This points to the bimodal nature of the community mentioned above: the new professionals arriving from the Philippines have changed everything. The book's only flaw as a teaching device—though it is not a flaw as a novel—is the absence of that group, which is, by the way, disproportionately female. The Filipino world is dividing into highly educated female professionals, arrived since the 1965 immigration law change, and older, blue-collar males, whose parents came in the 1920s and early 1930s.

Page 150
Barkada is discussed above at page 7. This provides a good illustration.

Pages 182–183
Murders in the barrio. This episode is a mirror of the Korean and Clara. That culture has come to America.

Page 200
The book ends with a scene uniting many themes: violence, utang, the Filipino as Catholic. The Ilocano gang kid (Bacho has described Ilocanos fondly as "rough northerners") sticks a gun at Ben and demands that Ben, as a priest, give him absolution. The open ending parallels, in an interesting way, the open ending Wayne Wang gives his movie *Dim Sum*. (See Chapter 57.) Critics have speculated on an Asian American fondness for oblique discourse, suggestion, and indirect communication. Open endings, which do not force the author's conclusion on the audience, may relate to those cultural values.

Dark Blue Suit

Peter Bacho's new work of linked short stories, *Dark Blue Suit*, follows up on the success of *Cebu*. With this work Bacho emerges as the finest writer of the Filipino

experience and one of the finest American realists to appear since James T. Farrell *(Studs Lonigan)* and a figure to compare with Martin Scorsese *(Raging Bull,* in particular).

Bacho continues to grow. *Dark Blue Suit* is an advance in power and technique. "Ethnic" literature is so often marred by defensiveness, by political correctness. The "burden of representation" (Cornel West's phrase) crushes the writer into a mere spokesperson, a spin doctor. Great ethnic literature flows without apology from the facts. James T. Farrell feels no nostalgia for the hard world of Studs Lonigan, Scorsese does not sentimentalize the "mean streets," the Little Italies of Jake La Motta and the "goodfellas." *Dark Blue Suit's* fighters and fight fans, moving in a world of grasping prostitutes, scarred ex-soldiers, and hardbitten union men, is as vivid a creation as Farrell's Chicago or Scorsese's New York, an unforgettable picture of Seattle's rainy Chinatown and Manilatown as it really was. In *Dark Blue Suit,* Seattle joins the landscape of the American imagination.

Bacho is a second-generation American novelist, and he follows certain recognizable patterns. The second-generation American fictionalist frequently follows the larger mythic formula of Oedipus unearthing his past and his identity—Al Pacino discovering from Marlon Brando why the Corleones had to flee to America and how the Godfather really made his money. In the second-generation novel, the secrets involve the gap between the protected American present and the horrors the parents had to survive in the old country, as well as the tough old neighborhood of their greenhorn days. "Dad, is Manong Chris a communist?" "Is this my illegitimate half-sister?" "Was this woman my father's lover?"

I will be arguing in a moment for Bacho's fiction's deep American-ness, so it is important not to slight its Filipino quality as well. Contrary to Michel Foucault, it matters a great deal to us who wrote a particular story, and deconstructionism's inability to address multicultural literature is a strong critique of deconstruction's limits. It would be doubly awful to bleach these stories by turning their Filipino author into a mere Foucauldian "authorial function," for, as I've mentioned, Filipino scholars call themselves "the forgotten Asian Americans," so little known is the group even by the late 1990s.

Many interviews with Bacho lead me to say that two Filipino values in particular unite the far-flung events of Bacho's fiction: *Utang* and *Barkada:* debt and loyalty (and consequently, paying one's debt to the point of revenge). Debts of obligation and loyalty to one's group are not confined to a kinship group, like the Chinese *xiao* ("filial piety"). Filipino debts often extend to one's whole *barkada,* one's friends, business associates, pals, courtesy uncles, boxing buddies, and even, in Bacho's work, gang members. A conspicuous term in any Bacho book is *Manong,*

the obligatory term of respect, almost reverence, accorded—even in the most casual conversations—to one's elders and anyone of importance. "A Manong's Heart" is one story's title in *Dark Blue Suit*. Buddy's terrifying Dad is addressed, "Manong, sir" *Dark Blue Suit* is itself a deeply Filipino act, a debt paid, a work of *utang* to one's old *Manongs* and the whole Seattle Chinatown-Manilatown *barkada* one grew up with.

As for Filipino aesthetic elements, Bacho has spoken, in interviews, of his admiration for earlier Filipino American authors. He sometimes also imitates the slambang plots and action of the Philippine Islands' action flicks he loves. On a deeper level, *Cebu's* ending was deliberately left open to two interpretations. In this new book, Bacho's haiku-ish stories look sideways at conflicts, see them through limited knowledge (one storyteller, often young or a child), hint at resolutions, but never insist on them. The reader observes, judges, moves on. Critics have speculated on a general Asian American authorial fondness for oblique discourse, suggestion, indirect communication. (Compare Wayne Wang's ending to his most characteristic work, **Dim Sum**.) Open endings, which do not force the author's conclusion on the audience, may relate to deep cultural values.

For all that, Bacho's fiction feels American, not exotic. This new book of short stories is really a novel formed of linked short stories, a form with American roots in Sherwood Anderson's *Winesburg, Ohio,* and Hemingway's *In Our Time.* The closest parallel to *Dark Blue Suit* is, as I've said, Martin Scorsese's *Raging Bull,* which also used a world of prize fighters to bring out the values of Little Italy as it was in Scorsese's youth.

Which leads to the final point: We needn't be interested in ethnic America to love Scorsese's movies *or* Bacho's stories. They're exciting, they're moving. Their consciousness of ethnicity is only a mark of their completeness. In the best American naturalistic fiction, the characters do not live in a vacuum, but at a particular time and in a particular place, which shapes their acts and fates. That these characters are of a particular ethnicity, as well, only adds one more shaping factor, a heightening of the realism, a deepening of the human motivation. Bacho's work is not sociology, it is literature, and it stands on the interest its characters generate, not on the sociological interest in the group (however valid that interest may be). Ultimately, it is the characters themselves—Buddy, his friends, Uncle Kikoy the fight fan (who builds a shrine in his room to the Trinity of Joe Louis, Sugar Ray Robinson, and Willie Pep), and Buddy's loving, rough-hewn father, proudly wearing his Borsalino and "magnificent" Bogartish "dark blue suit"—who will hold the reader and not let go.

Further Reading

Bacho, Peter. *Cebu*. Seattle, WA: University of Washington Press, 1991.
————. *Dark Blue Suit*. Seattle, WA: University of Washington Press, 1997.

Jessica Hagedorn

An Interview with a Filipina Novelist

JOYCE JENKINS

Performance artist, poet, and playwright Jessica Hagedorn was born and raised in the Philippines. Her debut novel was the *Dogeaters,* which *The New York Times Book Review* deemed "sharp and fast as a street boy's razor," a turbulent story of movie stars, junkies, and political assassination as seen through the lens of a young Filipina's loss of home and immigration to America. *Danger and Beauty* is a collection of short fiction and poetry from her first books, including *Dangerous Music, Pet Food and Tropical Apparitions,* and new writings. Her multimedia theater pieces have been presented at New York's Public Theater and include *Holy Food, Teenytown,* and *Mango Tango;* she has been a commentator for a syndicated weekly news magazine on public radio.

Jessica Hagedorn lived in San Francisco for many years, where she read and performed her lyrics with her rock group, the West Coast Gangster Choir: "My work by then [1974] is becoming more rhythmic and musically influenced, needs to be "performed" before an audience. I dream about putting a band together." And later, "I am consumed by music. How to fit rock 'n' roll into such dark words?"

Hagedorn embarked on a life of letters at a tender age. Poet and critic Kenneth Rexroth supported her in her search from the first. Here is a verbal snapshot from a biography by Linda Hamalian, *A Life of Kenneth Rexroth:* "Despite a killing schedule, Rexroth set aside time for younger writers. An acquaintance on *The Wall Street Journal* showed him a sheaf of poems by Jessica Hagedorn, a girl who had recently immigrated from the Philippines with her mother to San Francisco and who had never heard of Rexroth. After Rexroth read the poems, he invited Jessica for dinner, a casual but elegant meal graciously served by Carol Tinker. . . .

"That evening marked the beginning of a friendship between Hagedorn and Rexroth, who reminded her of her Chicago grandfather—a lovable, sad, big,

cranky man. Rexroth was 'magical.' He was very sympathetic to her artistic aspirations, her Filipino childhood, and her education. He set her on a course of reading—which included anthologies of black writers and French writers like Apollinaire, Artaud, and Clevel—and invited her to use his library whenever she liked. . . . He never tampered with her poetry, or condescended to her about it, but would suggest, for example, that she think more in terms of shape when she was writing . . ." He went on to write about her work and urged her to read in public at the Blue Unicorn to "develop her ear." Hagedorn writes in *Danger and Beauty,* "We shop for books and talk to real poets and one or two glamorous poseurs. Kenneth seems to know them all. His flat on Scott Street is the ultimate boho heaven for me. Poetry is respected. Writing is life. I am awed by his library of ten thousand books in all sorts of languages; a kitchen stocked with Japanese goodies; Cubist paintings on the walls; and a living room where you might chance upon James Baldwin, Gary Snyder, or Amiri Baraka—in town for a hot minute."

Hagedorn's work has been called charming, witty, fast paced, powerful, even hair-raising. It "combines narrative drive with a lyric sensibility." Her friend Ntozake Shange wrote, "Her language leaps from fiery memories of Hendrix, soft reveries of Holiday, and her own visceral attachments to Tagalog and Spanish in a Filipino way." As Hagedorn herself ends her introduction to *Danger and Beauty,* "It will never end. I hope—whatever 'it' is. The gift, the quest, the visions, the dreams in secret languages. The songs and the storytelling. It will never end; it is still writing itself."

The Interview

JJ: *Danger and Beauty*—you dedicated this book to Kenneth Rexroth, and I thought that was wonderful. I wondered if you'd like to talk about why you did that.

Hagedorn: Well, I think Kenneth was responsible for me taking myself seriously as a writer, and I think he is one of the truly underrated or forgotten great American poets and cultural critics and thinkers. Controversial as he was, and he wasn't everybody's cup of tea, he was a mover and a very generous man in his time. He could be cantankerous, and he had his fights, but I think Kenneth was quite a generous person, and he always had time for younger writers. I feel that I owe it to him, in his lifetime I never quite thanked him enough. So hopefully his spirit is listening. I thought this book was a gesture toward that. Thank God I listened to a friend of mine—because my original plan was to reprint se-

lected writings from *Dangerous Music* and *Pet Food* and then the new work, but she said, "What about that first book, that Rexroth book?" "Oh, come on," I said, "that's so old!" "But no, it meant something to me," she said. "As a young Filipino in school I ran across that book," she said. "How can you say that's too old?" So I picked four selections from that.

JJ: That would be *The Death of Anna May Wong.*

Hagedorn: Yes. And that was the book that Kenneth edited and that he got published back in 1972, and so it was fitting. I mean, what person could I say thank you to most?

JJ: In some way, he embodies San Francisco . . .

Hagedorn: Yeah, and this book is a lot about San Francisco; I think it's my way of also really acknowledging San Francisco as my other home, my second home, my home as an artist, and the fact that so much of my life as a writer began here.

JJ: Did he have anything more to do with publishing you as a young writer?

Hagedorn: I'm sure McGraw-Hill couldn't give a shit about publishing four young unknown women poets. They wouldn't have done that book without Kenneth! It was his idea; he put us together, and he presented them with a manuscript, and he wrote the introduction.

JJ: The *Four Young Women: Poems* anthology [1973] with you and Alice Karle, Barbara Szerlip, and Carol Tinker? He was the editor.

Hagedorn: Yes, and he chose the poems, it was his push; it was his idea. We were all 20, 21. What did I know about a book? I wasn't even thinking about a book, I thought, you know, that will come one day, or it won't come. It was his whole push. Earlier today [talking to San Francisco State students], I remembered that Kenneth took me to my first reading. He said to me, "You're going to come with me and read a poem." And I thought, "What do you mean? Just get up there and read?" The notion of a poetry reading was very alien to me, and he exposed me to that, and I think it was really important; it was my education; it was my writer's education, and I talk about it in the *Danger and Beauty* introduction quite a bit. Because, I realize, it's time to think about those things; it's the time in my life where I can look back and recall all these things that you just live with. You go on and on, and one day "Wow! This man was really instrumental."

JJ: One thing you don't mention in *Danger and Beauty* is Rexroth's connection to jazz, to music. He was one of the first to bring together the poetry reading and the jazz experience, and I know that's been an important part of your development.

Hagedorn: I probably didn't mention it because when I knew him really as a 14-year-old, when I met him, there was so much about him that I had no idea about. He took me to the Straight Theater in the Haight once. Again, we did a reading together. It was wonderful. He read with a band, a rock band. See, that was my exposure to him. I read later about his work with jazz groups, but my exposure to Kenneth was this night at the Straight Theater where he performed with a group called Serpent Power.

JJ: Wasn't that the poet David Meltzer's group?

Hagedorn: I think so, 'cause he knew David Meltzer. And so, he did this quite fascinating incantatory poem, and I'd never seen anything like it, and I was like, "Wow!" So that's what I knew; it was more like rock 'n' roll. I didn't know about the other stuff then. I was trying to do the intro in that honest way of doing it—as I remembered it in all my ignorance.

JJ: You went on, of course, to the Gangster Choir, which was very famous in San Francisco in the seventies, I remember just loving your performances. You were at Hotel Utah and at San Francisco State and all those places, and I just hung on that. It was really electric, and there was nothing like that happening. There were a few other poet bands that came after. Comidas Chinas in Seattle, and there were young poets like Deborah Lyall with Romeo Void, I think she studied with Phillip Levine at Fresno State University, but you were really one of the first. You're not doing that now, though.

Hagedorn: Not right now. Not because of wanting to go out of it, but because I realized I had spread myself too thin, and the novel was something I really wanted to finish, and I said, "I can't be everything, you know, at the same time; something's got to go." And the most draining was keeping a band together in New York, where I moved in 1978. I'd just had a baby, and the band meant not only writing the words for the band, but also, in a sense, being the manager, and being a mommy to all these people with egos and desires, and I had to keep feeding it, and looking for work for us. I couldn't! And I said, "The band has got to go. For now." I think last night's experience with [jazz musician] Eddie Gale here in San Jose, and with [poet and Miles Davis biographer] Quincy Troupe, taught me how much I really love to work with musicians. In New York a couple of years ago I worked with Urban Bushwomen, the dance company, and they had Craig Harris and his band do the music live, the whole band was on stage, and we were guest artists. It was so great, 'cause here I had this band again, without the headaches. We did my work, and I got to enjoy it without all that stress, and if I can, in the future, do that again, I will. But it's got to be smooth like that.

JJ: I'm really glad you took the break to write *Dogeaters,* because it's a great novel. Of course, it was nominated for the National Book Award, 1990. It's such an incredibly powerful piece. You really broke ground with the rich way you use language and the way you used Filipino words with English. That was real pioneering. I think you were one of the first to really make Filipino speech sing in fiction, make it really work and not have it be sheer artifice, or artificial in some way.

Hagedorn: Thank you. I wanted to capture the music of the language . . . the English, the "Taglish" that had evolved in my country and this country, and I always thought that a lot of novels that had to do with the Philippines were too stiff; they were too proper. And they didn't capture the rhythm of how people talk, and to me what they do to the English language is wonderful. As Quincy said today. "We speak the American language; we don't even speak English anymore," and he's so right. That fascinates me.

JJ: That whole question of writing a literature of place—people have conferences about it, write papers on it; sometimes I think it's just a gimmick, something to hang a few writers' work around. I think your work really is about the essence of a place, about being from the Philippines, and then coming to San Francisco in your teens, and then being a New Yorker, and how that's radically changed your work and your whole life. You must be asked that a lot. Are you?

Hagedorn: No, I don't think about it much. I just write about what I love. Elmar Abinader said something great last night; she said that the literature we both seem to be drawn to is character-driven. And so when you say place, that's interesting to me, because what it is about those places that intrigued me are the characters. Because what some people might say about me is that I write about displacement.

JJ: Yes. But it seems to me what you write actually comes out of the place, in a way, it's almost like the language of the place, the particular quality of the place, the postcolonial soul of the place.

Hagedorn: Yeah. I think so too. I mean I hope so, I hope so. I'm trying to write about New York now in the new novel, as well as other places where my characters are seeming to go to, and it's interesting because I'm living there and it's harder. 'Cause you're right in it, and there's so much about New York that could so easily fall into a stereotype.

JJ: And San Francisco, as we said before, seems so much the source of *Danger and Beauty.*

Hagedorn: It's easy for me to write about San Francisco. It's so inside me. Even though I've been away for a long time.

JJ: Poems of memory, mostly written in San Francisco . . . In the intro, you say something that really caught my eye, and I wondered if you could elaborate a little bit on it. You were talking about working with Thulani Davis and Ntozake Shange, and that being most of the reason that you moved to New York from San Francisco, and you talk about performing "where the Mississippi Meets the Amazon" at Joseph Papp's Public Theater, "it is an intense collaboration among volatile poets and musicians, and I've fallen in love with New York. I continue writing, well aware that my voice is hardened, become more dissonant and fierce."

Hagedorn: Well, Alan Soldofsky [Center for Literary Arts, San Jose State University] said an interesting thing after our reading Thursday night, he thought the new work had a sad edge to it; and that something had changed since living in New York. And I think life in New York is so different and so sort of relentless, you have to be up for it if you're going to be there, whether you're ready for it or not. It's a brutal place. It's a wonderful place, but it is brutal, and things go by you so fast. I've seen a lot of very sad things happen, to my friends, to people I work with, and it touches what I do. I think too, it's a very competitive city. One good thing it has done for my writing is to toughen it up, in a good way, maybe in a bad way to some people, and I think the music of New York is dissonant and fierce, and I think that's the rhythm of the city. There's a rhythm there, and you have to match it if you're going to survive there.

The difference between the way I write now and how I was writing in San Francisco in the seventies is—another good perception of Alan's—is that there were poems of celebration. And I did some of the poems last night with the music, 'cause they were fitting. Eddie Gale lives here. Some of his music is dark, but there is a joy to the music. And those poems worked very well! I thought, "Gee, they were written so long ago."—It seems like so long ago to me.—They came from another time, when we were all running around celebrating, not in a corny way, but I think we were really coming to terms with who we were, and we were enjoying ourselves for the first time. And this was a big deal to me, feeling isolated and kind of having to find out who I was, living in this new country, this scary new country. So to enjoy myself finally as a person, as a woman, as an artist—it was a wonderful time. I think a lot of the artists in the Bay Area at the time were having a ball. And not in an inane way. We were really finding ourselves as artists, enjoying each other very much. So it was a very different mood. I don't mean to say that you go to New York and everybody is like, "grrrr, grrr," growling at you; you have cause for celebration there, too, but you have a different atmosphere there, real different.

JJ: Some people are saying—I hear it a lot—that that pendulum is swinging back, and that some celebratory energy is coming back into the arts.

Hagedorn: I hope so. I don't mean we have to go around tossing daisies, that's not what we did in the seventies. A lot of the stuff I wrote was quite dark. You look at "Solea" now, and the first line is, "there are rapists/out there." It wasn't dippy whippy happy stuff.

JJ: But it was somehow a celebration of the power to fight back and the power to be aware of what was happening and reflected a real inner strength.

Hagedorn: Yeah, so I just wanted to point to the "celebration" as opposed to the "fierce dissonance." Let's be fierce, here.

JJ: What about the new Asian American anthologies that are coming out now? There's a whole raft of them, suddenly.

Hagedorn: I know. There is, isn't there.

JJ: The new edition of *The Big Aiiieeeee!,* edited by Shawn Wong and Lawson Inada . . .

Hagedorn: And Frank Chin and Jeff Chan.

JJ: *The Open Boat,* which is all poetry, edited by Garrett Hongo, and then *Quarry West* magazine's anthology, *Dissident Song. Quarry West* is a journal that comes out of the University of California at Santa Cruz. Marilyn Chin was the poetry editor, and David Wong Louie was the fiction editor. Now, you're editing *Charlie Chan Is Dead . . .*

Hagedorn: Another celebratory title. It's an anthology of fiction, and there are 48 writers. Thank god I had finished editing when I found out that actually it will be the first major anthology just of Asian American *fiction* ever in this country.

JJ: So this is the first fiction anthology with both men and women . . .

Hagedorn: There have been things like *Home to Stay,* which was an anthology of women's fiction, and then there's *Aiieeee,* but *Aiieeee* had different literary genres, and fiction, and then there's another one, *The Forbidden Stitch,* but it was all women again; it had fiction and poetry. So I looked back, and I called several people to make sure that this wasn't some idle boast of mine. I called Shawn Wong and Russell Leong at UCLA and said, "Is there one I don't know?" And I kept looking at my bookshelf, and I looked at Elaine Kim's book, *Reading the Literatures of Asian America,* and they said, "I think you're right; there isn't one that has had men and women that was exclusively fiction." She's writing the preface to my anthology, by the way.

JJ: Is that the primary way your anthology differs?

Hagedorn: Well, there's a lot of sex in mine, a lot of sex, death, and just kinky stuff, so mine isn't a proper anthology. It's very fun. These anthologies don't have to be all nice and proper. I hope *Charlie Chan Is Dead* is disturbing and also exhilarating.

JJ: So you feel yours is more open in some way than some of the others.

Hagedorn: Yes. I didn't impose any theme on any of the writers. I wrote a letter that said, I'm looking for riskier work, or more experimental work, that you feel is kind of on the dangerous side. But it can be about living here, or it can be about living back where your origins are. If you're from Vietnam or whatever, it doesn't need to be set in America. It was very open. And I went with what I liked. So there's some pretty traditional stuff in there, and then there's some very experimental stuff. John Yau submitted a wonderful "psychosexual sinister piece." This is from a poet. So there are poets who are writing fiction. I really tried to invite as many different people as possible to submit.

JJ: I think that openness feels like it would be new, in and of itself.

Hagedorn: Yeah, I think so. It's sort of sad in a way; you'd think everybody would be open, but they're not.

JJ: Most of the other anthologies, maybe just because of the fact that they were among the first, tried to encompass so much that some of them did turn out more traditional or historical, and yours sounds very much in the moment. Fresher in that way.

Hagedorn: I hope so. That's how I saw it. But it is historical also. In there you will find I have Carlos Bulosan. I have Jose Garcia Villa, who was superexperimentalist in 1933—a story that's one line . . . each sentence is numbered.

JJ: How he was a poet . . .

Hagedorn: He still is a poet; in fact, he once said to me, "I don't read fiction." But he writes fiction. He lives in my neighborhood in New York. I don't know how old Garcia Villa is—I got very excited!—It's like, there he is. My mother had given me some of his books when I was younger, and I have them. I called him up and asked, "Is it okay to use?" I think it will be exciting for him, even if he doesn't admit it 'cause it's fiction. But it's a very poetic piece, what I picked, very experimental. Who else is in there? Toshiro Mori. So you have those guys, and then you have the Han Ong's and the [critic] Lawrence Chua's, and all these 24-year-old boys and girls, like Cherylene Lee, she's a playwright and a fiction writer, she lives in San Francisco. Really good stuff.

JJ: It sounds as if you're going to put some of these people on the map, so to speak. A lot of them really haven't been published before, like Han Ong, or they haven't been brought before a broader trade book audience.

Hagedorn: No, it's great, because again, I was hoping to find new people, but if I didn't like any of the work, I wasn't going to force myself into it. But half, more than half of the book, are all these writers who either have published only in small press collections, magazines, or not at all. And I have a few Hawaiians, so I'm really thrilled about that . . .

JJ: That's new!

Hagedorn: I think Hawaii is a very rich place literally, and very ignored. I have several writers writing in pidgin English, and they are super great. Lois-Ann Yamanaka is hot. You know when you just have a feeling about a writer? She's in her early 20s, very humble, and she is wonderful! She's a poet, and she's writing this fiction; she's funny, very sensual, and sharp. Her dialogue is incredible, very good ear, and her characters are unforgettable. I hope someone picks her up, 'cause she deserves it. And Darryl Lum, he's wonderful; he writes in pidgin, and he just makes you cry and laugh. It's these wonderful characters— they all speak to you. And there's a young gay writer, Zamora Linmark; he's Filipino Hawaiian, and he has eight vignettes. Each story is like that, and they're great. It's about growing up gay in Filipino and Hawaii; they're tragicomic, and beautifully written. I demanded both: that the content be as cutting edge as possible, but also the writing. And they are just a few of the people. And then we have Maxine Hong Kingston and Amy Tan and David Wong Louie . . .

JJ: Those usual, wonderful, suspects for anthologies.

Hagedorn: Those great criminals of literature.

JJ: You mentioned Han Ong.

Hagedorn: I have, 'cause he's really smart; I respect a 24-year-old with perception and vision, and he can write his socks off. I went to see him at the Public Theater in New York. Someone said to me—George Wolf was curating a performance series, "New Performer-Writers"—"Let's go see this guy! I've never heard of him, he's Filipino!" And I said, "Really? Han Ong, right?" So I actually went to see him, and it was a great bill, because it was Han Ong and Anna Devere Smith. I went to see Han Ong, and she happened to be on the bill, and it was a great evening! Han did a piece called "Symposium in Manila." Very simple, he works à la Spaulding Grey, minimal, maybe a desk, a few slides, a chair and he talks to you, and he takes on personas, and he does movement; he's very graceful. But it's very simple and repetitive and beautifully done. It's not corny; it's not over produced; it's very simple and startling. I went to meet him afterwards, and turned out he'd read *Dogeaters,* so we had a connection. I'd started the anthology, and I sort of looked at him . . . I never assume that just 'cause someone's a performer that they don't write. I always think, "Somebody's writing something." So I said, "Do you have something for my anthology?" He goes, "Are you taking plays?" I said, "No, it's fiction, fiction, fiction. Or prose." He says, "Well, I'm writing a novel." He brought it over to my house the next day because he was coming back to L.A. where he lives—he's only been in this country since 1984.

JJ: From the Philippines?

Hagedorn: Yes. And he has such a take on this country. He feels like he's been born and raised here, and he has a real understanding of the craziness, so I'm impressed with that. He brought me this manuscript and said, "Oh, this is a little excerpt," and I was blown away. It's from the point of view of a hustler in L.A., and it's very strong stuff, poetically written and very brutal, too. Of course, I had to have it, there was no question. And then he came back to New York this year and did another solo piece that dealt a lot with the racial tensions in L.A. in a very . . . not obvious way.

JJ: Subtle.

Hagedorn: Language, he does *language,* and I loved it. So when Laura Jason of BAWW asked me who I'd like to read with, I thought of Han Ong. He's exciting; he's new; he really can perform; and he knows what to do with the words, so it will be a wonderful sort of balance.

JJ: I think the whole reading will be an incredible balance between performance and the word.

Hagedorn: And the characters. Because I just heard David Wong Louie in New York, and he read from his forthcoming novel. All the characters were rich, they were just wonderful. My favorite stories in his collection for me are favorites because of the characters, they're the most character-oriented ones, character-driven ones. And I think that Han, because of his theater background, is character-driven, 'cause he takes on all these personalities. I do too, in my work.

JJ: Even your poems are "persona poems."

Hagedorn: So we'll just drive the audience nuts with our personas.

Further Reading

Hagedorn, Jessica. *Dogeaters.* London: Pandora Press, 1991.
————, ed. *Charlie Chan Is Dead.* New York: Viking, 1995.

Lawson Fusao Inada

Japanese American Poet

JEFFERY PAUL CHAN AND GEORGE J. LEONARD

Still in Camp

"The always sharply dressed Lawson Inada is seated at my dining-room table, waiting to be interviewed," Morton Marcus wrote in 1993. "His six-foot frame, with its wide shoulders tapering to narrow hips, reminds me of a platform diver's. Although he is approaching 55, he doesn't look more than 35. With his impeccable grooming and dress, he has an elegance all his own. But his mellow, relaxed voice and smooth movements can be convulsed by raucous laughter in an instant, letting those around him know that a lot is going on beneath the calm exterior."

Lawson Inada, a third-generation Japanese American, was born in Fresno, California in 1938. He spent his early childhood as an all-American boy with the white picket fence and the German shepherd. This All-American life came to an end when his family was forced into America's wartime internment camps. "Probably a consensus of opinion picks Lawson Inada as the finest Japanese American poet," Jeff Chan reports. "Certainly the finest of his generation."

Lawson Inada's case is a fascinating one for anyone interested in "ethnic literature" as a concept. He is self consciously, and assertively, a Japanese American, an altruistic model of the poet-as-member-of-his-community, of the success-who-never-forgets-his-responsibility. Yet, there is also a consensus that the great influence on his work has not been Asian, but African American: jazz. He has written perhaps the finest poems about jazz, poems that embody jazz, of any American writer—the poems that the Beats and Ginsberg and even Phillip Larkin were always trying to write. Yet Inada's poems are relatively unknown, and their obscurity seems to have something to do with Inada's public persona as "Great Japanese American Poet."

The American poetry audience, in short, is still putting Inada in camp. He was sent to camp physically, the first time, because—American citizen, white picket fence, German shepherd or no—America couldn't get over his racial ancestry. The non–Japanese American poetry audience still can't. It is as if Saul Bellow were permitted to write *Mr. Sammler's Planet,* but not *Henderson the Rain King.*

Inada's poetry raises an issue larger than poetry: is the ethnic American ever free to be an individual, living, breathing, representing no one but himself? Is he, or she, never to be "my friend," but always to be, "my Japanese friend," "my black friend," "my Jewish friend"? Does one ever get out of that camp? What is the relationship between the individual's drive to be individual, and his or her acceptance of a larger membership too?

Finding His Calling

"The music speaks for itself. And it certainly spoke to me. It *called* me, *called* me by my name: 'Laaawwwson! Laaawwwson!'"

Inada's Nisei father nurtured his interest in jazz, Inada later recalled. His father was 4-F, and spent the war doing government work in Chicago, where he saw the greats—Fats Waller, Earl 'Fatha' Hines, and Art Tatum in his youth. Chicago, full of southerners come north for the plentiful war work, was enjoying a black renaissance comparable to the one Harlem had had in the 1920s.

His father brought home jazz records, nightclub memories, and a message of hope from Bon Ton Jenny's and the black South Side. "Yes, indeed, kid—those guys are really doing something in the great big world out there!" In the impoverished west side of Fresno, a place with "no library, no galleries, no museums, no civic orchestra, no ballet company," Lawson, a child who had spent his childhood incarcerated in Jerome, Arkansas, heard in his father's jazz records "an enduring philosophy—of adaptability, ingenuity, creation; of humor, wisdom, resourcefulness; of individuality and collectivity; of power and empowerment; of the strength and beauty of the human spirit." Tumbling out of the recordplayer's speaker in his Fresno of the poor and the alienated, the music was a "testament to life, to love of life." Half a century later, in his memoir, "Jazz," Inada declares flatly, underlining the words, that African American jazz is "America's gift to the world. And the practitioners of the music are, undeniably, among the *greatest artists the world has ever known.*" He took up the bass, and mused later, "if I had been a better bassist, or started sooner," he would have chosen not poetry, but jazz.

Which, as Jeff Chan argues, raises the most important poetic issue about him: Inada is no Japanese poet. He is an *American* poet—Japanese American, certainly and surely, but American. The greatest influence on his poetry, as on many an American life, has been the African American practice of an (originally) African American art form.

At Fresno State Inada was befriended by a youthful teacher, Philip Levine, also a jazz aficionado (and later one of America's most renowned poets). Critics have tried to call the poetry audience's attention to Inada, as poet of jazz. In his essay on Inada, Ishmael Reed notes the African American and jazz influence in his poetry. Leslie Marmon Silko agrees about the jazz, adding, "Inada plays the music of the continent itself: the song of the Rogue River pines and the song of the humble bunchgrass become Buddhist prayer. Inada celebrates be-bop and jazz; he sings love songs and laments from history, the Sand Creek Massacre and the imprisonment of American Japanese families only fifty years ago. Inada's ear for the musicality of English is unsurpassed . . . "

Many of Inada's poems are about, simply, jazz. They bear titles like "Two Variations on a Theme by Thelonious Monk as Inspired by Mal Waldron," "Listening Images," "Lester Young," "Billie Holiday," "Charlie Parker," etc. But beyond that, the influence of jazz, and jazz playing, permeates all his work. He has recalled himself in the 1950s, sitting on a fire escape trying to write a poem, listening to Monk, "studying Monk's prosody—how each time he'd come out of the speakers in a different, distinctive way, and always swinging."

Nor were Monk's tactics of surprise the only influence absorbed. "I hear the insistent choruses of Miles Davis's 'So What' in the rhythmic striding lines of Lawson Fusao Inada," Garrett Hongo, a younger Japanese American poet, writes. Hongo, a fine poet himself, analyzes the way in which jazz tactics (or rhetoric, or prosody, as you will) shape Inada's use of language:

> *His words have the timbre of ecstasy and transport, of tenderness and rage. They have, of course, the force of history and a highly developed personal consciousness, but they partake as much to me of a tradition of sacred speech, heightened speech—a reverence for power, precision, and beauty in language. One hears vernacular vocabulary and syntax ordered and filigreed through dithyramb and repetition into chant and variation something like the energetic jazz-sonata convention of post-bop theme, improvisation, and chorus.*

The Public Man

Inada's situation is made the more poignant by his own willingness to shoulder what Henry Louis Gates has called the ethnic American writer's "Burden of Representation."

He was the first Asian American to have a book of poetry published by a major American house. He has read his poetry at the White House. He has received two writing fellowships from the National Endowment for the Arts and been named one of America's "Heavy 100" by *Rolling Stone*. The Los Angeles Public Schools and Visual Communications produced a film based on his life, *I Told You So.*

And he has interpreted his stature as an obligation to the Asian American community. He became one of the editors of *Aiiieeeee!* and *The Big Aiiieeeee!,* the canon-making anthologies of Asian American literature. He has written fine poems of the camp experience and its aftermath, has even written celebrations of Asian American pioneers like John Okada. (For Inada's involvement with Asian American literature, see Chapter 38.)

From "The Discovery of Tradition" (for Toshio Mori and John Okada)

. . . Those older ones—
I had to claim them as my own.
I had to sit down with them
In a room ripe with rumor,
Blatant with shadows
And claim them as my own.

And in the end, of course,
It was they who claimed me,
Who bade me to be—
Unafraid, unashamed—
Who bade me to see,
Clasping my face
With the faith of love.

"I am your mother's brother."
"I am your father's brother."

"Come."

. . . .

Inada, feeling himself a link in the poetic chain connecting the Asian American past with the future, has felt a responsibility to mentor younger Asian American poets. Garrett Hongo has recorded his personal debt to Inada. "From college, I had written to Lawson, and he'd sent me a first-edition copy of John Okada's *No-No Boy,* the first Japanese American novel, then out of print." Imagine Martin Scorsese willing to write a personal letter to every Italian American kid who wrote him from college—and willing to enclose a rare first edition of some Italian American classic with it. We know of Hongo's debt because he became famous enough to write about it; but Inada didn't know who Hongo was going to be. It can't have been an isolated act.

Lawson Inada speaks best for himself, of course. His attitude to himself as Asian American, and to other Asian Americans—to the tensions he knows between one's wish to be purely one's self, and one's acceptance of one's membership in a group—is best articulated in his moving poem to the Asian American children who will follow him, here quoted in full:

On Being Asian American
 for our children

Of course, not everyone
can be an Asian American.
Distinctions are earned,
and deserve dedication.

Thus, from time of birth,
the journey awaits you
ventures through time,
the turns of the earth.

When you seem to arrive,
the journey continues;
when you seem to arrive,
the journey continues.

Take me as I am, you cry.
I, I, am an individual.
Which certainly is true.
Which generates an echo.

Who are all your people
assembled in celebration,
with wisdom and strength,
to which you are entitled.

For you are at the head
of succeeding generations,
as the rest of the world
comes forward to greet you.

As the rest of the world
comes forward to greet you.

Further Reading

Chan, Jeffery Paul, Frank Chin, Lawson Fusao Inada, and Shawn Wong. *Aiiieeeee! An Anthology of Asian American Writers.* Howard University Press, 1974.

————. *The Big Aiieeeee!* New York: A Meridian Book, 1991.

Hongo, Garrett. *The Open Boat: Poems from Asian America.* New York: Anchor Doubleday, 1993. Hongo's statements were from the "Introduction."

Hsu, Kai-yu, and Helen Palubinskas, eds. *Asian-American Authors.* Boston: Houghton Mifflin Company, 1972.

Inada, Lawson. *Before the War: Poems as They Happened.* New York: William Morrow, 1971.

————. *Legends from Camp.* Minneapolis, MN: Coffee House Press, 1992. All material quoted in this essay appears in *Legends.*

Laughlin, J., ed. *New Directions in Prose and Poetry 23.* New York: New Directions, 1971.

Lum, Wing Tek. *Expounding the Doubtful Points.* Honolulu: Bamboo Ridge Press, 1987.

Garret Hongo

An Interview with a Hawaiian Japanese American Poet

JENNY STERN

[Garret Kaoru Hongo was born on May 30, 1951 in Volcano, Hawaii and grew up in Gardena, California. In 1982 he published his first book of poems, *Yellow Light.* He has won many awards and was a finalist for the Pulitzer Prize in poetry in 1989 for *The River of Heaven.* In 1993 he edited an important anthology, *The Open Boat: Poems from Asian America.* Late in 1995 he published a poetic memoir, *Volcano: A Memoir of Hawai'i* as well as *Under Western Eyes,* an anthology of essays by important Asian American writers. Hongo is currently a Professor of English and Director of Creative Writing at the University of Oregon at Eugene.]

Jenny Stern: What do you see as the role of Asian American literature?

Garret Hongo: I see Asian American literature as a move outward from the ghetto into a global literature. A kind of re-imagining of global consciousness. Writers are seeking a way out from a narrow identity, from identities given us by anyone, even by ourselves. It is an opportunity to re-imagine everything, to see a bit down the street, maybe even to the end of the world. I see a movement toward *world* speaking.

Jenny Stern: How are the writers today different from those such as Jade Snow Wong or Pardee Lowe, of the 1940s?

Garret Hongo: In the past, writers worked from an idea of *origination,* an idea of what is essential in life, permanent, genetic. They made a kind of accommodation to American culture, putting it on like a set of clothes. Today I listen to what writers have to say, individually. They are answering a question in their mind. "What *is* cultural identity in America?" Most of all, they are trying to avoid any proscriptives.

Jenny Stern: Do you see any difference in the Asian American woman's voice from the Asian American man's voice?

Garret Hongo: I see women writers as witnesses to woman's experience, and I suppose men are witnesses to their own, different experiences. I really don't know how to answer that question.

Jenny Stern: Tell me about the new anthology, *Open Boat,* that you edited and contributed to as a poet.

Garret Hongo: This anthology is about poetry and the Asian American writer. It specifically is a book of poets, by poets. I think the term "multicultural" is a hype, a buzz word. It wasn't originally. When I first heard Ishmael Reed use it, he meant "all of us today." Now it has become a political term that has lost its meaning.

Jenny Stern: What message are you trying to set forth in your own work?

Garret Hongo: My message keeps changing. I am interested in the poverty of spirit and the poverty of mind. Living uses up the spirit and thinking makes it live. Right now I am interested in how cruelty reproduces itself, how it is given moral authority. It seems like what originates as an exploited economic need, is given moral authority when it is learned, and finally becomes translated as a facet of ethnicity. My new work concentrates on one terrible thing, a plantation on the North Shore of Hawaii, Oahu, where the poor indentured servant is treated with cruelty; and how it is learned and passed on to his family; and then becomes defined as an aspect or characteristic of that particular culture. I have a burning passion for this subject. Why this plantation, why this misery, why these poor?

Jenny Stern: Could you comment on the Pan-Asian culture? Is there any? Or are there just individuals dealing with a balance between two worlds?

Garret Hongo: I think it is always just individuals *speaking.* We have, though, grown into a Pan-Asian culture, a forum, a grouping of voices. The scholars have us in jail, and we are breaking out. There is a literature of global alienation, a literature of diaspora, where the writers have a similarity in voices of cultural displacement. I call them "cousins of unease." These writers of exile of all cultures, are my inspiration. Writers must answer, "What do you *do* with this consciousness that you have grown into?" Writers are re-imagining the real culture. They create a space for the active mind in which to live. Even world leaders need active minds. Writing is a way to imagine the world—to create it, if you will.

Further Reading

Hongo, Garret, ed., *The Open Boat.* New York: Doubleday, 1993.

Lum, Wing Tek. *Expounding the Doubtful Points.* Honolulu: Bamboo Ridge Press, 1987. Central work by a leading Hawaiian poet and cultural figure.

The Literature of Korean America

S.E. SOLBERG

From another epic, another history. From the missing narrative, from the
multitude of narratives. Missing. From the chronicles. For another telling
for other recitations.

—Theresa Hak Kyung Cha

I met Ko Won first in the unheated editorial rooms of, as I recall, the *Choson ilbo* newspaper in a bombed-out Seoul sometime during the cold of the 1954–1955 winter. A photo I recently came across shows me parka'd with green woolen winter uniform bloused over combat boots posing with a group of young Korean newsmen clad only in shabby business suits. In retrospect I realize they were layered against the cold from the skin out, realizing full well there was small chance of winding up anywhere near warm enough to justify shedding an outside layer. Nevertheless the arrogance of a superfluity of clothing against the austerities of a blasted world dominate the image.

In the late summer of 1960 during the heady interlude between the fall of Syngman Rhee and before the first military coup, Ko Won and I again met in Seoul. Fresh from an interlude in England, Ko Won was teaching at university, writing and publishing his own poetry, and, in his capacity as Secretary of the Korea Centre P.E.N. International, working toward the publication of modern Korean literature, both poetry and prose, in English translation, a project in which I collaborated to the then-best of my abilities. Four years later we were both in the United States, he in Iowa, I in Seattle. We both followed our tortuous paths to the doctorate. Yet, something over a quarter of a century later we find ourselves again collaborating in this business of promoting the writing and publication of new and unknown, at least to their English-language audience, writers. There is little fame and less fortune in it. Why bother?

The first issue of *Ulim / The Echo,* in the way of little magazines and ethnic community publications, fell afoul of its own founding. Ko Won continues the effort with a new masthead, more Korean in tone and, to that extent, less evocative of the immigrant situation, *Munhak segye / The Literary Realm.* Ko Won has been at this a long time; it is not at all surprising to find him working at the job of helping a new segment of the American literary world find its voice.

The reasons why we bother have somehow to do with literature as an artifact and somehow to do with literature as phenomenon, with that high and numinous value that resides in our aesthetic productions. Some inchoate inner sense decrees that the whole literary enterprise is important, and important it becomes. The literary work has qualities both public and private; mysteries concealed in public display are capable of being at once elitist and populist. Above all, the text, the book, the published story or poem, takes on a life of its own validating or denying its subject.

On an international scale literature and the arts can and do become a kind of glorified show-and-tell anything you can do . . . international literary prizes, the Nobel laureateship in particular, become goals of the state, tangible evidence of the culture it wants to display and purvey. Language and literature lie at the core of the nationalistic effort. Within states that have diverse populations questions of language, ethnicity, nationality, or race become springboards; the literary effort, regardless of authorial intent, may be seen as a means to grasp political recognition, the author idolized or vilified as the case may be. Examples of this are such widely divergent movements as the Gaelic language writers in Ireland and Scotland, Korean language literary journals from Japan, the People's Republic of China, and central Asia or, closer to home, the struggles of Ole Rolvaag and his immigrant generation to maintain the "mother tongue" as cultural marker, a viable literary or daily language, in the United States. For later generations language, except in respect to varieties of English, is no longer the ground; the shift is to ethnicity and nationality.

These are all matters of great and holy concern fit for spinning off reams of exposition and analysis from the halls of the higher learning. For the moment I am content to consider the least holy among them, the question of personal reward and personal commitment posed above. To illustrate—

In poems by a young Korean American poet, Wahn Yoon, which were sent to me by Ko Won when first read, I knew we had a poet. There was unity of tone, language—that identifiability that marks the strong poetic voice—and a passion for the saying as great as for what was said that held the half-dozen poems together while giving every promise of more to come. There was, as well, the added

bonus for a publication directed at the Korean American community that many of the poems were firmly rooted in the Korean immigrant experience. I was elated.

I asked Ko Won to put me in touch with the nameless author; a letter arrived with some basic information, Harvard undergraduate taking the year off to work at the *Paris Review,* had only been writing poetry seriously for two years, spent two hours a day in it, and yet more poems, a quicker fulfillment of that implied promise than I had anticipated.

The reward is in this act of discovery and disclosure, accepting and purveying, and, along the way, creating a record of the heart and the journey, of not only an individual, but an individual who belongs to, and to that degree alone, represents, a larger group which, for all the sociologists, psychologists, journalists, and their ilk who make a profession of prying, would never have its story told.

We are each of us guests on this land, after all, each having made his representative journey; and, while the many ways may ultimately merge, we travelers continue our own idiosyncratic paths with, one would hope, a modicum of friction. Korean America has yet only begun to tell its stories of immigrants and native born. But there are enough beginnings to sustain the idea of continuity, if not a tradition. The *Comprehensive Bibliography for the Study of American Minorities,* published in 1976, has no separate entry for Koreans; the following year *Amerasia Journal* began a discrete listing in the annual bibliography.

This pretty well reflects the facts of the matter: ten years or so after the new wave of immigration loosed by the Immigration Act of 1965, which changed the old bias against race to a bias for those with family ties and needed occupational skills, the new immigrants began to make their presence known. In 1965 Koreans represented 0.7 percent of total immigration to the United States; by 1976 that had risen to over 7.5 percent of total immigration, an increase in raw numbers from 2,165 immigrants in 1965 to well over 37,000 in 1975. The rate has remained at 20,000 to 30,000 arrivals per year since 1975: 55 to 85 Koreans a day. Given natural increase within the established community as well, we should be rapidly approaching that magic million mark that confers some sort of Dow Jones-like validity to burgeoning ethnic populations, if we have not already passed it.

By way of contrast the original Korean immigration was a brief affair; there were a number of students from Korea in the United States at the end of the nineteenth century. A few of them remained becoming community leaders among the next immigrant group of some 6,000 men, women, and children who, from 1903

to 1905, wound up for the most part on Hawaiian sugar cane and pineapple plantations. A third group of mostly student "refugees" from Japanese oppression followed, and then, picture brides, those intrepid and independent women who came between 1910 and 1924 to marry men already in Hawaii or on the mainland. Emigration, in any significant number, had been cut off by the Japanese prior to 1910 (as was immigration by the United States Immigration Act of 1924—the so-called "Asian Exclusion Act") until well after the end of World War II.

That may be taking it a little too fast. Some additional dates and events are in order. Korea was the last of the closed nations of East Asia, "the Hermit Nation" as Griffis characterized her in his 1879 book. The first "Western" treaty Korea entered into was with Japan in 1876, followed by the opening of the ports of Pusan and Inchon to trade. The second treaty was with the United States in 1882. Prior to this there was no emigration, and extremely limited opportunity for travel abroad. The first recorded emigrants to the United States were a group of three political exiles whose plans had gone awry. They came in 1885. One of them, Sŏ Chae-p'il (Philip Jaison), remained, attended medical school, and worked for many years for the United States Public Health Service. Ginseng merchants are reported in the late 1880s, registered as Chinese, whether they came to buy or sell is not stated, but probably to buy since commercial ginseng cultivation did not begin in Korea until the first decade of this century. At about the same time the first group of students serious about Western ideas and technology arrived—they were in large part to become the future community leaders overseas as well as in Korea. There were restrictions on emigration, and it was not until 1903 that the Hawaiian plantation owners through Protestant missionary contacts in Korea managed to open up emigrant doors for laborers. In 1905 in the aftermath of the Russo-Japanese war, Japan asserted her muscle in the Far East by establishing a protectorate in Korea with full control of the foreign office. Emigration was again banned. In 1910 Japan annexed Korea. On March 1, 1919 Korea rose in peaceful revolt against her Japanese master only to be brutally suppressed. March 1 as Independence Day remains an important holiday in all Korean communities. August 15, 1945, the end of the Pacific War, is another important date. "Liberation Day"—in the vernacular, of an older generation at least, this becomes the orienting point, events occur before or after "liberation." It also marks the beginnings of the "two Koreas," North and South, with the decision that the surrender of Japanese forces be accepted by Soviet forces north of the 48th parallel, by United States forces to the south. From June 1950 to July 1953 the peninsula was decimated by war.

Where then are the storytellers and singers of Korean America? Certainly until recently not highly visible. While there has been a considered, and considerable, reification of the shards and shells, the icons and idols, of the Asian American past into a viable tradition in English from which young writers can work, if so inclined, the Korean element has been shorted. Yet there has been a beginning.

A quick run-through of Korean American narrative-fiction and autobiography: the first narrative in English seems to be Sŏ Chae-p'il's (Philip Jaison's) self-published *Hansu's Journey* of 1921, then Il-Han New's *When I Was a Boy in Korea* (1928), then the well-known in their time, works of Younghill Kang, *The Grass Roof* in 1931 (growing up in rural Korea at the turn of the century with exile to Canada in 1920) and *East Goes West*, 1937, the life of a Korean intellectual immigrant in the New York of the 1920s, followed by No-yong Pak's autobiography, *Chinamen's Chance*, in 1940. After a considerable gap we have the English-language writing of Young-ik Kim and Richard Kim in the post-Korean War years, somewhat on the edge of the proto-tradition I am thinking of here, though Young-ik Kim does on occasion write about Koreans in America. Next in line would be Kichung Kim whose limited publications show great potential, then Ty Pak with his stories of the trials of the current generation of immigrants and their roots in Korea in *Guilt Payment*, 1983. The latest major work in this line is the late Kim Ronyoung's (Gloria Hahn) *Clay Walls* (see Chapter 53).

So far as poets go we have Jaihium Kim's *Wall* in 1968 (essentially, a Korean writing in English rather than Korean American), Ko Won's *The Turn of Zero* in 1974, Chungmi Kim's *Selected Poems* and Theresa Hak Kyung Cha's *Dictee* in 1982, followed by Kathy Song's *Picture Bride* in 1983. Walter Lew's work anthologized since the early eighties shows considerable promise, but as of now I have not seen a book. Not an extensive list, but a respectable one. It is on this base that the current flowering of Korean American authors lasts.

Gloria Hahn (Kim Ronyoung) was one of those who, in N. W. M. Gonzolez's words, "must have an account of how things are." How things are for her meant finding meaning and form in the story of a first generation of Korean immigrants. In the quest for meanings the past, as always, impinged upon the present. Kichung Kim, writing in commemoration said that "in a very real sense Gloria is with us still, in the one significant legacy she left us, which bears witness to our common past of extraordinary valor, tribulations and triumphs, which we must learn to both remember and celebrate. As Gloria herself said: 'A whole generation of Korean immigrants and their American born children could have lived and died in the United States without knowing they had been here. I could not let that happen.'"

Before her untimely death, Gloria Hahn had conceived of a writing workshop together with Kichung Kim, again in his words: "Her idea was that we'd do one specifically designed to bring together recent Korean immigrants and American-born Koreans."

The immigrant story is, after all, one of the United States' most resonant myths. (We should in general, as the Scandinavians do, make a distinction between the immigrant myth and the emigrant myth. An emigrant literature grows up very rapidly following mass migrations. Well-developed in Japan, China and Korea both can also boast their emigrant myths.) We return to it for confirmation, that we collectively have made *the* passage. Each immigrating ethnic or national group goes through this initiation. Most have had their tales told by writers among them: Rolvaag's Norwegian farmers on the cruel North Dakota plain, Henry Roth's urban Jews, Kazuo Miyamoto's farmer Japanese, Gloria Hahn's struggling Koreans. These are literary validation, reception, and valediction. Our immigrant past finds its place in song and story, and ultimately in the novels that record a truth deeper than fact, more lasting than history.

Clay Walls was and is the first work of fiction from and about the original Korean immigrants to the West Coast of these United States to tap that myth. It profiles a family from the early twenties to the end of the Pacific War, from an alien first generation rooted in the soil of the Korean homeland, denied citizenship by virtue of race, to a second generation, citizens by birth, rooted on these shores.

The immigrant characters ring true: exiles to an apparent lost cause, lives charged with the memory of the Korean Independence Movement of March 1, 1919 and hatred of the Japanese overlord of their beloved peninsula. When they manage the time to come together, it is to reaffirm old loyalties, political and personal, to relax once again in the language of their mothers, a language that structured distinctions of rank and age, ancestry and education, where everyone fell into a linguistically assigned and familiar place. Outside this protected circle they know only too well where they stand, ineligible for citizenship, unable to own land, no vote, no political strength individually or as a group.

For their children things are different. Citizens by birth, they are torn between the demands of home and family and their desires to enter the greater society. They know the odds and are willing to take their chances. Near the end of the novel one of them says, "I haven't found a book yet written about the people I know." *Clay Walls* is her book. A third, fourth, and new second generation of Korean Americans no longer need search in vain for a book about the people they know, about a past they can share.

That said, it is worth noting that now, after more than a century of immigrant novels of the American experience, there is about what is perceived by some as a new way of viewing American literature, one that finds this steady accretion of a literature forged in our immigrant communities central, contributing the flavor and form that differentiates the English language literatures of the United States from that of the mother-tongue-land. This emphasis on the immigrant does not, of course, exclude all those overlapping categories that also have served to fructify the mainstream: local color, ethnic, regional, national, urban. There are many ways to slice the pie, but every piece makes up an indispensable part of the whole. The immigrant slice does, however, serve to point up better the "American-ness" of it all. (Menken, you should be living at this hour.) No longer need the Korean American, the Asian American, student or reader, seek in vain for personal literary validation in the white man's new Zion on the rocky hillside of New England. There is a part of American literature that is Asian American, validated by its own Gold Mountain on our western seaboard, Korean, Japanese, Chinese, Filipino, all.

Central to immigrant fictions is a celebratory, heroic tone. *Clay Walls* encapsulated and formed that triumphant myth for the Korean American community, pulled feelings and memories together and focused for the first time what would otherwise be dissipated throughout the autobiographies, letters, the written and oral traditions that are part and parcel of the baggage of every immigrant community, of everyone descended from an immigrant family, whether still rooted in or uprooted from that original community.

Kichung Kim and Ty Pak themselves exemplify the changed make-up of the new immigrants, who in many cases come with exemplary credentials, and whose stories they set out to tell. Both are university professors of English. Kichung Kim's "A Homecoming" is an impassioned vignette that captures in painful detail the ambiguity of exile. It seems to be a fragment of a much larger work, and, skillfully focused and carefully crafted as it is, it begs for more to come.

"No Korean is whole, wherever he or she may be," says a character in one of Ty Pak's thirteen *Guilt Payment* stories. At their best there is an unflinching confrontation here with the voids and wounds, both psychic and physical, that drive and inhibit a generation of Koreans born to division, war, and a homeland that is not whole either. The vulnerability of exile, the sense of loss, the impermanence of identity, as fragile and tentative as the I.D. card and photo that attests it, the ironic coincidence that confronts the present with the past, the past with the present, these are the materials out of which Ty Pak has crafted his

stories, stories that suggest what it has meant to be Korean and Korean American, in this last half of the twentieth century.

The imaginative center of Ty Pak's stories is the Korean War, event and place, that fratricidal conflict fueled by international confrontations where the present-day dispersion began with relentless armies moving up and down the peninsula followed, or preceded, by weaponless and homeless columns of dispossessed refugees. Yet the stories are relentlessly of the present. The Korean War and the resulting division of the peninsula into two states, perpetually combat-ready, has been the central fact of childhood and youth for nearly three generations of Koreans and still drives and divides them wherever they may be.

Younghill Kang was the first Korean American novelist to deal with Korean Americans *in situ,* so to speak. His pair of novels, *The Grass Roof* and *East Goes West,* carry a single protagonist-narrator from late-nineteenth-century Korea through Greenwich Village in the twenties. (Philip Jaison's [Sŏ Chae-p'il] *Hansu's Journey* was a fictionalized account of the flight from Korea of one participant in the 1919 Independence Movement against the Japanese, not a story of the American experience.) *The Grass Roof* met with instant success upon its publication in 1931, was translated into many major European languages and went on to garner *Le Prix Halperine Kaminsky* in 1937, the year that saw the publication of *East Goes West.* It is clear that Kang knew what he was about, note his comment in Kunitz: "*The Grass Roof* may be said to have been written in the mood of the Everlasting Nay of Carlyle; *East Goes West* may be compared to the mood of the Everlasting Yea" (*Twentieth Century Authors,* New York, 1955). Elaine Kim (*Asian American Literature,* Philadelphia, 1982) does not seem to sense the importance of this patterning of the immigrant myth. Kang is still a better guide: "My exile seems as if ended. But I have never gone back. The opportunity has not come. My father's family is all dead or scattered. My own beyond-time, time traveling ties have been made on American soil. There are, besides, political difficulties besetting the Korean who returns to the native shores. Perhaps spiritually, it would be difficult to return wholeheartedly, and I would be there as an exile from America. The soul has become molded to the Western pattern, the whole man has become softened somewhat by the luxuries of Western living (*East Goes West,* Chicago, 1965)." In the course of the two novels his narrator-hero moves from his rejection of the "old Korea" to a joyful, if qualified, acceptance of his new life in the United States, but not without sounding the somber counterpoint of the cosmopolitan scholar, Kim, representing the best of traditional Korea, whose tragedy constitutes a major subplot in *East Goes West.*

In the autobiography of No-yong Park, that acerbic Manchurian-born Korean Harvard Ph.D. qua Chinaman, *Chinaman's Chance,* the utopian theme even surfaces as the hint of a pseudo-Taoist paradise where "Having shaken off most of the costly vices of civilized life, I now live, except during the three months a year when I have to make a living, a carefree life of leisure and freedom, go where I like and do what I will in a way that few men save some millionaires and those who are on federal relief, can do."

And the poets?

From A Far
What nationality
or what kindred and relation
what blood relation
what blood ties of blood
what ancestry
what race generation
what house clan tribe stock strain
what lineage extraction
what breed sect gender denomination caste
what stray ejection misplaced
Tertium Quid neither one thing nor the other
Tombe des nues de naturalized
what transplant to dispel upon
　　　　　—Theresa Hak Kyung Cha (*Dictee*, New York: Tanam Press, 1982)

From the third-generation Kathy Song to the more recent immigrant, the "fatherland" intrudes. Ko Won distills the element of exile in the lines "Time is an exile,/so is he." Kathy Song captures that exiled time in the celebration of her picture-bride grandmother whose brave journey made possible the side of the family uprooted from Korea; the Chinese side comes later. The image of the journey, the coming, lives on unto the third, and even later, generations. There is that at least in common between this gracious, fine-spoken young lady from Wahiawa and the emigré poet from Seoul. But they inhabit very different worlds, Kathy Song carefully building her own myths, the close-knit texture of the world evoked by her poetry approaching that of the Japanese American seamstress of her "The Seamstress": "The world for me is the piece of cloth/ I have at the

moment beneath my hands. / I am not surprised/ by how little the world changes." In Ko Won's poetry there is a disjunction of image, a clashing of meaning and event that carries over from his earlier work in Korean. Fifteen years ago, at least, he was still surveying a panorama with meaning squeezed out of it: war, not only the homeland, the world. He was not so much myth-maker as debunker in a world where "the myth is missing."

Theresa Hak Kyung Cha's *Dictee,* an impassioned meditation addressed to all nine of the classical muses one at a time, comes head on with myths that govern the modern Korean, Korean American immigrant, or exile:

> *The population standing before North standing before South for every*
> *bird that migrates North for Spring and South for Winter becomes a*
> *metaphore for the longing of return. Destination. Homeland.*
> —Theresa Hak Kyung Cha, *Dictee*

Every natural event, the changing colors of the seasons a painful reminder of the exile and the past. Chungmi Kim, erstwhile warrior against Seattle rains, catches a glimpse of "the color of the bush down the road" and is spun back:

> *When I was ten, my Mother made me a dress*
> > *Out of silk, she dyed the very same color for*
> > *the August Full Moon Harvest Day. I remember*
> > *the sleepless night waiting for the dawn.*
> *I wore it once, and never again. The war like a wind*
> > *came and stole everything; everything for a mound*
> > *of ash. The dress in the light flesh hue of the*
> > *weedy branch never found me alive since then.*
> —Chungmi Kim, *Selected Poems* (Anaheim, California:
> Korean Pioneeress, 1982)

The mothers, blood ties transcending oceans and time, are there always. Chungmi Kim:

> *Mama*
> *Brother wrote me a letter the other day that*
> *you were too sad to hold your head up, because*
> *your son was leaving you like I did many years ago.*

Mama
How did you ever make me this way
never forgetting
the sorrow of your unspoken life?

—Chungmi Kim, *Selected Poems* (p. 67)

Theresa Hak Kyung Cha:

Why resurrect it all now. From the Past. History, the old wound. The past
emotions all over again. To confess to relive the same folly. To name it now
so as not to repeat history in oblivion. To extract each fragment by each
fragment from the word from the image another word another image the
reply that will not repeat history in oblivion.

—Theresa Hak Kyung Cha, *Dictee* (p. 33)

Further Reading

Cha, Theresa Hak Kyung. *Dictee*. New York: Tanam, 1982.

de Bary, W. T. *et al.*, eds. *Sources of Korean Tradition*, New York: Columbia U. Press, 1997.

Kang, Younghill. *East Goes West: The Making of an Oriental Yankee*. New York: Scribner's, 1937.

———. *The Grass Roof*. New York: Scribner's, 1931.

———. *The Happy Grove*. New York: Scribner's, 1931.

Kim, Richard. *The Innocent*. Boston: Houghton, 1968.

———. *Lost Names: Scenes from a Korean Boyhood*. New York: Praeger, 1970.

———. *The Martyred*. New York: Braziller, 1964.

Kim, Ronyoung. *Clay Walls*. New York: Permanent, 1986.

Kim, Yong Ik. *Blue in the Seed*. Boston: Little, 1964.

———. *The Diving Gourd*. New York: Knopf, 1962.

———. *The Happy Days*. Boston: Little, 1960.

———. *The Shoes from Yan San Valley*. New York: Doubleday, 1970.

New, Il-Han. *When I Was a Boy in Korea*. Boston: Lothrop, 1928.

Pahk, Induk. *September Monkey*. New York: Harper, 1954.

Pak, Ty. *Guilt Payment*. Honolulu: Bamboo Ridge, 1983.

Song, Cathy. *Picture Bride*. New Haven: Yale University Press, 1983.

Won, Ko. *The Turn of Zero*. Merrick, NY: Cross-Cultural Communications, 1974.

The Korean American Novel

Kim Ronyoung

A MEMOIR BY HER DAUGHTER, KIM HAHN

My Mother

My mother, Kim Ronyoung (nee Gloria Jane Kim), grew up in the Korean community of Los Angeles in the late 1920s and 1930s. Her parents had both emigrated from North Korea and arrived in the United States penniless and unemployed. Her mother came from the educated, *yangban,* upper class, and her father from a family of countryfolk. My grandfather was in love with my grandmother; she "put up" with him. Despite this imbalance of affection, their difficult marriage was blessed with the birth of six children. Gloria was the first daughter after a string of four males (hence, her name) who presented a constant threat to her peace of mind. Asian families often impose a double standard of gender-specific behavior upon their children. While neither male nor female children are given much leeway, particularly difficult is the position of the daughter, which mixes the oil and water of responsibility with no power. The requirement is to serve and keep quiet, to work tirelessly for the well-being of others, especially males, while subordinating one's own feeling states and thinking processes.

Gloria managed to fulfill the parental expectations well despite frequent scare tactics and practical jokes played on her by her brothers. They were constantly pulling stunts such as jumping out of the bushes and screaming at their younger sister as she arrived home from nightschool, or popping out of closets in the middle of the night while she was groping her way down the hall. Gloria was afraid of the dark for the entirety of her life, but for the most part the conflict with her brothers made her tough, and she believed it was the reason why later on in her life she was able to break from the culturally accepted submissive female behavior standard to become a fiercely independent and strong-willed individual.

Her father died when she was 11. Though strict and cool, he was fond of Gloria. His death presented her at an early age with the awareness that life was finite, and that it was a gift, not a given. Neither poverty nor discrimination (both inner family sexual discrimination and racial discrimination from the society at large) were to impress her with the realization of her own limitation to the same extent as the death of her father. This was learned at such a young age that it became a dominant part of her being and her spirit. It seems odd that a fear of the dark, which could easily translate into a fear of death itself, found a comfortable place next to a wide-eyed acceptance of mortality. In this respect, as well as many others, my mom was an enigma.

I knew her to be tough, outspoken, and willful. I cannot imagine how she could have been the shy, passive, dependent female as described by my father upon his first meeting her. By her own admission as well, she needed to be taught how to do everything from turning down the sheeting to frying an egg. I think she may have been spoiled by her own mother because she was the first girl. I also think she may have known perfectly well how to fry an egg, but that my father simply did not like the way she did it and that she accepted his lead at that point in her life. At any rate, there are stories and more stories about the things he had to teach her. And about how one night when she woke him to walk her down the hall to the bathroom, he took her arm sternly and guided her through the entire house, opening closets and drawers, asking her if she saw anything in there that was dangerous. She never woke him up again, but her fear of the dark was not lessened by his "lesson."

My father came from a Midwestern upbringing and belonged to no Korean subculture even though both of his parents were Korean by birth. Part of this was due to his father's need to move from place to place for work. In addition, unlike the Los Angeles that my mother came from, the little Midwestern towns that my father and his family lived in simply did not have Korean American communities. Throughout their married life, my parents experienced a marked difference between what each of them considered to be the "root" society from which they came. This difference caused a great deal of confusion for both of them. The fact that they were Korean brought them close together while the way in which they were Korean kept them apart.

To further complicate matters, my parents set upon a career path and lifestyle that would place them in the upper-middle ranks of the predominant white society. My father became a surgeon, fulfilling both his father's yangban urgings and "the American Dream." They settled in a white community, sent their children to private schools attended by white children, and expected that their

children would carry on in the same fashion with their own life choices. Despite my mother's fluency in Korean, and my father's ability to understand it, the Korean language was used at home only to the extent that the children were taught words for food, parts of the body, and unmentionables such as *toocan*, toilet. Food prepared at home varied from authentic Korean dishes such as *kimchee*, pickled cabbage or cucumber, *pop*, white rice, *namul*, salad, and *khalbi*, barbequed shortribs, to hamburgers and hot dogs. My father claimed to be an atheist, and my mother an agnostic, and the holidays were observed in non-religious American style with Santa Claus and the Easter Bunny taking precedence over the Christ child and ascension. Because this system of values made sense only within our family and could not be shared with non-Korean friends or Christian Koreans outside of it, the nuclear family became for us a kind of safety zone where we could take refuge. If being Korean was a liability in the outer society, it was considered an asset within the family.

In addition to being Korean, we were also well off. The inner circle therefore excluded our own blood relatives. We were somehow better than everyone else. The discrimination that my parents endured as they were growing up in a prejudiced society came full circle to rear its ugly head within the very fabric of our family. The greatest confusion occurred when their children were ready to go out into the greater society to look for mates. Despite our white community roots, we were expected to bring home Asians. I remember one evening when my mom sat down with her three daughters to announce her ranking of acceptability of race: Korean, Chinese, Japanese, Filipino, *Pagin*, caucasian, or *Gumdang*, black. Of course, black was not acceptable, it was simply the last one on the list. In addition to this list, we were cautioned to marry for love first and security second. When I finally did decide to marry, my mom asked me, "Why?" I told her that I loved him, and she was surprised. "You can love someone without marrying him," she said. I asked her what would constitute a good reason for marriage, and she said there were several. Then I asked her why she had married. "Security," she said, "Why else?" We never talked about the fact that my husband-to-be wasn't Korean; but I am certain that in her mind love and security were interchangeable as long as the most important variable was in place.

This seemingly hypocritical point of view was common in our household. There was always a lofty, philosophical reason for doing things a certain way, and then the recommended, practical approach, which was usually just the opposite. This was due to a combination of the distinct differences that existed between my mother and father and the cultural custom of presenting a unified,

if confusing, parental front to the children. We were all confused about our identities, but because of the immense pressure we felt in trying to fit in, never allowed ourselves to admit the confusion. The outward success of our family, complete with racecars and swimming pool, belied the tension and strain that existed within.

My mom found out that she had breast cancer when she was 50. It came as a surprise to all of her children as she had always been so healthy. Looking back on her life, I see that she must have been under stress. But then, it is always easy to find a reason for cancer after the fact. At that point in her life she was finally able to muster the courage to disengage herself from the traditional guidelines of behavior that had confined her and her artistic temperament. She had been married for 30 years. She had performed the roles of Asian wife and mother to a tee and had struggled to fit in with the upper-middle-class white society that her husband's profession demanded of her, all the time placing her personal interests last. At 50 she saw her own mortality looming before her, and she allowed herself to redefine her priorities. Her own mother died at this time, giving my mom a double impetus to create something of significance in her lifetime. She sat about to write a book about her mother (see *Clay Walls*). In the process, my mom moved closer to her own origins. Though she had never run away from her background entirely, she had certainly lost sight of it. In turning to it once again, she came into her own identity, free and clear.

Just as Mom was approaching the 10-year anniversary of the onset of her breast cancer, she succumbed to a massive relapse, this time in all of the major bones of her body. It was sudden. She was hospitalized and given radiation therapy and chemotherapy. Her lifelong fear of the dark was increased by the steroids she was given, and she was unable to get any rest at night unless one of her three daughters slept in the hospital room with her. After six weeks, she came home and was bedridden for almost a year before the cancer won the battle. Private duty nurses introduced her to meditation and massage, and she spent hours listening to tapes of crashing waves and Tibetan bells.

During that terrible year she and I had a chance to see a lot of one another. We had a chance to become very close, and we took it. Mom was only 21 when she gave birth to me. We were like sisters in many ways as her growing up happened concurrently with that of her children. For this reason as well as our personality differences, we spent most of our life together butting heads. She commented on the irony that we had to go through something terrible to find out we could be friends, but that it would have been wrong to expect anything else of life but the ironic.

Her struggle with cancer hardened my mother's will to survive as much as it softened her inability to accept certain values and perceptions that up until then had posed such a threat to her. She realized during the year that the ways in which she had raised her children, tried to fit into the greater society, and even the ease with which she had accepted her role as a wife had not necessarily been for the best of all concerned. She did not express regret at this realization, but she did find a new way of being at peace with herself and others.

On Christmas Eve, a month before she died, Mom allowed herself to be carried downstairs to join the rest of the family who were making every effort to introduce normalcy into an already bizarre situation. Mom had not been able to keep her meals down for weeks, and yet we somehow expected that if we went through the motions of the traditional Christmas dinner, everything would be just as it had been before. Denial was so thick around the house at that point that any knife you could find to cut it with would have been perceived to be a spoon. At the top of the stairs she looked at me for the first time with fear in her eyes. Then she grabbed me, and her eyes welled up with tears. She stopped crying almost as abruptly as she had begun. A single tear remained on her left cheek. As she removed it with a quick swipe of her hand, I said her name should have been One Drop Hahn. She laughed a big laugh until tears rolled down her cheeks, and I realized that Mom's way of crying was to laugh so hard that she cried. It was such an Asian way to feel—out the backdoor to come in.

When Mom gave us our Christmas present after dinner, I realized that it was the gift she had wanted for herself all her life. I never realized before how true the saying is: the best gift you can give is the one you want for yourself. She turned to my father. She had obviously made previous arrangements with him that he was to deliver the gift. He cleared his throat and announced in uncertain tones, "We would like to present you girls with our Christmas gift." We looked around for the packages, which in the past had contained CD players, Cuisinarts, and stereo systems. There were no packages to be seen this year. Our father got our attention once again by saying, "Girls, your mother and I would like to give you a . . . a gift of freedom." Mom sat in her wheelchair with her eyes straight ahead, looking at no one, making sure that he said the right words. I knew the gift was as much a message to him as it was to us, but for different reasons. Freedom does not have to be given if it already exists.

She sat back and smiled. To this day I do not believe that my father understood the extent of my mother's intention, but out of his unending love for her, he would have done anything she asked. Hearing him say the words made her feel good. It was the best thing he could have ever given to her, and she to us.

"You can do anything you want," she said. "You're free now." As was she.

The Writing of Clay Walls

My mother spent 10 years writing her first and only book, *Clay Walls*. The first several drafts were very difficult for her. As English was not her native tongue, she struggled with turns of phrases, idioms, grammar, and syntax. All her life she was eloquent as far as spoken language was concerned, at least in an expressive sense. But she had some trouble with usage, and never took the time to look things up until she began her book. For her, writing a book was as much a way to learn the language properly as it was a way to tell her own mother's story. She was also facing the difficult task of having her character speak the vernacular (pidgin English) without "sounding stupid," a problem for writers of any subculture.

Mom began writing *Clay Walls* when she found out that she had cancer. She was 50 at the time. She had never had any major illness until then. It terrified her, but her ability to focus all of her energy toward the writing of her book during a time of crisis was typical of her. She had always been able to direct energy with precision, but in this instance it was almost intense. For the first time during her married life she set up a daily schedule that involved a task having nothing to do with the usual chores associated with being a mother and a wife. She would sit at her word processor for a minimum of eight hours a day regardless of what came of it. She took a few writing classes at the local community college and read various books on the art of writing, but for the most part she was on her own. She literally learned (and, learned literally) as she went along.

After her first draft was completed years after she began it, she sent a query letter to various publishers. At that point in time, few books by Asian American writers had ever been published. No book had been written by a Korean American about the first-generation's experience in the United States. However, this was not the reason that my mother wrote *Clay Walls*. She wanted to tell a personal story, and her story happened to be that of a Korean American.

For several years my mother received only rejections from publishers. These ranged from form letters to personal notes with either encouraging or discouraging comments. Despite the constant rejection, Mom never allowed herself to lose faith. She viewed the idea of publishing her own work with disdain. She wanted to be recognized by the publishing community as a valid writer. For her, recognition would be as much a proof of her ability as the actual writing of the book. Finally, she received word from a small press in New Jersey. The publisher knew nothing about Korean culture, but he was quite taken with my mother's story.

Strangely, while my mother was still reeling from the first acceptance, she received a call within 24 hours from another publisher. This time it was a major

publishing house. There was no doubt in her mind that if she went with the second offer, the readership of her book would be huge. However, she rejected it for two reasons. First of all, my mother believed in the "order theory." This belief translated into what she believed was fair action. Whoever claimed the drumstick first was the one who got it. Second, she feared that the large publishing house would require her to rewrite the book. More than possible loss of artistic integrity, she feared that a mainstream treatment of her story would relegate it to a stereotypical "third world" account. She was especially concerned that her mother's experience would be viewed as just another "Asian" experience rather than a distinctly "Korean" one.

Clay Walls was published while my mom was bedridden with cancer. She was radiant the day it hit the bookstores. Despite her desire that her book be noteworthy as a piece of writing and not as an exemplary "Asian American experience," she had written it for her children so that they "would know where they came from." My hope is that *Clay Walls* will be appreciated for both reasons, by Korean Americans and lovers of fiction of all ethnic backgrounds alike. There is no one Asian American story as we are beginning to see now that many more Asian writers are becoming published. As our society pushes through its stereotypes and racial phobias, we will see more and more how similar all the "assimilation" experiences are, regardless of race.

As I think back on my mom's life and all of her personal achievements, which ranged from calligraphy, painting, docent work at the Asian Art Museum, and even pottery, I believe that if she had lived she would have continued to write. Writing, despite the difficulty of it for her, was the expression best suited to her temperament and mental acuity. She enjoyed everything about writing, the challenge, the solitude, the condition of never being completely finished. She was fortunate that before she died she found the doing that best expressed her being. Few are lucky enough to find it, fewer are courageous enough to take up the challenge, and fewer still are willing to fight to the finish.

Further Reading

Ronyoung, Kim. *Clay Walls.* New York: Permanent, 1986.

Discovering Korean American Literature

The Manuscript of Clay Walls

S.E. SOLBERG

On March 21, 1989, I found myself aboard an American Airlines flight from Seattle bound for Los Angeles. The purpose of my trip was to speak briefly on the occasion of the family's presentation of the papers and memorabilia of Gloria Hahn, author of the Korean American novel *Clay Walls,* to the University of Southern California Library.

It had been nearly a decade since the manuscript that was to be polished and shaped into *Clay Walls* came into my hands by way of Shawn Wong who had it through that remarkable network that supports good writing and writers in general but, most importantly, Asian American writers and writing. Shawn was well aware that there was no major fictional treatment of the first generation Korean community; he asked me to read it for authenticity—veracity with regard to the Korean American experience—insofar as I could judge it. Shortly thereafter I was in contact with Gloria Hahn (or, as she appears on the title page, Kim Ronyoung) encouraging, even exhorting, her to get on with what I saw as a major contribution to American, Asian American, and Korean American literature. Though we were never to meet, a friendship I came increasingly to value developed over the phone and by letter down the following years.

On one level Gloria's had been the annalist's passion to establish a record as true as it could be of that indomitable first generation of Koreans in the United States and the condition and achievement of their lives here. But she was also driven by the artist's desire to tell a well-fashioned tale, a story that would rise to "universal" meaning from the specificity in the manuscript when I first saw it. There was at that time no compelling story of first-wave Korean immigrants in Los Angeles, or Hawaii, or anywhere else for that matter, beyond the atypical hero of Younghill Kang's *East Goes West.*

There is, of course, value in history, oral or written, and personal records, material of the sort that the Hahn family was presenting to the USC Library, but they seldom carry the emotional weight and perceived truth of the work of art, the novel, short story, or poem. The voices we have from that first wave of Koreans is limited, historical and political narratives, often self-serving, more than often focused on the "large issues," that is, of Korean independence from the Japanese or the moral reform, Christian or otherwise, of Korean, that is, in Korea, society. Few of them projected a staying, a growing of the Korean American community with the birth of the U.S. citizen children and through them the availability of property and other of those rights denied those first Korean immigrants as aliens ineligible to citizenship.

Kim's novel, *Clay Walls,* had given life and substance to this wrenching experience, common to all the Asian immigrants of the time, and its specifically Korean nuance. When I suggested at one point that she continue the narrative in the form of a family/community chronicle, she disclaimed interest: it was the immigrant story, her parents' story that fired her imagination for she felt, and rightly it would seem, that there was no one else to tell that tale. In *Clay Walls* she formed that first-wave story in the manner of the immigrant novel, made it into a part of the American experience and setting rather than a footnote to the Korean independence movement. It was a generation of giants, "giants in the earth," as Ole Rolvaag characterized their Norwegian counterparts.

They are gone; their memory remains in the texture of *Clay Walls*: recognition with all due respect in the telling of the tale, the echoing song of their descendant:

"Rise and fall all belong to destiny" goes Won Ch'on-sok's fifteenth century Korean *sijo*. "The Full Moon Terrace is deep in autumn grass;/ In the tune of the cowherd's pipe lingers the meaning of a five century rule/ Bringing tears to the eyes of a traveler passing in the setting sun/" Generations like dynasties pass, leaving only the echoes of their passing in the flute tunes, the songs, poems, and stories that remain to raise a tear in the eyes of the passing traveler, the discerning reader.

Clay Walls

The Great Korean American Novel

S.E. SOLBERG

The author of *Clay Walls,* Kim Ronyoung has a sharp eye for telling detail. Man and place are clear and focused in a credible rendering of the life of Koreans in Los Angeles a half century ago (see Chapter 50). The strength of a novel lies in two things: that it be true to itself, the interior vision of the author, and the narrative demands of the form meshing to create a self-contained imaginative world rushing down the millcourse of destiny to an inevitable close; and that this fictional world somehow references the "actual" world of day-to-day experience. Koreans should behave as Koreans, Model T's should behave as Model T's (and so they do in an exemplary way in *Clay Walls,* though I remember Model T's as somewhat more malevolent, delivering an occasional disabling "kick" to the man on the crank).

The first and second sections of *Clay Walls* are told from the point of view of a first-generation woman and her husband, two voices of the immigrant generation. This is a risky undertaking, one which can succeed, as it does admirably here, only when limited to what is central to character and narrative. There is no superimposition of anachronistic post–World War II attitudes, political, social, or psychological, of the sort that mar so many attempts at re-creating the past. The objective narrative voice is a kind yet firm guide, leading us through the world as experienced by the central characters. In these sections, Kim maintains a subtle distinction between the world of the participants and that of the narrator. The narrative voice may not moralize or generalize, but it does require us to see with the perspective of the past through an awareness that belongs to the present.

Constant attention to detail, awareness of instances where reality verges on absurdity, nuance of language, and careful selection of situation culminate in scenes that linger in memory. For example, the sentence "Koreans had crowded into the living room, hands outstretched, ready to grasp any hand found in their path . . ." illustrates that quintessential Korean setting where the hands and the

handshakes seem to take on lives of their own. The touch here is just right—a step further and it would broach the absurd and one step less, the banal. The narrative voice Kim has created for the first two sections maintains a necessary balance, all the more difficult because it involves seeing behavior on its own cultural terms while making it accessible to readers from a different time and culture.

The characters ring true. Exiles to an apparent lost cause, their lives are charged with the memory of the Korean independence movement of March 1, 1919 and hatred of the Japanese overlord of their beloved peninsula. The exile always dreams of return: the first generation always dreams of going back, their fortunes made, to the comfort of the old ways they remember through a haze that hides from view the landscape that precipitated their departure in the first place. Our textbooks and histories are full of it: the first Chinese were sojourners; the Japanese were always going to retire in Japan until war and children directed otherwise. In *Clay Walls* the exiles come together in the new homeland seldom, but often enough to reaffirm old loyalties, political and personal, and to relax once again in the comfort and familiarity of their mother tongue. Their language structures distinctions of rank, age, ancestry, and education. Outside this protected circle they know only too well where they stand. Ineligible for citizenship, unable to acquire land or political strength, here, for the moment at least, they can be what they are. There are flashes of bitterness, but no rancor: "I would certainly like to know why the Korean Declaration of Independence was modeled after the American Declaration of Independence."

The first section is titled "Haesu" after the proud, restless, and determined matriarch whose presence informs the novel. Haesu has too firm a sense of herself and of her **yangban**, aristocratic, background to be servant to anyone. Married in Korea to a commoner through the meddling interference of an American missionary whose request her parents could not refuse, she finds much of life in America degrading and unpalatable. If it were not for the Japanese presence she could return to Korea, resume her place in a well-ordered society, and demand the respect she deserves. Least of all does she want to be the sexual servant of her commoner husband, yet she remains true to her culture and time. She submits her body and serves her putative master.

Three children are born of this union. Two boys and a girl are subject to their mother's savage protection as they grow up amidst all the vicissitudes of being Korean and American in Los Angeles of the 1920s.

Haesu, discouraged by the trouble her sons get into as public school students, attempts to enroll them in a private military academy "for white Prot-

estant boys only." The bitter frustration she experiences in the realization that not even money can buy the equality of education and treatment rightfully theirs by virtue of being United States citizens sets Haesu's exile dreams of the homeland afire. They will buy land and go back to the life of *yangban* landholders in Korea where they will not have to put up with constant humiliation for reasons of race or nationality.

In the summer of 1931, shortly before the Manchurian Incident that spurs Japan's militarization and leads to greater repression and surveillance in Choson (Korea), Haesu and her children board a Japanese liner on their way to Korea. Her husband Chun remains behind, planning to join her later with the money after she finds some suitable property.

Caught up in a web of false identities, violence, and intrigue, Haesu comes to realize that the Japanese overlords and the Koreans who serve them have utterly changed her old home. The pounded clay walls that enclose Korean courtyards become symbols of the desperate search for personal, national, and political stability. "Korean walls were made of clay, crumbling under repeated blows, leaving nothing as it was before. Chun had wanted a wall around their house in Los Angeles, she remembered, and she had ridiculed him." Haesu is not comfortable being walled in. In the end they buy their land and return to Los Angeles to await a more opportune time to return. But Haesu comes back with no illusions as she is "all too familiar with the walls that surrounded her in America."

Part Two, "Chun," focuses on the father. Missionary-educated and mistakenly identified as a participant in the March 1, 1919 independence movement, he had been forced to flee Korea for the United States. A simple man, Chun is deeply in love with his wife and does all he can to take care of her. But he is also inarticulate, never able to convey the depth of his feelings for or to anyone in his family except his daughter, Faye.

The distressing trip to Korea and investment in Korean land marks a turning point in the family's luck. Chun returns to find his once-prosperous wholesale grocery business nearly bankrupt. In the past he had been a Saturday night gambler, controlled and, within bounds, a winner. With all other avenues closed to him, he turns to gambling with the hope of winning enough to buy a piano Haesu wants for the children. He loses everything and leaves home in a futile search for work in the midst of the Depression.

The third section is told from Faye's point of view. We move into the American world of the second generation through her eyes as her voice brings the story through the 1930s and the war years to the conclusion. It is a voice that lives on in mind and ear, a fresh new version of "becoming American." Through Faye's eyes

the struggle of her parents and their generation begins to take on a different shape and meaning. To her American-born generation the focus is upon growing up and taking a place in the familiar American world. Even the traditional enmity between Korean and Japanese can, or could but for the parents, be forgotten. The adolescent eye humanizes the deadly serious patriotic heroics that give meaning to a life of exile. There is a wry, ironic humor in Faye's perceptions; it is a gentle humor, taking joy in what it reveals about character and situation. It takes great depth of experience to see through the innocent truth-seeing eyes of adolescence. To maintain balance and direction as well requires both sweat and skill.

With Pearl Harbor comes a new set of risks and opportunities. Letting it be known you are Korean takes on a new urgency as all Japanese are hauled off to "relocation camps." The white government officials are not able to distinguish one Asian group from another. As the war progresses, Korean-community involvement grows deeper with bond drives, the young men all in uniform. It does not take a special effort to mobilize support as Japan is a common enemy.

Faye finishes her growing up against the background of World War II. As the story rushes on to its necessary end we are left with memories of an indomitable group of characters enriching and illuminating our sense of a formerly little-known American world. How much poorer we would be without access through this warm and moving story. This is a book that has been a long time coming. Near the end of the novel Faye says: "I haven't found a book yet written about the people I know." This is that book. Korean Americans no longer need search in vain for a book about the people they know, about a past they share.

Further Reading

de Bary, W.T., *et al.*, eds. *Sources of Korean Tradition*. New York: Columbia University Press, 1997.
de Bary, W.T., *Asian Values and Human Rights*. New York: Harvard University Press, 1998.

Cathy Song and the Korean American Experience in Poetry

Peering Through "Frameless Windows, Squares of Light"

S.E. SOLBERG

Cathy Song, the poet, was born in Honolulu in 1955 where she makes her permanent home with her husband and two children. Her first book of poetry, *"Picture Bride,"* won the Yale Series of Younger Poets Award in 1982, one of the most prestigious literary awards for young poets in the United States. Published by Yale University Press in 1983 the book was nominated for a National Book Circle Award that same year. Her second book of poetry, "Frameless Windows, Squares of Light" (W.W. Norton) was published in 1988.

Song, who is of Chinese and Korean American descent, was a published poet by the time she was 20 years old and was one of the first Asian American poets from Hawaii to write explicitly of an Asian American heritage. In her Korean grandmother she found the subject and object of the title poem of her first collection, "Picture Bride." The grandmother was one of those intrepid women who, in the early years of this century, left home and family for an unknown future in Hawaii with men they did not know.

> *"She was a year younger than I,*
> *twenty-three when she left Korea.*
> *Did she simply close*
> *the door of her father's house*
> *and walk away?"*

It is true that in the wonder of that single, isolated event from which stemmed her own father's side of the family, this third-generation (samse) lady celebrates her Korean roots, but, as she would be the first to point out, it is not all that simple. If her poems are grown out of her experience and knowledge to the extent that she is Korean American, her poetry will be Korean American. But

there is no easy scale upon which we weigh the "Korean-ness" or "Korean American-ness" of a poem. Attractive as ethnic labels and categories might be at first glance, they tell us more about the insecurities of the labeler than about the poem itself.

Cathy Song disdains labels. She would tell you, as she did a Seattle interviewer a few years back, that she is a poet who only happens to be Asian. The poetry comes first as it should and must with anyone who aspires to the title of poet. It is, after all, the poet's experience and felt knowledge of her world that determines the subject of her poetry. A contrived book or wish-generated ethnicity can only result in contrived poems.

Yet today's new wave of immigrant Korean Americans and their offspring are subject to a nagging curiosity, a constant questioning of the terms of their relationship to their new country, of the nature of their ties to the Korea they have recently left. And on occasion, in bemused appraisal of their forerunners, those descendants of that small first wave who have been here three generations or more, the Cathy Songs, with whom they seem to hold so little in common, continue to ask: Is there anything we share beyond the Korean label? What is the nature of this "Korean-ness" we are said to share? When does being a Korean in America change to being a Korean American? What specific Korean values or traits are passed on to following American generations?

These are questions sociologists ponder, parents agonize over, and, perhaps, only poets can answer. Cathy Song writes: "I have never been to Korea. I do not speak the language. And I know that if I were to go there, I would not feel as though I were coming home, returning to a long lost place. My link to Korea is through my paternal grandparents. It is a fragile link; my grandparents have been dead for almost 20 years. I have missed them all my adult life.

"My grandfather left Korea to work in the sugarcane fields of Hawaii. It was 1903. He was 18 years old. It was not until 1921 that my grandmother arrived as a picture bride. She was 23. Once she arrived and they married and had children, the link to Korea was essentially broken. They rarely spoke, if at all, of their respective families, their former lives. It was as if they had developed a kind of necessary amnesia; remembering what they had given up was probably too painful. So much remains a mystery; photographs of my grandmother's mother, a stern-looking matriarch surrounded by figures no one in my family, least of all my father, can identify."

If the measure of "Korean-ness" is to be found in identification with the homeland and homeland ways from food and family to custom and culture, it is clear that the first wave and the new wave exist in different worlds. The terms of

their "exile," the very physical condition of their relation to the "motherland," are different. Distances that were once measured in weeks and months are now measured in hours; trips "home" that once represented years of desperately accumulated savings are now a matter of putting aside a few weeks' pay. The day's headline story is the same on the streets of Los Angeles, Seattle, or New York as in Seoul and in the same language. The homeland pops up on the television news as well as in the endless miles of Korean-made video tapes, soap operas to high dramas that are reeled out in countless Korean American apartments, family rooms, and bedrooms to assuage the pain of daily confrontation with a society too often hostile and alienating.

What then of the American bred or born from among this new wave? And their children? Will America have its way with them as well, despite the wonders of communication and the transportability of so many of these artifacts of the surface culture? In the end will it be only the poets among this new first generation's grandchildren who are able to reach out with sympathy and imagination to capture the actuality of their parents' and grandparents' lives? Will this greater physical accessibility of the homeland and its products be paralleled by a greater spiritual affinity with Korea? A bonding with an ancestral home that is near at hand in fact as well as memory?

Though we press for answers now, they remain for the future. But perhaps the record of the past as seen in the lives of that first wave and its descendants may suggest both how natural the "becoming American," as the phrase has it, was and is, and yet, paradoxically, how powerful are the sense of origins, of family, class, and nation.

The poet's voice is a rare and precious thing that should not be called upon to answer questions other than those of its own choosing. Yet in the intensity and honesty of Cathy Song's poetic quest for the meaning of her past and present we may perhaps gain some sense of what a future "samse" poet might choose to find looking back at the struggles of this current new wave of Koreans becoming Americans through their children. But that is the sociology, not the poetry of it.

In her poem, "Picture Bride," Cathy Song reflects on the human center of her grandmother's life; in the prose selection that follows she reflects, not only on the genesis of that poem, but also on the passing of generations and what being "Korean" might mean for her and her children in today's (and tomorrow's) complex and confusing world.

When I wrote the poem 'Picture Bride,' I was thinking of my grandmother
and the distance she had to travel. She was about my age at the time I

wrote the poem. I was recently out of college, homesick in New England, far from my family, Hawaii, my place of birth. But the loneliness was an illusion; I could always return. Once my grandmother left (Korea), it was forever. She could never go back. I find that incomprehensible, that she could leave willingly, forfeit all that was familiar for a place she had never seen, to marry a man she had never met. And there were thousands like her. They died never seeing their families again.

They started new families, made new attachments; their children became their surrogate country. By the next generation, the bloodline, the link to the other life, was further diluted; my father married my mother, a second-generation Chinese, in 1949. Thirty years later, I married a man from New Mexico of Scottish-English descent. If my grandparents were to see my son, their great-grandson, they would be mortified. He is incongruously blond. He knows he is Korean, but he thinks everyone is Korean, including his very blond father. When his Chinese grandmother gives him good luck money, wrapped in shiny red paper on Chinese New Year, he thanks her politely for the "Japanese money." And he says with certainty that when we die we will go to China. His idea of Heaven.

It's as though I—and others like myself, third-generation Asian Americans, descendants of migration and displacement—have little sense of our cultural heritage. We may eat certain foods, observe certain customs, but for the most part, we go through the motions; the gestures are haphazard and meaningless, however well-intended. We do not speak the language. Neither do our parents. They were too busy learning to be model citizens, eager to leave behind the accents and odors of the old country. Our grandparents, in turn, were actually paving the way for a better life. Perhaps it's better this way; to know no boundaries, to dispense with the restrictions of remote allegiances.

I do not think of myself as being simply Korean. The world has become more complicated than that. I prefer to think that I belong, as we all do, to the human dwelling. When I look at my son, my link to the future, I wonder what the world will be like for him. Maybe the blond hair framing the Asian face is a sign of what the world is gradually becoming: a blending, a mixture; capable of a great generosity.

That evaluation of the weight of the poet's return to and recreation of the past may be taking the whole enterprise a bit too lightly; the true modesty of an accomplished artist.

While it is true that life cannot turn back, memory and imagination can. And it is also true that through the imagination of the poet we the readers can derive a meaning from that past that illuminates this present, a particular substance that far transcends nostalgia.

Cathy Song has demonstrated that informing power of the poet in two substantial collections of poetry published within a decade; a time in which she has also created her own family, a new generation in present space and time plus a poetic family of four generations in her poetry; she is one of those chosen few for whom poetry is the vocation around which life is organized, or, perhaps better, by which life is given meaning.

The subjects of the poems in "Picture Bride" range far afield, from contemplations of paintings by Georgia O'Keeffe and ukiyo-e prints of Utemoro, to brothers and parents and grandparents, family present and past. It is a remarkable achievement for a first book, yet, almost paradoxically, the narrower scope of "Frameless Windows, Squares of Light" centering more and more around motherhood and family, open out more, tap deeper themes, carry a greater load of passion. In a poem titled "The Binding," Song offers a meditation upon a mother's love for her son in light of the Virgin Mary's bargain; to be the consort of God only that her son might be well-known.

> *We love them more than life, these children who are born to us. How did*
> *Mary endure it? It was more than she bargained for that this son destined for*
> *sacrifice, was destined in his "greatest hour" to love her not more, not less than*
> *he loved the soldier who wept at his feet. It was cruel to ask that of her . . .*

This is the cry of the universal mother; there are no direct evocations of Korea or Korean-ness in "Frameless Windows, Squares of Light" where the fourth-generation of Song's poetic family (the children of the speaker of the poems) begins to dominate. Ethnically and specifically we are led only to the "Chinese" heaven of the blond 4-year-old in a poem called simply, "Heaven." In the poem "Living Near the Water," we join the poetic family at the death of the grandfather whose "young man's eyes had scanned / the cargo the brides / who bowed before the grim life held out to them . . ." and where, in the time and place of the poem, "Those of us assembled on that day had descended from that moment of regret; my grandmother stepping forward to acknowledge her own face was the last to give herself away."

We are again back to origins that are Korean in this reference to the meeting of picture bride and sugarcane-worker husband, references obscure enough to lead

a serious reader of the later book back to the first and the Korean picture bride that gave it its title. Then once the source of this luminous four-generation poetic family has been established, there comes a realization that in poetry as in life, there neither is nor can there be a constant minute by minute reference to origins. Life is where you are as well as where you come from; the poetry speaks to wider concerns as well. "Frameless Windows, Squares of Light" could be read without any reference to things Korean. But how much richer the poems or the Korean American life become by that awareness.

Further Reading

Song, Cathy. *Picture Bride*. New Haven, CT: Yale University Press, 1983.
———. *Frameless Windows, Squares of Light: Poems*. New York: W.W. Norton, 1991.

Part VI

The Arts

Chinese Opera

MARY SCOTT

In this country, many people of Chinese descent have vivid childhood memories of the old-style Chinese theater. They may have been taken to performances as children, or had an uncle who was a talented amateur performer, or they may simply have grown up in a household where the radio was always tuned to the local Cantonese-language music station. Although the political and cultural changes of the twentieth century have dealt a heavy blow to traditional performance styles in China itself, film, television, and video cassettes have extended the Chinese diaspora audience for these ancient forms of entertainment. Many older people in Chinese-speaking communities from Singapore to San Francisco and Vancouver are fans and amateur performers who will turn out in large numbers to hear a visiting troupe from Taipei, Beijing, or Hong Kong.

The common English term Chinese opera obscures the real richness of the Chinese theatrical tradition. The Chinese theater is not just a musical experience, but a sensory banquet. It is first of all a gorgeous spectacle. It is impossible to forget one's first sight of Guan Yu, the God of War, singing an impassioned aria with a phalanx of battle flags mounted on his shoulders, his head cocked and his eyes glaring through his brilliant red and black face paint, and the pheasant feathers and red pompoms on his headdress quivering with righteous anger.

The richly dressed actors move against the plainest of backdrops, almost unencumbered by props and scenery, so that the grace and precision of each gesture are clearly visible even to people at some distance from the stage. This is important, because in the near-absence of props and scenery the gestures convey a great deal. An actor may pole a nonexistent boat, or drive away imaginary chickens, or sew an invisible robe, miming the action so skillfully that a real boat or chickens or a robe would seem superfluous or even crassly literal.

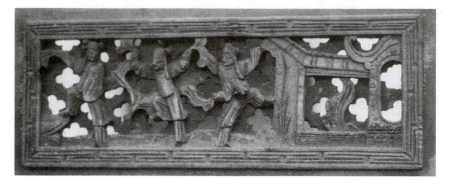

*Figure 55—1: Chinese Opera dancers, carved in low relief on a Qing
Dynasty wedding bed panel. Photo by George J. Leonard.*

Traditionally trained Chinese actors specialize in particular role types.
The theatrical repertoire is also conceived in terms of these types, with plays
for various subtypes and combinations of *sheng,* male lead, *dan,* female lead, *jing,*
painted-face, often a military hero, and *chou,* clown. Each type has instantly
recognizable costume and makeup. A clown, for example, always has a patch of
white around his eyes and over his nose and cheeks, with the rest of his face
left unpainted. All *dan* characters except elderly women wear heavy white
makeup and rouge, but a *qing yi dan,* "blue-gowned lady," is a proper young
woman with a relatively subdued dress and makeup and demurely downcast
eyes, while a *hua dan,* gaudy lady, wears a multicolored gown and plenty of jewels
in her elaborately arranged hair. In the past, since women were forbidden by
Confucian propriety to appear onstage with men, women's roles were often
played by men, and some of the greatest actors made their reputations on their
ability to convey an entirely convincing femininity.

Each role type has its characteristic style of vocalization and movement.
Clowns speak in witty vernacular asides, while a young lady speaks and sings in a
distinctive piercing falsetto. If a young lady picks up a fan and fans herself, she
does it completely differently from a young scholar who picks up a fan and fans
himself. A *wu sheng,* or martial hero, walks with a forthright stride, while *dan* per-
formers wear special high-soled shoes and mincing gaits to imitate the movements
of footbound women. The repertoire of gestures for each role type is entirely styl-
ized, and performers undergo years of rigorous training to move perfectly within
their role type.

Actors often use their costumes to convey a character's emotional state.
An old man may communicate an emotional nuance by stroking or tugging on
his false beard in various ways. A young lady shows emotional distress by releas-

ing her water sleeves—white silk sleeve extensions that reach nearly to the floor but are normally folded neatly at her wrists. Other costume details may reveal important information about the character's circumstances. A military hero's shoulder flags, for example, mean that his authority comes from the emperor himself, while an actor with strips of white paper over his ears is playing a ghost. The painted-face roles have a particularly complex symbolic code. An honest, straightforward hero has a black-painted face, while a red-painted face suggests goodness and a white-painted face, treachery. More complicated characters can be suggested through combinations of several colors.

Stage properties are also used suggestively, to communicate actions and circumstances without depicting them literally. A table and a chair or two, the only furnishings on the stage, may represent an actual table and chair, or perhaps a bed, or a city wall, or a mountaintop. A prop man who waves a black flag shows the audience that a strong wind is coming up. An actor who opens his arms and steps over an invisible threshold is passing through a doorway, while one who carries a wand with colored tassels is riding a horse. For audiences accustomed to these conventions, this makes for a theatrical experience that can go far beyond the ordinary limits of time, space, and one's notions of the plausible.

Although these role types and performance conventions hold true in a general way for all styles of traditional theater, the Chinese theater has always had enormous social and regional diversity. Every corner of China has produced its own distinctive theatrical style or styles, some of which have achieved wide popularity outside their area of origin. Some types of theater have appealed mostly to a highly literate elite, while others have had socially mixed or predominantly poor and illiterate audiences. The most prestigious form now is the so-called *jingju* or Beijing (Peking) opera, which has been designated the national style, but Sichuan opera, Shaanxi clapper opera, Shaoxing opera, Taiwanese opera, and other regional styles are still more popular than Beijing opera in their places of origin. Outside of mainland China, one is probably most likely to hear *yueju*, Cantonese opera, which unlike Beijing opera has assimilated a variety of Western musical influences, from classical music to big-band to rock music.

Local styles are sung in local languages, making them more accessible to most ordinary people than the Beijing theater, which is sung in a theatrical variant of Mandarin that even many Mandarin speakers find difficult to follow. The music, particularly the orchestration, most strongly defines a local style and endears it to its local audience. Each style has its own characteristic tunes and overall sound. The Beijing style has a small orchestra dominated by the distinctive nasal whine of the *huqin* and the gentler-sounding *erhu,* each a two-string bowed in-

strument, plus a variety of clappers, drums, and gongs. Other styles have a different instrument mix: more flutes, perhaps, or other kinds of stringed instruments, or—as in Cantonese opera—Western instruments of various kinds.

Plays are generally classified as either *wu,* martial, or *wen,* civil or domestic, and some local styles tend more toward one or the other. *Wu* plays are generally star vehicles for painted face or martial hero actors. They are often based on actual historical events and frequently have lots of heroic singing, spectacle, and acrobatic action. *Wen* plays, which are often love stories, are more likely to feature famous *dan* and *sheng* artists, who can communicate the most delicate nuance of feeling in a vocal shading or a bowed head.

The playscript itself is perhaps the least important factor in people's enjoyment of a performance. Most people go for the sake of the singing and acting. People flock to see a particular actor in one of his or her famous roles, rather than to see a particular play. The usual program is a selection of famous scenes, often from several different plays. The stories are all well known and no one is ever in much doubt about the sequence of events or the outcome. Although some people do read printed texts of classical plays like *The Peony Pavilion (Mudanting)* or *The Western Chamber (Xixiangji),* which are known for their moving stories and beautiful language, even very famous plays are rarely performed from beginning to end.

In the past, theatrical performance in China was much more than just a form of entertainment. Many performances, in fact, had a strong ritual dimension, since people believed that the gods, like human beings, loved to watch plays. Although commercial theaters have existed in Chinese cities for more than 1,000 years, through the early decades of the twentieth century most country people were far more likely to see plays at their local Buddhist temple, where well-to-do local people would hire a troupe to perform publicly as an offering. Amateur players also performed on improvised temporary stages to celebrate the harvest or various festivals.

Since it had such a wide audience, the theater was also a form of public education, and Chinese governments have generally understood it as such. For one thing, historical plays have traditionally been one of the most popular types, so that even today ordinary people are apt to have a remarkable knowledge of the broad outlines of Chinese history. The last several dynasties used the theater to shape public morality, suppressing politically seditious or obscene forms of theater and encouraging plays that promoted filial piety and other Confucian virtues. Both the Nationalist and the Communist parties used political theater to spread their views among ordinary people during the 1930s and 1940s.

Since 1949, the traditional theater has continued to play an important part in Chinese political life. During the tumult of the Cultural Revolution (1966–1976), the dominant Communist Party faction traumatized the Beijing theater world by suppressing the traditional theater and enforcing the performance of a hybrid called revolutionary opera. The traditional style and repertoire were condemned as "feudal-reactionary," and some of the most famous performing artists were severely persecuted. Although the Beijing theater has recovered somewhat in recent years, increasing competition from electronic forms of entertainment has made it something of a museum art. As an art and as a social phenomenon, however, it has inspired a new international generation of Chinese artists, like the film director Chen Kaige, whose film *Farewell My Concubine* explores the shattering twentieth-century changes in the Beijing theater's social world, in a cinematic language still marked by the old theatrical conventions.

Further Reading

Dolby, William. *History of Chinese Drama*. London: Paul Elek, 1976.

Hung, Josephine Huang. *Children of the Pear Garden*. Taipei: Heritage Press, 1961.

Johnson, David, Andrew J. Nathan, and Evelyn S. Rawski, eds. *Popular Culture in Late Imperial China*. Berkeley, CA: University of California Press, 1985.

Makerras, Colin. *Chinese Drama: A Historical Survey*. Beijing, China: New World Press, 1990.

———. *The Chinese Theater in Modern Times: From 1840 to the Present Day*. Oxford: Clarendon Press, 1972.

———. *The Rise of the Peking Opera, 1770–1870*. Amherst, MA: University of Massachusetts Press, 1975.

———, eds. *Chinese Theater from Its Origins to the Present Day*. Honolulu: University of Hawaii Press, 1983.

Bernardo Bertolucci and the Westernization of The Last Emperor

A Conversation with Bernardo Bertolucci's Advisor, the Emperor's Grand Tutor's Son, Leo Chen

GEORGE J. LEONARD

Bernardo Bertolucci's film *The Last Emperor* won the 1988 Best Picture Oscar and four Golden Globe awards. Not only does it seem a humanizing and sensitizing film, it synopsizes twentieth-century Chinese history from 1900 to the 1960s Cultural Revolution. Since the People's Republic of China granted Bertolucci the unprecedented privilege of filming the emperor's life on location inside the Forbidden City, the film projects an unusually great aura of authenticity.

Art, of course, need not be authentic or even factual to be satisfying. Shakespeare's Joan of Arc *(Henry VI, Part I)* is a demon from hell, who, to our delight, trysts exuberantly with the slimy French Dauphin. If we were, however, picking a work that would "represent French culture" to ourselves or to our students, we might, regretfully, have to pass Shakespeare's Joan by. This article questions how useful the film is for a multicultural course's purposes. The answer: very. First, it is unusually accurate. Second, where it is not, it makes a good illustration of how "orientalism" works.

When Bertolucci was constructing his film, he came to San Francisco State University's Leo Chen, boyhood playmate of Aisin Gioro PuYi, "the last emperor," and son of his Grand Tutor. Though Professor Chen has frequently been interviewed and has even participated in a seminar with Bertolucci on *The Last Emperor,* this is his first detailed analysis for Western scholars to appear in print.

One of the truisms of Asian studies is that, as Edward Said argued in *Orientalism,* the West does not "study" the East as much as "use" the East. The history of Asian studies has been a history of the West beholding its fantasies in the glass: "orientalism." Here is a classic case. As Professor Chen speaks, we find ourselves in the unusual privileged position of watching Bertolucci, an important Western artist, contact Asia first hand. He sees it without the intertextual mediation of previous Western dramatizations. We can watch a Western artist choose what to

leave in and what to leave out until he has transformed the Eastern cultural materials into a Western artwork—an artwork the West accepted easily and with acclaim. The following interview is a condensation of conversations and a long tape transcript. Leo Chen then made pen revisions and approved the manuscript.

George Leonard: Was Bertolucci's main source PuYi's autobiography, *From Emperor to Citizen?*

Leo Chen: Bertolucci told me he had read the book six times.

G.L.: That's worried a lot of critics. The "last emperor" dictated his memoirs while he was in Mao's hands in China. The film is, therefore, based upon a book-length confession dictated by a paroled prisoner with reason to fear for his freedom, if not for his life. No court would accept a confession made under such duress. *The New York Review of Books* has asked, wasn't PuYi, after all, "the world's champion puppet"? You were also a refugee from Mao. Based on your first-hand knowledge of imperial China, how much did the Communists force PuYi to slant his book?

L.C.: First, the Western version Bertolucci used is a digest. A much longer version than the Western translation exists in China, in two parts: "My Life Before" and "My Life After." Before and after what? [Conversion to] Communism. He divided his whole life into those two periods. From what I personally know [as the son of the Grand Tutor himself], "My Life Before" communism is quite accurate—perhaps 90 percent. As for "My Life After" . . . Well, the Communists really brainwashed him. The *New York Review of Books* wondered if he wrote it with a gun to his head. That I doubt. I think they successfully brainwashed him. Reeducated him. When he wrote, he was sincere.

G.L.: Presumably Bertolucci would have fewer worries about a possible ideological slant to the document, because he was a Communist once.

L.C.: I think Bertolucci still is a Communist. He wouldn't have gotten permission back in 1986–87 to shoot in the Forbidden City otherwise.

G.L.: How much of the Forbidden City was Bertolucci allowed to use?

L.C.: Not that much. I think he only used the front part of it. He told me, though, the government said he could use everything—everywhere. And he had been in the Forbidden City at least four times just by himself. And an interpreter. Because Bertolucci wanted to get the feeling of how it felt to be so alone, the *one man* in the Forbidden City. PuYi was usually attended by eunuchs and ladies—other men were rarely allowed inside. When Bertolucci tried it, he said all he felt was how small he was. Ha, ha! The emperor should feel how big he is!

G.L.: When I went to the Forbidden City, it turned out the movie had only used one or two courtyards, just as you said. What a place!

Pu Yi's autobiography has considerable literary merit. Can the text really be his work?

L.C.: The famous Chinese novelist Lao She had something to do with that literary merit you speak of. [Lao She, who rewrote Pu Yi's transcript into a narrative, was the author of highly regarded novels about lower-class life.] But the man who had the most to do with it was named Li, Wen-Da. (His latest work "Childhood Pu Yi" was published in 1989)—I met him.

G.L.: Can students read about the book?

L.C.: I'm sorry, there's little 'scholarship' about the book, even in Chinese. China doesn't have book reviews quite the way we do here.

G.L.: Let's talk about Bertolucci's changes.

L.C.: At the seminar [with Bertolucci on his film] I said that the film was 60 percent accurate. I couldn't say less—Bertolucci was there, ha ha! Actually, about 50 percent. That's pretty good. I think it's made a great contribution. It had to be adapted to Western audiences, of course.

G.L.: It had to please a large audience. It was an expensive film to make. A great many Western caucasians with little prior interest in China would have to identify quickly with the characters.

If I may read you something from the autobiography, just to set up our conversation for our future readers. The emperor wrote of your father, *Chen Pao-shen,* that he was the advisor who had "the deepest influence on me"; the man played by Peter O'Toole in the movie, *Reginald Johnston,* was only "the next most influential." And your father was later appointed Grand Guardian—that is, the adolescent emperor's chief advisor. The emperor records your father coaching him through political negotiations, and, if I may read some more to you, when Pu Yi's own father tried to stage a revolution against the Republic in Pu Yi's favor, Chen "hurried over to tell me to refuse them" because "it was their extreme incompetence" that had brought on the Republic. The emperor says, "I followed his advice."

L.C.: You know, my father was already 60, 61 when they first called him to be the Grand Tutor. This was toward the end of his career. He'd been a famous statesman and jurist.

G.L.: And all that's in the book. So Bertolucci knew of it, from the book and from you. Yet in the Western movie version, the emperor's Chinese advisor virtually disappears.

L.C.: Obviously, Bertolucci built up Peter O'Toole's part, the emperor's English teacher Reginald Johnston. I don't blame him! Otherwise he wouldn't

have been able to bring the film out in the West. In the book, Johnston's role is much smaller, and Huang Shang—I always called him Huang Shang, "Emperor," so I'll continue to do so—once or twice even speaks of Johnston with amusement. Johnston's love of Chinese dress, for instance.

G.L.: We're watching how market pressures influence "orientalism." You're saying Bertolucci enlarged Johnston's importance to give the Western audience a caucasian protagonist to identify with?

L.C.: Well, in Huang Shang's book, as you mentioned before, his Chinese advisor, Chen Bao-Shen, plays a much greater role than the Westerner played. But—Hollywood!

G.L.: Johnston certainly becomes important in the film. In one scene, the emperor climbs up on a roof and threatens suicide. And Johnston has to get him down.

L.C.: He doesn't threaten suicide.

G.L.: Yes he does—in the film. And Johnston climbs up and—

L.C.: Got him down?

G.L.: Got him down. Did that really happen?

L.C.: Ha, ha! Oh, I don't think so!

G.L.: I couldn't find it in the autobiography—

L.C.: I don't think so! Ha, ha!

G.L.: Obviously, Bertolucci didn't read of it in the memoirs and he didn't hear of it from you, Professor Chen. Plainly, he made it up.

About the casting. As Pu Yi's Western advisor, Bertolucci cast a famous "leading man" Peter O'Toole. In sharp contrast, for Pu Yi's Chinese advisor he cast a tiny, chubby, one-eyed comic actor, Victor Wong, best known as the lovable Uncle Tam in *Dim Sum*. The most significant thing Bertolucci's Chen does in the movie is give the boy his pet cricket. I don't suppose your father ever gave him that cricket?

L.C.: The cricket is, well, an invention.

G.L.: Was your father anything like that in real life?

L.C.: When my father, Chen Bao-Shen, came back to Beijing to serve as the Grand Tutor to the emperor he was already 61 years old. He was very blunt and straightforward, a member of the "Clear Spring Party" known for ruthlessly criticizing the court. Particularly the Dowager Princess [Cixi (1835–1908) mother of the Tong Zhi emperor and co-regent with him. Cixi is usually referred to in Western histories as the Dowager Empress. This former concubine dominated her son and when he died she had the political abilities to engineer a nephew's improper ascent to the throne at the age of 4, when she could dominate him as well. (Guang Xu, 1875–1908.) Cixi's rule was notoriously luxurious and corrupt. One

classic symbol of it was her use of a large sum of money meant for the Navy to build a nearly lifesize marble paddlewheel steamer, on the lake at her magnificent Summer Palace outside Beijing.]

G.L.: She appears in the first scene. She personally makes Pu Yi the emperor. Is that really possible?

L.C.: That part's all true. She could name whom she wanted as emperor.

G.L.: Some have worried that Bertolucci made her into an old-fashioned "Dragon Lady" stereotype?

L.C.: That's no stereotype, that was her. In the palace people said that she poisoned the Guang Xu emperor. She worked very closely with the eunuchs—

G.L.: Are they accurately—

L.C.: Oh, yes, they're the way I remember them too. The foreign governments kept the Princess Dowager and the eunuchs in power because they weakened China. My father made his reputation by risking his life to criticize her—and them—once, when she was going to have a sentry at the Wu Men [the Forbidden City's front gate] flogged.

One day she told a eunuch, Jiang, to take 2,000 ounces of silver to her sister, and the guard stopped him at the gate, Wu Men, and asked to see a pass. The eunuch was furious. "How dare you! I'm on business for the Princess Dowager!" She was ready to have the guard flogged. [Death from such a flogging was not unusual.] Everyone knew he was following the law—but really there *were* no laws, the Princess Dowager was the law. People were killed just for criticizing her.

My father wrote out a formal opinion telling her the guard shouldn't be punished, he should be given an award for doing his duty! One of my father's friends ran to beg him not to send it, and when he heard it was sent, he threw up his hands: "You're finished!" But she relented and my father was a hero after that.

G.L.: It's been noticed that when Western literature represents the wise men of other cultures, it makes them merely "clever" or "in touch with nature." Not scientific or logical. In the film the Chinese advisor, with his invented cricket, became more a repository of "folk wisdom," a foil to the civilized scientific Westerner Johnston. On the other hand, what seemed orientalism wasn't? Even though it seemed Bertolucci had fallen into Western stereotypes, the eunuchs and the Dowager Princess *are* accurately portrayed?

L.C.: They are.

G.L.: If I were to ask you what the most inaccurate, most Western twist was, that Bertolucci gave the material, what would you say?

L.C.: The way the actor played Pu Yi as a boy—Pu Yi would never be so disrespectful to his elders as he is in the film! Bertolucci made him into a Western

Figure 56–1: Wang Rong, *1996, by Hung Liu. The last empress of China.*
The artist painted portraits of the last imperial dynasty, based on photographs.
© *Hung Liu. Oil on canvas, painted wood, bird cage, 81"x 36"x 12"*
(46"x 36"canvas). Courtesy Steinbaum Krauss Gallery, NYC.

boy. Or maybe they wanted to make him interesting to Westerners, show him thinking for himself. I don't think he ever did, actually. He did what people told him. In this country a teenage boy is always rebelling against his parents. [Westerners] take that for granted—but not in China. Oh, Pu Yi had a bad temper, of course. I heard about him making the eunuch drink the ink—that scene in the film. Recently I've heard he would also frequently have his guards grab a eunuch and flog him—lay him down flat and have him beaten by guards on each side with paddles as long as a man. Usually 40 times. *"Si-shr da ban,"* it's called. I never personally saw that but that's possible. He was spoiled. It was a way they punished people, even in the Inner Court.

G.L.: I suppose the movie's ceremonies are also less formal, more Westernized?

L.C.: No, they're very close. Very good.

G.L.: In his confessions, and in Bertolucci's movie, the emperor allows himself to become the puppet of the Japanese, placed on the throne of a Manchurian puppet state called Manchukuo.

L.C.: That's all correct. Manchuria was the Qing dynasty's homeland, and they never forgot that. We always called the Qing the "Man Qing," the Manchurian Qing. We were still very aware of them as foreigners, Manchurians. They had assimilated, but when you go to the Forbidden City you can still see the Han characters (Chinese) on one side of their inscriptions and the Man, Manchurian characters, on the other side.

G.L.: This is not just Chinese Communist propaganda, then. The last Qing emperor really did sell out to the Japanese.

L.C.: After Huang Shang was deposed and forced to leave the Forbidden City and live in Tien Jing, I believe that was the most difficult time for him. Financially. He was forced to sell his treasures to get some money. He was cheated by a White Russian—spent a lot of money on anyone who he thought would help restore his throne again. Even the Japanese. And also, he was quite lonely.

G.L.: He had his wife and concubine with him, didn't he?

L.C.: Very interesting. His wife, Wan Rung, I remember, was really very pretty. Joan Chen plays her in the movie. I met her only once, when Wan Rung turned 20—my whole family was invited to her birthday party. Bertolucci was so interested to know about her, but I told him I saw her only once! First to kowtow to her at her birthday, but then we stayed until dark, to watch a movie in the open air. I'll never forget it—it was the first time I ever saw a motion picture! A black and white silent movie. When I mentioned this to Bertolucci he jumped up, started talking with his producer: "We were right! Here's our witness!" Though

it's not in the autobiography, someone had told him Huang Shang showed a movie on her birthday, and, happily, I was there.

G.L.: Bertolucci *must* have been excited. The last emperor admiring Bertolucci's art form.

L.C.: Very excited! But that's the only time I met her, because whenever I met Huang Shang the empress was not around.

G.L.: In the film, Bertolucci makes this period a time of great debauchery. The emperor gets corrupted by Roaring Twenties Western ways . . .

L.C.: He was more complex than that. I told Bertolucci about another side to him that Bertolucci chose not to include. During this time Huang Shang used to invite me over to play.

G.L.: "Play"?

L.C.: Frequently Huang Shang would call up after dark, eight or eight thirty. We were in bed already. And my father would have to get us dressed, and take us to the palace. In Tien Jing.

G.L.: To "play."

L.C.: To play with him.

G.L.: How old were you?

L.C.: I was 8.

G.L.: And the emperor?

L.C.: He was about 19.

G.L.: Nineteen years old! And he wanted to play with—

L.C.: With me and my brother. That's what Bertolucci asked me too: "Was he . . . Nuts?" Ha, ha! I told Bertolucci, "I wouldn't say he was nuts." If I can think back to those days—why a 19 year old would want to play with a kid— we were really kids to him . . . But of course, there was no one around for him to . . . We may have been the closest in age. To play games.

G.L.: What sort of games?

L.C.: Oh . . . Chasing each other. Hide and go seek. I told Dr. Yang Lian Sheng of Harvard about it once and Dr. Yang remarked, "In 3,000 years of Chinese history, probably no one was ever carried on the Emperor of China's back but you." He used to give me "donkey rides." You call it "Piggy-back"? I rode on his back. And my brother would chase us around . . .

G.L.: Rather a different side to him than the debauchery the film shows.

L.C.: That's right! He was very lonely. At 19, he was still . . . naive and immature. He was surrounded by much older people, always. He had a lot of pressure on him. To play with us—maybe that was his escape . . .

G.L.: He saw you like little brothers?

Figure 56–2: Baby King, 1995, by Hung Liu. A portrait of PuYi, the last
Emperor. ©Hung Liu. Oil on canvas, 72" x 60". Collection of Penny and
Moreton Binn, NewYork. Courtesy Steinbaum Krauss Gallery, NYC.

L.C.: Yes. But I don't know why, when we were there, playing with
PuYi, his own little brother Pu Jie, was not around. I asked Pu Jie that a couple
of years ago, when I was in Beijing.

G.L.: He's still alive?

L.C.: Still alive. In Beijing. His Japanese wife just passed away. He was
in the same prison with Huang Shang after World War II. That's not in the film.

G.L.: Even when you played with him you called him "Huang Shang?"

L.C.: Huang Shang. That's what you call an emperor. Like "Your Majesty."
I called him Huang Shang all my life.

G.L.: Your father didn't accompany him to Manchukuo. In the book your
father is always warning him against the Japanese.

L.C.: My father went there only once, to visit him on his 30th birthday.
Not until my father died in Beijing and we took off his clothes, and put the funeral
clothes on him, did we discover a letter he wrote to Pu Yi. A draft. A copy. In the
old days the Chinese wore—some of the kids have started wearing it—a piece of
cloth, like an apron against your stomach, tied from behind, to make a pocket?

G.L.: Like a "fanny pack" in front?

L.C.: A pocket against your stomach. Secret. We discovered the letter.
In the letter he said [to the emperor] "I'm old, I may not see you again but I want
you to be aware that you are just like a piece of merchandise. You're in storage
there. They're waiting for the price to grow. And there are so many merchants
around you. And you can never, never trust the Japanese. And you will not be an
emperor of the Qing dynasty."

I asked Pu Jie, his little brother, if he had ever seen this letter? He said no.
Later we printed it. There's still very few people in China who know it, and it's
never been translated into English.

G.L.: In the film, Bertolucci shows Pu Yi finally waking up to the truth,
realizing he's not a real emperor, he's virtually the prisoner of the Japanese.

L.C.: That's all true. When I was a kid, I'd never realized what a sad per-
son Pu Yi was. My last meeting with him was the winter of 1935. My father passed
away in March, 1935. Huang Shang wrote me a letter, "I want to see you. Come."
He was up in Manchukuo then, he was the emperor. He'd sent my brother, the
one that used to play with him and me, to Japan to Aviation School.

Anyway, I went there. And when I [first] arrived, it was strange. He was so
cold. When he saw me he just said, "Take him to his quarters, see him settled."

I felt . . . I was so disappointed. I'd gotten his letter, I'd traveled all the way
to Manchukuo.

It was not until the next day that I found out [why he'd acted so distant].
He had me meet him in the stable. He liked to ride. And we had a couple of hours,
at least, walking around in the ring there. Then he told me the truth. How much
pain he was in. He was totally watched by the Japanese. He said, "The reason I
couldn't say more yesterday, in the palace, is, there's a microphone everywhere."

Then he asked me, did I want to study in Japan. I said no. He had a camera,
and he took pictures of me. In those days film was so expensive—a roll of film, 24
shots, we'd make it last for three months. But he just snapped off a roll of film.

I said, "Huang Shang, that's a waste. Why are you taking so many pictures of me?"

He laughed and said [here Mr. Chen made a bitter smile, imitating Pu Yi], "That's all right, ha, ha, I'm an emperor." [Shaking his head sadly:] "Ha, ha! I'm an emperor."

Further Reading

de Bary, W.T. *Asian Values and Human Rights*. Cambridge: Harvard U. Press, 1998.

de Bary, W.T. *et al.*, eds. *Sources of Chinese Tradition*. New York: Columbia U. Press, revised ed. 1998. Contains many 20th century historical documents giving the background to the "last emperor's" story.

Yi, Aisin-Gioro Pu. *From Emperor to Citizen*. Vol. 1. Beijing: Foreign Languages Press, 1986.

———. *From Emperor to Citizen*. Vol. 2. Beijing: Foreign Languages Press, 1986.

A Viewer's Guide to Wayne Wang's Dim Sum

An Interview with Its Star and Co-Screenwriter, Laureen Chew

GEORGE J. LEONARD

The film of choice for classes—the reasons why

Wayne Wang (1949–), who moved to San Francisco at 18 from Hong Kong, has become the leading Chinese American director. Even better for this book, Wang's work has been intensely related to the Chinese American community, the way the works of Martin Scorcese and Francis Coppola have been to theirs. His prize-winning film **Dim Sum** is historically important, the first feature-length film about Asian Americans made from the Asian American perspective. It is unquestionably the best and most accurate movie yet made about Chinese American life: the Great Chinese American Movie. That it is also funny and heart-warming, instantly accessible to undergraduates, makes it the classroom film of choice.

The following guide grew out of a taped interview with its star and co-screenwriter, Laureen Chew, who was kind enough to speak to my class about the film. The film had appeared only two years before, and everything was fresh in her mind. *Dim Sum* is set in San Francisco's "New Chinatown," a few blocks from where this interview took place (and no accident. Laureen is a professor at San Francisco State, and the director, Wang, like Amy Tan, studied there.) It's a community my Chinese American resource people and students (both Asian and non-Asian) know well. A decade of reading knowledgeable student critiques of the film and researching the answers to their questions, shaped this guide.

The Genre of Humanization

Dim Sum, like Wang's beautiful film of Amy Tan's *The Joy Luck Club*, exemplifies what I have called elsewhere the genre of humanization. *The Jazz Singer, Farewell to*

Manzanar, The Grapes of Wrath, Goodbye, Columbus, are all members of this principal American genre, whose goal is humanizing Americans to each other. To be sure, other countries know this genre. Dickens, John D. Rosenberg has said, wrote to humanize the degraded urban poor to the Victorian middle class. But humanization becomes a *central* literary task in a country of immigrant strangers assembled from peoples that had hated each other for centuries. This genre is a species of what we may call external ethnic literature, fashioned for an audience of curious outsiders. The authors must assume what H.L. Gates has called the burden of representation. Inescapably, they are saddled with the responsibility of fairly representing their group—a burden many resent, complaining that Faulkner and Hemingway were allowed to tell their tales, without the burden of being "fair" or "accurate."

There is a *stylistic* burden of representation such authors bear, too. They must explain more than they would have to in a work of internal ethnic literature directed at insiders only. Indeed, in an external work, the group's aesthetic pleasure is often sacrificed for the outsider's, since the director must dwell on certain matters to the point of boredom, as far as viewers from the ethnicity are concerned. When Kim Chew, the sixty-plus Chinese American housewife who played herself in *Dim Sum* finally saw the movie, she exclaimed, "Who would go to see *that?* It's just life."

Not to its intended external audience it wasn't—people like my student, Laura M., an Irish American who grew up in the district where *Dim Sum* takes place. We understand why the genre of humanization is needed, when she writes:

> There is a joke among [that district's] natives when a "sold" sign is placed
> on the front of a house. "Well, it's good to see another five Chinese families
> have found a place to live." I realize this is an unkind stereotype, but I
> think it shows the prejudice which exists between people who grew up in
> the Richmond area (i.e., white people) and the recently arrived Asians.
> I have lived with the fear that the Chinese are stealing my neighborhood
> of sixteen years and have watched as it has become the "new chinatown."
> Though the Asian population has grown considerably, I have successfully
> avoided all but the most casual contact. So when the movie *Dim Sum*
> offered me an intimate look into a Chinese American family, I tuned in.
> As I have no immediate plans to move, I hoped the movie would show me
> a more human side (American side?) of the Chinese Americans I had care-
> fully avoided all these years, and it did.

An African-American student, Rochelle H., added:

> *I have never known what goes on in Asian homes . . . I noticed how they*
> *ate all the time and I would give an arm to have that much good food. . . .*
> *I felt for the daughter who was persistently pestered to marry.*

Humanization indeed! In our strange country, where Chinese-, Irish-, and African Americans are all required to "get along," as Rodney King phrased it, this humanizing genre takes on an importance it never had in monoethnic countries.

Wang's *The Joy Luck Club,* though also external ethnic literature, wasn't as faithful to the truth as *Dim Sum.* Though excellent, the film thirsts for the giant mainstream audience of the book, and it went Hollywood. The most glamorous actresses from Asian American film history play Tan's characters, all of whom apparently live in million dollar homes and wear designer clothes. Visually, the film has more to do with *Knot's Landing* than with Chinese San Francisco. Tan's book had told it quite another way. The Joy Luck Club meets in a house in the foggy, unfashionable Sunset district, filled with "greasy odors" from "too many Chinese meals cooked in a too small kitchen." (Chinese food is stir-fried, and even though my wife lays newspaper all over the counters when she cooks, and we have bought an industrial-strength stove fan, smoke and grease fly everywhere.) The twenty-something heroine recognizes all the house's furniture, unchanged since her child-hood, when Auntie An-Mei put "clear plastic coverings" over it. "It's all there, still looking mostly new under yellowed plastic": a "nubby tweed" couch, fake "colonial" maple endtables, a lamp of "fake cracked porcelain" and a "scroll-length calendar, free from the Bank of Canton." The ladies themselves wear "slacks, bright print blouses, and different versions of sturdy walking shoes." That wasn't glamorous enough to make the movie. You can't picture Linda Evans and Joan Collins in that living room.[1]

The Making of Dim Sum: *A Star Is Born*

You can, however, picture the characters from *Dim Sum,* which gives you the real look and feel of Chinese America. Wayne Wang mixed professionals with amateurs in a daring version of *cinéma vérité.* He and his then-wife, screenwriter Terrel Seltzer (Jewish, by the way, not Chinese) started making a film about some women who collected for a weekly mah-jong game. As Laureen Chew explained, Wang actually began shooting that film. "The ladies you saw in the M-J scene, the

mah-jong party, the younger group of women. That was the first movie. It didn't work out. He filmed for six weeks, and he didn't like it. He didn't see what he wanted to see."

Filming involves a lot of sitting around and waiting. Wang became "fascinated" with the off-screen interplay between Laureen and her mother, who, supported by the other older women, was pressuring her to get married. Neither was a professional actress, but Laureen—a professor and an elementary school teacher—was, from classroom necessity, an experienced performer. Her mother, Kim Chew, audiences have agreed, was a natural. "She was a side character," Laureen remarks, and—just like in the movies—the director spotted her: "A star is born!"

Wang made the brave, difficult, and enormously expensive decision to throw out his first year of work, already shot in 35mm, to follow the Chew mother-daughter relationship. He was able to follow this one relationship in much greater depth, which gave his script "more substance." ("A twenty-minute tape of the out-takes, the scenes cut from the first version, exists," Laureen says. And adds, deadpan: "It's called 'Chinese Take-Out.'") Since these amateurs had "day jobs," filming took three years. Despite this decision, the film, shot in people's homes with nonunion staff, still only cost $400,000. Kevin Costner's famous flop *Waterworld* probably cost $400,000 a day.

Wang and Seltzer, working with Laureen Chew, who shares screen credit, scripted a movie in which the Chews could pretty much play themselves. Y.F. Du, an extra in *The Joy Luck Club*, reported that Wang used *cinéma vérité* techniques with the China-born extras in that movie, asking them for advice, writing in the actions they thought appropriate to the scenes. So much so, that the extras became alarmed—they mistook this difficult technique for lack of control! (Didn't the director *know* what they were supposed to do?) In *Dim Sum*, Wang and Seltzer took fiction to the point of documentary, and it made for the most accurate fiction film about Chinese American people. Ironically, when Wang tried this technique again in 1998, armed with 10 million dollars and ultraprofessionals Jeremy Irons and Gong Li, *Chinese Box* failed.

The Film's Style

Wang's first hit film, *Chan Is Missing*, made on a $27,000 NEA grant, was a model of suggestion. Chan, like Godot, never shows up, and what it all means may be left—like Godot's meaning—to the viewer. *Dim Sum* is also a puzzler—since it

is fantastically restrained, understated. I have seen the film nearly 20 times; have read, conservatively, 1,100 student papers explicating it; and it never grows stale, for I still uncover things in it I never saw before. (Three years of filming can give that depth.) Laureen Chew, when asked if Wang, for this unusual film, had taken anyone's work as his model, nodded vehemently. "Ozu! He patterned it on Ozu!"

Yasujiro Ozu (1903–1963), the Japanese director, made delicate, quiet, family dramas, often about parents and grown children, twice about grown children leaving elderly parents for marriage—about *Dim Sum*'s dramatic situation. Ozu builds his films with a slow progression of quiet, lyric images—the opposite of flash. Wang adapts Ozu to America and creates a parallel style here. Laureen, who confesses she finds Ozu "very taxing," explains Ozu's appeal to Wang. Since she was his co-writer, her explanation deserves quoting at length.

> To watch an Ozu film, you have to work. We're not used to it. As Americans, growing up in our media culture, we're always spoonfed. As an audience, we're not asked to think. And to think, you have to have space. You have to have time. But we're the-Pow-Pow-Slap-Em-Wham-Em-Whatever! Right? And that's fine! But, as a result, a lot of people who watched this movie had a real difficult time. Because it's like, "So . . . why do I have to see that bird again?" [Laughter] And . . . "Why do we see these shoes . . . again?" And . . . "They're not saying anything, why don't they talk?" [Laughter.] But let's look at our relationships. Do you talk every minute of the day? And—at a larger level—what I think this kind of movie does is help us see that nonverbally, we do communicate. And at another level, maybe a more culturally specific level, I buy into the philosophy that what is not said, has as much meaning as what is said; what is not said, is just as important as what is said. I think that our American culture tends to be so verbal, we do very little active listening.

The film's style, therefore, is rooted in Asia, through Ozu. The film's goal, however, is, as I indicated, deeply American: the humanization of an ethnic group to their fellow Americans. During the film Uncle Tam will mention how fascinated he had been, in his youth, watching a classic American film that took Tam and his Chinese friends right into an American home. We'd never had a chance to see that! Tam exclaims. Right into their homes! The subtle joke is, that at the instant Tam talks about peering into our American homes, we, in the dark, are peering back through the screen into his.

GEORGE J. LEONARD

The Film From the Beginning

We Meet the Characters

The story takes place in the film's present, the early 1980s. Ma is 62 years old. We see her, widowed for 15 years, living in a modest townhouse in "the Avenues," a working-class, usually foggy section of West San Francisco, formerly an Irish enclave. She enters and turns on a sewing machine that sounds oddly powerful—it is indeed. A closer cousin to a bandsaw than to the family Singer, it is an industrial sewing machine that one needs training to operate. Ma, who speaks no English, must have worked in a "sweat shop" earlier in life, probably with other women from her home district back in China. She is still accepting piece work now, from force of habit. An excellent short film on this subject, which seems almost to fill in Ma's earlier years, is Arthur and Lorraine Dong's 15-minute documentary about their mother, *Sewing Woman,* which won an Oscar nomination.

Geraldine (Laureen Chew—in real life Ma's daughter, as in this movie) is thirtyish, working on her doctorate, single. She is the youngest of three children.

Uncle Tam (a pun on Uncle Tom?) played by the great veteran comic actor Victor Wong, is Ma's brother-in-law and Geraldine's uncle. His brother, Ma's husband, has been dead for 15 years. Uncle Tam still manages the bar they owned together back in Chinatown. Ma has inherited her husband's share and, in a later scene, carefully checks the books with Uncle Tam.

At the Bar

Geraldine goes to the bar to help Uncle Tam clean out the jukebox, an unlikely episode probably stuck in to introduce a central theme: American life involves keeping what works, and throwing the rest away. Culling is a constant process. All through the movie, the characters continually sort through belongings, ideas, customs, throw out what doesn't work, and create new lives for themselves. Asian Americans, coming from a non-Western culture, are hard at this job from the moment they reach America. The culture they've created, part Western, part Asian, is something entirely new that never existed on either continent: strong Confucian families (see Chapter 5) tempered by Western ideas of feminism, democracy, individualism. Be careful not to say "her language" or "her culture," referring to American-born Geraldine, and mean Chinese. The mah jong scene, later, is a potent symbol for this process. (It took a caucasian anthropological student, David Smith, to point this out to me.) Mah jong is played with decorated tiles, instead of decorated cards, but—as in many card games—you win by keeping only what

works for your hand, as it evolves, and throwing what doesn't work away; discarding tiles the way the people in *Dim Sum* discard old customs and pick up new ones. My wife adds a further parallel: in mah jong you sit according to the compass points, East-West-South-North *(Dong Xi Nan Bei)*. Mah jong players, then, symbolically straddle the globe, and the tiles they pick up are also marked, among other things, East, West, North and South. In mah jong you gamble your money on your ability to save and throw away until you come up with your personal winning combination of East and West, of North and South. The people in *Dim Sum* (and in Asian America) gamble their lives on their ability to keep and discard customs, choosing from East and West. You could analyze the whole film in mah jong terms, speculating who has thrown away too much (like Kevin and Amy?) and who has held on to too much (Geraldine?).

For, even though you're gambling your life's success on it, you don't discard deeply ingrained lessons from your parents' culture as easily as a mah jong tile. At the bar, Uncle Tam jokes—to his loafer friends who drink up the profits—Geraldine is "real Chinese, you know?" A loafer agrees: "You can take the girl out of Chinatown, but you can't take the Chinatown out of the girl." While a traditional melody plays, an advertising card revolves: on one side a maiden in traditional dress; on the flip side of the same card, the modern young woman—Geraldine's two sides, the two cultures her personal mah jong hand is drawn from.

As Uncle Tam later says, "That old Confucius stuff doesn't work anymore. Here you only keep what you can use." The problem is, if Geraldine threw away her duties to Ma, she would no longer be a person she herself would respect.

At Home With Ma

Geraldine and Ma speak Cantonese together. Until recently, nearly 95 percent of Chinese Americans had roots in a tiny area, the six counties surrounding the city of Canton (now spelled Guangdong). It's as if all the Americans in one foreign country came from Los Angeles, and all that country knew of America was, really, the food, customs, and faces of Los Angeles.

How well does Ma fit the stereotype of the submissive Asian woman? We always see Ma working: sewing, cooking, cleaning. These are tasks that some feminists, during the 1970s, virtually equated with domestic servitude. My students very quickly catch on that Ma is the power in her family. Notice that Ma speaks to everyone in Cantonese, but people reply in English. She understands perfectly, but doesn't bother to learn to speak it. "She gets what she wants," Geraldine observes to Uncle Tam, "and she's not going to change."

And Ma does exactly what she wants. "She's Chinese when she wants to be," Geraldine points out. Ma too—although she seems so traditional—has been keeping only the customs she wishes to keep and throwing the others away. She's gained power through the move to America, and her busy widowhood, in the company of her daughter, suits her fine. She doesn't need a man to give her an identity. When her brother-in-law Tam later proposes marriage, citing an old cultural custom, she says nothing, and when he persists, she raps him on the head. She only keeps the old cultural customs she likes. She likes her quiet life. There are many shots of a bird in a clean, shining cage—contentedly singing.

Ma comments that "another family has come out from Chinatown." As my student Laura M. noted, Ma lives in an Irish district being infiltrated by Chinese families, one of the "New Chinatowns." Since the immigration laws were liberalized in 1965, Asian immigration has soared. Before the 1965 Immigration Act, the 1960 census showed only 199,000 Chinese in the continental United States. By 1989 there were about 1.3 million, and many of the 700,000 "Vietnamese" who immigrated in the 1980s were actually "ethnic Chinese" small-business people who had run stores in Vietnam, fleeing special oppression by the Vietnamese Communists. If your definition of "Asian American" includes a half million Asian Indians, as the U.S. Census does, Asian Americans reached 10 million by 1997 (still only about 3.7 percent of the U.S. population). The Chinese were the largest group, followed closely by the Filipinos.

Getting the chance to look inside one of her neighborhood's new Chinese American homes gave my student Laura some surprises: "The house is decorated in very modest 1970s American, which did surprise me. I expected to find it decorated in antique oriental furnishings, oriental rugs, vases, and exotic art brought over from the old country. But there is nothing exotic about it." Amen. One may as well go into an Italian American home expecting to find Old Master paintings.

A traditional Chinese fortune teller has predicted Ma will die, and she's traditional enough to be concerned. What religion is Ma? Though Geraldine wears a cross, which means Ma was nominally Christian, she believes casually in a whole complex of spritualities, the way we might be Christian yet still hate to walk under a ladder. In her eminently practical way, she's getting her affairs in order, taking Polaroids of her jewelry to establish clearly which kid will inherit what. (Uncle Tam won't look at them. "It gives me the willies.") She has decided to go back to China to "pay her respects," and tells Geraldine she must be an American citizen before she goes. She's never bothered before, but she wants a triumphal homecoming, the "American citizen" returning in grand style to hand out gifts to her relatives. All American immigrant communities know that custom (though only the Filipinos have a word for it: making your *balikbayan* trip).

The Family Comes for New Year's

That is, Chinese New Year's, which is usually in February. Everyone must get "lucky money" in a lucky red envelope, and firecrackers are set off. Of course, Chinese New Year is an excuse for the real Chinese religious ceremony: the family dinner. Family ties, celebrated by consuming tons of food, are the living Chinese religion. (See Chapter 5.)

The dinner uncovers the source of Ma and Geraldine's problem, but it's hard for Americans to spot: Geraldine's brother Kevin and her sister Amy have both, unlike Geraldine, become highly Americanized. (Both of these characters are played by actors unrelated to Ma and Laureen Chew.)

In the traditional Chinese system, the closest human tie is thought to be between mother and eldest son. Amy Tan's *The Joy Luck Club* gives an excellent picture of this. Marriages are arranged, not love matches. The woman—perhaps barely into her teens—goes to live in her stranger husband's house as a virtual lady-in-waiting to his mother, who teaches her the domestic arts and how to care for her son. One respects one's husband, hopes to love him, but it's not strictly required. Marriage is serious business, concerning family obligations and heirs. With luck and prayer, she produces a son and heir—or keeps trying until she does.

The bond between mother and son, unlike the marriage bond, *is* a love bond, natural and intense. A woman finally comes into her own when her husband dies, her eldest son becomes head of household, and she rules through her adored and adoring child. In Monica McGoldrick's *Ethnicity and Family Therapy*, therapists Steven P. Shon and Davis Y. Ja explain that "thus, although the oldest son is the ruler of the family, it is frequently the mother who rules the son" and through him, the rest of the family. That power is the "reward" a good mother gains in her "later years." She acquires appropriate wives for her son, and they wait on her as well. American women students, when they come to understand this system, are often unexpectedly appreciative, since it empowers mature women more than our own does. To paraphrase an old commercial, in China you really are "not getting older, you're getting better."

In the Old Country Ma, a widowed mother, would now be living regally at the home of Kevin, her eldest son. Yet Kevin, wrapped up in career and his nuclear family, has moved away. His attitude to all his childhood family functions is boredom and sarcasm. He gibes at Uncle Tam, races out the door at New Year's dinner's end, and evades Ma's invitation to return for his uncle's birthday party. He's only a typical American in all that. How many grown men go to their uncle's birthday parties? But Ma had expected more. Later, Kevin manages to drag himself to the important yearly Ching Ming ceremony of tidying his father's grave,

Figure 57—1: "From mother to daughter": three generations of women blessing a new home, San Francisco suburbs, 1996. A first generation grandmother (from Guangdong, like the mother in Dim Sum*) teaches her daughter and granddaughter the traditional blessing which her own grandmother taught her in China. All foods shown have symbolic*

significance. The small brown sticky rice balls, for instance, symbolize the family sticking together; the golden cakes symbolize prosperity. The candles and wine are for "Tian," the guardian ancestors watching from heaven.
Photos by George J. Leonard.

only to gripe about how "depressed" everyone acts in the cemetery. One pictures this self-involved dork living in nearby Silicon Valley, a Yuppie computer executive.

Shon and Ja say that if the oldest son lacks "responsibility," and "abdicates" his role as the mother's caretaker, "the vacated role" may be "filled by a daughter." Ma's older daughter, Amy, would be the next choice. Amy is the heavy-set lady with the half African American child. A husband is nowhere to be seen and is never mentioned. At the mah-jong party Amy wears a set of comic sunglasses and makes loud fun of herself. It's hard to picture silent, hard-working Ma meshing with Amy's lifestyle, whatever it is. If we picture Kevin in Silicon Valley, we picture Amy in what's left of Haight Ashbury, a leftover hippie.

Geraldine, "very Chinese, you know," has become her mother's caretaker. This job freezes her between two lives. She is engaged to a doctor, Richard, who has a practice in Los Angeles and must stay there.

The Aunties

My Asian American women students have been delighted to see how accurately *Dim Sum* pictures their lives. The Chinese American social world (at least on the domestic, day to day level) is run by coalitions of powerful "aunties," just like the women in *The Joy Luck Club*. (Since the film, after all, is based so closely on two real life people, its accuracy is no accident.) In their essays the women say the pressure brought on Geraldine to marry is absolutely typical.

These first-generation women have expanded the power they already had in Asia, where, the proverb says, "Women hold up half the sky." Their husbands earn most of the money, but seem no more than tax collectors for the executive branch—the women who decide where it will be spent and on what. In traditional Chinatown marriages, Lorraine Dong (*Sewing Woman* screenwriter) told my class, the husbands handed the paycheck to the wives and never interfered after that. The wife would tell him if she had decided they should buy a house, and if she had saved enough money for it. Knowing Ma, we can believe that.

My student Laura M. wisely comments, "Auntie Mary lives next door. Though whether she lives next door because she's an aunt, or is an aunt because she lives next door is not clear." Chinese families adopt people as relatives, and these people are often thought of as closer kin than many W.A.S.P. families would think of their blood uncles and aunts. Geraldine isn't a blood

relative of any of her "aunties." Yet the intimate way they hound her about getting married is typical.

Julia

Auntie Mary's pretty niece is Julia, played by Hong Kong movie star Cora Miao. She and Geraldine talk as Julia dresses for an evening with her white boyfriend, Max. Julia jokes that Chinese men shouldn't marry Chinese women.

Intermarriage has become as important a topic for Asian America as it is for Jewish America. 1995 Census figures showed that 55 percent of Japanese Americans and 40 percent of Chinese Americans were married outside their ethnicities (outmarriage). Anywhere from 15 to 20 percent of California's marriages were now mixed. Julia's putdown of Asian men relates to a much re-marked-on situation. High marriage rates between Asian women and white men became a cause célèbre in San Francisco during the early 1990s. The most mail the *San Francisco Examiner*'s Sunday magazine ever received came after Joan Walsh's December 2, 1990 article, "Asian Women, Caucasian Men." She cited Prof. Larry Shinagawa's research to establish that women were doing most of the outmarrying. San Francisco marriage records showed "four times as many Asian women as Asian men married whites," and in Sacramento, eight times as many.

As Joan Walsh discovered, anyone who raises this important, serious topic should prepare for an exciting, valuable but highly emotional discussion. The *Dim Sum* scene conceals an in-joke, though. The actress putting down Chinese American men is in real life married to the Chinese American director of this film. Not only that, but the screenwriter writing those lines is that director's ex-wife. Wang is so self-confident, he can afford to joke!

Richard's Visit

Geraldine's doctor fiancé arrives from LA. They pick him up in an enormous Mercedes, symbol of "how much money these kids have these days," as Auntie Mary puts it later. By 1989, 40 percent of Asian Americans lived in households with incomes greater than $50,000, though only 32 percent of non-Hispanic whites did. Asian Americans also, according to *Population Reference Bulletin* 47:4 voted overwhelmingly Republican in the 1992 Presidential election: Clinton 32 percent; Bush 52 percent; Perot 17 percent.[2] Asian American women students, like Oliva R., write with pride about the prosperous, modern women that *Dim Sum* portrays:

Old Hollywood movies often portrayed Asian women as passive . . . In re-
cent war films, Asian women are either war victims or bar hostesses and
prostitutes. These films feed into the stereotype of Asian women as non-
intellectuals and docile. This has led many white Americans I've met, espe-
cially men, to believe Asian women really are, quiet, passive, and powerless.
Dim Sum *depicts Asian women as they really are, intelligent, traditional*
and modern and quite capable of leading independent lives.

Here is Geraldine's dilemma: she cannot bring herself to throw away her
Chinese habit of filial duty, leave Ma, marry Richard, move to LA (as she appar-
ently would have to. His practice is there). For a traditional Chinese woman like
Ma, "life is with people," indeed, life is with family. Geraldine cannot picture Ma
living like an American oldster alone.

But Ma's tradition requires her to help her daughters find husbands. She
urges Geraldine to marry Richard—indeed, nags her. "If you marry while I'm
alive, I'll know my responsibility to you is over." Asked what kind of cultural be-
liefs such a statement represents, Laureen Chew says, "Weird!" and laughs. Then,
seriously: "Actually, I've heard it so much throughout my life, I haven't intellec-
tualized why [she always tells me that]." But Laureen conjectures:

> *When I take it into context about what Chinese American culture is about,*
> *there is a whole cycle of life that I think we buy into, either consciously or*
> *subconsciously. And especially people like my Mom, who were truly nur-*
> *tured in a society that believed this: Part of the task of life is to perpetuate*
> *your family. Part of your major responsibility as a human being is to raise*
> *a family and see that the next generation goes on well. That's a responsi-*
> *bility of being alive.*
>
> *There's another element. A real* mother *thing. She thinks she might be*
> *dying. She hears all her friends say, "I feel good now, all my kids are married*
> *and someone is taking care of them." Her whole bottom line is, she's afraid, if*
> *I don't get married [and she dies] no one would take care of me. And I will*
> *be like, starving. [We remember in the film Geraldine, briefly alone, living on*
> *Cheeze-Whiz and dining at McDonald's.] Living at home she cooks for me,*
> *and she's my pal, or my not-pal, but at least there's communication. And if she*
> *dies, who's going to substitute for her? And they really believe that, when you*
> *get older, it's good to have someone there that you can cling to—or at least,*
> *call. A built-in support system. In the movie, Ma doesn't even care if Geraldine*
> *loves Richard. At this point, it's "Marry anyone!"*

She's a Chinese mother. It's partially culture, and it's partially just being a mom.

Geraldine and Richard have been engaged for so long that Geraldine remarks glumly, marrying him is starting to seem "like incest." At the house Ma, to urge them along, even makes for Richard and Geraldine a piece of **dim sum** (a kind of Cantonese hors d'oeuvre) with the suggestive name "a little bit of heart" (courage), and another urging her to have "several precious sons." Yet she and Geraldine know full well Ma can't survive alone. When Geraldine moves out as an experiment, Ma—after a pathetic scene in which she brushes her own hair at night, as Geraldine did for her earlier in the picture—collapses and has to be hospitalized. (A mild stroke? Hypertension?)

Uncle Tam Throws Out the Past

Geraldine finds Uncle Tam doing what people do all through the movie—sorting and throwing out what they can no longer use. Here he's throwing away relics of a vanished world, the Chinese **bachelor society**.

Tam has never married. He never had a chance—he is a survivor of the Chinese "bachelor society." The Chinese who came to this country to build the railroads and work the mines had been heavily male—there were 2,107 men for every hundred women in 1880. (In 1880, most of those women, sadly, were contract prostitutes imported from the Old Country to spend a few miserable years in virtual slavery. Few survived.) Before many men could save enough to send for families, Chinese were barred from immigrating, starting with the Exclusion Act in 1882.

During Uncle Tam's youth there were 300 to 400 men for every 100 Chinese women in America, and California miscegenation laws invalidated marriages between Chinese and whites until 1948. In this scene Uncle Tam tells how he had a little nightclub beneath the bar, with white strippers: "It was the only place a Chinese man could look at a white woman in those days!" "A public service," Geraldine wisecracks. Chinatowns were communities of forced bachelors, including men sending money home to wives they hadn't seen for years. Wayne Wang made a film about this period after *Dim Sum: Eat a Bowl of Tea*.

Ma came to this country in her teens: the timing means she almost certainly entered under the "Brides and GI Fiancees Act," as thousands of Chinese women did. Uncle Tam's brother must have been a World War II serviceman who took advantage of America relaxing its prohibitions, since China was now her ally. The film, then, incorporates an amazing amount of Asian American history, stretching backward through the century.

Julia's Mother Dies

Julia accidentally worsens Geraldine's mental dilemma when she returns from Hong Kong. Her mother was dying, so the children came back from all over the world—a good illustration of the Chinese *diaspora,* dispersion. When she seemed to recover they left again. As soon as she's home in San Francisco, Julia finds a letter saying her mother died when all her children left. "She died alone!" Julia wails to Geraldine. Geraldine, shaken, must see in Julia's story what could happen to her own mother if she left her; and how guilty she would feel.

Ma's Illness

Nonetheless Geraldine experimentally moves out. After some pathetic scenes of stoic loneliness, Ma has a breakdown or mild stroke and is hospitalized. Uncle Tam, in a magnificent, poetic scene, laments the loss of tradition, symbolized by the secrets of Chinese food, which were handed down "mother to daughter, mother to daughter." But when Geraldine's "time comes" she won't know how to make the classics of Chinese cuisine.

Some critics have commented on the omnipresence of food in *Dim Sum* as if it were an obsession, or perhaps a symbol. One might as well wonder at the respect accorded cuisine in a French film! Cuisine is as central to Chinese culture as it is to French culture. As E.N. Anderson points out in his classic anthropological study, *The Food of China* (Yale University Press, 1988), all around the world as incomes rise, food becomes a smaller percentage of a household's budget—except in China. There, as income rises, the percent spent on food rises. The emperors and their courts, with little to do, invented and enjoyed new delicacies, which, like the dim sum of the film's title, all Chinese culture subsequently inherited. You can't get a bad meal in Paris or Beijing, and everyone you know seems to be an amateur chef. In this film Geraldine, Uncle Tam, and even Dr. Richard are quite typical in their gastronomic interests, their stints in cooking school, their successful attempt at the end to wrap a fine dim sum.

The Film's Perplexing End

Ma, recovered, makes her journey to China and returns to the United States. Geraldine says obscurely that she and Richard have reached a decision. Before she can speak, Ma, looking panicky, says the fortune teller was wrong, she isn't going to die yet, and Geraldine "doesn't have to" get married. In a closeup, Geraldine cries, a twisted smile on her lips.

Does she marry Richard? my class wanted to know. Laureen Chew had some problem with the question, because one of the "emotionally draining" things

about having done the film was everyone's assumption that "that person on the screen, whoever she is," was *identical* to Laureen. "Part of it's me, but part of it's not me." Laureen wasn't entirely Geraldine. How would she know what Geraldine does? We rephrased the question. At least tell us—it may be a clue—what you, Laureen, were thinking when you played the scene. "I was thinking, come *on!* You're driving me crazy—telling me 'Get married! Don't get married!' I got one sister off in Bozoland, and the brother doesn't want to be involved with the family, but you're telling me to leave you alone?—" She said that Wayne Wang made her take that scene over and over until finally she was weeping with frustration, anger, and confusion. That was the look he wanted, and he kept that shot. It was a fine piece of method acting and afterward her mother, who had watched her tears with amazement, said "What's wrong with you! Don't you have any restraint?"

I at first felt the ambiguous ending a flaw, a cop-out. Now I recognize that any resolution would reduce the sense with which the picture now leaves us— the sense of a person stuck in the middle, living an unresolved life, caught between two worlds, unable to discard a certain cultural mah jong tile—loyalty to one's mother—that her life would be smoother, but diminished, without.

In one of the last shots, we see the family's shoes, and classes have been eager to see a man's—Richard's?—among them. In old-fashioned Asian films, that shot was a conventional symbol for intimacy between a man and woman; nothing more explicit could be shown. Marriage! they're eager to conclude. But Laureen Chew says, "No, none of the shoes were Richard's. All those shoes were ours. I took the shot to mean: For the moment, things will not change." She laughed and joked, "Tomorrow she'll pull a new story—'I'm dying!'" And she laughed.

For the record, in real life Laureen married, had a child, and became Professor of Education at San Francisco State University. We have every reason to hope that Geraldine's life turned out equally happy.

Notes

1. Which is not to say that Amy Tan imagined her ladies to be at all poor! They may indeed own the outfits the women in the film wear, but would never do something so ostentatious as actually wear them. Ma never wears any of the valuable jewelry that she shows Geraldine in the polaroid pictures. Such clothes would be packed away carefully on a back shelf and left, hopelessly out of date, in yellowed plastic bags, to their daughters (with identifying polaroids?), for the ladies themselves are *she bu de,* ostentatiously self-denying. In a wonderfully knowing, wickedly funny scene, Tan's heroine describes her mother telling her stories while she takes impracti-

cal "ski sweaters" relatives had mailed from Vancouver, "snips the bottoms" and unravels them into plain, useful yarn.

2. William P. O'Hare. "America's Minorities—the Demographics of Diversity" 47. *Population Bulletin* 4 (December 1992), p. 39.

Wayne Wang Filmography

Features

1975: *Man, a Woman and a Killer*
1981: *Chan Is Missing*
1985: *Dim Sum: A Little Bit of Heart*
1987: *Slam Dance*
1989: *Eat a Bowl of Tea*
 Life is CheapBut Toilet Paper Is Expensive
1993: *The Joy Luck Club*
1998: *Chinese Box*

Shorts

"Smoke," "Blue in the Face"

In Development

Anywhere but Here (feature)

Further Reading

de Bary, W.T. *The Trouble With Confucianism*. Cambridge: Harvard University Press, 1991. For advanced researchers interested in the deep cultural contradictions which Ma inherits from China. Highly recommended.

Asian American Visual Arts

An Interview with Betty Kano

TIMOTHY DRESCHER*

People sometimes wonder if it makes sense to group artists by their ethnicity when considering their work. If we group Asian American artists together are we suggesting there is no difference in the quality, theme, or style of their works? Do we implicitly ghetto-ize them?

Of course not. Nor are we doing anything unusual. After all, art historians group artists by their *nationality* all the time: English artists, French artists, Italian artists. Ethnicity is just one more way of looking at what a body of work can be about. Cultural groupings present infinite possibilities for study. We're not saying any culture is monolithic, characterized by any single parameter or generalization. Rather, any culture, including "Asian American," can be studied in greater depth. The idea is to study it, look at it, see what its boundaries are, what its concerns are, what the driving issues and interests are. Is there overlap with other cultures? Are there common bases? And how do other relationships interact with the cultural factors? It's a very rich and multifaceted approach.

Merged Cultures

Hyphenated cultures, merged cultures—like the one we're discussing, which merges Asia and America—are geometrically more complex. It is important to develop an open-ended theoretical model for discussing the artwork that grows from them, one that does not say "Asian American art is . . . " My purpose is to identify some characteristics of Asian American art representative of the blurred boundaries that result from cultural hybridization.

*Edited by Diane Rosenblum and George J. Leonard

The Legacy of the Brush

One such characteristic, for instance, is the legacy of the brush. There is a strong calligraphic base to all Asian culture (I did not say "Asian American") that probably distinguishes it from any other culture. From the Middle East eastward Asians have a deep relationship with the brush. In many Asian countries not a day goes by that one doesn't pick up a brush, not necessarily for painting, but for *writing;* even just for signing your name. Whatever you write, then, is a visual manifestation of your experience, your character. That's an underlying principle. Of course, many Asian American artists are far removed from that life today. Few of the American-born can write Chinese characters. But if, as artists, they look back to Asia, they do find that legacy—the omnipresent brush—and we do see the memory of it in many works.

Abstraction and Symbolism

Also, Asian American art often combines symbolism with an expressionistic impulse, what might be called an "abstraction of essential being." Abstraction balances symbolism. Some Asian American artists deal with media, with ideas within the visual arts, in a manner that deconstructs images. They maintain an Asian relationship to language, even though, again, many artists may not speak an Asian language. They invest their lines with symbolic value.

Political Activism

When the artists tend toward activism, they naturally tend to invest their work with more Asian references than another group might. Mel Chin, for instance, is one of the best known Asian American artists working. Sculptures entitled "Forgetting Tiananmen," "Kent State," and "Tlatiloco," compose one of his installations, memorializing the students martyred in those separate incidents. All the memorials look the same, each with wreaths made up of plants from their geographical location. (The one from Tlatiloco has calla lilies from Mexico.) An artist from another ethnicity might not have linked Tiananmen.

Skowmon Hastanan lives in the Bronx, a second generation Thai American. She's very active in THAI, a community-based group in Thailand that's trying to teach the prostitutes of Thailand's abusive sexual business the

dangers of unprotected sex because of the AIDS risk. The sex industry accounts for an astonishing 30 to 40 percent of the business industry in Thailand. She does pieces like "You Only Live Twice"—with doll figures mounted on a record, so that when the record is played the poor little dolls go whirling around.

Yet, don't try to limit Asian American artists to Asian American themes. In another work Mel Chin collaborated with scientists on "Revival Field" that showed desert plants growing in heavy metals as organic cleaners of toxic dumps. His environmental art statements have been a major part of his work and quite controversial. He was initially awarded a National Endowment for the Arts grant for that installation in Texas that John Frohnmeyer, then head of the NEA, put on hold. Frohnmeyer was concerned that the NEA was being maneuvered into the position of publicly alleging a site was toxic before the State of Texas had so declared it. National controversy was extremely strong and Frohnmeyer met with Chin for over an hour. In the end Chin's explanation of his intentions was convincing and the NEA continued its support. Nothing particularly Asian about that work, you can see, but its activism is central to Chin's *oeuvre*. It's important we don't try to relegate these artists to *only* doing "Asian American" works.

The Spiritual and the Self: Other Themes

Other impulses identifiable in Asian American work are a spiritual component and—just as for the Asian American writers—the great identity issues which accompany assimilation, or resistance to it. For example, Dinh Le is a recent Vietnamese immigrant, in the United States only since the early 1980s. He's a phenomenon: came at 13, graduated high school at 16, accepted to the University of California, Santa Barbara and graduated there in another 3 years! Dinh Le takes portraits of himself, Superchrome photographs on woven paper. Then he blows up a detail from a famous Renaissance painting, or from someone like Bosch, to a gigantic 40 by 57 inches. And then he cuts them up and interweaves them with his own image—interweaving both cultures, weaving himself physically into the art history of the European tradition and the European tradition into himself. (What a wonderful symbol for the process of forming a new Asian American identity.) Many of the images are of Jesus Christ, so in some of them Dinh Le even becomes Jesus Christ or the Christ child on top of a Bosch.

Like any other group, Asian Americans have had artists that banded together for various causes. New York has a long history of Asian American causes and organizations. Basement Workshops was organized in the 1970s. It featured performing arts, as the "workshop" name implies, but it brought stage *and* visual artists together and had a continuing interest in community activism. There were publications, too. It lasted at least 16 years. One thinks also of Bob Lee's Asian American Art Center down on the Bowery in Chinatown and the Asian American Arts Alliance in New York.

In San Francisco there was the Japantown Art and Media, and the Kearney Street Workshops. KSW is still happening, as is JAM. The Chinese Cultural Center has been in existence for decades. In L.A. there's the mammoth Japanese American Community Cultural Center, with its permanent museum spaces and continual art shows. UCLA has been influential with people like the poet Russell Leong, editor of the important *Amerasia Journal*.

The coming together of these artists really grew out of the activism of the 1960s, the big push for Asian American studies being added to the curriculum. There was a theoretical thrust from Marxism, from 1960s theater, from the Third World Studies Conference. A lot of Asian Americans came together for the first time and blossomed through that energy.

Ken Chu has been the driving force behind the best-known organization now active, "Godzilla." Godzilla is located in New York, but it's a national effort. Information on Asian American art is culled nationally, then published in newsletters. Their first attempt at organizing artists came after the 1990 Whitney Biennial in which no Asian Americans appeared outside the video section.

Having Said All That . . .

Having said all that, what have we said? That the variety is total, that it is wide-ranging stylistically, technically, in terms of media, mixtures of media, and subject matters. Even in this short introduction I've talked about artists whose concerns are autobiographical, political, or spiritual, and who work in every kind of medium known—just like all other artists.

Obviously artists often paint about what they know, so for these artists, experiences in a bicultural setting will often come out. But just as often, people are talking about their private dreams, their hopes, the events that have moved

them positively or negatively: the same table of contents that would apply to any group. The themes, like the techniques, are not fixed either. They move, they change, they grow.

So, finally returning to the question with which we began: Yes, it makes sense to look at an artist's ethnicity, as one of the infinite possibilities for study. How does the ethnicity factor interact with all the others?

On the other hand: No, we must never let that study degenerate into an attempt to define any diverse group of people with any one generalization. We must always see them as they are: people, infinitely various; dealing—through every medium known—with the whole of human experience.

Story Cloths

The Hmong, the Mien,
and the Making of an Asian American Art

GEORGE J. LEONARD

One of the strangest stories of the Vietnamese War has led to one of the most moving—and unusual—art forms to come out of Asian America.

I stumbled across this art in 1988, the way many professors and students have. Twice a year my university holds a "Crafts Faire": across the main lawn, San Francisco's would-be potters, candle dippers, tie dye twisters, and T-shirt hawkers erect a jumble of ramshackle booths. There, among the shlock and "junque," two Asian women sat quietly inside a booth festooned with small tapestries. The work was already famous among American needleworkers, had acquired an extensive bibliography, and had even been, four years before I saw it, the subject of a museum show at University of California, Davis's C.N. Gorham Museum.

The two women wordlessly began to turn over for me, like pages in a book, the pile of small cloths in front of them: abstract patterns, folk-ish floral motifs reminiscent of American quilts; tiny animals drinking from pools; a kind of "Noah's Ark" or "Peaceable Kingdom" theme.

Then, to my amazement, across a blue background, marched small figures carrying machine guns through a tropical forest. A tiny stitched jet fired red rockets, and—in convincing detail—a small hand-sewn soldier knelt for balance, to discharge a heavy bazooka he held on his shoulder (Fig. 59–1). The needleworker had carefully stitched in the bazooka's trigger guard and its unusual sight. She had sketched a scene she knew. On another part of the cloth, riflemen advanced. From the golden threads of the Kalishnikovs they carried, tiny black ammo clips curved accurately forward. I had never seen anything like this on a quilt. But I *had* seen something very like it worked in bronze on the Romanesque doors of San Zeno in Verona; and in the Byzantine mosaics of St. Mark's, in Venice. Those were acknowledged masterpieces of world art. To encounter Real Art on an

Figure 59–1: Man with bazooka. Photo by George J. Leonard.

American college campus among over-aged hippies selling sand candles and black market tapes of the Grateful Dead!

Who in the world *were* these people? And how had they wound up at a Crafts Faire in California?

The answer was, necessarily, as unusual as the art. The two women—one of them, Pao Thao, the artist of the war scene—were members of a preliterate Asian hill tribe, the Hmong, who, until a few years before, had been living in their tribal village, high in the mountains of Laos. "Preliterate" means that, although they did not know how to read and write their own language, they were not *il*-literate; rather, the Hmong (long "o," as in "roam") had never invented a way to write or read their language. Instead, the tribe's women sewed the tribe's cultural lore onto cloth, at which work, over the centuries, they had become fabulously skillful.

The war scene was a "story cloth," telling what will probably be the last Hmong story. The artist, Pao Thao, simply called it "the Leaving Story." The delicate figures firing automatic weapons were enacting how the United States recruited the Hmong during the Vietnam War, and what happened to the Hmong after we went home, leaving them at the mercy of everyone we had been fighting.

The Hmong are *minzu,* the Chinese term for "ethnic minority." So are the *Mien* and several other Asian minority tribes now in the United States. Paul and Elaine Lewis, in their definitive *Peoples of the Golden Triangle* (1983), based on 15 years of living with the tribes in Thailand, distinguish among the cultures of the Hmong, Mien (whom the other tribes call "Yao"), Karen, Lahu, Akha, and Lisu; but affirm that the tribes consider themselves related. What I say here of the Hmong will hold true, broadly, for the Mien too—the two principal hill tribes now in America.

The tribes' lack of written records plus China's historic contempt make for contradictory history now. In one version, all the tribes are a nineteenth-century offshoot of the Miao "tribe" in China. There is indeed a tribe by that name. In another version, the Han Chinese ethnic majority simply dismissed them as Miao or Meo, "barbarians," a word they resented. But my Chinese sources have never heard that the word Miao means "barbarian"; and "Meo," I've learned, is simply the Thai version of the word Miao. "Hmong," the Hmong themselves claim, means "free."

Their origins in northern China, the more flattering version holds, can be traced back 2,000 years, to the time when the majority Han ethnicity, spreading classical Chinese civilization southward—and stamping out local cultures, banning ancient languages and religions—encountered them. Their American supporters enjoy comparing them to the Seminoles, who retreated from American culture, keeping their own by moving further and further back into the Everglades. So, over the centuries, the Hmong retreated south, fighting pitched battles with the Chinese; at last (this much is certain) migrating, about 1825, up into the inaccessible mountains of Laos. There they could guard their language, beliefs, and traditions. "The Mien people are still living in B.C. times," a Hmong leader, Seng Lee, joked with a reporter in 1986. "We Hmong are just a little ahead of them. And maybe we are not." (For this reason, we can't call the hill tribes Lao or Laotians, since the Lao in the lowlands are another ethnicity altogether, which disdained the primitive hill tribes as the Han Chinese had.)

Their needlework, called *Pa nDau* ("flower cloth"), spelled many ways, pronounced "pon dow," was their culture's central art. You may see very strange spellings, indeed, since the missionaries transliterating Hmong sounds into our alphabet added silent letters to the words' ends, to indicate what tone the word was spoken in. The silent "b" you might see on the end of Dau in some articles means only, "say Dau in the first tone." For the record, if you say "Pon! Dau . . . " you'll come close.

The Hmong may once have referred to themselves as "M'peo," the "embroidery people." By the 1800s the Chinese had supposedly classified them into 70 (in other accounts, 55) clans and required them to wear certain costumes, to

Figure 59–2: Scorpion. Photo by George J. Leonard.

segregate them. If so, the Hmong bested the Chinese by turning the costumes into extravagant works of art—turbans, sashes, caps with extravagant red tassels. The Hmong today still use the Chinese system of classification by costume: Blue Hmong, White Hmong, Striped Hmong. If these were only costumes that oppressors imposed, why would "the free people" do that? More likely the Chinese tried to classify these unmalleable people by the costumes they found them already wearing.

Subsistence farmers, the Hmong owned little but some handworked silver jewelry and the clothes on their back. The women enriched all those clothes with the needle. Courting couples exchanged squares of worked cloth, women made costumes for marriages, births, funerals; even costumes for medicine, since primitive peoples often combat evil spirits with objects, ornaments, or magical designs. The Hmong—like the Chinese peasantry—sewed images of spiders, scorpions, snakes and other dangers onto baby quilts and toddler jackets to magically protect them. (It probably did. A good way to remind toddlers of what they'd better not play with, if they saw it, would be to sew it, with an angry looking face, right onto their sleeves. See Fig. 59–2.)

Magical semi-abstract designs persist in American Hmong work to this day. Eight-pointed stars are lucky. A long spiral, called the snail shell, keeps bad spirits out, and symbolizes the family, extending out from the ancestors. Two spirals meeting symbolizes and brings luck to a marriage. Many story cloths have a chain of mountains as a border, keeping good in and evil out—mountains historically

have meant safety to the Hmong. "In preparation for special ceremonial days," Marsha MacDowell wrote in a Michigan State University museum exhibit on the Hmong, "a young girl might spend a whole year" creating a special piece of pa ndau for her costume. "Women began learning how to sew as early as five or six years of age and memorized literally hundreds of traditional basic designs."

Different clans were known for different arts. In America, the Blue Hmong have continued making handwoven, hand-dyed batik cloth. The White Hmong women's costumes have an apron-like front panel. The Mien, whom the Chinese converted to Taoism in the thirteenth century (a form of Taoism only they still follow today) incorporate images of Taoist gods into religious clothing, and even some Chinese letters which they have learned. All the Hmong and Mien use embroidery, applique (building up of cloth layers), and reverse applique. Almost all the work is still done by hand, slowly, painstakingly. Maxine Hong Kingston wrote a poem to the Hmong cloth she owned:

> We bought from Laotian refugees a cloth
> that in war a woman sewed, appliqued
> 7000 triangles—mountain ranges
> changing colors with H'mong suns and seasons. . . .
>
> Sometimes caught from across the room, twilighted,
> the lace in the center smokes, and shadows move
> over the red background, which should shine.
> One refugee said, "This is old woman's design."
> (selected from "Absorption of Rock")

Yet the Hmong women have been unusually unsentimental about pa ndau and have drawn freely on America's resources. Although in Laos colors were obtained from natural dyes, here in America the Hmong are unabashedly impressed by the durability of synthetic fabrics. They've also proved willing to learn marketing. In the Thailand refugee camps, stripped of their occupations as farmers, poppy growers, soldiers, the Hmong men had few marketable skills. The women's prodigious skill at needlework, however, looked promising. The relief agencies running the camps set up CAMA (Christian and Missionary Alliance), Marsha MacDowell reports, to help the women gain some money and "leadership" skills, as well as to help them preserve memories of Hmong culture. At first the women, provided with materials, produced traditional objects and abstract designs, but CAMA encouraged them to make non-traditional—but marketable—products,

Figure 59–3: Animals at waterhole. Photo by George J. Leonard.

like wall hangings and pillow covers. (The Hmong had worn this art, not hung it on walls.) Later CAMA encouraged the women to stitch not only images of insects, say, to protect children, but images of village life back in the hills, or the animals and plants they'd known, or scenes from traditional legends. That would sell in the West.

The Hmong women embraced these ideas (Money! Respect! Independence!) even adding captions and explanations in their newly acquired English. When a story cloth panel carries the stitched caption, "THAT NIGHT THE TIGER ATE THE WIFE AND HE ATE ALL THE CHILDREN CRUNCH CRUNCH" the Hmong women have invaded the Western art world (even if the piece was created in Thailand by relatives according to California Hmong specifications).

In this hybrid American form melding their new life and their old skills, the Hmong women become recognizably Asian American. Story cloths are a *new* art, an Asian American art. These charming folk stories are done by people who have heard all about the prices an American quilt can fetch. Some of what they now produce is kitsch, like latter day Amish art. A *Tia Lee* "Peaceable Kingdom," in which every kind of animal comes peacefully to the same waterhole together, contains a kangaroo—which Tia Lee never saw in Laos *or* California—and, for good measure, a baby-blue triceratops (Fig. 59–3). But even their attempts at Bible themes have integrity, since their struggle to comprehend the novel ideas always

frees them from pictorial cliche; and besides, the technique is so good. One thinks of the Yiddish theater of the 1920s, refashioning *King Lear* in its own image. Even the lesser pa ndau pieces will one day be prized, for the younger women are American kids not growing up needle in hand, but TV remote control in hand. Like the Yiddish theater, this art is doomed to end with the immigrant generation.

Above all, in the course of recording their history on the cloths, the Hmong women found a voice to speak out their pain. They have produced one theme markedly unpicturesque and personal: "The Leaving Story." There are hundreds of versions, no two alike. The Leaving Story is their version of *The Grapes of Wrath,* the very American theme of the terrifying journey here. It is a cousin to Rolvaag's *Giants in the Earth,* the Jewish pogrom stories, the early history of the Godfather in Coppola's *Godfather II.* (See Pellegrino d'Acierno's article in this series's *Italian American Heritage,* and in this volume Chapter 40.) It is certainly great Asian American art. It is possibly great art, period.

To understand the Leaving Story one must understand their history. Aside from their women's needlework, the hill tribes had another ancient tradition: the men hired out as mercenary soldiers. After the French colonized Laos and Vietnam in 1893, they hired the tribes to fight, giving them yet another name: "Montagnard," which in French simply means "mountain people." The phrase "Montagnard tribesmen" (usually prefaced by "fierce") will ring a bell with Americans old enough to remember the Vietnam War. The French lost. We entered the picture.

"From 1961 on, we worked for the CIA," Hmong leaders told journalist Frank Viviano in 1986. "We Hmong fought what Americans call the secret war in Laos." Viviano, interviewing the Hmong refugees in California, comparing their memories with admissions in U.S. government documents, pieced together the story. North Vietnam supplied its guerrillas in the South by the famous Ho Chi Minh Trail, which ran through Hmong territory in Laos, protected by North Vietnam's ally, the Pathet Lao. There was no love lost between the Hmong and the ethnic Lao down in the lowlands. Indeed, Viviano heard what he carefully called a "tale": when Christian missionaries first began to reach them in the 1950s, a "tale" spread that "a messiah" was about to come to them, "driving a U.S. Army Jeep, and he would hand out weapons"—presumably, to fight the Lao.

True or not, thousands of tribesmen agreed to help us fight the Pathet Lao. The Hmong even served under their own general, Vang Pao. They suffered casualty rates "ten times" what the American troops suffered in Vietnam. Then, in May 1975, the impossible happened: the United States lost. America left the hill tribes to face the full fury of the Pathet Lao. Those who have seen *The Killing Fields,* the Oscar winning film made about Cambodia during this historical period, know that

Figure 59–4: Jet attacking house. Photo by George J. Leonard.

Figure 59–5: Helicopter. Photo by George J. Leonard.

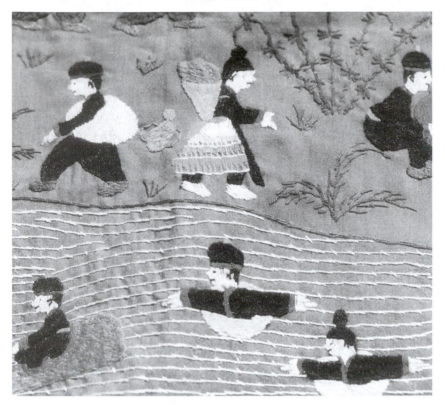

*Figure 59–6:Woman with belongings on her back, at river. Photo by
George J. Leonard.*

all through Southeast Asia the Communist victors embarked on genocidal cam-
paigns of "ethnic cleansing." Here the Leaving Story cloths begin.

"Thirty percent of the Hmong men had died in the war," Pao Thao told me,
explaining her cloth. "My brother-in-law worked for the United States as a signal
pilot and was killed," as were her uncle and cousins. Then the Americans left and
the Pathet Lao took their revenge. On Pao Thao's cloth, a jet, afterburner glow-
ing, swoops down on a thatched-roof village, all its guns firing (Fig. 59–4). A gi-
ant helicopter hovers above the jungle (Fig. 59–5), symbolized by a bamboo tree
on the left and a banana tree on the right. Through the jungle comes a tank with
the Communists' red flag, accompanied by soldiers in open transports, running
riflemen, and the kneeling man firing his bazooka.

Then the Hmong Exodus begins. As Wang Leng Vang told Viviano in 1976,
seven men from his village went into the jungle and cut a trail through it to the
Mekong River. It took almost a year to make a trail that would be only seven days'
march long.

Pao Thao's cloth shows the men, women, and children hiking through jungle so dense they could not be spotted and napalmed by the Communist forces— whom she always identified as "Russians," by the way. (I have never seen any other reference to Russian involvement but she was adamant, and an eyewitness. That was her village's experience.) Many Hmong died on the march, she said. "There was no food that the children could eat." On the cloth, a woman walks beneath the bamboo with all her belongings strapped to her back, and a water jug, discarded, lies behind her (Fig. 59–6). The figures have an expression, on this and some other story cloths, that Greek historians call "the archaic smile." The artists, to indicate emotion, create smiles, no matter what the situation. On another cloth, by Va Lee, she has omitted the mouths, and the figures are not improved by it.

At the Mekong River, the figures stop.

The river, in the Hmong art I've seen, is represented by a pattern of white lines, much the way it is in Byzantine Art, and no accident. The thirteenth century artists at St. Mark's, in Venice—artists of symbolism and pattern, not imitation or illusion—had represented rivers just that way—as when Jesus was baptized in the Jordan, or St. Mark traveled by boat. The Romanesque artists at San Zeno, even earlier, chose that image too, for San Zeno fishing (Figs. 59–7). The Renaissance interest in a picture as a window opening out onto three-dimensional space is only one way to think of a picture. The artists at St. Mark's and San Zeno thought of the picture plane as a two-dimensional surface filled with symbols. Such an art, Kenneth Clark once explained, will find its visual interest in the pattern one can make with the symbols, the combination of the colors and lines. "The less an artifact interests our eye as imitation," Clark pointed out, "the more it must delight our eye as *pattern,* and an art of symbols always evolves a language of decoration." Hmong art, until recently an art of abstract symbols in pleasing patterns, still works that way with images, seeing figures as a rhythm of flat black shapes appliqued against the nervous white lines which stand for the river. Hmong art is not a naive art or a "folk" art. While we once condescended to artists who came from technologically inferior countries, it never made any real sense, discussing their *art.* While we once labeled any form a man made with paint on canvas "art," but called the same form "craft" if a woman made it in cloth, we do no longer. Politics aside, it made no sense aesthetically.

At the Mekong, the figures sit down and . . . blow up inner tubes. The final harrowing part of the journey consisted of the Hmong casting themselves into the Mekong, "swimming with bamboo sticks in our arms to make us float," as Vang said, and trying to float down the river to Thailand where they would be accepted into refugee camps. Pao Thao's village put people into inner tubes. She reveals

Figure 59–7: St. Zeno fishing. Photo by George J. Leonard.

her commitment to the pattern of colors here. The tubes were certainly black, but so were the costumes of her Hmong villagers. She makes the inner tubes, therefore, every bright candy color: blue, red, green, yellow, orange. And these rings of color, like fruit flavored Lifesavers, she wraps around the small black figures.

Pao Thao may have made this bold change because the tubes were their salvation: in the river scenes, the small smiling figures seem for once believably happy, and the colors of the tubes underscore their relief at escape. The cheerful colors make you *feel* the Hmong's happiness. It would be a great mistake to doubt the artist understood the effect such cheery colors would make; or to underestimate any of these women as artists. They had as much training in their tradition as *any* modern artist has ever had.

Pao Thao's cloth story ends on the Mekong River. On a raft floating before the people in their Lifesaver-colored inner tubes, a little boy and girl sit comfortably, smiling, behind a man who has risen dangerously to his feet, in excitement, and is pointing forward, smiling, at something he can see and we can't, beyond the picture frame. The Thai refugee camp? Safety? Survival itself? It's a fine, dramatic ending. (Fig. 59–9, p. 603)

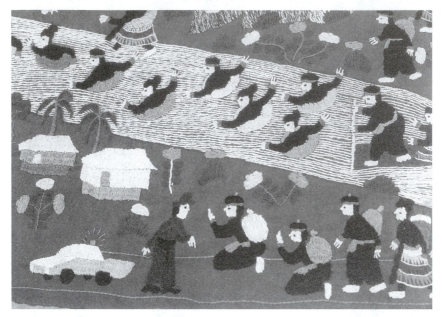

Figure 59–8: Bottom: refugees swearing allegiance to America.
Photo by George J. Leonard.

Other cloths, like Va Lee's, continue the story. Va Lee shows the large communal housing of the refugee camps. An American official pulls up in a car with a light or a siren. The Hmong kneel before him and raise their hands to swear a loyalty oath (Fig. 59–8). Then they leave, in the back of an open truck, for the airplanes that will take them to the United States. A woman points forward, as in Pao Thao's cloth, toward something she can see and we can't. But the difference between Pao Thao's artistry and Va Lee's shows when we contrast the parallel final scenes. We notice, now, the natural ease of the figures in Pao Thao's, the convincing way the children rest their arms on their knees, the way the girl's skirt bunches beneath her, narrowing its lines, the way the man lunges forward, pointing with his left hand.

Some story cloths are as large as a quilt, filled with hundreds of figures. One tells the whole Leaving Story in terrifying detail, ending with a most American of happy endings. The small black figures board planes, fly to the United States, and in the last image, after enduring the battles, strafings, bombings, rockets, and forced marches stitched above, they sit happily, in the last panel, watching a giant television. It is not a sentimental art. You suddenly understand how good it must feel, sometimes, to just sit there, safely, and watch the TV.

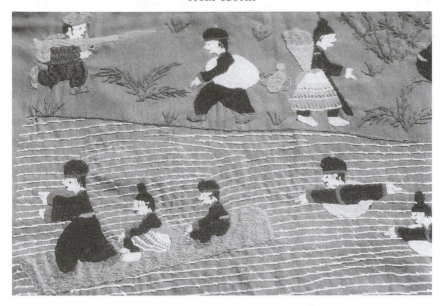

Figure 59–9: The dramatic climax: safety in sight.
Photo by George J. Leonard.

We airlifted our old allies, the Hmong, out of the wretched disease-filled Thai camps to this country—then scattered them over two dozen states, to minimize the shock to any one state's welfare and support systems. Someone must have thought it sounded practical. The Hmong, who had survived everything, almost didn't survive our forced separation of their clans into nuclear families living thousands of miles apart. From tropical forests they were sent to Minnesota winters. Someone had blundered.

Once they'd collected their wits, and saved some cash, they began climbing onto Greyhound buses and bunching together in old cars like the Joads in *The Grapes of Wrath* and heading for California's Central Valley. There, since the early 1980s, they have regathered, living incongruously among the Steinbeckian landscapes of Fresno and Arvin. Pao Thao was from Modesto, herself. Imagine, plunked down next to Tom Joad and George and Lenny, a preliterate Asian hill tribe that does needlework. California frequently lives up to its reputation for surrealism.

The U.S. Census Bureau recorded 52,887 "Laotians" in the United States in 1980—even by then, many of them Hmong, Mien, and other hill tribes. By 1990 that figure had reached 256,727. At least 50,000 refugees sit in Thailand's camps, waiting for "chain immigration" to bring them to their relatives, now American citizens.

It is not a happy ending, so far. As Frank Viviano reported back in 1986, the

Hmong had come to California expecting a chance to farm in the Central Valley. Instead they found "90 percent unemployment; a baffling disease that has seen scores of Hmong men die in their sleep; violent assaults by other minorities who regard refugees as rivals for shrinking public assistance funds; high rates of depression and suicide." Since Viviano's piece, the downward pull of American underclass culture has exerted itself on the American born. When fathers fall from heroes to bewildered welfare cases, boys turn to role models in gangs and the streets.

I never met Pao Thao again, but I took a picture of her. By the strangest coincidence, a scale model of the Vietnam Wall was touring American college campuses at that time. It had been erected on the lawn behind the crafts fair, and I took some pictures of Pao Thao against it, holding her story cloth—her own Vietnam War memorial.

In the summer of 1995, taking pictures in China to illustrate this volume, I went down to Wanfuxing Street in Beijing, to the People's Republic's stores that sell crafts, and particularly the work of the "minzu," minorities. The PRC sells *minzu* works much as the State of Arizona might sell Indian works. I was looking for Hmong or Mien needlework. Not story cloths, of course: those are Asian American, and the Leaving Story most American of all.

Disappointing. The hill tribes' works are famous in China, but some bureaucrats had obviously pressured them to create pieces for tourists. I had never heard of the Hmong having any previous interest in stitching portraits of Chinese tourist attractions like the Great Wall.

This book, though, needed a photo of the Great Wall, and eventually I wound up out there. I chose the Mutianyu section, far out in the countryside. It is more authentic than the scenes you usually see, shot at the heavily reconstructed Badaling section. In the past few years even Mutianyu has acquired tourists, however, and on the path leading up from the parking lot there were booths set up, hawking souvenirs.

There, amidst the shlock and "junque", I saw booths festooned with tapestries covered with small stitched shapes, staffed by women with faces unlike those of the Han Chinese majority. The tourists walked by them with their noses in the air, certain that anything offered for sale at a tourist attraction had to be bad. I spoke to one of the women, "Are you *minzu*, a minority?" And she replied, in Chinese, "Sir, I am Mien." Had her clan fled the ethnic cleansing of the 1970s and wandered back through China? There was probably a settlement nearby, farming in the inhospitable mountains that the Wall sits on top of. I suppose the women went to the Wall to sell their needlework the way they went to the "Crafts Faire" in California.

I told the lady I knew the Mien, and I had seen them living in California. She asked about them. I told her they were alive and doing fine. The second part was not quite true, but some day it may be.

Further Reading

Lewis, Elaine, and Paul Lewis. *Peoples of the Golden Triangle.* London and New York: Thames and Hudson, 1984. The best specific work on the hill tribes and their original crafts, researched in Thailand from 1968 to 1983. Copiously illustrated.

MacDowell, Marsha. "Hmong Textiles and Cultural Conservation." 1986 Smithsonian Festival of American Folklife Program Book.

MacDowell, Marshal. *Michigan Hmong Arts.* C. Kurt Dewhurst and Marsha MacDowell, eds. Michigan State University, 1983.

Quilting Today: The International Quilt Magazine. Issue 8, Aug.–Sept. 1988. Contains material more fully treated in *Michigan Hmong Arts* and "Hmong Textiles and Cultural Conservation."

Takaki, Ronald. *Strangers from a Different Shore: A History of Asian Americans.* New York: Penguin, 1989. Takaki augments Viviano (see below) with his own research.

Textiles, Silver, Wood of the Hmong-Americans; Art of the Highland Lao. Davis, CA: C.N. Gorman Museum, University of California, 1984. Included are valuable articles by L. Clair Christensen, Mary H. Fong, Pat Hickman, and others, plus an extensive bibliography of the Hmong's first years in America.

Viviano, Frank. "Strangers in the Promised Land." *San Francisco Examiner-Chronicle,* "Image" section, August 31, 1986. An excellent and much-quoted article describing the Hmong's early 1980s journey into California history.

Toi Hoang

Painting and Healing

AMY FELDMAN

As the first generation of Vietnamese Americans who grew up in the United States come of age, visual artists like Toi Hoang, a Vietnamese American painter and the 1994 Society for the Encouragement of Contemporary Art Award recipient, offer a new range of perspectives on the war, relocation, and Vietnamese American culture. Exposure to these newly recognized artistic contributions to American history will give both my generation—too young to remember the war, knowing it only through obsolete textbooks and Oliver Stone movies—and older American generations who witnessed the atrocities more directly, the opportunity to enrich our understanding of Vietnamese and Vietnamese American experiences. For Vietnamese Americans, Hoang brings a bit of Vietnam's tortured landscape with him to this new country. His artwork is a remembrance and a renewal.

Toi Hoang came to California, via Camp Pendelton near San Diego, at age 13 in 1975, the same year that over 130,000 Southeast Asians relocated to the United States. In April of that same year, North Vietnamese forces had reached Saigon (now Ho Chi Minh City), the U.S. stronghold in South Vietnam, and U.S. troops were forced to evacuate after a 10-year bloodbath. With them came the first wave of Vietnamese refugees. These earliest immigrants were mostly civilians who had supported the U.S. military, ex-South Vietnamese government workers, members of the middle class, or Northerners who had moved to the South when the country was divided in 1954 (a decision that Ho Chi Minh's followers branded traitorous).

Hoang was born in Thu Duc, near Saigon, in 1962. By the age of 13 he had joined the 800,000 Vietnamese children who lost one or both parents during the fighting: the war cost him his father, uncle, and sister. Hoang fled Vietnam (he considers himself a "political refugee") in 1975 with his mother and younger

brother, first to the Philippines, then to Guam, and finally to New Mexico before settling in California.

Hoang spent a good part of 10 years in college hashing out, by trial and error, a master plan for his life. Torn between paying the rent and finding a way to assert his concern for humanitarian issues, he finally, after a flirtation with medical school, discovered the expressive possibilities of painting. In his most recent works, he combines sand, tar, wire, plastic, clumps of straw, and mud glopped together with a dried blood-like substance, with fiery colors and delicate sketches of disintegrating human life. He has also devised several freestanding pieces, huge (120 by 120 by 6 inches) triangular constructions, dark bronze on the outside with glowing light escaping from tiny slits: "lanterns." Photographs can't reproduce Hoang's work: everything depends on texture and sheer scale.

Hoang's collages and constructions reflect a style that provokes many questions not only about his subject matter (the Vietnam War), but also about the nature of Asian American art. For instance, although he spent his childhood in Vietnam, Hoang matured in the United States where his formal art education took place (at San Jose State University). Asked about the painters who most influenced him, he mentions the German painter of World War II devastation, Anselm Kiefer (b. 1945), and abstract expressionist Jackson Pollock (1912–1956), a European and an American.

Indeed, Vietnamese painting, had Hoang tried to access it, would have offered him little guidance. Before the late nineteenth century, Vietnamese art history included only a modest amount of wall paintings or portraits on silk. The Vietnamese literati, in fact, were actively *not* fans of the brush (perhaps a gesture of resistance to the Chinese, who had been assaulting the Vietnamese, culturally and politically, since 3 B.C.E.), preferring instead sculpture, carving, lacquer, and architecture exemplified in the massive Imperial City of Hue, or the Buddhist temples in Bac Bo.

When the French invaded Vietnam in 1858, they brought oil paint, canvas, and the European painterly tradition with them. The French army occupied Danang in 1858 and spread south (in 1861 they took Saigon) until they annexed the entire southern region in 1867, renaming it Cochinchina. By 1883 France had extended its control to the north and, despite much rebel resistance, Vietnam completely lost its independence.

During the French occupation, the north and the south became more and more politically and culturally distant. French culture took root in the south, while Communist rebels held strong in the north. When the Geneva agreement, which officially divided the country in two at the 17th parallel, was signed in 1954,

southern artists continued to manipulate European modernism—abstraction, cubism, and fauvism—to their own creative sensibilities, while artists in the north, more nationalistic, investigated indigenous Vietnamese art forms and modes of expression. (Ironically, Left wing interest in "folk" forms was, like Communism itself, an imported European tradition.) However, these two seemingly divergent aesthetics did come to some of the same conclusions: the use of multiple perspectives, rejection of Renaissance symmetry and order, a commitment to emotional expression.

A recent exhibition of contemporary Vietnamese and Vietnamese American art, "An Ocean Apart: Contemporary Vietnamese Art from the United States and Vietnam," organized by the Smithsonian Institution, examined the threads that both connect Vietnamese and Vietnamese American art, and those that are broken in the immigration process.[1] The curators found that one of the main factors, despite different time periods and locations, that binds the participating artists is memory. Memory and the preservation of one's ancestors through memorial altars have always been central values in Vietnamese culture. In the traditional Vietnamese combination of Confucianism, Taoism, and Buddhism (Vietnamese Buddhism is mainly practiced at the village level and is a combination of Zen and *Amitabha,* devotional faith), man—both men and women—occupies the space between heaven and earth, but is never separate from either one. One's ancestors require the utmost attention in order to preserve this balance, thus the monthly trips to the cemetary with gifts and prayers for the ancestors, the celebration of "death days," the anniversary of a person's death, and the ever present ancestral altars.

Hoang, who was part of the San Jose Museum of Art's 1996 special San Francisco Bay Area addition of local Vietnamese American artists to the Smithsonian exhibition, has preserved the Vietnamese devotion to ancestral altars, but with a Western twist. He has created an entire series of triptychs, three canvas panels hung side by side to form a giant altar. In *Triptych C,* 1990 (144 by 216 by 26 inches), his ancestors are immortalized. Hoang sketches, in white, like body outlines at a murder scene, people trapped beneath barbed wire and among shreds of canvas, slashed and conspicuously stitched back together with thick cable. They are massive tributes to Hoang's private grief fused with the grief of his fellow countrymen.

Like Anselm Kiefer, Hoang infuses his wasteland-scapes with a morbid calm filtered through smoke and smoldering ashes. Like Pollock, he knows how to use imposing scale. Hoang's triptychs and diptychs also share some of Pollock's dynamic energy: compare Hoang's furious gashes with Pollock's raging trails of paint. Although Hoang's emotional force, barely contained within the painting's four edges, manages to slice through the canvas, he is determined

to complete the destructive cycle, a cycle that always returns to construction and mending. Remembering the first time he got the courage to attack a canvas, Hoang says, "It was very violent, I was so afraid."[2] But through this personal act of violence, Hoang gained the power to heal.

His wounded canvases required sutures and wire grids, some with excruciatingly bright plastic flowers twined around them, to span the gaps and draw the pieces of flapping cloth together. The artificial flowers, perhaps optimistic symbols of everlasting stability and life, perhaps an ironic commentary on Vietnam's war-induced barren soil that once had been so fertile, clash and contrast with Hoang's more organic painted forms. They also recall the fake plastic flowers many Vietnamese bring to their relatives' graves on "death days."

The Vietnam War is tragic history for both Vietnam and the United States. By the war's end, Vietnam was physically, and the United States emotionally, devastated. The two histories connected on a deeper level as more and more Vietnamese people established themselves and built strong communities in the United States. Guest curator of the Smithsonian exhibit's Bay Area section, Nguyen Qui Duc, suggests that those Vietnamese who immigrated to this country have an advantage in initiating the healing process for all of us: Vietnamese, American, Vietnamese American. The children who, like Toi Hoang, grew up never knowing life without the war can now look back from their safer vantage point in both cultures and begin to digest our shared traumatic past.

Notes

1. This has been a controversial exhibit, protested especially vigorously by parts of San Jose's Vietnamese population. They see the inclusion of works from Vietnam as an attempt by Hanoi to convince the world that freedom of expression actually exists in Communist Vietnam. Other critics of the exhibit feel that social issues have been sanitized (there are very few mentions in the catalog of Vietnamese resistance either to the colonial or the Communist agendas).

2. Toi Hoang, exhibition catalog. San Francisco: San Francisco Museum of Modern Art, 1994.

Further Reading

Fitzgerald, Francis. *Fire in the Lake*. New York: Vintage Books, 1972.

From the Studio: Recent Painting and Sculpture by 20 California Artists. Exhibition catalog. Oakland: The Oakland Museum, 1992.

Hoang, Toi. Exhibition catalog. San Francisco: San Francisco Museum of Modern Art, 1994.

First-Generation Painting

Conversation Among Hung Liu, George J. Leonard, and Jeff Kelley

JEFF KELLEY

April 7, 1995

George Leonard: Is there a difference between Asian art, and Asian American art? How, after all, can a physical object be said to be "Asian," or "Asian American?"

Hung Liu: I have thought about similar questions before. Since I am living in the United States, I can say that my life is now here, in the present tense. But China is just across the gulf, as if you could feel it. Like next door. That distance, which I have crossed, has fundamentally changed my perceptions. Like an ancient Chinese landscape painting, my life is filled with multiple perspectives. I no longer consider myself a "pure" Chinese. What that means is that I am a Chinese in the process of becoming an American, like most Americans. But for some of us, we were already adults when we came here. I had 36 years of my life in China. I was already educated and experienced enough. My language was good. But in coming here, I had to start all over again, to adapt to this culture as an adult. If I had been a child when I came here, it would have been easier. Life now runs in parallels, one real and present and one underneath the surface of everyday life. When I go back to China now, I realize how much I've become American without knowing it.

GL: Amy Tan, in the beginning of *The Joy Luck Club*, starts with the premise that a woman came to America and said, "Here my daughter will not be judged by the loudness of her husband's belch." Here, her daughter could be a person. Feminism as a motive for coming to the United States, does it ring any bells? Trigger any thoughts?

HL: I think there's a very *general* idea in China about Western humanism. We knew something about the Constitution, human rights, that human beings will be respected, no matter men, women, poor, or rich; that's the general idea about freedom in the West.

GL: Can you connect that then with the art? With being Asian American as an artist?

HL: You brought up Amy Tan's book. Because she was born here, she didn't come from China, her mom did. When I saw the movie, *The Joy Luck Club,* especially the flashback about people fleeing the civil war and her mother abandoning her baby sisters, I thought it was too theatrical, too fake, not even Hollywood. My mother told me about a similar story from the same period, and I was one of those babies. It wasn't like in the movie. The reality was too miserable. I am not saying that Amy Tan has to know what it was like, how could she?

GL: But I don't want to get into that so much as to know, to what extent can an *object* be Asian American, or Asian? Has your art changed?

HL: My art is absolutely not pure. It is already a hybrid that involves looking at historical materials and visual references, mostly photographs. Maybe because I'm Chinese, the Chinese subjects in those photographs stand out. For instance, the sequence of three paintings I did of a baby eating are hybrids of a kind of stereotypical Chinese subject—a small child eating—and the almost cinematic framing of three shots in a row, a sequence in time. This was almost never done by Chinese families. In the 1950s, Chinese families didn't have their own cameras. Each photograph was very precious; a roll of film could last a whole year, each picture reserved for important events. But here we have a very Western perspective—it reminds me of Muybridge—built into the sequence of the shots. The image is already very candid, almost a documentary of this cute girl. She wasn't posed either. If I had never left China I would probably look at it differently. I might not have seen the sequence as a sequence—as an esthetic structure. I would just have seen three similar—and maybe unnecessary—shots.

GL: Of the Asian American artists you've seen, is there anything about their art that looks obviously more American than Asian?

HL: Many artists from mainland China try to forget about being Chinese and "catch-up" by becoming "American" artists, like trying to be Jackson Pollock or whoever. We never had modernism in China, so in a way Chinese artists follow modernist footsteps when they get here.

GL: That's the peril of the first-generation artist? They're too desperate to catch up?

HL: Yes, and by doing so they date themselves. Also, in order to become "American" artists, they often change their styles, but not their concepts.

GL: I see how daring your own personal decision is then, to stay Chinese in your work.

HL: Yes, but using the training I had in China. In terms of technique, draftsmanship—I am very good. Why should I abandon it? The question is how to use it now. I want to frame it in a contemporary setting while still using my skills.

Jeff Kelley: Could I interject something? It's just an observation, but I've always thought, in relation to your (George's) question about how an object can be Asian American, I think that Hung is essentially a Russian painter. Her oil painting training came from Russia; it really is nineteenth-century Russian Realism with some French Impressionism filtered through it, except that modernism didn't get to China. If you look at the painting Hung did of the child eating, you'll see something that has much more to do with the Russian style of oil painting. So when you ask the question of whether an object can be Asian or Asian American, I think that Hung's are already hybrids, and that critics have hardly ever touched upon this kind of mixed pedigree when they write about her work. They're so focused upon her *being* Chinese—and on her Chinese subjects—that they seldom talk about the identity of the work as an object, which, if she weren't Chinese, is probably all they'd talk about.

HL: So then everything I do will be Chinese because of who I am?

JK: Well I think what's Chinese about your work—besides, of course, your subject matter—is probably some sensibility about a kind of wetness or dissolving quality that reminds me a lot of traditional Chinese landscape paintings. Even more, though, in a contemporary sense, your work is a postmodern hybrid of identities—it's European, via Russia, and then across the Pacific to California. And from here you can see all these properties.

GL: We've already begun to talk about a concept Cornel West and others have come up with, called "the burden of representation," a burden that affects everyone who is an "ethnic" artist. Hemingway can write about whatever the hell he wants; so can T.S. Eliot. But if your name is Hung Liu, then damn it, you've got to be Chinese. That's part of the burden. The second part is that you've got to represent your ethnicity *well*. If you're black, you can't write about Thomas Jefferson, you have to write, as West says, "the novel of blackness."

HL: I started with mixed blood: I am part Mongolian and, as Jeff said, my education is not pure—in China I learned more about Russian artists than Chinese. The burden you mention is an expectation from inside and outside: Americans expect me to be critical, and my Chinese country-fellows expect me to represent China in a way that doesn't expose its dirty laundry. These expectations deny one's individuality as an artist. I recently did a painting of turn-of-the-century child laborers in Baltimore, from a photograph of a cluster of young, bare-

Figure 61–1 a–c: Sequence (Simei 1954), *by Hung Liu, 1995. Photos by Jeff Kelley. Used by permission of the artist. Private Collection.*

foot children working in a cannery in very bad working conditions. There are no Chinese subjects in this painting, but the reason I had a passion to do it was because it reminded me of—you know what?—Russian painting. Art is the part that interested me—not class consciousness, political correctness, or ethnic identity, but the fact that it was in a sense already a Russian painting, like the kind I had studied in China. By doing this painting I was commemorating part of my *past as an artist.* The theme of immigration is not just autobiography, or a cultural story, but also a metaphor of how art changes.

JK: Still, a lot of people assume that the meaning of your work is the meaning of the subjects you select, especially the images of young prostitutes, concubines, and so forth—even of yourself. But the paintings are not just subjects, they are also objects. I guess what I'm asking is, What are the differences between your photographic subjects and the painted objects they become?

HL: Well, for me painting is a process that opens up the photographic instant. If a photograph was taken in a moment of time, then a painting extends that moment into a week, a month, or beyond. In a sense, the painting process erodes the documentary surface of a photographic image, opening it into layers

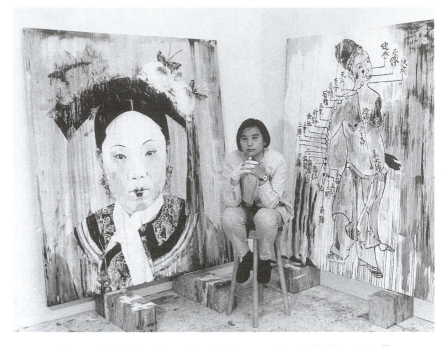

Figure 61–2: Hung Liu in her California studio, 1995. Photo by Jeff Kelley. Courtesy of the subject.

of canvas, wash, sketch, stroke, drip, and so forth. I often feel as though I am excavating the photo surface, trying to locate the narratives beneath it.

I think probably much of the meaning of my painting comes from the way the washes and drips dissolve the documentary authority of the photographs I base them on, creating marks of time—like the time it takes for a drip to drip or an image to dissolve—marks that record the ritual of painting, which is very different from the idea of a photographic instant.

For example, last summer I returned to my ancestral home, a small village in Manchuria, for the purpose of sweeping the graves of my grandparents and uncle. Most of the villagers—who are my relatives—turned out for the ceremony, which involved carrying offerings to the grave mounds, cleaning the mounds, installing new head-stones, and listening to oral narratives about my late relatives' place in the history of the village. As the day unfolded, one ceremonial moment rolled into the next with an informality that was different from the seriousness of Western funerals, but was no less moving as an emotional, communal event.

In the middle of this flow, we snapped pictures with our cameras, trying to capture its most posed, pictorial moments, like the high-points in a play. What this means to me is that the photographs taken that day were not isolated "slices

of reality," but photographic traces that emerged from the flow of ritual time and space.

Out of this experience, I painted a painting called "Burial at Little Golden Village," a large canvas of my face and a corn field beyond. The image came from a snapshot taken that day. Back in the studio, months later, I realized that the painting was not just an homage to the grave sweeping, but also a metaphor of my own emigration to America, since the corn field could also be in Iowa or Nebraska. Painting allowed me to complete a narrative of cultural and emotional transition that I didn't even think about when the photographs were being taken. It was only during the extended time of painting that the deeper resonance of my own personal and cultural memory could be experienced. Painting tied the experience into something larger than myself.

So I use one medium to thaw-out another. My art is a hybrid. Maybe that's what makes it Asian, or Asian American, like me.

Asian Pacific American Chronology and Statistics

D IANE R OSENBLUM, WITH D AVID W OO, C LAIRE E CKMAN, S TEPHEN E GAWA,
D EBBIE L EE, G ALIN L UK, AND M AX M ILLARD

1587 "Luzon Indians" (Filipinos) are reported to have arrived at Morro Bay in California with Pedro de Unamuno, a Spanish explorer.

1763 First possible settlement of Filipinos in modern-day United States when "Manilamen" jump ship in bayou country near New Orleans.

1778 Captain James Cook, an English explorer, comes upon the Sandwich Islands, which we now call Hawaii.

1779 The first documented Chinese in modern-day United States are some artisans who came with British traders.

1815 In the Battle of New Orleans, the Filipinos among the Baratia Bay dwellers fight along with Jean Lafitte against the British.

Antonio Maranda, a Filipino, is one of the founders of the city of Los Angeles.

1835 Americans establish the first sugar plantation in Hawaii.

1839–1842 1839 begins the first of two opium wars between China and Britain. The Treaty of Nanking is forced upon China when it loses the war. The treaty opens up the road for Western penetration into China.

1843 The first known Japanese immigrant arrives in the United States.

1846 Irish Potato Famine sends half a million impoverished Irish laborers—Roman Catholics—to the United States, creating a climate of anxiety among working-men and Protestants. The Chinese will arrive in the middle of a nativist backlash.

1848 United States Mexican War ends. United States gains Southwest from Mexico just before gold is discovered in northern California.

1849 Gold Rush begins, 80,000 people pour into San Francisco from around the world in one year.

1850 Manchu Qing Dynasty, humiliated in Opium War, suffers Taiping Rebellion in South China, which will kill perhaps 20 million people. By 1852 nearly 20,000 southern Chinese peasants arrive in California—many recruited to be contract laborers, others to mine.

 During the next decades, until the 1882 Exclusion Act, California will pass many unusual discriminatory laws and taxes aimed at discouraging Chinese immigration. The courts routinely find the laws unconstitutional within a year or two, but the harassment, often petty, only escalates: the 1850 Foreign Miner's Tax, the 1855 Immigrant Tax (charging shipowners more than the Chinese paid for passage), the 1860 law excluding non-whites from public schools, the 1860 Chinese fisherman's tax, the 1862 law against "Coolie Trade" contracts, the 1862 Police Tax (on anyone not already paying miner's tax), the 1863 law against persons with one half or more non-white blood giving evidence in court against whites, the 1871 San Francisco Cubic Air Ordinance (which jails Chinese sharing living quarters, as most must), the 1871 Chinese Opera prohibition, the 1871 Noise Law disabling Chinese laundries, the 1872 Queue Ordinance (to cut the Manchu braid off anyone jailed), the 1873 Laundry Ordinance, the 1877 State Dead Body Law (making it impossible to send one's ashes home to China for religious burial), the 1879 State Constitution confining Chinese to ghettos, depriving them of public services, the 1880 Laws provide fines and even jail time for anyone hiring a Chinese, the 1880 Miscegenation Act outlawing marriages with Chinese (thereby declaring the children bastards, depriving spouses of inheritances, pensions, and many routine legal protections).

1851 Chinese in San Francisco start the Sam Yup and Sze Yup organizations, the first two of the "Six Companies." (See 1854)

1852 Sugar planters bring 195 Chinese contract laborers to Hawaii to work on sugar plantations.

1853 Commodore Perry enters the port of Tokyo and forces Japan to open its territory to foreign trade, thus ending the policy of isolationism of the Tokugawa regime that had been in effect for 250 years.

1854 California suffers a business recession and white workers blame ethnic people, particularly the Chinese, for unemployment and economic distress.

The Chinese in San Francisco form the Chinese Consolidated Benevolent Association, more commonly known as the *Six Companies*. The members of the Six Companies are immigrants from any one of the six districts in the Kwangtung (Canton) province of China. (See 1851)

1860 Japan sends a diplomat to the United States.

1860 census in the United States shows the total number of Chinese to be 34,933. Many discover that white laborers are not interested in "women's work" and will tolerate Chinese working as laundrymen, cooks, and domestic servants. An ecological niche opens in the job market.

1862 Congress starts the building of the first transcontinental railroad by giving contracts to two companies, the Union Pacific and the Central Pacific Railroad Companies. The Union Pacific is to start from the east and move west and the Central is to start from the west and move east. Eventually the two companies will meet and the railroad will be completed. Most of the Central Pacific's workforce is made up of Chinese immigrants, and the companies actively recruit for them in China as well.

1865 Of the 10,000 laborers building the Central Pacific Railroad, 9,000 are Chinese.

1867 2,000 Chinese railroad laborers go on strike (unsuccessfully) to demand equal pay with whites, better treatment from foremen (they were constantly whipped), and fewer work hours.

1868 148 Japanese contract laborers are contracted to work on Hawaiian sugar plantations.

The first of 62 strikes and work stoppages by Japanese laborers on the Hawaiian sugar plantations begin.

First significant group of Japanese immigrants arrive in California.

1869 The Transcontinental Railroad is completed on May 10 at Promontory Point, Utah. A photograph of the "Golden Spike" (the last spike put into the tracks to join the west with the east) does not include a single Chinese laborer.

1870 The number of Chinese living in the United States reaches 64,199, most of whom live in the west.

Rev. Otis Gibson starts the Woman's Missionary Society in San Francisco to rescue Chinese prostitutes.

1871 In Los Angeles, there is a massacre of Chinese people: 15 are hanged, 4 shot, and 2 wounded.

1873 European economic crisis leads to a world-wide depression and enflames the growing labor movement. The International Workingmen's Association adopts an "anti-coolie" policy, opposing the immigration of Chinese laborers. Next year the unionized cigarmakers (an important early union) in San Francisco will call for a boycott of Chinese-made cigars. Dennis Kearney, an Irish immigrant, leader of San Francisco's powerful Workingmen's Party, adopts "The Chinese Must Go!" as his slogan and leads political rallies that end in mob violence against the Chinese. In 1877 a rally ends with 25 Chinese laundries being set afire.

A dismal pattern has begun which will affect all Asian American immigration until World War II. Large capitalist concerns (the railroads, the Hawaiian sugar planters) will recruit unknowing peasant laborers in Asia, then bring them to the United States to be pawns in the battle against the fledgling labor unions. The labor unions will sometimes try to educate and recruit these new workers, but usually labor's effort will be to exclude them from the United States. Quite frequently, this attempt will be accompa-

nied by blatant racism, unconstitutional laws, and even physical attacks. As soon as labor gets a group excluded, the big companies import another to exploit the same way. If an Asian group begins to unionize, the companies import a new group to undermine that one.

1876 Many Chinese are forced out of several towns in California, some are violently attacked.

1877 Chinese-owned buildings in Chico, California are burned down. Four Chinese are tortured and killed at the hands of white supremacists.

In San Francisco, Japanese Christians set up a Gospel Society, the first Japanese American organization of its kind.

1880 The United States and China sign a treaty giving the United States the right to extensively limit Chinese immigration but not to prohibit it. There are 105,465 Chinese living in the United States at this time.

1881 The first Chinese-Christian church appoints Sit Moon to be pastor in Hawaii.

1882 Chinese Exclusion Act. Union pressure climaxes in Congress prohibiting all new Chinese workers from entering the United States for 10 years. Chinese scholars, diplomats, and merchants may enter. Chinese living here but currently visiting China may re-enter. (Scott Act reverses that six years later, stranding 20,000 Chinese abroad.) Chinese already here are not eligible for citizenship. The Exclusion Act will be extended until 1943.

In this last year of legal immigration, Chinese immigrants number 39,579. Within five years that number will drop to 10. This stranded, aging population will form the Bachelor Society. Men outnumber women nearly 200 to 1.

Korea and the United States sign their first treaty. About 100 Korean diplomats and students enter the United States.

1885 In Rock Springs, Wyoming, white miners go on strike, and when Chinese miners continue working ("scabs"), the strikers riot and murder 28 of the strike breakers.

On November 20, Congress passes an act that prohibits contract laborers.

The Meiji government in Japan allows Hawaiian sugar planters to bring 30,000 Japanese laborers to Hawaii.

1886 Through threats and violence, white workers in the cities of Eureka, California; Tacoma and Seattle, Washington; and Oregon City and Albina, Oregon manage to drive out all Chinese residents in those areas.

Japan completely lifts ban on Japanese emigration.

1889 The first Japanese priest arrives in Hawaii. The U.S. court upholds the constitutionality of the Chinese Exclusion Act in *Chan Ping* vs. *United States.*

The first two Korean women arrive in the United States. They are the wives of Korean diplomats, Lee Wang-yong and Lee Chae-yon.

1890 The U.S. Census reports that there are 2,039 Japanese immigrants in the United States, of whom 1,147 are in California.

1890–1901 Battle between the spreading union movement and the great monopolies and trusts intensifies, fans anti-Asian sentiment. In 1886 "anarchists" had bombed Haymarket Square, Chicago, killing seven policemen. In 1890 Congress voted in the Sherman Anti-Trust Act. In 1892 Pinkerton guards fire on striking steel workers in Homestead, PA. United States troops put down the strike, and another against silver miners in Idaho. In 1894 Jacob Coxey leads a march of unemployed men, "Coxey's Army," on Washington. Pullman railroad car workers strike; Eugene V. Debs calls a general railroad strike to support them, and is sent to jail for six months. In 1901 an anarchist shoots and kills President McKinley.

1894 Japanese government creates a set of regulations known as the Regulations to Protect Emigrants. The regulations are imposed to control emigration companies. Sino-Japanese War starts on Korean soil. The Japanese will defeat the Chinese, the Qing dynasty will soon fall.

Sun-Yat-sen establishes a Chinese revolutionary organization in Honolulu called the Xingzhonghui. In 1911 he will overthrow the Qing dynasty and become first President of the Chinese Republic.

1898　Hawaii is annexed by the United States.

The Treaty of Paris ends the Spanish-American War giving Cuba, Puerto Rico, and the Philippines to the United States. Filipinos are declared "wards" of the United States and need no visas to travel to the United States. When Japanese and Korean laborers are excluded in 1907, Filipinos, as American "nationals," are allowed to remain—the planters will turn to them.

1899　The first Buddhist temple is established in San Francisco.

93 Korean contract laborers enter Hawaii to work on the sugar plantations.

Facing fierce resistance from Philippine nationalists, the 70,000 U.S. troops move beyond Manila to conquer and colonize the Philippines. Unpopular in the U.S., the fighting officially ends in 1902.

1900　United States enacts the Organic Act, which makes all U.S. laws applicable to Hawaii. This act ends contract labor. Many Japanese go to the mainland. Japanese population in the United States at this time amounts to 24,326. The Chinese population drops to 93,000.

1902　The Philippine Organic Act declares Filipinos to be American nationals.

Congress passes the Cooper Act, making it illegal for Filipinos to own property, vote, operate a business, hold public office, or become naturalized American citizens.

To counter Japanese workers' growing militancy in the Hawaiian sugar plantations, Horace Allen goes to Korea to recruit plantation workers. Mexican laborers are also being brought in.

1903　1,500 Mexicans and Japanese sugar beet workers go on strike in Oxnard, California.

On February 11, 500 Japanese and 200 Mexican workers come together to create the Japanese-Mexican Labor Association. Planters bring 7,000 Koreans to Hawaiian sugar plantations.

1904 Japanese workers in Hawaii go on strike.

Railroad companies begin to actively recruit Korean laborers from Korea. By 1907, 2,000 Koreans are in San Francisco.

6,647 more Korean laborers are brought to Hawaii to work on the sugar plantations.

The American Federation of Labor national convention calls for the 1902 Chinese Exclusion Act to be amended to include Japanese and Korean laborers.

1905 A conference is held in San Francisco by the Asiatic Exclusion League to prevent Asian immigration.

California Civil Code is amended to forbid marriages between whites and "Mongolians."

Japan defeats Russia in Russo-Japanese War, invades Korea, begins oppressive rule.

Segregation of Japanese school children is attempted by the San Francisco school board. Japan, deeply offended, lodges official protests.

1906 The earthquake in San Francisco causes a massive fire that destroys many of the city's records including birth certificates of many Chinese citizens. Many people take advantage of this by coming over from China to pose as citizens of the United States with false documents. The government creates a detention and interrogation center to examine these *"paper sons"* at Angel Island, in San Francisco Bay.

Sugar planters bring 15 young Filipino men to Hawaii for the sugar plantations.

1907 President Theodore Roosevelt brokers the "Gentlemen's Agreement" be-
 tween the United States and Japan; Japan agrees to stop issuing passports
 to Japanese and Korean laborers for entering the United States. San Fran-
 cisco backs down on segregating Japanese students in public schools as part
 of the Agreement.

 Roosevelt issues Executive Order 589, which disallows the re-emigration
 to the United States of Japanese with passports to Canada, Hawaii, or Mexico.

 Sugar planters bring 210 Filipino laborers to Hawaii.

 The peak year for American immigration: 1,285,349 immigrants enter
 the United States between 1905–1914, 10.1 million will enter, and not
 from Northwestern Protestant Europe, as before 1890, but from else-
 where: Catholic Sicilians, Russian Jews, Greeks, etc. The postwar back-
 lash against this rapid change will engulf the comparatively small Asian
 populations as well.

1909 The merger of Hawaii's United Korean Society and California Mutual As-
 sociation Society forms the Taehan Kookmin-hoe and lays claim to being
 the voice of the Korean homeland. They provide political services and pro-
 mote social welfare.

1910 Japan formally annexes Korea. Koreans in America band together to fight
 Japanese police state. Japanese fill all government positions, abolish the
 Korean alphabet, try to abolish Korean culture, rule by force alone.

1911 Pablo Manlapit establishes Filipino Federation of Labor in Hawaii.

 U.S. Immigration and Naturalization Service says that only whites and
 Negroes may be naturalized.

 Sun Yat-sen's revolution deposes Qing dynasty, starts first Chinese Re-
 public.

1913 The California Land Act is passed, which bars any alien ineligible for citi-
 zenship from owning land. More land acts will be passed in later years. The
 Issei put their land in their American children's names.

1917 Congress creates the "Asiatic Barred Zone Act," which bars immigrants from China, South and Southeast Asia, the Asian part of Russia, Afghanistan, Iran, part of Arabia, and Pacific and Southeast Asian Islands not owned by the United States.

1918 U.S. government extends citizenship to anyone who has enlisted or served in the military, race notwithstanding.

38 Korean Protestant churches are formed.

1919 Japanese in Hawaii form the Federation of Japanese Labor.

1920 10,000 Japanese and Filipino laborers go on strike in Hawaii.

The 1913 Alien Land Act is amended to make the lease of land to aliens illegal.

U.S. Census finds that there are 110,010 Japanese in the United States at this time.

The Census also shows 5,603 Filipinos in San Francisco. Most are single men, living in "Manilatown."

1922 The Cable Act passes. Any female U.S. citizen marrying an alien will lose her citizenship and any alien female marrying a male U.S. citizen will not be eligible for citizenship.

In *Ozawa* vs. *United States,* the court agrees that Japanese aliens are ineligible for citizenship.

1924 National Origins Act closes the "golden door" and tries to return America's ethnic make-up to that of the last century. 84 percent of legal immigrants will come from Northwestern Europe, only 16 percent from all Southeastern Europe, 2 percent from "other" places. No Asians or any other aliens ineligible for citizenship are allowed in as legal immigrants. Since Filipinos are technically not from a foreign country, the plantations can still bring them in.

1,600 Filipino workers strike in Hawaii for 8 months. Workers demand $2 for an 8-hour day.

1928 Congressman Richard Welch of California introduces a bill to exclude Filipinos from the mainland. The bill receives support from the states of Oregon and Washington, from labor unions, and from groups concerned about the ethnic composition of the United States.

1929 Wall Street crashes. The Depression begins. Violence breaks out in Watsonville, California against Filipinos. The riots carry on to the beginning of 1930 and extend into Washington, Idaho, and Utah.

1930 U.S. Census shows 56,000 Filipinos on the U.S. mainland, 64,000 in Hawaii. Filipino immigration restricted as a result of the Great Depression. Under Reed Bill, "citizens of the islands under the jurisdiction of the United States" are no longer allowed to immigrate. However, Filipinos are still allowed admittance to Hawaii, a territory.

1931 Japan takes Manchuria away from China, installs Pu Yi, the "Last Emperor" of the defeated Qing Dynasty, as its puppet.

1932 Hawes-Cutting-Hare Bill passed. Philippines will become independent after a transition period of 15 years of "commonwealth" status.

1934 The Tydings-McDuffie Act declares the Philippines an American "commonwealth" and reduces immigration to 50 per year. The Filipinos are classified as aliens. Planters can no longer bring them in.

1935 Congress passes the Repatriation Bill that encourages Filipinos to return to the Philippines by paying for their voyage back. Only 2,000 Filipinos leave.

1937 Japan launches full-scale invasion of China, bombing civilian populations, committing widespread atrocities like the "rape of Nanking." Chinese armies retreat into the interior, most under the Nationalist (Guomindang) party's leader, Chiang Kai-shek, a smaller group under Mao Tse-Tung and Communist leadership. Japan, already recognized as an enemy of democracy,

begins to change American public opinion toward all Chinese. Henry Luce, an admirer of General Chiang and of Madame Chiang Kai-shek, his charismatic, American-educated wife, puts *Time* and *Life* to work extolling the "heroic Chinese people."

1940 U.S. Census finds 126,947 Japanese in the United States. 70,624 (62.7 percent) are native-born.

U.S. Census lists 98,535 Filipinos.

1941 Japan attacks Pearl Harbor and the United States declares war on Japan. 2,000 Japanese community leaders along the west coast and Hawaii are interned in camps set up by the Department of Justice. Californians' fears of invasion and anger against Japanese turns them against Japanese Americans.

In December, the Japanese bomb Clark Air Base, land an expeditionary force in the Philippines, and fight their way down the Bataan Peninsula. Filipino soldiers fight alongside American soldiers. Together, they retreat to the fortress island of Corregidor.

1942 *Executive Order 9066* is signed into effect by President Franklin Roosevelt. It effectively interns 112,000 Japanese Americans in various relocation camps. Anyone not obeying this order is put in prison.

American and Filipino soldiers surrender Corregidor Island to the Japanese. Some 80,000 prisoners of war are forced to march 100 kilometers north in the hot sun to a prison camp, in the infamous Bataan Death March. About one tenth of them die on the way. General Douglas MacArthur makes his escape with the pledge, "I shall return."

1943 China's battle against America's enemy has changed public opinion. As a good will gesture toward China for being an ally, the United States repeals the Chinese Exclusion Act, establishes a small quota, and grants the Chinese the right to naturalization.

26,000 Japanese American *Nisei*, organized by *JACL* (Japanese American Citizens League), volunteer to fight in the *442nd* Regimental Combat Team. This heroic, much-publicized unit will help public opinion un-

derstand Japanese Americans as fully American.

1944 MacArthur, instead of "island hopping" on the way to the Japanese home islands, fulfills his "I shall return" pledge to liberate the Philippines. House-by-house fighting levels Manila.

Public Proclamation No. 24 passes on September 27, which calls for the "revocation of the West Coast mass exclusion order against persons of Japanese descent."

1945 World War II ends upon Japan's unconditional surrender, which leads to Korea gaining its independence from Japan.

War Brides Act, GI Fiancees Act, and Act of 9 August, 1946 allow the entrance of Asian warbrides, fiancees, and children. (20,000 warbrides enter the U.S.)

Third wave of Filipinos begins to arrive in America. Most are military personnel who served with the armed forces in the Philippines.

1946 The Philippines are finally independent. American citizenship is extended to Filipino residents of the United States before March 24, 1934. It also grants Filipinos the right to naturalization.

Tule Lake Relocation is the last relocation camp to close.

Wing F. Ong becomes the first Asian American to be elected to state office in the Arizona House of Representatives.

1947 Chinese American veterans are able to bring their brides into the United States when the War Brides Act is amended.

1948 The Evacuation Claims Act is signed into law. It authorizes payment to people of Japanese descent who suffered economic losses during internment. The payments amount to one tenth of the monetary amount lost.

U.S. Supreme Court rules that California's ban on interracial marriages is unconstitutional.

1949 The People's Republic of China is established by communist Mao Tse-Tung. Nationalist Chiang Kai-shek is driven out of China to Taiwan. Due to China's communist status, several refugee bills are passed in later years that allowed for several thousand Chinese to immigrate.

Huk Rebellion in the Philippines. The government is threatened by the Huks, communist-led guerrillas. U.S. military helps defeat them.

1950 Korean War begins.

U.S. Census counts 122,707 Filipinos.

1952 The McCarran-Walters Act abolishes "aliens ineligible for citizenship" category and allows for re-unification of families, particularly Asians. It allows citizens to bring over spouses, parents, and children on a non-quota basis. But each Asian country is given a quota of only 100 per year.

1953 The Korean War ends.

The Refugee Relief Act grants non-quota immigrant visas to Chinese and Eastern European refugees fleeing Communism.

1954 Communists under Ho Chi Minh defeat French in Vietnam. Geneva Agreement gives them control of North Vietnam.

Laos and Cambodia also gain independence from France.

An amnesty program is set up for "paper sons" who obtained citizenship by fraud. Under the program, they are given the status of permanent aliens.

1956 California repeals its land laws. (See 1913)

1959 Hawaii becomes the 50th state of the United States. Hiram Fong and Daniel K. Inouye are elected to represent Hawaii.

1960 U.S. Census shows the Chinese population reaches 237,292. Filipinos number 176,310, Japanese Americans 464,332, Koreans approximately 8,000.

1962 Daniel K. Inouye becomes the U.S. senator and Spark Matsunaga becomes U.S. congressman from Hawaii. Ben Menor becomes the first Filipino elected to the state senate in Hawaii.

1964 Tonkin Gulf Incident allows President Lyndon Johnson to escalate United States involvement in Vietnam.

The 1964 and 1965 Civil Rights Act calls for legislation against racial discrimination.

Patsy Takemoto Mink, the first Asian American woman to serve in Congress, is elected to be a representative of Hawaii.

1965 The Immigration Act of 1965 makes sweeping changes in Asian Pacific immigration. Senator Robert F. Kennedy and the Democrats abolish the National Origins Act, replace it with a plan permitting nuclear family unification, and beyond that, establishing a quota of 20,000 new immigrants per country. Since immigrant Irish, Italians, and Jews had been the backbone of the Democratic party, and since Kennedy publicly declared that only a few thousand Asians would probably come, the affect on their immigration numbers seems to have been an unforeseen side-effect. Instead of 100 per year, suddenly 20,000 Filipinos may enter the U.S. Instead of 100 Chinese per year, 20,000 Chinese can come from Hong Kong—and, since it is a separate country, another 20,000 from Taiwan—and, when relations are normalized, another 20,000 from the People's Republic of China, and so on. Korean Americans increased from some 8,000 in 1960 to 695,000 in 1990.

A second great change was the Immigration Act's high preference to professional people, scientists, and artists. Previously, Asian immigration had been primarily laborers from the poorest provinces, brought over as contract workers. Almost all were male, hence the "bachelor society." The new immigrants are highly educated, frequently from the upper classes, as often women as men. They frequently share little common ground with the older, male, blue collar communities, whom they soon equalled in numbers, then outnumbered. There is friction and a changing of the guard in Chinese and Filipino communities.

A third great change was that in 1960 Japanese Americans greatly outnumbered all other groups: 464,332 compared to 237,292 Chinese and 176,310 Filipinos. But most immigration is financially motivated, and

Japan's strong economy kept immigrants home. By 1990, Japanese Americans numbered some 760,000 but Chinese American numbers have soared to 1.3 million, and Filipino American to 1.2 million.

1966 Great Cultural Revolution breaks out in China.

1967 All bans on interracial marriage are ruled unconstitutional by U.S. Supreme Court.

Vietnam War polarizes country, creates Hippie Movement. Beatles go "psychedelic," release "Sgt. Pepper's Lonely Hearts Club Band" in June, sanction emerging drug culture. Summer of Love in San Francisco.

1968 United States has 525,000 men in Vietnam. Tremendous social upheaval in United States against the war—marches, student strikes. Strikers occupy Columbia University, disrupt Democratic Party convention. In Tet offensive Viet Cong guerrillas attack at will within Saigon and other American strongholds, destroy last hopes of an early victory. Discrediting of all forms of authority creates "generation gap," accelerates the Hippie Movement. Bitter strikes start at San Francisco State University, where police occupy the campus, and at University of California, Berkeley. San Francisco State strikers demand, and get, America's first School of Ethnic Studies and first Department of Asian American Studies. University of California, Berkeley, UCLA, and many other schools and programs quickly gain Asian American Studies programs.

1969 Nixon assumes presidency, Vietnam War continues. Protests include politically charged Woodstock Festival, "3 days of Peace and Freedom."

1970 Invasion of Cambodia.

National Guard fires on student protesters at Kent State.

The Shanghai Communique, which is issued jointly by Chinese Premier Chou En-lai and President Nixon, calls for the normalization of relations between China and the United States.

1972 The Civil Rights Act bans discrimination against workers on the basis of color, race, sex, religion, or national origin.

President Richard Nixon visits Communist China, talks with Mao about recognizing China and establishing relations.

1973 A peace agreement between the United States and Vietnam is reached.

1974 Bilingual education is required in schools for students with little or no English-speaking ability.

1975 The capital city of Cambodia, Phnom Penh, is attacked by the Khmer Rouge and a new government is established under Pol Pot. The reign of terror begins and does not end until more than 1 million Cambodians are killed.

The Paris Agreement is violated by North Vietnam when it attacks South Vietnam. Saigon falls and American troop involvement in Vietnam ends.

Congress authorizes the immigration of 130,000 Southeastern refugees, 125,000 of whom are Vietnamese.

1978 The Japanese American Citizens League begins movement for **Redress** for their internment during World War II.

Hundreds of thousands of "boat people" flee repressive regimes in Vietnam, Cambodia, and Laos, many drowning at sea or killed by pirates before rescue. America accepts 14,000 refugees per month.

David Hyun, Korean American, organizes a group of Japanese American mom-and-pop stores and creates the Japanese Village Plaza, a Japanese theme mall now widely credited as the first step in the revitalization of Los Angeles' downtown, as well as Little Tokyo. The Temporary Contemporary art museum, Japanese American Citizen's League headquarters and Japanese American National Museum follow in the next decades.

1979 President Jimmy Carter increases the quota for refugees in the United States to 7,000 per month.

Many Chinese American families are reunited when China and the United States resume diplomatic relations.

1980 166,700 Indochinese rufugees arrive in 1980 alone before the Refugee Act of 1980 sets an annual quota of 50,000.

1982 Vincent Chin, a Chinese American, is killed by two unemployed white autoworkers who mistake him for a Japanese, and claim he cost them their jobs. Although found guilty, a judge merely sentences them to three years probation and a fine of $3,780 each.

Amerasian Immigration Act enables children who were fathered by Americans to immigrate to the United States.

1983 Petitions are filed by Fred Korematsu, Min Yasui, and Gordon Hirabayashi to overturn their World War II convictions for violating executive orders and curfew. A federal lawsuit is filed on behalf of 120,000 Japanese American internees asking for monetary compensation by the National Committee for Japanese American Redress.

1984 About 711,000 refugees from Vietnam, Laos, and Cambodia have been admitted to the United States by this time, totalling 14% of Asian America.

1986 The Immigration and Reform Act is passed and imposes civil and criminal penalties for anyone employing illegal aliens. It also grants temporary resident status to aliens here before January 1, 1982 and grants permanent status to them after 18 months if they show minimal skills in English, U.S. history, and U.S. government.

Ferdinand Marcos, dictator of the Philippines for 20 years, is forced from power by "people power" demonstrations and is replaced by elected president Corazon Aquino.

1987 U.S. House of Representatives votes to make an official apology to Japanese American internees and to pay each survivor $20,000.

The Amerasian Homecoming Act passes, allowing those born in Vietnam but fathered by an American to be admitted to the United States.

The University of California, Berkeley's admission policy comes under attack by Asian Americans as being discriminatory against them. Asian Americans divide on "affirmative action" since, although they are an oppressed minority, "affirmative action" works against them.

1988 The U.S. Senate votes to support redress for Japanese American internees.

1989 President Bush signs into law the redress for the Japanese American internees as well as an official apology.

1990 The Immigration Act of 1990 goes into effect.

1991 On April 29, a jury finds police officers who had been videotaped beating an African American named Rodney King, not guilty. Protest riots by African Americans and Latinos in south central Los Angeles turn into a general looting of stores. Korean Americans, who own small convenience stores and shops all through the area (it had been abandoned by large chains after the Watts riots of the 1960s) are targets. 2,300 Korean-owned businesses are partly or completely destroyed, including 172 liquor stores. Nearly half the 1 billion dollars in LA's damages are sustained by this one ethnic group. People are shot, one Korean American dies. Korean Americans now call the event Sa-yi-gu, Korean for 4–29. Two years later, two-thirds of the stores had not reopened.

Family Veterans Bill is passed by U.S. Congress, allowing Filipino veterans who fought alongside the Americans in World War II to apply for U.S. citizenship.

Philippine Senate rejects the U.S. Bases Treaty that would have allowed the United States to keep its two bases in the Philippines for another 10 years.

1992 Kristi Yamaguchi, fourth generation, becomes the first American woman to win the Olympic gold medal in figure skating since Dorothy Hamill in 1976. Event is watched on TV by a larger audience than the Superbowl. Yamaguchi's victory and her continuing high profile as the new "All American Girl" is seen as a general cultural indicator of Asian American success, raising some inevitable worries about a "model minority" stereotype.

1993 First Korean American to hold national office, Rep. Jay C. Kim (Rep.) of suburban Los Angeles's middleclass Diamond Bar area.

1994 Since 1980, the Asian Pacifics have become one of the most "suburbanized" American ethnic groups. In the suburbs, black population grew 34.4 percent, Latin population grew 69.3 percent, and Asian Pacific, 125.9 percent while non-Hispanic white grew only 9.2 percent. The old urban enclaves emptied, as Asian America moved into the middle class.

1995 Census Bureau reports that Asian Pacifics increased from 7.3 million in 1990 to 8.8 million; are now 3 percent of all Americans nationwide, and, in the West, 8 percent of all Americans. 60 percent of Asian Americans live in the West. 41 percent hold a B.A., while 24 percent of non-Latino whites do so.

1996 The August 1 U.S. Census Bureau report says that the number of Asian Pacifics has grown 17 percent since 1987. The Old Country economic explosion is altering the Asian American experience. From 1980 to 1996 Asia's share of world economic output rose from 17 percent to 25 percent. From 1986 to 1996 annual economic growth in East Asia (excluding Japan) averaged 8.5 percent, "four times the rate in the West," Forbes Magazine reported.

1997 British lease expires on Hong Kong, and it is returned to the People's Republic of China, an event many predicted would cause a massive flight to the United States. But the PRC, although still a dictatorship, has become so business-oriented, few leave.

1998 From the 1882 Chinese Exclusion Act to the 1982 Vincent Chin affair, Asian Americans historically have been attacked disproportionately during recessions in the American economy. In the 1980s they were thought to be involved, somehow, in Japan's success at America's expense. It is a signifi-

cant predictor that the Japanese and Asian economies stumbled while the American economy, in 1998, continued its record-setting prosperity, with the Dow near 9000 and unemployment at 4.6 percent, the lowest rate since 1973 (for married men who live with a spouse, 2.3 percent).

The Future: U.S. Census Bureau Predictions about Asian Pacific Americans

The U.S. Census Bureau reports that 41 percent of Asian Pacific immigrants have attended college, and since 1987 the number of businesses they own has jumped 56 percent, from 386,000 to 603,000. The University of Hawaii's East-West Center reports three quarters of all Koreans planning to immigrate say they plan on starting a business here. These statistics give us an insight into the future of Asian Pacific America.

While on March 1, 1997 the Asian Pacific population totalled 10 million for the first time (3.7 percent of the total population) that population is expected to be 11 million in the year 2000 (4.1 percent of total U.S. population) and 34 million by 2100 (9 percent)—a year many of the youngest children now alive can expect to see. From 2018 through 2050 more Asians and Pacific Islanders than non-Hispanic whites will be added to the population, totalling, by 2100, 34 million (9 percent of the total population.)

A Caution about U.S. Census Statistics:

Unlike this book, and contrary to popular usage, all U.S. Census Bureau statistics define, and count, Asian Indians as "Asian." While there is no simple way to adjust the numbers, Asian Indians may be supposed to comprise roughly ten percent of Census Bureau totals.

Future Research: Statistical Updates on the Internet

The U.S. Census Bureau constantly updates. Start with the brief, simple "Facts For Asian and Pacific Islander American Heritage Month" at
http://www.census.gov/Press-Release/fs97-04.html
That page has dozens of useful links. Also helpful:
http://www.census.gov/apsd/www/wepeople.html
http://www.census.gov/Press-Release/cb96-36.html
http://www.census.gov/population/www/socdemo/race/api.html
http://www.census.gov/www/estimates/nation3.html
http://www.census.gov/population/socdemo/language/table5.txt
For extra help, contact the U.S. Census Bureau's Public Information Office at 301-457-3030; fax 301-457-3670; email pio@census.gov.

Advanced Research: For Graduate Students and Instructors

This volume, intended for the people teaching and taking the new multicultural courses (see Preface and Introduction) should make it far easier for the reader to access the myriad of excellent works and anthologies already done for Asian Pacific American studies. Many are listed in the "Further Reading" sections following our articles, but the literature is now so vast, and growing so rapidly, that even a partial bibliography is outside the scope of this book. The advanced researcher might start, however, with these general works, listed chronologically within each category:

Asian Pacific American Literature:

Jeffery Paul Chan, Frank Chin, Lawson Fusao Inada, and Shawn Wong. *The Big Aiiieeeee: An Anthology of Chinese American and Japanese American Literature.* New York: Meridian, 1991. Updated, enlarged version of the canon-making anthology. An invaluable collection, and historically important. For an evaluation, see Chapter 39.

Cheung, King-Kok and Stan Yogi. *Asian American Literature: An Annotated Bibliography.* New York: MLA, 1988. An excellent work which takes the story to the mid-1980s. See Cheung's 1997 work below.

Cheung, King-Kok, ed. *An Interethnic Companion to Asian American Literature,* New York: Cambridge University Press, 1997. Essential scholarly theorization of Asian American literature in the light of contemporary critical methodologies. Anyone doing graduate work in American literature, as well, shouldn't be without it. Often offers an opposing stance to what one critic in it calls "the *Aiiieeeee* group," (S.L. Wong, p. 48), that is, the critics associated with the *Aiiieeeee* anthology cited above.

Shirley Geok-lin Lim and Amy Ling, eds. *Reading the Literatures of Asian America.* Philadelphia: Temple University Press, 1992. Advanced critical discussions of many of the topics in this volume.

Gail M. Nomura, Russell Endo, Stephen H. Sumida, Russell C. Leong. *Frontiers of Asian American Studies: Writing, Research and Commentary.* Pullman, Washington: Washington State University Press, 1989. Important theoretical discussions of ethnic studies as a discipline from the Association for Asian American Studies. Pages 317–338 are an invaluable bibliography of bibliographies (1968–88) on all facets of Asian American life.

Asian Literature, Religion, Arts:

William Theodore de Bary, *East Asian Civilizations: A Dialogue in Five Stages.* Cambridge: Harvard University Press, 1988. Invited to give the Edwin O. Reischauer Lectures at Harvard, the field's ranking scholar—after 40 years of teaching undergraduates—summarized the key lessons of 3000 years of East Asian civilization in only 138 gracefully written pages.

William Theodore de Bary and Irene Bloom, eds. *Eastern Canons: Approaches to the Asian Classics.* New York: Columbia University Press, 1990. More fruit from Columbia's Asian Humanities core course. Short, readable introductions to the most taught classics written in each case by a leading, and perhaps the highest, authority on the work.

William Theodore de Bary and Ainslee Embree, *A Guide to Oriental Classics.* 3rd Edition, ed. by Amy Vladek Heinrich. New York: Columbia University Press, 1989. Essential, definitive, clearly organized and easy to use. The fruit of 40 years of teaching the Columbia Asian Humanities course. The classics of the East Asian tradition, plus those of India and the Islamic World, receive 2–3 page annotated bibliographies, evaluating editions, translations, secondary readings and suggesting 6 or 7 topics for college classroom discussion.

William Theodore de Bary, et al., eds. *Sources of Chinese Tradition.* New York: Columbia University Press, revised, 1998. Completely revised edition of the standard work used in the Asian Civilizations course, parallel to the Asian course. Selections, often quite brief, from a great many important cultural texts, all linked together in a running chain of prefaces and explicatory matter. Integrates smoothly with the interpretative books cited above.

William Theodore de Bary, et. al., eds. *Sources of Japanese Tradition.* New York: Columbia University Press, revised, 1999. Completely revised edition of the standard work used in the Asian Civilization course. See description of *Chinese Tradition.*

William Theodore de Bary, et. al., eds. *Sources of Korean Tradition.* New York: Columbia University Press, revised, 1997. The standard work used in the Asian Civilization course. See description of *Chinese Tradition.*

A Cultural Lexicon
for Asian Pacific Studies

Amy Feldman, Daniel Gonzales, and Geoffrey Nathan

This lexicon contains definitions of those Asian terms that can be regarded as central to or exemplary of the Asian American experience. These key words and phrases occur, often repeatedly, in the main body of this volume where their first appearance in each chapter is marked by **boldface type**. Please note: our contributors may have given their own scholarly definitions of these terms in their individual essays. Definitions vary among scholars! This lexicon will be a convenient central resource, and no more than that. When appropriate the reader is referred to an article in which the meaning of a given term is more fully explored.

ABC "American Born Chinese"—slang term, widely used. See *Nisei*.

Alien Land Acts California's 1913 Alien Land Law, the first of many passed in western states, made it illegal for "aliens ineligible for citizenship" to own land. Since all "Orientals" were ineligible, the law, although it did not mention them, was aimed at them. Asian Americans sometimes evaded the law by putting land in the name of their children who, since American born, were citizens.

Amae Japanese. An ideal of perfect social harmony in which all relate to each other as benevolently as parents and loving children—a harmony that assumes the loving acceptance of hierarchy, not equality. Sociologists Kitano and Kikumura consider this a core Japanese American value.

Bachelor society Most often used to describe the situation that evolved after the Chinese Exclusion Act of 1882 made it impossible for men to send for their wives to join them. At that time there were 2,107 men for every 100

Chinese women in this country. In addition, laws against "miscegenation" prohibited marriage between Asians and whites (California's wasn't invalidated until 1948). Bachelor societies came into being, to a lesser degree, for other Asian American groups after their immigration was curtailed, later.

Balikbayan Tagalog. Literally, "return traveler." A Filipino term now used by many Asian Pacifics for the important cultural custom in which the American immigrant makes a triumphant homecoming and performs, as an obligation, a large-scale dispensing of gifts to friends and relatives, no matter how humble the immigrant's economic circumstances in America.

Bango Japanese. Japanese workers on Hawaii's sugar plantations were required to wear at all times a small metal tag with a number stamped on it. Workers were never referred to by their names, only their numbers, when receiving pay or doing business at the sugar plantation stores. The "bango system" has become a general expression for dehumanization.

Barrio Tagalog. Village. Does not have the pejorative sense of a ghetto that barrio carries in American-Latino use.

B.C.E./C.E. Abbreviations meaning Before Common Era and Common Era. In the early Middle Ages, a Christian monk, Bede, popularized a system of dating world events from the birth of Christ onward. All events coming after his birth are thus termed in "the year of our lord" or, in Latin, *anno Domini* (that is, A.D.). Hence, the division of B.C. (before Christ) and A.D. was born. Its success lies in its almost universal usage today.

For the Jewish or Asian scholar, however, its use implies tacit consent to the system and the dominance of Christianity. But to use the Jewish calendaric system or the Asian lunar calendar would create confusion among the general readership, and probably among most Jewish and Asian Americans as well.

The origins of B.C.E./C.E. as an alternative means of dating in scholarship are unclear. It seems to have had its beginnings among Marxist writers in eastern Europe (the German abbreviation u.Z. *[unser Zeit]* means simply "our time"), but it was quickly seized upon almost universally by Jewish scholars. The abbreviations B.C.E./C.E. seems to have been first used in the 1960s.

Its success, however, has extended far beyond Jewish studies. Scholars of early Christianity have universally adopted B.C.E./C.E. as more religiously neutral in nature. The system appears, too, to have spread to diverse fields of study, including study of the classical Asian past and may well become predominant in scholarship in future years.

Big Five Hawaii's economy was dominated by five large firms controlled by the descendants of missionaries, the firms sewn together even more tightly in the tiny social world of the islands by intermarriage among the haole elite. The Big Five not only represented thirty-six sugar plantations, but so much of the islands' industry, that they had in effect a monopoly.

Buddhahead Mainland Japanese American slang for Japanese from Hawaii. The term dates back to World War II when Hawaiian and mainland Nisei were thrown together in the 442nd Regimental Combat Team. It may be a pun on the Japanese for pig, "buta." Supposedly dated, certainly politically incorrect, but still appears in literature and even on T-shirts. *See* Kotonk.

Chanoyu Japanese. The Zen ritual "tea ceremony," still popular among Nisei.

Chi Chinese. *See* Qi.

Confucianism *See* Kong fu tse.

Coolie Chinese, "Ku Li," "bitter labor." The lowest layer of the labor force, the coolies were Chinese peasants bound under contract to provide service for a specified period—five years under the British system, eight in Cuba and Peru. The mid-1800s "coolie trade" in Chinese peasant labor worldwide was a direct response to the end of the African slave trade. Cuba and Peru, for instance, brought the coolies over in ex-slave ships, housed them in old slave quarters, and worked them in the same fields. *See* Diaspora, and *see* Chapter 28, "The Chinese Diaspora."

Coram Nobis "Error before us." A legal plea for an earlier decision to be overturned because of error. In January 1983, petitions were filed for a writ of error, *coram nobis,* to reopen three early cases protesting the Japanese American concentration camps: the Korematsu, Hirabayashi, and Yasui cases. The resulting decisions against the United States government, for withholding important evidence, paved the way for Redress.

Cultural Relativism Having learned of one's ethnocentricity, newcomers to ethnic studies can go to the other extreme, cultural relativism, an impractical position defended only by academics with no interest in practice. Having overcome judging cultures exclusively by one's own, one becomes afraid to make any decisions about culture at all. Discovering that all cultures have varying standards, one overlooks that no culture has ever survived without some standards. *See* Ethnocentricity.

Death Anniversary A common celebration in the Philippines on which people gather around altars decorated in memory of a person who has died on that specific date. *See* Chapter 11, "First-Generation Memories: One Filipina's Story."

Diaspora From the Greek *diaspora,* meaning dispersion or scattering. The term is now widely used in ethnic studies for the dispersion of peoples. Originally, the word refers to several general migrations of Jews in Asia and Europe. Their origins lay in the ancient world, but Christian hostility toward Jews in the Middle Ages renewed forced departures from all over western Europe.

 The Diaspora had its beginnings in the destruction of the nations of Israel and Judea (in 722 and 597 B.C.E. respectively). The conquest of Israel by the Assyrian Empire led to forced deportation of Israelites to Syria, Armenia, and Iran. The destruction of Judea some 130 years later by the Chaldeans led to a similar movement of Jews to Babylonia (hence, the phrase "Babylonian captivity"). Much of the prophetic writings in the Old Testament were composed during this period and directly addressed these events.

 Widespread migration was unintentionally encouraged also by the conquests of Alexander the Great, since increased contact between East and West facilitated the travel of Jews in both directions. Nevertheless, the Diaspora seemed to have been more or less complete by the time of the early Roman Empire.

Dim Sum Chinese. Little tea cakes and snacks. Haute cuisine, a high art.

Durian Fruit popular throughout South East Asia with a highly pungent smell when opened, notoriously distasteful to Westerners. An "insider food" that reinforces the sense of ethnic identity. *See* Chapter 15, "Food and Ethnic Identity: Theory," Chapter 21, "South East Asian Food: The Durian and Beyond."

Eight Trigrams, The A Chinese method for communicating with spirits, prima-
rily by interpreting random stick tosses. "The Eight Trigrams of the I Ching,"
the Chou Dynasty "Book of Changes" (ca. 1100 B.C.), one of the most an-
cient sets of such analytic terms, consist of eight sets of three parallel hori-
zontal lines.

Enryo Japanese. An ideal of behavior that carries the idea of politeness and
modesty to the point of self-effacement. A central cultural value, sociolo-
gists like Harry Kitano report, even among Sansei.

Ethnic Enclave Term popularized during recent years. Militant 1960s rhetoric
styled all ethnic neighborhoods as ghettos and undoubtedly many had been.
"Ethnic enclave," however, underscores the positive communal values of
ethnic neighborhoods.

Ethnocentricity Judging all cultures exclusively by the standards of one's own
culture. *Compare with* "Cultural Relativism."

Evacuation *See* Executive Order 9066.

Executive Order 9066 After Pearl Harbor, under pressure from Californians
in Congress, President Roosevelt issued Executive Order 9066 requiring
all mainland Japanese Americans to be "relocated" or "evacuated" to "in-
ternment camps" (also called "concentration camps"). *See* Chapter 7, "Japa-
nese American Life in the Twentieth Century: A Personal Journey."

Face, Lose In Mandarin, *diu lian*. In Japanese, someone who "knows shame," *haji*.
A central Asian American cultural value. The standard translation, "lose
face," could be replaced by the more idiomatic "lose one's dignity." Asian
American culture still shows far more concern over public loss of dignity
than over loss of money or even loss of life.

Fengshui Xiansheng Chinese. Master geomancer. Mary Scott writes, "Most of
a fengshui xiansheng's practice is to devise alterations that will make the
best of physical environments that are less than ideal, or to help someone
to avoid a truly disastrous physical setting." *See* Chapter 23, "Fengshui,
Chinese Medicine, and Correlative Thinking."

Fengshui Chinese. Literally, it means "wind and water," but it is a term used for geomancy: the art of properly placing oneself within one's environment. It is based on an ancient Chinese understanding of the universe as a continuous flow of qi [or ch'i], vital energy or cosmic breath. Fengshui can redirect qi on a personal and environmental level. Like acupuncture, fengshui is almost universally respected in the Asian American community. In California, realtors consider it, architects try to build it in, and the white "New Age" enthusiasts study it. *See* Chapter 23, "Fengshui, Chinese Medicine, and Correlative Thinking."

Filial Piety Frequently used, this awkward Western phrase tries to capture the deep sense of duty to, first of all, one's parents, and after that, to all one's family—nuclear and extended—that characterizes the Confucian family system. The spirit of "loving teamwork" which is the cardinal Confucian virtue ("ren") reaches its full height in the family. *See* "Ren," Chapter 5, "Confucius and the Asian American Family."

Five Tastes, The This refers to the traditional five tastes of Chinese cooking (sweet, sour, bitter, pungent, and salty). They are derived from an ancient theory explaining the cosmos in terms of a perpetual interaction among the five elements—earth, fire, water, wood, and metal." *See* Chapter 16, "Chinese Food." The other chapters on Asian food mention variations.

FOB Originally, a humorous acronym for Fresh Off Boat. Now pronounced as one word, "fob" (rhymes with job), the word suggests, in current slang, tough foreign-born kids, even possibly youth gang members. Much recent use in literature.

Fortune Cookie Marvin Nathan reports that the fortune cookie, far from being Chinese, was invented in 1909 by the Japanese American proprietor of the Japanese tea house in Golden Gate Park, San Francisco. *See* Chapter 16, "Chinese Food."

"442nd" The 442nd Regimental Combat Team and the 100th Battalion in Europe, fabled for heroic exploits, was entirely composed of second-generation (Nisei) Japanese Americans who volunteered while in internment camps, eager to show that the slurs on their patriotism were a lie. *See* Chapter 8, "The Nisei Go to War: The Japanese American 442nd Regimental Combat Team."

Gaman Japanese. "Hang in there!" "You can take it!" Reflects a core Japanese value, endurance. *See* Shikataganai.

Ginseng (ren shen) Chinese. A medicinal plant commonly found in a Chinese apothecary, it has a caffeine-like effect. The "New Age" marketers have started adding it to snacks as varied as sodas and brownies.

Giri Japanese. K. Morgan Yamanaka writes, "Giri is your duty to fulfill your social obligation, the on. Until you have performed your duty, giri, you are 'wearing the On.'" See Chapter 7, "Japanese American Life in the Twentieth Century: A Personal Journey."

Gohan Japanese. Rice, the staple food of Japan, which, along with sake, plays an important role in Japanese ritual practice.

Gold Mountain Cantonese, *Gum Saan.* Cantonese nickname for America. Fitting, since their original destination was San Francisco during the Gold Rush. *Meiguo,* the more formal term for America, means "the beautiful land." Nearly all Chinese terms for America are overwhelmingly positive.

Guai Mandarin. Frequently translated as "cute," it is a more complex term suggesting one who perfectly fits into and knows one's place.

Guangdonghua Literally "language of the Guangdong area." Guangdong was romanized as Canton in English. The Cantonese "dialect" of Chinese. Actually, Chinese is a family of languages, like the Romance languages, and Cantonese is the most widespread of the six or seven Chinese languages spoken in southern China. Until the 1970s, 95 percent of U.S. Chinese came from the six counties surrounding Canton (Guangdong), and America's idea of all things Chinese was disproportionately Cantonese.

Gumdang Korean. Black; African American.

Hakujin Japanese. Literally, "white person." Pejorative in Japan, milder or merely descriptive in Japanese American use.

Han Chinese. A name the Chinese use to refer to themselves as a people. It means more literally, "those of the Han ethnicity," China's largest, nearly 95 percent of the population. Historically, the name of a great dynasty (206

B.C.–220 A.D.), roughly contemporary with Rome in the West. *See* Chapter 1, "Reading Asian Characters in English."

Hangul Korean. The Korean alphabet. In 1443 the Korean academy, encouraged by Korea's greatest king, King Sejong, created a 28-letter alphabet. Koreans revere their unique writing system as a national symbol.

Hanyu Pinyin *See* Pinyin.

Han Zi Chinese characters. *See also* Kanji.

Haole Hawaiian pidgin. All caucasians other than Portuguese, particularly those from the mainland United States. Mildly pejorative.

Happa, Hapa Hawaiian pidgin, from the term Hapa-haole ("half white"). A neutral term, not pejorative. Now in widespread Asian Pacific use for the children of any intermarriage with another group.

HSPA Hawaiian Sugar Planters Association. This was an organization of Hawaiian plantation owners that represents the interests of the sugar plantations organized by the Big Five. The association regulated wages, encouraged long-term contracts, and made it very difficult for workers from Japan, China, and the Philippines to earn enough money to leave the plantations by installing a debit system (each worker received a *bango* number, along with a coin inscribed with the number that was to be used at the company store and that drew on that worker's wages). It allowed owners to act as a forceful unit against labor strikes.

Ilokano, Ilocano A person from the Ilocos region of northwestern Luzon island (Philippines). It is also the name for the language from that region.

Issei Japanese. Literally, "first generation." The generation that immigrates to the United States. Ethnic studies scholars often use the Japanese generational terms colloquially, discussing any group, because the terms are precise. To say "first generation" alone, could mean first generation that comes here, or is born here. *See* Chapter 7, "Japanese American Life in the Twentieth Century: A Personal Journey."

JACL Japanese American Citizens League. An organization formed in the 1930s by American-born Japanese to challenge the first-generation-controlled Kenjinkai (*see* Kenjinkai) who had kept their faces turned back to Japan. In the concentration camps, power shifted to the JACL, led by "Mike" Masaoka and his brothers. The JACL believed that the best way to prove their loyalty was by outdoing all other Americans in patriotism and war heroism. Many fought in the much decorated 442nd Regimental Combat Team and the 100th Infantry Battalion. After the war, the JACL became the semi-official spokespersons for the Japanese American community in the United States. Their magnificent Los Angeles headquarters, which includes theaters, a garden, and cultural showcases, is a landmark.

Jeepney Tagalog. Salve Millard writes, "The jeepney is a jitney bus that was invented after World War II when the Filipinos took the jeeps that the Americans left behind and converted them into something new." *See* Chapter 11, "First-Generation Memories: One Filipina's Story."

Jiaozi Chinese. New Year's dumplings that signify prosperity both because they are filled with meat and because they are shaped like gold and silver ingots. *See* Chapter 16, "Chinese Food."

Jesus Maria Josep Tagalog and other Filipino dialects. A phrase of exclamation, literally translated as "Jesus Mary Joseph." Said when someone sneezes, as a way of saying, "God bless you." Dan Gonzales says, "Nobody says Jesus. Everybody says either 'Sus Mari Osep,' or 'Usep.' The closest they ever come to Jesus' real name is 'Aysus.' It is a little beyond darn, but not as bad as damn. It is a mild blasphemy, definitely not vulgar. Everybody says it, but usually older people and parents, because if a child says it, he will get whacked."

Kababayan Tagalog. One's countrymen or people from one's home district.

Kaiseki ryori Japanese. The meal that accompanies *chanoyu,* the Zen ritual of tea. *See* Chapter 17, "Japanese Food."

Kanji Japanese. Kanji is the Japanese word for the many Chinese characters they incorporate in their writing system. It is a translation of the Chinese *Han Zi,* "Chinese characters." *See* Chapter 1, "Reading Asian Characters in English."

Kano Tagalog. Short for Americano. Millard writes, "In the Philippines, this means a white person, whether he is from the United States or not—even if he doesn't speak a word of English." *Compare with* Haole, Hakujin.

Kasama Tagalog. Constant companion, best friend, buddy, wife.

Kenjinkai Japanese. K. Morgan Yamanaka writes, "Organizations grew up, the kenjinkai, where each province's *kenjin* [countrymen] could get together. They spoke the same dialect, socialized, circulated newsletters, chipped in to loan each other money to start businesses. And, very important, money to help poor people stay off public assistance, so your *kenjin* wouldn't lose face."

Kibei Japanese. Before the war, a small percentage of Japanese American children, though citizens born in the United States, were sent back to Japan for a few years of education.

Kimchee Korean. Pickled cabbage or cucumber, an "insider food."

Kitchen God Many Chinese families all over the world still keep a printed image of the Kitchen God on the wall near the stove. In some parts of China, this image shows only the Kitchen God himself, while in others he and his wife both appear as an expression of the ideal of marriage and domesticity. Molly Isham adds that just before Chinese New Year, food offerings are laid out for the Kitchen God (Zao Wangye) and his wife (Zao Wangnainai). A "male representative would be chosen to *ketou,* 'kowtow,' to the paintings of these celestial beings who had blessed and protected the family for almost a year." The two gods "ascend to heaven," as the paintings are ceremoniously burned. (The children then happily eat the offerings.) New pictures are purchased and hung to protect the kitchen during the new year. *See* Chapter 16, "Chinese Food."

Kong fu tse Chinese philosopher (551–479 B.C.) whose name the Jesuit missionaries latinized as Confucius. (In the newer pinyin spelling, Kongfuzi.) Much the way the statue of Abraham Lincoln is revered in Washington's Lincoln Memorial, so the figure of Confucius is revered in so-called "temples" throughout East Asia. Confucius, like Lincoln, is neither God nor prophet, but someone whose collected sayings (the *Analects*) not only inspire, but seem

to exemplify the national character at its finest. In Chinese, "Kong fu tse" means "Master Kong." (Note: the "tse" on the end is the same word/character that for some reason scholars have spelled "tzu" or "tsu" when writing of the Taoist sage, Lao Tzu.) Confucianism—or Confucian values, to be more exact—coexist peacefully in China, by now blended with Buddhism, Taoism and respect for the vast number of folk gods (like the Kitchen God and the Moon Lady) who have found homes in the Taoist temples. *See* Ren, Tao. *See* Chapter 5, "Confucius and the Asian American Family."

Kotonk Hawaiian Japanese American slang, slightly pejorative, for mainland Japanese Americans. Dates to World War II when mainlanders and Hawaiian Japanese Americans were thrown together in the 442nd. Brian Niija writes that kotonk was "allegedly the sound mainlanders made when knocked on their heads." *See* Buddhahead.

Kuya Tagalog. A still much-used title of respect for an older brother ("Kuya Bill," "Kuya Tom," etc.), which can also be used for male friends who are older than you. Older sister is Ate ("Ate Mary"). *See* Chapter 11, "First-Generation Memories: One Filipina's Story."

Lechon Tagalog. A whole baby roast pig, which is the centerpiece of many big Filipino feasts and celebrations. *See* Chapter 11, "First-Generation Memories: One Filipina's Story."

Liberatory Education Influential pedagogical theory that the classroom should be a place where one is freed from old social roles during the process of learning. The term is associated with Paolo Freire, but the methods are as old as John Dewey, who wrote, "learn by doing." For Asian Pacific studies, this means creating a classroom in which Asian Pacifics and women are encouraged to break out of the "culture of silence," encouraged to break out of the stereotypes of submissiveness and passivity—to speak out, to take leadership roles.

Little Red Book During the Cultural Revolution these miniature, red-jacketed collections of Chairman Mao's thoughts became the bible of the Red Guards, who carried them everywhere and—a scene frequently depicted in paintings of the time—waved them frantically at Mao to show obedience during enormous, hysterical mass rallies. *See* Red Guards.

Lola Tagalog. Grandmother, or a term of respect for an elderly woman.

Lolo Tagalog. Grandfather, or a term of respect for an elderly man.

Lumpia Tagalog. A highly popular dish in Filipino cuisine. It is a pastry filled with vegetables and meat. *See* Chapter 11, "First-Generation Memories: One Filipina's Story."

Lunar New Year Celebrated throughout Asia in diverse forms. Commonly called Chinese New Year in the United States. Every 12 years in the Chinese calendar is a cycle, represented by an animal symbol: rat, ox, tiger, rabbit, dragon, serpent, horse, ram, monkey, rooster, dog, boar. The year 2000 A.D. will be the year of the dragon, 4698th year in the lunar calendar. On New Year's Eve there is the all-important family reunion dinner. Family members call home from all over the world.

Manang Tagalog. It means "Mrs." but is also used as a title of respect for an older person. One can also say, "the manangs," to mean older ladies.

Manong Tagalog. It means "Mr." but is also used as a title of respect for an older person. One can also say "the manongs," to mean older people.

Maria Clara Fictional character, she now symbolizes the ideal Pilipina woman with characteristics of beauty, femininity and virtue. Jose Rizal, novelist and patriot, gave the name Maria Clara to all Pilipina women. She became so popular and idolized that the national doll is in her image and the traditional woman's fancy dress is named after her.

Mestizo Tagalog. A Filipino with partial Spanish ancestry. *Compare with* "happa." *See* Chapter 11, "First-Generation Memories: One Filipina's Story."

Mochi Japanese. Sticky cakes of pounded rice that are an important ceremonial food always eaten on New Year's Day.

Mooncakes Chinese. Round pastries with a variety of sweet and savory fillings, imprinted with a picture of the Moon Lady. They are eaten on Zhong qiu jie, the festival of the mid-autumn moon. *See* Moon Lady, Chapter 16, "Chinese Food"; Chapter 24, "Lunar New Year, The Moon Lady, and the Moon Festival."

Moon Lady Chinese. Chang E, a lady who runs away to the moon, is the star of a folk story, and the light-hearted harvest Moon Festival, one of the most popular in China. Since the festival falls each year after back-to-school but before Halloween, in a long slack time with no children's holidays, children all over the West Coast now celebrate it. Children hear a charming story (Amy Tan has a version out), get to eat sweets stamped with pictures, and try to see the Moon Lady or a Rabbit wizard on the face of the moon. *See* Mooncakes. *See* Chapter 24, "Lunar New Year, The Moon Lady, and the Moon Festival."

Mount Thai Son Vietnamese. The highest mountain in Vietnam, a familiar symbol in the literature, somewhat the way Mt. Fuji is in Japan.

Mu Lan Chinese. Legendary "woman warrior," heroine of a folk ballad in which a brave girl takes her aged father's place in the army by disguising herself as a man. (*See* chapter 43 for Maxine Hong Kingston's use in *The Woman Warrior.*) Mulan's story was little known in the West until 1998, when Michael Eisner, the benevolent despot who had dominated the Walt Disney company for over fifteen years, once again put Disney's awesome cultural might behind multiculturalism with the feature-length animated film, *Mulan.* Eisner and Disney had promoted a string of non-European heroines (*Aladdin*'s Jasmine, *Pocahontas,* and *Hunchback*'s Esmeralda the Gypsy) taking industry cynics' flack for watching more than the bottom line. For *Mulan,* producer Pam Coats was allowed to discard an earlier romantic script, and present a heroine who is not only Asian but is an unglamorous warrior who needs no prince to save her. "A cross-dressing heroine. Kick-butt Girl Power. . . . Nothing short of a watershed," Dennis Akizuki marvelled in the *San Jose Mercury News* (June 19, 1998). It is sad to note that Maxine Hong Kingston's celebrated novel, which introduced Mulan to the intellectual world, was almost overlooked in media accounts like *Newsweek*'s rave review of the movie. But Kingston has been the teacher of the teachers as J.S. Mill once phrased it. It is far more likely that the writers had encountered Kingston's book in college, than read the very obscure poem.

 Disney gave Mulan her full American culture apotheosis, with songs written in her praise by Stevie Wonder, and Eddie Murphy doing the voice of her comic dragon sidekick, "Mushu." The movie opened to "Mulan Happy Meals" at McDonald's, Michelle Kwan ice-skating in a Mulan television special, and three pages of Mulan stuffed toys and pajamas in the Disney catalog. Critics were enraptured. "I will see it as many times as I

can," said Jeff Yang, the Chinese American founder and publisher of the New York-based *A. Magazine*. "This is the first movie which I feel deeply moved me as an Asian American." Daphne Kwok, executive director of the Organization of Chinese Americans, added that Chinese American women would relate to the strong independent-minded heroine who upholds the family honor. "Mulan shows real warmth and love, among members of Mulan's family—a sharp contrast to the ususal images of stoic, even cold, Chinese parents. . . ." Television producer Darren Chew pointed out that the "Chinese men are also strong and heroic. . . . Hollywood usually depicts them as gangsters, servants, and computer geeks" (Akizuki, *op. cit.*). In *Rafu Shimpo* (June 25, 1998) [newspaper], the Media Action for Asian Americans' Guy Aoki reported Asian American men "crying uncontrollably at the end." All these virtues make the film a natural for showing in the lower grades, to prompt discussions of China, Confucian family loyalty, and women's roles.

Until this apotheosis, Mulan's ballad, *Mu Lan's Farewell,* was so little studied, even by Asianists, that we have done a new translation (below) for the scholar's convenience. (From here, we adopt the conventional romanization of her name, Mu Lan.)

Amy Ling, who researched Mu Lan for her work on Kingston recounted the story. "Mu Lan (variously known as Fa Muk Lan or Hua Mu Lan [Hua/ Fa means "flower"; Mu Lan "magnolia"]) is the heroine of a folk ballad that mothers traditionally sang to their children in China. When the emperor goes to war against northern invaders, the Hu, he drafts a son from each family. Mu Lan's family has no son old enough to fight, so her elderly father gets drafted. Mu Lan disguises herself as a man and takes his place.

"The new army takes the attack to the Hu, high up in their snowy Yen Mountain strongholds. Mu Lan fights for over a decade—unlike the movie, *without* being discovered—and [fights] so valiantly, that the emperor himself, bestowing medals, titles, and land grants after the war, offers to make her a Minister of State. She asks only to go home. There, she reopens the wing of her house that has been sealed for ten years, puts on her woman's dress again, and emerges, to the amazement of her old comrades-at-arms.

"Westerners perhaps too automatically compare Hua Mu Lan to Joan of Arc—although in the deepest sense, her actions are as pious as Joan's. But Mu Lan's religion is Confucianism.

She doesn't hear the voice of God, but [listens to] her con-
science, commanding this loving duty to her father. [It is also
not] possible to imagine the ballad's Mu Lan, so eager to regain
her womanhood and already the model of family duty, not pro-
ceeding to marriage and motherhood. Indeed, the poem dwells
on her rather amazing ability to effortlessly return to feminin-
ity, fashionable 'beauty patches' and all. Joan of Arc revels in the
battlefield, and it is impossible to imagine her wishing to return
to village life; Mu Lan, offered a government Ministry, asks only
for a camel to take her home. Modern accounts, even Disney's,
tend to present Mu Lan's army service as a feminist achieve-
ment. In the Chinese ballad, war seems, realistically, a catastro-
phe for everyone, men and women, soldiers and generals alike.
Mu Lan's long years in the army are presented only as a terrible
sacrifice to spare her father from going through them, and she
resumes her peaceful former life with relief.

"A few historical reports exist of women disguising them-
selves as men, in order to fight. Women, however, were not com-
monly trained in martial arts—or educated for any profession, in
fact. There are stories of women disguising themselves as men in
order to be educated (for instance, 'The Butterfly Lovers'). The
poem is potent myth, not history."

The following translation by George and Simei Leonard was based
on the Chinese text *Selected Chinese Poems,* ed. Ch'en Hui-Wen (Taibei,
Hua-Lien Publishing, 1968) which professor Ling furnished. This is the
best known of the many versions of the Mu Lan story, a story dating
back at least to the Tang Dynasty (618–907 A.D.). Even in anti-Confu-
cian Maoist times, PRC children like translator Simei Leonard had to
learn it by heart from their fifth grade readers, and recite it in class
together.

How old is "Mu Lan's Farewell"? The poem refers to the emperor sit-
ting in the "Ming tang," or "Ming Hall" but the term, our sources tell
us, is no reference to the Ming Dynasty (1368–1644 A.D.). The word
"Ming"means "brilliant" or even "splendid" and the term "Ming tang"
means a hall of splendor in which imperial rituals were conducted. The
term can be found all the way back to the Zhou Dynasty (founded, 1111
B.C.).

The Hu invasion is also not a clue to the poem's age. The Hu are described as a tribe of northern horsemen. The Great Wall, stretching across the tops of China's mountains from East to West, was built as a bulwark against such northern tribes in the 200's B.C. The Disney movie calls the Hu people the "Huns," but without foundation. Rather, "Hu people" is a catch-all term much as the Greek term "barbarian." China called any menacing northern barbarian tribes the "Hu" and each dynasty since the Han (206 BC–265 A.D.) used "Hu" for its current northern barbarian opponent.

Our best clue to the age of this poem is the designation of the emperor as the "Khan." While this version refers to the emperor as "the Son of Heaven," a standard designation, it also calls him, twice, the "Khan." Since no one but the Mongols of the Yuan Dynasty (c. 1206–1368 A.D.) would have used that term for an emperor, this version could not be older than 1206 A.D. and was most likely written in those years; or less likely, set in those years. *Mu Lan's Farewell,* then, is probably a folk ballad from the 1200–1300s A.D., nearly 800 years old.

Our translation, while faithful to sense, and even usually to word order, can only suggest the folk ballad quality of the original. Language of homely simplicity—far too concise for English to capture—alternates with flights of Homeric fancy. In the poem, you don't have an "audience" with the Emperor, you simply "meet" him as you would anyone; but a camel who could last out a long trip draws the fanciful epithet "thousand-mile-footed." The original poem is unrhymed, but strongly rhythmic. "Folk poetry" does *not* mean "amateur poetry." Notice the poet's sophisticated parallel constructions, in which Line B not only repeats the pattern of Line A but contrasts it. The cries of Mu Lan's parents are replaced by the terrifying sound of the enemy's horses. The poet (in that society, almost certainly a man) moves the story quickly, with startling jump cuts, and an impressionistic appeal to many senses. He dares to start with a sound effect, then, as his first shot, positions you outside Mu Lan's door, watching her. As you dolly in, Mu Lan's sighs drown the noise of the loom. At poem's end, as Mu Lan returns in victory, you stand outside the door once again, watching her older sister put on "red makeup" (perhaps festive, not mere "rouge") in Mu Lan's honor. The poet sketches years of battle in the mountains with a few sharp details, uniting sound, sight, and touch—the feel of the cold mountain wind. He spends no time on patriotic fervor or moral out-

rage against the enemy, but accepts the war as a job to be done. People die; those who come back alive will be rewarded; what you want most is to get it over with, and pick up life where you left off.

The parable of the rabbits at the end draws the moral. Generally, it claims, you can tell a male rabbit from a female by its behavior. But in times of crisis, when they're running, you can't tell which is male and which is female. The female runs just as well as the male. Hua Mu Lan's popular ballad does not so much reflect historical reality as it does the reality of women's dreams and aspirations; not so much an aspiration to shed blood, but an aspiration to be recognized as people who, when need arises, can do deeds as valiant as can any man. That the author of this "modern sounding" moral was very likely a medieval man, and that this story has been popular among the Chinese people for a millennium, and continues to be memorized in schools, should be taken into account before anyone summarizes traditional Chinese culture's attitude toward women.

Mu Lan's Farewell

Clickity-clack.—Clickity Clack.
Through the open door, see Mu Lan weaving.
Not a sound can you hear of her loom
The only sounds you can hear are her sighs.

Ask the girl, "What's on your mind?"
Ask the girl, "What can't you forget?"
The girl says, "Nothing, nothing on my mind."
The girl says, "Nothing, nothing to forget."
Last night she saw the army scrolls
The Khan is calling up his men
From the army have come twelve separate scrolls
And every scroll has her father's name.

The father has no grownup son
Mu Lan has no older brother
She'll go to the market for horse and saddle
She'll take to the road in place of her father.

She goes to East Market to buy her a charger
She goes to West Market to buy her a saddle
She goes to South Market to buy bit and bridle
She goes to North Market to buy the long whip.

In the morning, farewell to Father and Mother
At night, she sleeps by the Yellow River
Hearing no longer the cries of her parents
Hearing the rushing of the Yellow River.

In the morning, farewell to the Yellow River
In the dark, to the Black River's source she comes
No sound of the parents
Crying for their daughter
Just the Yen Mountain Hu tribe's
Warhorses snorting. ["singing 'Cheu! Cheu!'"]

Ten thousand leagues she marches to the battles
Through the mountain strongholds the warriors fly
On the cold north air blows the sound of metal clashing,
Flashing cold light off the chain link mail.

Generals and soldiers die in a hundred battles
The heroes who live come back in ten years.

Those still alive will meet the Son of Heaven
In the Hall of Splendour, the Son of Heaven sits.
Awarded—the medals
To all the twelve ranks
Granted—a hundred thousand acres of land.

The Khan asks, "What is your desire?"
Mu Lan doesn't need to be a High Official
Wishes only to borrow a sharp-eyed camel—
Thousand-mile-footed!—
To send the son back to his home village.

When Father and Mother hear Daughter is coming

They help each other hobble outside the city wall
When Older Sister hears Younger Sister is coming
Through the door you can see her putting on red makeup
When Little Brother hears that Sister is coming
He whets his knife—"Snick!"—chases pig and lamb.

"I open the door to my eastern pavilion.
I sit on my bed in the western room.
I take off
My chain link armor.
I put on
My dress of old."

Through the window
you can see her let down the clouds of hair.
At her mirror
She stands, putting on her adornments ("beauty patches").
Out the door
she comes, to see her fighting comrades—
And all her fighting comrades are amazed.
For twelve years they marched together
And never knew Mu Lan was a girl.

A male rabbit restlessly thumps the ground
A female rabbit shyly looks away
But when they run, how can you tell me,
Which is the male, which is the female?

Negro Tagalog. A black American. Black Americans are not called Americanos.
 See Chapter 11, "First-Generation Memories: One Filipina's Story."

Nikkei Japanese. All Japanese Americans, together, all the generations: Issei,
 Nisei, Sansei, and Yonsei.

Nipa Hut Tagalog. A traditional Phillipines lightweight thatched house that is
 raised off the ground on four tall wooden poles. See Chapter 11, "First-
 Generation Memories: One Filipina's Story."

Nisei Japanese. "Second generation," that is, the first generation born in America. *See* Chapters 8 and 9. In Japanese America, these were the interned citizens who formed the JACL and the 442nd, people now in their seventies. Like ABC (American-Born Chinese) the term Nisei is widely used colloquially for any Asian Pacific group's "nisei." It is best to let certain people decide if they are Issei or Nisei, since those who arrived before puberty usually acquire perfect English language skills and may consider themselves Nisei. (Korean Americans sometimes use the term "one-point-five" for this last-mentioned group.) *See* Chapter 13.

No No Boy Japanese American. In 1943 the American government gave Japanese Americans interned in concentration camps a questionnaire titled, "War Relocation Authority Application for Leave Clearance." Question 27 read: "Are you willing to serve in the armed forces of the United States on combat duty, wherever ordered?" Question 28: "Will you swear unqualified allegiance to the United States and faithfully defend the United States from any and all attacks from foreign and domestic forces and forswear any form of allegiance or obedience to the Japanese emperor or any other foreign government, power or organization?" Approximately 95 percent of the Nisei, American citizens, replied yes, yes. Five percent replied "No, no." Morgan Yamanaka writes that he refused to "forswear" (recant, repudiate) allegiance to the emperor because "I was *never* loyal to the Emperor of Japan." Signing would imply he had been and thereby excuse the United States for putting him into the concentration camp. "So I became what was called a No No Boy." The No No Boys were segregated in a special prisonlike camp, Tule Lake. Once scorned by other Japanese Americans, the Sansei generation adopted during the 1960s a newly respectful attitude to those who had resisted.

On Japanese. *See* Giri.

"One-Point-Five" Generation The generation born in the old country but brought to America before puberty, which means perfect English skills.

Overseas Chinese So many Chinese have emigrated all over the world that the Chinese people consider them a cultural category unto themselves. In mainland hotels, for instance, three prices will be posted, one for the Chinese themselves, one for tourists, and a third for Overseas Chinese making their homecomings. *Compare* Balikbayan.

Pagin Korean. Caucasian.

Paper Son Originally used by Chinese, now in wide use by many immigrant groups to refer to people attempting to enter the United States (under family reunification provisions) by posing as family members of U.S. citizens. *See* Chapter 36.

Picture Bride Japanese American. Widely used by all Asian Pacific groups now for arranged marriages in which women from the Old Country come to marry an American immigrant on the strength of some letters and an exchange of pictures.

Pinay Tagalog. A female Filipino American—a female of Filipino blood whether or not she was born in the United States.

Pinoy Tagalog. A male Filipino American—a male of Filipino blood whether or not he was born in the United States.

Pinyin Mandarin. The spelling system used for Chinese words in much of this book is the official Hanyu Pinyin system used in the People's Republic of China since 1958. The pronunciation of the six symbols unfamiliar to Americans is explained as follows: *Q* like "ch" in "cheese"; *X* like "sh" in "sheep"; *Z* like "ds" in "beds"; *C* like "ts" in "cats"; *Zh* like "dg" in "edge"; *E* like the "e" in "the" before a consonant.

Pop Korean. Rice.

Putonghua Chinese. Mandarin. The language most spoken by the Chinese, its use centers in northern China. *See* Chapter 2.

Qi Chinese. In older romanizations, "ch'i." The Chinese understanding of the universe is that it is a continuous flow of qi, vital energy or cosmic breath. Everything is made of qi: human bodies, clouds and mountains, or wind and water. *See* Chapter 23, "Fengshui, Chinese Medicine, and Correlative Thinking."

Red Guards When Mao unleashed the Great Cultural Revolution of the 1960s, he encouraged groups of children as young as 12 to form armed militias,

theorizing that they were born after the 1949 Communist victory and unharmed by pre-Communist thought. These unsupervised gangs were then encouraged to take over their schools, imprison their teachers, and in general, torture confessions out of any adults they wished. See Chapter 27, "Maoism, and Surviving the Great Proletarian Cultural Revolution: My Personal Experiences from 1966 to 1976."

Redress A successful movement led by the Japanese American Citizens League (JACL) culminating in the 1987 to 1988 approval of a bill (H.R. 442) to recompense survivors of the internment camps. Signed (to many people's amazement) by President Ronald Reagan on August 10, 1988, the bill provides for twenty-thousand dollars and a formal apology to each survivor. Important legal challenges that paved the way for this historic repentance by the American government included the *Coram Nobis* cases. *See Coram Nobis.*

Ren Chinese. The central Confucian virtue. Ren (in older romanizations spelled "jen"), a homonym for the word "human," has been defined as "human-heartedness," "empathy," "deeply humane," "a real human being." It is written in Chinese by adding the graph for "human" or "man" to the graph for "two": people in society, people getting along with other people. Perhaps even "loving teamwork" fits under "ren." *See* Chapter 5, "Confucius and the Asian American Family."

Rickshaw From the Japanese word *Jinrikisha,* which means "a vehicle powered by human strength." It was invented in Japan in the 1860s, and it quickly spread to China, Korea, Southeast Asia, and India.

Romanization A method of spelling out the sounds of another language into our Western European alphabet, for instance, the Wade-Giles romanization of Chinese characters. *See* Chapter 1, "Reading Asian Characters in English."

Sabong Tagalog and other dialects. A cockfight. Salve Millard writes that it is a "big gambling sport in the Philippine Islands. The chickens are from Spain. Very aggressive. People tie blades on the chicken's feet. They fight until death. Money is bet on each rooster."

Sake Japanese. Rice alcohol, potent as vodka. Served hot.

Sansei Japanese. Literally, the third generation. The second generation born in the United States. For Japanese Americans, that usually means the baby boomers born right after the Japanese Americans got out of the internment camps. *See* Chapter 10, "Being Sansei."

Santo Nino Tagalog. A miracle-working statue of the baby Jesus brought to the Philippines by Magellan. Salve Millard writes, "Most Filipino homes have a little altar with an image of the Santo Nino." *See* Chapter 11, "First-Generation Memories: One Filipina's Story," and Chapter 26, "Filipinos and Religion."

Sari-sari Tagalog. A small Philippines variety store. The name suggests immigrant ownership, probably East Indian.

Sarong Tagalog. A long, bright colored dress with puffy shoulders that is the Filipino national dress for women. The "Maria Clara" is another related dress. *See* Chapter 11, "First-Generation Memories: One Filipina's Story."

Shikataganai Japanese. Very roughly "it can't be helped." Yamanaka writes, "It's a very important value to the Japanese. Whatever cannot be helped, you just adjust to, you just do it. People shrug and say, 'shikataganai.'" *See also* Gaman.

Six Companies American name for the Chinese Consolidated Benevolent Association, also called "Huiguan (Company)." The Chinese American version of the hometown immigrant associations, which most American immigrant ethnic groups have formed soon after their arrival in an unfamiliar world. First established in San Francisco by Chinese merchants in the 1850s, following the discovery of gold, and formally reorganized on November 19, 1882, each "company" originally represented one of the six counties around Canton, which until the 1970s accounted for 95 percent of Chinese Americans. In the 1800s legally recognized by the state of California as the representatives of all Chinese America, the Six Companies representatives would meet the immigrant boat at the dock, sort out the newcomers by country of origin, house them, feed them, and place them at jobs. Once major labor brokers and power brokers, they are still in existence, though they have endured accounting scandals in recent years, and are fading into a kind of Chamber of Commerce. Not to be confused with Tongs. *See also* Kenjinkai.

Snakeheads Asian American for gangsters. (*She tou* in Chinese.) Newspaper exposés of drug runners and immigrant smugglers popularized the term during the 1990s.

Soba Japanese. Buckwheat noodles.

Social Darwinism A Western theory loosely based on the biological theories of Charles Darwin, Social Darwinists believed that only the fittest individuals or nations survive the international struggle for dominance. Widespread in China in the early twentieth century, it influenced the communists.

Tagalog Tagalog. Also called Pilipino. Since 1938, the national language of the Philippines, when it was officially designated "Pilipino," even though more people speak *Ilokano* and *Visayan*. Tagalog's debts to Spanish after three centuries of Spanish occupation have led to nationalist concerns over its purity. Vicente Albano Pacis writes, "Spanish words and phrases in use for centuries were considerable—about 30 to 35 percent of the total entries in the original Tagalog dictionary, according to UNESCO studies—and they were the most important unifying elements among the vernaculars of Luzon and the Visayas."

Taglish Salve Millard writes, "A lot of Filipinos speak English and Tagalog together, sometimes changing from one language to another in the middle of a sentence," producing a mixture called Taglish.

Tai Chi Chuan Chinese. (Tai ji chuan) A flowing physical exercise that aims to harmonize the flow of qi in the body. *See* Qi; also see Chapter 23, "Fengshui, Chinese Medicine, and Correlative Thinking."

Tao Chinese. Pronounced Dao. Literally, the "Way." Spiritually, the term is associated with the mystic ecstacy of apprehending the Way the cosmos works. Here Tao is similar to the Logos, in Greek, the "logic" behind all things. Practically, the Tao can mean as common an idea as "don't spit against the wind." Politically, it means the contention that a certain kind of society—such as Confucian, or Taoist, or Legalist—works most closely with the natural order of things and therefore should be adopted. (Here, Tao is used somewhat the way we use "natural," when we claim one system is "natural," and will succeed, while another "goes against nature,"

so eventually must fail. "Socialism failed because it went against human nature," could be expressed, "Socialism went against the Tao," or "against the Tao of humankind.") All Chinese schools of thought claim that *their* Tao is *the* Tao. There is a classic text, the *Tao te Ching, "The Way and its Power."* Its followers dared to call their school the *Taoists,* as if they had a monopoly on it—a kind of oneupsmanship.

Tinikling Tagalog and other dialects. The Philippine national dance performed with long bamboo sticks that are rhythmically clapped together just off the ground by kneeling people—the dancers must step adroitly in and out of them in time with the music. The steps can be graceful and complex, somewhat like an adult version of childhood ropeskipping games. Common throughout Southeast Asia.

Tong Cantonese. Chinese social and fraternal organizations that acquired lurid (and sometimes deserved) reputations for criminal affiliations during the 1800s. Not to be confused with Six Companies.

Toocan Korean. Toilet.

Visayan Visayan. One of the two major Philippine languages. Spoken in the Visayan Islands of the Philippines (also called Bisayas). It mixes Tagalog with Spanish and other indigeneous languages. *See* Tagalog.

Wok Chinese. A round-bottomed pan that allows quick cooking at high heat using a minimum of expensive cooking oil and scarce fuel. Variations throughout Asian cuisines.

Yangban Korean. Upper class.

"Yellow Peril" A political position driven by "irrational fear of Oriental conquest, with racist and sex fantasy overtones," as Roger Daniels defines it. Contemporaries who periodically raise fears that the Japanese, for instance, are going to "take over the United States" are said to be exploiting "Yellow Peril" emotionalism. Daniels, and later Gary Okihiro, trace the term back to Germany's loquacious, theatrical Kaiser Wilhelm II. In 1895 he commissioned a giant allegorical painting of Christian Europe as a group of

Christian maidens menaced by invaders carrying Chinese dragons and images of Buddha. That racist strain culminated in Nazism. Bizarrely, it was also Kaiser Wilhelm, Barbara W. Tuchman reports, who first proudly compared his "irresistible" German army to the army of the Huns, an Asiatic people famous for invasions.

Yin-Yang Chinese origin, pan-Asian. An ideal of harmony. Its familiar symbol, a black and white figure like the number 69 enclosed in a circle, does *not* represent a Western-style battle of good and evil. (Black does not symbolize evil in China.) It represents "characters." It represents the necessary cooperation of all complementary forces, like male and female, to create life and the world. An ideal of balance, not battle. Notice that the black zone contains a small white circle inside it, and the white a black circle.

Yonsei Japanese. The third generation born in the United States. For Japanese Americans this generation is the one entering college now (1998).

Contributors

Bacho, Peter

Peter Bacho's novel, *Cebu,* won the 1992 American Book Award. *First, There Were the Men* (short stories), published in 1997 by University of Washington Press. His work has been widely anthologized and includes a distinguished citation, Best American Short Stories, 1993. Although trained as an attorney (J.D., University of Washington, 1974) and licensed (Washington State Bar, U.S. 9th Circuit Court of Appeals Bar) his interest has always been writing. Before turning to fiction, he focused on U.S. foreign policy, as a regular contributor (1984–1987) to the *Christian Science Monitor* opinion page, as well as to foreign affairs journals, including the *Journal of International Affairs* and *SAIS Review.* He has taught at numerous universities, including a year as Student Recommended Visiting Professor, University of California, Irvine (1994–1995). Bacho is currently a professor in the Liberal Studies Program at the University of Washington, Tacoma.

Castillo-Pruden, Marie

Marie Cagahastian Castillo-Pruden writes a column for *The Filipino Guardian* and contributes cultural articles to *Filipinas* magazine in San Francisco. Born and raised in the Philippines, she studied at Maryknoll College, the University of Santo Tomas, and was a Fellow to the International Institute for Journalism in Berlin. She worked for UPI and two Manila newspapers before coming to the United States. She is now employed in the theater and movie advertising section of the *S.F. Chronicle & Examiner,* where, among other duties, she paints clothes on nude models in the porno ads. A Catholic, Marie Castillo-Pruden is a member of the Secular Franciscan Order.

Chan, Jeffery P.

Jeffery Paul Chan is a professor of Asian American Studies at San Francisco State University. Chan's fiction and essays have appeared in *Yardbird Reader, West, Amerasia Journal,* and numerous other periodicals. His play, *Bunny Hop,* was produced by the East/West Players in Los Angeles, and he is the former drama critic of Marin County's newspaper, *Independent Journal.* His short story "The Chinese in Haifa," which appeared in *Aiiieeeee! An Anthology of Asian American Writers* (1974) is one of the most talked about and thought-provoking pieces of fiction in Asian American literature. He is also the editor of the canon-making *Aiiieeeee! An Anthology of Asian American Writers,* and *The Big Aiiieeeee! An Anthology of Chinese American and Japanese American Literature.*

Chen, Leo

The Honorable Leo Chen, son of the last Qing Dynasty Emperor of China's Grand Tutor, played with the "Last Emperor" as a child, and knew him in exile. Chen was Bernardo Bertolucci's principal advisor on the film *The Last Emperor,* which won the Oscar for Best Picture. A teacher and scholar, Mr. Chen is also founder-owner of the United States' first Chinese American television station, where he produced and wrote for many of the shows.

Chin, Steven A.

Steven Chin, for many years a reporter for the *San Francisco Examiner,* has received national awards for his coverage of the Asian American community and its concerns.

Chu, Patricia P.

Patricia P. Chu, Assistant Professor of English at George Washington University, received her Ph.D. in English literature from Cornell University. She is the author of "The Invisible World the Emigrants Built: Cultural Self-Inscription and the Anti-Romantic Plots of *The Woman Warrior,*" *Diaspora: A Journal of Transnational Studies* 2.1 (Spring 1992): 95–116; "Maxine Hong Kingston's *The Woman Warrior,*" in *Resource Guide to Asian American Literature,* ed. Stephen H. Sumida and Cynthia Sauling Wong, New York: MLA; and "*Tripmaster Monkey,* Frank Chin and the Chinese Heroic Tradition," *Arizona Quarterly* (Autumn, 1997). She has received George Washington University's Junior Scholar Award and, while at Cornell, won the Martin Sampson Teaching Award, the Liu Memorial Award, the A.D. White Fellowship, and the Mellon Dissertation Fellowship. She is currently completing a book titled *Assimilating Subjects: Race, Gender, and Authorship in Asian American Literature.*

Chung, Chuong Hoang

Born in Vietnam, educated in the United States, Chung Chuong Hoang is Associate Professor of Asian American Studies and Director of the Vietnamese American Studies Center at San Francisco State University.

Cornell, Betty

Betty Cornell has taught at San Jose State University and is Professor of Design and Asian American Art at Canada College. For many years a docent at the Asian Art Museum of San Francisco, she has researched and lectured in both China and Hong Kong for the American Institute for Foreign Study and for the World Craft Council in Kyoto, Japan.

Drescher, Timothy

Dr. Timothy Drescher received his Ph.D. from the University of Wisconsin. His many books and articles have made him universally recognized as the leading American expert on the Community Mural movement, which grew out of the Mexican *muralista* tradition. He is himself a muralist and an activist. Drescher is a Professor of Humanities at San Francisco State University.

Du, Y.F.

Y.F. Du was born in the People's Republic of China where he became Associate Professor in the School of Business of Beijing College. He has translated more than one million words of American business literature into Mandarin.

Feldman, Amy

Amy Feldman earned a degree in World Arts and Cultures from UCLA where she studied Italian language and culture. She spent a year researching in Padua, and she was an Assistant Editor of *The Italian American Heritage: A Companion to Literature and Arts.* She received a Master's degree in the methodology of interdisciplinary criticism from San Francisco State University, writing her master's thesis about the seventeenth-century Italian woman painter Artemisia Gentileschi. She teaches Italian at UCLA, where she is earning her doctorate.

Gonzales, Daniel

Dr. Daniel Gonzales is the coordinator of the nation's first, and oldest, Filipino American Studies Program. He was a founder of the program at San Francisco State in 1969. He is also an Associate Professor in the Department of Asian American Studies at San Francisco State University.

Hahn, Kim

Kim Hahn was Assistant Managing Editor at the University of California Press on The International Encyclopedia of Dance, a landmark publication of five volumes that has been in the making for more than a decade. She was raised in Marin County, California, and received a B.A. in anthropology from the University of California, Berkeley, and an M.A. in Dance from Mills College.

Hu-DeHart, Evelyn

Evelyn Hu-DeHart is Professor of History and Ethnic Studies and the Chair of the Department of Ethnic Studies at the University of Colorado at Boulder. She received her B.A. in Political Science from Stanford University and her Ph.D. in History (Latin American and Caribbean) from the University of Texas at Austin. Currently she chairs the new department of Ethnic Studies, one of a handful of comparative race and ethnic studies degree departments in U.S. research universities. She has published three books and several articles on the Yaqui Indians of northwest Mexico and Arizona in English, Spanish, and Zoque Mayan, and numerous articles in English, Spanish, and Chinese on her current research on the Chinese diaspora in Latin America and the Caribbean. She also writes and lectures extensively on issues of race and politics, immigration, affirmative action, nativism, women of color, and ethnic studies. She has received fellowships from the Fulbright Commission, the Rockefeller Foundation, the Ford Foundation, the Kellogg Foundation, and the Social Science Research Council among others, and she has studied, taught and lectured around the world in English, Spanish, Portuguese, and Chinese.

Hyun, David

David Hyun, Hawaiian-born Korean American architect, writer, civic leader, and theoretician of the Asian Pacific American experience, won numerous architectural and civic awards for Japanese Village Plaza, Los Angeles, which he designed, developed, and ultimately owned. JVP's success is generally credited with reversing urban blight in downtown Los Angeles. It is now flanked by the Contemporary Art Museum, the national headquarters of the JACL, and the Japanese American National Museum.

Isham, Molly H.

Molly Isham works professionally as a California court interpreter and translator. She has also been a language teacher for more than 40 years. During

the filming of Amy Tan's *The Joy Luck Club,* she served as interpreter for the director, Wayne Wang, and was rewarded with a role as an extra in the film herself.

Jenkins, Joyce

Joyce Jenkins, the editor/impresaria behind the newspaper *Poetry Flash,* is herself a poet.

Kano, Betty

Betty Nobue Kano was born in Japan and came to the United States as a young girl. After participating in the struggle for a Third World College at the University of California, Berkeley, she returned to Japan and lived there for three years. Back in the United States, she completed her M.F.A. in Painting at University of California Berkeley, became an accomplished painter, and co-founded Asian American Women Artists Association and Godzilla West. She is Program Director of Pro Arts, a nonprofit gallery in Oakland, California. Among the numerous exhibits she has curated are "Roots in Asia," at the Richmond Art Center in 1996, "The Mythmakers," at the Jamaica Art Center, New York in 1992, "Masks, Monkeys, Magic, and Mysteries," at Pro Arts Gallery in Oakland, California in 1988. Her paintings have been exhibited nationally and internationally.

Kelley, Jeff

A practicing art critic since 1976, Jeff Kelley has written for such publications as *Artforum, Art in America, Vanguard,* the *Headlands Journal,* and the *Los Angeles Times,* among others. He edited *Essays on the Blurring of Art and Life,* by Allan Kaprow, published by the University of California Press in 1993, and is currently writing *Childsplay,* a book on Kaprow's Happenings since the 1950s, also for the University of California Press. Kelley's essays have been published in such anthologies as *Mapping the Terrain: New Genre Public Art, But Is It Art? The Spirit of Art as Activism,* and he has written catalogue essays for numerous galleries and museums, including the Corcoran Gallery of Art in Washington, D.C., and the Centre Pompidou in Paris. Now living in Oakland, California, he teaches both undergraduate and graduate courses in art theory and art criticism in the department of Art Practice at the University of California, Berkeley. Kelley earned an M.F.A. degree in Visual Arts Criticism in 1985 from the University of California, San Diego.

Kohn, James

James Kohn took his Ph.D. from Columbia Teacher's College with a specialty in applied linguistics. He has been an innovator in programs concerning

the teaching of English as a foreign language (TESOL). In addition to two decades of articles in the leading international journal, *TESOL Quarterly,* he is author of the TESOL textbook *Interactivities* (Harcourt, Brace: 1995). He and his wife Elaine— an educator and coordinator of outreach education programs—were in the early group of Americans allowed back into China to teach after the Cultural Revolution. In 1984 they taught American literature and culture for a full year at Shandong Teachers' University, during which they also studied Mandarin. He is Professor of English at San Francisco State University. He has created a Web-site in applied linguistics and TESOL that may be accessed through a hyperlink at http://userwwwsfsu.edu/jimkohn.

Kohn, Stefanie

Stefanie Kohn received her B.A. and a Multiple Subjects Teaching Credential from San Francisco State University. She teaches in San Francisco public schools, the most multicultural, multiethnic districts in California, and is finishing a Masters in elementary education at San Francisco State.

Lee, Jeeyeon

Jeeyeon Lee graduated from UCLA with a B.F.A. in painting. After teaching English in Korea, she returned to southern California where she is currently working on her M.F.A. at the Art Center in Pasadena.

Leonard, George J.

George J. Leonard received his Ph.D. With Distinction from Columbia University. Among many other publications, his work of aesthetic theory, *Into the Light of Things: The Art of the Commonplace from Wordsworth to John Cage,* was chosen by the American Library Association as "One of the Outstanding Academic Books of the Year." His novels include *Beyond Control* (Macmillan) and *The Ice Cathedral* (Simon and Schuster), recently purchased by Ron Howard/ Imagine Entertainment/ Universal Pictures. While in graduate school, he converted the Columbia *a capella* society into the rock-and-roll group Sha Na Na, which played the Woodstock Festival, the Warner Bros. film *Woodstock* and the Fillmores. He has taught at Yale, Scripps College/Claremont, and in Beijing. He is Professor of Interdisciplinary Humanities at San Francisco State University.

Leonard, Robert

Dr. Robert Leonard is Professor of Linguistics at Hofstra University. A Fulbright Fellow, he received his B.A. from Columbia College and his M.A.,

M.Phil., and Ph.D. from Columbia Graduate School. In the arts, Dr. Leonard cofounded and led the rock group Sha Na Na and as bass and lead singer, performed at the Woodstock Festival, the Fillmores East and West, on television's *Tonight Show,* and in the Academy Award-winning Woodstock movie. Dr. Leonard has taught at Columbia and was Vice President of Friends World College and for four years Director of their East African Center, teaching undergraduates and doing fieldwork among the Akamba and Swahili peoples. He has served as consultant on language and intercultural matters to the *New Yorker Magazine.* He and his wife, Wendy J. Saliba, have lived in Thailand and Kenya. Their research in the semiotics of food has been presented at the Oxford Food Symposium, St. Antony's College, Oxford University and published by Prospect Books of London. Leonard's works involve theoretical semantics and its application to the analysis of language and other semiotic systems such as food, space, and music.

Ling, Amy

Amy Ling is Professor of English and Director of the Asian American Studies Program at the University of Wisconsin, Madison. Born in Beijing, China, she immigrated to the United States with her parents at age six. She received her Ph.D. in comparative literature from New York University with a dissertation on William Thackeray, Emile Zola, and Henry James. Since then, she has educated herself on multicultural American literature. She has published a chapbook of her own paintings and poems entitled *Chinamerican Reflections* (1984), and her scholarly book, *Between Worlds: Women Writers of Chinese Ancestry* (Pergamon, 1991, Teacher's College Press), is a groundbreaking text of cultural history. She has published numerous scholarly articles on Asian American literature and coedited *Mrs. Spring Fragrance and Other Writings of Sui Sin Far* (University of Illinois Press, 1995), *Oxford Companion to Women's Writing in the U.S.* (Oxford University Press, 1995), *Visions of America: Personal Narratives from the Promised Land* (Persea, 1993), *Reading the Literatures of Asian America* (Temple University Press, 1992), *Imagining America: Stories from the Promised Land* (Persea, 1991), *Asian Americans: Comparative and Global Perspectives* (Washington State University Press, 1991), and *Heath Anthology of American Literature* (D.C. Heath and Houghton Mifflin, 1989, 1994).

Liu, Hung

Hung Liu was born in Changchun, China, in 1948. She earned an M.F.A. equivalence in mural painting at the Central Academy of Fine Art, Beijing, and an M.F.A. from the University of California, San Diego, in 1986. Liu is a two-time recipient of a National Endowment for the Arts Painting Fellowship, in 1989

and 1991, as well as a Society for the Encouragement of Contemporary Art (SECA) Award (SFMOMA) in 1992, and a Eureka Fellowship (Fleishhacker Foundation) in 1993. Notable recent exhibitions include "American Kaleidoscope," at the National Museum of American Art, Washington, D.C., 1996; "American Stories," at the Seragaya Art Museum, Tokyo, 1997; "Memory Beyond Gender," at the Tokyo Metropolitan Museum of Photography, Tokyo, Japan, 1996; "The Last Dynasty," at the Steinbaum/Krauss Gallery, New York, 1995; "Jin Jin Shan" (Old Gold Mountain) an installation commenting upon the history of Chinese immigration to California, at the M.H. deYoung Memorial Museum, San Francisco, 1994; "The Year of the Dog," new paintings at the Steinbaum/Krauss Gallery, New York, 1994; the Corcoran Gallery of Art's "43rd Biennial of Contemporary American Painting" in Washington, D.C., 1993–1994; "New Work," at the Rena Bransten Gallery, San Francisco, 1993; "In Transit," at the New Museum of Contemporary Art, New York, 1993; "Society for the Encouragement of Contemporary Art (SECA) Award Exhibition" at the San Francisco Museum of Modern Art in 1992; and "Mito Y Magic En America, Los Ochenta" (Myth and Magic in America, the 80s), at the Monterey Museum of Contemporary Art, Mexico, in 1991. She is represented by the Steinbaum/Krauss Gallery in New York and the Rena Bransten Gallery in San Francisco and is presently an Associate Professor of Art at Mills College in Oakland, California.

Millard, Max

Max Millard, former editor of *Asian Week* newspaper and frequent contributor to the black press, earned a B.A. degree in American history from Boston University in 1972. He is currently a freelance writer whose work appears on the Internet.

Millard, Salve

Salvacion Real Millard, an occasional contributor to the *Philippine News* and other publications, was born in the Philippines in 1966 and immigrated to the United States in 1986. She is a licensed vocational nurse at the Chinese Hospital in San Francisco.

Nathan, Geoffrey

Geoffrey Nathan is a Lecturer of Roman History at U.C.L.A. He is the author of several articles concerning the era of late antiquity. He has a forthcoming book from Routledge Press, tentatively titled *The Family in Late Antiquity*. His areas of expertise cover both the ancient and medieval periods.

Niiya, Brian

Brian Niiya is a curator for the Japanese American National Museum in Los Angeles, is editor of *Japanese American History: An A-Z Reference.* He is also a columnist for the *Rafu Shimpu,* the most widely read Japanese American newspaper.

Rosenblum, Diane

Diane Rosenblum has a B.A. from Marietta College and an M.A. in Interdisciplinary Humanities from San Francisco State University. For many years she taught high school English and creative writing in Ohio, Massachusetts, and Maine. She has published a theoretical study of the American canon's formation. She writes about American Indian concerns as Editor-in-Chief of the *American Indian Cultural Heritage: A Companion to Literature and Arts.*

Saliba, Wendy J.

Wendy J. Saliba is a linguist and foodways field researcher. As an undergraduate at Friends World College she conducted fieldwork on language planning in Kenya, India, Thailand, Singapore, and Malaysia. She received her Master of Management degree from Northwestern University's J.L. Kellogg School of Management and her M.A. in linguistics from Columbia University, where she was named a President's Fellow. She and her husband, Robert A. Leonard, have lived in Kenya and Thailand. Their research in the semiotics of food has been presented at the Oxford Food Symposium, St. Antony's College, Oxford University, and published by Prospect Books of London.

Scott, Mary

Mary Scott (B.A. Harvard College, M.A. Harvard, Ph.D Princeton) is Associate Professor of East Asian Humanities in the Department of Humanities, San Francisco State University. She was a lecturer in Asian Studies at Dartmouth College, where she taught Chinese and Japanese literature and Chinese language. She was Assistant Professor of Asian Studies and codirector of the Pacific Rim/ Asia Study Travel Program at the University of Puget Sound. She has spent several years studying and teaching in Taiwan, Japan, and Korea, and she has traveled extensively in Southeast Asia and India. She did a year of dissertation research at Beijing University as part of the official China-U.S. exchange of scholars, which led to the publication of scholarly articles in English and Chinese on seventeenth- and eighteenth-century Chinese fiction and drama. Her postdoctoral research in the social history of Chinese theater and storytelling

at the University of California, Berkeley, led to the publication of her translation of three nineteenth-century storytellers' tales, with a scholarly introduction. Her current project is a study of the political and intellectual contexts that shaped early twentieth-century Chinese studies of folk literature and art.

Solberg, S.E.

Dr. S.E. Solberg, after three years of study at Yonsei University in Seoul, Korea, received his Ph.D. in East Asian area studies and Comparative Literature from the University of Washington. In the early 1970s he organized several seminal journal issues and conferences relating to Korean literature, then Asian American literature, and guided the University of Washington Press into starting its now prestigious Asian American list. He is a longtime professor in the Department of American Ethnic Studies, the Program in Asian American Studies, and the Department of Comparative Literature at the University of Washington. His many articles, translations, and editorships include, with Sid White, editing the Washington State Governor's award book, the *Peoples of Washington*. Among his honors are the 1991 People's Scholar Award of the Korean American Journalists Association, presented "for his lifelong dedication to providing a voice and solace for the oppressed people in Korea and Koreans in America." He was the 1997 recipient of the Association for Asian American Studies Pioneer Award. He and his wife Joan have five children and eleven grandchildren.

Stern, Jenny

Jenny Stern has a B.A. in women's studies from Antioch University and an M.A. in humanities from San Francisco State University. After 15 years as a designer in New York City's fashion industry, she has devoted her studies to research, writing, and private educational counseling. Jenny has published poems, photography, essays, and articles on spiritual healing. Currently living in New York City, she is pursuing a Master's degree in social work.

Tran, Thuy

Thuy Tran came from a small fishing village in South Vietnam called Nha Trang. She experienced two political systems, a democratic Vietnam and then communist Vietnam. Although she was quite young then, she has vivid memories of joy and fear, of peace and violence, all from a warring country. The soul of her thoughts has its roots in old Vietnam. In 1979, her family emigrated to the United States as "boat people." She received her B.A. and M.A. in Humanities (focused on

Cross Cultural Literature and Comparative Philosophy) at San Francisco State University. A freelance writer, she currently teaches English at a University in Okinawa.

Woo, David

David Woo is a writer and political activist who received his B.A. at San Francisco State University. He is the founder and Coordinator of the Asian American History Outreach Program, which educates high school students on Asian American history via multiday seminars and workshops. He resides in San Francisco.

Yamanaka, K. Morgan

Mr. Yamanaka is one of the now-famous "No No Boys," one of only 5 percent of the Japanese Americans who resisted during internment and were punished. He has contributed to many publications and been a leader in many causes affecting the Japanese American community. He is Professor of Social Work at San Francisco State University.

Acknowledgment

A special thank you to all the researchers, librarians, fact checkers, typists, editors, assistants, and students who helped us over the years, including (but not limited to) Christine Owens, Sonja Hird, Marian Ganter, Joyce Morgan, C. De Naissance (Filipina section), Rhona Klein, Darlene Tong, Sarah Marsh, Joanna Perry.

Permissions

Portions of Chapter 28, "The Chinese Diaspora," appeared in an earlier version, in "Coolies, Shopkeepers, Pioneers: The Chinese of Mexico and Peru (1849–1930)" by Evelyn Hu-DeHart, in *Amerasia* 15:2 (1989) pp. 91–116.

Portions of Marie Castillo Pruden's section in Ch. 26, "Filipinos and Religion," appeared in an earlier version in "Filipino Christmas," in *Filipinas* (December 1992).

Index

A

"ABC" (American Born Chinese)
 Definition, 474, 643
ABC (Internment Rankings)
 After Pearl Harbor/internment camps,
 91, 97–98
Acupuncture, 235
Aeschylus, 44
Agta, 261–262, 264
Aiiieeeee!, 414–418, 435, 510
Alien Land Acts, 91
 California, 321
 Chronology, 628
 Definition, 643
Altaic Language, 9
Amae, 643
An, 25
Angel Island Poems, 377–380. See Ghosts
Angels
 Philippines, 263
Antin, David, 62
Asawang, Asuwang, 135, 265–267
Asian American Cultures
 Asian Americans Are Not Asians,
 43–44
 Global Significance of, 42–64
Asian Americans, Early History of
 All in Chronology Article, 619–641
 Chinese, 317–320
 Filipino, 321
 Japanese, 320–321
 Koreans, 321
Asian Ideograms, 15–27
Athenian Republic, 44
Auden, W. H., 41–42

B

Bacani, Rolando, 257
Bachelor society, 581
 Chronology, 623
 Definition, 643–644
Bacho, Peter, xxvi, 481–495
 Quote, 483
Baiyunguan, 58–59
Balikbayan
 Culture, 492, 574
 Definition, 136–137, 644
Bango
 Definition, 644
Bangus, 128
Barrio, 128–129, 491
 Definition, 644
Basho, xiii, 369–376
Beatles, The, 63
Beijing
 History of, 81–83
Berlin, Irving, xvii
Bertolucci, Bernardo, 555–565
Bhagavad-Gita, 163
Big Five
 Definition, 645
Black Nazarene, 252
Black Panther Party, 36
"Broken English," 335, 339
Buddha, 388, 390
 In relation to Kong Fu Tse, 44
Buddhahead
 Definition, 645
Buddhism, 47
 Japanese, 195
 Rinzai, 381–393

Suzuki, 388
Theravada Buddhism, 11
Buddhist, 364, 381–383, 389, 427
 Chronology, 625
 Names, 32–33
 Obon, 247–248
 Philippines, 491
 Zen, 193, 381–393 (article)
Bulosan, Carlos, 413, 417, 423–426
 Education of, 483

C

Cage, John, 381–382, 385
California Land Act
 Chronology, 627
Cambodian Americans
 Current Demographics, xxiii–xxiv
Cantonese, 17, 445
Catholicism
 Philippines, 251
Cebu, 481–495
 City, 128
Chan, Jeffery Paul, xiv, xxv, 400
 Articles by, 395–412, 435–438,
 507–512
Chan, Sarah, 22
Chanoyu, 193
 Definition, 645
Characters, Asian, 3–14, 15–27
Chen, Leo (interview), 555–566
Chew, Laureen (interview), 567–584
Chi, 450, 471
 Definition, 645
Chin Dynasty, First Emperor of (220s B.C.),
 46–48
 Builds Great Wall; Xian Tomb, 46
 First to unify China, 46
 Philosophy of, 46–47
Chin, Frank, 421, 435–437, 448
Chinese Opera, 549–553
Ch'ing Dynasty
 Pronunciation, 3–4
Chinatown, 36, 323–332
 Education, 35
 In films, 573–574
Chinese Exclusion Act, 320, 321
 Chronology, 623, 638–639
Chongra-bugdo, 11
Chongum, 10
Chopsticks, 185–186, 217
 Vietnam, 209

Chop Suey, 174, 186
Chou. See Zhou
Chow Mein, 187
Christmas
 In Philippines, 267–270
Chu, Hsi (A.D. 1130–1200)
 Synthesizes Neo-Confucianism, 47
Chu, Louis, 408–409, 425
Chu, Patricia, xiv
 Articles by, 439–446, 473–480
Chun-tzu
 Goal of Confucianism, 55
Chuong Hoang Chung
 Article by, 207–212
Clay Walls, 520, 521, 530, 532–533,
 535–536
Communist China, 272
Concentration Camps, xxv
 USA, 104–105, 114
Concubines, 69–81
 Definition, 460
Confucian, 163, 427
 Cooking/women, 202
 Family values in the face of Mao, 281
 Family values in film, 573
 Names, 33
 Principles, 182
 Vietnam, 209
Confucius
 Analects, 44–49, 56
 And the Age of Reason, 58
 As religion, 54–58
 Families, 52
 Pronunciation, 4
 Thought, 43–52
 Writing, 25
Confucianism, xiii, 41–66, 220, 363
 American Confucianism, 42
 Ancestor Worship, 43
 Compared to Western Religion, 57–64
 Definition, 645
 Does Not Transvalue the Values, 32–64
 Supports Human Rights, 55–56
Coolie, 299, 300, 301
 Contract, 303–305
 Cuba/Peru, 305–306
 Definition, 645
 Regulations, 303–305
 Trade, 300–301
Coram Nobis, 25, 645
Cornell, Betty (art by), 233, 243, 244

Cultural Relativism
 Definition, 646
Cultural Revolution, 272–273. *See* Great
 Proletarian Cultural Revolution
 History, 272–295

D

Dante
 Similarities to Confucius' Life, 45
Danto, Arthur, 381
Dark Blue Suit, 493–495
Death Anniversary
 Definition, 646
 Philippines, 130
de Bary, William Theodore, 64
 Confucianism supports human rights,
 55–56
 The Trouble with Confucianism, 42
 Works on Asian Humanities and Civilization,
 641
 Works on Confucianism, 65
Dialect, 336, 352, 353–362
Diaspora, 363,
 All Cultures Defined, 646
 Asian, 311
 Chinese, 299–308
Dim Sum (food), 187, 450 "dyansyin"
 (Mandarin equivalent), 187, 450, 581
Dim Sum (movie), 56, 567–584
Discrimination
 Asian, 36
Drescher, Timothy
 Article by, 585–590
Durian, xiii, 213–214
 Definition, 646
Du, Y.F., Calligraphy by, 19, 21–24, 26
 Mentioned, 29, 64, 223, 224, 226
Dwarfs/dwendi, 265
Dyansyin, 450

E

Eckman, Claire
 Article by, 619–640
Egawa, Stephen
 Article by, 619–640
Eight Trigrams, 229
 Definition, 647
Emblem food, 172, 173
Enryo
 Definition, 647
Ethnic Enclave

 Definition, 647
Ethnocentricity
 Definition, 647
 Korea, 148
Eurocentric, xiii
Evacuation. *See* Executive Order 9066
 Definition, 647
Exclusion Act of 1882
 History, 620
 Mentioned, xxiv
Executive Order 9066
 Definition, 647
 History, 91, 630
 Personal Experience, 90

F

Face
 Lose, 278, 454, 647
Faith Healers
 Philippines, 262–263
Fa Jia
 Definition, 46–47
Families, Asian American, 41–66
Fangyan, 6
Farewell My Concubine, 553
Feldman, Amy
 Article by, 641–660
Fengshui Xiangsheng
 Definition, 647
Fengshui, 229, 366
 Definition, 648
Filial Duty, 580
Filipino Values, 139–142
Filial Piety, 443
 Definition, 51, 494, 648
 In Confucius, 51–52
 See also Ren
Five Tastes, 184, 199
 Definition, 648
Flower Flag, 299, 378
"FOB," 423
 Chronology, 630
 Definition, 648
 Novel, 478
 Use, 474
Folk Religion
 Philippines, xiv, 260
Food
 Chinese, 181–188
 Filipino, 197–198
 Japanese, 189–196

Korean, 199–206
Southeast Asian, 207–212
Theory, Cultural, 171–180
Vietnamese, 207–218
Forbidden City, Beijing (Gugong), Imperial
Palace
Origins, 81
Making of *The Last Emperor,* 556, 559
Writing, 25
Fortune Cookies, 174, 187
American Origin of, 648
"442nd" Regimental Fighting Team, xviii,
113–117
Chronology, 630
Definition, 648
Frittata, 175
Fu, 25

G

Gaman
Definition, 89, 649
Gan zhi, 231
Gandhi, 255
Gang of Four, 292–293
Gate of Heavenly Peace. *See* Tian An Men
Gentlemen's Agreement, 321
Chronology, 627
Japan, 91
Ghosts
China, 452–453
Philippines, 260
Ginsberg, Allen, 381
Definition, 649
Ginseng, 184, 235
Giri, 89, 99
Definition, 649
Gohan
Definition, 649
Gold Mountain, 378
Definition, 649
Gonzales, Daniel
Articles by, 139–142, 197–198, 641–660
Quote, 486, 492
Great Proletarian Cultural Revolution, xiii,
271–295
Great Wall, 604
History, 46
Great Wall
Movie, 67
Guai
Definition, 649

Guangdonghua, 6
Definition, 649
Language, 17
See also Cantonese
Gumdang, 529
Definition, 649
Guomindang, 30

H

Hagedorn, Jessica, xxvi, 481, 487
interview, 497–506
Dogeaters, 497, 501, 505
Hahn, Gloria. *See* Ronyoung
Hahn, Kim, 527–534
Haiku, 369, 369–375
Hakujin, 649
Han
Definition, 649–650
Family name, 29–30
People, 17
Han Dynasty
China, 47
Literary history, 9
Hangul, xiii, 650
Hanyu Pinyin, 67, 448
Definition, 650
Han Zi, 17–18
Definition, 650
Hao, 20, 32
Haole, 339
Definition, 464, 650
Higgins, C.A.
Article by, 323–332
Hiragana, 9, 18
Happa, Hapa, 650
Hmong, The, 592–594
Names, 34
Exodus, 599
Hmong Needlework, xiv, 591–604
Ho Chi Minh, 607
Writing characters, 11
Hongo, Garrett, 513–514
Quote, 509
HSPA
Definition, 650
Hu-DeHart, Evelyn
Article by, 299–310
Humanism, 50
Hung Liu, 611–617
Hutong, 69
Hwang, David Henry, 473–480

I

I Ching
 Edited by Confucius, 46
Ideograms, 16–18
Ideographs, 16
Ilokano, Ilocano, 254
 Definition, 650
 Politics, 134
Immigration Act
 Of 1965, 36, 633
Inada, Lawson Fusao, 507–512
 Biography, 507
Indispensable foods, 173
Indochina, 33
Insider foods, 174
Internment Camps, 190
 Food, 191
 Personal experience, 90–93, 104
Isham, Molly
 Articles by, 67–84, 237–246, 447–472
Issei, xiii, 85, 103, 189–190, 195
 Definition, 36, 650

J

JACL (Japanese American Citizens League),
 103, 110, 630
 Definition, 651
Jade Emperor, 58–59
Japanese Haiku
Japanese School, 123
Japantown, 588
Jargon, 338
Jeepney
 Definition, 131, 651
 In literature, 489
Jenkins, Joyce
 Article by, 497–506
Jesus, 48, 60, 587
"Jesus Maria Josep"
 Definition, 651
Jia, 25
Jiaozi
 Definition, 651
Jiejie, 30
Journey To The West (a.k.a. *Monkey*), 363–368
Joy Luck Club, 239
 In the classroom, xvi, xxvi
 Lunar New Year, 242–243
 Mentioned, xiv, 56
Judiel Nieva, 258

K

Kababayan, 651
Kaiseki ryori
 Definition, 651
Kanji, 9, 17
 Definition, 651
Katakana, 9
"Kano" (Tagalog)
 Definition, 652
Kana, 9, 585–590
Kang, Younghill
 Literature, 413, 424, 425, 533
Kano, Betty, 585–589
Kaprow, Allan, 381
Kasama
 Definition, 139, 652
 Pakikisama, 486
Katakana, 18
Katsura Imperial Villa, 227
Kenjinkai, 103
 Definition, 652
Kelley, Jeff
 Article by, 611–618
Kerouac, Jack, 381
Kibei
 Definition, 652
 Internment Camps, 88, 97
Kim, Elaine
 Quote, 428
Kimchee, 199–203
Kingston, Maxine Hong, xiv, 361, 363,
 431, 439–445
 History, 439–440
 Literary works, xvi, xxiv–xxviii, 56,
 182
 Tripmaster Monkey, 442–443, 478
 Woman Warrior, 439–441, 444–445
Kitchen God, The, xiii, 56, 239
 Definition, 652
 Lunar New Year, 243
Kitchen God's Wife, The
 Novel, 182
Klein, Rhona, xxvi
Kobodaishi. *See* Kukai
Kohn, James J.
 Article by, 351–362
Kong Fu Tse, 25, 44. *See* Confucius
 Definition, 652
 Family, 41–42, 76
 Name, 32

Kong Miao, 59
Kotonk
 Definition, 653
Ko Won, 515–525
Kukai, 18
Kun, 33
Kuomintang. *See* Guomindang
Kuya
 Definition, 653
 Names, 128

L

Lac Long Quan, 207
Language
 In Literature, 333–350
 Theory, 351–362
Lao Tian Ye, 70. *See* Old Heaven Master
Lao Tzu, 32. *See* Taoism
 Mythic origins of, 49
Last Emperor, The, 555–565
LEAP, xiv
Lee, C.Y., 402–404
Lechon, 129
 Definition, 653
Lee, Debbie
 Article by, 619–640
Lee, Gen Leigh, xxiv
Lee, Jeeyeon
 Articles by, 143–150, 199–206
Leonard, Andrew
 Dedication, xx–xxi
 Photo with cousins, xx
Leonard, George J.
 Articles by, xii–xxix, 3–14, 15–27, 41–66,
 369–376, 377–380, 381–394, 395–412,
 481–496, 507–512, 567–584, 591–606
Leonard, Simei
 Article by, 377–380
Leonard, Robert A.
 Articles by, 171–180, 213–218, 333–350
Li (third tone)
 Courtesy, 7
 Significance, 52
Li (fourth tone)
 Force, "might makes right," 7, 20
Liberatory Education
 Definition, 653
Lincoln Memorial (similar to Confucian
 "temples"), 59
Ling, Amy, xiv
 Article by, 439–446

Little Red Book, 48
 Definition, 653
Little Tokyo, xxv, 36
Lola, 128
 Definition, 654
Lolo, 128
 Definition, 654
Lowe, Pardee, 397–401, 430
Lu, Duke of, 45
Luk, Galin
 Article by, 619–640
Lumpia, 129
 Definition, 654
Lunar New Year, 654, 237–246
 Chinese, 182

M

Ma, 18
Magellan, 251–252
Mahinhin, 261
Manang
 Definition, 654
Mandarin, 17
Manong
 Definition, 654
 In Bacho's works, 494–495
 Respect, 491
Mao, 6, 629, 632
 Characters, 18
 Family name, 29–30
 The Last Emperor, 556
 Politics, 48, 275–277
Maoism, 271–295
Marcos, President Ferdinand, 254
 History of, 487–488
Maria Clara
 Definition, 654
M. Butterfly, 473
Medicine
 Chinese, 229–236
Mestizo, 131
 Definition, 654
Mien (minority people), 593
Miles, Jack
 Acknowledgment to, 64–65
Millard, Max
 Articles by, 127–138, 197–198, 619–640
Millard, Salve
 Article by, 127–138, 197–198
Ming, 20, 29
Model Minority, 35–40

Analysis of Arguments, 53–54
 Explanation, 35–36
Mochi, 193, 654
Mohism, 47
Monkey King, 363–364. *See Journey to the West*
Mooncakes, 183
 Definition, 654
 Lunar New Year, 242
Moon Festival, 237–246, 459
Moon Lady, xiii, 237–246, 460
 Definition, 655
Mongols, 56
Mori, Toshio, 404–405
Mount Thai Son, 151–152, 162, 655
Mu Lan (poem), *Mulan* (Disney film), 655–661
Multiculturalism
 In classroom, xiii
Muslim
 Philippines, 251, 491
Mysticism, 60

N

Naming Systems, Asian, 29–34
Nan, 20
Nara Period, 17
Nathan, Geoffrey
 Article by, 643–660
Nathan, Marvin, 58
Natural Supernaturalism, 391
Negro, 133
 Definition, 661
New Year
 Chinese, 183
 In *Dim Sum* (film), 575
New Year's Dumpling, 183
Nietzsche
 And Confucius, 41, 62–63
Niiya, Brian
 Articles by, 113–118, 119–122, 123–126,
 317–322, 427–434
Nikkei
 Definition, 661
 Internment Camps, 101–104
 No No Boys, 107
Ninoy Aquino, 254, 255
Nipa hut, xiii, 128, 135
 Definition, 661
Nisei, xiv, 119–122, 190, 248
 Definition, 662
 Internment Camps, 85–91

No No Boys, becoming a, 103, 107, 108
No No Boy
 Becoming, 104, 107, 109
 Definition, 662
 Language, 123–125
 Novel, 410
 Vilification of, 436
Nonviolent resistance
 Philippines, 255
Novena, 253
Nú, 20

O

Obon Season, xvi, 247–249
Okada, John, xxvi
 Literature, 109, 410–411, 436
Okakura, Kakuzo
 Article by, 219–228
Okashi, 195
On, 89, 99. *See* Giri
 Definition, 662
"One-Point-Five" Generation, 143–149
 Definition, 143
Orientalism, 8
 In *M. Butterfly,* 555
 The Last Emperor, 558
Overseas Chinese
 Definition, 662
Ozu, 571

P

Pagin, 529
 Definition, 663
Pagan, 251
Paper Son, 377
Pearl Harbor, 323
 Personal Experience, 89
 San Francisco, 90
Pictographs, 18
Picture Bride, 541, 543–545
 Definition, 663
Pidgin, 339
Pinay
 America, 134
 Definition, 663
 Use today, 484
Pinoy
 America, 134
 Definition, 663
 Use today, 484
Pinyin, 448

Definition, 663
Names, 29–30
Piper, J.M., 213–214
Pop, 663
Protestantism
Philippines, 254, 256–257
Putonghua
Definition, 663
Language, 6, 17
PuYi (Given name of the "Last Emperor"),
451, 555–566

Q

Qi, 229, 234, 366
Qian Long Era, 15
Qing Dynasty, 15, 69, 78
Emperor, 561
History, 620, 624
Pronunciation, 3
QuYuan, 183

R

Raise High The Big Red Lanterns, 75
Ram khamheng, 11
Raspa, Richard, 174
Red Guards, 278, 279
Definition, 663–664
"Redress" (For Internment Camps),
110–111
Definition, 664
History, 635
RedTerror, 271
Religion
Filipino, 251–270
Relocation Camp. *See* Internment Camps
Ren
As highest Confucian virtue, 51, 664
In the sense of humane, 25
In the sense of man, 25
Pronunciation, 4, 6
Rhodes, Alexander de, 3
Ri, 18
Rickshaw
Definition, 664
Romanization
Definition, 664
Names, 29, 32–33
Romero, Ed
Article by, 197–198
Ronyoung, Kim, xxvi, 527–533
ClayWalls, 535–540

Rosenblum, Diane
Articles by, 85–112, 481–496, 619–640
Ru jia (the Confucian Scholars), 48
Ruiz, Saint Lorenzo, 253
Ruskin, John
Social Theory compared to Confucius, 323

S

Sabong, 137
Definition, 664
Sake, 193
Definition, 664
Saliba, Wendy
Articles by, 171–180, 213–218
Sama, 32
San, 32
Sansei, 247–248
Definition, 665
Japanese, 123–125
1960s and 70s, 85, 104, 109, 110
Santo Nino, 252, 264, 267
Definition, 665
Altar/Philippines, 130
Sari-sari
Definition, 128, 665
Sarong
Definition, 665
Special Occasions, 128
Satori, 381–383, 385, 387
Sau-ling Cynthia Wong, 53, 395, 398, 482
Scent of Green Papaya, The
Movie, 207
Schwartz, Benjamin, 43 (archaeology)
Scott, Mary
Articles by, 189–196, 229–236, 363–368,
549–554
Sejong, King, 10
Sensei, 33
Shang Dynasty, 18
Shek, Chiang Kai
Mentioned, xxv
Shikataganai
Definition, 89, 665
Internment camps, 98
Six Companies, 311–314, 620, 621
Smith, JoelT., 61, 64
Snakeheads
Definition, 666
Socrates, 44
Soba
Definition, 666

Solberg, S.E.
 Articles by, 413–422, 515–526, 535–536,
 537–540, 544–547
Sone, Monica, 406–407
Song, Cathy
 Picture Bride, Article, 541–546
Spring and Autumn Period (China, 770–
 464 B.C.), 44–45
Stern, Jenny
 Article by, 513–514
Story Cloths, 591–606
Sun Tze, 8
Suntse Niang Niang, 58
Sushi, 201
 Korean, 202, 204
Suzuki, D.T., 381–393

T

Tagalog, 254
 Definition, 666
 Makeup, 491
 Names of ghosts, 260
Taglish
 Popular culture, 127
Tai Chi Chuan
 Definition, 666
Tai dwole, 25
Tai ji chuan, 230
Tai tai, 25, 30, 468
Takaki, Ronald, 54
Tan, Amy, 335, 361, 431, 447–471, 567
 Joy Luck Club, 447–471, 488, 611, 612
 Lunar New Year, 242
 Mentioned, xiii, xiv, xvi, xxiv, xxvi, xxviii,
 56, 182
Tao
 Definition, 666–667
 Tao jia, 49
 Translation, 7
Tao te Ching, 58
Taoism, 58, 363, 365, 366
 Opposition to Confucianism, 48–49
Taoist, 47, 427
 Names, 32
 Temples, 55
Tea, 219–228
 History, 219
 Plant, 220
 Utensils, 223–228
Tian, 20, 25
 Definition, 457

Tian An Men, 25, 81
 Tiananmen Square, 57, 274
Tinikling
 Definition, 667
 Origin, 128
Toi Hoang, 607–610
Toishanese, 6
Tong, 311–312
 Definition, 667
Toocan
 Definition, 667
Tran, Thuy,
 Article by, 151–169
Triangle of Hate, 97
Tripmaster Monkey, 439
Tydings-McDuffie Act, 321, 485–486
 Chronology, 629

V

Virgin Mary
 Sightings, 130, 255
Visayas, 254
 Definition, 667
 Visayan Ghost, 260
 Visayan Language, 137–138
Vy Trac Do, xxvii

W

Wang, Wayne, xiv, 67, 597–584
 Dim Sum (movie), 493
Warring States Period
 China, 463–222 B.C., 45
Wedding and courtship customs, 567–583
 Chinese, 76
 Dim Sum, 567–583
 Joy Luck Club, 569, 570, 578
Weglyn, Michi, 88
Weltanschauung, 391
Weltreligion (Suzuki's Zen as), 392
White Ladies, 260–261
Whitman, Walt
 "Song of the Redwood Tree," 31
Wilde, Oscar, 60
Wok, 185, 667
Woman Warrior
 Book, 185, 439, 478
 Source of Disney film, "Mulan," 655–666
Wong, Jade Snow, 401–403, 430
Wong, Shawn, 411–412
Woo, David
 Article by, 619–640

World War II, 322
Affects on communities, xxv
Attitudes, 537
Internment camps, 85–112
Vietnam, 608
Wunsch, Marie Ann
Quote, 427

X

Xiaojie, 30
Xing, 29
Xuanzang, 364
Xu of Xiangshan (poet), 377–380

Y

Yamanaka, K. Morgan
Article by, 85–112
Yamamoto, 404–405
Yangban, 527, 538
Definition, 667
"Yellow Peril"
Definition, 667–668
Mentioned, xxv, 35
Yin-Yang, 229

Definition, 463, 668
Foods, 184
Yonsei, 85, 120, 247–248
Definition, 668
Younghill Kang, 423–426
Yuan Dynasty
mentioned, 56
Yue, 18

Z

Zen
D.T. Suzuki's American Zen, 381–393
Rinzai, 383, 386
Tea, 193
Zhong Guo, 25
Zhou, 52
Zhou Dynasty
Characters, 20
Documents, 45–46
History, 15
Mentioned, xxvii
Pronunciation, 3, 6
Zhuxi, 30
Zi, 15, 30